CW00924350

ROMAN COINS AND THEIR VALUES

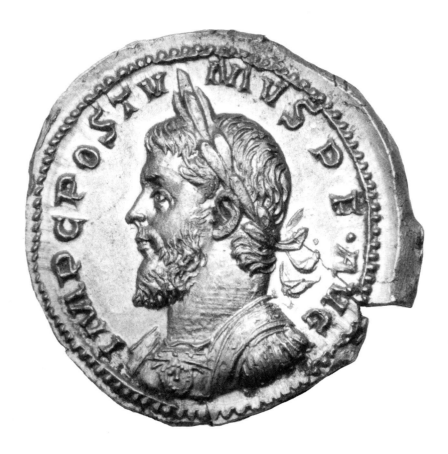

*The Gallic usurper
Postumus depicted on a gold
aureus minted in Cologne,
circa AD 261
(No. 10886 in catalogue; photo by* Andrew Daneman*)*

ROMAN COINS

AND THEIR VALUES

DAVID R. SEAR

Volume III

The 3rd century crisis and recovery
AD 235–285

LONDON 2005

© 2005 Spink and Son Ltd
69 Southampton Row
Bloomsbury
London, WC1B 4ET

ISBN 1-902040-69-4

Set in 8/9pt Times by Columns Design Ltd, Reading
Printed in Great Britain at The University Press, Cambridge

INTRODUCTION

The original edition of Sear's *Roman Coins and Their Values* was published by Seaby in 1964 and subsequently went through four revisions (1970, 1974, 1981 and 1988). However, the publication of Volume I of the 'Millennium Edition' in 2000 marked a radical departure from the previous traditions of this popular work. An expansion of the listings and an increase in the number of illustrations (now fully incorporated in the text) necessitated a new multiple-volume format, like the companion work on Greek coins. Originally envisioned as a two-volume work, it soon became apparent that a third, and now a fourth, volume would be required in order to do justice to the enormity of the subject.

Volume I covered a period of approximately 375 years, from the origins of the Roman coinage in the Republican period in the opening decades of the 3rd century BC down to the violent end of the second Imperial dynasty, the Flavian, in AD 96. Volume II extended coverage of the Imperial series from the accession of Nerva, the 'thirteenth Caesar' and first of the 'Adoptive' emperors, down to the overthrow of the Severan dynasty in 235. It encompassed what may justifiably be termed the 'golden age' of the Roman Imperial coinage. The present volume covers in detail the following half century, a very different period during which the Empire came perilously close to total disintegration under the pressure of foreign invasions and seemingly interminable civil war. The economy also collapsed and with it the Imperial coinage, a desperate situation which was only partially alleviated by the currency reform of Aurelian undertaken late in his reign. It would be left to Diocletian, two decades later, to effect a more fundamental reform which would sweep away for ever the final remnants of the Augustan currency system.

The complexities of the mint attributions in this chaotic period – lacking as they do in almost every instance the name or initial of the responsible mint – have been much facilitated by the pioneering work of Karl Pink, for the reign of Probus and the brief dynasty of Carus, and by the much more recent study of the period of Aurelian and his immediate successors by Sylviane Estiot in the CBN series and Robert Göbl in volume 47 of MIR. To these, and many other scholars, my debt of gratitude is immense.

Volume IV will conclude this comprehensive catalogue of the Roman coinage by covering the pivotal reigns of Diocletian and Constantine I, the later Constantinian dynasty, the houses of Valentinian and Theodosius, the decline and fall of the Empire in the West, and the survival of the eastern Empire under the dynasty of Leo.

Those familiar with the earlier editions of this work will immediately be aware of the transformation which has taken place in the 'Millennium Edition'. The number of types included in the listings shows a dramatic increase and the proportion of illustrated coins is much greater than before. The brief selection of 'Colonial and Provincial Coinage' previously included at the end of each reign has now been replaced by a comprehensive listing of the coins of Roman Egypt struck at Alexandria. Other provincial issues are no longer dealt with here as they receive much fuller treatment in my 1982 book *Greek Imperial Coins and Their Values*.

Throughout the catalogue the current market valuations have been expressed in two currencies (pounds sterling and US dollars) and in at least two grades of preservation

– usually 'VF' and 'EF' for precious metal coins, and 'F' and 'VF' for the billon and bronze issues of Roman Egypt. For regular *aes* denominations (*sestertii*, *dupondii*, *asses*, etc.) valuations in three grades ('F', 'VF' and 'EF') have normally been provided as better preserved specimens of this series are rather more frequently encountered than in the Alexandrian coinage. These changes have resulted from the preferences expressed over the past few years by collectors and dealers with whom I have corresponded or had personal contact. For the sake of clarity, the grades now appear under each catalogue entry; this has the added advantage of allowing more flexibility in expressing valuations for individual types and series which may only occur in lower grades by virtue of their place of mintage or the circumstances of the issue.

Another feature not present in earlier editions is the inclusion of the mint and precise date for each type. Recent scholarship has improved our understanding of the chronology of much of the Roman coinage and I consider it important that collectors and students should benefit from the more accurate information being made available on this important topic. On a similar theme, it will be noticed that a more scientific chronological approach has now been adopted in the presentation of the material, though for ease of reference Cohen's alphabetical arrangement has generally been retained within each denominational listing. Thus, the coins issued in the names of deified emperors and empresses will be found listed under the reign of their issuer. Use of the detailed index and the extensive cross references provided in the text should facilitate the easy location of any required type.

I have long considered the historical background information to be of prime importance in the presentation of catalogue listings of Greek and Roman coinage. Accordingly, I have fully revised the biographical sketches at the commencement of each reign and under certain subsidiary headings. Additionally, readers will notice that much information has been added on the significance of individual coin types within the catalogue itself and cross references provided to similar representations in other series. My invariable aim has been to enhance the enjoyment of the hobby of ancient coin collecting by drawing attention to its potential role as a natural gateway to the study of history. In the case of Roman coins this can lead to a fuller understanding and appreciation of a truly remarkable civilization which lies at the very foundations of our modern culture. As we stand in the opening years of a new millennium I believe it is vital not only to look forward to the future – exciting as that may be – but also to be keenly aware of the events of the past which have brought us to where we are today. Rome has contributed hugely to that past and still exerts a powerful influence on early 21st century society in Europe and America – on our languages, our basic concepts of law and order, and on our governmental institutions. Indeed, it is hardly overstating the case to quote the words of E.A. Freeman in his Introduction to the English translation of Mommsen's *History of Rome:* "The history of Rome is the greatest of all historical subjects, for this simple reason, that the history of Rome is in truth the history of the world".

In conclusion, I should like to express my gratitude to all of those individuals who so willingly gave of their time and expertise in order to assist in the success of this ambitious undertaking. Firstly, I should like to thank those dealers who bravely responded to my request to participate in the updating of current market values by providing their views on price levels of certain basic types within the series. I am keenly aware that this work must frequently have impinged on other more pressing business commitments, and it should serve as an indication of the unselfish attitude of many professionals in the ancient coin trade that they are prepared to make real

sacrifices in the cause of disseminating information to collectors. The following is an alphabetical listing of those who cooperated in this project: Harlan Berk of Chicago, IL.; Giulio Bernardi of Trieste, Italy; Dwayne Bridges of The Roman Connection, Dallas, TX; Tom Cederlind of Portland, OR; Kirk Davis of Claremont, CA; Allan and Marnie Davisson of Cold Spring, MN; Kenneth Dorney of Redding, CA; Matt Geary of Praetorian Numismatics, Philadelphia, PA; Rob Golan of Hillsborough, NC; Ira Goldberg of Beverly Hills, CA; Jonathan Kern of Lexington, KY; Herb Kreindler of Dix Hills, NY; Gavin Manton, formerly of Lennox Gallery Ltd., London; Chris Martin of C.J. Martin (Coins) Ltd., Southgate, London; Michael Marx of M & R Coins, Worth, IL; David Miller of Hemel Hempstead, England; Wayne Phillips of Phillips Ranch, CA; Paul Rabin of Zürich, Switzerland; Steve Rubinger of Antiqua Inc., Woodland Hills, CA; Dr. Arnold R. Saslow of Rare Coins & Classical Arts Ltd., South Orange, NJ; Fred Shore of Schwenksville, PA; Hans Voegtli, formerly of Münzen und Medaillen AG, Basel, Switzerland; and Bill Warden of New Hope, PA. In addition, Rick Ponterio of Ponterio & Associates Inc., San Diego, CA kindly provided many original photographs from his past auctions, and Victor England and Dawn Ahlgren of CNG, Lancaster, PA kindly provided photocopies of articles from their extensive library, as did Andrea Bignasca of Antikenmuseum, Basel, Switzerland. Finally, Jyrki Muona of the University of Helsinki and Curtis Clay of Harlan J. Berk Ltd., Chicago, were both very helpful in supplying information on the recently identified products of the Viminacium mint under Philip I, and Dr. Cathy King of the Heberden Coin Room, Ashmolean Museum, Oxford, provided at very short notice a photograph of the recently discovered antoninianus of the Gallic usurper Domitian. My sincere thanks to them all!

Special mention is due to my good friend Barry Rightman of North Hills, CA, who, over a period of several years, has given unstintingly of his time and numismatic knowledge in categorizing the enormous (but unsorted) photo library from which most of the illustrations for this book have been drawn; and to Andrew Daneman, formerly of Numismatic Fine Arts and now resident in Denmark, whose unparalleled skill as a numismatic photographer has contributed in no small part to the visual impact of this catalogue. As always, my gratitude goes out to my wife Margaret for her sympathetic support during the protracted and frequently frustrating creation process of this complex revision; and to Douglas Saville of Spink & Son and his wife Susan for their unfailing professionalism and friendship.

DAVID R. SEAR
Los Angeles

GLOSSARY

(For a comprehensive treatment of this subject, see John Melville Jones,
'A Dictionary of Ancient Roman Coins')

Abacus	a wooden tablet with moveable counters used for making arithmetical calculations. It is often identified as the object appearing as an invariable attribute of Liberalitas.
Acrostolium	the prow-stem of a warship, i.e. the curved decorative extension of the stem-post.
Adlocutio	(or allocutio), the act of addressing or haranguing a gathering of military personnel, the word normally accompanies a scene depicting the emperor atop a low platform.
Adventus	the arrival of an emperor in Rome or in one of the great provincial centres. Usually accompanying a depiction of him on horseback, but on the coinage of the much-travelled Hadrian also showing him as a standing figure, together with a personification of the region or city of his destination (ADVENTVI AVG GALLIAE, ADVENTVI AVG ALEXANDRIAE, etc.). See also Profectio.
Aegis	a small cloak, decorated with a gorgon's head at the centre, associated in mythology with Zeus (Jupiter) and his daughter Athena (Minerva). It was employed as a decorative feature of the portrait busts of many of the Roman emperors, appearing first on the coinage under Nero.
Aes	non-precious metal (copper, bronze, brass) used for the production of coinage (hence the abbreviation 'Æ').
Ancile	a shield of distinctive form (narrow central section of oval shape with broad curving extensions at top and bottom). It was a particular attribute of Juno Sospita and was associated with the Salian priesthood of Mars.
Aplustre	the curved decorative extension of the stern-post of a warship, usually of spread form composed of several frond-like elements.
Apex	the hat worn by certain Roman priests, originally referring to the rod or spike surmounting the headdress.
Aquila	(see Legionary eagle)
Aspergillum	a whisk or sprinkler associated with religious rituals, appearing on the coinage as a symbol of the Roman priesthood of the Pontifices (this word was not used by the ancient authors and is of relatively modern derivation).
Biga	a chariot drawn by a team of two animals, usually horses.
Billon	an impure alloy containing less than 50% of silver, sometimes declining to less than 5%. It is especially associated with the debased imperial tetradrachms of Alexandria and with the Roman antoninianus denomination in the 3rd century, though it is commonly encountered in the 4th century also.
Binio	a double unit, a term most commonly applied to the gold multiple aurei of the 3rd century which frequently show the emperor with a radiate crown.
Brockage	a mis-struck piece resulting from the failure of the mint personnel to remove a coin which had stuck in the reverse or upper die after minting. As a result, the next blank to be struck received the impression of the obverse of the previous coin instead of that of the reverse die, thus producing a coin with two obverses (one of them incuse and a mirror version of the other). Brockages are most commonly encountered on denarii of the Roman Republic, but

occur also on coins of all denominations in the Imperial series. Reverse brockages are much rarer and more difficult to explain as they would require a new blank to be placed on top of an existing piece which had remained in the obverse or lower die after striking.

Caduceus
the staff of Mercury, messenger of the gods, usually winged and ornamented with snakes.

Carpentum
a two-wheeled enclosed carriage permission to use which in central Rome was initially granted only to married women and, from early Imperial times, was restricted to a very select few. Carpenta appear on coins of a number of empresses in the 1st and 2nd centuries AD, drawn by mules and most frequently in connection with posthumous honours.

Christogram
the Christian monogram, consisting of the Greek letters *Chi* and *Rho* (CR = [Khr]istos).

Cippus
a squared stone pillar, usually bearing a commemorative inscription and set up as a monument or boundary marker.

Cista
(or cista mystica), a basket used for housing sacred snakes in connection with the initiation ceremony into the cult of Bacchus (Dionysus).

Cognomen
one of the three principal elements of a Roman name (*praenomen*, *nomen*, *cognomen*) it indicated the family name of the individual (*e.g.* Gaius Julius CAESAR). Usually acquired by an ancestor as a nickname indicating a personal characteristic the *cognomen* was afterwards inherited, thus becoming a family designation.

Congiarium
a ceremony in which the emperor distributed money to the citizenry. On the coinage of the 1st and 2nd centuries AD it is usually commemorated by an elaborate scene depicting the emperor atop a lofty platform, sometimes accompanied by the personification Liberalitas and with the legend CONGIARIVM or an abbreviated form (see also Liberalitas).

Conjoined
(see Jugate)

Contorniate
late Roman *aes* medallions which appear to have been produced in Rome in the late 4th and 5th centuries and are characterized by an incised border surrounding the obverse and reverse types. The designs are pagan and clearly betray a close connection with the circus and amphitheatre. They may well be associated with the anti-Christian sympathies of many of the late Roman aristocracy. Their purpose is unknown, though it has been speculated that they were used as entrance tokens, as counters in a board game, or as new-year's gifts. Like the earlier non-monetary medallions they have been excluded from this catalogue as they do not form part of the Roman coinage.

Cornucopiae
(plural cornuacopiae), the horn of plenty signifying prosperity, it is usually depicted overflowing with fruits and other agricultural produce. Although occasionally shown on its own, it more commonly appears as an attribute of an allegorical personification.

Curule chair
a folding stool with curved legs, it was symbolic of the highest or 'curule' magistracies in Rome (consulship, praetorship, and curule aedileship). It was said to derive from the seat placed in the royal chariot from which the Etruscan kings dispensed justice.

Decastyle
(see Tetrastyle)

Decennalia
the tenth anniversary of an emperor's rule, marked by the redemption of previous vows (*vota soluta*) and the undertaking of new ones (*vota suscepta*). It was often commemorated on the coinage by a depiction of the emperor sacrificing at an altar or by an inscription within a votive wreath. The quinquennalia (five years) and vicennalia (twenty years) were similarly celebrated, the latter of course far less frequently (see also Vota).

Decursio
a word used to describe rapid military manoeuvres, especially equestrian. Scenes of Nero galloping on horseback, accompanied by one or more of his soldiers, feature prominently on sestertii of AD 64–7.

Designatus	qualifies an individual who has been elected to future office but has not yet taken up the appointment. Most commonly encountered on the Imperial coinage on issues belonging to the end of the year, just prior to the emperor's assumption of a new consulship on January 1st (e.g. COS II DES III P P).
Diademed	wearing a form of head-dress indicating royalty. An eastern custom adopted by the Greek kings and queens of the Hellenistic age, the diadem is not generally worn by Roman emperors until the late Roman period, commencing with Constantine (though empresses are frequently depicted diademed at a much earlier period). The late Imperial diadem was usually ornamented with pearls and/or rosettes.
Die	the stamp from which a coin blank receives its design through the process of striking. Although very few have survived from ancient times, it seems clear that Greek and Roman dies were made of bronze or of iron and bore designs engraved usually in intaglio to produce a coin type in relief. The lower or anvil die would have received the obverse design and was engraved on the flat face of a cylinder which was then inserted into a circular aperture in an anvil block. The reverse die was engraved on the flat face of a cone or wedge. The top of this would have received the hammer blow after it had been placed above the heated blank which was resting on the anvil die. It has been estimated that this simple process could have produced at least ten thousand coins from a single pair of dies, possibly far more in the case of softer precious metals.
Distyle	(see Tetrastyle)
Equestrian	relating to horse-riding, the word derives from the Latin *equus* ('horse') . In the Roman social order the *Equites* formed a class second only to the senators. They originated from men who were selected for their special military abilities and were provided with a horse for the service of the state in wartime.
Exercitus	'army'. Encountered on Hadrian's series of coins issued to honour the provincial armies throughout his Empire (EXERCITVS SYRIACVS, EXERC BRITANNICVS, etc.). More general types celebrate the military establishment with inscriptions such as GLORIA EXERCITVS and VIRTVS EXERCITI. Also used in appeals for loyalty during unsettled times (CONCORDIA EXERCITVVM, FIDES EXERCITVVM).
Exergue	the small space (generally on the reverse of a coin) below the principal type, from which it is usually separated by the 'exergual' line. On the later Roman coinage it was utilized for the main element of the mint mark.
Fasces	literally 'faggots', it was used to describe bundles of rods bound together which, accompanied by an axe, symbolize the authority of the highest Roman magistrates.
Field	the area surrounding the principal obverse or reverse type, in which may be placed subsidiary symbols or letters (often elements of the mint mark on coins of the later Empire).
Flan	(also planchet), the metal blank of correct size and weight which has been prepared for striking between a pair of dies.
Fourrée	a plated counterfeit coin with base metal core, usually in imitation of a silver denomination, though occasionally of gold. This normally indicates an unofficial product, though some fourrée appear to have been produced from official dies at the mint.
Gens	a group of Roman families sharing a common *nomen*, indicated by the second element of a personal name. Thus, Gaius Julius Caesar and the Republican moneyer Lucius Julius Bursio both belonged to the *Gens Julia*, whilst Gnaeus Pompeius Magnus was a member of the *Gens Pompeia* (see also Nomen).

Graffiti	'scratches', letters and other marks scratched on the surface of a coin in ancient times to identify its owner.
Hexastyle	(see Tetrastyle)
Hybrid	(also mule), a coin on which the obverse and reverse designs are incorrectly combined.
Incuse	a design which is recessed into the surface of the flan rather than protruding in relief. Although frequently encountered on Greek coins this characteristic is very rare in the Roman series, being confined to the legends on certain quadrigati and denarii of the Republican series.
Janiform	two heads joined back to back in the manner of the god Janus.
Jugate	(also conjoined), two or more heads placed side by side. Not commonly encountered on Roman coins, though it does appear in both the Republican and Imperial series.
Labarum	a late Roman military standard ornamented with the Christian monogram (Christogram).
Laureate	wearing a wreath composed of laurel leaves. Originally associated with the god Apollo, and the standard head-dress of the emperors until the late Roman period.
Legend	the principal inscription appearing on the obverse and reverse of a coin, as opposed to a mint mark or mark of value.
Legionary eagle	(also aquila), the principal standard of the Roman legion. Normally affixed to a spear, the eagle was usually made of silver, this being the metal visible at the greatest distance.
Liberalitas	a ceremony in which the emperor distributed money to the citizenry. On the coinage of the 2nd and 3rd centuries AD it is usually commemorated by an elaborate scene depicting the emperor atop a lofty platform, accompanied by the personification Liberalitas and with the legend LIBERALITAS or an abbreviated form. Sometimes the figure of Liberalitas appears alone (see also Congiarium).
Lituus	a short curving staff used in religious ceremonies of divination to mark out an area for the observation of birds. It appears on the coinage as a symbol of the Roman priesthood of the Augures.
Lyre	a string instrument with a rounded sound box at the bottom, traditionally made from the shell of a tortoise, and thin curving arms forming the uprights of the frame. It was believed to have been invented by the Greek god Hermes (Roman Mercury).
Manus Dei	'Hand of God', a Christian image which appears on some coins from the late 4th century onwards in the form of a right hand holding a diadem above the emperor's head. The symbolism indicates that the temporal ruler of the Empire is receiving divine sanction for his authority.
Mappa	originally the white napkin dropped by an emperor or magistrate as a starting signal at the Circus, in late Roman iconography it came to be a used as one of the principal attributes of the consuls.
Mint mark	letters and symbols indicating the place of mintage of a coin and sometimes also the responsible workshop (*officina*) within the establishment. The precise form of the mark can often be a useful indication of chronology.
Modius	a measure of wheat, or any dry or solid commodity, containing the third part of an amphora. In form it resembled an inverted bucket standing on three legs. Serapis is usually shown wearing it on his head to denote his portrayal as god of the corn supply.
Mule	(see Hybrid)
Mural crown	(see Turreted)
Nimbate	wearing a nimbus or halo surrounding the head. Indicating an aura of glory or power, it was associated with the sun god Sol (Greek Helios) who was sometimes shown with a radiate nimbus in place of the usual radiate crown.

Antoninus Pius was the first emperor to appear nimbate (on the reverse of a sestertius) and although seen more frequently in the late Roman period it was never a common iconographic feature.

Nomen (see also Gens), one of the three principal elements of a Roman name (*praenomen, nomen, cognomen*) it indicated the clan to which the individual's family belonged (e.g. Gaius JULIUS Caesar). It was borne also by women (with a feminine ending, e.g. JULIA).

Obverse from the Latin obversus ('turned towards') the obverse is the 'front' of a coin bearing what is considered to be the more important of the two designs struck on a flan. The earliest Greek coins bore only a single type engraved on the lower (anvil) die, whilst the upper (punch) die consisted of a simple raised square. This effectively held the flan in place during striking and produced the well known incuse which typifies the reverses of the archaic Greek coinage. The anvil die thus came to be regarded as providing the chief element of a coin's design.

Octastyle (see Tetrastyle)

Officina one of the separate workshops within a mint establishment. From the mid-3rd century AD the products of an officina are often identified by a letter or numeral in the reverse field or exergue. Later, they are sometimes combined with the mint name, e.g. R P = 1st officina of Roma; ANT Δ = 4th officina of Antioch.

Orichalcum brass, a yellowish alloy of copper with zinc. It was used extensively for coinage in the Imperial period, principally for the sestertius and dupondius denominations. As the dupondius was not significantly heavier than its half, the copper as, orichalcum was clearly more highly prized, perhaps being officially overvalued to the benefit of the government.

Palladium a statue of Pallas-Athena (hence the name) reputedly stolen from Troy and subsequently brought to Italy by Aeneas. It was held in great reverence by the Romans who, because of its renowned protective powers, regarded it as the guardian of their city.

Parazonium a short sword or large dagger worn at the waist, it is usually depicted sheathed.

Patera a shallow bowl or dish without handles, it was frequently used in religious ceremonies for pouring libations or scattering grain and salt. It also served as a symbol of the priesthood of the Septemviri Epulones.

Petasus a flat hat, with or without a brim, especially associated with Mercury (Greek Hermes), the messenger of the gods. When depicted on Roman coins the petasus of Mercury is normally winged as an indication of his swiftness.

Pileus a conical felt hat associated with the Dioscuri (Castor and Pollux), twin sons of Jupiter; with Vulcan (Greek Hephaistos), god of iron and fire; and with Ulysses (Greek Odysseus), hero of Homer's *Odyssey*. The pileus was also symbolic of freedom, as it was given to former slaves who had been granted their freedom, hence its use as a symbol of Libertas.

Planchet (see Flan)

Plated (see Fourrée)

Praenomen one of the three principal elements of a Roman name (*praenomen, nomen, cognomen*) it indicated the personal name of the individual within his family (e.g. GAIUS Julius Caesar). It was selected from a relatively small number of recognized *praenomina*, the most common of which were Aulus (abbreviated A.), Decimus (D.), Gaius (C.), Gnaeus (Cn.), Lucius (L.), Marcus (M.), Publius (P.), Quintus (Q.), Servius (Ser.), Sextus (Sex.), Tiberius (Ti.), and Titus (T.).

Profectio the departure of an emperor from Rome at the commencement of a journey or military campaign. He is usually shown mounted, though is sometimes on foot (see also Adventus).

Quadriga	a chariot drawn by a team of four animals, usually horses.
Quinquennalia	(see Decennalia)
Radiate	decorated with rays, like those of the sun, this term is usually applied to the spiky crown sometimes worn by emperors as an alternative to a wreath. Normally indicating a double denomination (dupondius = two asses, antoninianus = two denarii) it derives from the headdress of the sun-god Sol (Greek Helios) and implies an association of the emperor with the divinity. The equivalent attribute for empresses was a crescent moon behind the shoulders, symbolic of the goddess Luna (Greek Selene).
Redux	'bringing back', this epithet was often applied to the goddess Fortuna in the sense that she was being invoked to protect the emperor on his return journey to Rome, both by sea and by land (the former represented by Fortuna's attribute of a rudder, the latter by a wheel placed beneath the seat of her throne or beside her standing figure).
Reverse	from the Latin *reversus* ('turned away') the reverse is the 'back' of a coin bearing what is considered to be the subordinate of the two designs struck on a flan. The earliest Greek coins bore only a single type engraved on the lower (anvil) die, whilst the upper (punch) die consisted of a simple raised square. This effectively held the flan in place during striking and produced the well known incuse which typifies the reverses of the archaic Greek coinage. The punch die thus came to be regarded as providing only the secondary element of a coin's design.
Rostrum	the beak or ram of a warship, often with three prongs (*rostrum tridens*). Those captured by C. Maenius from the fleet of the neighbouring city of Antium in 338 BC were used to adorn the speakers' platform in the Roman Forum. Thus, this structure acquired the name *rostra* ('beaks'), hence the word rostrum in modern English.
Serratus	*serrati* were Roman Republican denarii with notched or serrated edges, produced by chiselling the blank prior to striking. This practice was confined to specific issues and was especially common in the late 2nd century BC through the early decades of the 1st century. The reason for the contemporaneous production of *serrati* and regular denarii remains uncertain.
Signum	(see Standard)
Simpulum	an earthenware ladle with long handle used by the Pontifices for pouring wine at sacrifices. It appears on the coinage as a symbol of this important priesthood.
Sistrum	a ceremonial rattle which appears as an attribute of the Egyptian goddess Isis. It is also held by the personification of the province *Aegyptus* on Hadrian's coinage commemorating his visits to various parts of the Empire.
Standard	a military ensign (*signum*) borne by a *signifer* as an emblem of a cohort within a legion. It took the form of a pole or spear surmounted by a hand and with additional decorations on the shaft, including *phalerae* (metal discs), wreaths, and emblems commemorating the battle honours won by the unit.
Tetrastyle	used to describe a building (usually a temple) showing four columns along its façade. Also distyle (two columns), hexastyle (six columns), octastyle (eight columns), and decastyle (ten columns).
Thyrsus	the staff of Bacchus (Greek Dionysos) usually surmounted by a pine cone and wreathed with tendrils of vine or ivy.
Togate	clad in a toga, the cloak worn by Roman citizens on formal occasions.
Trident	a three-pronged fishing spear, the regular attribute of Neptune.
Triga	a chariot drawn by a team of three animals, usually horses.
Tripod	a three-legged stand, usually serving to support a seat or a large bowl (*cortina* = Greek *lebes*). It was especially associated with Apollo, because the priestess of the god at Delphi transmitted prophecies while seated on a

	tripod. At Rome, it also served as a symbol of the priesthood of the Quindecimviri Sacris Faciundis, who had charge of the Sibylline oracles.
Triskeles	(Latin *triquetra*), 'three-legs', a device comprising three human legs joined at the hip and radiating from a central point. On Roman coins it symbolizes Sicily. Because of its shape, the island was sometimes called *Trinacria* ('three-cornered').
Trophy	the arms of a vanquished enemy, attached to a vertical shaft with cross piece, set up to commemorate a notable victory and often appearing on coins with captives at its foot.
Turreted	wearing a crown in the form of a city wall with towers or battlements (normally an attribute of Cybele or a city goddess and often called a mural crown).
Vexillum	a military standard consisting of a square-shaped piece of cloth bearing a device suspended from a cross bar attached to a pole. Originally a standard of the legionary cavalry, in Imperial times it was used by auxiliary cavalry units (*alae*) and was borne by the senior standard-bearer, the *vexillarius*. It was also used by detached units (*vexillatio*). Its primary function seems to have been that of a commander's flag used for signalling. Miniature vexilla were awarded as military decorations.
Vicennalia	(see Decennalia)
Victimarius	an attendant at a ceremonial sacrifice whose task was to slay the sacrificial animal.
Vota	(plural of *votum*). A vow made to a god in order to obtain a divine favour stipulated in advance. The granting of the request obliged the vower to fulfil his promise. This usually took the form of a sacrifice to the deity or an offering to his (or her) temple. Public *vota* in Imperial times were normally for the welfare of the emperor over a stated period of time (five or ten years) and were regularly undertaken (*vota suscepta*) and hopefully paid (*vota soluta*). Sometimes they were more specific, relating to the safety of the emperor on a particularly hazardous journey or military campaign, or the current state of his health. The undertaking and fulfillment of these public vows was frequently recorded on the coinage and in the late Empire especially may provide useful evidence for the chronological arrangement of issues (see also Decennalia).

LEGEND ABBREVIATIONS

Roman coin inscriptions contain numerous abbreviations which are rarely separated by punctuation marks. The following are amongst the commonest forms and collectors should try to familiarize themselves with these before attempting to transcribe legends.

AVG
= *Augustus*, the honorific title bestowed on Octavian by the Senate on 16 January 27 BC and thereafter adopted by all of his successors as an indication of their supreme authority. [On some earlier coins of the Imperatorial period the abbreviation 'AVG' may be used to designate membership of the Augures, one of Rome's four principal priestly colleges].

C or CAES
= *Caesar*, originally a *cognomen* of the Julia *gens*. In 49 BC Gaius Julius Caesar (later dictator) initiated the period of civil conflict which led to the downfall of the Republic and the establishment of autocratic rule under his heir, Octavian (Augustus). After the extinction of the Julio-Claudian dynasty Caesar was adopted as an imperial title by their successors. It was also borne by the heir to the throne prior to his assumption of supreme authority.

CONOB
= *Constantinopolis Obryza*, 'Pure Gold of Constantinople'. This form of mint mark, appearing in the exergues of late Roman and Byzantine solidi and fractional gold denominations, had its origins in the second half of the 4th century. 'Obryza', a word of obscure derivation, indicated that the gold from which the coin had been struck had been tested and was guaranteed pure. Initially, other mints employed a similar formula (ANTOB for Antioch, MDOB for Mediolanum, etc.) but eventually CONOB came to be utilized universally, without regard to the actual place of mintage. An important variation appearing at a number of western mints was COMOB. This may have had a slightly different meaning, the COM possibly indicating the office of *Comes Auri* ('Count of Gold'), the official charged with the responsibility of supervising the Imperial gold supplies in the western provinces of the Empire (see also under MINTS AND MINT MARKS OF THE LATER ROMAN EMPIRE).

COS
= *Consul*, the highest annually elected magistracy of the Roman Republic. From 509 BC until the fall of the Republic two consuls were appointed each year to act as temporary heads of state. Consuls continued to hold office under the Imperial constitution and quite frequently the emperor himself, or his heir, occupied the position (see also under 'DATING ROMAN IMPERIAL COINS').

D N
= *Dominus Noster*, 'Our Lord'. Introduced under the First Tetrarchy in the early years of the 4th century AD. Common after the middle of the century when it replaced IMP (erator) at the beginning of inscriptions.

DD NN
= *Dominorum Nostrorum*, the plural of *Dominus Noster*.

III VIR/IIII VIR
= *Triumvir/Quattuorvir*, 'One of Three/Four Men'. This title was used to describe the annual mint magistrates (usually three in number, but sometimes four) of the Republic and early Empire. This appointment formed an important step in the progression (*cursus honorum*) of a public career, possibly leading to an eventual consulate. The full title was *Tres Viri/Quattuor Viri Aere Argento Auro Flando Feriundo* ('Three/Four Men for the Casting [and] Striking of Bronze, Silver [and] Gold'). This sometimes appears on the coinage, notably the reformed *aes* denominations of Augustus where it is rendered as III VIR A A A F F.

III VIR R P C	= *Triumvir Reipublicae Constituendae*, 'One of Three Men for the Regulation of the Republic'. The title adopted in November of 43 BC by the three Caesarian leaders (Mark Antony, Octavian and Lepidus) when they formed the Second Triumvirate to oppose the tyrannicides Brutus and Cassius.
IMP	= *Imperator*, 'Commander'. Under the Republic it came to designate a victorious general whose success was enthusiastically acclaimed by his troops. For its later development as an Imperial title, see under 'DATING ROMAN IMPERIAL COINS'.
PERP or PP	= *Perpetuus*, 'Continuous'. In the early Empire this indicated the holding of a specific office for life, e.g. CENS(or) PERP(petuus) under Domitian. However, from the late 5th century into Byzantine times it replaced the traditional 'P F', standing on its own as an Imperial title immediately preceding that of Augustus.
P F	= *Pius Felix*, 'Dutiful' (to the gods, the State, and to one's family) and 'Happy' (in good fortune and success). From the mid-3rd to the late 5th centuries AD these titles often immediately preceded that of Augustus, until superseded by 'PP' (*Perpetuus*).
P M	= *Pontifex Maximus*, 'Greatest of the Pontifices'. The sixteen Pontifices formed one of the four senior colleges of priests in Rome and were charged with the supervision of ceremonies connected with the state religion. The head of the Pontifices was the Pontifex Maximus (a title still borne by the Pope today). Augustus received the title in 13 BC on the death of its last Republican holder, the former Triumvir Lepidus. Thereafter, it was normally assumed by each emperor at the time of his accession (see also under 'DATING ROMAN IMPERIAL COINS').
P P	= *Pater Patriae*, 'Father of his Country'. Augustus received this title in 2 BC and it was subsequently adopted by most of his successors at the time of their accession (see also under 'DATING ROMAN IMPERIAL COINS'). An earlier version (*Parens Patriae*) had been bestowed on Cicero after his exposure of the Catiline conspiracy in 63 BC and on Caesar in the final months of his life.
S C	= *Senatus Consulto*, 'by Decree of the Senate'. Sometimes expressed more fully as EX S C. Referring to the authority by which the issue was made. Appears on most Imperial *aes* until the mid-3rd century, but also occasionally on precious metal issues of the Republic and early Empire.
S P Q R	= *Senatus Populusque Romanus*, 'The Roman Senate and People'. The traditional formula expressing the joint authority of the conscript fathers and the common citizenry. Although having little meaning in Imperial times it continues to appear quite regularly on the coinage down to the time of Constantine the Great.
TR P	= *Tribunicia Potestas*, 'Tribunician Power'. Established in the early days of the Republic, the office of Tribune of the Plebs ultimately carried with it wide ranging powers and protections, including inviolability of person. On 1 July 23 BC Augustus obtained a lifetime grant of the tribunician power, an important step in the establishment of an autocracy as it gave him the absolute right of veto as well as the authority to convene the Senate. The tribunician power was generally assumed at the commencement of each new reign, though some emperors had already received it during their predecessor's reign (e.g. Tiberius, Titus, Marcus Aurelius, etc.). It is of special interest when followed by a numeral as this allows a coin to be assigned to its precise year of issue, the tribunician power being renewed annually for the purpose of regnal dating (see also under 'DATING ROMAN IMPERIAL COINS').

THE DENOMINATIONS OF THE ROMAN COINAGE

The earliest coinage of central Italy, known as *Aes Grave*, was of bronze, the various pieces being cast and not struck. Previous to the currency of these, irregular lumps of bronze (*Aes Rude*) and cast bronze bars or ingots bearing designs on both sides (*Aes Signatum*) were in use, although these may have been used as bullion exchangeable by weight rather than as money. *Aes Grave* was first issued by the Roman Republic about 280 BC, but the Romans soon realized that in order to facilitate commerce with other Italian and and non-Italian states it was also necessary to have a more convenient coinage comprising silver denominations and struck bronzes. Accordingly, they introduced silver *didrachms* and bronze *double litrae* and *litrae* closely resembling the coinages of the cities of Magna Graecia. Some years later, between the First and Second Punic Wars, the coinage underwent certain modifications. This resulted in the introduction of a new series of *Aes Grave*, the standardized types of which were subsequently adopted as the norm for most of the later issues of Republican bronze; and a fundamental change in the design of the silver coinage, which saw the large scale production of *quadrigatus-didrachms* bearing a janiform head of the Dioscuri on obverse and Jupiter in a four-horse chariot (quadriga) on reverse. The following table shows the obverse types and relative values of the various bronze denominations, the common reverse type being the prow of a galley:

As	head of Janus	mark of value I	= 12 *unciae*
Semis	head of Saturn	mark of value S	= 6 *unciae*
Triens	head of Minerva	mark of value 4 pellets	= 4 *unciae*
Quadrans	head of Hercules	mark of value 3 pellets	= 3 *unciae*
Sextans	head of Mercury	mark of value 2 pellets	= 2 *unciae*
Uncia	head of Roma	mark of value pellet	

(The mark of value is usually shown on both sides of the coin).

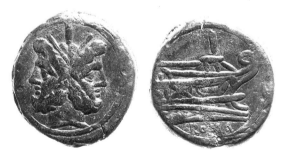

Struck bronze as of 211–206 BC (no. 627)

In the closing years of the 3rd century BC the crisis of the Second Punic War was responsible for a complete restructuring of the Roman currency system. The *Aes Grave* underwent a rapid series of weight reductions and were gradually superseded by lighter struck bronze coins, the transition being complete by *circa* 211 BC. The same date also saw the abandonment of the silver *quadrigatus-didrachm* in favour of the *denarius*, a smaller and lighter piece valued at 10 *asses* (mark of value X). Seven decades later the *denarius* was re-tariffed at 16 *asses* (mark of value XVI), a value

Aes Grave as of 225–217 BC (no. 570)

Silver didrachm of 280–275 BC (no. 22)

Silver quadrigatus-didrachm of 215–213 BC
(No. 32)

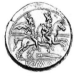

Silver denarius of 206–194 BC (no. 54)

Silver victoriatus of 211–206 BC (no. 49)

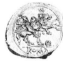

Silver quinarius of 211–206 BC
(no. 44)

Silver sestertius of
211–206 BC (no. 46)

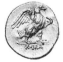

Gold 60-as of 211–208 BC
(no. 3)

which it retained into the Imperial period. The *denarius* was destined to be the principal denomination of both the Republican and the Imperial monetary systems until its replacement by the *double denarius* (*antoninianus*) in the mid-3rd century AD. At the same time as the inauguration of the *denarius* (*circa* 211 BC) two fractional silver pieces were also introduced. However, the *quinarius* or *half denarius* (mark of value V = 5 *asses*) and the *sestertius* (mark of value IIS = 2 asses and a semis) were struck only for the first few years following the reform of *circa* 211 BC, though both were to be revived at a much later date. The *victoriatus* (so-called because of its reverse type of Victory crowning a trophy) was another new denomination resulting from the reform of *circa* 211 BC. In weight it was the same as the pre-reform *drachm* or *half quadrigatus* and was the equivalent of three-quarters of the *denarius*. Its primary purpose was for circulation amongst Greek communities, principally those of southern Italy, but with the expansion of Rome's horizons following her victory over the Carthaginians in the Second Punic War the denomination gradually lost its importance and was finally discontinued about 170 BC.

 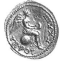

Gold aureus of Brutus, 42 BC Gold quinarius of Tiberius (no. 1761 var.)
(no. 1430)

Gold coins were seldom issued and formed no part of the regular coinage in the Republican period. They were struck usually for military purposes at times of emergency and all types are now rare. In the period of civil strife following the assassination of Julius Caesar on the Ides of March, 44 BC, gold was issued by and for many of the contenders for political power, notably the Triumvirs Mark Antony and Octavian and the Republican leaders Brutus and Cassius. The gold issues of Octavian (later Augustus) eventually evolved into the first Roman Imperial gold coinage.

No regular Republican bronze was issued after about 82 BC, but once Augustus had achieved supreme power and restored peace to the Roman world he resumed the large scale production of *aes* as part of his re-organization of the currency system (*circa* 18 BC). Authority for the minting of gold and silver was retained by Augustus, but the orichalcum (brass) and copper coins were issued under the nominal control of the Senate, as evidenced by the ubiquitous formula 'S C' (*Senatus Consulto*). Initially, the names of the responsible moneyers appeared prominently on the Augustan *aes* (as on the coinage of the Roman Republic), but this practice ceased after about 4 BC.

Gold issues now became a regular part of the coinage and the various denominations of the re-organized system are shown in the following table:

Gold *aureus*	=	25 silver *denarii*
Gold *quinarius*	=	12½ silver *denarii*
Silver *denarius*	=	16 copper *asses*
Silver *quinarius*	=	8 copper *asses*
Brass *sestertius*	=	4 copper *asses*
Brass *dupondius*	=	2 copper *asses*
Copper *as*	=	4 copper *quadrantes*
Brass *semis*	=	2 copper *quadrantes*
Copper *quadrans*		

Copper as of Tiberius (no. 1770) Copper quadrans of Augustus (no. 1693)

The *dupondius* and *as*, though of similar size, could be distinguished by the colour of the metal (yellow brass, red copper), the radiate head of the emperor only coming into use as a regular feature of the former coin at a later date. Other than a small early Augustan issue the silver *quinarius* was not struck during the Julio-Claudian period. It was revived by Galba in AD 68 and thereafter its production continued under the Flavian emperors and their successors.

 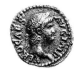

Silver cistophorus of Claudius (no. 1838) Brass semis of Nero (no. 1979)

At certain Asian mints – notably Ephesus and Pergamum – Augustus and some of his successors continued to strike the large silver pieces known as *cistophori*, equal in value to three *denarii*. Coins of this size and value, bearing as one of their types the Dionysiac snake-basket or *cista mystica*, had been the chief currency of the kingdom of Pergamum in Asia Minor (later the Roman province of Asia) from early in the 2nd century BC. Although in the Imperial period the types of the *cistophorus* were more in accord with the general style of Roman issues the coin was still recognizable to the people of *provincia Asia* and readily passed current.

Nero (AD 54–68), who, with all his faults, was a man of innovation and artistic appreciation, took a keen interest in the Imperial coinage and this led him to institute the experimental issue of an *as* and a *quadrans* struck in orichalcum (brass) in addition to those of copper. Whether his ultimate intention was to discard copper altogether is uncertain, but with the exception of a few isolated issues the experiment did not survive his suicide in AD 68 which ended the Julio-Claudian dynasty.

Brass *sestertii* of the 1st and 2nd centuries AD are amongst the most attractive of all the coins in the Roman series. They frequently bear interesting types which, because of the large size of the flan, are rendered in great detail, thus adding to the visual impact of these handsome pieces. When in the finest condition *sestertii* are much sought-after by collectors and consistently realize high prices. Although their smaller flans do not provide the same scope, the *dupondii* and *asses* also are

Brass sestertius of Hadrian

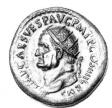

Brass dupondius of Vespasian　　　　　Silver quinarius of Domitian

often beautiful examples of the Roman engraver's art. In the 3rd century, however, the weight and the artistic level of the *sestertius* and its fractions underwent a decline. In fact, by the time the Emperor Trajan Decius (AD 249–51) introduced his experimental *double sestertius*, showing the emperor wearing a radiate crown, the coin weighed little more than many of the *sestertii* of the Julio-Claudian era. Although not continued by Decius' immediate successors, the *double sestertius* was incorporated into his *aes* coinage by the Gallic usurper Postumus (AD 260–268).

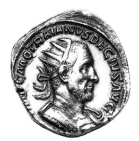

Brass double sestertius of Trajan Decius　　　Gold aureus of Nero (no. 1927)

The weight of the *aureus* and the *denarius*, as well as the fineness of the latter, were reduced by Nero as part of his currency measures undertaken in AD 64. Successive emperors – always pressed for money – carried on the evil process until, by the reign of Caracalla, the *denarius* contained barely 40% silver. This emperor further debased the coinage by introducing a new denomination of similar metal which, although only equivalent in weight to about one and a half *denarii*, was

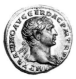

Silver denarius of Trajan Silver antoninianus of Pupienus

apparently officially tariffed as the equivalent of two. This new piece, which we know as an *antoninianus* (after Caracalla's official name Antoninus), always shows the emperor wearing a radiate crown instead of the laurel-wreath of the *denarius*. In the case of empresses, the larger silver denomination is distinguished by the addition of a crescent placed beneath the bust.

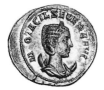

Silver antoninianus of Otacilia Severa Billon antoninianus of Aurelian

By the middle of the 3rd century the *antoninianus* had driven the *denarius* out of circulation. With the acute political and economic crisis which was afflicting the Empire at this time the *antoninianus* became increasingly debased until, by the latter part of the sole reign of Gallienus (AD 260–68), it was reduced to a mere base metal coin of diminished size with only a tiny silver content. Aurelian, in his reform of the coinage (*circa* AD 273), restored the *antoninianus* to something like its original size and fixed the silver content at about 5% (perhaps indicated by the 'XXI' mark which it frequently bore in the exergue). He also revived the *denarius* (struck in the same metal as the *antoninianus*) and attempted to reintroduce *aes*, principally *asses*. Prior to this reform *antoniniani* of Gallienus' successor Claudius II Gothicus (AD 268–70) and of the Gallic usurper Tetricus (AD 270–73) had been extensively imitated by unofficial mints in the West, chiefly in Britain and Gaul. Although sometimes reasonably competent copies of the originals, many of these *'barbarous radiates'* are quite grotesque as well as being much smaller than the officially minted coins. With Aurelian's reconquest of the Gallic Empire and his subsequent measures to regularize the currency these imitations were demonetized and quickly disappeared from circulation.

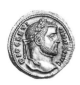 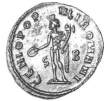
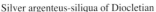

Silver argenteus-siliqua of Diocletian Billon follis of Diocletian

Thus, by the closing decades of the 3rd century, Rome's Imperial coinage bore little resemblance to the system instituted by Augustus almost three centuries before. The silver coinage had become hopelessly debased; *aes* production had virtually ceased, despite Aurelian's attempt to

restore it in AD 273; and gold, though still retaining its fineness, was no longer struck on a consistent weight standard. The time was ripe for radical reform and, beginning about AD 294, the Emperor Diocletian undertook a series of measures with the object of restoring confidence in the Imperial coinage. The most important of the changes was the introduction of two new denominations: the *siliqua* (commonly referred to as the *argenteus*), a silver coin of approximately the same weight and fineness as the reformed Neronian *denarius*; and the *follis*, a large billon coin containing about 5% silver. Production of the *antoninianus* was now discontinued, though a coin of similar appearance remained in issue for about a decade following the reform. This piece no longer bore the mark 'XXI' on the reverse and it contained no trace of silver. It is referred to in this catalogue as a *post-reform radiate*.

 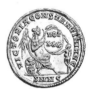

Bronze post-reform radiate of Diocletian Gold solidus of Constantine I

Constantine the Great (AD 307–37) made further changes to the monetary system. In place of the *aureus*, which was currently being struck at 60 to the pound of gold (5.4 grams), he introduced into the western provinces a new and lighter coin called the *solidus*, which was produced at 72 pieces to the pound (4.5 grams). With the defeat of Constantine's eastern rival Licinius (AD 308–24) production of the *solidus* became universal throughout the Empire. The *aureus* was still occasionally struck thereafter, but its issue was generally confined to the celebration of special occasions. Two gold fractional denominations accompanied the *solidus*, though they were never produced in the same quantities as the larger piece. The *semissis* was the equivalent of a *half solidus*, while the *9–siliqua* piece (also called the *one and a half scripulum*) was the equivalent of three-eighths of a *solidus*. Before the end of the 4th century this curious and seemingly inconvenient denomination was replaced by a *one-third solidus* or *tremissis*.

 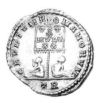

Silver argenteus-siliqua of Constantius II Silver miliarensis of Constans

In AD 325 Constantine resumed production of the Diocletianic *siliqua* or *argenteus* which had lapsed after about AD 310. At the same time he introduced the larger silver *miliarensis* which was one-third heavier than the *siliqua* (four scruples instead of three) and the same weight as the gold *solidus* (4.5 grams). A few years later, after the death of Constantine, a heavier version of the *miliarensis* was introduced. This '*heavy miliarensis*' was struck at 60 to the pound, the same weight as the old gold *aureus* (5.4 grams). Both versions of the *miliarensis* remained in issue over a considerable period of time, extending even into the Byzantine period. The *siliqua*, however, soon underwent some fundamental changes. About AD 357 Constantius II, the last surviving son of Constantine I, reduced the weight of the *siliqua* from 1/96 of a pound (3.375 grams or three

scruples) to 1/144 pound (2.25 grams or two scruples). In consequence, the lighter version of the *miliarensis* now became a *double siliqua*.

 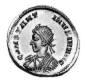

Silver reduced siliqua of Julian II Billon centenionalis of Constantine II

The late Roman bronze coinage presents many problems. The billon *follis* denomination, introduced by Diocletian in the final decade of the 3rd century, soon began to decline in size and weight. Its original weight of about 10 grams was, by *circa* AD 318, down to about one-third of that level and it became clear to Constantine that measures needed to be undertaken to stabilize the situation. Accordingly, a new billon coin, weighing a little over 3 grams, was introduced at this time at the mints under the western emperor's control. This was extended to all the mints of the Empire after the defeat of Licinius in AD 324. The name of this new coin is not certainly known, though it appears likely that it was called a *centenionalis* (most cataloguers refer to it simply as '*Æ 3*'). In AD 330 the weight of the *centenionalis* itself began to decline, just as its predecessor had done, and by AD 336 its weight was down to a mere 1.7 grams. With the political troubles consequent on Constantine's death in 337 remedial measures were delayed for more than a decade and it was not until about AD 348 that Constantius II and Constans reformed the bronze coinage by introducing

 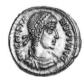

Billon maiorina of Constantius II Billon half maiorina of Constans

several new denominations to replace the *centenionalis* – the billon *maiorina*, struck on two weight standards (5.2 grams and 4.5 grams) and a *half maiorina*, weighing about 2.6 grams. Once again, the nomenclature is not certain and the *maiorina* has frequently been referred to in previous catalogues as a *centenionalis*. Unfortunately, the new arrangement was destined to have the same chequered history as its predecessors, with a rapid decline in size and weight culminating in a tiny billon piece weighing only 1.9 grams by the end of Constantius' reign in AD 361. The picture was further complicated by the issues of a western usurper Magnentius (AD 350–53) who, in obvious financial straits towards the end of his reign, attempted to replace the billon *maiorina* with a larger bronze piece. This initially weighed over 8 grams, but underwent a series of rapid reductions as the rebel regime neared its violent end.

A final brave attempt to revive the ailing late Roman bronze coinage was made by Julian II late in his reign (AD 363). Interestingly, the introduction of a large billon piece weighing about 8.25 grams looks remarkably like an attempt to restore the Diocletianic *follis*, inviting speculation that the pagan emperor had the deliberate intention of reverting to the last coinage reform of pre-Christian times. The experiment was, of course, short-lived and the denomination was soon abandoned by his Christian successors. More lasting was another denomination introduced by Julian – a bronze '*Æ 3*' weighing just under 3 grams and closely resembling the Constantinian billon *centenionalis* of AD 318. This revived *centenionalis* survived into the 5th century and although, like

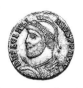

Billon restored follis of Julian II Bronze restored centenionalis of Julian II

other 4th century bronze denominations, its weight tended to decline with the passage of years there was actually an attempt to restore it to its original level in AD 395. Another bronze denomination which appeared in the closing decades of the 4th century was an '*Æ 2*' introduced by the western emperor Gratian *circa* AD 379. Although struck in bronze rather than billon, this piece was otherwise reminiscent of the *maiorina* introduced three decades before and may be considered a revival of that denomination. It was to last until AD 395 when it was demonetized under the terms of a rescript preserved in the *Codex* Theodosianus (ix. 232), though there were still a few isolated

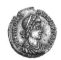

Bronze restored maiorina of Theodosius I

Bronze half centenionalis
or nummus of
Magnus Maximus

issues of '*Æ 2s*' during the course of the 5th century. Also appearing about AD 379 was a new '*Æ 4*' denomination, presumably representing the half of the revived *centenionalis*. This diminutive coin was to have a much longer history, eventually becoming the only bronze denomination in regular issue as the disastrous 5th century progressed. Also known as the *nummus*, the latest miserable examples of the '*Æ 4*' frequently weigh less than 1 gram, being almost indistinguishable from imitations produced by the various barbarian tribes who were now invading and occupying former Roman territory. Unofficial 'barbarous' copies of late Roman bronze coinage had been produced from Constantinian times onwards, many of them imitated from the post-348 *maiorinae* of Constantius II with reverse legend **FEL TEMP REPARATIO** and type soldier spearing fallen horseman.

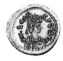

Gold semissis of Zeno Gold tremissis of Leo I

In AD 498 the Emperor Anastasius carried out a sweeping reform of the bronze coinage. This introduced a whole new range of denominations, each being a multiple of the old *nummus* and bearing its mark value conspicuously on the reverse (*e.g.* M = *40 nummi*, K = *20 nummi*, I = *10*

nummi, etc.). As the introduction of these novel coins marks an almost complete break with the traditions of the Roman coinage, the Anastasian *aes* reform has been considered a convenient point at which to commence the Byzantine series, though no adjustments to the precious metal coinage were made at this time.

THE REVERSE TYPES OF THE IMPERIAL COINAGE

Although most collectors of Roman Imperial coins begin by attempting to acquire a selection of portraits of the emperors and their families, it is in the remarkable array of reverse types that the unique interest and historical value of the series will be found. Moreover, a sound knowledge of these types will often make it possible to attribute a coin even when the legends are obscure (especially important when coins from excavations are being used as archaeological evidence).

I. DEITIES AND PERSONIFICATIONS

In the following notes it is proposed briefly to outline the more important types (the chief deities of the Roman pantheon and a few other divinities which achieved great popularity in the Roman World) and their customary attributes, after which the principal personifications, which constitute the majority of the reverse types, will be dealt with.

As of Caracalla

Aesculapius. The god of medicine and healing, he is shown as a man of mature years, holding a staff about which a snake twines. He is often accompanied by a small figure representing his attendant, Telesphorus.

His image appears on Roman Provincial ('Greek Imperial') coins at a number of mints, including Epidaurus, where the great temple of **Asklepios** was situated, and Pergamum, where there was a celebrated sanctuary of the god (the Asklepieion) which was greatly embellished during the reign of Hadrian.

Antoninianus of Trebonianus Gallus (Apollo)

Apollo. The sun-god, Apollo, was also god of music and the arts, of prophecy, and the protector of flocks and herds: he is usually depicted with a lyre. Amongst his titles are CONSERVATOR, PALATINVS (as protector of the imperial residence on the Palatine), and PROPVGNATOR. He appears at intervals on the Imperial coinage from Augustus to Carausius and then, like most pagan types, falls out of use in the 4th century.

On Roman Provincial coins Apollo is a frequent type, appearing on the Alexandrian series as Apollo Aktios or Pythios, and on coins of Ephesus with the title Hikesios, indicating his role as protector of suppliants. On colonial bronzes of Apamea he is named APOLLO CLARIVS, after his sanctuary at Clarus near Colophon. More commonly encountered are depictions of the god without name or title.

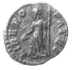

Denarius of Septimius Severus

Bacchus. Under his ancient Italian name of **Liber,** the god of wine occasionally appears as a coin type. He is generally shown holding a wine-cup and thyrsus and is accompanied by his attendant panther. Sometimes his head only is depicted, crowned with vine or ivy leaves. On a coin of Gallienus the panther appears on its own, with the legend LIBERO P CONS AVG. Few emperors, however, adopted Bacchus as a coin type.

In the Roman Provincial series, however, **Dionysos** was a very popular type and occurs on the coins of many cities.

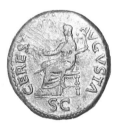

Dupondius of Claudius

Ceres. In the 1st and 2nd centuries AD Ceres appears frequently as a coin type and is generally shown holding ears of corn to symbolize her function as presiding goddess of agriculture. Sometimes she bears a torch to signify her search in the darkness for her lost daughter Proserpina, who had been abducted to Hades by Pluto. The epithet most most commonly applied to her is Frugifera ('bearing fruits').

On Roman Provincial coins she appears as the goddess **Demeter,** sometimes accompanied by her daughter Persephone (the Greek name for Proserpina).

Aureus of Julia Domna (Cybele)

Cybele. Of Asian origin, the Mother of the Gods was not commonly depicted as a Roman coin type, except in the 2nd and early 3rd centuries AD. She is usually shown wearing a turreted crown and holding a tympanum (small drum or tambourine), and is either in a car drawn by lions or enthroned between the animals. The accompanying legend is normally MATER DEVM or MATRI MAGNAE, or a similar variant.

Many Greek cities have **Kybele** on their coins during the Imperial period, her cult being very popular in Asia Minor.

Sestertius of Faustina Junior

Diana. The sister of Apollo, Diana was regarded as the moon-goddess and is sometimes represented with a lunar crescent above her forehead. When given the title of LVCIFERA ('the light-bringer') she is depicted holding a long torch, symbolic of moonlight. She was also protectress of the young and deity of the chase. In the latter role she is equipped with bow and arrows and is sometimes accompanied by a hound or deer. Her other titles include CONSERVATRIX and VICTRIX. As DIANA EPHESIA she appears as a cultus-figure on Asian cistophori of the reigns of Claudius and Hadrian.

The most famous shrine of Diana (or **Artemis** as she was called by the Greeks) was the celebrated Artemision at Ephesus, one of the Seven Wonders of the World. It is mentioned in the *Acts of the Apostles* (19, 27) and some of the local issues of the city show the statue of Artemis Ephesia either alone or within a representation of the famed temple. The cult of Artemis Ephesia was widespread and was honoured on the coinages of many cities, utilizing similar types.

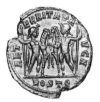

Follis of Maxentius

The Dioscuri. The twins Castor and Pollux, sons of Jupiter and Leda, appear frequently on the Republican coinage and their mounted figures galloping side by side was selected as the exclusive type for the denarius during its initial phase of issue and the principal type for the first seven decades. Invariably, their headdress is the conical pileus, often surmounted by a star to denote divinity. In Imperial times, however, the Dioscuri are rarely featured. Castor alone stands beside his horse on gold of Commodus and silver of Geta, whilst both figures make a final appearance on the early 4th century coinage of Maxentius.

On the Roman Provincial coinage the **Dioskouroi** appear on the issues of a number of cities, notably the Ionian mint of Phocaea, and sometimes they are represented solely by their pilei surmounted by stars.

Aureus of Carausius

Hercules. Son of Jupiter by the mortal Alcmene, Hercules was a popular coin type from the 1st century AD until the time of Constantine the Great. He can always be recognized by his splendid physique and by his constant attributes of club and lion's skin. Commodus, who regarded Hercules as his tutelary deity and even, in his final years, appears to have believed himself a reincarnation of the demi-god, struck many medallions and coins bearing either the figure of Hercules or types relating to him. At a later date, Postumus issued a series bearing types alluding to the various 'labours'. The titles of Hercules are many, and include CONSERVATOR, DEFENSOR, ROMANVS, and VICTOR.

Many Roman Provincial mints depicted **Herakles,** especially those named Heraclea after the demi-god. Under Antoninus Pius the mint of Alexandria issued a remarkable series of bronze hemidrachms illustrating the deity's extraordinary exploits.

Small bronze of the time of Julian II

Isis. Of purely Egyptian origin, Isis, the wife of Osiris, became one of the most popular deities with the Romans and even had several temples dedicated to her in the Imperial capital. She rarely appears, however, on the Imperial coinage, though she is sometimes shown in the company of Serapis. Her normal attribute is the sistrum (rattle), but on a coin of Julia Domna she nurses the infant Horus.

Isis also appears on a number of Roman Provincial issues, especially, of course, on the coinage of Alexandria. Sometimes her head only is shown, and sometimes she is represented as Isis Pharia, holding a sail billowing in the wind, with or without a representation of the celebrated Pharos (lighthouse) of Alexandria.

As of Hadrian (Janus)

Janus. Although the double head of Janus was the regular obverse type of the Republican *as* throughout almost the entire period of its issue, the deity very seldom appears on any of the issues of the emperors. He was the god of beginnings, looking both to past and future, and the first month of the year was named after him. He appears at infrequent intervals as a reverse type – a full-length figure holding a sceptre – and the *Ianus Geminus* ('Twin Janus') features on an extensive issue of *aes* under Nero. When there was peace throughout the Empire the doors of this small shrine were ceremonially closed – an event sufficiently rare to warrant commemoration on the coinage.

Aureus of Julia Soaemias

Juno. The sister and consort of Jupiter is depicted as a tall matron, either seated or standing, holding a patera and a sceptre. She is frequently accompanied by a peacock and on certain posthumous issues of empresses the bird may appear alone, either standing or in flight, bearing the deceased Augusta to heaven (the same role fulfilled by Jupiter's eagle in the case of deified emperors). The temple of Juno Moneta on the Capitoline Hill was of special importance from a numismatic standpoint as the Roman mint was established in its vicinity in Republican times. Eventually, this led to the use of the word *moneta* to mean 'mint' and later 'money', though its original meaning as an epithet of Juno is unknown. Her titles include REGINA, LVCINA (referring to her role as the presiding deity of childbirth), CONSERVATRIX, and VICTRIX.

The representations of **Hera** on Roman Provincial issues are far less frequent than those of her consort Zeus, though she does appear at Chalcis in Euboea and at the Bithynian mint of Nicomedia. On an Alexandrian tetradrachm of Nero the veiled bust of Hera Argeia (Hera of Argos) is shown, identified by the accompanying legend HPA APΓEIA.

Sestertius of Domitian

Jupiter. Jove, or Jupiter, Optimus Maximus ('the Best and Greatest'), is usually depicted as a tall bearded man in the prime of life, nude or semi-nude, holding a thunderbolt in his right hand and a sceptre in his left. Sometimes standing, sometimes enthroned, the figure of the Father of the Gods must have been a familiar sight to every Roman from the numerous statues erected in his honour in Rome and in all the principal cities of the Empire. On some coins he is depicted holding a small figure of Victory, or his attendant eagle, instead of a thunderbolt: often the eagle is shown standing at his feet. He may also be represented by an eagle alone, both on regular issues and on posthumous coins of deified emperors. The titles of Jupiter are numerous: they include CONSERVATOR, CVSTOS (Protector of the emperor), LIBERATOR, PROPVGNATOR, STATOR (the Stayer of armies about to flee), TONANS (the Thunderer), TVTATOR, and VICTOR. One unusual representation of the god is as a child seated on the back of the nymph Amalthea's goat, with the legend IOVI CRESCENTI, "to the Growing Jupiter". This appears on a coin of the young Caesar

Valerian, son of Gallienus, and clearly implies a comparison between the young prince and the young god.

On Roman Provincial coins representations of **Zeus** are legion and often are accompanied by one of his many titles, such as Kapetolios (referring to the Roman Capitoline Jupiter), Kasios (referring to his worship on Mount Casium in Syria), and Olympios (at Alexandria).

Antoninianus of Gallienus

Luna. The moon-goddess is usually equated with Diana Lucifera and only appears with her own name on coins of Julia Domna and Gallienus.

Her Greek counterpart, **Selene,** appears rather more frequently on the Roman Provincial coinage and sometimes her head is shown conjoined with that of the sun-god Sol.

The crescent-moon, which is symbolic of Luna, sometimes occurs as a type, usually in association with a number of stars. In the 3rd century the crescent of Luna appears at the empress's shoulders on the obverses of *antoniniani* and *dupondii* to indicate the double value of these denominations (cf. also under Sol).

Antoninianus of Elagabalus

Mars. The god of war – always a popular deity with the Romans – appears frequently as a coin type down to the time of Constantine the Great. He is usually shown with his spear and shield, or with a trophy instead of the latter indicating success in a military campaign. He is sometimes nude, except for a helmet and cloak, and sometimes in full armour. When given the title of PACIFER he bears the olive-branch of Peace, though in this connection one remembers the words which Tacitus puts into the mouth of a British chieftain who, referring to the Romans, says 'They make a desert and call it peace'. Amongst the other titles of Mars are CONSERVATOR, PROPVGNATOR (the Champion of Rome), VLTOR (the Avenger), and VICTOR.

Mars, known to the Greeks as **Ares,** appears on a few Roman Provincial issues, but his name or titles are rarely given.

Sestertius of Herennius Etruscus (Mercury)

Mercury. The messenger of the gods was reverenced as the patron of artists, orators, travellers, merchants and, curiously, thieves. He is one of the least frequent of the major deities to appear as a coin type in Imperial times, though his head had been the standard obverse type for the *sextans* and *semuncia* denominations on the Republican coinage. He is generally depicted wearing the winged cap or petasus and carrying a purse and a caduceus. The latter is occasionally used alone as a coin type, notably on the smaller denominations.

On Roman Provincial coins the Greek **Hermes** was only adopted as a type by some half-dozen cities, appearing without name or title.

As of Claudius

Minerva. The counterpart in Roman mythology of the Greek **Pallas Athene,** Minerva frequently appears on coins, particularly those of Domitian who regarded her as his special tutelary deity. A war-like goddess, she usually bears a spear and a shield and is equipped with helmet and aegis. Sometimes she holds a small figure of Victory or is accompanied by her attendant bird, the owl. Minerva guided men in the dangers of war, where victory is gained by prudence, courage, and perseverance. She was also goddess of wisdom and patroness of the arts. Amongst her titles are PACIFERA, bringer of Peace, and VICTRIX.

On the Roman Provincial issues she is sometimes named as Athena, with perhaps an additional title such as Areia (at Pergamum), Ilias (at Ilium), and Argeia (at Alexandria).

Denarius of Claudius

Nemesis. Originally associated with the concept of rightful apportionment, Nemesis came to be regarded as the avenger of crimes and punisher of wrong-doers. Her complex character led to many local interpretations of her role as a goddess and sometimes she was associated with other deities, such as Aequitas, Pax, and Victory, who appeared to be able to assist her in the fulfillment of her various functions. Nemesis makes comparatively few appearances on the Imperial coinage. When she does, she is depicted winged, holding a caduceus or olive-branch, and sometimes with a snake at her feet. A curious gesture especially associated with this goddess is the drawing out of a fold of drapery from her breast. This has been explained as expressing the idea of aversion by spitting upon her bosom inside the opened garment. It was said that humans could avoid her anger by making this same gesture.

Depictions of Nemesis on the Roman Provincial coinage are rather more frequent. Here, she is not always winged and is typically shown holding a bridle or cubit-rule with a wheel at her feet. Occasionally, two Nemeses may appear standing face to face. This relates to a legend in which the twin Nemeses of Smyrna appeared in a vision to Alexander the Great commanding him to refound the city.

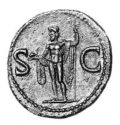

As of Agrippa

Neptune. The god of the sea had appeared only infrequently on the later Republican coinage, the first occasion being on a silver *quinarius* of the moneyer L. Rubrius Dossenus in 87 BC. In Imperial times his depictions were more varied, though they remained sporadic. He is usually represented holding a dolphin and a trident, but sometimes holds an acrostolium (the prow ornament of a galley) instead of the former. The prow itself may be shown beside him, sometimes with his right foot resting on it.

Poseidon, the Greek counterpart of Neptune, is of rare occurrence as a type on the Roman Provincial coinage. However, he does appear at Rhodes, with the name Poseidon Asphaleios ('bringing safety'), and at Alexandria as Poseidon Isthmios (referring to the Isthmus of Corinth).

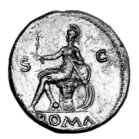

Sestertius of Nero

Roma. The goddess who personified the city of Rome (and in a wider sense the Empire which she had conquered) is usually represented helmeted and in armour, holding a small figure of Victory, or a wreath, and a parazonium. She is often seated on a pile of arms representing the spoils of war. When the Roman Empire became Christian, the type continued in use as a personification of the city or the state, much as the figure of Britannia is regarded today.

Roma also appears on the coinage of Alexandria, identified by the accompanying legend PΩMH.

Alexandrian tetradrachm of Hadrian

Serapis. This deity was a creation of Ptolemy I of Egypt who wished to establish a cult in which his native Egyptian subjects and their new Greek rulers could participate together, thereby fostering a spirit of national unity. Thus, the Egyptians would be able to recognize the characteristics of Osiris and the Greeks would see Zeus, Hades, and Asklepios. The idea appears to have been a resounding success, as Serapis quickly became established as a major deity and later achieved enormous popularity in Rome and throughout the Empire, many splendid temples being erected in his honour.

He appears intermittently on the Roman Imperial coinage from the time of Hadrian onwards and is usually shown raising his right hand and holding a sceptre. On his head he frequently wears a modius and the triple-headed dog Cerberus, guardian of the infernal regions, sometimes sits at his feet. Late in the 2nd century the Emperor Commodus invoke his special protection on a remarkable series inscribed **SERAPIDI CONSERV AVG**, and the early Severan emperors also showed great favour to the cult of Serapis, Septimius himself being of African birth.

Serapis appears on the coins of a number of Roman Provincial mints, principally, of course, on those of Alexandria. Sometimes his bust is shown conjoined with that of the Egyptian goddess Isis, the consort of Osiris.

Antoninianus of Aurelian

Sol. The sun-god frequently appears as a type during the 3rd century and the early decades of the 4th, down to the advent of Christianity under Constantine. He is usually depicted nude, or almost so, wearing a radiate crown and holding a globe or a whip. Sometimes he is shown in his chariot drawn by four lively horses and occasionally his bust only occurs as a type. His titles include **COMES** ('Companion') and **INVICTVS** ('Unconquered'). When he is styled **ORIENS**, a name which properly refers to the eastern or rising sun, it may be taken as alluding to the rising fortunes of the emperor using the type.

Helios, the Greek equivalent of Sol, appears in the Roman Provincial series on the coins of a number of Greek cities. Sometimes his head is shown conjoined with that of the moon-goddess Selene (Roman Luna).

The radiate crown, which the emperor is usually shown wearing on the *dupondius* and *antoninianus* denominations (as well as the rare *double sestertius*), may be taken as an allusion to his position as the earthly personification of the sun-god. Similarly, from the time of Julia Domna to the end of the 3rd century, the empress is normally depicted on the same denominations with a crescent at her shoulders, this being a reference to the moon-goddess Luna. In both instances these distinctions also indicated the double value of the denomination (two *asses*, two *denarii*, and two *sestertii* respectively).

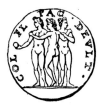

Colonial bronze of Deultum in Thrace

The Three Graces. The Gratiae, or Charites (Euphrosyne, Aglaia, and Thalia), were minor deities who personified the ideals of beauty, gentleness, and friendship. They were attendants of Aphrodite (Roman Venus) and they especially favoured poetry and the arts. Their images, consisting of a standing group of three nude female figures, do not appear on the Imperial coinage. However, the type was used by a number of mints in the Roman Provincial series, including Marcianopolis, Argos, Itanus, Naxos, and Magnesia ad Maeandrum, as well as the colonial mint of Deultum in Thrace. Statues of the Graces were popular throughout the Roman world and the Museum at Cyrene possesses one of the Hadrianic period. The type inspired Italian medallists as late as the 16th century.

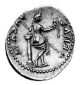

Denarius of Julia, daughter of Titus

Venus. The goddess of beauty and love was a favourite Roman coin type from Republican times until early in the 4th century. Amongst her titles are CAELESTIS, FELIX, GENETRIX, and VICTRIX, and she is usually depicted fully, or almost fully, clothed. Sometimes she holds an apple, sometimes a helmet and a sceptre, and occasionally she is accompanied by Cupid (Greek Eros). In those instances where she is shown semi-nude she is usually posed with her back modestly turned towards the spectator. Julius Caesar, who claimed descent from the goddess, depicted her on many of his coins, generally holding a small figure of Victory.

On Roman Provincial coins the goddess **Aphrodite** was sometimes adopted as a coin type, often because in or near the issuing city there was an important temple dedicated to the deity. In a few cases, such as at Corinth and Cnidus, the representation of the goddess is known to have been copied from a statue for which the issuing city was famous.

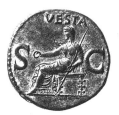

As of Caligula (Vesta)

Vesta. One of the most honoured deities of the Romans, Vesta was the special protectress of the family hearth and was worshipped as a goddess of the Roman state as well as by individuals as the guardian of family life. Following a number of appearances on the later Republican coinage (including a depiction of her temple in the Forum) she was represented on the coins of many emperors, from Caligula to Gallienus, as a matron holding a patera and a sceptre, or a torch, a simpulum, or the Palladium. The well-known *as* of Caligula, with a seated figure of the goddess, is perhaps one of the best examples of her image as a coin type. The distinctive circular temple of Vesta also appears from time to time, often in connection with its restoration following some disastrous fire. The titles of Vesta include MATER and SANCTA.

Her Greek counterpart **Hestia** rarely appears on the Roman Provincial coinage, despite the universality of her cult in the Greek world. One of the few possible exceptions is the city of Maeonia in Lydia, where coins were issued depicting both the goddess and her temple (she is not named, however, and the identification has been contested).

Antoninianus of Valerian

Vulcan. The Roman god of iron and fire was of Italic origin and was regarded as the chief deity of smiths and ironworkers. He seldom occurs as a coin type, but when featured he wears a conical hat (pileus) and holds attributes appropriate to the blacksmith's trade, such as a hammer and tongs. His earliest appearance had been on bronze *dodrantes* of 127–126 BC on which his head was shown as the obverse type, wearing a pileus and with tongs over his shoulder. The last appearance was on *antoniniani* of the joint reign of Valerian and Gallienus, on which the god appears at work within a tetrastyle temple, accompanied by the legend DEO VOLKANO. These coins were minted in Gaul where the cult of Vulcan was especially popular.

It was natural that the Roman Vulcan should be equated with the Greek **Hephaistos,** the son of Hera and Zeus and husband of Aphrodite. He appears at a number of Greek mints in the Roman Provincial series and is sometimes depicted seated on a rock, forging the shield of Achilles, as described by Homer.

We can now proceed briefly to summarize the chief allegorical personifications which appear on the Imperial coinage. In the following list, the Latin name of each is given first, followed in brackets by the Greek equivalent (where used on a provincial issue). Then comes the closest English rendering of the name, and finally the attributes normally associated with the personification. Feminine names are listed first, in alphabetical order, followed by the masculine, which are far fewer in number.

FEMALE

Abundantia Aequitas (Macrianus) Aeternitas (Faustina Sr.)
(Severus Alexander)

Abundantia (Euthenia). Abundance, Plenty. Holds cornucopiae and corn-ears, or is shown emptying the former.

Aequitas (Dikaiosyne). Equity, Fair Dealing. Holds scales and cornucopiae or sceptre.

Aeternitas. Eternity, Stability. Holds globe, torch, phoenix, or sceptre, or the heads of the Sun and Moon.

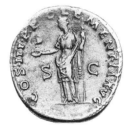

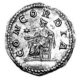

Annona Clementia (Hadrian) Concordia
(Antoninus Pius) (Julia Paula)

Annona. The Annual Grain Supply of Rome. Holds corn-ears and cornucopiae, usually with modius and ship's prow beside her.

Clementia. Clemency, Mercy. Holds branch and sceptre, and sometimes leans on a column.

Concordia (Homonoia). Concord, Harmony. Holds patera and cornucopiae or sceptre. As Concordia Militum, holds two standards.

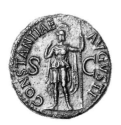
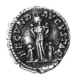

Constantia Fecunditas Felicitas (Julia Mamaea)
(Claudius) (Faustina Jr.)

Constantia. Constancy. Her right hand raised to her face. Sometimes in military attire, also holding spear. [Confined to the coinage of the reign of Claudius].

Fecunditas. Fertility (of an empress). Holds child, or children, and sceptre. Sometimes the children are depicted standing at her feet.

Felicitas (Eutycheia). Happiness, Prosperity. Holds caduceus and cornucopiae or sceptre. Sometimes depicted leaning on a column.

Fides Militum Fortuna (Domitian) Hilaritas (Hadrian)
(Maximinus I)

Fides. Good Faith, Loyalty, Trustworthiness. Holds patera and cornucopiae or corn-ears and basket of fruit. As Fides Militum, holds two standards or standard and sceptre.

Fortuna (Tyche). Fortune. Holds rudder, sometimes resting on globe, and cornucopiae; a wheel may be shown beside her. Sometimes her attributes include an olive-branch or a patera.

Hilaritas. Rejoicing. Holds long palm and cornucopiae, sceptre or patera; is sometimes accompanied by one or two children.

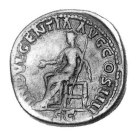

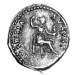

Indulgentia
(Antoninus Pius)

Justitia (Nerva)

Laetitia
(Gordian III)

Indulgentia. Indulgence, Mercy. Holds patera and sceptre.

Justitia. Justice. Holds olive-branch, or patera, and sceptre; rarely (on posthumous coins of Constantine) she holds a pair of scales.

Laetitia. Joy, Gladness. Holds wreath and sceptre, or occasionally rudder on globe in place of the latter, or may rest her left hand on an anchor.

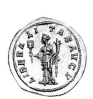

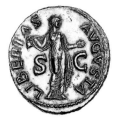

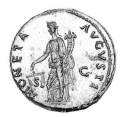

Liberalitas (Severus
Alexander)

Libertas (Claudius)

Moneta (Domitian)

Liberalitas. Liberality. Holds tessera (or abacus) and cornucopiae.

Libertas (Eleutheria). Freedom, Liberty. Holds pileus (conical hat) and sceptre.

Moneta. Mint, Money. Holds scales and cornucopiae. Sometimes represented as the Three Monetae (gold, silver and *aes*), each with a pile of metal (or coins) at her feet.

Nobilitas (Geta)

Ops (Antoninus Pius)

Pax (Severus
Alexander)

Nobilitas. Nobility, High Birth. Holds Palladium and sceptre.

Ops. Power, Prosperity, Aid. Holds sceptre or corn-ears. [Confined to the coinages of Antoninus Pius and Pertinax].

Patientia. Endurance, Patience. Holds sceptre.

Pax (Eirene). Peace. Holds olive-branch and sceptre, cornucopiae or caduceus.

| Pietas (Julia Maesa) | Providentia (Caracalla) | Pudicitia (Herennia Etruscilla) |

Pietas (Eusebeia). Piety, Dutifulness. Often veiled, holds patera and sceptre; sometimes shown sacrificing at an altar and holding a box of incense.

> *'Roman piety unites in one whole, reverence for the gods, devotion to the Emperor, affection between the Augusti or between the Augustus and the people, tenderness of parents to sons, respect or affectionate care of the latter for their parents, and in general, love of one's neighbour, or in one word Religion'* (Gnecchi).

Providentia (Pronoia). Foreseeing. Holds rod, with which she sometimes points to a globe at her feet, and sceptre. In the 3rd century she is often shown holding the globe. The legend may also accompany types which express the concept of *providentia* in more symbolic ways.

Pudicitia. Modesty, Chastity. Holds sceptre and is usually veiled.

| Salus (Maximinus I) | Securitas (Antoninus Pius) |

Salus (Hygieia). Health, Safety, Welfare. Holds sceptre and patera from which she feeds a snake coiled round an altar; or holds the snake in her arms and feeds it from the patera.

Securitas. Security, Confidence. Holds patera or sceptre, and may be depicted leaning on a column, legs crossed; sometimes sits back at ease in a chair.

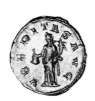

| Spes (Claudius) | Uberitas (Trajan Decius) | Victoria (Antoninus Pius) |

Spes (Elpis). Hope. Holds flower, and is usually shown walking and slightly raising the drapery of her dress behind.

Uberitas *or* **Ubertas.** Fruitfulness, Abundance. Holds cornucopiae and purse or bunch of grapes (possibly even a cow's udder).

Victoria (Nike). Victory. Winged, holding a wreath and a palm; may be shown with a shield, which she sometimes inscribes, or erecting a trophy.

MALE

Bonus Eventus
(Antoninus Pius)

Genius (Hadrian)

Bonus Eventus. Good Outcome. Holds patera over altar, and cornucopiae.

Genius. Spirit. Holds patera and cornucopiae, sometimes with altar at feet. Most frequently appears as Genius of the Roman People (**GENIVS POPVLI ROMANI**), but is represented in a variety of other forms, such as Genius of the Senate (bearded and togate), Genius of the Emperors (and Caesars), and Genius of the Army (with military standard). In the early 4th century he sometimes holds the head of Serapis.

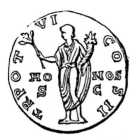

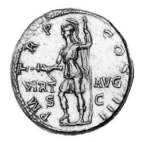

Honos (Marcus Aurelius) Virtus (Hadrian)

Honos. Honour. Holds olive-branch or sceptre and cornucopiae. Sometimes appears in association with another male personification, Virtus.

Virtus. Valour, Bravery. Usually depicted in complete armour, holding Victory or parazonium and spear, or with spear and shield. Sometimes appears in association with another male personification, Honos.

It should be emphasized that the foregoing notes do not pretend to do anything like justice to the subject, about which, indeed, a lengthy book could be written. It is hoped, however, that the information provided, although brief, will be found of interest and may lead collectors of the series to study the subject in more detailed works.

II. REPRESENTATIONS OF THE EMPEROR AND HIS FAMILY

In addition to monopolizing the obverses of Roman Imperial coins, the emperors and their families also make frequent appearances as reverse types.

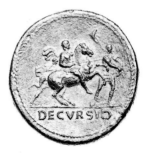

Agrippa as a Nero on horseback
reverse type of
Augustus

Augustus set the precedent by authorizing his representation as the victor of Actium and conqueror of Egypt riding in a triumphal quadriga on the reverse of a denarius issued in the autumn of 30 BC. Several other types of Augustus followed during his long reign, including several of 13 BC depicting both the emperor and his trusted friend and colleague, Marcus Agrippa. With the exception of Tiberius, the Julio-Claudian emperors made increasingly frequent appearances on the

reverses of their coins. Nero, the last representative of the dynasty, is depicted distributing gifts to the people, haranguing his troops, taking part in military exercises on horseback, and even singing to his own accompaniment on a lyre, in the guise of Apollo.

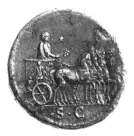

<table>
<tr><td align="center">Titus in triumphal procession</td><td align="center">Domitian sacrificing
during Secular Games</td></tr>
</table>

In the Flavian period, Vespasian and Titus appear most frequently in connection with two main themes – the quelling of the Jewish Revolt and the recovery of the Roman State following the Civil Wars of AD 68–69. Vespasian is shown raising a kneeling female figure (the State) on one of his *aurei*, and both father and son are depicted riding in their chariots in the triumphal procession which celebrated the victory in Judaea. Domitian appears as conqueror of the German tribes on a *sestertius* which shows him standing in military attire, a personification of the Rhine reclining at his feet. This emperor's most interesting appearances, however, are in connection with the Secular Games of AD 88, when he is depicted as a participant in various ceremonies, often with the temple of Jupiter Capitolinus as a backdrop.

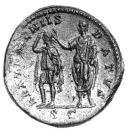

<table>
<tr><td align="center">Hadrian arriving in
Mauretania</td><td align="center">Antoninus Pius crowning
the king of Armenia</td></tr>
</table>

The Golden Age of Trajan, Hadrian, and the Antonine emperors produced a great variety of interesting reverse types depicting the emperor. Trajan, the great warrior, is shown at full gallop thrusting his spear at a Dacian enemy, whilst Hadrian's famous peregrinations spanning his vast Empire are fully documented on the coinage. Antoninus' stature as a statesmen is suitably illustrated by a *sestertius* which shows a togate figure of the emperor in the act of creating a new king of Armenia by placing a diadem on the head of the monarch. With the recurrence of bitter frontier wars under Marcus Aurelius, he, and his co-emperor Lucius Verus, are frequently depicted in military scenes. One type shows Aurelius standing amidst four standards, whilst on a coin of Verus the emperor spears a fallen eastern enemy as he gallops past. The first joint reign in the history of the Empire is commemorated by a type showing togate figures of the two emperors clasping right hands.

The megalomania of Commodus is quite evident on several of his reverse types, as well as on the obverses which show his head clad in the lion's skin of Hercules. A type common to both

sestertius and *as* feature the emperor dressed as a priest and ploughing with a yoke of two oxen, symbolic of his insane notion to refound the city of Rome and give to it the new name of *Colonia Lucia Antoniniana Commodiana.*

Elagabalus as
priest of the sun-
god

Severus Alexander in
consular procession

The military anarchy which crippled the Empire for a large part of the 3rd century led to a decline in the representation of the emperor in any guise other than as commander-in-chief of the armed forces. Septimius Severus is shown togate, as *Fundator Pacis* ('Founder of the Peace'), on one type, but he and his sons usually appear in scenes of military significance. Elagabalus, who was far from being a soldier, is often depicted in his role as Chief-Priest of the Syrian Sun-God, providing a brief interlude in this martial period. Elagabalus' cousin and successor, Severus Alexander, wears the civilian toga while sacrificing over a tripod-altar, but most of his representations are military in character. Over the next few decades the Roman citizen, observing the reverses of the coins he handled, saw his ruler represented only in a few rather stereotyped poses, usually standing in military attire or mounted on horseback. Few other types break the monotony, although Gallienus, the type content of whose coinage is generally more interesting than that of other emperors of the period, is depicted in a greater variety of poses. In one of these, he raises a kneeling figure representing the Gallic provinces. Soon after this type was struck, however, the region was lost by Gallienus to the usurper Postumus and remained independent of the central government for the following fourteen years.

Magnus Maximus
and Flavius Victor
enthroned

Arcadius
trampling on
captive

Towards the end of the 3rd century successive emperors were often shown receiving a figure of Victory from the hands of Jupiter and this type continued in use into the early years of the 4th century. With the adoption of Christianity by Constantine and the subsequent slow demise of pagan traditions coin types in general became more limited in number and monotonous in content. The emperor usually appears as the champion of the new faith, holding a labarum (Christian standard) and a figure of Victory (which was now becoming equated with the Christian Angel). The Victory-Angel also appears on a series of later 4th century post-Constantinian gold *solidi*, hovering

between two emperors enthroned side by side. By this time the Empire had become more or less permanently divided into eastern and western halves, with at least two emperors reigning simultaneously.

The grandsons
of Augustus

The sisters of Caligula

Representations of empresses and princes (and in a few rare instances deceased parents) as reverse types occur throughout most of the period, although there were very few Imperial heirs (as opposed to youthful co-emperors) after the Caesarship of Julian II (AD 355–60). In the early Empire, the emperor's relatives appeared most often on the reverses of his own coins, as their own coinages were very small, where they existed at all. Thus, we see Gaius and Lucius Caesars standing side by side on the reverse of their grandfather Augustus' most prolific issue of *aurei* and *denarii*, and the Empress Livia seated on the reverse of her son Tiberius' principal precious metal type (the 'Tribute Penny' of the Bible). Caligula, on one of his *sestertii*, has a most interesting reverse type depicting his three sisters, Agrippina, Drusilla and Julia. On the reverses of some of his *aurei* and *denarii* Claudius featured the portraits of his fourth wife, Agrippina, and his step-son, Nero; whilst the brief reign of Vitellius in AD 69 produced several interesting family types depicting the emperor's young children and his deceased father, the celebrated Lucius Vitellius.

Hostilian as 'Prince
of the Youth'

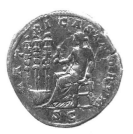

Faustina Junior as
'Mother of the Camps'

From the Flavian period, the princes (or 'Caesars') began issuing substantial coinages in their own right, and from the early part of the 2nd century the empresses also were given a much larger share of the total output of the mint. The Caesars, where they appear on the reverses of their own coins, are usually represented as 'Prince of the Youth' (PRINCEPS IVVENTVTIS). The Caesar Marcus Aurelius, who served an unprecedented term of over two decades as heir under Antoninus Pius (AD 139–161) was accorded an extensive coinage of his own, and additionally his head appears as the reverse type on a whole range of denominations of Antoninus himself. Empresses appear in a variety of roles as reverse types, often in the guise of some female deity. Faustina Junior, wife of

Marcus Aurelius, features on a number of types as 'Mother of the Camps' (**MATER CASTRORVM**), a reference to her devotion to the interests of the soldiers during her husband's arduous military campaigns, the hardships of many of which she shared. Another reverse type seen frequently on the coinages of empresses, particularly in the early decades of the 3rd century, shows the Augusta and the Augustus clasping hands, often in commemoration of the actual imperial nuptials.

Septimius Severus and his family

Before closing this brief survey of imperial representations as reverse types, mention should be made of the uniquely extensive series of 'dynastic coins' issued under Septimius Severus (AD 193–211). These depict his wife, Julia Domna, his daughter-in-law, Plautilla, and his two sons, Caracalla and Geta, as well as himself. All these pieces are in the *aureus* and *denarius* denominations and all are rare or very rare. The obverses usually show a single bust, though occasionally two are represented, whilst the reverses have one, two, or even three imperial portraits. Perhaps the most celebrated coin in this series is the *aureus* of Severus issued in AD 201 displaying as its reverse type a remarkable facing portrait of the empress between the confronted busts of her two sons. But despite the seeming promise of continuity, this phase of the Severan dynasty was destined to be extinct within a mere sixteen years of this issue.

III. TYPES OF MILITARY CONQUEST AND VICTORY

During the five centuries of its existence the Roman Empire was involved in numerous wars and campaigns, some expansionist, some defensive, and some domestic. Many of these were commemorated on the coinage, one of the earliest instances being a type of Octavian (Augustus) with crocodile reverse and legend **AEGYPTO CAPTA**. This refers to the defeat of Antony and Cleopatra in 30 BC and the subsequent annexation of the former Ptolemaic kingdom to the Empire of Rome.

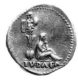

| Claudius triumphing for his British conquest | Captive Judaea (Vespasian) | Captive Germania (Domitian) |

The invasion of Britain in AD 43 was well recorded on the gold and silver coinage of Claudius, with a type depicting the arch erected in Rome to commemorate the conquest. The great Jewish Revolt, which began under Nero in AD 66, was a serious embarrassment to the Romans, coming, as it did, at a time of acute political upheaval in the Empire which saw the rapid succession of four

emperors during the years AD 68 and 69. The rebellion in Judaea was actually crushed by the general Vespasian and his son Titus who used their success in this campaign to seize the Imperial throne and establish a new dynasty, the Flavian. Vespasian gave great publicity to his victory in the East on a large output of coins in all metals, known collectively as the 'Judaea Capta' series. One of the commonest types appears on *aurei* and *denarii* and depicts a captive Judaea seated at the foot of a Roman trophy. The German wars of Vespasian's younger son, Domitian, are also commemorated by a large number of types, one of which shows a female German captive in despair seated upon a shield.

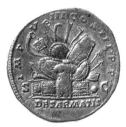

<table>
<tr><td>Captive Dacia
(Trajan)</td><td>Captive
Armenia
(Lucius Verus)</td><td>Pile of Sarmatian arms
(Marcus Aurelius)</td></tr>
</table>

Captive Dacia (Trajan) Captive Armenia (Lucius Verus) Pile of Sarmatian arms (Marcus Aurelius)

Trajan's expansionist policy in the early 2nd century led to prolonged campaigns in several widely separated theatres of war. Undoubtedly, his greatest achievement was the conquest of Dacia. This received considerable publicity on the coinage, with no fewer than twelve main types alluding to the event. The eastern wars of AD 163–5 also received extensive notice on the coinages of the joint emperors Marcus Aurelius and Lucius Verus. A notable type in this series shows captive Armenia seated amidst arms. Much of the final decade of Aurelius' rule was taken up with warfare on the harsh northern frontier, and a *sestertius* struck in AD 177 depicts a large pile of arms, symbolic of the successful conclusion of the German and Sarmatian Wars.

Commemoration of victory in northern Britain (Caracalla) and in Germany (Maximinus I)

Septimius Severus' numerous campaigns in both the East and West are well documented on the Imperial coinage, but perhaps the series of greatest interest to British students is the one which commemorates the events of AD 208–11. During this period Severus and his elder son Caracalla campaigned on the northern frontier in Britain and restored Hadrian's Wall, which appears to have suffered damage in the troubled period more than a decade before. Caracalla's Parthian 'war' received some notice on the coinage, and even Macrinus' inglorious encounter with Artaban of Parthia was celebrated as a **VICTORIA PARTHICA** on coins of all metals. More deserving of

commemoration were Maximinus' victories in Germany in AD 235 and *aes* of the following year shows the emperor being crowned by Victory.

The second half of the 3rd century was a disastrous period for Roman arms, with large parts of the Empire succumbing to foreign attack and much of what remained being rent by internal rebellion. Miraculously, however, the situation was restored by a succession of short-lived but very strong military rulers, known collectively as the 'Illyrian' emperors, foremost amongst whom were Claudius Gothicus (AD 268–70), Aurelian (270–75) and Probus (276–82). A coin of this period struck by Aurelian's ephemeral successor, Tacitus, celebrates a victory over the Goths with the inscription VICTORIA GOTTHI.

Victory over the
Goths (Tacitus)

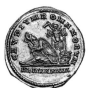

Captive Alamanni
(Crispus)

In the 4th century commemorative reverse types became increasingly rare. One of the last to be issued depicts a personification of the Alamanni (a confederation of Germanic tribes) seated in captivity at the foot of a trophy. This appears on a gold *solidus* of Crispus Caesar, eldest son of Constantine, issued at Trier in AD 319–20. The young prince had led a successful campaign against the Alamanni in 318. A similar contemporary type bears the legend FRANCIA instead of ALAMANNIA and records success against the Franci (Franks), another Germanic people who were later to conquer Gaul and give it the name of France.

IV. LEGIONARY TYPES, ETC

The 'legionary' series forms a compact group within the Roman coinage, most of it having being issued by just five rulers over a period of about 325 years, from the battle of Actium to the late 3rd century AD. Those of Mark Antony (issued 32–31 BC) and Septimius Severus (AD 193) are similar in that both have the same basic reverse type – a legionary eagle between two standards. In contrast, the later 3rd century issues of Gallienus, Victorinus and Carausius interestingly bear the actual badges of the various legions, e.g. a lion for the *IIII Flavia* and a capricorn for the *XXII Primigenia*. The primary reason for the issue of these exceptional types was to inspire the loyalty of the troops whose legions were being honoured. Curiously, in some cases those troops appear not to have been under the command of the emperor issuing the coins. In such instances it must be assumed that what we are seeing is a very artful use of the propaganda value of the coinage, *i.e.* an attempt to win over the loyalty of an opponent's army by means of flattery.

Standards of
Legio XIV
Gemina (Severus)

Badge of Legio
XXII Primigenia
(Gallienus)

Another series of exceptional interest is the 'Army' coinage produced by Hadrian (AD 117–38) in the closing years of his reign. This honoured the army comprising the legionary garrison of each military province (EXERC BRITANNICVS, EXERCITVS SYRIACVS, etc.) and was mostly confined to the large *sestertius* denomination. It was connected with the emperor's keen interest in the military establishment, and in particular the strengthening of the defences of the frontier regions (the policy which led to the construction of Hadrian's Wall in Britain and the German *limes*). These coins, all of which are very rare today, depict the emperor addressing his soldiers from a platform, or saluting them whilst mounted on horseback. Related types of Hadrian and Antoninus Pius refer to military discipline and are inscribed DISCIPLINA AVG.

In addition to calls for allegiance and discipline aimed at specific legions and armies there were also pleas for loyalty addressed to the military in general. This sometimes came at times when that loyalty was in doubt. Thus, on coins of Nerva (AD 96–8), whose brief regime was very unpopular with the soldiers, we see clasped hands holding a legionary eagle set on a prow, accompanied by the legend CONCORDIA EXERCITVVM; whilst much later, the short-lived Gallic usurper Marius (AD 268) used a similar type on his coinage, though on this occasion clasped hands only were shown encircled by the legend CONCORDIA MILITVM. The 'valour of the soldiers' (VIRTVS MILITVM) was proclaimed on a large issue of silver *argentei*, or *siliquae*, issued under the rulers of the First Tetrarchy at the end of the 3rd century; and the 'renown of the army' (GLORIA EXERCITVS) was celebrated on an extensive series of small billon *centenionales* introduced in the closing phase of Constantine's reign and carried on for some years after his death by his sons.

 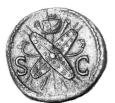

Appeal for loyalty to Captured German
the military (Nerva) shields (Domitian)

Many other types of military and naval significance may be found amongst the reverses of the Roman coinage. Noteworthy are a *denarius* of Octavian (Augustus) displaying a naval trophy; a *dupondius* of Domitian depicting two German shields crossed over a vexillum, trumpets and spears; and a coin of Trajan, of the same denomination, with a fine representation of a cuirass (body-armour). Naval power, in the form of a war-galley, was featured in the later 3rd century on coins of the Gallic usurper Postumus and on those of the British usurpers Carausius and Allectus.

V. GEOGRAPHICAL TYPES

The Roman Empire was a unique association of peoples and cultures, such as the Mediterranean World had never seen before and has not witnessed since. What had formerly been a patchwork of Hellenistic monarchies, independent city states and Celtic tribes was miraculously transformed by the genius of Rome and her code of laws into one great political entity, and held together not so much by force of arms as by the *Pax Romana*.

Female personifications of many of the provinces within this vast State were depicted on several coin series during the Imperial period, and even particular cities and rivers receive occasional notice (the latter normally appearing as a bearded male figure in a reclining attitude).

Denarii of Augustus and Galba featuring the city of Emerita and heads of the 'Three Gauls'

An early *denarius* of Augustus' reign shows the city gate and defensive walls of *Emerita* in Spain, a colony which was founded in 25 BC and populated by Roman soldiers whose term of service had expired (*emeritus*). Galba, in AD 68, issued a remarkable type showing three small female heads accompanied by the legend TRES GALLIAE. These represented the three great divisions of the province of Gaul – Narbonensis, Aquitania and Lugdunensis –in recognition of the support which he received from the western provinces during his revolt against Nero's tyrannical rule. Dacia, the province added to the Empire by Trajan, is commemorated on *sestertii* and *dupondii* of that emperor, identified by the legend DACIA AVGVST PROVINCIA. The type shows Dacia seated on a rock, accompanied by two children, symbolic of future generations of Dacians who could now look forward to an era of peace under the protection of omnipotent Rome.

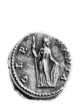 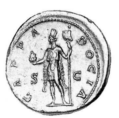

Germany, Cappadocia, Egypt and the Nile, all featured on the coinage of Hadrian

The coinage of Hadrian provides us with a far more complete geographical survey of the Roman World than that of any other emperor. His extensive travels all over his vast Empire were commemorated on several remarkable series of coins, mostly issued towards the end of his reign when he had finally returned to Italy. In addition to honouring most of the provinces, two cities (Alexandria and Nicomedia) receive special attention, as does the River Nile (NILVS). The following is a list of the provinces whose personifications appear on Hadrian's coinage: Britain; Spain; Gaul; Germany; Italy; Sicily; Noricum; Dacia; Macedonia; Moesia; Thrace; Achaea; Asia; Bithynia; Phrygia; Cilicia; Cappadocia; Judaea; Arabia; Egypt; Africa; Mauretania.

Hadrian's successor, Antoninus Pius, also issued a 'provincial' series of coins, in this case to celebrate the remission of half of the *aurum coronarium* ('crown-gold'). This was a demand made by the emperor on the communities of the Empire (and sometimes even on foreign states) at the time of his accession and on certain anniversaries of his rule. Antoninus' remission of half of this burdensome tax at the time he came to the throne was greeted with much enthusiasm and led to the production of an extensive series of *aes* coinage depicting crown-bearing personifications of various provinces (and even of the Parthian kingdom). The advancement of the Roman frontier in Britain to the line of the new Antonine Wall prompted the issue of several attractive Britannia types on *sestertii* of AD 143. This was followed more than a decade later by another type (mostly on *asses*) depicting the personification of the island province in an attitude of dejection and commemorating the quelling of a serious tribal uprising. An elegant personification of Italy, seated on a globe, appeared on a variety of denominations in AD 140, possibly in anticipation of the celebration of Rome's 900th anniversary in 147.

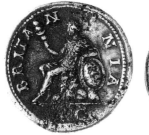

Britannia and Asia on sestertii of Antoninus Pius

Geographical types are less commonly encountered on coins struck in the second half of the 2nd century. Marcus Aurelius has an *as* showing a reclining figure of the River Tiber, whilst Commodus issued two *sestertius* types, one with Italia seated on a large globe, the other a very rare depiction of a standing Britannia. At the very end of the century, Clodius Albinus, in rebellion against Septimius Severus, struck a *denarius* featuring the Genius of the City of Lugdunum in Gaul.

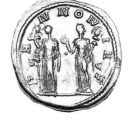

Genius of
Lugdunum
(Clodius
Albinus)

Dacia and the Pannoniae on sestertii of Trajan Decius

During the course of the 3rd century there was a continued decline in the frequency of geographical references on the Imperial coinage. Septimius Severus makes mention of Italy, Africa and Carthage, and half-way through the century Trajan Decius honours the provinces of Dacia and the two Pannoniae with standing figures of their personifications. Dacia appears again on coins of Claudius Gothicus and Aurelian, and the Pannonian provinces are commemorated by Quintillus, Aurelian and Julian. The city of Siscia receives special notice on *antoniniani* of both Gallienus and Probus, and a reclining figure of the Rhine is depicted on coins of the Gallic usurper Postumus. Britannia makes her final appearance on the Roman coinage clasping hands with the late 3rd century rebel Carausius, who had succeeded in temporarily detaching the island-province from the rule of the central government.

The late Roman coinage of the 4th and 5th centuries contain very few geographical references amongst their reverse types. Africa and Carthage occur on *folles* of several of the emperors and usurpers in the early years of the century, and one of the last types of any geographical significance is found on the Constantinopolitan silver and billon coinage of the unfortunate young prince Hanniballianus (AD 335–7). This shows a reclining figure of the river-god Euphrates and its appearance at this time is made all the more remarkable by comparison with the general lack of imagination being shown in the selection of reverse types in the closing years of Constantine's reign.

Africa (Diocletian)

The Euphrates
(Hanniballianus)

VI. ARCHITECTURAL TYPES

The Romans were great builders, a fact attested by the many splendid examples of their architecture which are still to be seen in countries all over the Mediterranean World and in northern Europe. Many of the emperors took a special pride in adorning the capital, and other cities, with edifices which were not only functional (such as the great market of Nero and Trajan's *Basilica Ulpia*), but often possessed considerable architectural merit as well. Doubtless, Rome's autocrats were also well aware of the excellent potential for long-term survival of such structures and saw them as a means of perpetuating their prestige in people's minds. A number of these buildings were displayed on the coins (usually at the time of their construction or renovation) and these reverse types form one of the most sought-after groups within the Roman coinage.

Augustus issued a number of architectural types, a very early example being the temple of Divus Julius depicted on *aurei* and *denarii* of 36 BC, when the building was still under construction. Also appearing on his pre-27 BC coinage is a representation of the *Curia Julia* (the Senate House in the Forum) which was dedicated by Augustus on 28 August 29 BC. On the later Augustan coinage a variety of architectural types are featured, mostly on *denarii*: these include the *Arcus Augusti*, which replaced the earlier Actian arch; the temples of Jupiter Tonans and of Mars Ultor (both on the Capitol); the *Porta Fontinalis* and part of Rome's Servian Wall; and another depiction of a city-gate and defensive walls, this time of the colonial foundation of Emerita in Spain. The celebrated Altar of Lugdunum, dedicated by the emperor in 10 BC, forms the sole reverse type of the Lugdunese *aes* coinage which was produced in considerable quantity in the latter part of the reign.

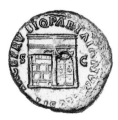

Temple of Divus The 'Twin Janus' (Nero) The Colosseum (Titus)
Julius (Octavian)

As one of his *sestertius* types Tiberius has a depiction of the temple of Concord in the Forum. This building was used to house antique sculpture and is shown adorned with a variety of statues. Caligula features an elaborate representation of the temple of Divus Augustus, also on a *sestertius*; whilst Claudius shows the arch spanning the *Via Flaminia* which was constructed to commemorate

his conquest of Britain. Nero, last of the Julio-Claudian emperors, has a number of architectural types which are depicted principally on his handsome *aes* coinage: the *Macellum Magnum*, or Great Market, which was completed in AD 59; the celebrated *Ianus Geminus* ('Twin Janus'), the doors of which were closed with great ceremony to celebrate peace throughout the Empire; an elaborate arch which has since disappeared without trace, probably the one erected to commemorate Corbulo's eastern victories; a remarkable aerial view of the harbour of Ostia, improved under Claudius and Nero; and (on precious metal only) the domed temple of Vesta in the Forum, restored by Nero following its destruction in the great fire of AD 64.

Later emperors eagerly continued the tradition of architectural reverse types. The great Flavian Amphitheatre, known today as the Colosseum, appears on a *sestertius* of Titus under whom the famous edifice was completed and dedicated. A *cistophorus* of Domitian shows the temple of Jupiter Capitolinus, together with the legend **CAPIT RESTIT**, a reference to that emperor's rebuilding of the famous temple following the devastating fire of AD 80. Domitian also has a rare series of *denarii* depicting various temples, identified by Hill as those of Serapis, Cybele, Minerva Chalcidica, and Jupiter Victor, in addition to the Capitoline temple itself. Trajan's coinage has many types of architectural interest, such as the Circus Maximus, restored by Trajan *circa* AD 103; Trajan's celebrated Forum and Basilica; Trajan's Column, erected to commemorate the conquest of Dacia; the 'Danube' bridge (in all probability the *Pons Sublicius* in Rome); a triumphal arch inscribed **I O M**; and two octastyle temples, one of which may be that of Divus Nerva.

 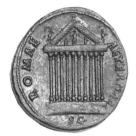

Trajan's
Column
(Trajan)

The 'Danube' bridge (Trajan)

Temple of Roma
(Antoninus Pius)

The great temple of Venus and Roma, designed by Hadrian himself, appears both on the coinage of its architect's reign and on that of his successor, Antoninus Pius, under whom it was completed. Antoninus also depicts the temple of Divus Augustus, in commemoration of his restoration of the famous edifice (now disappeared without trace). The temple which Antoninus built in honour of his wife Faustina (later dedicated to her memory also) is shown on *denarii* of the deified empress. The ruins of the shell of this structure, enclosing the church of S. Lorenzo in Miranda, are still to be seen in the Roman Forum. A temple of Mercury, of very unusual form, appears on a *sestertius* of Marcus Aurelius, accompanied by the legend **RELIG AVG**; whilst a coin of Commodus of the same denomination features a distyle shrine of Janus.

The famous Arch of Severus, which still stands in all its ancient majesty in the Roman Forum, is depicted on the coinages of both Septimius and Caracalla. A representation of the Circus Maximus, very similar to the one of Trajan, occurs also on *sestertii* of Caracalla struck in AD 213 to commemorate yet another restoration of the structure. Under Severus Alexander several fine architectural types appear, including the Colosseum on an *aureus* and *aes* of AD 223; the Nymphaeum (a monumental fountain at the terminal of the *Aqua Alexandrina*) the ruins of which may still be seen in the Piazza Vittorio Emanuele II; and a very elaborate depiction of the Temple of Jupiter Ultor (or Victor).

Throughout the remainder of the 3rd century architectural reverses occur rather less frequently and are confined in the main to conventional representations of temples, often containing a statue

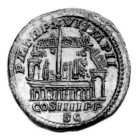

Temple of Circus Maximus (Caracalla) Temple of Juno Martialis
Faustina (Volusian)
(Faustina Senior)

of Roma. Exceptions to this include a very interesting circular temple dedicated to Juno Martialis, appearing on coins of Trebonianus Gallus and his son Volusian; and a triumphal arch on *aes* of the Gallic usurper Postumus.

With the advent of Christianity as the official state religion in the early part of the 4th century pagan temple types disappear entirely from the coinage. The only subsequent reverses which have any claim to be architectural are the 'camp gate' types, usually on small billon and bronze denominations of the Constantinian era and later; the plan of a military camp on billon *centenionales* of Thessalonica; a bridge over a river on a reduced *centenionalis* of Constantinople; and a distyle shrine with arched roof which occurs on silver *miliarenses* under a number of emperors from Constantine to Valentinian and Valens.

VII. ANIMALS, ETC

For several centuries before the rise of Rome there had been a tradition of featuring animals, birds, fish and insects (as well as various mythological beasts) on the coinages of many of the Greek city-states. Rome inherited this tradition, and although the representation of fauna is less frequent and varied than on coins of the Greek series, they nevertheless form a most appealing group within the Roman coinage.

Crocodile and heifer on the coinage of Augustus Capricorn Eagle (Domitian)
 (Vespasian)

Crocodile, heifer, bull, wild boar, lion attacking stag, eagle, crab and butterfly, capricorn, Pegasus and Sphinx all appear on the coinage of Augustus, who was the inheritor of the late Republican tradition of great diversity in the selection of coin types. However, during the course of his long reign that tradition was gradually superseded by a more conservative approach to the type content of the new Imperial coinage. Accordingly, the coinages of the later Julio-Claudian emperors feature virtually no representations of animals, other than the elephants drawing the car of

Divus Augustus on a *sestertius* issued by Tiberius, and the eagle appearing on the reverse of a Divus Augustus *as*. The Flavian revival of earlier coin types led to a reintroduction of the tradition of animal depiction on the Imperial coinage. A particularly interesting reverse of this period shows a goat being milked by a goat-herd and another has a sow with its young.

Sow (Antoninus Pius)

In the 2nd century the Pegasus and the griffin appear on several *aes* denominations of Hadrian, whilst his successor Antoninus Pius struck *asses* showing an elephant and a sow suckling its young beneath an oak tree, both types probably having reference to the celebrations connected with the 900th anniversay of the foundation of Rome. An attractive representation of a dove appears on an *aureus* of Antoninus' daughter, the younger Faustina, and elephants occur on an *as* of Commodus and a *denarius* of Septimius Severus.

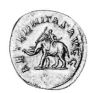

Elephant, lion and stag on the coinage of Philip I

Hippopotamus
(Otacilia Severa)

The 'king of beasts' is depicted on the coinage of Caracalla, wearing a radiate crown and holding a thunderbolt in its jaws, and several decades later the lion reappears as part of the 'Saeculares' series of Philip I. Similarly, the elephant was popular as a coin type during the first half of the 3rd century, appearing on pieces of Caracalla, Geta, and Philip I. To celebrate Rome's thousandth anniversary in AD 247–8 Philip I staged magnificent games in which many wild beasts were exhibited in the arena of the Colosseum. This resulted in a series of coins featuring the hippopotamus, antelope, stag, and goat, in addition to the lion already mentioned. The city's emblem, the she-wolf suckling the twins Romulus and Remus, also appears as part of this series.

A few years later, during the sole reign of Gallienus (AD 260–68), an extensive series of 'animal' reverses was featured on the debased *antoninianus* denomination. Subsequent to this date such types appear far less frequently and are, in the main, restricted to the 'legionary badge' issues of the usurpers Victorinus in Gaul and Carausius in Britain. The charismatic British usurper also has types showing the milking of a cow, a griffin, and the traditional wolf and twins device.

In the late Empire, the wolf and twins appear on coins of another usurper, Maxentius (AD 306–12), whose policy was to try to revive the past glories of the Imperial capital; and several decades later on small billon pieces (reduced *centenionales*) of the time of Constantine and his successors. In the mid-4th century a phoenix is shown on *half maiorinae* of Constantius II and

Phoenix (Constans) Bull (Julian II)

Constans; and a very fine representation of a bull, sometimes accompanied by an eagle, occurs on large billon pieces of Julian II towards the end of his short reign (AD 360–63). One of the last animal representations on the Roman coinage is on a tiny bronze *nummus* of the eastern Emperor Leo I (AD 457–74) where a lion appears as a punning allusion to the emperor's name.

VIII. TYPES OF PROPAGANDA

There can be little doubt that the emperors of Rome were fully aware of the value of the Imperial coinage as a tool of propaganda, it being one of the most effective means of mass communication available to them. Everyone, from the provincial governor down to the peasant working the land, was likely to take notice of the ever-changing messages appearing as reverse types on the money which they were daily handling. The government of the day was thus able to present itself and its achievements in surprising detail to almost all of the inhabitants of the vast Empire. However, as it was a means of communication on which the government had a complete monopoly, the propaganda sometimes only told half the truth or was even, on occasions, a complete misrepresentation of reality.

A very large proportion of reverses could be included under the heading of 'Types of Propaganda'. Even the ubiquitous personifications were often intended to proclaim the virtues of the emperor or the good fortune of the age which was lucky enough to witness his enlightened rule. In this brief survey, therefore, mention is made only of those types which have a specific message to convey regarding the wisdom, beneficence and achievements of the emperor.

Augustus early established the propaganda role for the Imperial coinage when he gave extensive coverage to his victory over Cleopatra's Egyptian kingdom which left him sole master of the State and provided the financial resources to carry through his program of reforms. A decade later he produced a whole range of types on his precious metal coinage designed to extract the maximum publicity value from his great diplomatic achievement which led to the restoration in 20 BC of the Roman standards of Crassus and Antony captured years before by the Parthians.

An elegant *sestertius* type of Tiberius proclaims the munificence of the emperor in a reference to the restoration, at his own expense, of several cities in western Asia Minor which had been badly damaged by a severe earthquake in AD 17. Nero publicized his care for the annual corn supply from Egypt on a very attractive *sestertius* type showing an artistic grouping of Annona standing before a seated Ceres, with a ship's stern in the background. The enlightenment and benevolence of Nerva's brief rule is amply attested by his choice of coin types. One *sestertius* shows two mules and a cart, with a legend referring to the measures taken by the emperor to transfer the cost of Imperial posting on the main roads in Italy from the taxpayer to the exchequer. Another represents a distribution scene, or *Congiarium*, depicting the emperor bestowing gifts on the citizenry; whilst others commemorate a special distribution of corn to the urban poor, and the correction of abuses in the collection of the poll tax levied on Jews (*fiscus Iudaicus*).

Restoration of the
Roman standards
(Augustus)

Care for Rome's corn
supply (Nero)

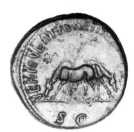
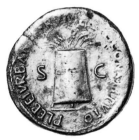
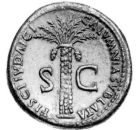

Funding of Imperial posting, corn distribution to the poor, and reform of Jewish poll tax,
all on sestertii of Nerva

A further example of the humanitarianism of this period is to be found on coins of Trajan publicizing the *Alimenta* system. Under this scheme wealthy philanthropists (including emperors from the time of Nerva) made substantial gifts to communities, both in Italy and the provinces, for the purpose of providing sustenance for needy children through agricultural investment. Trajan's successor, Hadrian, in an attempt to gain popularity after having come to the throne under somewhat dubious circumstances, made a grand gesture of cancelling all debts due to the state treasury – a sum equivalent to many millions of pounds. Not surprisingly, this extraordinary act of liberality received full publicity on the coinage, with a remarkable *sestertius* type showing a lictor setting fire to a heap of documents in the presence of three joyful citizens. The notes and bonds were, in fact, publicly destroyed in Trajan's Forum. The orphanage for girls which Antoninus Pius founded in honour of his deceased wife (*Puellae Faustinianae*) is recorded on posthumous *aurei* and *denarii* of Faustina Senior. Antoninus' great stature as a statesman is portrayed on a *sestertius* type where he is shown bestowing a new king on the Quadi, a barbarian tribe who inhabited territory on the left bank of the Danube.

In addition to those already mentioned there are so many other examples of propaganda types on the Roman Imperial coinage that it is simply not possible to do justice to the topic in an article of this scope. It is hoped, however, that many readers will be sufficiently stimulated to pursue on their own the study of this fascinating subject. In the later period the types are generally of a less specific nature, as typified by the *antoniniani* of the joint Emperors Balbinus and Pupienus (AD 238). These all feature clasped right hands accompanied by one of six different forms of legend (e.g. AMOR MVTVVS AVG, CARITAS MVTVA AVGG, etc.) the common aim being to create a public impression of perfect harmony between the ill-matched and, ultimately, ill-fated rulers.

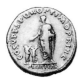
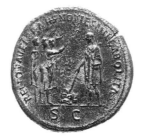

The Alimenta
system (Trajan)

Cancellation of public debts (Hadrian) and
appointment of barbarian king (Antoninus Pius)

Harmony of the joint emperors (Balbinus)

IX. POSTHUMOUS TYPES

Some of the emperors and empresses were publicly deified following their deaths, *i.e.* placed among the official gods of the State, and in most cases commemorative coins were produced in their honour by their immediate successors. The reverse types of these issues form a distinctive group within the Imperial coinage, the same basic types often being repeated through many series of posthumous coins.

Divus Augustus asses struck under Tiberius

The honours paid to Rome's first emperor, Augustus, were of an extraordinary nature and all four of his Julio-Claudian successors struck issues in commemoration of 'Divus Augustus' (Nero only on the Alexandrian coinage). The most extensive of these series was produced under Tiberius and has a wide variety of reverse types, including a thunderbolt, an eagle, the shrine of Vesta on the Palatine, and the altar of Providentia. The eagle and the altar were to become popular types on future posthumous issues.

Aurei and *denarii* struck under Nero in honour of Divus Claudius show an elaborate funerary vehicle drawn by four horses; whilst an intriguing precious metal type produced in AD 80 for Divus Vespasian has two capricorns back to back supporting a shield inscribed S C, a design recalling one of the *sestertius* types of Divus Augustus. A rare *aureus* type of Divus Trajan depicts a radiate phoenix, the fabulous bird which was regarded as a symbol of immortality.

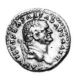

Denarii of Divus Claudius and Divus Vespasian

Despite the alleged strained relationship between Hadrian and his wife Sabina, an interesting coinage was produced in her honour following her death and deification in AD 136. A *sestertius* type shows the new goddess being borne aloft by an eagle. Subsequently, this was to become a popular theme on the posthumous coinages of both emperors and empresses, though in the case of the latter a peacock (symbolic of Juno) usually took the place of Jupiter's eagle. Another posthumous type which achieved popularity during the course of the 2nd century was the so-called 'funeral pyre' (more accurately the crematorium in which the pyre was placed). This pyramidal structure surmounted by a facing quadriga occurs commonly from the time of the coinage of Divus Antoninus Pius onwards. Fragmentary remains of the crematorium of Marcus Aurelius were discovered in the Campus Martius in 1908 and lie below the present Chamber of Deputies.

Denarii of Divus Antoninus Pius and Diva Faustina Senior

Antoninus Pius himself had issued an extensive posthumous coinage in honour of his wife, the elder Faustina, who predeceased him by two decades. In many respects this coinage is unique, both in its large volume and in the diversity of reverse types, many of which would seem to be more in keeping with the coinage of a living empress. Ceres, Juno, Venus, Vesta, and Pietas are amongst a surprising variety of goddesses and personifications making their appearance on this series, the later issues of which probably coincide with various anniversaries of Faustina's deification (fifth, tenth, etc.). The earlier issues are more obviously connected with the apotheosis of the empress, *viz* a funerary car drawn by elephants, an empty throne with peacock beneath, and a flying Victory carrying Faustina to heaven.

The type of an empty throne was revived by Caracalla and Geta on a denarius issued for their deceased and deified father, Septimius Severus, in AD 211. In this case, however, a wreath is shown on the seat to represent the departed Augustus. During the 3rd century the posthumous coinages settled down into a regular and predictable pattern, generally utilizing only a few basic types – an eagle or a large altar for emperors, and a peacock (either standing or bearing the new deity to heaven) for empresses. An intriguing series of *antoniniani* issued by Trajan Decius in AD 250–51 honours the memories of many of the deified emperors dating back to Augustus, each having two reverse types (eagle and altar). In AD 317–18 Constantine the Great issued from several of his mints a series of small bronzes, probably representing two denominations (reduced *folles* and *half folles*),

Diva Paulina borne aloft to heaven

in honour of the deified emperors Claudius II Gothicus (a claimed ancestor), his father Constantius I Chlorus, and father-in-law Maximian. The reverses of these coins exhibit three different types (emperor seated on curule chair, eagle, and lion) and their purpose seems to have been to establish in the public mind Constantine's superior imperial 'pedigree' at a time of intense rivalry with his eastern colleague Licinius.

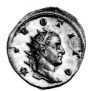

Antoniniani issued by Trajan Decius in honour of Divus Titus and Divus Nerva

With the advent of Christianity the posthumous coinages inevitably cease, the last emperor to be accorded these honours being Constantine himself (died AD 337). His issues, produced under his three sons, were all of the tiny reduced *centenionalis* denomination ('Æ 4') and were of two main types: one showing a standing figure of the emperor, veiled and togate; the other depicting him in a quadriga being borne aloft to heaven, where the hand of God (*manus Dei*) is extended to greet him.

X. OTHER TYPES

The nine categories of reverse types which have been covered in this brief survey certainly comprise the bulk of the Roman Imperial coinage. There are, however, a number of types which do not classify satisfactorily under any of these groups, and these are described under the following five subheadings.

The Julian comet Star (Faustina Crescent moon
(Augustus) Senior) and star
 (Hadrian)

1. Heavenly Bodies. Objects such as stars and crescent moons make fairly regular appearances on the Imperial coinage. A more unusual representation, on a *denarius* of Augustus, shows the *sidus*

Iulium, the comet with flaming tail which appeared in the heavens shortly after Caesar's assassination and was taken as a sign of the late dictator's divinity. The type depicting a group of stars around a crescent moon was quite popular in the 2nd century and appears on issues of Hadrian, Faustina Senior and Junior, Pescennius Niger, Septimius Severus, and Julia Domna. The type of a single star continued to appear well into the 4th century, the latest example being on silver of Julian II.

2. Inscriptions. It was not unusual, especially in the early Empire, for inscriptions to appear in place of pictorial types on the reverses of coins. The practice was especially common on *aes* denominations and had its origin in the Augustan currency reform of *circa* 18 BC, when *sestertii* and *dupondii* (and later *asses* also) were introduced showing the moneyer's name around a large 'S C' as their reverse type. This was later replaced by an Imperial inscription normally giving the name and titles of the emperor, though sometimes of some other member of the Imperial family. The type was used up until the end of the 1st century AD but does not appear after the reign of Nerva. Another form of epigraphic reverse, showing the inscription in several lines across the field (usually enclosed by a wreath), first appeared under Augustus and became popular from the time of

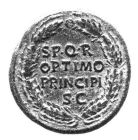

Drusus, son of Tiberius Trajan, 'Best of Princes'

Caligula. It continued in use right up until the end of the Roman period in the late 5th century and even extended into early Byzantine times. In the 1st century S P Q R P P OB C S and EX S C OB CIVES SERVATOS are typical examples of the legends shown in this way; and the 2nd century saw the use of inscriptions such as S P Q R OPTIMO PRINCIPI, PRIMI DECENNALES COS III, and VOTA PVBLICA. During the 3rd century the legend VOTIS DECENNALIBVS appeared quite regularly, whilst in the Constantinian era the trend was towards inscriptions giving the emperor's name. Later 4th and 5th

Votive inscription (Trajan Decius) Votive inscription (Constantius II)

century epigraphic reverses are confined almost exclusively to commemoration of the vows undertaken for various periods of the emperor's rule, e.g. VOT V, VOT V MVLT X, VOTIS XXX MVLTIS XXXX, etc. This type of reverse extended into early Byzantine times, though ultimately the numerals came to be reproduced mechanically from earlier issues without regard to their true meaning. The latest examples appear on Carthaginian silver coins of Justinian I (AD 527–65).

3. Mythological Types. These are rare on the Imperial coinage, except for the representations of the she-wolf suckling the twins Romulus and Remus (this type occurs on the coinages of many of the emperors from Vespasian to Constantine). A *denarius* of Augustus depicts the fate of Tarpeia, the Roman traitress, who admitted the Sabines to the citadel in return for the promise of gold. Instead of giving her their armlets the enemy soldiers, disgusted at her treachery, cast their shields

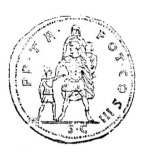

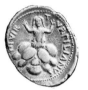

Aeneas (Antoninus Pius) Tarpeia (Augustus) Wolf and twins
 (Maxentius)

upon her and crushed her to death. An interesting reverse of Antoninus Pius shows a striding figure of the Trojan prince Aeneas, bearing his aged father Anchises on his shoulders and leading his son Ascanius by the hand. This formed part of a series produced in anticipation of the upcoming 900th anniversary of Rome.

4. Nautical Types. Representations of ships are not uncommon on the Roman coinage and there are even two instances of a 'bird's-eye' view of the harbour installations at Ostia (on *sestertii* of Nero and Trajan). The galley type which appears frequently on the coinage of Hadrian is commemorative of the emperor's numerous voyages during his Empire-wide travels. Similar depictions, though not always so finely rendered, appear on the coins of many of Hadrian's successors (Marcus

Ostia harbour (Nero) Galley (Hadrian)

Aurelius and Lucius Verus, Commodus, Caracalla, Elagabalus, Postumus, etc.). Especially noteworthy are the galleys shown on the coinages of the British usurpers Carausius and Allectus (AD 287–296) whose regimes depended so heavily on naval power. Even as late as the reign of Theodosius the Great (379–95) there is a type on the *maiorina* ('Æ 2') denomination which shows the emperor standing on a galley with Victory at the helm. One other type which has claim to be included under this heading is the 'dolphin entwined around anchor' reverse which occurs on *aurei* and *denarii* of Titus and Domitian.

5. Symbolic Types. These appear sporadically throughout the entire period of the Roman Imperial coinage and usually have some religious association. Exceptions to this are types such as the *pileus* or felt cap, symbolic of liberty, on *quadrantes* of Caligula; and four young boys at play, representing spring, summer, autumn, and winter, on the coins of several of the emperors from Commodus to Constantine. The thunderbolt, however, which sometimes appears on its own as a reverse type,

Emblems of the
priesthoods
(Augustus)

Thunderbolt
(Antoninus Pius)

does have religious significance, it being symbolic of Jupiter, the chief deity in the Roman pantheon. More obviously of a religious nature are the types which depict various groups of emblems symbolic of the Roman priesthoods, such as the simpulum, lituus, tripod, patera, aspergillum, apex, sacrificial knife, axe, and jug. An early denarius of Nero (under Claudius) shows the first four of these symbols, each one representing one of the priestly colleges (the *Pontifices*, the *Augures*, the *Quindecimviri Sacris Faciundis*, and the *Septemviri Epulones*) to which the young Nero was admitted in AD 51. This type of reverse, which appeared quite frequently up to the end of the 3rd century, was superseded from the time of Constantine by types alluding to Christianity, the new state religion of the Roman Empire. The first representation of the labarum (the Christian standard) occurs on Constantinopolitan *centenionales* of Constantine issued in AD 327, whilst a large Christogram appears in the 350s as the main type on coins of the western usurpers Magnentius and Decentius, and on subsequent issues of Constantius II. The Cross, the supreme symbol of the Christian faith, became popular as a reverse type in the 5th century and occurs most frequenty on the gold *tremissis* denomination.

Christogram
(Magnentius)

Cross
(Romulus
Augustus)

The foregoing notes can make no claim to completeness in describing the various aspects of Roman Imperial reverse types. The topic is so vast that the author can only hope to have stimulated the reader sufficiently to encourage further study in more detailed works. Collectors may also have found here some challenging new themes for the formation of a collection.

Before concluding this section of the introductory material brief mention should be made of the typology of the pre-Imperial Republican series which spans the first two and a half centuries of the Roman coinage. Although Republican coins exhibit an enormous variety of imagery, especially in their later stages, there are few consistent themes which can be traced throughout the series as a whole. The reason for this may be sought in the nature of the issuing authority, for under the Republican constitution responsibility for coin production was in the hands of the annually elected mint magistrates, or moneyers. Initially, during the 3rd century BC, there was little originality shown in the selection of types and the entire process would seem to have been under the control of the Senate as a whole, with the moneyers serving merely in an administrative capacity. Soon after the currency reform of *circa* 211 BC, however, the moneyers' names began to appear on the coins, initially as monograms but soon evolving into longer forms which make identification easier. At this stage the typology of the standard silver coin (*denarius*) is monotonous and clearly under rigid control (head of Roma/Dioscuri galloping) with just occasional variations in the standard design, such as the introduction of the 'Luna in biga' reverse in the first decade of the 2nd century BC and the 'Victory in biga' type in the years before the middle of the century. Around 140 BC, however, there is a clear and dramatic change, with a whole new range of types suddenly appearing. Obviously, some reassessment of the moneyer's role had taken place and his authority had been expanded to include participation in the selection of the design of the coins being struck in his name. This resulted in an explosion of diversity in the types of the *denarius*, many of them making reference to the ancestral history of the individual moneyers. Thus, the types produced by the mint in one year frequently bore no resemblance to those that had preceded them or those that were to follow. Although adding immeasurably to the interest of the series as a whole, this development precludes the possibility of any kind of ordered categorization, there being nothing governing the type selection other than the individual whim of the moneyer. This situation continued to the very end of the series, though with the rise of powerful individuals such as Sulla, Pompey, and Caesar in the final decades of the Republic the selection of types often began to serve the political agendas of the Imperators rather than the vanity of the moneyers. With the triumph of the principle of auto-cratic rule in the person of Caesar's heir, Octavian, the prerogative of coinage passed under an entirely new authority and one which would certainly not brook interference from any other source. The Imperial coinage was, from first to last, a jealously guarded and vital publicity tool of the emperor.

A series closely related to the Roman Imperial coinage is the Roman Provincial coinage, often referred to as 'Greek Imperial'. Issued from hundreds of mints in Europe, Asia Minor, the Levant, Egypt and North Africa, these coinages served the needs of many local communities, especially in the East, over the first three centuries of the Empire's existence. They exhibit an extraordinary diversity of reverse types many of which make reference to topics of local interest, such as noted architectural features of the city and local festivals and associated games. The names of civic and provincial officials appear quite frequently on these issues, making the series as a whole an invalu-able resource for students of Roman provincial administration. With the notable exception of the Alexandrian coinage of Egypt, these issues fall outside the scope of the present work and the reader is referred to the author's companion volume *Greek Imperial Coins and Their Values* as well as to the magisterial new series *Roman Provincial Coinage*.

COUNTERMARKS ON THE AES COINAGE
OF THE EARLY EMPIRE

During the Julio-Claudian period and up to the opening months of Vespasian's reign the practice of countermarking brass and copper coins was quite widespread. These overstrikings served three main purposes: to extend the area in which the coin would be accepted as currency; to prolong the useful life of a coin which had been in circulation over an extended period of time; and to denote that a new authority was converting someone else's issue into its own.

To the first category belong countermarks of the reigns of Augustus and Tiberius which were intended for the use of Roman troops engaged on campaigns, principally in Germany. These

include overstrikings such as AVG (with AV in monogram form), AV (in monogram), and IMP (in monogram), all of the time of Augustus; and TIB, TIB IMP (IMP in monogram), and TIB AV (AV in monogram) from the reign of Tiberius. Claudius seems to have followed a similar practice at the time of his invasion of Britain in AD 43, applying countermarks such as TI AV (AV in monogram), T C IMP (MP in monogram), and TI CLAV IM (LAV in monogram).

Countermarks extending the period of circulation of old coins belong mainly to the early years of Nero's reign, when no new *aes* coinage was being produced by the Rome mint. The purpose of this was to withdraw those pieces which had become too worn for continued use and to counter-mark (usually with 'NCAPR') coins which were still in good enough condition to remain in circula-tion for a few years more. A particularly interesting countermark of this period has been noted on a very worn *sestertius*. It contains the legend 'DVP' thus indicating that the piece was being officially authorized to remain in circulation, though only at half of its original value.

In the period of civil strife at the end of Nero's reign and immediately following his death, countermarks such as SPQR, PR, and VITE (VIT in monogram) were employed. The first two were used by Vindex, leader of the anti-Nero uprising in Gaul, and the third was the mark of the Emperor Vitellius. Vindex countermarked *dupondii* and *asses* of Nero, whilst Vitellius used only his *sestertii*. Vespasian, the ruler who eventually emerged victorious from the chaos of the civil wars and went on to found the Flavian dynasty, also countermarked *dupondii* and *asses* of Nero with a monogram of his name. The same emperor was also responsible for a remarkable series of countermarks on silver coins of the Republic and early Empire, possibly applied at the Antioch mint. Being without the facilities to produce a regular coinage to publicize his regime in the early days of his revolt against Vitellius, he adopted the expedient of marking with the legend 'IMP VESP' as many denarii as he could lay his hands on.

Countermarks were rarely applied on Roman coins after this period, but in the Roman Provincial ('Greek Imperial') series they occur quite frequently well into the 3rd century, possibly even as late as the reign of Aurelian (AD 270–75).

ROMAN MINTS FROM AUGUSTUS TO THE REFORM OF DIOCLETIAN

The chaotic monetary system which Octavian inherited on gaining supreme power in 30 BC was the result of decades of civil strife and the eclipse of the Senate as the supreme authority in the Roman World.

In the days of the Republic the issue of coinage was entirely in the hands of the Senate, who annually appointed the monetary magistrates to superintend the operations of the mint. Rome itself was the principal mint, but sometimes, under special circumstances, establishments were utilized in other locations, not always in Italy, though still under the control of the Roman Senate. In the final half century before the overthrow of the Republican constitution a new minting authority appeared in the Roman World – the Imperator. These powerful military commanders in the field assumed the right to produce coinage, and although at first they applied to the Senate for permission to strike money for the payment of their troops this irksome formality was quickly dispensed with. These 'military coinages' gradually started appearing in various parts of the Roman World quite inde-pendently of all Senatorial authority. As a final blow, early in 49 BC the Senate was obliged to flee to Greece at the time of the war between Caesar and Pompey, thus leaving control of the mint of Rome entirely in the hands of Caesar. Following the dictator's assassination on the Ides of March, 44 BC, the Senate looked forward to a restoration of many of the prerogatives it had surrendered during the previous half decade, including its control over the operations of the mint. However, Caesar's youthful heir, Octavian, quickly took charge of the situation in Rome, thereby putting paid to the Senate's hopes of a revival of their authority. Coinage from the Capitoline mint ceased alto-gether in 40 BC and thereafter all the currency needs of the State were provided by military estab-lishments under the control of the Triumvirs Octavian and Mark Antony.

Once Octavian – now called Augustus – had firmly established his constitutional position, in the years following his victory over Antony and Cleopatra, he turned his attention to the much-needed reorganization of the coinage. About 19 BC minting of *aurei* and *denarii* in Rome was resumed after more than two decades, and soon afterwards *aes* coinage was instituted as a regular part of the currency system. However, the new precious metal coinage from Rome was destined to be short-lived and ceased altogether after 12 BC. Augustus had other plans for the creation of a new mint establishment to produce his regular gold and silver issues. A number of provincial mints had been active from the mid-twenties down to about 16 BC, notably in Spain, but the city selected was Lugdunum, the provincial capital of Gaul, where a mint was opened in 15 BC. It soon became the only mint striking in the precious metals and was destined to retain this monopoly down to the time of Nero's currency reform in AD 64. Additionally, the Gallic mint had a substantial output of *aes*, in various denominations, commencing in 10 BC and extending down to the early years of Tiberius' reign. These depicted on the reverse the celebrated 'Altar of Lugdunum' dedicated by Augustus in 10 BC. Another Gallic mint, Nemausus, was also active at this time (and earlier) in the production of dupondii bearing the heads of Augustus and Agrippa on obverse. In the East, the great Asian cities of Ephesus and Pergamum produced large issues of silver *cistophori* (= 3 *denarii*) in the 20s BC, though this coinage ceased after 18 BC and was not revived until the reign of Claudius.

The mint system established by Augustus continued with little change down to the time of the reform enacted by Nero in AD 64. A notable addition was the mint of Caesarea in Cappadocia where silver drachms (and later didrachms and hemidrachms also) were produced from the closing years of Tiberius' reign. Nero's reform saw the return of precious metal minting to Rome for the first time in three-quarters of a century. Lugdunum continued as an important mint, but now striking *aes* denominations to supplement the output of Rome.

The Civil Wars of AD 68–9 occasioned the opening of many new temporary mints, as the various contestants for power required plentiful supplies of coined money to secure the loyalty of their troops. Tarraco, Narbo, Vienne, Nemausus, Lugdunum, Carthage, and an uncertain location in Lower Germany, are all credited with having been Imperial mints at this time. In the East, the revolt of Vespasian against Vitellius' regime led to the opening of other temporary mints, such as Alexandria, Tyre, Antioch, Ephesus, and Aquileia, though none of these was destined to survive for long into the Flavian period. Once Vespasian had emerged as the victor from this complicated series of internal conflicts Rome soon resumed its dominant place as the provider of the Empire's currency. Lugdunum still struck sporadically in *aes* throughout the reign; Ephesus seems to have had a late output of denarii in AD 76; and Samosata in Commagene produced a series of orichacum denominations (*dupondius*, *as*, and *semis*) spanning most of the reign. With the return to more settled conditions, the coinages of the reigns of Vespasian's sons, Titus (AD 79–81) and Domitian (81–96), belong almost entirely to Rome, though silver *cistophori* were produced in Asia, probably at Ephesus.

Throughout most of the 2nd century the mint of Rome exercised a virtual monopoly in the production of the regular Roman coinage. *Cistophori* were still struck at various mints in Asia Minor down to the time of Hadrian, whose output was on an impressive scale, but thereafter production ceases (except for an isolated late issue under Septimius Severus). This period of stability came to an end in the final decade of the century when the Empire was again plunged into civil war through the rivalries of Septimius Severus, Pescennius Niger, and Clodius Albinus. Antioch, the Syrian capital and third city of the Empire, produced coinage for Niger, as did Alexandria and Caesarea; whilst Albinus utilized Lugdunum for his independent coinage between AD 195 and 197. Following the defeat of Niger in 194 or 195 Antioch was disgraced for having served as the seat of opposition to Severus. Accordingly, when coinage was subsequently struck for Severus in Syria this was produced at Emesa, the home of Severus' wife Julia Domna, and later at Laodicea (Alexandria and other eastern mints may also have participated in this coinage). Laodicea was the last of the temporary mints to cease production of Roman denominations under Severus, following the Imperial family's return to Rome after an extended absence in the East (AD 203). Rome, meanwhile, was continuing its steady output of all denominations, and after 203 regained its monopoly of production of the Imperial coinage following a decade of turbulence.

For the next fifteen years Rome remained the sole mint, but with Elagabalus' revolt against Macrinus in AD 218 production of *aurei* and *denarii* recommenced in Syria. Antioch was the

probable mint for these issues which extended intermittently into the early years of Severus Alexander. After this, and until the reign of Gordian III (AD 238–44), Rome again struck alone, but this was to be the final period of mint monopoly which the Imperial capital was destined to enjoy. In addition to striking all denominations at Rome, Gordian issued some of his *antoniniani* from at least two other mints. Because of his extensive military operations in the East the Syrian capital of Antioch was, undoubtedly, responsible for part of this provincial coinage. The Balkan mint of Viminacium is the other suggested mint-place for a number of types which clearly are of a style distinct from those attributed to Antioch. The Antiochene issues of *antoniniani* continued under Philip (244–9), Trajan Decius (249–51), and Trebonianus Gallus (251–3); whilst Aemilian (253) issued all of his coins at Rome, with the sole exception of a number of rare *antoniniani* struck at some unidentified mint in the Balkans.

The joint reign of Valerian and Gallienus (AD 253–60) saw some important developments significant of the future move towards total decentralization of the Imperial mint system. A new western mint, probably at Cologne, was opened at this time and another new establishment, located either at Cyzicus in Asia Minor or at Emesa in Syria, commenced operation. Other than the products of Rome, precise mint identification at this time remains problematic because of the lack of explicit mint marks. Antioch certainly seems to have maintained its output of coinage and a Balkan mint, perhaps at Viminacium, seems also to have been active. A notable policy change at this time was the decision to allow provincial mints to strike gold on a regular basis, a precedent which was followed in varying degrees by most of Valerian's successors. This was by no means the first time that mints other than Rome had produced coinage in gold, but from this point on such issues become a normal feature of the Imperial coinage and serve to emphasize the dwindling importance of the capital as the coining centre of the Empire.

During the troubled sole reign of Gallienus (AD 260–68) the beleaguered emperor was forced to revise his father's mint arrangements, due to considerable losses of territory in both the eastern and western halves of the Empire. In the West, the rebellion of Postumus in Gaul (AD 260) meant that the newly-opened mint at Cologne was lost to the central government and to take its place Gallienus opened a new mint at Siscia (Sisak, Croatia). Mediolanum (Milan) also seems to have become active at this time, producing *antoniniani* and gold. In the East, the capture of Valerian by Sapor of Persia in AD 260 inaugurated a period of about twelve years during which Rome exercised very little authority in the eastern provinces, the real power being in the hands of Odenathus and Zenobia, rulers of the desert kingdom of Palmyra. During this period Gallienus certainly produced substantial issues of coinage in the East which are generally assigned to Antioch, though given the prevailing political and military situation in the region it would, perhaps, be preferable to attribute them to Cyzicus. It is possible that other subsidiary mints were also operating at this time in western Asia Minor. Claudius II Gothicus (AD 268–70), the successor of Gallienus, continued to use all of the mints already in operation and available to the central government (Rome, Milan, Siscia, and Cyzicus), whilst *antoniniani* were also struck in his name at Antioch, the Palmyrene rulers having decided to adopt a more conciliatory attitude towards the new regime in Rome.

Aurelian (AD 270–75), the great restorer of Rome's fortunes in the later 3rd century and reformer of the currency, seems to have issued coins from at least eleven mints: Rome; Cologne; Trier, and Lugdunum (the Gallic provinces having been recovered in AD 273); Milan; Ticinum (opened by Aurelian at the time of the currency reform in 273/4 to replace Milan as the northern Italian mint); Siscia; Serdica (another creation of Aurelian); Cyzicus; Antioch (Palmyra having been conquered in 272); and Tripolis in Phoenicia (also opened by Aurelian). Gold was issued at seven of these mints. The Gallic Empire of Postumus had pursued its own policies from AD 260, though Gallienus' recently created mint at Cologne appears to have been retained as the principal source of coinage throughout the thirteen years of the rebel state's existence. Postumus (AD 260–68) seems to have used a secondary Gallic mint for some of his extensive *aes* issues, and a number of *antoniniani* and *aurei* may also be attributed to Milan. The rare coinage of the usurper Laelianus (268) was struck in Lower Germany, either at Moguntiacum (Mainz) or Trier. Postumus' short-lived successor Marius (AD 268) struck most of his coinage at Cologne, though the products of a secondary mint are clearly identifiable and the establishment was probably located at Trier. The final two rulers of the Gallic Empire, Victorinus (268–70) and Tetricus (270–73), would seem to have retained this two-mint system (Cologne and Trier) down to the end of the state's

independent existence. Aurelian assumed control of the 'rebel' mints on his defeat of Tetricus in 273, but soon replaced them with a new establishment at Lugdunum.

The final two decades of the period covered by this survey (Tacitus to Diocletian's currency reform, mid-270s to mid-290s) saw few changes in the mint system established by Aurelian. Two new mints appear under Diocletian in the pre-reform period; one of them (Trier) a revival of an establishment utilized by the Gallic usurpers in the late 260s and early 270s; the other (Heraclea in Thrace) an entirely new creation. The independent British Empire of Carausius (AD 287–93) and his successor Allectus (293–6) brought into being several new mints, though only one of these (London) was destined to survive the restoration of the rule of the central government by the Caesar Constantius Chlorus. Camulodunum (Colchester) is usually regarded as the site of the second mint in Britain, though Clausentum (Bitterne) also has its supporters. Products of this mint are usually marked 'C' or 'CL' and the matter cannot be regarded as having been satisfactorily settled. Certain coins of Carausius show a distinctive style and may represent activity on the part of a mint in northwestern Gaul where the usurper's naval superiority allowed him to control some territory, at least in the earlier part of his reign. Rotomagus (Rouen) has been postulated on the basis of local finds, but the attribution can only be regarded as conjectural.

MINTS AND MINT MARKS OF
THE LATER ROMAN EMPIRE

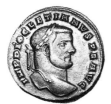

Carthage: follis of Diocletian from
the first officina

Alexandria: follis of Galeria Valeria
from the third officina

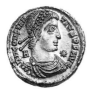

Siscia: maiorina of Constantius II from
the first officina

Treveri: solidus of Valentinian I
from the third officina

Roman Imperial coins began to bear mint marks about the middle of the 3rd century, though the practice had occurred much earlier on *denarii* and *aurei* of Ephesus issued during the reign of Vespasian (AD 69–79). The marks which began to appear – principally on *antoniniani* – from the closing years of Philip I's reign are seldom self-explanatory, normally identifying only the specific workshop or *officina* within the mint. Presumably, these were placed on the coins so that there

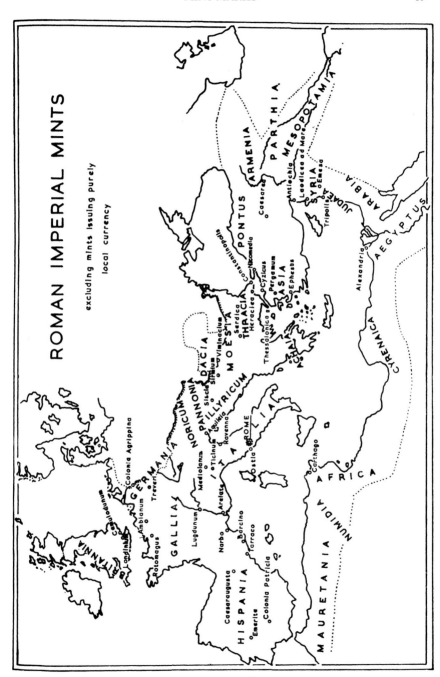

ROMAN IMPERIAL MINTS

excluding mints issuing purely
local currency

might be some accountability on the part of mint officials and workers. Coins of less than standard weight or fineness could be traced back to those responsible for their production and the culprits suitably dealt with. With the advent of the monetary reform of Diocletian in the final decade of the 3rd century the name of the mint city itself customarily becomes an integral part of the mint mark, though it is sometimes abbreviated to a single initial letter, *e.g.* H = Heraclea, N = Nicomedia. A mint mark is normally placed in the exergual space on the reverse side of the coin and may be composed of up to three elements: firstly, a letter or letters indicating *Pecunia* (P), *Sacra Moneta* (SM), or simply *Moneta* (M); secondly, a letter or letters identifying the mint city, such as LON for Londinium; and finally, a letter or letters showing which of the mint's workshops or *officinae* had produced the coin. At the western mints the *officina* letters are usually Latin – P, S, T and Q standing for *Prima, Secunda, Tertia* and *Quarta*. In the East, however, the system of Greek letter-numerals prevailed, the comparable officina letters being A, B, G and D. Thus, a coin of Alexandria may bear the mint mark SMALB showing that it was struck in the second officina. Some eastern mints had many *officinae*. Antioch, for example, had fifteen (IE) under Constantius II, and Constantinople eleven (IA). Certain mints sometimes omit the prefix letter or letters, an example being Trier where the commonest forms of mint mark are TRP and TRS. Where PTR and STR occur the prefix letters are *officina* marks placed before instead of after the mint letters. Sometimes the *officina* letter appears in the field rather than the exergue. A small mint, such as London, may have no indication of *officina* (presumably because the mint establishment comprised a single workshop only). Many of the London issues of the Constantinian period are signed simply PLN or PLON.

Under Valentinian I and Valens the letters PS (on silver) and OB (on gold) make their first appearance. These are abbreviations for *pusulatum* ('pure silver') and *obryza* ('pure gold') and they follow the mint letters, *e.g.* TRPS and TROB. Eventually, the form CONOB came to be utilized universally, without regard to the place of mintage, the actual mint letters sometimes appearing as a secondary element in the field. An important variation used at a number of western mints was COMOB. This may have had a slightly different meaning, the COM possibly indicating the office of *Comes Auri* ('Count of Gold'), the official charged with the responsibility of supervising the Imperial gold supplies in the western provinces of the Empire.

In addition to the mint and *officina* letters, symbols, such as a wreath, a crescent, or a palm-branch, are sometimes found in the exergue or in the reverse field. Of rarer occurrence are letters or symbols appearing in the obverse field, usually behind the ruler's head. All of these denote the specific issue to which the coin belongs.

There follows a list of the mints employed at various times from Diocletian's reform down to the end of the Roman period about two centuries later. To list all the complex mint signatures would be a task beyond the scope of this work. However, most of the commoner mint marks are included, though all reference to symbols and officina letters has, of necessity, been omitted. Nevertheless, it is anticipated that the details provided will be sufficient to enable collectors to identify the mints of most of the late Roman coins he or she is likely to encounter.

Alexandria (Egypt): ALE, SMAL. *Operational for Roman currency from ca.* AD 294. *Finally closed under Leo I (*AD 457–74*).*

Ambianum, more correctly **Civitas Ambianensium,** previously **Samarobriva** (Amiens, France): AMB. *Briefly operational under the usurper Magnentius (a native of the city),* AD 350–53.

Antioch-on-the-Orontes (Antakyé, Turkey): AN, ANT, ANTOB, SMAN. *Operational down to the time of Zeno, the final issues being of the usurper Leontius (*AD 484–8*).*

Aquileia (Udine, Veneto, Italy): AQ, AQVIL, AQOB, AQPS, SMAQ. *Operational from ca.* AD 294. *Finally closed in the early years of Valentinian III, soon after* AD 425.

Arelate/Constantina (Arles, France): A, AR, ARL, CON, CONST, KON, KONSTAN. *Operational from* AD 313 *(establishment transferred from Ostia). Finally closed ca.* AD 476.

(In AD 328 *the name of Arelate was changed to Constantina in honour of Constantine II. After his death in 340 the name reverted to Arelate, but in 353 Constantius II changed it back to Constantina. During the 5th century Arelate seems again to have been generally preferred).*

Barcino (Barcelona, Spain): SMBA. *Briefly operational under the usurper Maximus, AD 410–11.*

Camulodunum or **Clausentum** (Colchester or Bitterne near Southampton): C, CL. *Briefly operational under the usurpers Carausius and Allectus, AD 287–96.*

Carthage (near Tunis, Tunisia): K, PK, KART. *Operational AD 296–307 and 308–11.*

Constantinople (Istanbul, Turkey): C, CP, CON, CONS, CONSP, CONOB. *Operational from AD 326 (establishment transferred from Ticinum).*

Cyzicus (Belkis or Balkiz, Turkey): CM, CVZ, CVZIC, CVZIKEN, K, KV, MK, MKV, SMK. *Finally closed under Zeno (AD 474–91).*

Heraclea (Eregli, Turkey): H, HT, HERAC, HERACL, SMH, SMHT. *Operational from ca. AD 291. Finally closed under Leo I (AD 457–74).*

(The old Greek city of Perinthus on the European coast of the Propontis, its name was changed to Heraclea some time during the course of the 3rd century AD).

Londinium (London): L, ML, MLL, MLN, MSL, PLN, PLON, AVG, AVGOB, AVGPS. *Operational AD 287–325, and for a brief period under the usurper Magnus Maximus (AD 383–8).*

Lugdunum (Lyon, France): LG, LP, LVG, LVGD, LVGPS, PL, PLG. *Finally closed under Honorius, ca. AD 418.*

Mediolanum (Milan, Italy): MD, MDOB, MDPS, MED. *Operational intermittently from ca. AD 352 down to the reign of Zeno (AD 474–91).*

Nicomedia (Ismit, Turkey): MN, NIC, NICO, NIK, SMN. *Operational from ca. AD 294 down to the reign of Zeno (AD 474–91).*

Ostia (the port of Rome): MOST, POST. *Operational under the usurper Maxentius and for a brief period under Constantine, AD 308/9–313.*

Ravenna (Italy): RV, RVPS. *Established by Honorius ca. AD 402 and operational down to the time of Zeno (AD 474–91).*

Roma: CORMOB, R, RM, RMPS, ROMA, ROMOB, SMR, VRB·ROM. *Operational down to the time of Zeno (AD 474–91).*

Serdica (Sophia, Bulgaria): SMSD, SER. *Operational briefly ca. AD 303–8 and again in 313–14.*

Sirmium (Sremska Mitrovica, Yugoslavia): SIRM, SIROB, SM (?). *Operational only sporadically, from AD 320–26, 351–64, 379, and possibly also in 393–5.*

Siscia (Sisak, Croatia, Yugoslavia): SIS, SISC, SISCPS, SM *(?)*. *Finally closed in the early 390s, or possibly as late as the reign of Honorius, after the death of Arcadius in AD 408.*

Thessalonica (Thessaloniki, Greece): CHES, COM, COMOB, CONOB, SMTS, TS, TES, TESA, TESOB, THES, THS, THSOB. *Operational from ca. AD 298/9 and finally closed under Zeno (AD 474–91).*

Ticinum (Pavia, Italy): SMT, T. *Finally closed AD 326 (establishment then transferred to Constantinople).*

Treveri, more correctly **Augusta Treverorum** (Trier, Germany): SMTR, TR, TRE, TRIOB, TRMS, TROB, TROBS, TRPS. *Operational from ca. AD 291. Finally closed under Valentinian III in the late 420s.*

The following mints were reopened in Byzantine times: Alexandria (*ca. AD* 538); Antioch (*ca. AD* 498); Carthage (*ca. AD* 534); Cyzicus (*ca. AD* 518); Nicomedia (*ca. AD* 498); Ravenna (*ca. AD* 555); Rome (*ca. AD* 552); and Thessalonica (*ca. AD* 518).

DATING ROMAN IMPERIAL COINS

The ability to date with a surprising degree of precision many of the coins struck under the Roman Empire provides the student of this remarkably varied series yet another theme for the formation of a collection.

Many people collect Roman Imperial coins in order to assemble a 'portrait gallery' of emperors and empresses; others form their collections on the basis of illustrating the bewildering variety of deities, architectural themes, or commemorations of military campaigns appearing as reverse types; whilst some collectors are attracted by the diversity of mints, scattered throughout the Mediterranean world and northern Europe, at which the Imperial coinage was produced over more than half a millennium. A collection formed on the basis of important dates in Roman history is, however, one theme which most numismatists have probably overlooked and it can be most rewarding.

Thus, one might acquire a coin of AD 70, the year of the capture of Jerusalem by Titus; one of AD 79, which saw the famous eruption of Vesuvius which buried Pompeii and Herculaneum; a coin of Hadrian of the year in which construction began on Hadrian's Wall following the emperor's visit to the province (AD 122); and a coin of Constantine, the first Christian emperor, struck in the year in which he experienced his celebrated 'vision of the Cross' (AD 312). The scope for such a collection is obviously very great, and it has the added advantage of encouraging the collector to undertake his or her own research in order to discover the significance of coins already acquired before pursuing the process further.

One reason for the neglect of this approach is that many collectors are unaware of how to set about dating Roman Imperial coins. It is hoped, therefore, that the following notes, together with the tables of 'Principal Chronological Criteria' appearing in each of the two volumes in this work, will provide much of the necessary information. Users of this new *Millennium Edition* will also notice that in the catalogue entries much fuller information has been provided on the place and time of mintage of each individual type, thus increasing the awareness of chronology.

Tribunicia Potestas (the tribunician power, usually TR P on the coins). The tribunes of the people were first appointed in the early days of the Republic to protect the rights of the lower classes (plebeians) against the powerful aristocrats (patricians). From these humble beginnings the power of the tribunes gradually increased until, under the pretext of defending the rights of the people, they were able to do virtually anything they pleased. This almost unlimited power was drastically curtailed in later Republican times, notably by Sulla, and although many of the rights and privileges of the tribunes were restored after the dictator's death, a few decades later they were again deprived of power by Julius Caesar.

Augustus, in establishing the constitutional basis for his new Imperial rule, quickly realized the advantages to be gained through possession of the power of the tribunes. An added attraction was its popularity with the people, in sharp contrast to the hated titles of *rex* and *dictator*. Accordingly, in 23 BC he had the tribunician power conferred on him for life, thus gathering into his hands many important prerogatives previously enjoyed by the tribunes of the people. He was now empowered to convene and dismiss both the Senate and the Assembly of the People and also to veto any order of the Senate. In addition, the tribunician power rendered his person sacred and inviolable, a valuable asset for an autocrat.

As the emperor wished the tribunician power to be regarded as the basis for his authority it was natural that he should introduce the custom of reckoning the years of his reign by the date of its symbolic annual renewal. The precedent having thus been instituted, this became the normal practice of Augustus' successors and the number of annual renewals of the tribunician power, appearing regularly in the inscriptions on the coinage, provide valuable evidence in establishing the numismatic chronology of each reign. The method employed for selecting the actual date of this annual renewal seems to have varied from reign to reign. Some emperors used the day of its initial conferment (June 27th in the case of Augustus), whilst others preferred the traditional Republican date for the appointment of the tribunes (December 10th). Yet another practice was to renew on January 1st, thus making the tribunician year coincide with the calendar year.

Imperator (usually IMP on the coins). This title, originally meaning 'commander' and used to

describe a victorious general, was utilized in several different ways in Imperial times. One use was as a *praenomen* or personal name of the emperor, by virtue of his supreme command over all the legions, auxiliaries, and naval officers comprising the Empire's armed forces. From the reign of Vespasian it was normally placed before all the other names and titles of the emperor and at about the same time it replaced *princeps* as the popular designation of the emperor.

Another use of 'imperator' was to enumerate the victories of the emperor during the course of his reign. Whenever a Roman army achieved some outstanding military success the emperor received an imperatorial acclamation, regardless of whether or not he was personally in command. The numbers of these acclamations are sometimes included in coin inscriptions and when they are frequent, as in the cases of Domitian, Marcus Aurelius, and the early years of Septimius Severus, they can provide valuable chronological evidence.

Consul (usually COS on the coins). The annual office of consul was established immediately after the abolition of the monarchy in Rome in 510 BC and was the highest of the annual magistracies. There were two colleagues in the consulship and during their year of office they wielded an almost regal power over the government of the Republic, only exceeded by that of a dictator appointed on rare occasions in cases of extreme national crisis. Their authority, however, was considerably diminished by the appointment of the tribunes of the people, who were the only magistrates not subject to the consuls. During the final half century of the Republic's existence their influence was frequently compromised by the authority of the powerful military commanders in the field, the imperators. Nevertheless, being the supreme magistrates of the State, the power of the Consuls remained considerable as long as the Republic endured

Under the Empire consuls continued to be appointed. However, although all the grandeur of the office was retained, the holders of the consulship no longer exercised any of the political power of their Republican predecessors. Quite frequently, more than one pair of consuls were appointed for each year and from the reign of Vespasian it was normal for at least five pairs to hold office annually.

The emperor himself would sometimes hold the consulship. If he did so frequently, and advertised the fact regularly on his coins, then it can be a useful indicator of date. In this respect the Flavian emperors were especially helpful: Vespasian held the consulship eight times in ten years; Titus eight times in twelve years; and Domitian seventeen times in twenty-seven years. In marked contrast, Hadrian only held the consulship three times, in the first three years of his 21-year reign. In consequence, the inscription COS III for Hadrian covers the long period AD 119–138.

Pontifex Maximus (usually P M on the coins). The *Pontifex Maximus* was the head of the *Pontifices*, one of the four senior colleges of priests in Rome, who were charged with the supervision of ceremonies connected with the state religion (interestingly, in a remarkable example of long-term continuity this title is still borne by the Pope today). It was a dignity which, once conferred, was held for life and Augustus did not receive it until after the death of Lepidus (Caesar's successor as *Pontifex Maximus*) in 13 BC. Thereafter, it became one of the titles normally assumed by the emperors at the time of their accession.

Prior to the brief rule of Balbinus and Pupienus in AD 238 the title of Pontifex Maximus always went to the senior emperor in the case of a joint reign, the title of *Pontifex* going to the junior partner (this lesser designation usually also applied to the Caesar, or heir to the throne). Balbinus and Pupienus set a precedent for succeeding emperors by sharing the office of *Pontifex Maximus*.

Pater Patriae (usually P P on the coins). This title of honour, meaning "Father of his Country", was conferred on Augustus in 2 BC and was subsequently assumed by most, but not all, of his successors at the time of their accession. Tiberius steadfastly refused the title and some emperors, such as Hadrian and Marcus Aurelius, only accepted it after they had reigned for a number of years. Thus, coins of Hadrian containing P P in their obverse or reverse legends must be dated subsequent to AD 128, at least eleven years after the commencement of his reign.

Armeniacus, Britannicus, Germanicus, Parthicus, *etc.* (usually abbreviated to ARM, BRIT, GERM, PARTH, *etc.* on the coins). These were titles awarded in commemoration of military victories achieved over foreign enemies.

The following will serve as an example in the use of the tables of 'Principal Chronological Criteria' appearing in each of the two volumes in this catalogue. A *sestertius* of Commodus (AD

177–192) bears the legends M COMMODVS ANT P FELIX AVG BRIT (on obverse) and P M TR P XI IMP VII COS V P P S C (on reverse). Referring to the tables it will be seen that the eleventh year of Commodus' tribunician power spanned the years AD 185–186. As Commodus seems to have renewed his tribunician power on December 10th it is obviously more likely that this piece was struck in 186. However, in order to confirm this some title must be found on the coin to verify the attribution. If we look at the obverse legend we will find that the titles *Pius* (P), *Britannicus* (BRIT) and *Felix* were bestowed on Commodus in AD 183, 184 and 185 respectively and thus provide no assistance in confirming the coin to AD 186. Turning to the reverse legend, we see that Commodus bears the title *Pontifex Maximus* (P M), but according to the table we see that he achieved this status in 180, on the death of his father Marcus Aurelius. His seventh imperatorial acclamation (IMP VII) was in 184 and probably records victories of the Roman governor Ulpius Marcellus in northern Britain; whilst the title of *Pater Patriae* (P P) had been bestowed on him as early as AD 177. This leaves us with COS V which, on checking, we will find is the only title which can securely attribute our coin to AD 186 – the year which saw the remarkable mutiny instigated by the army deserter Maternus on the Rhine frontier which was to spread throughout Gaul and into Spain.

Many issues, of course, do not bear strings of titles enabling them do be dated with great precision, and the coinages of empresses lack all such indications. However, over recent decades much work has been done by scholars on establishing the chronological sequence of issues within specific periods, and in this connection collectors and students are strongly recommended to the works of Dr. Philip V. Hill ('The Undated Coins of Rome, A.D. 98–148' and 'The Coinage of Septimius Severus and his Family of the Mint of Rome, A.D. 193–217', both published by Spink & Son).

ABBREVIATIONS

cuir.	=	cuirassed	laur.	=	laureate
diad.	=	diademed	mm.	=	millimetres
dr.	=	draped	Obv.	=	obverse
ex.	=	exergue	r.	=	right
gm.	=	grammes	rad.	=	radiate
hd.	=	head	Rev.	=	reverse
l.	=	left	stg.	=	standing

CONDITIONS OF COINS IN ORDER OF MERIT

Abbreviation	English	French	German
FDC	mint state	fleur-de-coin	stempelglanz
good EF			
EF	extremely fine	superbe	vorzüglich
nearly EF			
good VF			
VF	very fine	tres beau	sehr schon
nearly VF			
good F			
F	fine	beau	schon
nearly F			
fair	fair	tres bien conservé	sehr gut erhalten
M	mediocre	bien conservé	gut erhalten

ROMAN IMPERIAL COINAGE, 27 BC–AD 491

(Continued from Vol. II)

Principal references:

Baldus = H.R. Baldus, *Uranius Antoninus, Münzprägung und Geschichte*. Bonn, 1971.

Bastien = P. Bastien, *Le Monnayage de Bronze de Postume*. Wetteren, 1967.

BMCG = R.S. Poole, *A Catalogue of the Greek Coins in the British Museum*, Alexandria and the Nomes. London, 1892.

BMCG/Christiansen = E. Christiansen, *Coins of Alexandria and the Nomes, a Supplement to the British Museum Catalogue*. London, 1991.

BMCRE = H. Mattingly, R.A.G. Carson, *Coins of the Roman Empire in the British Museum*, vols. I-VI. London, 1923–62.

BMCRR = H.A. Grueber, *Coins of the Roman Republic in the British Museum*. London, 1910.

C = H. Cohen, *Description Historique des Monnaies Frappées sous l'Empire Romain*, vols. I-VIII. 2nd edition. Paris, 1880–92.

Calicó = X. Calicó, *The Roman Aurei*. Barcelona, 2003.

CBN = J.-B. Giard, *Catalogue des Monnaies de l'Empire Romain*, vols. I-III (Augustus to Nerva). Paris, 1976–2001.

S. Estiot, *Catalogue des Monnaies de l'Empire Romain*, vol. XII, part 1 (Aurelian to Florian). Paris, 2004.

Cologne = A. Geissen, W. Weiser, *Katalog Alexandrinischer Kaisermünzen der Sammlung des Instituts für Altertumskunde der Universitat zu Köln*. Opladen, 1974–83.

CSS = P.V. Hill, *The Coinage of Septimius Severus and his Family of the Mint of Rome, A.D. 193–217*. London, 1977.

Curtis = J.W. Curtis, *The Tetradrachms of Roman Egypt*. Chicago, 1957.

Dattari = G. Dattari, *Numi Augg. Alexandrini*. Cairo, 1901.

Emmett = K. Emmett, *Alexandrian Coins*. Lodi, 2001.

Gilljam = H.H. Gilljam, *Antoniniani und aurei des Ulpius Cornelius Laelianus, Gegenkaiser des Postumus*. Cologne, 1982.

Gnecchi = F. Gnecchi, *I Medaglioni Romani*, vols. I-III. Milan, 1912.

Göbl = R. Göbl, *Regalianus und Dryantilla*. Vienna, 1970.

Hunter = A.S. Robertson, *Roman Imperial Coins in the Hunter Coin Cabinet, University of Glasgow*, vols. I-V. Oxford, 1962–82.

Metcalf = Wm. E. Metcalf, *The Cistophori of Hadrian*. New York, 1980.

Milne = J.G. Milne, *Catalogue of Alexandrian Coins*, University of Oxford, Ashmolean Museum. Oxford, 1971.

MIR = W. Szaivert, *Moneta Imperii Romani*, vol. 18 (Marcus Aurelius, Lucius Verus and Commodus). Vienna, 1986.

M. Alram, *Moneta Imperii Romani*, vol. 27 (Maximinus I Thrax). Vienna, 1989.

R. Göbl, *Moneta Imperii Romani*, vol. 47 (Aurelian). Vienna, 1995.

MPN = R.F. Bland, A.M. Burnett, S. Bendall, *The Mints of Pescennius Niger*. Numismatic Chronicle, vol. 147. London, 1987.

Pink = K. Pink, *Der Aufbau der römischen Münzprägung in der Kaiserzeit, VI/1 Probus*, in Numismatische Zeitschrift, Vol. 73, pp. 13–74. Vienna, 1949.

Der Aufbau der römischen Münzprägung in der Kaiserzeit, VI/2 Carus und Söhne, in Numismatische Zeitschrift, Vol. 80, pp. 5–67. Vienna, 1963.

RIC = H. Mattingly and E.A. Sydenham, P.H. Webb, J.W.E. Pearce, P.M. Bruun, C.H.V. Sutherland, J.P.C. Kent, *The Roman Imperial Coinage*, vols. I-X. London, 1923–94.
RPC = A. Burnett, M. Amandry, P.P. Ripolles, I. Carradice, *Roman Provincial Coinage*, vols. I-II. London and Paris, 1992–9.
RSC = H.A. Seaby, C.E. King, *Roman Silver Coins*, vols. I-V. London, 1952–87.
Schulte = B. Schulte, *Die Goldprägung der gallischen Kaiser von Postumus bis Tetricus.* Frankfurt-am-Main, 1983.
T = M. Thirion, *Le Monnayage d'Elagabale (218–222).* Brussels and Amsterdam, 1968.
Toynbee = J.M.C. Toynbee, *Roman Medallions.* New York, 1944.
UCR = P.V. Hill, *The Dating and Arrangement of the Undated Coins of Rome, A.D. 98–148.* London, 1970.

The coinage of the Roman Empire extended over a period of more than five hundred years, from the establishment of autocratic rule in the city on the Tiber by Caesar's heir Octavian, now called Augustus, down to the accession in Constantinople ('New Rome') of Anastasius I, whose monetary reforms at the end of the 5th century marked the commencement of what is generally termed 'Byzantine' coinage.

For the first two and three-quarter centuries of its production the Roman Imperial coinage maintained a remarkable uniformity. Rome remained the principal mint throughout this lengthy period, though from the later years of Augustus to the coinage reform of Nero in AD 64 the Gallic mint of Lugdunum seems to have been responsible for most of the precious metal issues. The same mint was also active in the large scale production of *aes* from Nero's later years into early Flavian times. Otherwise, provincial minting centres played a significant role only at times of civil war, such as the years following the downfall of Nero in AD 68 and the assassination of Pertinax in 193. Mint marks were almost unknown before the mid-3rd century, though a few had appeared on eastern issues of aurei and denarii in the initial phase of Vespasian's reign.

With the economic and political collapse of the state in the second half of the 3rd century many of the old traditions of the Augustan monetary system disappeared. Production of the *aes* denominations virtually ceased, the silver coinage became hopelessly debased, and there was a rapid decentralization of production, with important new minting centres now being permanently established in the Balkans and in the East. As the Imperial residence Rome remained a prominent mint, though it had forever lost its position of pre-eminence.

The sweeping reforms of Diocletian and Constantine in the late 3rd and early 4th centuries brought drastic changes not only to the Imperial coinage but also to the way in which the government and defence of the Empire were organized. Being too far removed from the vital frontier regions Rome finally ceased to be the seat of Imperial administration. A whole network of mints was now operating throughout the eastern and western provinces of the Empire, supplying the needs of a population which was frequently ruled by a duality or plurality of emperors based in various strategic centres. But the Empire was never again to enjoy the remarkable stability which had been such a feature of the Augustan currency system. Good quality silver coins were reintroduced by Diocletian in the final decade of the 3rd century, but the experiment was short-lived and it was not until ca. 325 that Constantine succeeded in reintegrating the metal back into the monetary system. The history of the *aes* denominations in the 4th and 5th centuries was even more unsettled, with a bewildering succession of reforms and weight reductions which must have seemed almost as incomprehensible to the citizens of the time as they do to numismatists today.

The only real stability in the late Roman currency system was provided by the gold coinage. About AD 310 Constantine the Great introduced a new lighter-weight standard gold denomination known as the solidus. This coin was to have a long and illustrious history extending deep into the Byzantine period. An even more significant innovation by the first Christian emperor was his establishment two decades later of a new Imperial capital at Constantinople, on the site of old Byzantium, at the crossroads of Europe and Asia. This was to mark the beginning of a whole new chapter in Imperial history. The Christian Empire was to endure for more than a millennium, until the Turkish conquest of 1453, ironically ensuring the survival of much of the science and literature of the classical world of Greece and Rome through its meticulous preservation of pagan writings.

NB The following listings represent only a sample selection of the known types and varieties. For a catalogue of all the silver coins of the Imperial period, see "Roman Silver Coins" vols. I-V, by H.A. Seaby and C.E. King.

THE THIRD CENTURY CRISIS AND RECOVERY:
1. MILITARY ANARCHY AND ECONOMIC COLLAPSE, AD 235–270

MAXIMINUS I
19 Mar. AD 235-May/Jun. 238

8307

Gaius Julius Verus Maximinus was born of Thracian peasant stock probably early in the reign of Commodus. As a youth he was attracted to the military life and enlisted in a Roman auxiliary unit. His legendary size and strength attracted the attention of the emperor Septimius Severus who gave him the position of imperial bodyguard and he was later promoted by Caracalla to the rank of centurion. He relinquished his military rank following the assassination of Caracalla and his career was not resumed until the reign of Severus Alexander, under whom he gained rapid promotion. By ad 232 he seems to have been in command of a legion in Egypt and subsequently was appointed governor of the frontier province of Mesopotamia. In March of 235 he was in charge of Pannonian recruits on the Rhine. Disillusioned by the unaggressive policy of Alexander in his conduct of the German war the army mutinied and murdered both the emperor and his mother Julia Mamaea. In their place the troops raised Maximinus to the imperial office and a reluctant but intimated Senate felt obliged to confirm the soldiers' choice. Although militarily the short reign of Maximinus I was highly successful, providing a marked contrast to that of his predecessor, the advantages gained by his dramatic victories beyond the Rhine and Danube frontiers were achieved at a heavy cost to the internal security of the Empire. His reputation for harsh discipline and even brutality made him feared not only by the military but by the population at large, including the Roman aristocracy which felt apprehensive of his probable conduct on his return to Rome at the end of the campaign. This fear eventually manifested itself in a senatorial conspiracy involving the elderly governor of Africa, M. Antonius Gordianus, and his son of the same name. The Senate's complicity is evidenced by the preparation of coin dies in the names of the usurpers at the Rome mint prior to the rebellion. Following the rapid collapse of the revolt in North Africa the Senate had little choice but to openly back a new uprising against Maximinus and accordingly two of its own number, Balbinus and Pupienus, were proclaimed joint Augusti. Maximinus thereupon abandoned his frontier wars and invaded Italy in order to punish the recalcitrant Senate. However, stubborn resistance to the invaders was encountered in the north where the citizens of Aquileia refused to submit. The protracted siege and shortage of supplies led to disaffection amongst Maximinus' troops and the emperor and his son the Caesar Maximus were both murdered in camp as they slept following a midday meal. The precise date of the assassinations is unclear but appears to have been in May or June of ad 238.

Rome was the only mint involved in the production of the state coinage during this reign. Like his predecessor Maximinus struck no antoniniani (double denarii) though this inflationary

denomination was soon to be reintroduced and rapidly supplant the denarius. Gold was issued in very limited quantity but silver denarii and brass sestertii were plentiful. The early portraiture of Maximinus on the coinage of AD 235 displays facial features which are clearly adapted from the late images of Severus Alexander, the die-engravers presumably being ignorant of the new emperor's true appearance. Coinage was also struck in the name of Maximinus' son, the Caesar C. Julius Verus Maximus, and briefly for his deceased and deified wife, Caecilia Paulina.
 There are two varieties of obverse legend:

A. IMP MAXIMINVS PIVS AVG
B. MAXIMINVS PIVS AVG GERM

The normal obverse type for all denominations other than the dupondius is laureate, draped and cuirassed bust of Maximinus right. Dupondii have radiate, draped and cuirassed bust right.

8301 **Gold aureus.** A. Rev. LIBERALITAS AVG, Maximinus seated l. on curule chair atop platform, accompanied by officer stg. behind, Liberalitas stg. l. before him, holding abacus and cornucopiae, citizen mounting steps of platform about to receive largess. RIC 9. BMCRE 50*. C 23. MIR 4–1. [Rome, AD 235].
VF £16,500 ($25,000) / **EF** £40,000 ($60,000)

8302 A. Rev. PAX AVGVSTI, Pax stg. l., holding olive-branch and sceptre. RIC 12. BMCRE 4, 67*. C 30. MIR 10–1. *[Rome, AD 235–6].* **VF** £14,000 ($21,000) / **EF** £33,500 ($50,000)

8303 A. Rev. PROVIDENTIA AVG, Providentia stg. l., holding rod and cornucopiae, globe at feet. RIC 13. BMCRE 85*. Cf. C 74 (obv. misdescribed?). MIR 11–1. *[Rome, AD 235–6].* **VF** £14,000 ($21,000) / **EF** £33,500 ($50,000)

8304

8304 A. Rev. SALVS AVGVSTI, Salus enthroned l., feeding snake arising from altar. RIC 14. BMCRE 20, 98*. C 84. MIR 12–1. *[Rome, AD 235–6].*
VF £14,000 ($21,000) / **EF** £33,500 ($50,000)

8305 A. Rev. VICTORIA AVG, Victory advancing r., holding wreath and palm. RIC 16. BMCRE 104. C 98. MIR 13–1. *[Rome, AD 235–6].* **VF** £14,000 ($21,000) / **EF** £33,500 ($50,000)

8306 **Gold quinarius.** B. Rev. VICTORIA GERM, Victory stg. l., holding wreath and palm, German captive seated at feet. RIC 23. BMCRE 185,. C 105. MIR 27–2. *[Rome, AD 236–8].*
VF £12,500 ($18,500) / **EF** £30,000 ($45,000)

8307 **Silver denarius.** B. Rev. FIDES MILITVM, Fides Militum stg. l., holding standard in each hand.. RIC 18A. BMCRE 137. RSC 9. MIR 21–3. *[Rome, AD 236–8].*
VF £22 ($32) / **EF** £65 ($100)

8308 **Silver denarius.** A. Rev. INDVLGENTIA AVG, Indulgentia enthroned l., r. hand extended, holding sceptre in l. RIC 8. BMCRE 31*. RSC 16. MIR 2–3. *[Rome, AD 235]*.
VF £65 ($100) / **EF** £200 ($300)

8309 A. Rev. LIBERALITAS AVG, Liberalitas stg. l., holding abacus and cornucopiae. RIC 10. BMCRE 45. RSC 19. MIR 5–3. *[Rome, AD 235]*.
VF £28 ($42) / **EF** £85 ($130)

 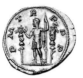

8310 8311

8310 As 8302 (rev. PAX AVGVSTI, Pax stg.). RIC 12. BMCRE 5, 68. RSC 31, 31a. MIR 10–3. *[Rome, AD 235–6]*.
VF £22 ($32) / **EF** £65 ($100)

8311 A. Rev. P M TR P P P, Maximinus, in military attire, stg. l. between two standards, touching standard with r. hand and resting on spear held in l. RIC 1. BMCRE 9. RSC 46. MIR 8–3. *[Rome, AD 235]*.
VF £23 ($35) / **EF** £75 ($110)

8312 Similar, but with rev. legend P M TR P II COS P P. RIC 3. BMCRE 77. RSC 55. MIR 16–3. *[Rome, AD 236]*.
VF £23 ($35) / **EF** £75 ($110)

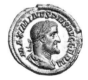 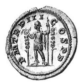 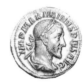 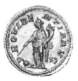

8313 8315

8313 B. Rev. P M TR P III COS P P, Maximinus stg., as 8311. RIC 5. BMCRE 161. RSC 64. MIR 28–3. *[Rome, AD 237]*.
VF £25 ($40) / **EF** £80 ($120)

8314 Similar, but with rev. legend P M TR P IIII COS P P. RIC 6. BMCRE 219. RSC 70. MIR 29–3. *[Rome, AD 238]*.
VF £28 ($42) / **EF** £85 ($130)

8315 As 8303 (rev. PROVIDENTIA AVG, Providentia with globe at feet). RIC 13. BMCRE 15, 86. RSC 77, 77a. MIR 11–3. *[Rome, AD 235–6]*.
VF £22 ($32) / **EF** £65 ($100)

 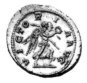

8316 8317

8316 **Silver denarius.** As 8304 (rev. **SALVS AVGVSTI**, Salus enthroned). RIC 14. BMCRE 21, 99. RSC 85, 85a. MIR 12–3. *[Rome, AD 235–6].* **VF** £22 ($32) / **EF** £65 ($100)

8317 As 8305 (rev. **VICTORIA AVG**, Victory advancing). RIC 16. BMCRE 105. RSC 99a. MIR 13–3. *[Rome, AD 235–6].* **VF** £22 ($32) / **EF** £65 ($100)

8318

8318 As 8306 (rev. **VICTORIA GERM**, Victory stg. with captive at feet). RIC 23. BMCRE 186. RSC 107. MIR 27–3. *[Rome, AD 236–8].* **VF** £23 ($35) / **EF** £75 ($110)

8319 A. Rev. **VOTIS / DECENNA / LIBVS** in three lines within laurel-wreath. RIC 17. BMCRE 38. RSC 117. MIR 1–3. *[Rome, AD 235].* **VF** £130 ($200) / **EF** £330 ($500)

8320 **Silver quinarius.** A. Rev. **FIDES MILITVM**, Fides Militum holding standards, as 8307. RIC 7A. BMCRE 62*. RSC 8. MIR 9–4. *[Rome, AD 235–6].*
VF £1,175 ($1,750) / **EF** £2,300 ($3,500)

8321 A. Rev. **MARTI PACIFERO**, Mars stg. l., r. foot on helmet, holding olive-branch and resting on spear. RIC 11. BMCRE 34*. RSC 29a. MIR 3–4. *[Rome, AD 235].*
VF £1,250 ($1,850) / **EF** £2,500 ($3,750)

8322 B. Rev. **PAX AVGVSTI**, Pax stg., as 8302. RIC 19. BMCRE 147*. RSC 37a. MIR 22–4. *[Rome, AD 236–8].* **VF** £1,175 ($1,750) / **EF** £2,300 ($3,500)

8323 B. Rev. **P M TR P III COS P P**, Maximinus stg. between standards, as 8311. RIC 5. BMCRE 164. RSC 65. MIR 3–4. *[Rome, AD 237].* **VF** £1,175 ($1,750) / **EF** £2,300 ($3,500)

8324 As 8303 (rev. **PROVIDENTIA AVG**, Providentia with globe at feet). RIC 13. BMCRE 89. RSC 78. MIR 11–4. *[Rome, AD 235–6].* **VF** £1,175 ($1,750) / **EF** £2,300 ($3,500)

8325 B. Rev. **SALVS AVGVSTI**, Salus enthroned, as 8304. RIC 21. BMCRE 174*. RSC 91a. MIR 24–4. *[Rome, AD 236–8].* **VF** £1,175 ($1,750) / **EF** £2,300 ($3,500)

8326 As 8306 (rev. **VICTORIA GERM**, Victory stg. with captive at feet). RIC 23. BMCRE 190. RSC 108. MIR 27–4. *[Rome, AD 236].* **VF** £1,175 ($1,750) / **EF** £2,300 ($3,500)

8327 **Brass sestertius.** A. Rev. **FIDES MILITVM S C**, Fides Militum stg. l., holding standard in each hand. RIC 43. BMCRE 2, 63. C 10. MIR 9–5. *[Rome, AD 235–6].*
F £40 ($60) / **VF** £100 ($150) / **EF** £300 ($450)

8328 A. Rev. **INDVLGENTIA AVG S C**, Indulgentia enthroned l., r. hand extended, holding sceptre in l. RIC 46. BMCRE 32*. C 17. MIR 2–5. *[Rome, AD 235].*
F £80 ($120) / **VF** £200 ($300) / **EF** £600 ($900)

8329 A. Rev. **LIBERALITAS AVG S C**, Liberalitas stg. l., holding abacus and cornucopiae. RIC 49. BMCRE 46. C 21. MIR 5–5. *[Rome, AD 235].*
F £55 ($80) / **VF** £130 ($200) / **EF** £400 ($600)

8327

8330 **Brass sestertius.** A. Rev. — Maximinus seated l. on curule chair atop platform, accompanied by two officers stg. behind, Liberalitas stg. l. before him, holding abacus and cornucopiae, citizen mounting steps of platform about to receive largess, five figures (soldiers?) stg. l. along base of platform, each resting on spear. RIC 48. BMCRE 51. C 24. MIR 4–5. *[Rome, AD 235].* F £150 ($225) / **VF** £365 ($550) / **EF** £1,100 ($1,650)

8331 A. Rev. MARTI PACIFERO S C, Mars stg., as 8321. RIC 55. BMCRE 35. C 28. MIR 3–5. *[Rome, AD 235].* F £65 ($100) / **VF** £170 ($250) / **EF** £500 ($750)

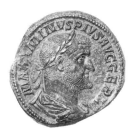

8332

8332 B. Rev. PAX AVGVSTI S C, Pax stg. l., holding olive-branch and sceptre. RIC 81. BMCRE 148. C 38. MIR 22–5. *[Rome, AD 236–8].*
 F £40 ($60) / **VF** £100 ($150) / **EF** £300 ($450)

8333 A. Rev. P M TR P P P S C, Maximinus, in military attire, stg. l. between four standards, his r. hand extended, resting on spear held in l. RIC 24. BMCRE 14. Cf. C 48. MIR 8–5. *[Rome, AD 235].* F £55 ($80) / **VF** £130 ($200) / **EF** £400 ($600)

8334

8334 **Brass sestertius.** A. Rev. P M TR P II COS P P S C, Maximinus in triumphal quadriga l., holding branch and sceptre, crowned by Victory stg. behind him. RIC 27. BMCRE 55. C 53. MIR 14–5. *[Rome, AD 236].* **F** £120 ($180) / **VF** £300 ($450) / **EF** £900 ($1,350)

8335 B. Rev. P M TR P III COS P P S C, Maximinus stg. l., similar to 8333, but with only one standard to r. and emperor touches the farther one on l. RIC 37. BMCRE 165. C 67. MIR 28–5. *[Rome, AD 237].* **F** £55 ($80) / **VF** £130 ($200) / **EF** £400 ($600)

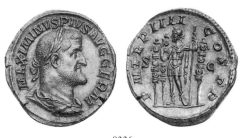

8336

8336 Similar, but with rev. legend P M TR P IIII COS P P S C. RIC 40. BMCRE 221. C 71. MIR 29–5. *[Rome, AD 238].* **F** £55 ($80) / **VF** £130 ($200) / **EF** £400 ($600)

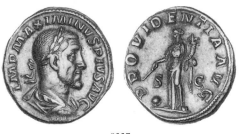

8337

8337 A. Rev. PROVIDENTIA AVG S C, Providentia stg. l., holding rod and cornucopiae, globe at feet. RIC 61. BMCRE 17, 90. C 80. MIR 11–5. *[Rome, AD 235–6].*
 F £40 ($60) / **VF** £100 ($150) / **EF** £300 ($450)

8338 B. Rev. SALVS AVGVSTI S C, Salus enthroned l., feeding snake arising from altar. RIC 85. BMCRE 175. C 92. MIR 24–5. *[Rome, AD 236–8].*
 F £40 ($60) / **VF** £100 ($150) / **EF** £300 ($450)

8339 A. Rev. VICTORIA AVG S C, Victory advancing r., holding wreath and palm. RIC 67. BMCRE 27, 108. C 100. MIR 13–5. *[Rome, AD 235–6].*
 F £40 ($60) / **VF** £100 ($150) / **EF** £300 ($450)

8340 B. Rev. VICTORIA AVGVSTORVM S C, Maximinus l., in military attire, and Maximus r., togate, stg. facing each other, holding Victory between them, two German captives at their feet, each with soldier stg. behind him. RIC 89. BMCRE 183. C 104. MIR 33–5. *[Rome, AD 238].* **F** £230 ($350) / **VF** £600 ($900) / **EF** £1,900 ($2,800)

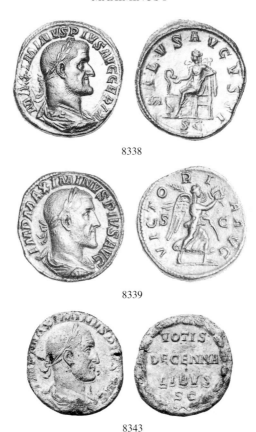

8338

8339

8343

8341 **Brass sestertius.** B. Rev. VICTORIA GERMANICA S C, Victory stg. l., holding wreath and palm, German captive seated at feet. RIC 90. BMCRE 191. C 109. MIR 27–5. *[Rome, AD 236–8]*. **F** £55 ($80) / **VF** £130 ($200) / **EF** £400 ($600)

8342 B. Rev. — Maximinus, in military attire, stg. l., his r. hand raised, holding spear in l., captive seated at feet, crowned by Victory stg. l. behind him, holding palm. RIC 93. BMCRE 198. C 114. MIR 26–5. *[Rome, AD 236–8]*. **F** £95 ($140) / **VF** £230 ($350) / **EF** £665 ($1,000)

8343 A. Rev. VOTIS / DECENNA / LIBVS / S C in four lines within laurel-wreath. RIC 75. BMCRE 40. C 118. MIR 1–5. *[Rome, AD 235]*. **F** £95 ($140) / **VF** £230 ($350) / **EF** £665 ($1,000)

8344 **Brass dupondius.** B. Rev. FIDES MILITVM S C, Fides Militum holding standards, as 8327. RIC 79. BMCRE 142*. C 15. MIR 21–6. *[Rome, AD 236–8]*. **F** £48 ($70) / **VF** £115 ($175) / **EF** £350 ($525)

NB The emperor's portrait on this denomination invariably shows him wearing a radiate crown.

8345 **Brass dupondius.** A. Rev. LIBERALITAS AVG S C, Liberalitas stg., as 8329. RIC 50. BMCRE 48*. C 22. MIR 5–6. *[Rome, AD 235].* **F** £60 ($90) / **VF** £150 ($225) / **EF** £450 ($675)

8346 A. Rev. MARTI PACIFERO S C, Mars stg., as 8321. RIC 56. BMCRE 36*. C —. MIR 3–6. *[Rome, AD 235].* **F** £75 ($110) / **VF** £185 ($275) / **EF** £550 ($825)

8347 A. Rev. PAX AVGVSTI S C, Pax stg., as 8332. RIC 59. BMCRE 8. 75. C 36. MIR 10–6. *[Rome, AD 235–6].* **F** £48 ($70) / **VF** £115 ($175) / **EF** £350 ($525)

8348 A. Rev. P M TR P II COS P P S C, Maximinus, in military attire, stg. l. between four standards, touching the nearer one on l. and resting on spear held in l. hand. RIC 31. BMCRE 84. C 61. MIR 16–6. *[Rome, AD 236].*
 F £60 ($90) / **VF** £150 ($225) / **EF** £450 ($675)

8349 B. Rev. P M TR P III COS P P S C, Maximinus stg. l., similar to previous, but with only one standard to r. and emperor touches the farther one on l. RIC 38. BMCRE 166. C 69. MIR 28–6. *[Rome, AD 237].* **F** £60 ($90) / **VF** £150 ($225) / **EF** £450 ($675)

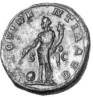

8350

8350 A. Rev. PROVIDENTIA AVG S C, Providentia with globe at feet, as 8337. RIC 62. BMCRE 18, 93*. C 82. MIR 11–6. *[Rome, AD 235–6].*
 F £48 ($70) / **VF** £115 ($175) / **EF** £350 ($525)

8351 B. Rev. SALVS AVGVSTI S C, Salus enthroned, as 8338. RIC 86. BMCRE 178. C 94. MIR 24–6. *[Rome, AD 236–8].* **F** £48 ($70) / **VF** £115 ($175) / **EF** £350 ($525)

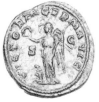

8352 8353

8352 A. Rev. VICTORIA AVG S C, Victory advancing, as 8339. RIC 68. BMCRE 28, 110. C 102. MIR 13–6. *[Rome, AD 235–6].* **F** £48 ($70) / **VF** £115 ($175) / **EF** £350 ($525)

8353 B. Rev. VICTORIA GERMANICA S C, Victory with captive at feet, as 8341. RIC 91. BMCRE 196. C 111. MIR 27–6. *[Rome, AD 236–8].*
 F £60 ($90) / **VF** £150 ($225) / **EF** £450 ($675)

8354 **Brass dupondius.** A. Rev. VOTIS / DECENNA / LIBVS / S C in wreath, as 8343. RIC 76. BMCRE 42. C 120. MIR 1–6. *[Rome, AD 235].*
F £110 ($160) / **VF** £265 ($400) / **EF** £800 ($1,200)

8355 **Copper as.** A. Rev. FIDES MILITVM S C, Fides Militum holding standards, as 8327. RIC 45. BMCRE 66. C 11. MIR 9–7. *[Rome, AD 235–6].*
£40 ($60) / **VF** £100 ($150) / **EF** £300 ($450)

8356 A. Rev. INDVLGENTIA AVG S C, Indulgentia enthroned, as 8328. RIC 47. BMCRE 33*. C 18. MIR 2–7. *[Rome, AD 235].* **F** £75 ($110) / **VF** £185 ($275) / **EF** £550 ($825)

8357 A. Rev. LIBERALITAS AVGVSTI S C, Liberalitas stg., as 8329. RIC 54. BMCRE 49*. C —. MIR 7–7. *[Rome, AD 235].* **F** £55 ($80) / **VF** £130 ($200) / **EF** £400 ($600)

8358 A. Rev. MARTI PACIFERO S C, Mars stg., as 8321. RIC 57. BMCRE 37*. C 29. MIR 3–7. *[Rome, AD 235].* **F** £65 ($100) / **VF** £170 ($250) / **EF** £500 ($750)

8359 B. Rev. PAX AVGVSTI S C, Pax stg., as 8332. RIC 83. BMCRE 155. C 39. MIR 22–7. *[Rome, AD 236–8].* **F** £40 ($60) / **VF** £100 ($150) / **EF** £300 ($450)

8360 A. Rev. P M TR P II COS P P S C, Maximinus in quadriga l., as 8334. RIC 29. BMCRE 55, note. C 54. MIR 14–7. *[Rome, AD 236].*
F £115 ($175) / **VF** £285 ($425) / **EF** £825 ($1,250)

8361 B. Rev. P M TR P III COS P P S C, Maximinus stg. between standards, as 8349. RIC 39. BMCRE 168. C 68. MIR 28–7. *[Rome, AD 237].*
F £55 ($80) / **VF** £130 ($200) / **EF** £400 ($600)

8362 A. Rev. PROVIDENTIA AVG S C, Providentia with globe at feet, as 8337. RIC 63. BMCRE 94. C 81. MIR 11–7. *[Rome, AD 235–6].* **F** £40 ($60) / **VF** £100 ($150) / **EF** £300 ($450)

8363

8363 A. Rev. SALVS AVGVSTI S C, Salus enthroned, as 8338. RIC 66. BMCRE 103. C 89. MIR 12–7. *[Rome, AD 235–6].* **F** £40 ($60) / **VF** £100 ($150) / **EF** £300 ($450)

8364 A. Rev. VICTORIA AVG S C, Victory advancing, as 8339. RIC 69. BMCRE 29, 111. C 101. MIR 13–7. *[Rome, AD 235–6].* **F** £40 ($60) / **VF** £100 ($150) / **EF** £300 ($450)

8365 B. Rev. VICTORIA GERMANICA S C, Victory with captive at feet, as 8341. RIC 92. BMCRE 197. C 110. MIR 27–7. *[Rome, AD 236–8].*
F £55 ($80) / **VF** £130 ($200) / **EF** £400 ($600)

8366 B. Rev. — Maximinus crowned by Victory, as 8342. RIC 94. BMCRE 199. C 115. MIR 26–7. *[Rome, AD 236–8].* **F** £85 ($130) / **VF** £220 ($325) / **EF** £650 ($975)

8367 **Copper as.** A. Rev. VOTIS / DECENNA / LIBVS / S C in wreath, as 8343. RIC 77. BMCRE 43*. C 119. MIR 1–7. *[Rome, AD 235].* **F** £95 ($140) / **VF** £230 ($350) / **EF** £665 ($1,000)

Alexandrian Coinage

8368 **Billon tetradrachm.** AVTO MAΞIMINOC EVC CEB, laur., dr. and cuir. bust r. Rev. Rev. Sarapis enthroned l., his r. hand extended over Kerberos at his feet and holding sceptre in l., L A (= regnal year 1) before. Dattari 4596. BMCG —. Cologne 2550. Milne 3190. *[AD 235].*
F £32 ($50) / **VF** £80 ($120)

8369 Obv. Similar. Rev. Rev. Zeus reclining l., holding patera and sceptre, above eagle facing, wings spread, hd. r., L A (= regnal year 1) above. Dattari 4609. BMCG 1768. Cologne —. Milne 3187. *[AD 235].* **F** £32 ($50) / **VF** £80 ($120)

8370 — Rev. Bust of Athena r., wearing crested Attic helmet and aegis, L B (= regnal year 2) before. Dattari 4565. BMCG 1777. Cologne 2552. Milne 3199. *[AD 235–6].*
F £32 ($50) / **VF** £80 ($120)

8371 — Rev. Rad. bust of Helios r., L B (= regnal year 2) before. Dattari 4572. BMCG 1771. Cologne 2554. Milne 3196. *[AD 235–6].* **F** £32 ($50) / **VF** £80 ($120)

8372 — Rev. Bust of Nilus r., crowned with lotus, cornucopiae before, L B (= regnal year 2) behind. Dattari 4586. BMCG 1800. Cologne 2558. Milne 3211. *[AD 235–6].*
F £32 ($50) / **VF** £80 ($120)

8373 — Rev. Bust of Sarapis l., wearing modius, sceptre behind, L B (= regnal year 2) before. Dattari 4592. BMCG 1793. Cologne 2560. Milne 3207. *[AD 235–6].*
F £32 ($50) / **VF** £80 ($120)

8374 8376

8374 — Rev. Sarapis stg. facing, hd. r., resting on sceptre, L — B (= regnal year 2) in field. Dattari 4595. BMCG 1795. Cologne 2562. Milne 3209. *[AD 235–6].*
F £32 ($50) / **VF** £80 ($120)

8375 — Rev. Laur. hd. of Zeus r., L B (= regnal year 2) before. Dattari 4605. BMCG 1765. Cologne 2564. Milne 3192. *[AD 235–6].* **F** £32 ($50) / **VF** £80 ($120)

8376 — Rev. Eirene (= Pax) stg. l., holding olive-branch and sceptre, L B (= regnal year 2) before. Dattari 4571. BMCG/Christiansen 3189. Cologne 2553. Milne 3201. *[AD 235–6].*
F £38 ($55) / **VF** £95 ($140)

8377 — Rev. Homonoia (= Concordia) enthroned l., r. hand extended, holding double cornucopiae in l., L B (= regnal year 2) before. Dattari 4578. BMCG 1785. Cologne 2556. Milne 3202. *[AD 235–6].* **F** £32 ($50) / **VF** £80 ($120)

8378 **Billon tetradrachm.** — Rev. Nike (= Victory) advancing r., holding wreath with both hands, palm over l. shoulder, **L B** (= regnal year 2) before. Dattari 4581. BMCG 1787. Cologne 2557. Milne 3204. *[AD 235–6]*. **F** £32 ($50) / **VF** £80 ($120)

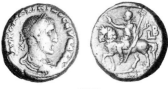

8379

8379 — Rev. Maximinus on horseback pacing l., his r. arm outstretched, holding eagle-tipped sceptre in l., **L B** (= regnal year 2) behind. Dattari 4561. BMCG 1807. Cologne —. Milne 3213. *[AD 235–6]*. **F** £38 ($55) / **VF** £95 ($140)

8380 — Rev. Laur. bust of Asklepios r., snake-entwined staff before, **L Γ** (= regnal year 3) behind. Dattari 4564. BMCG 1782. Cologne 2567. Milne 3236. *[AD 236–7]*. **F** £38 ($55) / **VF** £95 ($140)

8381 — Rev. Athena enthroned l., holding Nike and sceptre, shield at side, **L Γ** (= regnal year 3) before. Dattari 4568. BMCG 1780. Cologne 2569. Milne 3233. *[AD 236–7]*. **F** £32 ($50) / **VF** £80 ($120)

8382 — Rev. Conjoined busts r. of Helios, rad., and Selene, with large lunar crescent before, **L Γ** (= regnal year 3) behind. Dattari 4575. BMCG 1776. Cologne 2571. Milne 3228. *[AD 236–7]*. **F** £45 ($65) / **VF** £110 ($160)

8383 — Rev. Laur. bust of Hermanubis r., wearing modius, combined caduceus and palm before, **L Γ** (= regnal year 3) behind. Dattari 4576. BMCG 1798. Cologne —. Milne 3250. *[AD 236–7]*. **F** £38 ($55) / **VF** £95 ($140)

8384 — Rev. Hermanubis stg. r., wearing modius, holding caduceus and palm, jackal at his feet behind, **L — Γ** (= regnal year 3) in field. Dattari 4577. BMCG 1799. Cologne —. Milne 3253. *[AD 236–7]*. **F** £45 ($65) / **VF** £110 ($160)

8385 — Rev. Conjoined busts r. of Sarapis, wearing modius, and Isis, wearing disk and plumes, knot on breast, **L — Γ** (= regnal year 3) in field. Dattari 4598. BMCG 1797. Cologne 2574. Milne 3247. *[AD 236–7]*. **F** £38 ($55) / **VF** £95 ($140)

8386

8386 — Rev. Bust of Selene r., wearing taenia, large lunar crescent before, **L Γ** (= regnal year 3) behind. Dattari 4600. BMCG 1774. Cologne 2575. Milne 3221. *[AD 236–7]*. **F** £38 ($55) / **VF** £95 ($140)

8387 **Billon tetradrachm.** Obv. As 8368. Rev. Zeus stg. l., holding patera and sceptre, eagle at feet, L Γ (= regnal year 3) behind. Dattari 4607. BMCG 1766. Cologne 2578. Milne 3215. *[AD 236–7].* **F** £32 ($50) / **VF** £80 ($120)

8388 — Rev. Bust of Zeus Ammon r., with ram's horn, wearing headdress of ram's horns, uraei disk and plumes, L — Γ (= regnal year 3) in field. Dattari 4611. BMCG 1770. Cologne 2566. Milne 3244. *[AD 236–7].* **F** £38 ($55) / **VF** £95 ($140)

8389 8391

8389 — Rev. Rev. Tyche (= Fortuna) reclining l. on couch, holding rudder, L — Γ (= regnal year 3) above. Dattari 4604. BMCG —. Cologne 2577. Milne 3242. *[AD 236–7].*
 F £32 ($50) / **VF** £80 ($120)

8390 — Rev. Bust of Alexandria r., wearing laur. cap surmounted by turrets and arches, L — Δ (= regnal year 4) in field. Dattari 4563 var. (year 2). BMCG 1805 var. (year 3). Cologne 2579. Milne —. *[AD 237–8].* **F** £50 ($75) / **VF** £120 ($180)

8391 — Rev. Athena stg. facing, hd. l., resting on spear and shield, L — Δ (= regnal year 4) in field. Dattari 4567. BMCG 1778. Cologne 2580. Milne 3270. *[AD 237–8].*
 F £32 ($50) / **VF** £80 ($120)

8392 — Rev. Bust of Isis r., wearing disk and plumes, knot on breast, L — Δ (= regnal year 4) in field. Dattari 4579. BMCG —. Cologne —. Milne —. *[AD 237–8].*
 F £50 ($75) / **VF** £120 ($180)

8393 — Rev. Nilus reclining l., holding cornucopiae and reed which bends over his hd., his l. arm resting on hd. of hippopotamus, L Δ (= regnal year 4) before. Dattari 4590. BMCG 1803. Cologne 2585. Milne 3285. *[AD 237–8].* **F** £32 ($50) / **VF** £80 ($120)

8394 — Rev. Nike (= Victory) advancing l., holding wreath and palm, L Δ (= regnal year 4) before. Dattari 4584. BMCG 1790. Cologne 2582. Milne 3274. *[AD 237–8].*
 F £32 ($50) / **VF** £80 ($120)

8395 — Rev. Similar, but Nike seated l. Dattari 4585. BMCG 1791. Cologne 2583. Milne 3276. *[AD 237–8].* **F** £32 ($50) / **VF** £80 ($120)

8396 — Rev. Tyche ⅋= Fortuna) stg. l., holding rudder and cornucopiae, L Δ (= regnal year 4) before. Dattari 4602. BMCG —. Cologne —. Milne 3278. *[AD 237–8].*
 F £38 ($55) / **VF** £95 ($140)

8397 — Rev. Eagle stg. l., hd. r., holding wreath in beak, L — Δ (= regnal year 4) in field. Dattari 4612. BMCG 1806. Cologne —. Milne 3287. *[AD 237–8].*
 F £32 ($50) / **VF** £80 ($120)

8398 **Billon tetradrachm.** — Rev. Trophy, at base of which two bound captives seated, L — Δ
 (= regnal year 4) in field. Dattari 4614. BMCG 1809. Cologne 2586. Milne 3291.
 [AD 237–8]. **F** £32 ($50) / **VF** £80 ($120)

For other local coinages of Maximinus I, see *Greek Imperial Coins & Their Values*, pp. 334–40.

Issues of Maximinus I in honour of Diva Paulina

*Although she is not named in the ancient literary sources a wife of Maximinus is mentioned by the
fourth century historian Ammianus Marcellinus and the twelfth century Byzantine chronicler
Zonaras. A "Diva Caecilia Paulina Pia Augusta" appears on an inscription (CIL x. 5054) but
unfortunately her relationship to the emperor is not mentioned. The coinage, however, leaves no
room to doubt her connection with Maximinus and Maximus. Her rare denarii and sestertii are
very much in the style of the coins of this reign, especially the portraiture, and the connection is
confirmed by a local bronze issue of Anazarbus in Asia Minor which bears the same era date (254
= AD 235–6) as coins of Maximus Caesar from this mint. As Paulina has the imperial title of
Augusta on the CIL inscription and on the provincial piece (though not on her Roman coins) it is
just possible that she was still alive at the time of her husband's accession, though if so she must
have died soon after as the posthumous Anazarbus coin belongs to Maximinus' first year.*

8399 8400

8399 **Silver denarius.** DIVA PAVLINA, veiled and dr. bust of Paulina r. Rev. CONSECRATIO,
 peacock stg. facing, its tail in splendour, hd. l. RIC 1. BMCRE 135. RSC 1. MIR 39–3.
 [Rome, AD 235–6]. **VF** £265 ($400) / **EF** £630 ($950)

8400 Obv. Similar. Rev. — peacock flying r., bearing on its back seated figure of Paulina l., her
 r. hand raised, holding sceptre in l. RIC 2. BMCRE 127. RSC 2. MIR 38–3. *[Rome, AD
 235–6].* **VF** £230 ($350) / **EF** £550 ($850)

NB a gold aureus of this type has also been noted from a specimen in Florence (RIC 2,
BMCRE 126*, MIR 38–1) though the authenticity of this piece has not recently been
confirmed.

8401

8401 **Brass sestertius.** Obv. As 8399. Rev. CONSECRATIO S C, Paulina on peacock, as previous. RIC 3. BMCRE 129. C 3. MIR 38–5. *[Rome, AD 235–6].*
 F £175 ($260) / **VF** £430 ($650) / **EF** £1,350 ($2,000)

8402 Obv. Similar. Rev. — Diana in galloping biga r., holding torch, her veil billowing in semicircle behind hd. RIC 4. BMCRE 136. C 4. MIR 40–5. *[Rome, AD 235–6].*
 F £330 ($500) / **VF** £825 ($1,250) / **EF** £2,500 ($3,750)

MAXIMUS
Caesar under Maximinus I,
AD 235/6–May/Jun. 238

8406

Gaius Julius Verus Maximus, son of Maximinus and Paulina, was born probably late in the reign of Caracalla. Strikingly handsome but indolent in nature, Maximus was raised to the rank of Caesar either in the closing months of ad 235 or early in the following year. He accompanied his father on his military campaigns, doubtless somewhat reluctantly as he had been brought up in the luxury of the capital. He was with Maximinus at the siege of Aquileia in the early summer of ad 238 and shared the emperor's fate at the hands of mutinous troops. He was never advanced to the senior imperial rank of Augustus.

* There are three principal varieties of obverse legend:*

A. C IVL VERVS MAXIMVS CAES
B. IVL VERVS MAXIMVS CAES
C. MAXIMVS CAES GERM

All coins have as obverse type bare-headed and draped bust of Maximus right.

8403 **Gold aureus.** C. Rev. PRINCIPI IVVENTVTIS, Maximus, in military attire, stg. l., holding baton and spear, two standards set in ground to r. RIC 5. BMCRE 210*. C —. MIR 37–1. *[Rome, AD 236–8].* *(Unique)*

8404

8404 **Silver denarius.** B. Rev. PIETAS AVG, lituus, knife, jug, simpulum and sprinkler (emblems of the priestly colleges). RIC 1. BMCRE 118. RSC 1. MIR 34–3. *[Rome, AD 235–6].*
 VF £110 ($160) / **EF** £300 ($450)

8405 Similar, but with obv. C. RIC 2. BMCRE 201. RSC 3. MIR 36–3. *[Rome, AD 236–8].*
 VF £130 ($200) / **EF** £330 ($500)

8406 **Silver denarius.** C. Rev. PRINC IVVENTVTIS, Maximus with standards, as 8403. RIC 3. BMCRE 211. RSC 10. MIR 37–3. *[Rome, AD 236–8].* **VF** £95 ($145) / **EF** £265 ($400)

8407 **Silver quinarius.** As previous. RIC 3. BMCRE —. RSC 10a. MIR 37–4. *[Rome, AD 236–8].* **VF** £1,350 ($2,000) / **EF** £2,700 ($4,000)

8408 **Brass sestertius.** A. Rev. PIETAS AVG S C, lituus, knife, patera, jug, simpulum and sprinkler (emblems of the priestly colleges). RIC 6, 8. BMCRE 119. C 5, 9. MIR 34–5. *[Rome, AD 235–6].* **F** £60 ($90) / **VF** £150 ($225) / **EF** £450 ($675)

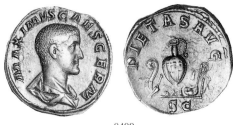

8409

8409 Similar, but with obv. C. RIC 11. BMCRE 204. C 7. MIR 36–5. *[Rome, AD 236–8].*
F £60 ($90) / **VF** £150 ($225) / **EF** £450 ($675)

8410 A. Rev. PRINCIPI IVVENTVTIS S C, Maximus with standards, as 8403. RIC 9. BMCRE 123. C 12. MIR 35–5. *[Rome, AD 235–6].* **F** £65 ($100) / **VF** £170 ($250) / **EF** £500 ($750)

8411

8411 Similar, but with obv. C. RIC 13. BMCRE 213. C 14. MIR 37–5. *[Rome, AD 236–8].*
F £55 ($80) / **VF** £130 ($200) / **EF** £400 ($600)

8412 **Brass dupondius/copper as.** A. Rev. PIETAS AVG S C, emblems of the priestly colleges, as 8408. RIC 7. BMCRE 121. C 6. MIR 34–6, 7. *[Rome, AD 235–6].*
F £60 ($90) / **VF** £150 ($225) / **EF** £450 ($675)

8413 Similar, but with obv. C. RIC 12. BMCRE 208. Cf. C 8. MIR 36–6, 7. *[Rome, AD 236–8].*
F £60 ($90) / **VF** £150 ($225) / **EF** £450 ($675)

8413

8414 **Brass dupondius/copper as.** A. Rev. PRINCIPI IVVENTVTIS S C, Maximus with standards, as 8403. RIC 10. BMCRE 125. C 13. MIR 35–6, 7. *[Rome, AD 235–6]*.
F £60 ($90) / **VF** £150 ($225) / **EF** £450 ($675)

8415 Similar, but with obv. C. RIC 14. BMCRE 218. C 15. MIR 37–6, 7. *[Rome, AD 236–8]*.
F £60 ($90) / **VF** £150 ($225) / **EF** £450 ($675)

Alexandrian Coinage

8416 **Billon tetradrachm.** Γ ΙΟΥΛ ΟΥΗΡ ΜΑΞΙΜΟC ΚΑΙ, bare-headed, dr. and cuir. bust r. Rev. Rev. Nilus reclining l., holding cornucopiae and reed which bends over his hd., his l. arm resting on hd. of hippopotamus, L B (= regnal year 2) before. Dattari 4636. BMCG —. Cologne 2587. Milne —. *[AD 235–6]*.
F £55 ($80) / **VF** £130 ($200)

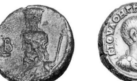

8417 8423

8417 Obv. Similar. Rev. Bust of Sarapis l., wearing modius, sceptre behind, L B (= regnal year 2) before. Dattari 4639. BMCG —. Cologne —. Milne 3208. *[AD 235–6]*.
F £55 ($80) / **VF** £130 ($200)

8418 — Rev. Sarapis stg. facing, hd. r., resting on sceptre, L — B (= regnal year 2) in field. Dattari 4641. BMCG —. Cologne —. Milne —. *[AD 235–6]*.
F £48 ($70) / **VF** £115 ($175)

8419 — Rev. Eirene (= Pax) stg. l., holding olive-branch and sceptre, L B (= regnal year 2) before. Dattari —. BMCG —. Cologne —. Milne —. Emmett 3315. *[AD 235–6]*.
F £55 ($80) / **VF** £130 ($200)

8420 — Rev. Homonoia (= Concordia) enthroned l., r. hand extended, holding double cornucopiae in l., L B (= regnal year 2) before. Dattari 4627. BMCG 1814. Cologne —. Milne —. *[AD 235–6]*.
F £55 ($80) / **VF** £130 ($200)

8421 **Billon tetradrachm.** — Rev. Nike (= Victory) advancing r., holding wreath with both hands, palm over l. shoulder, L B (= regnal year 2) before. Dattari 4629. BMCG —. Cologne —. Milne —. *[AD 235–6].* **F** £55 ($80) / **VF** £130 ($200)

8422 — Rev. Laur. bust of Asklepios r., snake-entwined staff before, L Γ (= regnal year 3) behind. Dattari 4615. BMCG 1813. Cologne 2588. Milne (Supplement) 3237a. *[AD 236–7].* **F** £48 ($70) / **VF** £115 ($175)

8423 — Rev. Bust of Athena r., wearing crested Attic helmet and aegis, L Γ (= regnal year 3) before. Dattari 4617. BMCG/Christiansen 3190. Cologne —. Milne 3231. *[AD 236–7].* **F** £55 ($80) / **VF** £130 ($200)

8424 — Rev. Athena enthroned l., holding Nike and sceptre, shield at side, L Γ (= regnal year 3) before. Dattari 4620. BMCG —. Cologne —. Milne —. *[AD 236–7].* **F** £55 ($80) / **VF** £130 ($200)

8425 — Rev. Rad. bust of Helios r., L — Γ (= regnal year 3) in field. Dattari 4622. BMCG 1810. Cologne 2589. Milne 3219. *[AD 236–7].* **F** £40 ($60) / **VF** £100 ($150)

8426 — Rev. Conjoined busts r. of Helios, rad., and Selene, with large lunar crescent before, L Γ (= regnal year 3) behind. Dattari 4624. BMCG 1811. Cologne —. Milne —. *[AD 236–7].* **F** £60 ($90) / **VF** £150 ($225)

8427 — Rev. Laur. bust of Hermanubis r., wearing modius, combined caduceus and palm before, L Γ (= regnal year 3) behind. Dattari 4626. BMCG —. Cologne 2590. Milne 3252. *[AD 236–7].* **F** £60 ($90) / **VF** £150 ($225)

8428 — Rev. Hermanubis stg. r., wearing modius, holding caduceus and palm, jackal at his feet behind, L — Γ (= regnal year 3) in field. Dattari —. BMCG —. Cologne 2591. Milne —. *[AD 236–7].* **F** £60 ($90) / **VF** £150 ($225)

8429 — Rev. Conjoined busts r. of Sarapis, wearing modius, and Isis, wearing disk and plumes, knot on breast, L — Γ (= regnal year 3) in field. Dattari 4642. BMCG 1819. Cologne —. Milne 3249. *[AD 236–7].* **F** £55 ($80) / **VF** £130 ($200)

8430 — Rev. Bust of Selene r., wearing taenia, large lunar crescent before, L Γ (= regnal year 3) behind. Dattari 4644. BMCG —. Cologne —. Milne 3226. *[AD 236–7].* **F** £48 ($70) / **VF** £115 ($175)

8431 — Rev. Zeus stg. l., holding patera and sceptre, eagle at feet, L Γ (= regnal year 3) behind. Dattari 4650. BMCG —. Cologne —. Milne 3217. *[AD 236–7].* **F** £48 ($70) / **VF** £115 ($175)

8432 — Rev. Bust of Zeus Ammon r., with ram's horn, wearing headdress of ram's horns, uraei disk and plumes, L — Γ (= regnal year 3) in field. Dattari 4651. BMCG —. Cologne —. Milne 3246. *[AD 236–7].* **F** £48 ($70) / **VF** £115 ($175)

8433 — Rev. Nike (= Victory) stg. l. between two seated captives, holding wreath and trophy in r. hand, palm in l., L Γ (= regnal year 3) before. Dattari 4633. BMCG 1817. Cologne —. Milne —. *[AD 236–7].* **F** £55 ($80) / **VF** £130 ($200)

8434 — Rev. Tyche (= Fortuna) reclining l. on couch, holding rudder, L — Γ (= regnal year 3) above. Dattari 4647. BMCG —. Cologne —. Milne —. *[AD 236–7].* **F** £55 ($80) / **VF** £130 ($200)

8435 **Billon tetradrachm.** Obv. As 8416. Rev. Trophy, at base of which two bound captives seated, L — Γ (= regnal year 3) in field. Dattari —. BMCG —. Cologne —. Milne 3263. *[AD 236–7].* **F** £60 ($90) / **VF** £150 ($225)

8436 — Rev. Athena stg. facing, hd. l., resting on spear and shield, L — Δ (= regnal year 4) in field. Dattari 4619. BMCG 1812. Cologne —. Milne 3271. *[AD 237–8].*
F £40 ($60) / **VF** £100 ($150)

8437 — Rev. Bust of Isis r., wearing disk and plumes, knot on breast, L — Δ (= regnal year 4) in field. Dattari 4628. BMCG —. Cologne —. Milne 3282. *[AD 237–8].*
F £60 ($90) / **VF** £150 ($225)

8438 — Rev. Bust of Nilus r., crowned with lotus, cornucopiae at r. shoulder, L Δ (= regnal year 4) before. Dattari 4635. BMCG 1820. Cologne —. Milne —. *[AD 237–8].*
F £48 ($70) / **VF** £115 ($175)

8439 — Rev. Bust of Sarapis r., wearing modius, L — Δ (= regnal year 4) in field. Dattari 4640. BMCG 1818. Cologne 2597. Milne 3281. *[AD 237–8].* **F** £55 ($80) / **VF** £130 ($200)

8440 — Rev. Laur. bust of Zeus r., L — Δ (= regnal year 4) in field. Dattari 4649. BMCG —. Cologne —. Milne 3265. *[AD 237–8].* **F** £48 ($70) / **VF** £115 ($175)

8441 — Rev. Nike (= Victory) advancing l., holding wreath and palm, L Δ (= regnal year 4) before. Dattari 4631. BMCG 1815. Cologne 2595. Milne —. *[AD 237–8].*
F £40 ($60) / **VF** £100 ($150)

8442 — Rev. Similar, but Nike seated l. Dattari 4632. BMCG 1816. Cologne —. Milne —. *[AD 237–8].* **F** £48 ($70) / **VF** £115 ($175)

8443 — Rev. Tyche (= Fortuna) stg. l., holding rudder and cornucopie, L Δ (= regnal year 4) before. Dattari 4646. BMCG —. Cologne —. Milne —. *[AD 237–8].*
F £55 ($80) / **VF** £130 ($200)

8444 — Rev. Eagle stg. l., hd. r., holding wreath in beak, L — Δ (= regnal year 4) in field. Dattari 4653. BMCG 1823. Cologne 2594. Milne 3289. *[AD 237–8].*
F £40 ($60) / **VF** £100 ($150)

For other local coinages of Maximus, see *Greek Imperial Coins & Their Values*, pp. 340–45.

GORDIAN I AFRICANUS
22 Mar.–12 Apr. AD 238

8446

The initial challenge to the authority of the emperor Maximinus took place in North Africa where, towards the end of March AD 238, the octogenenarian governor Marcus Antonius Gordianus Sempronianus Romanus was proclaimed emperor by members of the provincial nobility whose wealth was being threatened by extortions on the part of imperial agents. Initially reluctant to take on this heavy burden Gordian eventually agreed and, formally entering the provincial capital of

Carthage, associated his son of the same name in the imperial office, both assuming the additional name of Africanus. Showing remarkable courage the Roman Senate quickly espoused the cause of the usurpers and declared Maximinus a public enemy. However, the reign of the two Gordians was destined to be exceedingly brief. Capellianus, governor of the neighbouring province of Numidia, remained loyal to Maximinus and marched against the Gordiani who lacked a regular army. The younger Gordian perished on the field of battle on 12 April and on hearing the news his father, realizing the hopelessness of his situation, committed suicide. Their reign had lasted a mere 21 days. Born in the closing years of the reign of Antoninus Pius (late AD 150s) the elder Gordian had enjoyed a long and distinguished career which included the governorship of Lower Britain probably late in the reign of Caracalla. His son, born about AD 192, also had considerable administrative experience and served as governor of Achaea as well as holding the consulship in 226 or 229 under Severus Alexander.

Although the revolt took place in North Africa the Roman coinage of the two Gordians was all produced in the imperial capital. This suggests that the Senate must have had prior knowledge of the uprising which allowed time for the preparation of dies for aurei, denarii and sestertii. Following the collapse of the rebel regime the Senate, now committed to opposing Maximinus, probably allowed production of coins of the two Gordians to continue until it could be replaced by issues in the names of the new senatorial nominees for imperial office, Balbinus and Pupienus.

There are two varieties of obverse legend which are identical for both Gordian I and Gordian II:

A. IMP CAES M ANT GORDIANVS AFR AVG
B. IMP M ANT GORDIANVS AFR AVG

The obverse type for all denominations is laureate, draped and cuirassed bust of Gordian I right. The elder emperor's portrait on well preserved specimens is easily distinguishable from that of his son as his face is somewhat thinner, his features older, and the hair extends well onto his forehead, being clearly visible in front of the laurel wreath.

8445 **Gold aureus.** A. Rev. ROMAE AETERNAE, Roma seated l., holding Victory and sceptre, shield at side. RIC 3. BMCRE 7*. C 7. *[Rome].* (*Unique*)

8446 **Silver denarius.** B. Rev. P M TR P COS P P, Gordian I (or Genius of the Senate), togate, stg. l., holding branch and short sceptre. RIC 1. BMCRE 1. RSC 2. *[Rome].*
 VF £1,000 ($1,500) / **EF** £2,000 ($3,000)

8447 8448

8447 B. Rev. ROMAE AETERNAE, Roma seated, as 8445. RIC 4. BMCRE 8. RSC 8. *[Rome].*
 VF £1,000 ($1,500) / **EF** £2,000 ($3,000)

8448 B. Rev. SECVRITAS AVGG, Securitas seated l., holding sceptre. RIC 5. BMCRE 11. RSC 10. *[Rome].* **VF** £1,000 ($1,500) / **EF** £2,000 ($3,000)

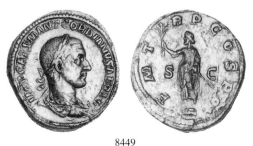

8449

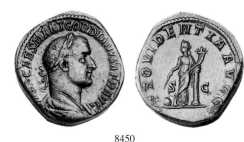

8450

8449 **Brass sestertius.** A. Rev. P M TR P COS P P S C, Gordian I (or Genius of the Senate) stg., as 8446. RIC 7. BMCRE 4. C 3. *[Rome]*.
F £400 ($600) / **VF** £1,000 ($1,500) / **EF** £3,000 ($4,500)

8450 A. Rev. PROVIDENTIA AVGG S C, Providentia stg. facing, hd. l., legs crossed, resting on column and holding rod and cornucopiae, globe at feet. RIC 9. BMCRE 5. C 6. *[Rome]*.
F £400 ($600) / **VF** £1,000 ($1,500) / **EF** £3,000 ($4,500)

8451 A. Rev. ROMAE AETERNAE S C, Roma seated, as 8445. RIC 10. BMCRE 10. C 9. *[Rome]*.
F £400 ($600) / **VF** £1,000 ($1,500) / **EF** £3,000 ($4,500)

8452 A. Rev. SECVRITAS AVGG S C, Securitas seated, as 8448. RIC 11. BMCRE 12. C 11. *[Rome]*.
F £400 ($600) / **VF** £1,000 ($1,500) / **EF** £3,000 ($4,500)

8453 A. Rev. VICTORIA AVGG S C, Victory advancing l., holding wreath and palm. RIC 12. BMCRE 14. C 14. *[Rome]*.
F £400 ($600) / **VF** £1,000 ($1,500) / **EF** £3,000 ($4,500)

8454 A. Rev. VIRTVS AVGG S C, Virtus stg. l., resting on shield and spear. RIC 14. BMCRE 17. C 15. *[Rome]*.
F £400 ($600) / **VF** £1,000 ($1,500) / **EF** £3,000 ($4,500)

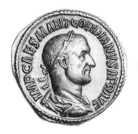

8453

Alexandrian Coinage

8455 **Billon tetradrachm.** A K M AN ΓΟΡΔΙΑΝΟC CEM AΦP EY CEB, laur, dr. and cuir. bust r. Rev. Rev. Athena stg. facing, hd. l., resting on spear and shield, L — A (= regnal year 1) in field. Dattari 4654. BMCG 1825. Cologne 2599. Milne 3294.

F £130 ($200) / **VF** £330 ($500)

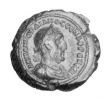

8456 8459

8456 Obv. Similar. Rev. Athena seated l., holding Nike and sceptre, shield at side, L A (= regnal year 1) before. Dattari 4656. BMCG 1826. Cologne 2600. Milne 3296.

F £130 ($200) / **VF** £330 ($500)

8457 — Rev. Nilus reclining l., holding cornucopiae and reed which bends over his hd., his l. arm resting on hd. of hippopotamus, L A (= regnal year 1) before. Dattari 4660. BMCG 1830. Cologne 2603. Milne 3301.

F £130 ($200) / **VF** £330 ($500)

8458 — Rev. Bust of Sarapis r., wearing modius, L A (= regnal year 1) before. Dattari 4661. BMCG —. Cologne —. Milne —.

F £170 ($250) / **VF** £400 ($600)

8459 — Rev. Zeus seated l., holding patera and sceptre, eagle at feet, L A (= regnal year 1) before. Dattari 4663. BMCG 1824. Cologne 2605. Milne 3293.

F £130 ($200) / **VF** £330 ($500)

8460 — Rev. Homonoia (= Concordia) stg. l., r. hand extended, holding double cornucopiae in l., L A (= regnal year 1) before. Dattari 4657. BMCG 1827. Cologne 2601. Milne 3298.

F £150 ($225) / **VF** £365 ($550)

8461 — Rev. Nike (= Victory) advancing l., holding wreath and palm, L A (= regnal year 1) before. Dattari 4658. BMCG —. Cologne —. Milne —. F £150 ($225) / **VF** £365 ($550)

8462 — Rev. Similar, but Nike seated l., L A (= regnal year 1) before. Dattari 4659. BMCG 1828. Cologne 2602. Milne 3299. F £150 ($225) / **VF** £365 ($550)

8461 8463

8463 **Billon tetradrachm.** Obv. As 8455. Rev. Tyche (= Fortuna) stg. l., holding rudder and
cornucopiae, L A (= regnal year 1) before. Dattari 4662. BMCG 1829. Cologne 2604.
Milne 3300. **F** £150 ($225) / **VF** £365 ($550)

8464 — Rev. Eagle stg. l., hd. r., holding wreath in beak, L — A (= regnal year 1) in field.
Dattari 4665. BMCG 1831. Cologne 2598. Milne 3302. **F** £130 ($200) / **VF** £330 ($500)

For other local coinages of this brief reign, see *Greek Imperial Coins & Their Values*, p. 345.

GORDIAN II AFRICANUS
22 Mar.–12 Apr. AD 238

8473

*The son of Gordian I, Gordian II was born late in the reign of Commodus (AD 191/2) and bore the
same names as his father. He possessed considerable administrative experience and was made co-
emperor at the commencement of the rebellion against Maximinus, as related in the historical note
to the reign of Gordian I. A man of culture (he reputedly possessed a library of 62,000 volumes) the
younger Gordian nevertheless was addicted to the pursuit of pleasure and had numerous mistresses.
When Capellianus, governor of Numidia, refused to join the rebellion and marched against
Carthage at the head of a legionary force it fell to the lot of the younger Gordian to lead an
undisciplined and hastily assembled rabble, comprised of local militia and armed civilians, against
them. The inevitable result was a mass slaughter of the rebel force and its commander's body was
never recovered. This defeat effectively ended the uprising in Africa as the elder emperor
committed suicide immediately on receipt of the news.
 There are two varieties of obverse legend for the coinage of Gordian II and these are identical
to those employed for his father:*

A. IMP CAES M ANT GORDIANVS AFR AVG
B. IMP M ANT GORDIANVS AFR AVG

*The obverse type for all denominations is laureate, draped and cuirassed bust of Gordian II right.
The younger emperor's portrait on well preserved specimens is easily distinguishable from that of
his father as his face is somewhat plumper, his features younger, and his hair has receded to reveal
a bald forehead in front of the laurel wreath.*

 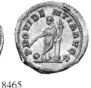

8465 8466

8465 **Silver denarius.** B. Rev. PROVIDENTIA AVGG, Providentia stg. facing, hd. l., legs crossed, resting on column and holding rod and cornucopiae, globe at feet.. RIC 1. BMCRE 19. RSC 5. *[Rome]*. **VF** £1,000 ($1,500) / **EF** £2,000 ($3,000)

8466 B. Rev. VICTORIA AVGG, Victory advancing l., holding wreath and palm. RIC 2. BMCRE 28. RSC 12. *[Rome]*. **VF** £1,000 ($1,500) / **EF** £2,000 ($3,000)

8467

8467 B. Rev. VIRTVS AVGG, Virtus stg. l., resting on shield and spear. RIC 2. BMCRE 28. RSC 12. *[Rome]*. **VF** £1,000 ($1,500) / **EF** £2,000 ($3,000)

8468 **Brass sestertius.** A. Rev. P M TR P COS P P S C, Gordian II (or Genius of the Senate), togate, stg. l., holding branch and short sceptre. RIC — (cf. p. 164, note). BMCRE 18. C 4. *[Rome]*. **F** £500 ($750) / **VF** £1,200 ($1,800) / **EF** £3,700 ($5,500)

8469 A. Rev. PROVIDENTIA AVGG S C, Providentia resting on column, as 8465. RIC 4. BMCRE 21. C 6. *[Rome]*. **F** £450 ($675) / **VF** £1,100 ($1,650) / **EF** £3,000 ($5,000)

8470

8470 A. Rev. ROMAE AETERNAE S C, Roma seated l., holding Victory and sceptre, shield at side. RIC 5. BMCRE 23. C 9. *[Rome]*. **F** £400 ($600) / **VF** £1,000 ($1,500) / **EF** £3,000 ($4,500)

8471 A. Rev. SECVRITAS AVGG S C, Securitas seated l., holding sceptre. RIC 6. BMCRE 27. C 11. *[Rome]*. **F** £500 ($750) / **VF** £1,200 ($1,800) / **EF** £3,700 ($5,500)

8472 **Brass sestertius.** A. Rev. VICTORIA AVGG S C, Victory advancing, as 8466. RIC 7. BMCRE 29*. C 13. *[Rome].* **F** £450 ($675) / **VF** £1,100 ($1,650) / **EF** £3,000 ($5,000)

8473 A. Rev. VIRTVS AVGG S C, Virtus stg., as 8467. RIC 8. BMCRE 31. C 15. *[Rome].* **F** £400 ($600) / **VF** £1,000 ($1,500) / **EF** £3,000 ($4,500)

Alexandrian Coinage

The tetradrachms of the younger Gordian may be distinguished from those of his father by the absence of the abbreviated name 'CEM' in the obverse inscription.

8474 **Billon tetradrachm.** A K M AN ΓΟΡΔΙΑΝΟC AΦP EY CE, laur, dr. and cuir. bust r. Rev. Rev. Athena stg. facing, hd. l., resting on spear and shield, L — A (= regnal year 1) in field. Dattari —. BMCG —. Cologne —. Milne —. Emmett 3352.
F £330 ($500) / **VF** £825 ($1,250)

8475 Obv. Similar. Rev. Athena seated l., holding Nike and sceptre, shield at side, L A (= regnal year 1) before. Dattari —. BMCG —. Cologne —. Milne —. Emmett 3353.
F £330 ($500) / **VF** £825 ($1,250)

8476 — Rev. Nilus reclining l., holding cornucopiae and reed which bends over his hd., his l. arm resting on hd. of hippopotamus, L A (= regnal year 1) before. Dattari 4668. BMCG —. Cologne —. Milne —. **F** £330 ($500) / **VF** £825 ($1,250)

8477 — Rev. Zeus seated l., holding patera and sceptre, eagle at feet, L A (= regnal year 1) before. Dattari 4669. BMCG —. Cologne —. Milne —.
F £265 ($400) / **VF** £665 ($1,000)

8478 — Rev. Homonoia (= Concordia) stg. l., r. hand extended, holding double cornucopiae in l., L A (= regnal year 1) before. Dattari —. BMCG 1832. Cologne —. Milne —.
F £330 ($500) / **VF** £825 ($1,250)

8479 — Rev. Nike (= Victory) advancing l., holding wreath and palm, L A (= regnal year 1) before. Dattari 4666. BMCG —. Cologne —. Milne —.
F £330 ($500) / **VF** £825 ($1,250)

8480 — Rev. Similar, but Nike seated l., L A (= regnal year 1) before. Dattari 4667. BMCG 1833. Cologne —. Milne —. **F** £300 ($450) / **VF** £750 ($1,100)

8481 — Rev. Tyche (= Fortuna) stg. l., holding rudder and cornucopiae, L A (= regnal year 1) before. Dattari —. BMCG —. Cologne —. Milne —. Emmett 3359.
F £330 ($500) / **VF** £825 ($1,250)

8482

8482 — Rev. Eagle stg. l., hd. r., holding wreath in beak, L — A (= regnal year 1) in field. Dattari 4670. BMCG —. Cologne —. Milne —. **F** £265 ($400) / **VF** £665 ($1,000)

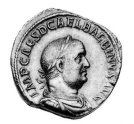

8495

BALBINUS
22 Apr.–29 Jul. AD 238

Balbinus, born probably in the middle years of the reign of Marcus Aurelius, had twice held the office of consul (AD 210 and 213, the latter as the colleague of Caracalla) and was, at the time of the revolt of the Gordiani, a distinguished member of the Roman Senate. That body, having now committed itself to the cause of rebellion against Maximinus, on receipt of the news of the failure of the uprising in North Africa was obliged to continue the struggle against the tyrant by the election of two new emperors (22 April AD 238). These they chose from their own ranks, Decimus Caelius Calvinus Balbinus and Marcus Clodius Pupienus Maximus. The immediate concern of the new regime was the defence of Italy against Maximinus and Pupienus was charged with this difficult task while the more elderly Balbinus took responsibility for the civil administration. Fortunately for the senatorial nominees the murder of Maximinus by own men during the siege of Aquileia (May or June) removed the spectre of civil war and Balbinus and Pupienus were left as undisputed masters of the Empire. However, their mutual antipathy boded ill for the long-term prospects of the administration and they endeavoured to counter their growing unpopularity by the adoption as Caesar of the 13-year-old grandson of Gordian I Africanus. But the situation continued to deteriorate and late in July a band of disgruntled praetorian guards broke into the palace and seized the hapless emperors who had reigned for little more than three months. They were dragged through the streets of the city and ultimately murdered to avoid rescue by their German bodyguard The young Caesar was then hailed as Augustus and ascended the throne as Gordian III.

The scarce state coinage of Balbinus and Pupienus was, for the last time in the history of the imperial currency, all produced by the mint of Rome. The most noteworthy numismatic event of the reign was the reintroduction of the silver antoninianus, or double denarius, first issued by Caracalla in AD 215 and last struck under Elagabalus four years later. Following its revival the inflationary antoninianus quickly drove the traditional denarius out of circulation and Gordian III was the last emperor to issue in appreciable quantities the denomination which had been the mainstay of the Roman coinage ever since the Second Punic War four and a half centuries before.

There are two varieties of obverse legend for the coinage issued in the name of Balbinus:

A. IMP C D CAEL BALBINVS AVG
B. IMP CAES D CAEL BALBINVS AVG

The normal obverse type for all denominations other than the antoninianus and the dupondius is laureate, draped and cuirassed bust of Balbinus right. Antoniniani and dupondii have radiate, draped and cuirassed bust right.

8483 **Gold aureus.** B. Rev. VICTORIA AVGG, Victory stg. facing, hd. l., holding wreath and palm. RIC 9. BMCRE 36*. C —. *[Rome].* (*Unique*)

8484 **Silver antoninianus.** B. Rev. CONCORDIA AVGG, clasped r. hands. RIC 10. BMCRE 67. RSC 3. *[Rome].* **VF** £200 ($300) / **EF** £400 ($600)

NB The double denarius was reintroduced probably in late May or early June of AD 238. Thereafter, it rapidly became the principal silver denomination of the Roman coinage, replacing the denarius which had filled that role since ca. 211 BC.

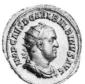

8484 8485

8485 **Silver antoninianus.** Similar, but with rev. legend FIDES MVTVA AVGG. RIC 11. BMCRE
71. RSC 6. *[Rome]*. **VF** £200 ($300) / **EF** £400 ($600)

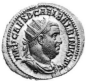
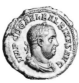

8486 8487

8486 Similar, but with rev. legend PIETAS MVTVA AVGG. RIC 12. BMCRE 74. RSC 17.
[Rome]. **VF** £200 ($300) / **EF** £400 ($600)

8487 **Silver denarius.** A. Rev. IOVI CONSERVATORI, Jupiter stg. l., holding thunderbolt and
sceptre. RIC 2. BMCRE 22. RSC 8. *[Rome]*. **VF** £200 ($300) / **EF** £400 ($600)

8488 A. Rev. LIBERALITAS AVGVSTORVM, Liberalitas stg. l., holding abacus and cornucopiae.
RIC 3. BMCRE 1. RSC 10. *[Rome]*. **VF** £200 ($300) / **EF** £400 ($600)

8489 8490

8489 A. Rev. P M TR P COS II P P, Balbinus (or Genius of the Senate) stg. l., togate, holding
branch and short sceptre. RIC 5. BMCRE 26. RSC 20. *[Rome]*.
VF £185 ($275) / **EF** £365 ($550)

8490 A. Rev. PROVIDENTIA DEORVM, Providentia stg. l., holding rod and cornucopiae, globe at
feet. RIC 7. BMCRE 33. RSC 23. *[Rome]*. **VF** £185 ($275) / **EF** £365 ($550)

8491 A. Rev. VICTORIA AVGG, Victory stg., as 8483. RIC 8. BMCRE 37. RSC 27. *[Rome]*.
VF £185 ($275) / **EF** £365 ($550)

8492 A. Rev. VOTIS / DECENNA / LIBVS in three lines within laurel-wreath. Cf. RIC p. 172.
BMCRE 6. RSC 32. *[Rome]*. **VF** £300 ($450) / **EF** £665 ($1,000)

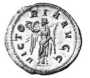

8491

8493 **Silver quinarius.** A. Rev. VICTORIA AVGG, Victory stg., as 8483. RIC 8. BMCRE 39.
 RSC 28. *[Rome]*. (*Unique*)

8494

8494 **Brass sestertius.** B. Rev. CONCORDIA AVGG S C, Concordia seated l., holding patera and
 double cornucopiae. RIC 22. BMCRE 18. C 4. *[Rome]*.
 F £120 ($180) / **VF** £300 ($450) / **EF** £900 ($1,350)

8495 B. Rev. LIBERALITAS AVGVSTORVM S C, Liberalitas stg., as 8488. RIC 15. BMCRE 2. C
 11. *[Rome]*. **F** £130 ($200) / **VF** £330 ($500) / **EF** £1,000 ($1,500)

8496 B. Rev. — Balbinus, Pupienus and Gordian III Caesar seated l. on curule chairs atop
 platform, accompanied by officer stg. behind them and Liberalitas stg. l. before, holding
 abacus and cornucopiae, citizen mounting steps of platform about to receive largess. RIC
 14. BMCRE 5. C 13. *[Rome]*. **F** £330 ($500) / **VF** £825 ($1,250) / **EF** £2,500 ($3,750)

8497 B. Rev. PAX PVBLICA S C, Pax seated l., holding olive-branch and sceptre. RIC 24.
 BMCRE 25. C 16. *[Rome]*. **F** £130 ($200) / **VF** £330 ($500) / **EF** £1,000 ($1,500)

8498

8498 B. Rev. P M TR P COS II P P S C, Balbinus (or Genius of the Senate) stg., as 8489. RIC 16.
 BMCRE 28. C 21. *[Rome]*. **F** £120 ($180) / **VF** £300 ($450) / **EF** £900 ($1,350)

8499

8499 **Brass sestertius.** B. Rev. PROVIDENTIA DEORVM S C, Providentia stg., as 8490. RIC 19. BMCRE 34. C 24. *[Rome].* **F** £120 ($180) / **VF** £300 ($450) / **EF** £900 ($1,350)

8500 B. Rev. VICTORIA AVGG S C, Victory stg., as 8483. RIC 25. BMCRE 40. C 29. *[Rome].*
 F £130 ($200) / **VF** £330 ($500) / **EF** £1,000 ($1,500)

8501 B. Rev. VOTIS / DECENNA / LIBVS / S C in four lines within laurel-wreath. RIC 20. BMCRE 7. C 33. *[Rome].* **F** £250 ($375) / **VF** £600 ($900) / **EF** £1,850 ($2,750)

8502 **Brass dupondius.** B. Rev. IOVI CONSERVATORI S C, Jupiter stg., as 8487. RIC 13. BMCRE 23. C 9. *[Rome].* **F** £200 ($300) / **VF** £500 ($750) / **EF** £1,500 ($2,250)

8503 B. Rev. LIBERALITAS AVGVSTORVM S C, Liberalitas stg., as 8488. RIC 15A. BMCRE 4*. C 12. *[Rome].* **F** £200 ($300) / **VF** £500 ($750) / **EF** £1,500 ($2,250)

8504 B. Rev. P M TR P COS II P P S C, Balbinus (or Genius of the Senate) stg., as 8489. RIC 17. BMCRE 31*. C 22. *[Rome].* **F** £200 ($300) / **VF** £500 ($750) / **EF** £1,500 ($2,250)

8505 B. Rev. VOTIS / DECENNA / LIBVS / S C in wreath, as 8501. RIC 21. BMCRE 8*. C 34. *[Rome].* **F** £220 ($325) / **VF** £550 ($850) / **EF** £1,650 ($2,500)

8506 **Copper as.** B. Rev. CONCORDIA AVGG S C, Concordia seated, as 8494. RIC 23. BMCRE 21. C 5. *[Rome].* **F** £200 ($300) / **VF** £500 ($750) / **EF** £1,500 ($2,250)

Alexandrian Coinage

8507 8508

8507 **Billon tetradrachm.** A K ΔEK KAIΛ BAΛBINOC EY C, laur, dr. and cuir. bust r. Rev. Rev. Athena stg. facing, hd. l., resting on spear and shield, L — A (= regnal year 1) in field. Dattari 4680 var. BMCG 1841. Cologne 2609 var. Milne —. **F** £100 ($150) / **VF** £265 ($400)

8508 Obv. Similar. Rev. Athena seated l., holding Nike and sceptre, shield at side, L A (= regnal year 1) before. Dattari 4681 var. BMCG 1842 var. Cologne 2610 var. Milne 3307 var.
 F £100 ($150) / **VF** £265 ($400)

8509 **Billon tetradrachm.** A K ΔEK KAIΛ BAΛBINOC CEB, laur, dr. and cuir. bust r. Nilus
 reclining l., holding cornucopiae and reed which bends over his hd., his l. arm resting on
 hd. of hippopotamus, L A (= regnal year 1) before. Dattari 4686. BMCG 1846 var. Cologne
 2612 var. Milne —. **F** £120 ($180) / **VF** £300 ($450)

8510 A K ΔEK KAIΛ BAΛBINOC EY, laur, dr. and cuir. bust r. Rev. Zeus seated l., holding patera
 and sceptre, eagle at feet, L A (= regnal year 1) before. Dattari 4688. BMCG 1840.
 Cologne 2613. Milne —. **F** £100 ($150) / **VF** £265 ($400)

8511 Obv. As 8509, but CE for CEB. Rev. Homonoia (= Concordia) stg. l., r. hand extended,
 holding double cornucopiae in l., L A (= regnal year 1) before. Dattari 4683.
 BMCG/Christiansen 3194. Cologne 2611. Milne 3309. **F** £120 ($180) / **VF** £300 ($450)

8512

8512 Obv. As 8509. Rev. Nike (= Victory) advancing l., holding wreath and palm, L A (= regnal
 year 1) before. Dattari 4684. BMCG 1843 var. Cologne —. Milne 3312.
 F £120 ($180) / **VF** £300 ($450)

8513 Obv. As 8511. Rev. Similar to previous, but Nike seated l. Dattari 4685. BMCG 1844.
 Cologne —. Milne (Supplement) 3315a. **F** £120 ($180) / **VF** £300 ($450)

8514 — Rev. Tyche (= Fortuna) stg. l., holding rudder and cornucopiae, L A (= regnal year 1)
 before. Dattari 4687. BMCG 1845. Cologne —. Milne —.
 F £100 ($150) / **VF** £265 ($400)

8515 Obv. As 8510. Rev. Eagle stg. l., hd. r., holding wreath in beak, L — A (= regnal year 1) in
 field. Dattari 4689. BMCG 1847. Cologne —. Milne —. **F** £100 ($150) / **VF** £265 ($400)

For other local coinages struck in the name of Balbinus, see *Greek Imperial Coins & Their Values*,
pp. 346–7.

PUPIENUS
22 Apr.–29 Jul. AD 238

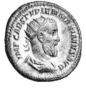

8522

*Marcus Clodius Pupienus Maximus was born probably in the closing years of the reign of Marcus
Aurelius and was thus a little younger than his imperial colleague Balbinus. According to the
unreliable testimony of the authors of the 'Historia Augusta' he was of humble birth, but as he had
twice held the consulship prior to his elevation (AD 210 and 234) it seems more likely that he was
descended from a distinguised family, as reported by the historian Herodian who was his*

contemporary. The remarkable circumstances of Pupienus' elevation to imperial rank have already been described in the introduction to the reign of Balbinus. The younger emperor, who may have possessed the greater military experience of the two, assumed responsibility for the defence of Italy against Maximinus. Fortunately, he was spared the necessity of facing his formidable rival on the battlefield when Maximinus was murdered by his own troops outside Aquileia. But the inability of the new co-emperors to cooperate in the government of the Empire soon led to their violent downfall, as already related, and their place on the imperial throne was taken by the totally inexperienced 13-year-old Gordian III.

The coinage of Pupienus follows the same general pattern as that of Balbinus, though with one significant difference. Late in the reign (probably at the beginning of July) Pupienus altered the form of his obverse legend by the addition of the name 'Maximus'. This change, which is also reflected on the Alexandrian coinage, may have been in celebration of Pupienus' successful defence of Italy against Maximinus. But whatever the reason this provocative move would undoubtedly have exacerbated the rivalry between the co-emperors and thus hastened the downfall of the unpopular regime.

There are three varieties of obverse legend for the coinage issued in the name of Pupienus:

A. IMP C M CLOD PVPIENVS AVG
B. IMP CAES M CLOD PVPIENVS AVG
C. IMP CAES PVPIEN MAXIMVS AVG

The normal obverse type for all denominations other than the antoninianus and the dupondius is laureate, draped and cuirassed bust of Pupienus right. Antoniniani and dupondii have radiate, draped and cuirassed bust right.

8516 **Gold aureus.** B. Rev. VICTORIA AVGG, Victory stg. facing, hd. l., holding wreath and palm. RIC 8A. BMCRE 57*. C 37. *[Rome].* (*Unique*)

8517 **Silver antoninianus.** B. Rev. AMOR MVTVVS AVGG, clasped r. hands. RIC 9a. BMCRE 77. RSC 1. *[Rome].* **VF** £220 ($325) / **EF** £430 ($650)

NB The double denarii of Pupienus complement those of his co-emperor Balbinus by combining the same reverse type with three different variations of legend. Those of Pupienus with obverse legend 'B' were struck probably in June and those with legend 'C' in July of AD 238.

8518 8520

8518 Similar, but with obv. legend C. RIC 9b. BMCRE 82. RSC 2. *[Rome].*
 VF £200 ($300) / **EF** £400 ($600)

8519 B. Rev. CARITAS MVTVA AVGG, clasped r. hands. RIC 10a. BMCRE 80. RSC 4. *[Rome].*
 VF £220 ($325) / **EF** £430 ($650)

8520 Similar, but with obv. legend C. RIC 10b. BMCRE 87. RSC 3. *[Rome].*
 VF £200 ($300) / **EF** £400 ($600)

8521 **Silver antoninianus.** B. Rev. PATRES SENATVS, clasped r. hands. RIC 11a. BMCRE 81.
RSC 19. *[Rome].* VF £230 ($350) / EF £465 ($700)
*"Fathers of the Senate" was certainly highly appropriate to the two elderly members of
that august body who had been raised to the imperial purple. The real power, however, lay
in the hands of the military as subsequent events were rapidly to demonstrate.*

8522 Similar, but with obv. legend C. RIC 11b. BMCRE 92. RSC 21. *[Rome].*
VF £220 ($325) / EF £430 ($650)

8523

8523 **Silver denarius.** A. Rev. CONCORDIA AVGG, Concordia seated l., holding patera and
double cornucopiae. RIC 1. BMCRE 42. RSC 6. *[Rome].*
VF £185 ($275) / EF £365 ($550)

8524 A. Rev. IOVI CONSERVATORI, Jupiter stg. l., holding thunderbolt and sceptre. RIC 2.
BMCRE 44*. RSC 12. *[Rome].* VF £220 ($325) / EF £430 ($650)

8525 A. Rev. LIBERALITAS AVGVSTORVM, Liberalitas stg. l., holding abacus and cornucopiae.
RIC 3. BMCRE 9*. RSC 14. *[Rome].* VF £220 ($325) / EF £430 ($650)

8526 8528

8526 A. Rev. PAX PVBLICA, Pax seated l., holding olive-branch and sceptre. RIC 4. BMCRE 46.
RSC 22. *[Rome].* VF £185 ($275) / EF £365 ($550)

8527 A. Rev. P M TR P COS II P P, Felicitas stg. l., holding caduceus and sceptre. RIC 6. BMCRE
52. RSC 26. *[Rome].* VF £185 ($275) / EF £365 ($550)

8528 A. Rev. — Pupienus (or Genius of the Senate) stg. l., togate, holding branch and short
sceptre. RIC 5. BMCRE 50*. RSC 29. *[Rome].* VF £220 ($325) / EF £430 ($650)

8529 A. Rev. VOTIS / DECENNA / LIBVS in three lines within laurel-wreath. Cf. RIC p. 176.
BMCRE 15*. RSC 43. *[Rome].* VF £300 ($450) / EF £665 ($1,000)

8530 **Brass sestertius.** B. Rev. CONCORDIA AVGG S C, Concordia seated, as 8523. RIC 20.
BMCRE 43. C 7. *[Rome].* F £120 ($180) / VF £300 ($450) / EF £900 ($1,350)

8531 B. Rev. LIBERALITAS AVGVSTORVM S C, Liberalitas stg., as 8525. RIC 14. BMCRE 10. C
15. *[Rome].* F £130 ($200) / VF £330 ($500) / EF £1,000 ($1,500)

8530

8531

8532 **Brass sestertius.** B. Rev. LIBERALITAS AVGVSTORVM S C, Pupienus, Balbinus and Gordian III Caesar seated l. on curule chairs atop platform, accompanied by officer stg. behind them and Liberalitas stg. l. before, holding abacus and cornucopiae, citizen mounting steps of platform about to receive largess. RIC 13. BMCRE 13. C 18. *[Rome]*.
F £330 ($500) / **VF** £825 ($1,250) / **EF** £2,500 ($3,750)

8533

8533 B. Rev. PAX PVBLICA S C, Pax seated, as 8526. RIC 22a. BMCRE 48. C 23. *[Rome]*.
F £120 ($180) / **VF** £300 ($450) / **EF** £900 ($1,350)

8534 Similar, but with obv. legend C. RIC 22b. BMCRE 96. C 24. *[Rome]*.
F £150 ($225) / **VF** £365 ($550) / **EF** £1,100 ($1,650)

8535 B. Rev. P M TR P COS II P P S C, Felicitas stg., as 8527. RIC 16. BMCRE 55*. C 28. *[Rome]*.
F £200 ($300) / **VF** £500 ($750) / **EF** £1,500 ($2,250)

8536 B. Rev. — Pupienus (or Genius of the Senate) stg., as 8528. RIC 15. BMCRE 51. C 30. *[Rome]*.
F £120 ($180) / **VF** £300 ($450) / **EF** £900 ($1,350)

8536

8537 **Brass sestertius.** Similar, but with obv. legend C. Cf. RIC p. 176. BMCRE 97*. C 32.
 [Rome]. **F** £170 ($250) / **VF** £430 ($650) / **EF** £1,350 ($2,000)

8538 B. Rev. PROVIDENTIA DEORVM S C, Providentia stg. l., holding rod and cornucopiae, globe
 at feet. RIC 17. BMCRE 56. C 34. *[Rome]*.
 F £150 ($225) / **VF** £365 ($550) / **EF** £1,100 ($1,650)

8539

8539 B. Rev. VICTORIA AVGG S C, Victory stg., as 8516. RIC 23a. BMCRE 58. C 38. *[Rome]*.
 F £120 ($180) / **VF** £300 ($450) / **EF** £900 ($1,350)

8540 Similar, but with obv. legend C. RIC 23b. BMCRE 98*. C 40. *[Rome]*.
 F £170 ($250) / **VF** £430 ($650) / **EF** £1,350 ($2,000)

8541

8541 B. Rev. VOTIS / DECENNA / LIBVS / S C in four lines within laurel-wreath. RIC 18. BMCRE
 16. C 44. *[Rome]*. **F** £250 ($375) / **VF** £600 ($900) / **EF** £1,850 ($2,750)

8542 **Brass dupondius.** B. Rev. IOVI CONSERVATORI S C, Jupiter stg., as 8524. RIC 12.
 BMCRE 45*. C 13. *[Rome]*. F £200 ($300) / VF £500 ($750) / EF £1,500 ($2,250)

8543

8543 B. Rev. VICTORIA AVGG S C Victory stg., as 8516. RIC 24. BMCRE 61. C 39. *[Rome]*.
 F £200 ($300) / VF £500 ($750) / EF £1,500 ($2,250)

8544 B. Rev. VOTIS / DECENNA / LIBVS / S C in wreath, as 8541. RIC 19. BMCRE 17. C —.
 [Rome]. F £220 ($325) / VF £550 ($850) / EF £1,650 ($2,500)

8545 **Copper as.** B. Rev. CONCORDIA AVGG S C, Concordia seated, as 8523. RIC —. BMCRE
 43A*. C —. *[Rome]*. F £220 ($325) / VF £550 ($850) / EF £1,650 ($2,500)

8546 Similar, but with obv. legend C. RIC 21. BMCRE 95. C 9. *[Rome]*.
 F £200 ($300) / VF £500 ($750) / EF £1,500 ($2,250)

Alexandrian Coinage

8547 **Billon tetradrachm.** A K M KΛШ (or KΛШΔ) ΠΟVΠΙΗΝΟC CE (or EY C), laur, dr. and cuir.
 bust r. Rev. Rev. Athena stg. facing, hd. l., resting on spear and shield, L — A (= regnal year
 1) in field. Dattari 4671. BMCG —. Cologne —. Milne —.F £120 ($180) / VF £300 ($450)

8548 Obv. Similar. Rev. Athena seated l., holding Nike and sceptre, shield at side, L A (= regnal
 year 1) before. Dattari —. BMCG 1835. Cologne —. Milne —.
 F £120 ($180) / VF £300 ($450)

8549 — Rev. Nilus reclining l., holding cornucopiae and reed which bends over his hd., his l.
 arm resting on hd. of hippopotamus, L A (= regnal year 1) before. Dattari 4674. BMCG —.
 Cologne —. Milne —. F £130 ($200) / VF £330 ($500)

8550 — Rev. Laur. bust of Zeus r., L A (= regnal year 1) before. Dattari 4678. BMCG —.
 Cologne —. Milne —. F £130 ($200) / VF £330 ($500)

8551 — Rev. Zeus seated l., holding patera and sceptre, eagle at feet, L A (= regnal year 1)
 before. Dattari —. BMCG 1834. Cologne 2608. Milne —.
 F £100 ($150) / VF £265 ($400)

8552 A K M KΛШ ΠΟVΠ ΜΑΞΙΜΟC CEB, laur, dr. and cuir. bust r. Rev. Homonoia (= Concordia)
 stg. l., r. hand extended, holding double cornucopiae in l., L A (= regnal year 1) before.
 Dattari 4676. BMCG 1836. Cologne —. Milne 3308 var. F £130 ($200) / VF £330 ($500)

8553 **Billon tetradrachm.** Obv. As 8547. Rev. Nike (= Victory) advancing l., holding wreath
 and palm, L A (= regnal year 1) before. Dattari 4672. BMCG 1837. Cologne 2607. Milne
 (Supplement) 3312a. **F** £100 ($150) / **VF** £265 ($400)

8554

8554 — Rev. Similar to previous, but Nike seated l. Dattari 4673. BMCG —. Cologne —.
 Milne —. **F** £120 ($180) / **VF** £300 ($450)

8555 — Rev. Tyche (= Fortuna) stg. l., holding rudder and cornucopiae, L A (= regnal year 1)
 before. Dattari 4677. BMCG 1838. Cologne —. Milne 3316.
 F £120 ($180) / **VF** £300 ($450)

8556

8556 — Rev. Eagle stg. l., hd. r., holding wreath in beak, L — A (= regnal year 1) in field.
 Dattari 4679. BMCG 1839. Cologne 2606. Milne 3318. **F** £100 ($150) / **VF** £265 ($400)

For other local coinages struck in the name of Pupienus, see *Greek Imperial Coins & Their Values*,
pp. 347–8.

GORDIAN III
29 Jul. AD 238–25 Feb. 244

8583

*Marcus Antonius Gordianus was born about AD 225. His mother was a daughter of Gordian I
Africanus and sister of Gordian II and with the deaths of his grandfather and uncle in April of 238
the 13-year-old boy inherited an enormous fortune. This, and his popularity with both the people
and the army, made the young boy an attractive prospective heir to the joint emperors Balbinus
and Pupienus and they eagerly adopted him soon after their accession, bestowing on him the rank
of Caesar and the right to a share in the coinage (much of which was no doubt financed out of his
vast wealth). On the downfall of Balbinus and Pupienus in late July of AD 238 the young Caesar
ascended the thrown without serious opposition, the Senate believing that it could maintain its*

newly-found political influence through the teenage emperor and the army regarding him as their protégé. Little is known of the opening years of the reign of Gordian III, though the Senate doubtless remained influential in the formulation of policy. Loyal to the memory of his grandfather and uncle, the young emperor's government ventured to cashier the legion of the Numidian governor Capellianus which had brought about the downfall of Gordian I and II. For this act of piety he received the title of 'Pius' which first appeared on the coinage in 240. A turning-point in the reign was marked by the promotion in 241 of the cultured and politically astute C. Furius Sabinus Aquila Timesitheus to the influential office of praetorian prefect. Timesitheus jealously guarded the interests of Gordian and later in the year the 16-year-old ruler married the prefect's daughter Furia Sabinia Tranquillina, it being Timesitheus' clear ambition that his descendants would one day rule the Empire. The following year (AD 242) saw a massive Persian invasion of Rome's eastern provinces. Led by their dynamic new ruler Shapur I (241–272) the Sasanids were threatening the Syrian capital of Antioch, one of the Empire's most important cities, and the situation demanded the urgent presence of the emperor. Temporarily delayed by problems on the Danubian frontier, Gordian and Timesitheus finally reached the East at the head of a great army in 243. They quickly achieved some notable successes against the invaders. Antioch was relieved and several Mesopotamian cities which had fallen into enemy hands were returned to Roman control, the final defeat of the Persian army taking place at Rhesaena. Unfortunately, during the following winter Timesitheus fell ill and died, his place as praetorian prefect being taken by his ambitious deputy Philip the Arab. In the light of subsequent events one may legitimately suspect that Timesitheus' death was due to poisoning. With his eye on the imperial office, Philip soon set about undermining the popularity of the teenage emperor and by late February of 244 he felt sufficiently secure of his position to stage a coup. The army declared that at this time of crisis they needed to be led by a man, not a mere boy, and the helpless Gordian was deposed and put to death, his place on the throne being taken by his praetorian prefect, now the emperor Philip I. The Senate was informed that Gordian had died of natural causes and had no choice but to accept the fait accompli. The army had thus reasserted its dangerous prerogative to make and unmake emperors at will and the brief revival of senatorial authority was at an end.

The denarius, the standard Roman silver denomination since the time of the Second Punic War in the late 3rd century BC, was issued in quantity for the last time during the reign of Gordian III. The double denarius, or antoninianus, first issued by Caracalla less than a quarter of a century before and reintroduced by Balbinus and Pupienus in 238, now rapidly superseded the traditional silver denomination and drove it out of circulation. Other denominations continued without significant change. The gold aureus was struck in considerable numbers again, though on a significantly lighter weight standard than during the last large scale issue under Severus Alexander (4.9 instead of 6.4 grams). In addition to coinage in the name of Gordian a very small issue was made for the empress Tranquillina at the time of the imperial wedding late in AD 241.

This reign saw the resumption of the minting of Roman coin denominations in the provinces for the first time since early in the reign of Severus Alexander one and a half decades before. While it would not have been recognized as such at the time this development in effect marked the beginning of the end for Rome's traditional monopoly of state coinage production. Over the following decades a whole network of provincial mints began to evolve, due in large part to the chaotic political situation and to the fragmentation of the state. Although it maintained its supremacy for much of the remainder of the 3rd century Rome was ultimately to lose this position in the final decade with the establishment of Diocletian's tetrarchy system of government. Under Gordian III the enormous issues of debased silver antoniniani from Rome were augmented by a more limited production from at least one eastern centre. This is normally identified as Antioch in Syria, though there are two quite different series, one of AD 239 and another of 242–4. The later series may, perhaps, belong to an eastern mint other than Antioch, though if so its precise location has not yet been identified.

There are three principal varieties of obverse legend:

A. IMP CAES M ANT GORDIANVS AVG
B. IMP CAES GORDIANVS PIVS AVG
C. IMP GORDIANVS PIVS FEL AVG

The normal obverse type for all denominations other than the antoninianus and the dupondius is laureate bust of Gordian III right. Antoniniani and dupondii have radiate bust right. The bust is usually depicted draped and cuirassed, although the cuirass is often indistinct and may even be omitted on some dies. On later antoniniani of the mint of Antioch (AD 242–4) the bust is often shown cuirassed only.

Issues as Caesar under Balbinus and Pupienus, late Apr.–29 Jul. AD 238

(BMCRE references are to the coinage of Balbinus and Pupienus)

8557 8559

8557 **Silver denarius.** M ANT GORDIANVS CAES, bare-headed and dr. bust r. Rev. PIETAS AVGG, lituus, knife, patera (sometimes omitted), jug, simpulum and sprinkler (emblems of the priestly colleges). RIC (IV, part II) p. 177, 1. BMCRE 62–3. RSC 182. *[Rome].*
VF £185 ($275) / **EF** £365 ($550)

8558 **Brass sestertius.** Obv. Similar. Rev. LIBERALITAS AVGVSTORVM S C, Liberalitas stg. l., holding abacus and cornucopiae. RIC (IV, part II) p. 177, 2. BMCRE 17A*. Cf. C 128. *[Rome].* F £265 ($400) / **VF** £665 ($1,000) / **EF** £2,000 ($3,000)

8559 Similar to 8557, but also with S C on rev. and the patera always represented. RIC (IV, part II) p. 177, 3. Cf. BMCRE 64–6. C 183. *[Rome].*
F £120 ($180) / **VF** £300 ($450) / **EF** £900 ($1,350)

For the Alexandrian issues of Gordian III as Caesar, see nos. 8811–23.

Issues as Augustus, AD 238–244

8560 **Gold binio or double aureus.** C, rad., dr. and cuir. bust r. Rev. P M TR P III COS P P, Gordian, togate, stg. l., sacrificing over tripod-altar and holding short sceptre. RIC 72. C 225. Gnecchi 2. *[Rome, AD 240].* VF £5,000 ($7,500) / **EF** £12,000 ($18,000)

8561 Obv. Similar. Rev. P M TR P VI COS II P P, Apollo seated l., holding laurel-branch and resting l. arm on lyre. RIC 96. C 270. Gnecchi 3. *[Rome, AD 243–4].*
VF £5,000 ($7,500) / **EF** £12,000 ($18,000)

NB a 5-aureus piece (26.26 grams) has also been recorded for this reign: obv. IMP GORDIANVS PIVS FELIX AVG, laureate and cuirassed bust right; rev. TRAIECTVS AVG, emperor with soldiers and rowers aboard galley moving right (RIC 132 = Jameson Collection IV, p. 106, 59, "trouvée en Palestine"). This exceptional issue probably commemorates the crossing from Europe to Asia of Gordian and his army on their way to confront the invading Persians.

8562 **Gold aureus.** A. Rev. **AEQVITAS AVG**, Aequitas stg. l., holding scales and cornucopiae. RIC 40. C 16. Hunter, p. lxxxiii. *[Rome, AD 239].*
 VF £1,000 ($1,500) / **EF** £2,700 ($4,000)

NB Under Gordian III the weight of the aureus declined to an average level of 4.87 grams, though individual specimens may vary considerably.

8563 Similar, but with obv. legend B. RIC 57. C 21. Hunter, p. lxxxiv. *[Rome, AD 239–40].*
 VF £1,150 ($1,750) / **EF** £3,000 ($4,500)

 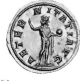

 8564 8565

8564 C. Rev. **AETERNITATI AVG**, Sol stg. l., raising r. hand and holding globe in l. RIC 97. C 37. Cf. Hunter 41. *[Rome, AD 241–3].* **VF** £850 ($1,300) / **EF** £2,300 ($3,500)

8565 A. Rev. **CONCORDIA AVG**, Concordia seated l., holding patera and cornucopiae (sometimes double). RIC 41. C 47, 49. Hunter 17. *[Rome, AD 239].*
 VF £1,000 ($1,500) / **EF** £2,700 ($4,000)

8566 C. Rev. **DIANA LVCIFERA**, Diana stg. r., holding lighted torch in both hands. RIC 121. C 68. Hunter 46. *[Rome, AD 241–2].* **VF** £1,000 ($1,500) / **EF** £2,700 ($4,000)
 Issued in celebration of the marriage of Gordian and Tranquillina (see also nos. 8576, 8591–2, 8598, 8673, 8677 and 8681–3).

8567 C. Rev. **FELICIT TEMP**, Felicitas stg. l., holding long caduceus and cornucopiae. RIC 157. C 70. Hunter, p. lxxxv. *[Rome, AD 243–4].* **VF** £1,150 ($1,750) / **EF** £3,000 ($4,500)

8568 A. Rev. **FIDES MILITVM**, Fides Militum stg. l., holding standard and transverse sceptre. RIC 7. C 85. Hunter, p. lxxxiii. *[Rome, AD 238–9].* **VF** £1,000 ($1,500) / **EF** £2,700 ($4,000)

8569 C. Rev. **FORT REDVX**, Fortuna seated l., holding rudder and cornucopiae, wheel below seat. RIC 160. C 96. Hunter, p. lxxxv. *[Rome, AD 243–4].*
 VF £1,150 ($1,750) / **EF** £3,000 ($4,500)

8570 A. Rev. **IOVI CONSERVATORI**, Jupiter stg. l., holding thunderbolt and sceptre, small figure of emperor at feet to l. RIC 8. C 104. Hunter, p. lxxxiii. *[Rome, AD 238–9].*
 VF £1,150 ($1,750) / **EF** £3,000 ($4,500)

8571 C. Rev. **IOVI STATORI**, Jupiter stg. facing, hd. r., resting on sceptre and holding thunderbolt. RIC 99. C 108. Hunter, p. lxxxv. *[Rome, AD 241–3].*
 VF £1,000 ($1,500) / **EF** £2,700 ($4,000)

8572 C. Rev. **LAETITIA AVG N**, Laetitia stg. l., holding wreath and resting on anchor. RIC 101. C 119. Hunter 54. *[Rome, AD 241–3].* **VF** £1,000 ($1,500) / **EF** £2,700 ($4,000)

8573 A. Rev. **LIBERALITAS AVG II**, Liberalitas stg. l., holding abacus and cornucopiae. RIC 42. C 129. Hunter 18. *[Rome, AD 239].* **VF** £1,000 ($1,500) / **EF** £2,700 ($4,000)

8572

8575

8574 **Gold aureus.** Similar, but with obv. legend B. RIC 58. C —. Hunter, p. lxxxiv. *[Rome, AD 239].* **VF** £1,150 ($1,750) / **EF** £3,000 ($4,500)

8575 A. Rev. PAX AVGVSTI, Pax stg. l., holding olive-branch and transverse sceptre. RIC 9. C —. Hunter, p. lxxxiii. *[Rome, AD 238–9].* **VF** £1,000 ($1,500) / **EF** £2,700 ($4,000)

8576 C. Rev. PIETAS AVGVSTI, Pietas stg. l., both hands raised in invocation. RIC 122. C 185. Hunter, p. lxxxv. *[Rome, AD 241–2].* **VF** £1,000 ($1,500) / **EF** £2,700 ($4,000)
 Issued in celebration of the marriage of Gordian and Tranquillina (see also nos. 8566, 8591–2, 8598, 8673, 8677 and 8681–3).

8577 A. Rev. P M TR P II COS P P, Jupiter protecting small figure of Gordian, as 8570. RIC 21. C 188. Hunter, p. lxxxiii. *[Rome, AD 239].* **VF** £1,150 ($1,750) / **EF** £3,000 ($4,500)

8578 A. Rev. — Pax stg., as 8575. RIC 22. C 202. Hunter, p. lxxxiii. *[Rome, AD 239].* **VF** £1,000 ($1,500) / **EF** £2,700 ($4,000)

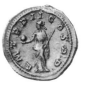

8579

8579 A. Rev. — Providentia stg. l., holding globe and transverse sceptre. RIC 23. C 195. Hunter, p. lxxxiii. *[Rome, AD 239].* **VF** £1,000 ($1,500) / **EF** £2,700 ($4,000)

8580 A. Rev. — Victory advancing l., holding wreath and palm. RIC 24. C 198. Hunter, p. lxxxiii. *[Rome, AD 239].* **VF** £1,000 ($1,500) / **EF** £2,700 ($4,000)

8581 A. Rev. — Virtus stg. l., resting on shield and spear. RIC 25. C 193. Hunter, p. lxxxiii. *[Rome, AD 239].* **VF** £1,000 ($1,500) / **EF** £2,700 ($4,000)

8582 C. Rev. P M TR P III COS P P, Gordian sacrificing over tripod-altar, as 8560. RIC 74. C 227. Hunter, p. lxxxiv. *[Rome, AD 240].* **VF** £1,000 ($1,500) / **EF** £2,700 ($4,000)

8583 C. Rev. — Gordian on horseback pacing l., his r. hand raised, holding sceptre in l. RIC 80. C 233. Hunter, p. lxxxiv. *[Rome, AD 240].* **VF** £1,350 ($2,000) / **EF** £3,300 ($5,000)

8584 C. Rev. P M TR P IIII COS II P P, Apollo seated l., holding laurel-branch and resting l. arm on lyre. RIC 102. C 249. Hunter, p. lxxxiv. *[Rome, AD 241–2].*
 VF £1,000 ($1,500) / **EF** £2,700 ($4,000)

 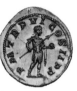

8585 8587

8585 **Gold aureus.** C. Rev. P M TR P IIII COS II P P, Gordian, in military attire, stg. r., holding transverse spear and globe. RIC 105. C 252. Hunter, p. lxxxiv. *[Rome, AD 241–2]*.
VF £1,000 ($1,500) / **EF** £2,700 ($4,000)

8586 C. Rev. P M TR P V COS II P P, Apollo seated, as 8584. RIC 103. C 260. Hunter, p. lxxxiv. *[Rome, AD 242–3]*. VF £1,000 ($1,500) / **EF** £2,700 ($4,000)

8587 C. Rev. P M TR P VI COS II P P, Gordian stg. in military attire, as 8585. RIC 107. C 275. Hunter, p. lxxxiv. *[Rome, AD 243–4]*. VF £1,000 ($1,500) / **EF** £2,700 ($4,000)

8588 C. Rev. PROVID AVG, Providentia stg. l., holding rod and sceptre, globe at feet. RIC 163. C 295. Hunter, p. lxxxv. *[Rome, AD 243–4]*. VF £1,150 ($1,750) / **EF** £3,000 ($4,500)

8589 A. Rev. PROVIDENTIA AVG, Providentia stg. l., holding globe and transverse sceptre. RIC 10. C 301. Hunter, p. lxxxiii. *[Rome, AD 238–9]*. VF £1,000 ($1,500) / **EF** £2,700 ($4,000)

8590 C. Rev. SECVRIT PERP, Securitas stg. facing, hd. l., legs crossed, holding sceptre and resting on column. Cf. RIC 164. C 326. Hunter, p. lxxxv. *[Rome, AD 243–4]*.
VF £1,150 ($1,750) / **EF** £3,000 ($4,500)

8591 C. Rev. SECVRITAS PVBLICA, Securitas seated l., at ease, her hd. propped on l. hand and holding sceptre in r. RIC 124. C 339. Hunter, p. lxxxv. *[Rome, AD 241–2]*.
VF £1,000 ($1,500) / **EF** £2,700 ($4,000)
This and the following type were issued in celebration of the marriage of Gordian and Tranquillina (see also nos. 8566, 8576, 8598, 8673, 8677 and 8681–3).

8592 C. Rev. VENVS VICTRIX, Venus stg. l., holding helmet and sceptre and resting on shield. RIC 125. C —. Hunter, p. lxxxvi. *[Rome, AD 241–2]*. VF £1,150 ($1,750) / **EF** £3,000 ($4,500)

8593 A. Rev. VICTORIA AVG, Victory advancing l., holding wreath and palm. RIC 11. C 356. Hunter 10. *[Rome, AD 238–9]*. VF £1,000 ($1,500) / **EF** £2,700 ($4,000)

8594 A. rev. VIRTVS AVG, Virtus stg. l., resting on shield and spear. RIC 12. C —. Hunter, p. lxxxiii. *[Rome, AD 238–9]*. VF £1,150 ($1,750) / **EF** £3,000 ($4,500)

8595 C. Rev. VIRTVTI AVGVSTI, Hercules stg. r., r. hand on hip, l. holding lion's skin and resting on club set on rock. RIC 108. C 401. Hunter 69. *[Rome, AD 241–3]*.
VF £1,150 ($1,750) / **EF** £3,000 ($4,500)

8596 **Gold quinarius.** As 8564 (rev. AETERNITATI AVG, Sol holding globe). RIC 109. C 38. Hunter, p. lxxxv. *[Rome, AD 241–3]*. VF £1,500 ($2,250) / **EF** £4,000 ($6,000)

8597 C. Rev. P M TR P V COS II P P, Gordian, in military attire, stg. r., holding spear and globe. RIC —. C —. Hunter —. *[Rome, AD 242–3]*. VF £2,000 ($3,000) / **EF** £5,000 ($7,500)

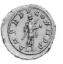

8595 8597

8598 **Gold quinarius.** As 8592 (rev. **VENVS VICTRIX**, Venus holding helmet). RIC 126. C 346. Hunter, p. lxxxvi. *[Rome, AD 241–2].* **VF** £1,500 ($2,250) / **EF** £4,000 ($6,000)
Issued in celebration of the marriage of Gordian and Tranquillina (see also nos. 8566, 8576, 8591–2, 8673, 8677 and 8681–3).

8599 As 8595 (rev. **VIRTVTI AVGVSTI**, Hercules resting on club). RIC 110. C 402. Hunter, p. lxxxvi. *[Rome, AD 241–3].* **VF** £1,500 ($2,250) / **EF** £4,000 ($6,000)

8600

8600 **Silver antoninianus.** A. Rev. **AEQVITAS AVG**, Aequitas stg. l., holding scales and cornucopiae. RIC 34. RSC 17. Hunter 14. *[Rome, AD 239].* **VF** £14 ($20) / **EF** £32 ($50)

NB Under Gordian III the fineness of the antoninianus ranges from about 48% in the earlier issues down to 42% at the end of the reign, and the average weight declines from about 4.50 grams down to 4.20 grams.

8600A Similar, but of eastern style. RIC 177a. RSC 17a. Cf. Hunter, p. lxxxvi. *[Antioch, AD 239].* **VF** £20 ($30) / **EF** £50 ($75)

8601 B. Rev. As 8600. RIC 51. RSC 22. Hunter 23. *[Rome, AD 239–40].* **VF** £16 ($25) / **EF** £40 ($60)

8602 C. Rev. As previous. RIC 63. RSC 25. Hunter 26. *[Rome, AD 240].* **VF** £14 ($20) / **EF** £32 ($50)

8603 C. Rev. **AETERNITATI AVG**, Sol stg., as 8564. RIC 83. RSC 41. Hunter 42. *[Rome, AD 241–3].* **VF** £14 ($20) / **EF** £32 ($50)

8604 A. Rev. **CONCORDIA AVG**, Concordia seated l., holding patera and double cornucopiae. RIC 35. RSC 50. Hunter, p. lxxxiii. *[Rome, AD 239].* **VF** £14 ($20) / **EF** £32 ($50)

8605 A. Rev. — Concordia stg. l., holding patera and cornucopiae, altar at feet. RIC 178a. RSC 58. Cf. Hunter, p. lxxxvi. *[Antioch, AD 239].* **VF** £22 ($35) / **EF** £55 ($85)

8606 C. Rev. **CONCORDIA MILIT** (or **MILITVM**), Concordia seated, as 8604. RIC 65 and note. RSC 62, 67. Hunter 45. *[Rome, AD 240].* **VF** £14 ($20) / **EF** £32 ($50)

8607 **Silver antoninianus.** C. Rev. FELICIT TEMP (or TEMPOR), Felicitas stg., as 8567. RIC 140, 141. RSC 71, 72. Hunter 48. *[Rome, AD 243–4].* **VF** £14 ($20) / **EF** £32 ($50)

8608 Similar, but FELICITAS TEMPORVM. RIC 142. RSC 81. Hunter 49. *[Rome, AD 243–4].*
 VF £14 ($20) / **EF** £32 ($50)

8609 A. Rev. FIDES MILITVM, Fides Militum stg. l., holding standard and transverse sceptre. RIC 1. RSC 86. Hunter 6. *[Rome, AD 238–9].* **VF** £14 ($20) / **EF** £32 ($50)

8610 A, rad., dr. and cuir. bust left. Rev. — as previous, but holding standard and cornucopiae. RIC 183b. RSC 90a. Cf. Hunter, p. lxxxvi. *[Antioch, AD 239].*
 VF £170 ($250) / **EF** £330 ($500)

8611 C. Rev. — as previous, but holding two standards. RIC 209. RSC 92. Hunter 165. *[Uncertain eastern mint, possibly Antioch, AD 242–4].* **VF** £20 ($30) / **EF** £50 ($75)

8612 C. Rev. FORT (or FORTVNA) REDVX, Fortuna seated l., holding rudder and cornucopiae, wheel below seat. RIC 143, 144. RSC 97, 98. Hunter, p. lxxxv. *[Rome, AD 243–4].*
 VF £14 ($20) / **EF** £32 ($50)

8613 C. Rev. FORTVNA REDVX, similar, but without wheel below seat. RIC 210. RSC 98a. Hunter 50, and note. *[Uncertain eastern mint, possibly Antioch, AD 243–4].*
 VF £16 ($25) / **EF** £40 ($60)

8614 A. Rev. IOVI CONSERVATORI, Jupiter stg. l., holding thunderbolt and sceptre, small figure of emperor at feet to l. RIC 2. RSC 105. Hunter 7. *[Rome, AD 238–9].*
 VF £14 ($20) / **EF** £32 ($50)

8615

8615 C. Rev. IOVI STATORI, Jupiter stg. facing, hd. r., resting on sceptre and holding thunderbolt. RIC 84. RSC 109. Hunter 51. *[Rome, AD 241–3].*
 VF £14 ($20) / **EF** £32 ($50)

8616 Similar, but with rev. legend IOVIS STATOR. RIC 85. RSC 115. Hunter, p. lxxxv. *[Rome, AD 241–3].* **VF** £16 ($25) / **EF** £40 ($60)

8617 C. Rev. LAETITIA AVG N, Laetitia stg. l., holding wreath and anchor. RIC 86. RSC 121. Hunter 55. *[Rome, AD 241–3].* **VF** £14 ($20) / **EF** £32 ($50)

8618 A. Rev. LIBERALITAS AVG, Libertas stg. l., holding pileus and transverse sceptre. RIC 187a. RSC 126. Cf. Hunter, p. lxxxvi. *[Antioch, AD 239].* **VF** £25 ($40) / **EF** £62 ($95)

8619 A. Rev. LIBERALITAS AVG II, Liberalitas stg. l., holding abacus and cornucopiae. RIC 36. RSC 130. Hunter 19. *[Rome, AD 239].* **VF** £14 ($20) / **EF** £32 ($50)

8620 **Silver antoninianus.** Similar, but with obv. legend B. RIC 53. RSC 133. Hunter, p. lxxxvi.
 [Rome, AD 239]. **VF** £16 ($25) / **EF** £40 ($60)

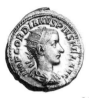

 8621 8623

8621 C. Rev. LIBERALITAS AVG III, as previous. RIC 67. RSC 142. Hunter 56. *[Rome, AD 240].*
 VF £14 ($20) / **EF** £32 ($50)

8622 Similar, but with rev. legend LIBERALITAS AVG IIII. RIC 137. RSC 147. Hunter 57. *[Rome,*
 AD 241]. **VF** £16 ($25) / **EF** £40 ($60)

8623 C. Rev. MARS PROPVG (or PROPVGNAT), Mars advancing r., carrying transverse spear and
 shield. RIC 145, 146. RSC 155, 156. Hunter 58. *[Rome, AD 243–4].*
 VF £14 ($20) / **EF** £32 ($50)

8624 Similar, but with rev. legend MARTEM PROPVGNATOREM. RIC 147. RSC 160. Hunter 59.
 [Rome, AD 243–4]. **VF** £14 ($20) / **EF** £32 ($50)

8625 C. Rev. MARTI PACIFERO, Mars running l., holding olive-branch in r. hand, spear and shield
 in l. RIC 212. RSC 162a. Hunter 166. *[Uncertain eastern mint, possibly Antioch, AD 242–4].*
 VF £20 ($30) / **EF** £50 ($75)

 8626

8626 C. Rev. ORIENS AVG, Sol stg. l., raising r. hand and holding globe in l. RIC 213. RSC 167.
 Hunter 167. *[Uncertain eastern mint, possibly Antioch, AD 242–4].*
 VF £16 ($25) / **EF** £40 ($60)

8627 A. Rev. PAX AVGVSTI, Pax stg. l., holding olive-branch and transverse sceptre. RIC 3.
 RSC 173. Hunter 8. *[Rome, AD 238–9].* **VF** £14 ($20) / **EF** £32 ($50)

8628 Similar, but with obv. type rad., dr. and cuir. bust left. RIC 189b. RSC 174b. Cf. Hunter,
 p. lxxxvi. *[Antioch, AD 239].* **VF** £170 ($250) / **EF** £330 ($500)

8629 Similar, but with obv. legend C and Pax running l. on rev. RIC 214. RSC 179. Cf. Hunter,
 p. lxxxvi. *[Uncertain eastern mint, possibly Antioch, AD 242–4].*
 VF £20 ($30) / **EF** £50 ($75)

8630 **Silver antoninianus.** A. Rev. P M TRI P CON P P, Gordian, togate, stg. l., sacrificing over tripod-altar and holding short sceptre. RIC 169. RSC 187. Hunter, p. lxxxvi. *[Antioch, AD 239].* **VF** £25 ($40) / **EF** £62 ($95)

8631 A. Rev. P M TR P II COS P P, Jupiter protecting small figure of Gordian, as 8614. RIC 16. RSC 189. Cf. Hunter, p. lxxxiii. *[Rome, AD 239].* **VF** £16 ($25) / **EF** £40 ($60)

8632 A. Rev. — Fides Militum stg. l., holding standard and transverse sceptre. RIC 15. RSC 205. Hunter 1. *[Rome, AD 239].* **VF** £16 ($25) / **EF** £40 ($60)

8633 A. Rev. — Pax stg. l., holding olive-branch and transverse sceptre. RIC 17. RSC 203. Cf. Hunter, p. lxxxiii. *[Rome, AD 239].* **VF** £16 ($25) / **EF** £40 ($60)

8634 A. Rev. — Providentia stg. l., holding globe and transverse sceptre. RIC 18. RSC 196. Hunter 2. *[Rome, AD 239].* **VF** £16 ($25) / **EF** £40 ($60)

8635 A. Rev. — Victory advancing l., holding wreath and palm. RIC 19. RSC 199. Hunter 3. *[Rome, AD 239].* **VF** £16 ($25) / **EF** £40 ($60)

8636 A. Rev. — Virtus stg. l., resting on shield and spear. RIC 20. RSC 194. Hunter 4. *[Rome, AD 239].* **VF** £16 ($25) / **EF** £40 ($60)

8637 8641

8637 A. Rev. — Gordian sacrificing over tripod-altar, as 8630. RIC 37. RSC 210. Hunter 13. *[Rome, AD 239].* **VF** £14 ($20) / **EF** £32 ($50)

8638 B. Rev. — As previous. RIC 54. RSC 212. Hunter, p. lxxxiv. *[Rome, AD 239–40].* **VF** £16 ($25) / **EF** £40 ($60)

8639 A. Rev. — Gordian on horseback r., his r. hand raised. RIC 174. RSC 219a. Hunter, p. lxxxvi. *[Antioch, AD 239].* **VF** £65 ($100) / **EF** £170 ($250)

8640 A. Rev. — Gordian in triumphal quadriga r., holding eagle-tipped sceptre. RIC 173. RSC 220a. Hunter, p. lxxxvi. *[Antioch, AD 239].* **VF** £250 ($375) / **EF** £500 ($750)

8641 A. Rev. — Gordian seated l. on curule chair, receiving olive-branch from Pax stg. r. before him and crowned by Victory stg. l. behind. RIC 175. RSC 223a. Hunter, p. lxxxvi. *[Antioch, AD 239].* **VF** £250 ($375) / **EF** £500 ($750)

8642 C. Rev. P M TR P III COS P P, Gordian sacrificing over tripod-altar, as 8630. RIC 69. RSC 226. Hunter 29. *[Rome, AD 240].* **VF** £14 ($20) / **EF** £32 ($50)

8643 C. Rev. P M TR P III COS II P P, Apollo seated l., holding laurel-branch and resting l. arm on lyre. RIC 87. RSC 237. Hunter, p. lxxxiv. *[Rome, AD 241].* **VF** £16 ($25) / **EF** £40 ($60)

8644 **Silver antoninianus.** C. Rev. — Gordian, in military attire, stg. r., holding transverse spear and globe. RIC 91. RSC 242. Hunter 32. *[Rome, AD 241].* **VF** £16 ($25) / **EF** £40 ($60)

8645 C. Rev. P M TR P IIII COS II P P, Apollo seated, as 8643. RIC 88. RSC 250. Hunter 34. *[Rome, AD 241–2].* **VF** £14 ($20) / **EF** £32 ($50)

8646 C. Rev. — Gordian stg. in military attire, as 8644. RIC 92. RSC 253. Hunter 36. *[Rome, AD 241–2].* **VF** £14 ($20) / **EF** £32 ($50)

8647 C. Rev. — Gordian in triumphal quadriga l., holding branch and sceptre, crowned by Victory stg. behind him. RIC 139. RSC 258. Hunter, p. lxxxiv. *[Rome, AD 241–2].* **VF** £250 ($375) / **EF** £500 ($750)

8648 C. Rev. P M TR P V COS II P P, Apollo seated, as 8643. RIC 89. RSC 261. Hunter 37. *[Rome, AD 242–3].* **VF** £14 ($20) / **EF** £32 ($50)

8649 C. Rev. — Hercules advancing r., wielding club and holding bow. RIC 206. RSC 264. Hunter, p. lxxxvi. *[Uncertain eastern mint, possibly Antioch, AD 242–3].* **VF** £100 ($150) / **EF** £230 ($350)

8650 8657

8650 C. Rev. — Gordian stg. in military attire, as 8644. RIC 93. RSC 266. Hunter 39. *[Rome, AD 242–3].* **VF** £14 ($20) / **EF** £32 ($50)

8651 C. Rev. P M TR P VI COS II P P, Apollo seated, as 8643. RIC 90. RSC 272. Hunter, p. lxxxiv. *[Rome, AD 243–4].* **VF** £16 ($25) / **EF** £40 ($60)

8652 C. Rev. — Gordian stg. in military attire, as 8644. RIC 94. RSC 276. Hunter, p. lxxxiv. *[Rome, AD 243–4].* **VF** £16 ($25) / **EF** £40 ($60)

8653 C. Rev. P M TR P VII COS II P P, Mars advancing r., carrying transverse spear and shield. RIC 167A. RSC 280. Hunter, p. lxxxv. *[Rome, AD 244].* **VF** £20 ($30) / **EF** £50 ($75)

8654 C. Rev. PROVID (or PROVIDENT or PROVIDENTIA) AVG, Providentia stg. l., holding rod and sceptre, globe at feet. RIC 148, 149, 150. RSC 296, 298, 299. Hunter 60, 61. *[Rome, AD 243–4].* **VF** £14 ($20) / **EF** £32 ($50)

8655 A. Rev. PROVIDENTIA AVG, Providentia stg. l., holding globe and transverse sceptre. RIC 4. RSC 302. Hunter 9. *[Rome, AD 238–9].* **VF** £14 ($20) / **EF** £32 ($50)

8656 A. Rev. — Annona stg. l., holding corn-ears and anchor, modius at feet. RIC 199a. RSC 308. Cf. Hunter, p. lxxxvi. *[Antioch, AD 239].* **VF** £20 ($30) / **EF** £50 ($75)

8657 A. Rev. — Fortuna stg. l., holding rudder and cornucopiae. RIC 196. RSC 306. Cf. Hunter, p. lxxxvi. *[Antioch, AD 239].* **VF** £20 ($30) / **EF** £50 ($75)

8658 **Silver antoninianus.** C. Rev. ROMAE AETERNAE, Roma seated l., holding Victory and sceptre, shield at side. RIC 70. RSC 314. Hunter, p. lxxxiv. *[Rome, AD 240]*.
VF £14 ($20) / **EF** £32 ($50)

8659 C. Rev. SAECVLI FELICITAS, Gordian stg. in military attire, as 8644. RIC 216. RSC 319. Hunter 169. *[Uncertain eastern mint, possibly Antioch, AD 242–4]*. **VF** £16 ($25) / **EF** £40 ($60)

8660 C. Rev. SECVRIT PERP (or PERPET), Securitas stg. facing, hd. l., legs crossed, holding sceptre and resting on column. RIC 151, 152. RSC 327, 328. Hunter 63. *[Rome, AD 243–4]*.
VF £14 ($20) / **EF** £32 ($50)

8661 Similar, but with rev. legend SECVRITAS PERPETVA. RIC 153. RSC 336. Hunter 64. *[Rome, AD 243–4]*. **VF** £14 ($20) / **EF** £32 ($50)

8662 C. Rev. VICTOR AETER, Victory stg. l., resting on shield set on captive and holding palm. RIC 154. RSC 348. Hunter 67. *[Rome, AD 243–4]*. **VF** £14 ($20) / **EF** £32 ($50)

8663 Similar, but with rev. legend VICTORIA AETER (or AETERNA). RIC 155, 156. RSC 349, 353. Hunter 68. *[Rome, AD 243–4]*. **VF** £14 ($20) / **EF** £32 ($50)

8664 A. Rev. VICTORIA AVG, Victory advancing l., holding wreath and palm. RIC 5. RSC 357. Hunter 11. *[Rome, AD 238–9]*. **VF** £14 ($20) / **EF** £32 ($50)

8665 C. Rev. VICTORIA AVG (or AVGVSTI), similar, but Victory advancing r. RIC 217, 218. RSC 362, 375. Cf. Hunter, p. lxxxvi. *[Uncertain eastern mint, possibly Antioch, AD 242–4]*.
VF £20 ($30) / **EF** £50 ($75)

8666 8668

8666 A. Rev. — Gordian on horseback pacing l., his r. hand raised, holding sceptre in l. Cf. RIC 203, 204 (Gordian r., in error). Cf. RSC 366, 376. Cf. Hunter, p. lxxxvi. *[Antioch, AD 239]*.
VF £170 ($250) / **EF** £330 ($500)

8667 C. Rev. VICTORIA GORDIANI AVG, type as 8665. RIC 219. RSC 380. Hunter, p. lxxxvi. *[Uncertain eastern mint, possibly Antioch, AD 242–4]*. **VF** £55 ($80) / **EF** £130 ($200)

8668 A. Rev. VIRTVS AVG, Virtus stg. l., resting on shield and spear. RIC 6. RSC 381. Hunter 12. *[Rome, AD 238–9]*. **VF** £14 ($20) / **EF** £32 ($50)

8669 C. Rev. — Mars stg. l., holding olive-branch and spear, shield at feet to l. RIC 71. RSC 388. Hunter 28. *[Rome, AD 240]*. **VF** £14 ($20) / **EF** £32 ($50)

8670 C. Rev. VIRTVTI AVGVSTI, Hercules stg. r., r. hand on hip, l. holding lion's skin and resting on club set on rock. RIC 95. RSC 404. Hunter 71. *[Rome, AD 241–3]*.
VF £14 ($20) / **EF** £32 ($50)

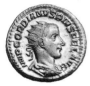

8670 8672

8671 **Silver antoninianus.** A. Rev. VOTIS / DECENNA / LIBVS in three lines within laurel-wreath. RIC 14. RSC 409. Hunter, p. lxxxiii. *[Rome, AD 238].* **VF** £200 ($300) / **EF** £400 ($600)

8672 **Silver denarius.** C. Rev. AETERNITATI AVG, Sol stg. l., raising r. hand and holding globe in l. RIC 111. RSC 39. Hunter 43. *[Rome, AD 241].* **VF** £20 ($30) / **EF** £50 ($75)

NB This reign saw the last large scale production of the traditional silver denarius, the mainstay of the Roman currency system since its introduction in *circa* 211 BC. At about 48% its fineness was somewhat higher than the antoninianus and its weight averaged a little over 3 grams.

8673 8674

8673 C. Rev. DIANA LVCIFERA, Diana stg. r., holding lighted torch in both hands. RIC 127. RSC 69. Hunter 46. *[Rome, AD 241–2].* **VF** £20 ($30) / **EF** £50 ($75)
Issued in celebration of the marriage of Gordian and Tranquillina (see also nos. 8566, 8576, 8591–2, 8598, 8677 and 8681–3).

8674 C. Rev. IOVIS STATOR, Jupiter stg. facing, hd. r., resting on sceptre and holding thunderbolt. RIC 112. RSC 113. Hunter 53. *[Rome, AD 241].* **VF** £20 ($30) / **EF** £50 ($75)

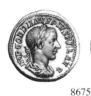

8675 8677

8675 C. Rev. LAETITIA AVG N, Laetitia stg. l., holding wreath and anchor. RIC 113. RSC 120. Hunter, p. lxxxv. *[Rome, AD 241].* **VF** £20 ($30) / **EF** £50 ($75)

8676 A (but C for CAES). Rev. LIBERALITAS AVG II, Liberalitas stg. l., holding abacus and cornucopiae. RIC 45. RSC 131. Hunter, p. lxxxiii. *[Rome, AD 239].*
VF £40 ($60) / **EF** £100 ($150)

8677 **Silver denarius.** C. Rev. PIETAS AVGVSTI, Pietas stg. l., both hands raised in invocation.
RIC 127. RSC 69. Hunter 46. *[Rome, AD 241–2].* **VF** £20 ($30) / **EF** £50 ($75)
*Issued in celebration of the marriage of Gordian and Tranquillina (see also nos. 8566,
8576, 8591–2, 8598, 8673 and 8681–3).*

8678 C. Rev. P M TR P III COS P P, Gordian on horseback pacing l., his r. hand raised, holding
sceptre in l. RIC 81. RSC 234. Hunter 30. *[Rome, AD 240].* **VF** £25 ($40) / **EF** £65 ($100)

8679 C. Rev. P M TR P III COS II P P, Apollo seated l., holding laurel-branch and resting l. arm on
lyre. RIC 114. RSC 238. Hunter, p. lxxxiv. *[Rome, AD 241].* **VF** £22 ($35) / **EF** £55 ($85)

8680 C. Rev. — Gordian, in military attire, stg. r., holding transverse spear and globe. RIC 115.
RSC 243. Hunter 33. *[Rome, AD 241].* **VF** £22 ($35) / **EF** £55 ($85)

8681 8682

8681 C. Rev. SALVS AVGVSTI, Salus stg. r., feeding snake held in her arms. RIC 129A. RSC
325. Hunter 62. *[Rome, AD 241–2].* **VF** £20 ($30) / **EF** £50 ($75)
*This and the following two types were issued in celebration of the marriage of Gordian
and Tranquillina (see also nos. 8566, 8576, 8591–2, 8598, 8673 and 8677).*

8682 C. Rev. SECVRITAS PVBLICA, Securitas seated l., at ease, her hd. propped on l. hand and
holding sceptre in r. RIC 130. RSC 340. Hunter 65. *[Rome, AD 241–2].*
VF £20 ($30) / **EF** £50 ($75)

8683 C. Rev. VENVS VICTRIX, Venus stg. l., holding helmet and sceptre and resting on shield.
RIC 131. RSC 347. Hunter 66. *[Rome, AD 241–2].* **VF** £20 ($30) / **EF** £50 ($75)

8684

8684 C. Rev. VIRTVTI AVGVSTI, Hercules resting on club, as 8670. RIC 116. RSC 403. Hunter,
p. lxxxvi. *[Rome, AD 241].* **VF** £20 ($30) / **EF** £50 ($75)

8685 **Silver quinarius.** As 8672 (rev. AETERNITATI AVG, Sol holding globe). RIC 117. RSC 40.
Hunter, p. lxxxv. *[Rome, AD 241].* **VF** £500 ($750) / **EF** £1,000 ($1,500)

8686 C. Rev. CONCORDIA MILIT, Concordia seated l., holding patera and double cornucopiae.
RIC 75. RSC 63. Hunter, p. lxxxv. *[Rome, AD 240].* **VF** £500 ($750) / **EF** £1,000 ($1,500)

8687 **Silver quinarius.** C. Rev. FELICIT TEMP, Felicitas stg. l., holding long caduceus and cornucopiae. RIC 167. RSC 71a. Hunter, p. lxxxv. *[Rome, AD 243–4].*
VF £600 ($900) / **EF** £1,200 ($1,800)

8688 As 8674 (rev. IOVIS STATOR, Jupiter holding thunderbolt). RIC 118. RSC 114. Hunter, p. lxxxv. *[Rome, AD 241].* **VF** £500 ($750) / **EF** £1,000 ($1,500)

8689 A (but C for CAES). Rev. P M TR P II COS P P, Fides Militum stg. l., holding standard and transverse sceptre. RIC 26. RSC 206. Hunter, p. lxxxiii. *[Rome, AD 239].*
VF £600 ($900) / **EF** £1,200 ($1,800)

8690 — Rev. — Gordian, togate, stg. l., sacrificing over tripod-altar and holding short sceptre. RIC 46. RSC 210a. Hunter, p. lxxxiii. *[Rome, AD 239].* **VF** £600 ($900) / **EF** £1,200 ($1,800)

8691 C. Rev. P M TR P III COS P P, as previous. RIC 77. RSC 228. Hunter, p. lxxxiv. *[Rome, AD 240].* **VF** £600 ($900) / **EF** £1,200 ($1,800)

8692 C. Rev. P M TR P III COS II P P, Apollo seated l., holding laurel-branch and resting l. arm on lyre. RIC 119. RSC 239. Hunter, p. lxxxiv. *[Rome, AD 241].*
VF £600 ($900) / **EF** £1,200 ($1,800)

8693 C. Rev. ROMAE AETERNAE, Roma seated l., holding Victory and sceptre, shield at side. RIC 78. RSC 315. Hunter, p. lxxxiv. *[Rome, AD 240].*
VF £600 ($900) / **EF** £1,200 ($1,800)

8694 A (but C for CAES). Rev. VICTORIA AVG, Victory advancing l., holding wreath and palm. RIC 13. RSC 361. Hunter, p. lxxxiii. *[Rome, AD 238–9].*
VF £500 ($750) / **EF** £1,000 ($1,500)

8695 C. Rev. VIRTVS AVG, Mars stg. l., holding olive-branch and spear, shield at feet to l. RIC 79. RSC 389. Hunter, p. lxxxiv. *[Rome, AD 240].* **VF** £600 ($900) / **EF** £1,200 ($1,800)

8696 C. Rev. VIRTVTI AVGVSTI, Hercules stg. r., r. hand on hip, l. holding lion's skin and resting on club set on rock. RIC 120. RSC 405. Hunter, p. lxxxvi. *[Rome, AD 241].*
VF £500 ($750) / **EF** £1,000 ($1,500)

8697 **Bronze sestertius.** A. Rev. ABVNDANTIA AVG S C, Abundantia stg. r., emptying cornucopiae held with both hands. RIC 274a. C 1. Hunter 84. *[Rome, AD 239].*
F £30 ($45) / **VF** £75 ($110) / **EF** £250 ($375)

NB The traditional use of brass/orichalcum (for sestertii and dupondii) and copper (for asses) was gradually abandoned during the first half of the 3rd century. In their place, leaded bronze was used for the production of all three denominations. Accordingly, from this point on in the catalogue the designation 'bronze' will be used in place of 'brass' and 'copper', though this does not imply that a major change occurred during the reign of Gordian III.

8698 C (but FELIX for FEL). Rev. ADLOCVTIO AVGVSTI S C, Gordian stg. r. on platform, accompanied by the praetorian prefect Timesitheus, haranguing gathering of three armed soldiers, vexillum, legionary eagle and horse in background. RIC 313b. C 13. Hunter, p. lxxxv. *[Rome, AD 243].* **F** £330 ($500) / **VF** £825 ($1,250) / **EF** £2,500 ($3,750)

8699 A. Rev. AEQVITAS AVG S C, Aequitas stg. l., holding scales and cornucopiae. RIC 267a. C 19. Hunter, p. lxxxiii. *[Rome, AD 239].* **F** £25 ($40) / **VF** £65 ($100) / **EF** £230 ($350)

8700 **Bronze sestertius.** Similar, but with obv. legend B. RIC 277. C 23. Hunter, p. lxxxiv.
[Rome, AD 239–40]. **F** £32 ($50) / **VF** £80 ($120) / **EF** £265 ($400)

8701 C. Rev. **AETERNITAS AVGVSTI S C,** Gordian on horseback pacing r., holding globe (?). RIC
314. C 36. Hunter, p. lxxxv. *[Rome, AD 243–4].*
F £120 ($180) / **VF** £300 ($450) / **EF** £900 ($1,350)
*This rare type may commemorate the erection of an equestrian statue in honour of the
young emperor.*

8702

8702 C. Rev. **AETERNITATI AVG S C,** Sol stg. l., raising r. hand and holding globe in l. RIC 297a.
C 43. Hunter 123. *[Rome, AD 241–3].* **F** £25 ($40) / **VF** £65 ($100) / **EF** £230 ($350)

8703 A. Rev. **CONCORDIA AVG S C,** Concordia seated l., holding patera and double
cornucopiae. RIC 268. C 51. Hunter 87. *[Rome, AD 239].*
F £25 ($40) / **VF** £65 ($100) / **EF** £230 ($350)

8704 C. Rev. **CONCORDIA MILIT S C,** type as previous. RIC 288a. C 64. Hunter, p. lxxxv. *[Rome,
AD 240].* **F** £25 ($40) / **VF** £65 ($100) / **EF** £230 ($350)

8705 C. Rev. **FELICIT TEMPOR** (or **FELICITAS TEMPORVM) S C,** Felicitas stg. l., holding long
caduceus and cornucopiae. RIC 328a, 330. C 73, 82. Hunter 127. *[Rome, AD 243–4].*
F £25 ($40) / **VF** £65 ($100) / **EF** £230 ($350)

8705A C. Rev. **FELICITAS AVG S C,** type as previous. RIC 310a. C 76. Hunter 128. *[Rome,
AD 241–3].* **F** £25 ($40) / **VF** £65 ($100) / **EF** £230 ($350)

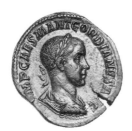

8706

8706 A. Rev. **FIDES MILITVM S C,** Fides Militum stg. l., holding standard and transverse sceptre.
RIC 254a. C 88. Hunter 74. *[Rome, AD 238–9].*
F £25 ($40) / **VF** £65 ($100) / **EF** £230 ($350)

8707 **Bronze sestertius.** C. Rev. — Gordian on horseback pacing r. between two standards, his r. hand raised. RIC 315. C 94. Hunter 129. *[Rome, AD 243–4].*
F £100 ($150) / **VF** £230 ($350) / **EF** £665 ($1,000)

8708 C. Rev. **FORTVNA REDVX S C**, Fortuna seated l., holding rudder and cornucopiae, wheel below seat. RIC 331a. C 99. Hunter 130. *[Rome, AD 243–4].*
F £25 ($40) / **VF** £65 ($100) / **EF** £230 ($350)

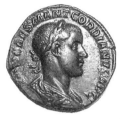

8709

8709 A. Rev. **IOVI CONSERVATORI S C**, Jupiter stg. l., holding thunderbolt and sceptre (or spear), small figure of emperor at feet to l. RIC 255a. C 106. Hunter 76. *[Rome, AD 238–9].*
F £25 ($40) / **VF** £65 ($100) / **EF** £230 ($350)

8710

8710 C. Rev. **IOVI STATORI S C**, Jupiter stg. facing, hd. r., resting on sceptre and holding thunderbolt. RIC 298a. C 111. Hunter 134. *[Rome, AD 241–3].*
F £25 ($40) / **VF** £65 ($100) / **EF** £230 ($350)

8711 Similar, but with rev. legend **IOVIS STATOR S C**. RIC 299a. C 116. Hunter, p. lxxxv. *[Rome, AD 241].*
F £30 ($45) / **VF** £75 ($110) / **EF** £250 ($375)

8712 C. Rev. **LAETITIA AVG N S C**, Laetitia stg. l., holding wreath and anchor. RIC 300a. C 122. Hunter 140. *[Rome, AD 241–3].*
F £25 ($40) / **VF** £65 ($100) / **EF** £230 ($350)

8713 A. Rev. **LIBERALITAS AVG II S C**, Liberalitas stg. l., holding abacus and double cornucopiae. RIC 269a. C 136. Hunter 88. *[Rome, AD 239].*
F £25 ($40) / **VF** £65 ($100) / **EF** £230 ($350)

8714 C. Rev. **LIBERALITAS AVG III S C**, type as previous, but single cornucopiae. RIC 290a. C 143. Hunter 144. *[Rome, AD 240].*
F £25 ($40) / **VF** £65 ($100) / **EF** £230 ($350)

8712

8714

8715 **Bronze sestertius.** Similar, but with rev. legend LIBERALITAS AVG IIII S C. RIC 316a. C 148. Hunter, p. lxxxv. *[Rome, AD 241].* **F** £32 ($50) / **VF** £80 ($120) / **EF** £265 ($400)

8716 A. Rev. LIBERALITAS AVGVSTI II S C, Gordian seated l. on curule chair atop platform, accompanied by praetorian prefect and soldier stg. behind him and Liberalitas stg. l. before, holding abacus and cornucopiae, citizen mounting steps of platform about to receive largess. RIC 275. Cf. C 146 (rev. misdescribed). Hunter, p. lxxxiii. *[Rome, AD 239].*
F £200 ($300) / **VF** £500 ($750) / **EF** £1,500 ($2,250)

8717

8717 C. Rev. LIBERTAS AVG S C, Libertas stg. l., holding pileus and sceptre. RIC 318a. C 153. Hunter 147. *[Rome, AD 240].* **F** £25 ($40) / **VF** £65 ($100) / **EF** £230 ($350)

8718 C. Rev. MARS PROPVGNAT S C, Mars advancing r., carrying transverse spear and shield. RIC 332a. C 157. Hunter 148. *[Rome, AD 243–4].*
F £25 ($40) / **VF** £65 ($100) / **EF** £230 ($350)

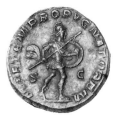

8719

8719 **Bronze sestertius.** Similar, but with rev. legend MARTEM PROPVGNATOREM S C. RIC 333. C 161. Hunter 149. *[Rome, AD 243–4].* **F** £25 ($40) / **VF** £65 ($100) / **EF** £230 ($350)

8720 C. Rev. PAX AETERNA S C, Pax advancing l., holding olive-branch and sceptre. RIC 319a. C 169. Hunter 150. *[Rome, AD 240].* **F** £25 ($40) / **VF** £65 ($100) / **EF** £230 ($350)

8721 A. Rev. PAX AVGVSTI S C, similar, but Pax stg. and the sceptre transverse. RIC 256a. Cf. C 175. Hunter 77. *[Rome, AD 238–9].* **F** £25 ($40) / **VF** £65 ($100) / **EF** £230 ($350)

8722 A. Rev. P M TR P II COS P P S C, Roma seated l., holding Victory and spear (or sceptre), shield at side. RIC 264a. C 207. Hunter, p. lxxxiii. *[Rome, AD 239].*
F £32 ($50) / **VF** £80 ($120) / **EF** £265 ($400)

8723 A. Rev. — Victory advancing r., holding wreath and palm. RIC 265a. C 200. Hunter, p. lxxxiii. *[Rome, AD 239].* **F** £32 ($50) / **VF** £80 ($120) / **EF** £265 ($400)

8724 A. Rev. — Gordian, togate, stg. l., sacrificing over tripod-altar and holding short sceptre. RIC 271. C 211. Hunter 81. *[Rome, AD 239].*
F £25 ($40) / **VF** £65 ($100) / **EF** £230 ($350)

8725 Similar, but with obv. legend B. RIC 280. C 213. Hunter, p. lxxxiv. *[Rome, AD 239–40].*
F £32 ($50) / **VF** £80 ($120) / **EF** £265 ($400)

8726 A. Rev. — Gordian, in military attire, advancing r., carrying transverse spear and shield. RIC 266. C 218. Hunter 82. *[Rome, AD 239].*
F £30 ($45) / **VF** £75 ($110) / **EF** £250 ($375)

8727

8727 A. Rev. — Gordian in triumphal quadriga l., holding eagle-tipped sceptre. RIC 276a. C 221. Hunter 83. *[Rome, AD 239].* **F** £120 ($180) / **VF** £300 ($450) / **EF** £900 ($1,350)

8728 **Bronze sestertius.** C. Rev. P M TR P III COS P P S C, Gordian, togate, seated l. on curule chair, holding globe and short sceptre. RIC 294a. C 231. Hunter 107. *[Rome, AD 240].*
F £32 ($50) / **VF** £80 ($120) / **EF** £265 ($400)

8729 C. Rev. — Gordian on horseback pacing l., his r. hand raised, holding sceptre in l. RIC 295a. C 235. Hunter, p. lxxxiv. *[Rome, AD 240].*
F £65 ($100) / **VF** £170 ($250) / **EF** £500 ($750)

8730 C. Rev. P M TR P III COS II P P S C, Apollo seated l., holding laurel-branch and resting l. arm on lyre. RIC 301a. C 240. Hunter, p. lxxxiv. *[Rome, AD 241].*
F £25 ($40) / **VF** £65 ($100) / **EF** £230 ($350)

8731 C. Rev. P M TR P IIII COS II P P S C, Gordian, in military attire, stg. r., holding transverse spear and globe. RIC 306a. C 254. Hunter 114. *[Rome, AD 241–2].*
F £25 ($40) / **VF** £65 ($100) / **EF** £230 ($350)

8732

8732 C. Rev. P M TR P V COS II P P S C, Apollo seated, as 8730. RIC 303a. Cf. C 262. Hunter 117. *[Rome, AD 242–3].* F £25 ($40) / **VF** £65 ($100) / **EF** £230 ($350)

8733 C. Rev. P M TR P VI COS II P P S C, Gordian with spear and globe, as 8731. RIC 308a. C 277. Hunter 121. *[Rome, AD 243–4].* F £30 ($45) / **VF** £75 ($110) / **EF** £250 ($375)

8734

8734 C. Rev. P M TR P VII COS II P P S C, Mars advancing r., carrying transverse spear and shield. RIC 339a. C 281. Hunter 122. *[Rome, AD 244].*
F £32 ($50) / **VF** £80 ($120) / **EF** £265 ($400)

8735 A. Rev. PROVIDENTIA AVG S C, Providentia stg. l., holding globe and transverse sceptre. RIC 257a. C 304. Hunter 78. *[Rome, AD 238–9].*
F £25 ($40) / **VF** £65 ($100) / **EF** £230 ($350)

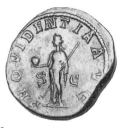

8735

8736 **Bronze sestertius.** A. Rev. ROMAE AETERNAE S C, Roma seated, as 8722. RIC 272a. C
 316. Hunter 91. *[Rome, AD 239].* **F** £25 ($40) / **VF** £65 ($100) / **EF** £230 ($350)

8737 A. Rev. SALVS AVG S C, Salus stg. r., feeding snake held in her arms. RIC 260a. C 320.
 Hunter 92. *[Rome, AD 239].* **F** £30 ($45) / **VF** £75 ($110) / **EF** £250 ($375)

8738 A. Rev. — Salus seated l., feeding snake arising from altar. RIC 261a. C 322. Hunter 93.
 [Rome, AD 239]. **F** £30 ($45) / **VF** £75 ($110) / **EF** £250 ($375)

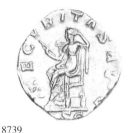

8739

8739 C. Rev. SECVRITAS AVG S C, Securitas seated l., holding sceptre, her hd. propped on l. hand,
 sometimes with altar at feet. RIC 311a, 312. C 333, 332. Hunter 154. *[Rome, AD 240].*
 F £25 ($40) / **VF** £65 ($100) / **EF** £230 ($350)

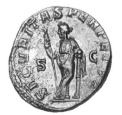

8340

8740 C. Rev. SECVRITAS PERPETVA (or SECVRIT PERPET) S C, Securitas stg. facing, hd. l., legs
 crossed, holding sceptre and resting on column. RIC 336, 335a. C 337, 329. Hunter 152.
 [Rome, AD 243–4]. **F** £25 ($40) / **VF** £65 ($100) / **EF** £230 ($350)

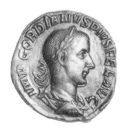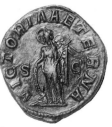

8741

8741 **Bronze sestertius.** C. Rev. VICTORIA AETER (or AETERNA) S C, Victory stg. l., resting on
shield set on captive and holding palm. RIC 337a, 338a. C 351, 354. Hunter 155. *[Rome,
AD 243–4].* **F** £25 ($40) / **VF** £65 ($100) / **EF** £230 ($350)

8742 A. Rev. VICTORIA AVG S C, Victory advancing l., holding wreath and palm. RIC 258a. C
358. Hunter 80. *[Rome, AD 238–9].* **F** £25 ($40) / **VF** £65 ($100) / **EF** £230 ($350)

8743 Similar, but Victory advancing r. RIC 262a. C 363. Hunter 94. *[Rome, AD 239].*
F £30 ($45) / **VF** £75 ($110) / **EF** £250 ($375)

8744 C. Rev. VICTORIA AVGVSTI S C, Gordian on horseback pacing l., his r. hand raised,
holding sceptre in l., preceded by Victory holding wreath and palm. RIC 325. C 377.
Hunter, p. lxxxvi. *[Rome, AD 243–4].* **F** £100 ($150) / **VF** £230 ($350) / **EF** £665 ($1,000)

8745 A. Rev. VIRTVS AVG S C, Mars stg. l., holding olive-branch and spear, shield at feet to l.
RIC 273a. C 384. Hunter 96. *[Rome, AD 239].*
F £30 ($45) / **VF** £75 ($110) / **EF** £250 ($375)

8746 Similar, but with obv. legend B. RIC 281a. C 387. Hunter, p. lxxxiv. *[Rome, AD 239–40].*
F £32 ($50) / **VF** £80 ($120) / **EF** £265 ($400)

8747 A. Rev. — Gordian, in military attire, advancing r., carrying transverse spear and shield.
RIC 259a. C 393. Hunter —. *[Rome, AD 239].*
F £32 ($50) / **VF** £80 ($120) / **EF** £265 ($400)

8748 C. Rev. VIRTVS AVGVSTI S C, Gordian, in military attire, galloping r., thrusting spear at
enemy who is trampled by horse's fore-hooves. RIC 327. Cf. C 395. Hunter, p. lxxxvi.
[Rome, AD 243–4]. **F** £170 ($250) / **VF** £400 ($600) / **EF** £1,200 ($1,800)

8749 A. Rev. VOTIS / DECENNA / LIBVS / S C in four lines within laurel-wreath. RIC 263a. C 410.
Hunter 97. *[Rome, AD 238].* **F** £80 ($120) / **VF** £200 ($300) / **EF** £600 ($900)

8750 **Bronze dupondius.** A. Rev. ABVNDANTIA AVG S C, Abundantia emptying cornucopiae,
as 8697. RIC 274c. C 3. Hunter, p. lxxxiii. *[Rome, AD 239].*
F £32 ($50) / **VF** £85 ($125) / **EF** £265 ($400)

NB The emperor's portrait on this denomination invariably shows him wearing a radiate
crown.

8751 A. Rev. AEQVITAS AVG S C, Aequitas stg., as 8699. RIC 267b. C 20. Hunter, p. lxxxiii.
[Rome, AD 239]. **F** £32 ($50) / **VF** £85 ($125) / **EF** £265 ($400)

8752 **Bronze dupondius.** Similar, but with obv. legend B. RIC —. C —. Hunter 98. *[Rome, AD 239–40].* **F** £40 ($60) / **VF** £100 ($150) / **EF** £300 ($450)

8753 C. Rev. CONCORDIA MILIT S C, Concordia seated, as 8704. RIC 288c. C 66. Hunter, p. lxxxv. *[Rome, AD 240].* **F** £32 ($50) / **VF** £85 ($125) / **EF** £265 ($400)

8754 A. Rev. FIDES MILITVM S C, Fides Militum stg., as 8706. RIC 254c. C —. Hunter 75. *[Rome, AD 238–9].* **F** £32 ($50) / **VF** £85 ($125) / **EF** £265 ($400)

8755 C. Rev. IOVI STATORI S C, Jupiter stg., as 8710. RIC 298c. C —. Hunter 137. *[Rome, AD 241–3].* **F** £32 ($50) / **VF** £85 ($125) / **EF** £265 ($400)

8756 C. Rev. LAETITIA AVG N S C, Laetitia stg., as 8712. RIC 300c. C 124. Hunter, p. lxxxv. *[Rome, AD 241–3].* **F** £32 ($50) / **VF** £85 ($125) / **EF** £265 ($400)

8757 A. Rev. LIBERALITAS AVG II S C, Liberalitas stg., as 8713. RIC 269b. C —. Hunter 90. *[Rome, AD 239].* **F** £32 ($50) / **VF** £85 ($125) / **EF** £265 ($400)

8758 C. Rev. LIBERALITAS AVG III S C, Liberalitas stg., as 8714. RIC 290c. C 145. Hunter, p. lxxxv. *[Rome, AD 240].* **F** £32 ($50) / **VF** £85 ($125) / **EF** £265 ($400)

8759 Similar, but with rev. legend LIBERALITAS AVG IIII S C. RIC 316c. C 149. Hunter, p. lxxxv. *[Rome, AD 241].* **F** £32 ($50) / **VF** £85 ($125) / **EF** £265 ($400)

8760 C. Rev. PAX AETERNA S C, Pax advancing, as 8720. RIC 319c. C 171. Hunter, p. lxxxv. *[Rome, AD 240].* **F** £32 ($50) / **VF** £85 ($125) / **EF** £265 ($400)

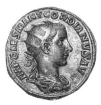

8761

8761 A. Rev. PAX AVGVSTI S C, Pax stg., as 8721. RIC 256c. Cf. C 177. Hunter, p. lxxxiii. *[Rome, AD 238–9].* **F** £32 ($50) / **VF** £85 ($125) / **EF** £265 ($400)

8762 C. Rev. P M TR P III COS P P S C, Gordian seated on curule chair, as 8728. RIC 294c. C 232. Hunter, p. lxxxiv. *[Rome, AD 240].* **F** £40 ($60) / **VF** £100 ($150) / **EF** £300 ($450)

8763 C. Rev. P M TR P IIII COS II P P S C, Gordian with spear and globe, as 8731. RIC 306c. C 256. Hunter, p. lxxxiv. *[Rome, AD 241–2].* **F** £32 ($50) / **VF** £85 ($125) / **EF** £265 ($400)

8764 C. Rev. P M TR P V COS II P P S C, Apollo seated, as 8730. RIC 303c. C —. Hunter, p. lxxxiv. *[Rome, AD 242–3].* **F** £32 ($50) / **VF** £85 ($125) / **EF** £265 ($400)

8765 A. Rev. ROMAE AETERNAE S C, Roma seated, as 8722. RIC 272c. C 318. Hunter, p. lxxxiii. *[Rome, AD 239].* **F** £32 ($50) / **VF** £85 ($125) / **EF** £265 ($400)

8766 **Bronze dupondius.** A. Rev. SALVS AVG S C, Salus stg., as 8737. RIC 260c. C 321. Hunter, p. lxxxiii. *[Rome, AD 239].* F £32 ($50) / **VF** £85 ($125) / **EF** £265 ($400)

8767 A. Rev. — Salus seated, as 8738. RIC 261c. C 324. Hunter, p. lxxxiii. *[Rome, AD 239].* F £32 ($50) / **VF** £85 ($125) / **EF** £265 ($400)

8768 A. Rev. VICTORIA AVG S C, Victory advancing, as 8743. 262c. C 365. Hunter, p. lxxxiii. *[Rome, AD 239].* F £32 ($50) / **VF** £85 ($125) / **EF** £265 ($400)

8769 A. Rev. VIRTVS AVG S C, Mars holding olive-branch, as 8745. RIC 273c. C 385. Hunter, p. lxxxiii. *[Rome, AD 239].* F £32 ($50) / **VF** £85 ($125) / **EF** £265 ($400)

8770 Similar, but with obv. legend B. RIC 281b. C —. Hunter, p. lxxxiv. *[Rome, AD 239–40].* F £40 ($60) / **VF** £100 ($150) / **EF** £300 ($450)

8771 **Bronze as.** As 8697 (rev. ABVNDANTIA AVG S C, Abundantia emptying cornucopiae). RIC 274b. C 2. Hunter 85. *[Rome, AD 239].* F £30 ($45) / **VF** £75 ($110) / **EF** £250 ($375)

8772 C. Rev. AEQVITAS AVG S C, Aequitas stg. l., holding scales and cornucopiae. RIC 286b. C 27. Hunter 102. *[Rome, AD 240].* F £30 ($45) / **VF** £75 ($110) / **EF** £250 ($375)

8773

8773 As 8702 (rev. AETERNITATI AVG S C, Sol holding globe). RIC 297b. C 44. Hunter 126. *[Rome, AD 241–3].* F £30 ($45) / **VF** £75 ($110) / **EF** £250 ($375)

8774 As 8704 (rev. CONCORDIA MILIT S C, Concordia seated). RIC 288b. C 65. Hunter, p. lxxxv. *[Rome, AD 240].* F £30 ($45) / **VF** £75 ($110) / **EF** £250 ($375)

8775 As 8705 (rev. FELICIT TEMPOR S C, Felicitas stg.). Cf. RIC 328b. C 74. Hunter, p. lxxxv. *[Rome, AD 243–4].* F £30 ($45) / **VF** £75 ($110) / **EF** £250 ($375)

8776 As 8705A (rev. FELICITAS AVG S C, Felicitas stg.). RIC 310b. C —. Hunter, p. lxxxv. *[Rome, AD 241–3].* F £30 ($45) / **VF** £75 ($110) / **EF** £250 ($375)

8777 As 8706 (rev. FIDES MILITVM S C, Fides Militum stg.). RIC 254b. C 89. Hunter, p. lxxxiii. *[Rome, AD 238–9].* F £30 ($45) / **VF** £75 ($110) / **EF** £250 ($375)

8778 As 8708 (rev. FORTVNA REDVX S C, Fortuna seated). RIC 331b. C 100. Hunter, p. lxxxv. *[Rome, AD 243–4].* F £30 ($45) / **VF** £75 ($110) / **EF** £250 ($375)

8779 As 8709 (rev. IOVI CONSERVATORI S C, Jupiter protecting small figure of Gordian). RIC 255b. C 107. Hunter, p. lxxxiii. *[Rome, AD 238–9].* F £30 ($45) / **VF** £75 ($110) / **EF** £250 ($375)

8780 **Bronze as.** As 8710 (rev. IOVI STATORI S C, Jupiter stg.). RIC 298b. C 112. Hunter 138.
 [Rome, AD 241–3]. **F** £30 ($45) / **VF** £75 ($110) / **EF** £250 ($375)

8781 Similar, but with rev. legend IOVIS STATOR S C. RIC 299b. C 117. Hunter 139. *[Rome,
 AD 241].* **F** £32 ($50) / **VF** £80 ($120) / **EF** £265 ($400)

8782

8782 As 8712 (rev. **LAETITIA AVG N S C**, Laetitia stg.). RIC 300b. C 123. Hunter 141. *[Rome,
 AD 241–3].* **F** £30 ($45) / **VF** £75 ($110) / **EF** £250 ($375)

8783 As 8714 (rev. **LIBERALITAS AVG III S C**, Liberalitas stg.). RIC 290b. C 144. Hunter 145.
 [Rome, AD 240]. **F** £30 ($45) / **VF** £75 ($110) / **EF** £250 ($375)

8784 As 8717 (rev. **LIBERTAS AVG S C**, Libertas stg.). RIC 318b. C 154. Hunter, p. lxxxv. *[Rome,
 AD 240].* **F** £30 ($45) / **VF** £75 ($110) / **EF** £250 ($375)

8785 As 8718 (rev. **MARS PROPVGNAT S C**, Mars advan cing). RIC 332b. C 158. Hunter,
 p. lxxxv. *[Rome, AD 243–4].* **F** £30 ($45) / **VF** £75 ($110) / **EF** £250 ($375)

8786 As 8720 (rev. **PAX AETERNA S C**, Pax advancing). RIC 319b. C 170. Hunter 151. *[Rome,
 AD 240].* **F** £30 ($45) / **VF** £75 ($110) / **EF** £250 ($375)

8787 As 8721 (rev. **PAX AVGVSTI S C**, Pax stg.). RIC 256b. Cf. C 176. Hunter, p. lxxxiii. *[Rome,
 AD 238–9].* **F** £30 ($45) / **VF** £75 ($110) / **EF** £250 ($375)

8788 As 8722 (rev. **P M TR P II COS P P S C**, Roma seated l.). RIC 264b. C 208. Hunter, p. lxxxiii.
 [Rome, AD 239]. **F** £32 ($50) / **VF** £85 ($130) / **EF** £285 ($425)

8789 As 8727 (rev. **P M TR P II COS P P S C**, Gordian in quadriga l.). RIC 276b. C 222. Hunter,
 p. lxxxiii. *[Rome, AD 239].* **F** £100 ($150) / **VF** £230 ($350) / **EF** £665 ($1,000)

8790 C. Rev. **P M TR P III COS P P S C**, Gordian, togate, stg. l., sacrificing over tripod-altar and
 holding short sceptre. RIC 292b. C 230. Hunter, p. lxxxiv. *[Rome, AD 240].*
 F £30 ($45) / **VF** £75 ($110) / **EF** £250 ($375)

8791 As 8729 (rev. **P M TR P III COS P P S C**, Gordian on horseback l.). RIC 295b. C 236. Hunter,
 p. lxxxiv. *[Rome, AD 240].* **F** £55 ($80) / **VF** £130 ($200) / **EF** £400 ($600)

8792 C. Rev. **P M TR P III COS II P P S C**, Gordian, in military attire, stg. r., holding transverse
 spear and globe. RIC 305b. C 245. Hunter, p. lxxxiv. *[Rome, AD 241].*
 F £30 ($45) / **VF** £75 ($110) / **EF** £250 ($375)

8793 Similar, but with rev. legend **P M TR P IIII COS II P P S C**. RIC 306b. C 255. Hunter 115.
 [Rome, AD 241–2]. **F** £30 ($45) / **VF** £75 ($110) / **EF** £250 ($375)

8794

8794 **Bronze as.** C. Rev. P M TR P V COS II P P S C, Apollo seated l., holding laurel-branch and resting l. arm on lyre. RIC 303b. Cf. C 263. Hunter, p. lxxxiv. *[Rome, AD 242–3]*.
 F £30 ($45) / **VF** £75 ($110) / **EF** £250 ($375)

8795 C (but FELIX for FEL), laur., dr. and cuir. bust l. Rev. P M TR P VI COS II P P S C, as previous. RIC 304c. C 274. Hunter, p. lxxxiv. *[Rome, AD 243–4]*.
 F £100 ($150) / **VF** £230 ($350) / **EF** £665 ($1,000)

8796 As 8734 (rev. P M TR P VII COS II P P S C, Mars advancing r.). RIC 339b. C —. Hunter, p. lxxxv. *[Rome, AD 244]*. **F** £32 ($50) / **VF** £85 ($130) / **EF** £285 ($425)

8797

8797 C. Rev. PONTIFEX MAX TR P III COS P P S C, Gordian, togate, stg. r., accompanied by soldier holding standard, receiving globe from Roma seated l., holding spear, shield at her side, a second soldier with standard stg. facing in background between them. RIC 296b. C 286. Hunter 109. *[Rome, AD 240]*. **F** £120 ($180) / **VF** £300 ($450) / **EF** £900 ($1,350)

8798 C. Rev. PONTIFEX MAX TR P IIII COS II P P S C, Gordian in triumphal quadriga l., holding branch and eagle-tipped sceptre, crowned by Victory stg. behind him, two soldiers before horses. RIC 321a. C 289. Hunter 116. *[Rome, AD 241–2]*.
 F £130 ($200) / **VF** £330 ($500) / **EF** £1,000 ($1,500)

8799 As 8735 (rev. PROVIDENTIA AVG S C, Providentia stg.). RIC 257b. C 305. Hunter, p. lxxxiii. *[Rome, AD 238–9]*. **F** £30 ($45) / **VF** £75 ($110) / **EF** £250 ($375)

8800 A. Rev. ROMAE AETERNAE S C, Roma seated l., holding Victory and spear (or sceptre), shield at side. RIC 272b. C 317. Hunter, p. lxxxiii. *[Rome, AD 239]*.
 F £30 ($45) / **VF** £75 ($110) / **EF** £250 ($375)

8801 As 8738 (rev. SALVS AVG S C, Salus seated). RIC 261b. C 323. Hunter, p. lxxxiii. *[Rome, AD 239]*. **F** £30 ($45) / **VF** £75 ($110) / **EF** £250 ($375)

8802 **Bronze as.** C. Rev. SECVRIT PERPET S C, Securitas stg. facing, hd. l., legs crossed, holding sceptre and resting on column. RIC 335b. C 330. Hunter, p. lxxxv. *[Rome, AD 243–4].*
F £30 ($45) / **VF** £75 ($110) / **EF** £250 ($375)

8803 C. Rev. SECVRITAS AVG S C, Securitas seated l., holding sceptre, her hd. propped on l. hand. RIC 311b. C 334. Hunter, p. lxxxv. *[Rome, AD 240].*
F £30 ($45) / **VF** £75 ($110) / **EF** £250 ($375)

8804 As 8741 (rev. VICTORIA AETER or AETERNA S C, Victory resting on shield). RIC 337b, 338b. C 352, 355. Hunter 156, 157. *[Rome, AD 243–4].*
F £30 ($45) / **VF** £75 ($110) / **EF** £250 ($375)

8805 A. Rev. VICTORIA AVG S C, Victory advancing l., holding wreath and palm. RIC 258b. C 359. Hunter, p. lxxxiii. *[Rome, AD 238–9].* **F** £30 ($45) / **VF** £75 ($110) / **EF** £250 ($375)

8806 Similar, but Victory advancing r. RIC 262b. C 364. Hunter, p. lxxxiii. *[Rome, AD 239].*
F £30 ($45) / **VF** £75 ($110) / **EF** £250 ($375)

8807 C. Rev. VIRTVS AVG S C, Mars stg. l., holding olive-branch and spear, shield at feet to l. RIC 293b. C 391. Hunter, p. lxxxiv. *[Rome, AD 240].*
F £30 ($45) / **VF** £75 ($110) / **EF** £250 ($375)

8808 A. Rev. — Gordian, in military attire, advancing r., carrying transverse spear and shield. RIC 259b. C 394. Hunter —. *[Rome, AD 239].*
F £32 ($50) / **VF** £85 ($130) / **EF** £285 ($425)

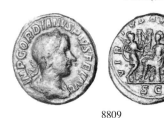

8809

8809 C. Rev. VIRTVS AVGVSTI S C, Gordian, in military attire, seated l. on cuirass, holding spear, crowned by Victory stg. l. behind him and receiving branch from Mars or Virtus stg. r. before, two standards in background. RIC 326. C 400. Hunter 158. *[Rome, AD 242–3].*
F £120 ($180) / **VF** £300 ($450) / **EF** £900 ($1,350)

8810 C. Rev. VIRTVTI AVGVSTI S C, Hercules stg. r., r. hand on hip, l. holding lion's skin and resting on club set on rock. RIC 309. C 406. Hunter 159–61. *[Rome, AD 241–3].*
F £30 ($45) / **VF** £75 ($110) / **EF** £250 ($375)

Alexandrian Coinage

As Caesar

8811 **Billon tetradrachm.** M ANT ΓΟΡΔΙΑΝΟC ΚΑΙCΑ (or ΚΑΙC), bare-headed, dr. and cuir. bust r. Rev. Athena stg. facing, hd. l., resting on spear and shield, L — A (= regnal year 1) in field. Dattari 4691. BMCG 1848–9. Cologne 2616. Milne 3304–6. *[AD 238].*
F £65 ($100) / **VF** £170 ($250)

8812 **Billon tetradrachm.** Similar, but with obv. legend M ΛN ΓOPΔIANOC CEB. Dattari —. BMCG —. Cologne —. Milne 3320. *[AD 238].* **F** £80 ($120) / **VF** £200 ($300) *Although he still appears bare-headed this variety may represent Gordian's initial issue as Augustus, struck during the first month of his reign (see also nos. 8820 and 8823).*

8813 Obv. As 8811. Rev. Athena seated l., holding Nike and sceptre, shield at side, L A (= regnal year 1) before. Dattari 4692. BMCG —. Cologne —. Milne —. *[AD 238].*
 F £80 ($120) / **VF** £200 ($300)

8814 — Rev. Nilus reclining l., holding cornucopiae and reed which bends over his hd., his l. arm resting on hd. of hippopotamus, L A (= regnal year 1) before. Dattari 4696. BMCG —. Cologne —. Milne 3317. *[AD 238].* **F** £80 ($120) / **VF** £200 ($300)

8815 — Rev. Laur. bust of Zeus r., L A (= regnal year 1) before. Dattari —. BMCG/Christiansen 3195. Cologne —. Milne —. *[AD 238].* **F** £80 ($120) / **VF** £200 ($300)

8816 — Rev. Zeus seated l., holding patera and sceptre, eagle at feet, L A (= regnal year 1) before. Dattari 4697 *bis.* BMCG/Christiansen 3196. Cologne —. Milne —. *[AD 238].*
 F £80 ($120) / **VF** £200 ($300)

8817

8817 — Rev. Homonoia (= Concordia) stg. l., r. hand extended, holding double cornucopiae in l., L A (= regnal year 1) before. Dattari 4693. BMCG 1850. Cologne 2617. Milne 3310–11. *[AD 238].* **F** £65 ($100) / **VF** £170 ($250)

8818 — Rev. Nike (= Victory) advancing l., holding wreath and palm, L A (= regnal year 1) before. Dattari 4694. BMCG —. Cologne —. Milne 3313–14. *[AD 238].*
 F £80 ($120) / **VF** £200 ($300)

8819 — Rev. Nike seated l., holding wreath and palm, L A (= regnal year 1) before. Dattari 4695. BMCG 1851–2. Cologne 2618. Milne 3315. *[AD 238].*
 F £65 ($100) / **VF** £170 ($250)

8820 Obv. As 8812. Rev. As previous. Dattari 4698. BMCG —. Cologne —. Milne —. *[AD 238].*
 F £80 ($120) / **VF** £200 ($300) *Although he still appears bare-headed this variety may represent Gordian's initial issue as Augustus, struck during the first month of his reign (see also nos. 8812 and 8823).*

8821 Obv. As 8811. Rev. Tyche (= Fortuna) stg. l., holding rudder and cornucopiae, L A (= regnal year 1) before. Dattari 4697. BMCG —. Cologne 2619. Milne —. *[AD 238].*
 F £80 ($120) / **VF** £200 ($300)

8822 — Rev. Eagle stg. l., hd. r., holding wreath in beak, L — A (= regnal year 1) in field. Dattari —. BMCG 1853. Cologne 2614–15. Milne 3319. *[AD 238].*
 F £65 ($100) / **VF** £170 ($250)

8823 **Billon tetradrachm.** Obv. As 8812. Rev. As previous. Dattari 4698 *bis*. BMCG —.
 Cologne —. Milne —. *[AD 238].* **F** £80 ($120) / **VF** £200 ($300)
 Although he still appears bare-headed this variety may represent Gordian's initial issue as
 Augustus, struck during the first month of his reign (see also nos. 8812 and 8820).

As Augustus

8824 **Billon tetradrachm.** A K M AN ΓΟΡΔΙΑΝΟC EY C (or CE or CEB), laur., dr. and cuir. bust r.
 Rev. Conjoined busts r. of Helios, rad., and Selene, with large lunar crescent before, L B (=
 regnal year 2) behind. Dattari 4732. BMCG —. Cologne —. Milne —. *[AD 238–9].*
 F £30 ($45) / **VF** £75 ($110)

8825 Obv. Similar. Rev. Hermanubis stg. r., wearing modius, holding caduceus and palm, jackal
 at his feet behind, L — B (= regnal year 2) in field. Dattari 4728. BMCG 1898. Cologne —.
 Milne 3333. *[AD 238–9].* **F** £25 ($40) / **VF** £65 ($100)

8826 — Rev. Nilus reclining l., holding cornucopiae and reed which bends over his hd., his l.
 arm resting on hd. of hippopotamus, L B (= regnal year 2) before. Dattari 4760–61. BMCG
 1900. Cologne 2628–9. Milne 3343–4. *[AD 238–9].* **F** £20 ($30) / **VF** £60 ($90)

8827 — Rev. Laur. bust of Zeus r., L B (= regnal year 2) behind. Dattari 4786.
 BMCG/Christiansen 3198. Cologne 2631. Milne 3321. *[AD 238–9].*
 F £16 ($25) / **VF** £55 ($80)

8828 — Rev. Elpis (= Spes) advancing l., holding flower and lifting skirt, L — B (= regnal year
 2) in field. Dattari 4723–4. BMCG —. Cologne 2624. Milne 3325. *[AD 238–9].*
 F £20 ($30) / **VF** £60 ($90)

8829 — Rev. Nike (= Victory) advancing l., holding wreath and palm, L B (= regnal year 2)
 before. Dattari 4746–7. BMCG 1880. Cologne —. Milne —. *[AD 238–9].*
 F £16 ($25) / **VF** £55 ($80)

8830 — Rev. Gordian on horseback pacing l., his r. hand raised, holding sceptre in l., L B (= regnal
 year 2) behind. Dattari —. BMCG —. Cologne —. Milne —. Curtis 1264. *[AD 238–9].*
 F £65 ($100) / **VF** £170 ($250)

8831 — Rev. Gordian on horseback galloping r., spearing enemy on ground beneath him, L B (=
 regnal year 2) behind. Cf. Dattari 4699. BMCG/Christiansen 3220. Cologne —. Milne —.
 [AD 238–9]. **F** £65 ($100) / **VF** £170 ($250)

8832

8832 — Rev. Eagle stg. l., hd. r., holding wreath in beak, L — B (= regnal year 2) in field. Dattari
 4805–6. BMCG 1907–8. Cologne 2620. Milne 3345–7. *[AD 238–9].*
 F £16 ($25) / **VF** £55 ($80)

8833 **Billon tetradrachm.** Obv. As 8824. Rev. Bust of Athena r., wearing crested Corinthian helmet and aegis, L — Γ (= regnal year 3) in field. Dattari 4704. BMCG —. Cologne 2634. Milne —. *[AD 239–40].* **F** £30 ($45) / **VF** £75 ($110)

8834 — Rev. Athena stg. l., holding Nike and resting on spear, shield at feet to l., L — Γ (= regnal year 3) in field. Dattari 4706. BMCG 1863. Cologne 2635. Milne 3352. *[AD 239–40].*
F £20 ($30) / **VF** £60 ($90)

8835 — Rev. Bust of Sarapis facing, wearing modius, L — Γ (= regnal year 3) in field. Dattari 4768. BMCG/Christiansen 3211. Cologne —. Milne 3361. *[AD 239–40].*
F £32 ($50) / **VF** £80 ($120)

8836 — Rev. Eirene (= Pax) stg. l., holding olive-branch and transverse sceptre, L — Γ (= regnal year 3) in field. Dattari 4720. BMCG 1872. Cologne —. Milne 3354. *[AD 239–40].*
F £16 ($25) / **VF** £55 ($80)

8837 — Rev. Nike (= Victory) seated l., holding wreath and palm, L Γ (= regnal year 3) before. Dattari 4753. BMCG 1885. Cologne —. Milne 3357. *[AD 239–40].*
F £16 ($25) / **VF** £55 ($80)

8838 — Rev. Tyche (= Fortuna) stg. l., holding rudder and cornucopiae, L Γ (= regnal year 3) before. Dattari 4779. BMCG 1889. Cologne —. Milne 3358–9. *[AD 239–40].*
F £16 ($25) / **VF** £55 ($80)

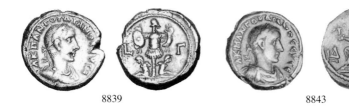

8839 8843

8839 — Rev. Trophy with two captives seated back to back at base, L — Γ (= regnal year 3) in field. Dattari 4802. BMCG 1914. Cologne 2638. Milne 3368. *[AD 239–40].*
F £30 ($45) / **VF** £75 ($110)

8840 — Rev. Ares stg. l., resting on spear and holding parazonium, shield at feet, L — Δ (= regnal year 4) in field. Dattari 4700. BMCG —. Cologne —. Milne —. *[AD 240–41].*
F £20 ($30) / **VF** £60 ($90)

8841 — Rev. Laur. bust of Asklepios r., snake-entwined staff before, L Δ (= regnal year 4) behind. Dattari —. BMCG/Christiansen 3206. Cologne —. Milne —. *[AD 240–41].*
F £32 ($50) / **VF** £80 ($120)

8842 — Rev. Asklepios stg. l., holding patera over altar and resting on snake-entwined staff, L Δ (= regnal year 4) before. Dattari 4702. BMCG 1867. Cologne 2642. Milne 3377. *[AD 240–41].*
F £25 ($40) / **VF** £65 ($100)

8843 — Rev. Athena seated l., holding Nike and resting on spear, shield at side, L Δ (= regnal year 4) before. Dattari 4712. BMCG 1864. Cologne 2643. Milne 3375–6. *[AD 240–41].*
F £16 ($25) / **VF** £55 ($80)

8844 — Rev. Similar, but Athena seated r., L — Δ (= regnal year 4) in field. Dattari 4713. BMCG —. Cologne —. Milne —. *[AD 240–41].* **F** £30 ($45) / **VF** £75 ($110)

8845 **Billon tetradrachm.** — Rev. Bust of Selene r., wearing taenia, large lunar crescent before,
L Δ (= regnal year 4) behind. Dattari 4777. BMCG 1860. Cologne —. Milne —.
[AD 240–41]. **F** £25 ($40) / **VF** £65 ($100)

8846 — Rev. Zeus stg. l., holding patera and sceptre, eagle at feet, L — Δ (= regnal year 4) in
field. Dattari —. BMCG/Christiansen 3200. Cologne —. Milne 3370. *[AD 240–41].*
F £25 ($40) / **VF** £65 ($100)

8847 — Rev. Bust of Zeus Ammon r., with ram's horn, crowned with horns and disk, L — Δ
(= regnal year 4) in field. Dattari 4799. BMCG/Christiansen 3202. Cologne —. Milne
3389. *[AD 240–41].* **F** £25 ($40) / **VF** £65 ($100)

8848 — Rev. Homonoia (= Concordia) stg. l., r. hand extended, holding double cornucopiae in
l., L Δ (= regnal year 4) before. Dattari 4737. BMCG 1876. Cologne 2645. Milne 3380.
[AD 240–41]. **F** £16 ($25) / **VF** £55 ($80)

8849 — Rev. Nike (= Victory) advancing r., holding wreath and palm, L — Δ (= regnal year 4)
in field. Cf. Dattari 4743. BMCG 1882. Cologne —. Milne 3381–2. *[AD 240–41].*
F £16 ($25) / **VF** £55 ($80)

8850 — Rev. She-wolf stg. r., suckling the twins Romulus and Remus, L Δ (= regnal year 4)
above. Dattari 4812. BMCG 1906. Cologne 2651. Milne 3401–2. *[AD 240–41].*
F £20 ($30) / **VF** £60 ($90)

8851 Α Κ Μ ΑΝΤ ΓΟΡΔΙΑΝΟC ΕΥ (or ΕΥ C), laur. and cuir. bust r. Rev. Bust of Hermanubis r.,
wearing modius, taenia and lotus-petal, combined caduceus and palm-branch before, L Ε
(= regnal year 5) behind. Dattari 4726. BMCG —. Cologne —. Milne 3427. *[AD 241–2].*
F £30 ($45) / **VF** £75 ($110)

8852 Obv. As 8824. Rev. Roma, helmeted, stg. l., her r. hand raised, holding spear in l., L Ε (=
regnal year 5) before. Dattari 4767. BMCG 1905. Cologne —. Milne 3408. *[AD 241–2].*
F £20 ($30) / **VF** £60 ($90)

8853 Obv. As 8851. Rev. Bust of Sarapis l., wearing modius with floral ornaments, sceptre over
l. shoulder, L Ε (= regnal year 5) before. Dattari 4772. BMCG 1894. Cologne —. Milne
3426. *[AD 241–2].* **F** £25 ($40) / **VF** £65 ($100)

8854 — Rev. Zeus seated l., holding patera and sceptre, eagle at feet, L Ε (= regnal year 5) before.
Dattari 4795–6. BMCG/Christiansen 3201. Cologne 2663. Milne 3411–12. *[AD 241–2].*
F £16 ($25) / **VF** £55 ($80)

8855 — Rev. Bust of Athena l., wearing crested Corinthian helmet and aegis, L Ϛ regnal year 6)
before. Dattari 4705. BMCG 1862. Cologne —. Milne —. *[AD 242–3].*
F £25 ($40) / **VF** £65 ($100)

8856 — Rev. Athena stg. facing, hd. l., holding Nike and resting on shield, L Ϛ regnal year 6)
before. Dattari 4707. BMCG —. Cologne —. Milne 3437. *[AD 242–3].*
F £25 ($40) / **VF** £65 ($100)

8857 — Rev. Bust of Zeus Ammon l., with ram's horn, crowned with horns and disk, sceptre over l.
shoulder, L Ϛ regnal year 6) before. Dattari 4800. BMCG —. Cologne —. Milne —. *[AD 242–3].*
F £30 ($45) / **VF** £75 ($110)

8858 Α Κ Μ ΑΝΤ ΓΟΡΔΙΑΝΟC ΕΥ (or ΕΥ C), laur., dr. and cuir. bust r. Rev. Rad. bust of Helios r.,
L — Ζ (= regnal year 7) in field. Dattari 4731. BMCG 1859. Cologne —. Milne 3466.
[AD 243–4]. **F** £16 ($25) / **VF** £55 ($80)

8859 **Billon tetradrachm.** Obv. As 8858. Rev. Bust of Nilus r., crowned with lotus, cornucopiae before, L Z (= regnal year 7) behind. Dattari 4758. BMCG 1899. Cologne 2676. Milne 3491. *[AD 243–4].* **F** £20 ($30) / **VF** £60 ($90)

8860 — Rev. Sarapis stg. facing, hd. r., wearing modius and resting on sceptre held in r. hand, L — Z (= regnal year 7) in field. Dattari 4774. BMCG 1895. Cologne 2678. Milne 3483. *[AD 243–4].* **F** £16 ($25) / **VF** £55 ($80)

8861 — Rev. Sarapis seated l., wearing modius, his r. hand outstretched, holding sceptre held in l., Kerberos at his feet, little Nike on back of throne, L — Z (= regnal year 7) in field. Dattari 4776. BMCG 1897. Cologne —. Milne 3486. *[AD 243–4].* **F** £20 ($30) / **VF** £60 ($90)

8862 — Rev. Dikaiosyne (= Aequitas) stg. l., holding scales and cornucopiae, L Z (= regnal year 7) before. Dattari 4716. BMCG 1869. Cologne 2673. Milne 3469. *[AD 243–4].* **F** £16 ($25) / **VF** £55 ($80)

8863 — Rev. Tyche (= Fortuna) reclining l. on couch, holding rudder, L Z (= regnal year 7) above. Dattari 4784. BMCG 1893. Cologne 2679. Milne 3480. *[AD 243–4].* **F** £16 ($25) / **VF** £55 ($80)

8864 — Rev. Eagle stg. facing, hd. r., wings spread, holding wreath in talons, L — Z (= regnal year 7) in field. Dattari 4811. BMCG 1912. Cologne 2671. Milne 3493. *[AD 243–4].* **F** £16 ($25) / **VF** £55 ($80)

For other local coinages of Gordian III, see *Greek Imperial Coins & Their Values*, pp. 349–64.

TRANQUILLINA

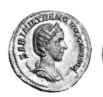

8865

Furia Sabinia Tranquillina, daughter of the praetorian prefect Timesitheus, was married to Gordian III late in AD 241, her first appearance on the Alexandrian coinage being in regnal year 5 (late August AD 241–2). The unfortunate young empress lost her father during the winter of 243–4 and her husband just a few months later, her subsequent fate being unknown.

Roman coinage in the name of Tranquillina is of great rarity and may have been confined to the actual occasion of the marriage. On the other hand, her Alexandrian and other provincial coinage is surprisingly abundant and certainly continued throughout the entire period of her marriage (late AD 241-early 244).

RIC references are to the coinage of Gordian III.

8865 **Silver antoninianus.** SABINIA TRANQVILLINA AVG, diad. and dr. bust r., crescent behind shoulders. Rev. CONCORDIA AVGG, Concordia seated l., holding patera and double cornucopiae. RIC 249. RSC 1. Hunter, p. lxxxvii. *[Rome, AD 241].* **VF** £4,000 ($6,000) / **EF** £8,000 ($12,000)

8866 **Silver antoninianus.** Similar, but with rev. type Gordian r. and Tranquillina l., stg. facing each other, clasping r. hands. RIC 250. RSC 4. Hunter, p. lxxxvii. *[Rome, AD 241].*
VF £4,000 ($6,000) / EF £8,000 ($12,000)

8867 **Silver denarius.** SABINIA TRANQVILLINA AVG, diad. and dr. bust r. Rev. As 8865. RIC 252. RSC 1a. Hunter, p. 212, 1. *[Rome, AD 241].*
VF £5,000 ($7,500) / EF £10,000 ($15,000)

8868 **Silver quinarius.** As previous. RIC 253. RSC 2. Hunter, p. lxxxvii. *[Rome, AD 241].*
(Unique)

8869 **Bronze sestertius.** Obv. As 8867. Rev. CONCORDIA AVGVSTORVM S C, emperor and empress clasping hands, as 8866. RIC 341a. C 5. Hunter, p. lxxxvii. *[Rome, AD 241].*

8870 — Rev. FELICITAS TEMPORVM S C, Felicitas stg. l., holding long caduceus and cornucopiae. RIC 342. C 8. Hunter —. *[Rome, AD 241].*

NB Although the two recorded sestertius types have been listed here there are serious doubts whether any authentic coins of Tranquillina of this denomination really exist. Of the nine known specimens (three of 8869, six of 8870) all are from the same obverse die and the same reverse die is shared by all the coins of each type (cf. *Bulletin on Counterfeits*, 1994, Vol. 19, No. 1, pp. 12–14.)

8871 **Bronze dupondius.** Obv. As 8865. Rev. As 8869. RIC 341c. C 6. Hunter, p. lxxxvii. *[Rome, AD 241].*
F £1,350 ($2,000) / VF £3,300 ($5,000)

8872 **Bronze as.** Obv. As 8867. Rev. CONCORDIA AVGG S C, Concordia seated, as 8865. RIC 340b. C 3. Hunter, p. lxxxvii. *[Rome, AD 241].* F £1,350 ($2,000) / VF £3,300 ($5,000)

8873 SABINIA TRANQVILLINA AVG, diad. and dr. bust l. Rev. As 8869. RIC 341b. C 7. Hunter, p. lxxxvii. *[Rome, AD 241].* F £1,500 ($2,250) / VF £3,700 ($5,500)

Alexandrian Coinage

8874 **Billon tetradrachm.** CAB TPANKVΛΛEINA CEB, diad. and dr. bust r. Rev. Athena seated l., holding Nike and resting on spear, shield at side, L E (= regnal year 5) before. Dattari 4817. BMCG 1923. Cologne 2682. Milne 3417. *[AD 241–2].* F £55 ($80) / VF £130 ($200)

8875

8875 Obv. Similar. Rev. Bust of Hermanubis r., wearing modius, taenia and lotus-petal, combined caduceus and palm-branch before, L E (= regnal year 5) behind. Dattari —. BMCG 1935. Cologne —. Milne —. *[AD 241–2].* F £65 ($100) / VF £170 ($250)

8876 **Billon tetradrachm.** Obv. As 8874 Rev. Nilus reclining l., holding reed and cornucopiae, l. arm resting on hd. of hippopotamus, crocodile r. below, L E (= regnal year 5) before. Dattari 4833. BMCG 1936. Cologne —. Milne 3429. *[AD 241–2].* **F** £60 ($90) / **VF** £150 ($225)

8877 — Rev. Eirene (= Pax) stg. l., holding olive-branch and transverse sceptre, L — E (= regnal year 5) in field. Dattari 4820. BMCG —. Cologne —. Milne —. *[AD 241–2].*
F £60 ($90) / **VF** £150 ($225)

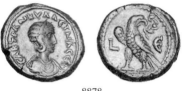

8878

8878 — Rev. Eagle stg. l., hd. r., holding wreath in beak, L — E (= regnal year 5) in field. Dattari 4847. BMCG 1937. Cologne 2681. Milne 3432. *[AD 241–2].*
F £48 ($70) / **VF** £115 ($175)

8879 — Rev. Trophy with two captives seated back to back at base, L — E (= regnal year 5) in field. Dattari —. BMCG/Christiansen 3226. Cologne —. Milne —. *[AD 241–2].*
F £65 ($100) / **VF** £170 ($250)

8880 — Rev. Bust of Athena l., wearing crested Corinthian helmet and aegis, L Ϛ regnal year 6) before. Dattari 4814. BMCG 1921. Cologne —. Milne 3436. *[AD 242–3].*
F £55 ($80) / **VF** £130 ($200)

8881 — Rev. Athena stg. facing, hd. l., holding Nike and resting on shield, L Ϛ regnal year 6) before. Dattari 4815. BMCG 1922. Cologne —. Milne 3438. *[AD 242–3].*
F £48 ($70) / **VF** £115 ($175)

8882 — Rev. Bust of Nilus r., crowned with lotus, cornucopiae behind, L — Ϛ regnal year 6) in field. Dattari 4832. BMCG —. Cologne —. Milne —. *[AD 242–3].*
F £60 ($90) / **VF** £150 ($225)

8883 — Rev. Bust of Sarapis r., wearing modius with floral ornaments, sceptre over shoulder, L Ϛ regnal year 6) before. Dattari 4834. BMCG —. Cologne 2690. Milne —. *[AD 242–3].*
F £60 ($90) / **VF** £150 ($225)

8884 — Rev. Similar, but bust of Sarapis l. Dattari 4835. BMCG —. Cologne —. Milne 3456. *[AD 242–3].* **F** £60 ($90) / **VF** £150 ($225)

8885 — Rev. Zeus seated l., holding patera and sceptre, eagle at feet, L Ϛ regnal year 6) before. Dattari 4844. BMCG 1918. Cologne 2691. Milne 3435. *[AD 242–3].*
F £48 ($70) / **VF** £115 ($175)

8886 — Rev. Bust of Zeus Ammon r., with ram's horn, crowned with horns and disk, L — Ϛ regnal year 6) in field. Dattari 4846. Cf. BMCG 1919. Cologne —. Milne —. *[AD 242–3].*
F £60 ($90) / **VF** £150 ($225)

8887 — Rev. Similar, but bust of Zeus Ammon l., sceptre over shoulder, L Ϛ regnal year 6) before. Dattari —. BMCG 1920. Cologne 2686. Milne —. *[AD 242–3].*
F £55 ($80) / **VF** £130 ($200)

8888 **Billon tetradrachm.** — Rev. Nike (= Victory) advancing r., holding wreath and palm, Ⴑ —
 Ϛ regnal year 6) in field. Dattari 4826. BMCG —. Cologne —. Milne —. *[AD 242–3]*.
 F £60 ($90) / **VF** £150 ($225)

8889 — Rev. Nike (= Victory) seated l., holding wreath and palm, Ⴑ Ϛ regnal year 6) before.
 Dattari 4831. BMCG 1930. Cologne 2689. Milne 3451. *[AD 242–3]*.
 F £48 ($70) / **VF** £115 ($175)

8890 — Rev. Tyche (= Fortuna) stg. l., holding rudder and cornucopiae, Ⴑ Ϛ regnal year 6)
 before. Dattari 4840. BMCG 1932. Cologne —. Milne 3454. *[AD 242–3]*.
 F £48 ($70) / **VF** £115 ($175)

8891 — Rev. Rad. bust of Helios r., Ⴑ — Z (= regnal year 7) in field. Dattari —. BMCG —.
 Cologne —. Milne 3467. *[AD 243–4]*. F £60 ($90) / **VF** £150 ($225)

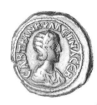
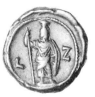

8892

8892 — Rev. Sarapis stg. facing, hd. r., wearing modius and resting on sceptre held in r. hand, Ⴑ —
 Z (= regnal year 7) in field. Dattari 4836. BMCG 1933. Cologne —. Milne 3485. *[AD 243–4]*
 . F £48 ($70) / **VF** £115 ($175)

8893 — Rev. Sarapis seated l., wearing modius, his r. hand outstretched, holding sceptre held in
 l., Kerberos at his feet, little Nike on back of throne, Ⴑ — Z (= regnal year 7) in field.
 Dattari 4837. BMCG —. Cologne 2694. Milne 3487. *[AD 243–4]*.
 F £60 ($90) / **VF** £150 ($225)

8894 — Rev. Bust of Selene r., wearing taenia, large lunar crescent before, Ⴑ Z (= regnal year 7)
 behind. Dattari —. BMCG —. Cologne —. Milne —. Emmett 3460. *[AD 243–4]*.
 F £65 ($100) / **VF** £170 ($250)

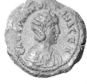
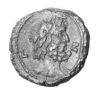

8895

8895 — Rev. Laur. bust of Zeus r., Ⴑ — Z (= regnal year 7) in field. Dattari 4842. BMCG 1917.
 Cologne —. Milne 3465. *[AD 243–4]*. F £55 ($80) / **VF** £130 ($200)

8896 — Rev. Dikaiosyne (= Aequitas) stg. l., holding scales and cornucopiae, Ⴑ Z (= regnal year
 7) before. Dattari 4819. BMCG —. Cologne —. Milne 3472. *[AD 243–4]*.
 F £48 ($70) / **VF** £115 ($175)

8897

8897 **Billon tetradrachm.** Obv. As 8874. Rev. Homonoia (= Concordia) stg. l., r. hand
extended, holding double cornucopiae in l., L Z (= regnal year 7) before. Dattari 4824.
BMCG 1927. Cologne —. Milne 3478. *[AD 243–4]*. **F** £48 ($70) / **VF** £115 ($175)

8898 — Rev. Nike (= Victory) advancing l., holding wreath and palm, L Z (= regnal year 7)
before. Dattari 4829. BMCG 1928. Cologne —. Milne (Supplement) 3479a. *[AD 243–4]*.
F £55 ($80) / **VF** £130 ($200)

8899 — Rev. Tyche (= Fortuna) reclining l. on couch, holding rudder, L Z (= regnal year 7)
above. Dattari 4841. BMCG —. Cologne 2695. Milne 3482. *[AD 243–4]*.
F £55 ($80) / **VF** £130 ($200)

8900 — Rev. Eagle stg. facing, hd. r., wings spread, holding wreath in talons, L — Z (= regnal
year 7) in field. Dattari 4851. BMCG 1939. Cologne 2692. Milne 3498. *[AD 243–4]*.
F £48 ($70) / **VF** £115 ($175)

For other local coinages of Tranquillina, see *Greek Imperial Coins & Their Values*, pp. 364–70.

<div align="center">

PHILIP I
25 Feb. AD 244–Sep. 249

</div>

 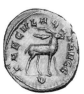

8958

*Marcus Julius Philippus, a native of Arabia Trachonitis, was born about AD 204 and was the son of
an Arab chieftain named Marinus who had attained Roman equestrian rank. 'Philip the Arab', as he
became known, held a high command in the Roman army during Gordian's Persian campaign and
during the winter of 243–4 he became praetorian prefect in place of the emperor's father-in-law
Timesitheus, in whose sudden death Philip may have been implicated. It soon became clear that the
new prefect had designs on the throne itself and he set about undermining the authority of the young
Gordian. By late February he felt sufficiently secure to make his move and the unfortunate emperor
was deposed by the army and put to death, Philip being proclaimed in his place. Anxious to return to
Rome as soon as possible he hastily negotiated a peace treaty with Shapur and assumed the title of
'Persicus Maximus'. His wife, Otacilia Severa, was given the rank of Augusta and their 7-year-old
son, Philip Junior, became Caesar, both being granted a share in the imperial coinage. In further
moves to strengthen the stability of his new dynasty Philip appointed his brother C. Julius Priscus to
the governorship of Mesopotamia (later supreme commander in the East), and his father- (or
brother-) in-law Severianus to the governorship of Moesia. He even granted posthumous deification
to his father Marinus and coins in honour of the new deity were struck at the recently established
colony of Philippopolis in Arabia, probably the emperor's birthplace. Philip was back in Rome by
the summer and received formal ratification of his accession from an obedient Senate. Much of the*

following two years was spent in campaigning on the northern frontier against the Dacian Carpi and the German Quadi and in AD 247 the emperor celebrated a triumph in Rome. The event was used as the setting for the further elevation of the younger Philip to the status of Augustus and co-emperor. The following year magnificent games and other spectacles were staged in the capital in celebration of the city's millennium (thousandth birthday) and the occasion was marked by an extensive issue of coinage in all metals. This was to be the high-point of Philip's reign. Later in the year serious revolts broke out in Moesia, where the uprising was headed by Pacatian, and in Cappadocia and northern Syria, where Jotapian was proclaimed emperor. Although neither rebellion was successful they were enough to undermine confidence in Philip's ability to rule. When he sent his general Decius to Moesia to settle the disturbed situation there the army proclaimed their commander emperor in Philip's place. Although reputedly reluctant to accept the doubtful honour Decius nevertheless marched on Italy and met Philip in battle at Verona. Philip and his son were both killed in the disastrous defeat and Decius was left in uncontested possession of the imperial throne (September 249). The tradition has come down to us that Philip had stromg Christian sympathies. However, this may be due to nothing more than the stark contrast between Philip's tolerant attitude in religious matters and the cruel persecutions of his successor, Trajan Decius.

The silver denarius, though still occasionally minted under Philip I, was no longer part of the regular monetary system and specimens today are of considerable rarity. It was replaced as the principal denomination by the radiate double denarius, or antoninianus. Gold is also much rarer than under Gordian III, but sestertii continued to be issued in large quantities. In addition to coinage in the name of Philip I himself issues were made in the names of his son Philip II (as Caesar until AD 247, thereafter as Augustus) and his wife Otacilia Severa.

Rome remained the principal mint for the production of coinage throughout this reign, though in the minting of antoniniani it was assisted at various times by at least two, and possibly three, provincial establishments. One of these was at Viminacium, an important city of the Danubian province of Upper Moesia, though the rare products of this mint have only recently been identified. Another mint was located at Antioch in Syria, though as under Gordian III the issues usually attributed to it fall into two distinct groups, one early (AD 244–5), the other late (247–9). Stylistically these groups are quite different from one another which has led some numismatists to believe that only the later group should be assigned to the Syrian capital, whilst the earlier coinage should instead be given to the same uncertain eastern mint which had produced some of Gordian's later coinage. A remarkable feature of the metropolitan antoninianus coinage in 248 was the earliest appearance of officina marks at Rome, indicating that the mint at this time comprised six workshops, four operating for Philip I and one each for Philip II and Otacilia Severa. It further reveals that in any one issue each officina produced its own distinctive reverse type. Although the practice of adding officina marks was not immediately adopted for succeeding issues this development nevertheless marked an important numismatic turning point. Before long mint marks of increasing complexity began appearing not only on the issues of Rome itself but also on those of the ever-expanding network of provincial establishments.

There are two principal varieties of obverse legend:

A. IMP M IVL PHILIPPVS AVG
B. IMP PHILIPPVS AVG

The normal obverse type for antoniniani and dupondii is radiate bust of Philip I right. All other denominations have laureate bust right. The Antioch antoniniani sometimes show the emperor's bust facing left and this is described under the relevant catalogue entries. The bust of Philip I is usually depicted draped and cuirassed, although the cuirass is often indistinct and may even be omitted on some dies.

8901 **Gold aureus.** A. Rev. AEQVITAS AVGG, Aequitas stg. l., holding scales and cornucopiae. RIC 27a. Cf. C 7. Hunter, p. lxxxviii. *[Rome, AD 245–7].*
 VF £3,300 ($5,000) / **EF** £8,300 ($12,500)

NB Under Philip I the weight of the aureus declined to an average level of 4.51 grams, though individual specimens may vary considerably.

8902 **Gold aureus.** A. Rev. ANNONA AVGG, Annona stg. l., holding corn-ears and cornucopiae, modius at feet. RIC 28a. C 23. Hunter, p. lxxxviii. *[Rome, AD 245–7].*
VF £3,300 ($5,000) / **EF** £8,300 ($12,500)

8903 A. Rev. FIDES MILITVM, Fides Militum stg. l., holding two standards. RIC 34a. C 57. Hunter, p. lxxxviii. *[Rome, AD 244–5].* VF £3,700 ($5,500) / **EF** £9,000 ($13,500)

8904

8904 B. Rev. FORTVNA REDVX, Fortuna seated l., holding rudder and cornucopiae, wheel below seat. RIC 63a. C 66. Hunter, p. lxxxix. *[Rome, AD 249].*
VF £4,000 ($6,000) / **EF** £10,000 ($15,000)

8905 A. Rev. LAET FVNDATA, Laetitia stg. l., holding wreath and rudder. RIC 35a. C 71. Hunter, p. lxxxviii. *[Rome, AD 244–5].* VF £3,700 ($5,500) / **EF** £9,000 ($13,500)

8906 A. Rev. LIBERALITAS AVGG II, Liberalitas stg. l., holding abacus and cornucopiae. RIC 38a. C 86. Hunter, p. lxxxviii. *[Rome, AD 245].*
VF £3,700 ($5,500) / **EF** £9,000 ($13,500)

8907 A. Rev. PAX AETERN, Pax stg. l., holding olive-branch and transverse sceptre. RIC 40a. Cf. C 104 (incomplete and inaccurate description). Hunter, p. lxxxviii. *[Rome, AD 244–5].*
VF £3,700 ($5,500) / **EF** £9,000 ($13,500)

8908 A. Rev. P M TR P II COS P P, Philip, togate, seated l. on curule chair, holding globe and short sceptre. RIC 2a. C 119. Hunter 2. *[Rome, AD 245].*
VF £3,700 ($5,500) / **EF** £9,000 ($13,500)

8909 A. Rev. ROMAE AETERNAE, Roma seated l., holding Victory and sceptre, shield at side. RIC 44a. C 168. Hunter, p. lxxxviii. *[Rome, AD 245–7].*
VF £3,300 ($5,000) / **EF** £8,300 ($12,500)

8910 Similar, but with obv. B, and altar at feet of Roma to l. Cf. RIC 106. Cf. C 164. Hunter, p. lxxxix. *[Rome, AD 247].* VF £4,000 ($6,000) / **EF** £10,000 ($15,000)

8911 B. Rev. SAECVLARES AVGG, cippus inscribed COS / III in two lines. RIC 24a. C 191. Hunter, p. xc. *[Rome, AD 248].* VF £5,000 ($7,500) / **EF** £12,000 ($18,000)
This type and the next belong to the extensive series, in all metals, commemorating the celebration in AD 248 of the thousandth anniversary of Rome's founding (see also nos. 8956–63, 8984, 9000, 9010–15, 9031, 9034–5, 9052 and 9061–2, and under Otacilia Severa and Philip II).

8912 B. Rev. SAECVLVM NOVVM, hexastyle temple containing seated statue of Roma. RIC 24a. C 191. Hunter, p. xc. *[Rome, AD 248].* VF £5,300 ($8,000) / **EF** £13,500 ($20,000)
This is a simplified depiction of the temple of Roma, part of Hadrian's remarkable double-temple of Venus and Roma completed under Antoninus Pius in AD 141. Its most recent appearance had been on Severan coins issued in AD 206 (see no. 7199 in Vol. II). See also nos. 8963, 9015, 9035 and 9062, and under Otacilia Severa and Philip II.

8913 **Gold aureus.** A. Rev. SECVRIT ORBIS, Securitas seated l., at ease, her hd. propped on l.
 hand and holding sceptre in r. RIC 48a. C 213. Hunter 13. *[Rome, AD 244–5].*
 VF £3,700 ($5,500) / **EF** £9,000 ($13,500)

8914 A. Rev. VICTORIA AVG, Victory advancing r., holding wreath and palm. RIC 49a. Cf. C
 226. Hunter, p. lxxxviii. *[Rome, AD 244–5].* **VF** £4,000 ($6,000) / **EF** £10,000 ($15,000)

 NB a 5-aureus piece (26.05 grams) of AD 248 has also been recorded: obv. IMP CAES M IVL
 PHILIPPVS AVG, laureate, draped and cuirassed bust right; rev. PONTIFEX MAX TR P V COS
 III P P, Philip I and Philip II in triumphal quadriga facing, crowned by Victory standing
 behind them, soldiers on either side of horses (Cohen 159 = Gnecchi 2 = RIC 11). This
 exceptional issue was probably associated with the celebration of Rome's millennium.

8915 **Gold quinarius.** A. Rev. FIDES MILIT, Fides Militum stg. l., holding two standards. RIC
 32a. C 56. Cf. Hunter, p. lxxxviii. *[Rome, AD 244–5].* *(Unique)*
 Cohen cites this from "Ancien catalogue" and the piece is therefore no longer verifiable,
 having been lost in the 'Great Theft' from the Paris Cabinet in 1831. If it has been
 inaccurately reported then there may have been no gold quinarii issued during this reign.
 The Hunter Catalogue describes the type as a silver quinarius, presumably in error.

 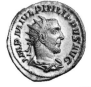

8916 8918

8916 **Silver antoninianus.** A. Rev. ADVENTVS AVGG, Philip I on horseback pacing l., his r.
 hand raised, holding sceptre in l. RIC 26b. RSC 3. Hunter 19. *[Rome, AD 245].*
 VF £20 ($30) / **EF** £50 ($75)

 NB Under Philip I the fineness of the antoninianus ranges from about 43% in the earlier
 issues with an improvement towards the end of the reign up to about 47%. The average
 weight , however, declines from about 4.20 grams down to 4.10 grams.

8917 A. Rev. AEQVITAS AVG, Aequitas stg. l., holding scales and cornucopiae. RIC —. RSC —.
 Hunter —. (J. Muona, "The Antoniniani of Philip the Arab", in *The Celator*, Feb. 2002,
 p. 10). *[Antioch, AD 247].* **VF** £25 ($40) / **EF** £65 ($100)

8918 Similar, but with rev. legend AEQVITAS AVGG. RIC 27b. RSC 9. Hunter 25. *[Rome,
 AD 245–7].* **VF** £14 ($20) / **EF** £32 ($50)

8919 Similar, but with obv. legend B. RIC 57. RSC 12. Hunter 29. *[Rome, AD 247].*
 VF £16 ($25) / **EF** £40 ($60)

8920 Similar to 8918, but with obv. type rad. and cuir. bust l. RIC 82. RSC 8. Hunter, p. xc.
 [Antioch, AD 247]. **VF** £50 ($75) / **EF** £100 ($150)

8921 B. Rev. AETERNITAS AVGG, elephant walking l., ridden by mahout who guides it with
 goad and rod. RIC 58. RSC 17. Hunter 31. *[Rome, AD 247].*
 VF £30 ($45) / **EF** £75 ($110)

8921 8925

8922 **Silver antoninianus.** A. Rev. ANNONA AVGG, Annona stg. l., holding corn-ears and
 cornucopiae, modius at feet. RIC 28c. RSC 25. Hunter 26. *[Rome, AD 245–7].*
 VF £14 ($20) / EF £32 ($50)

8923 Similar, but with prow instead of modius at Annona's feet. RIC 29. RSC 32. Hunter,
 p. lxxxviii. *[Rome, AD 247].* VF £16 ($25) / EF £40 ($60)

8924 Similar, but with obv. legend B. RIC 59. RSC 33. Hunter 30. *[Rome, AD 247].*
 VF £16 ($25) / EF £40 ($60)

8925 A. Rev. CONCORDIA AVGG, Concordia seated l., holding patera and cornucopiae. RIC 83,
 note. RSC 34. Hunter, p. xc. *[Antioch, AD 247].* VF £25 ($40) / EF £65 ($100)

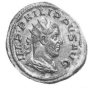
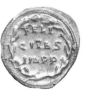

8926 8930

8926 B. Rev. FELI / CITAS / IMPP in three lines within laurel-wreath. RIC 60. RSC 39. Hunter 34.
 [Rome, AD 247]. VF £33 ($50) / EF £80 ($120)

8927 Similar, but with obv. A, rad., dr. and cuir. bust l. RIC 84. RSC 41. Hunter, p. xc. *[Antioch,
 AD 248].* VF £65 ($100) / EF £130 ($200)

8928 A. Rev. FELICITAS TEMP, Felicitas stg. l., holding long caduceus and cornucopiae. RIC 31.
 RSC 43. Hunter 6. *[Rome, AD 245].* VF £16 ($25) / EF £40 ($60)

8929 B. Rev. FIDES EXERCITVS, Fides Militum stg. l., holding vexillum and transverse standard.
 RIC 61. RSC 49. Hunter 35. *[Rome, AD 249].* VF £20 ($30) / EF £50 ($75)

8930 B. Rev. — four standards, one of which is usually a legionary eagle. RIC 62. RSC 50.
 Hunter 36. *[Rome, AD 249].* VF £23 ($35) / EF £60 ($90)

8931 Similar, but with obv. legend A. Cf. RIC 84A. Cf. RSC 50a. Cf. Hunter, p. xc.
 [Viminacium, AD 249]. VF £100 ($150) / EF £200 ($300)

8932 A. Rev. FIDES MILIT (or MILITVM), Fides Militum stg. l., holding two standards. RIC 32b,
 34b. RSC 55, 58. Hunter 7, 9. *[Rome, AD 244–5].* VF £16 ($25) / EF £40 ($60)

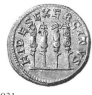

8931 8933

8933 **Silver antoninianus.** B. Rev. FORTVNA REDVX, Fortuna seated l., holding rudder and
 cornucopiae, wheel below seat. RIC 63b. RSC 65. Hunter 39. *[Rome, AD 249]*.
 VF £20 ($30) / **EF** £50 ($75)

8934 A. Rev. LAET FVNDATA, Laetitia stg. l., holding wreath and rudder. RIC 35b. RSC 72.
 Hunter 10. *[Rome, AD 244–5]*. **VF** £16 ($25) / **EF** £40 ($60)

8935 8937

8935 A. Rev. LAETIT FVNDAT, as previous. RIC 36b. RSC 80. Hunter 11. *[Rome, AD 244–5]*.
 VF £14 ($20) / **EF** £32 ($50)

8936 A. Rev. — Laetitia stg. l., r. foot on prow, holding patera and rudder. RIC 37b. RSC 81.
 Hunter, p. lxxxviii. *[Rome, AD 244–5]*. **VF** £16 ($25) / **EF** £40 ($60)

8937 A. Rev. LIBERALITAS AVGG II, Liberalitas stg. l., holding abacus and cornucopiae. RIC
 38b. RSC 87. Hunter 21. *[Rome, AD 245]*. **VF** £14 ($20) / **EF** £32 ($50)

8938 8941

8938 B. Rev. NOBILITAS AVGG, Nobilitas stg. r., holding sceptre and globe, officina mark Ϛ (= 6)
 in l. field. Cf. RIC 8. RSC 98. Hunter 41. *[Rome, AD 248]*. **VF** £23 ($35) / **EF** £60 ($90)

8939 A. Rev. PAX AETERN, Pax stg. l., holding olive-branch and transverse sceptre. RIC 40b.
 RSC 103. Hunter, p. lxxxviii. *[Rome, AD 244–5]*. **VF** £16 ($25) / **EF** £40 ($60)

8940 A. Rev. PAX AETERNA, Pax advancing l., holding olive-branch and sceptre. RIC 42. RSC
 109. Hunter 12. *[Rome, AD 244–5]*. **VF** £16 ($25) / **EF** £40 ($60)

8941 **Silver antoninianus.** IMP C M IVL PHILIPPVS P F AVG P M. Rev. PAX FVNDATA CVM
PERSIS, Pax stg., as 8938. RIC 69. RSC 113. Hunter 120. *[Uncertain eastern mint, possibly
Antioch, AD 244–5].* **VF** £50 ($75) / **EF** £100 ($150)
*This type commemorates Philip's negotation of a peace treaty with the Persian king
Shapur and his assumption of the title Persicus Maximus, hence the 'P M' on obverse.*

8942 A. Rev. P M TR P II COS P P, Minerva stg. l., r. foot on helmet, holding branch and spear.
RIC 1, note. RSC 117a. Hunter 1. *[Rome, AD 245].* **VF** £33 ($50) / **EF** £80 ($120)

8943 8949

8943 A. Rev. — Philip, togate, seated l. on curule chair, holding globe and short sceptre. RIC
2b. RSC 120. Hunter 3. *[Rome, AD 245].* **VF** £20 ($30) / **EF** £50 ($75)

8944 A. Rev. P M TR P III COS P P, Felicitas stg. l., holding long caduceus and cornucopiae. RIC
3. RSC 124. Hunter 4. *[Rome, AD 246].* **VF** £14 ($20) / **EF** £32 ($50)

8945 A. Rev. P M TR P IIII COS P P, as previous. RIC 75A. RSC 130. Hunter, p. xc. *[Antioch,
AD 247].* **VF** £25 ($40) / **EF** £65 ($100)

8946 A. Rev. P M TR P IIII COS II P P, as previous. RIC 4. RSC 136. Hunter, p. lxxxvii. *[Rome,
AD 247].* **VF** £14 ($20) / **EF** £32 ($50)

8947 Similar, but with obv. type rad. and cuir. bust l. Cf. RIC 76. RSC 135. Hunter, p. xc.
[Antioch, AD 247]. **VF** £50 ($75) / **EF** £100 ($150)

8948 Similar to 8946, but with obv. legend B. RIC 5. RSC 137. Hunter 28. *[Rome, AD 247].*
 VF £16 ($25) / **EF** £40 ($60)

8949 B. Rev. P M TR P V COS III P P, Mars stg. l., holding olive-branch and resting on shield,
spear propped against l. arm, officina mark A (= 1) in l. field. RIC 7. RSC 145. Hunter 40.
[Rome, AD 248]. **VF** £20 ($30) / **EF** £50 ($75)

8950 8952

8950 A. Rev. P M TR P VI COS P P, Felicitas stg. l., as 8944. Cf. RIC 78 and pl. 5, 20. RSC 155.
Hunter, p. xc. *[Antioch, AD 249].* **VF** £23 ($35) / **EF** £60 ($90)

PHILIP I					153

8951 **Silver antoninianus.** B. Rev. — Philip, togate, stg. l., sacrificing over tripod-altar and holding short sceptre. RIC 79b and pl. 7, 1. RSC 156a. Hunter, p. xc. *[Antioch, AD 249].*
VF £30 ($45) / **EF** £75 ($110)

8952 A. Rev. **ROMAE AETERNAE**, Roma seated l., holding Victory and sceptre, shield at side. RIC 44b. RSC 169. Hunter, p. lxxxviii. *[Rome, AD 245–7].* **VF** £14 ($20) / **EF** £32 ($50)

8953 8956

8953 Similar, but with obv. type rad., dr. and cuir. bust l. Cf. RIC 85. RSC 167. Hunter, p. xc. *[Antioch, AD 248].* **VF** £50 ($75) / **EF** £100 ($150)

8954 Similar to 8952, but with altar at feet of Roma. RIC 45. RSC 170. Hunter 27. *[Rome, AD 247].*
VF £16 ($25) / **EF** £40 ($60)

8955 As previous, but with obv. legend B. RIC 65. RSC 171. Hunter, p. lxxxix. *[Rome, AD 247].*
VF £16 ($25) / **EF** £40 ($60)

8956 B. Rev. **SAECVLARES AVGG**, lion walking r., officina mark I (= 1) in ex. RIC 12. RSC 173. Hunter 44. *[Rome, AD 248].* **VF** £30 ($45) / **EF** £75 ($110)

This and the following seven types belong to the extensive series, in all metals, commemorating the celebration in AD 248 of the thousandth anniversary of Rome's founding (see also nos. 8911–12, 8984, 9000, 9010–15, 9031, 9034–5, 9052 and 9061–2, and under Otacilia Severa and Philip II).

8957

8957 B. Rev. — she-wolf stg. l., suckling the twins Romulus and Remus, officina mark II (= 2) in ex. RIC 15. RSC 178. Hunter 46. *[Rome, AD 248].* **VF** £30 ($45) / **EF** £75 ($110)

8958 B. Rev. — stag stg. or walking r., officina mark V or U (= 5) in ex. RIC 19. RSC 182. Hunter 47. *[Rome, AD 248].* **VF** £30 ($45) / **EF** £75 ($110)

8959 B. Rev. — antelope stg. or walking l., officina mark VI or UI (= 6) in ex. RIC 21. RSC 189. Hunter 48. *[Rome, AD 248].* **VF** £30 ($45) / **EF** £75 ($110)

8960 **Silver antoninianus.** A. Rev. **SAECVLARES AVGG**, antelope walking r., UI (or III) in ex. RIC —. Cf. RSC 180. Hunter —. *[Viminacium, AD 248].* **VF** £100 ($150) / **EF** £200 ($300)

 NB there are rarer varieties of Philip's regular 'animal' antoniniani from the Rome mint, most of which show the reverse type facing in the opposite direction to the main series.

8961 8963

8961 B. Rev. — cippus (column) inscribed **COS** / **III** in two lines. RIC 24c. RSC 193. Hunter 50. *[Rome, AD 248].* **VF** £23 ($35) / **EF** £60 ($90)

8962 As previous, but with obv. legend A. Cf. RIC 107. Cf. RSC 194. Hunter —. *[Viminacium, AD 248].* **VF** £100 ($150) / **EF** £200 ($300)

8963 B. Rev. **SAECVLVM NOVVM**, hexastyle temple containing seated statue of Roma. RIC 25b. RSC 198. Hunter 52. *[Rome, AD 248].* **VF** £30 ($45) / **EF** £75 ($110) *This is a simplified depiction of the temple of Roma, part of Hadrian's remarkable double-temple of Venus and Roma completed under Antoninus Pius in AD 141. Its most recent appearance had been on Severan coins issued in AD 206 (see no. 7199 in Vol. II). See also nos. 8912, 9015, 9035 and 9062, and under Otacilia Severa and Philip II.*

8964 8968

8964 A. Rev. **SALVS AVG**, Salus stg. l., feeding snake arising from altar and holding rudder. RIC 47. RSC 205. Cf. Hunter 23. *[Rome, AD 244–5].* **VF** £16 ($25) / **EF** £40 ($60)

8965 A. Rev. — Salus stg. r., feeding snake held in her arms. RIC 46b. RSC 209. Hunter, p. lxxxviii. *[Rome, AD 244–5].* **VF** £16 ($25) / **EF** £40 ($60)

8966 A. Rev. **SECVRIT ORBIS**, Securitas seated l., at ease, her hd. propped on l. hand and holding sceptre in r. RIC 48b. RSC 215. Hunter 14. *[Rome, AD 244–5].*
 VF £16 ($25) / **EF** £40 ($60)

8967 Obv. As 8941. Rev. **SPES FELICITATIS ORBIS**, Spes advancing l., holding flower and lifting skirt. RIC 70. RSC 221. Hunter, p. xc. *[Uncertain eastern mint, possibly Antioch, AD 244–5].*
 VF £25 ($40) / **EF** £65 ($100)

8968 **Silver antoninianus.** B. Rev. TRANQVILLITAS AVGG, Tranquillitas stg. l., holding
 capricorn (?) and sceptre, officina mark B (= 2) in l. field. RIC 9. RSC 223. Hunter 42.
 [Rome, AD 248]. **VF** £23 ($35) / **EF** £60 ($90)

8969 A. Rev. VICTORIA AVG, Victory advancing r., holding wreath and palm. RIC 49b. RSC
 227. Hunter 16. *[Rome, AD 244–5].* **VF** £16 ($25) / **EF** £40 ($60)

8970 Similar, but Victory advancing l. RIC 50. RSC 231. Hunter, p. lxxxviii. *[Rome, AD 244–5].*
 VF £16 ($25) / **EF** £40 ($60)

8971 Similar, but with obv. legend B. RIC —. RSC —. Hunter —. *[Viminacium, AD 248–9].*
 VF £100 ($150) / **EF** £200 ($300)

8972 8973

8972 A. Rev. VICTORIA AVGG, Victory stg. l., holding wreath and palm. RIC 51. RSC 235.
 Hunter 24. *[Rome, AD 245].* **VF** £16 ($25) / **EF** £40 ($60)

8973 B. Rev. VICTORIA CARPICA, Victory advancing, as 8969. RIC 66. RSC 238. Hunter,
 p. lxxxix. *[Rome, AD 247].* **VF** £130 ($200) / **EF** £300 ($450)
 This commemorates Philip's victory over the Dacian Carpi and the subsequent celebration
 of a magnificent triumph in Rome, on which occasion he elevated his son to the rank of co-
 emperor.

8974 A. Rev. VIRTVS AVG, Virtus (or Minerva) stg. l., r. foot on helmet, holding olive-branch
 and spear. RIC 52. RSC 239. Hunter 17. *[Rome, AD 244–5].* **VF** £16 ($25) / **EF** £40 ($60)

8975 A. Rev. — Virtus seated l. on cuirass, holding olive-branch and resting on spear. RIC 53.
 RSC 240. Hunter 18. *[Rome, AD 244–5].* **VF** £16 ($25) / **EF** £40 ($60)

8976 8977

8976 B. Rev. VIRTVS AVGG, Philip I and Philip II galloping r., side by side, each raising r. hand,
 one of them holding spear, officina mark ε (= 5) below. RIC 10. RSC 241a. Hunter 43.
 [Rome, AD 248]. **VF** £25 ($40) / **EF** £65 ($100)

8977 Obv. As 8941. Rev. VIRTVS EXERCITVS, Virtus stg. r., foot sometimes on helmet, resting on
 spear and shield. RIC 71. RSC 243, 244. Hunter 122. *[Uncertain eastern mint, possibly*
 Antioch, AD 244–5]. **VF** £23 ($35) / **EF** £60 ($90)

8978 **Silver antoninianus.** Similar, but with obv. legend IMP IVL PHILIPPVS PIVS FEL AVG, P M (below bust). RIC 74. RSC 245. Hunter, p. xc. *[Uncertain eastern mint, possibly Antioch, AD 244].* **VF** £33 ($50) / **EF** £80 ($120)

8979 A. Rev. VOTIS / DECENNA / LIBVS in three lines within laurel-wreath. RIC 53A. RSC 245a. Hunter, p. lxxxviii. *[Rome, AD 244].* **VF** £200 ($300) / **EF** £500 ($750)

8980 **Silver denarius.** A. Rev. ADVENTVS AVGG, Philip I on horseback pacing l., his r. hand raised, holding sceptre in l. RIC 26a. RSC 5. Hunter, p. lxxxviii. *[Rome, AD 245].*
 VF £1,850 ($2,750) / **EF** £3,650 ($5,500)

8981 A. Rev. AEQVITAS AVGG, Aequitas stg. l., holding scales and cornucopiae. RIC —. RSC 12a. Hunter —. *[Rome, AD 245].* **VF** £2,000 ($3,000) / **EF** £4,000 ($6,000)

8982 A. Rev. SECVRIT ORBIS, Securitas seated l., at ease, her hd. propped on l. hand and holding sceptre in r. RIC 48a. RSC 214. Hunter, p. lxxxviii. *[Rome, AD 244–5].*
 VF £1,850 ($2,750) / **EF** £3,650 ($5,500)

 NB For another denarius type of Philip I, see no. 9134.

8983 **Silver quinarius.** A. Rev. ANNONA AVGG, Annona stg. l., holding corn-ears and cornucopiae, modius at feet. RIC 28b. RSC 24. Hunter, p. lxxxviii. *[Rome, AD 245].*
 VF £1,500 ($2,250) / **EF** £3,000 ($4,500)

8984 B. Rev. SAECVLARES AVGG, cippus (column) inscribed COS / III in two lines. RIC 24b. RSC 192. Hunter, p. xc. *[Rome, AD 248].* **VF** £1,650 ($2,500) / **EF** £3,300 ($5,000) *This type belongs to the extensive series, in all metals, commemorating the celebration in AD 248 of the thousandth anniversary of Rome's founding (see also nos. 8911–12, 8956–63, 9000, 9010–15, 9031, 9034–5, 9052 and 9061–2, and under Otacilia Severa and Philip II).*

8985 A. Rev. SALVS AVG, Salus stg. r., feeding snake held in her arms. RIC 46a. RSC 210. Hunter, p. lxxxviii. *[Rome, AD 244–5].* **VF** £1,500 ($2,250) / **EF** £3,000 ($4,500)

8986

8986 **Bronze sestertius.** A. Rev. ADVENTVS AVGG S C, Philip on horseback, as 8980. Cf. RIC 165. C 6. Hunter 87. *[Rome, AD 245].* **F** £40 ($60) / **VF** £100 ($150) / **EF** £300 ($450)

8987 A. Rev. AEQVITAS AVGG S C, Aequitas stg., as 8981. RIC 166a. Cf. C 10. Hunter 89. *[Rome, AD 245–7].* **F** £25 ($40) / **VF** £65 ($100) / **EF** £230 ($350)

8988 Similar, but with obv. legend B. RIC 166c. Cf. C 13. Hunter, p. lxxxix. *[Rome, AD 247].*
 F £32 ($50) / **VF** £80 ($120) / **EF** £265 ($400)

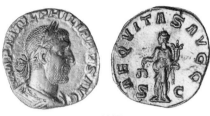

8987

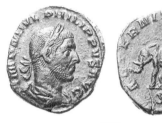

8989

8989 **Bronze sestertius.** A. Rev. AETERNITAS AVGG S C, elephant walking l., ridden by mahout who guides it with goad and rod. RIC 167a. C 18. Hunter 95. *[Rome, AD 247].*

 F £40 ($60) / **VF** £100 ($150) / **EF** £300 ($450)

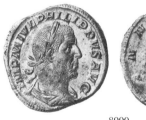

8990

8990 A. Rev. ANNONA AVGG S C, Annona stg., as 8983. RIC 168a. C 26. Hunter 91. *[Rome, AD 245–7].* **F** £25 ($40) / **VF** £65 ($100) / **EF** £230 ($350)

8991 Similar, but with obv. legend B. RIC 168d. C 29. Hunter, p. lxxxix. *[Rome, AD 247].*

 F £32 ($50) / **VF** £80 ($120) / **EF** £265 ($400)

8992 A. Rev. FELICITAS TEMP S C, Felicitas stg. l., holding long caduceus and cornucopiae. RIC 169a. C 44. Hunter 61. *[Rome, AD 245].* **F** £30 ($45) / **VF** £75 ($110) / **EF** £250 ($375)

8993 A. Rev. FIDES EXERCITVS S C, four standards, one of which is a legionary eagle. RIC 171a. C 51. Hunter 99. *[Rome, AD 249].* **F** £35 ($52) / **VF** £85 ($130) / **EF** £285 ($425)

8994 A. Rev. FIDES MILITVM S C, Fides Militum stg. l., holding two standards. RIC 172a. C 59. Hunter 63. *[Rome, AD 244–5].* **F** £30 ($45) / **VF** £75 ($110) / **EF** £250 ($375)

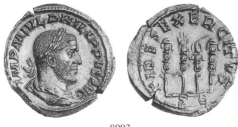

8993

8995 **Bronze sestertius.** Similar, but Fides holds sceptre and transverse standard. RIC 173a. C
62. Hunter, p. lxxxviii. *[Rome, AD 244–5]*. **F** £32 ($50) / **VF** £80 ($120) / **EF** £265 ($400)

8996 A. Rev. FORTVNA REDVX S C, Fortuna seated l., holding rudder and cornucopiae, wheel
below seat. RIC 174a. C 67. Hunter 101. *[Rome, AD 249]*.
F £32 ($50) / **VF** £80 ($120) / **EF** £265 ($400)

8997 A. Rev. LAET FVNDATA S C, Laetitia stg. l., holding wreath and rudder. RIC 175a. C 73.
Hunter 69. *[Rome, AD 244–5]*. **F** £30 ($45) / **VF** £75 ($110) / **EF** £250 ($375)

8998 Similar, but Laetitia has r. foot on prow and holds patera and rudder. RIC 176a. C 76.
Hunter, p. lxxxviii. *[Rome, AD 244–5]*. **F** £35 ($52) / **VF** £85 ($130) / **EF** £285 ($425)

8999 A. Rev. LIBERALITAS AVGG II S C, Liberalitas stg. l., holding abacus and cornucopiae. RIC
180a. C 88. Hunter 88. *[Rome, AD 245]*. **F** £30 ($45) / **VF** £75 ($110) / **EF** £250 ($375)

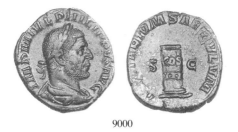

9000

9000 A. Rev. MILIARIVM SAECVLVM S C, cippus (column) inscribed COS / III in two lines. RIC
157a. C 95. Hunter 109. *[Rome, AD 248]*. **F** £40 ($60) / **VF** £100 ($150) / **EF** £300 ($450)
*This type belongs to the extensive series, in all metals, commemorating the celebration in
AD 248 of the thousandth anniversary of Rome's founding (see also nos. 8911–12,
8956–63, 8984, 9010–15, 9031, 9034–5, 9052 and 9061–2, and under Otacilia Severa
and Philip II).*

9001 A. Rev. NOBILITAS AVGG S C, Nobilitas stg. r., holding sceptre and globe. RIC 155a. Cf.
C 99. Hunter, p. lxxxix. *[Rome, AD 248]*. **F** £48 ($70) / **VF** £115 ($175) / **EF** £350 ($525)

9002 A. Rev. PAX AETERNA S C, Pax stg. (or advancing) l., holding olive-branch and transverse
sceptre. RIC 184a, 185a. C 105, 110. Hunter 71, 73. *[Rome, AD 244–5]*.
F £30 ($45) / **VF** £75 ($110) / **EF** £250 ($375)

PHILIP I 159

9003 **Bronze sestertius.** A. Rev. P M TR P II COS P P S C, Philip, togate, seated l. on curule chair,
 holding globe and short sceptre. RIC 148a. C 121. Hunter 54. *[Rome, AD 245].*
 F £32 ($50) / **VF** £80 ($120) / **EF** £265 ($400)

9004 A. Rev. P M TR P III COS P P S C, Felicitas stg. l., holding long caduceus and cornucopiae.
 Cf. RIC 149a. C 125. Hunter 56. *[Rome, AD 246].*
 F £25 ($40) / **VF** £65 ($100) / **EF** £230 ($350)

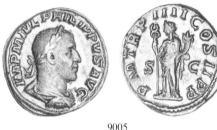

9005

9005 Similar, but with rev. legend P M TR P IIII COS II P P S C. Cf. RIC 150a. C 138. Hunter,
 p. lxxxvii. *[Rome, AD 247].* F £25 ($40) / **VF** £65 ($100) / **EF** £230 ($350)

9006 Similar, but with obv. legend B. Cf. RIC 150c. C 140. Hunter 58. *[Rome, AD 247].*
 F £30 ($45) / **VF** £75 ($110) / **EF** £250 ($375)

9007 A. Rev. P M TR P V COS III P P S C, Mars stg. l., holding olive-branch and resting on shield,
 spear propped against l. arm. RIC 152. C 146. Hunter, p. lxxxix. *[Rome, AD 248].*
 F £32 ($50) / **VF** £80 ($120) / **EF** £265 ($400)

9008 A. Rev. — Felicitas stg. l., as 9004. RIC 153a. C 149. Hunter, p. lxxxix. *[Rome, AD 248].*
 F £30 ($45) / **VF** £75 ($110) / **EF** £250 ($375)

9009 B. Rev. — Philip seated on curule chair, as 9003. RIC 154a. C 151. Hunter, p. lxxxix.
 [Rome, AD 248]. F £35 ($52) / **VF** £85 ($130) / **EF** £285 ($425)

9010 A. Rev. **SAECVLARES AVGG S C**, lion walking r. RIC 158. C 176. Hunter 105. *[Rome,
 AD 248].* F £40 ($60) / **VF** £100 ($150) / **EF** £300 ($450)
 *This and the following five types belong to the extensive series, in all metals,
 commemorating the celebration in AD 248 of the thousandth anniversary of Rome's
 founding (see also nos. 8911–12, 8956–63, 8984, 9000, 9031, 9034–5, 9052 and 9061–2,
 and under Otacilia Severa and Philip II).*

9011 A. Rev. — she-wolf stg. l., suckling the twins Romulus and Remus. RIC 159. C 179.
 Hunter 106. *[Rome, AD 248].* F £40 ($60) / **VF** £100 ($150) / **EF** £300 ($450)

9012 A. Rev. — stag stg. or walking r. RIC 160a. C 183. Hunter 107. *[Rome, AD 248].*
 F £40 ($60) / **VF** £100 ($150) / **EF** £300 ($450)

9013 A. Rev. — antelope stg. or walking l. RIC 161. C 190. Hunter 108. *[Rome, AD 248].*
 F £40 ($60) / **VF** £100 ($150) / **EF** £300 ($450)

9014 A. Rev. — cippus (column), as 9000. RIC 162a. C 195. Hunter 111. *[Rome, AD 248].*
 F £32 ($50) / **VF** £80 ($120) / **EF** £265 ($400)

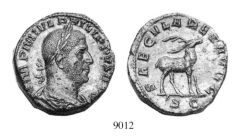

9012

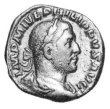

9015

9015 **Bronze sestertius.** A. Rev. SAECVLVM NOVVM S C, octastyle (or hexastyle) temple
containing seated statue of Roma. Cf. RIC 164, 163a. C 201, 202. Cf. Hunter 119, 117.
[Rome, AD 248]. **F** £40 ($60) / **VF** £100 ($150) / **EF** £300 ($450)
*These are simplified depictions of the temple of Roma, part of Hadrian's remarkable
double-temple of Venus and Roma completed under Antoninus Pius in AD 141. Its most
recent appearance had been on Severan coins issued in AD 206 (see no. 7199 in Vol. II).
See also nos. 8912, 8963, 9035 and 9062, and under Otacilia Severa and Philip II.*

9016

9016 A. Rev. SALVS AVG S C, Salus stg. l., feeding snake arising from altar and holding rudder.
Cf. RIC 187a. C 206. Hunter 76. *[Rome, AD 244–5]*.
 F £30 ($45) / **VF** £75 ($110) / **EF** £250 ($375)

9017 A. Rev. — Salus stg. r., feeding snake held in her arms. Cf. RIC 186a. C 211. Hunter 75.
[Rome, AD 244–5]. **F** £30 ($45) / **VF** £75 ($110) / **EF** £250 ($375)

9018 A. Rev. SECVRIT ORBIS S C, Securitas seated l., at ease, her hd. propped on l. hand and
holding sceptre in r. RIC 190. C 216. Hunter 78. *[Rome, AD 244–5]*.
 F £30 ($45) / **VF** £75 ($110) / **EF** £250 ($375)

9017

9018

9019 **Bronze sestertius.** A. Rev. TRANQVILLITAS AVGG S C, Tranquillitas stg. l., holding capricorn (?) and sceptre. RIC 156. C 224. Hunter103. *[Rome, AD 248].*
 F £48 ($70) / **VF** £115 ($175) / **EF** £350 ($525)

9020

9020 A. Rev. VICTORIA AVG S C, Victory advancing r., holding wreath and palm. RIC 191a. C 228. Hunter 79. *[Rome, AD 244–5].* **F** £30 ($45) / **VF** £75 ($110) / **EF** £250 ($375)

9021 Similar, but Victory advancing l. RIC 192a. C 232. Hunter 81. *[Rome, AD 244–5].*
 F £30 ($45) / **VF** £75 ($110) / **EF** £250 ($375)

9022 A. Rev. VOTIS / DECENNA / LIBVS / S C in four lines within laurel-wreath. RIC 195a. C 246. Hunter 84. *[Rome, AD 244].* **F** £55 ($80) / **VF** £130 ($200) / **EF** £400 ($600)

9023 **Bronze dupondius.** A. Rev. AETERNITAS AVGG S C, elephant and mahout, as 8989. RIC 167c. C 20. Hunter 97. *[Rome, AD 247].* **F** £48 ($70) / **VF** £115 ($175) / **EF** £350 ($525)

 NB The emperor's portrait on this denomination invariably shows him wearing a radiate crown.

9022

9023

9024 **Bronze dupondius.** Similar, but with obv. legend B. RIC 167d. C 21. Hunter, p. lxxxix.
[Rome, AD 247]. **F** £55 ($80) / **VF** £130 ($200) / **EF** £400 ($600)

9025 A. Rev. ANNONA AVGG S C, Annona stg., as 8983. RIC 168c. C 28. Hunter, p. lxxxix.
[Rome, AD 245–7]. **F** £32 ($50) / **VF** £85 ($125) / **EF** £265 ($400)

9026 A. Rev. FIDES EXERCITVS S C, four standards, as 8993. RIC 171c. C 53. Hunter, p. lxxxix.
[Rome, AD 249]. **F** £40 ($60) / **VF** £100 ($150) / **EF** £300 ($450)

9027 A. Rev. FIDES MILITVM S C, Fides Militum stg. l., holding two standards. RIC 172c. C 61.
Hunter 65. *[Rome, AD 244–5].* **F** £32 ($50) / **VF** £85 ($125) / **EF** £265 ($400)

9028 Similar, but Fides holds sceptre and transverse standard. RIC 173c. C 64. Hunter 67.
[Rome, AD 244–5]. **F** £32 ($50) / **VF** £85 ($125) / **EF** £265 ($400)

9029 A. Rev. LAET FVNDATA S C, Laetitia stg. l., holding wreath and rudder. RIC 175c. C 75.
Hunter, p. lxxxviii. *[Rome, AD 244–5].* **F** £32 ($50) / **VF** £85 ($125) / **EF** £265 ($400)

9030 Similar, but Laetitia has r. foot on prow and holds patera and rudder. RIC 176c. C 78.
Hunter, p. lxxxviii. *[Rome, AD 244–5].* **F** £40 ($60) / **VF** £100 ($150) / **EF** £300 ($450)

9031 A. Rev. MILIARIVM SAECVLVM S C, cippus (column) inscribed COS / III in two lines. RIC
157c. C 97. Hunter, p. lxxxix. *[Rome, AD 248].*
 F £48 ($70) / **VF** £115 ($175) / **EF** £350 ($525)
*This type belongs to the extensive series, in all metals, commemorating the celebration in
AD 248 of the thousandth anniversary of Rome's founding (see also nos. 8911–12,
8956–63, 8984, 9000, 9010–15, 9034–5, 9052 and 9061–2, and under Otacilia Severa
and Philip II).*

9032 **Bronze dupondius.** A. Rev. NOBILITAS AVGG S C, Nobilitas stg., as 9001. RIC 155b. Cf. C 100. Hunter, p. lxxxix. *[Rome, AD 248].* F £55 ($80) / VF £130 ($200) / EF £400 ($600)

9033 A. Rev. PAX AETERNA S C, Pax stg. (or advancing) l., as 9002. RIC 184c, 185c. C 107, 111. Hunter 72 and p. lxxxviii. *[Rome, AD 244–5].*
F £32 ($50) / VF £85 ($125) / EF £265 ($400)

9034 A. Rev. SAECVLARES AVGG S C, cippus (column), as 9031. RIC 162c. C 197. Hunter 112. *[Rome, AD 248].* F £40 ($60) / VF £100 ($150) / EF £300 ($450)
This type and the next belong to the extensive series, in all metals, commemorating the celebration in AD 248 of the thousandth anniversary of Rome's founding (see also nos. 8911–12, 8956–63, 8984, 9000, 9010–15, 9031, 9052 and 9061–2, and under Otacilia Severa and Philip II).

9035 A. Rev. SAECVLVM NOVVM S C, hexastyle temple containing seated statue of Roma. Cf. RIC 163c. C 204. Hunter, p. xc. *[Rome, AD 248].*
F £48 ($70) / VF £115 ($175) / EF £350 ($525)
This is a simplified depiction of the temple of Roma, part of Hadrian's remarkable double-temple of Venus and Roma completed under Antoninus Pius in AD 141. Its most recent appearance had been on Severan coins issued in AD 206 (see no. 7199 in Vol. II). See also nos. 8912, 8963, 9015 and 9062, and under Otacilia Severa and Philip II.

9036 A. Rev. SALVS AVG S C, Salus stg. l., feeding snake arising from altar and holding rudder. Cf. RIC 187c. C 208. Hunter, p. lxxxviii. *[Rome, AD 244–5].*
F £32 ($50) / VF £85 ($125) / EF £265 ($400)

9037 A. Rev. VICTORIA AVG S C, Victory advancing r., holding wreath and palm. RIC 191c. C 230. Hunter, p. lxxxviii. *[Rome, AD 244–5].*
F £32 ($50) / VF £85 ($125) / EF £265 ($400)

9038 Similar, but Victory advancing l. RIC 192c. C 234. Hunter 83. *[Rome, AD 244–5].*
F £32 ($50) / VF £85 ($125) / EF £265 ($400)

9039 A. Rev. VOTIS / DECENNA / LIBVS / S C in four lines within laurel-wreath. RIC 195c. C 248. Hunter 85. *[Rome, AD 244].* F £60 ($90) / VF £150 ($225) / EF £450 ($675)

9040 **Bronze as.** A. Rev. AEQVITAS AVGG S C, Aequitas stg. l., holding scales and cornucopiae. Cf. RIC 166b. Cf. C 11. Hunter, p. lxxxviii. *[Rome, AD 245–7].*
F £30 ($45) / VF £75 ($110) / EF £250 ($375)

9041 As 8989 (rev. AETERNITAS AVGG S C, elephant and mahout). RIC 167b. C 19. Hunter 98. *[Rome, AD 247].* F £45 ($65) / VF £110 ($160) / EF £320 ($475)

9042 A. Rev. ANNONA AVGG S C, Annona stg. l., holding corn-ears and cornucopiae, modius at feet. RIC 168b. C 27. Hunter 94. *[Rome, AD 245–7].*
F £30 ($45) / VF £75 ($110) / EF £250 ($375)

9043 As 8992 (rev. FELICITAS TEMP S C, Felicitas stg.). RIC 169b. C 45. Hunter 62. *[Rome, AD 245].* F £30 ($45) / VF £75 ($110) / EF £250 ($375)

9044 As 8993 (rev. FIDES EXERCITVS S C, four standards). RIC 171b. C 52. Hunter 100. *[Rome, AD 249].* F £38 ($55) / VF £95 ($140) / EF £300 ($450)

9045 As 8994 (rev. FIDES MILITVM S C, Fides Militum holding two standards). RIC 172b. C 60. Hunter, p. lxxxviii. *[Rome, AD 244–5].* F £30 ($45) / VF £75 ($110) / EF £250 ($375)

9046 **Bronze as.** Similar, but Fides holds sceptre and transverse standard. RIC 173b. C 63. Hunter 68. *[Rome, AD 244–5].* **F** £30 ($45) / **VF** £75 ($110) / **EF** £250 ($375)

9047 As 8996 (rev. FORTVNA REDVX S C, Fortuna seated). RIC 174b. C 68. Hunter 102. *[Rome, AD 249].* **F** £32 ($50) / **VF** £80 ($120) / **EF** £265 ($400)

9048 As 8997 (LAET FVNDATA S C, Laetitia holding wreath and rudder). RIC 175b. C 74. Hunter, p. lxxxviii. *[Rome, AD 244–5].* **F** £30 ($45) / **VF** £75 ($110) / **EF** £250 ($375)

9049 Similar, but Laetitia has r. foot on prow and holds patera and rudder. RIC 176b. C 77. Hunter, p. lxxxviii. *[Rome, AD 244–5].* **F** £35 ($52) / **VF** £85 ($130) / **EF** £285 ($425)

9050 A. Rev. LIBERALITAS AVGG S C, Philip I and Philip II seated l. on curule chairs atop platform, accompanied by soldier stg. behind them and Liberalitas stg. l. before, holding abacus and cornucopiae, citizen mounting steps of platform about to receive largess. RIC 85. C 85. Hunter. p. lxxxviii. *[Rome, AD 245 or 247].*
 F £120 ($180) / **VF** £300 ($450) / **EF** £900 ($1,350)

9051 As 8999 (rev. LIBERALITAS AVGG II S C, Liberalitas holding abacus and cornucopiae). RIC 180b. C 89. Hunter, p. lxxxviii. *[Rome, AD 245].*
 F £35 ($52) / **VF** £85 ($130) / **EF** £285 ($425)

9052 As 9000 (rev. MILIARIVM SAECVLVM S C, inscribed cippus). Cf. RIC 157b. C 6. Cf. Hunter, p. lxxxix. *[Rome, AD 248].* **F** £45 ($65) / **VF** £110 ($160) / **EF** £320 ($475)
 This type belongs to the extensive series, in all metals, commemorating the celebration in AD 248 of the thousandth anniversary of Rome's founding (see also nos. 8911–12, 8956–63, 8984, 9000, 9010–15, 9031, 9034–5 and 9061–2, and under Otacilia Severa and Philip II).

9053 As 9002 (rev. PAX AETERNA S C, Pax stg. or advancing) . RIC 184b, 185b. C 106. Hunter, p. lxxxviii. *[Rome, AD 244–5].* **F** £30 ($45) / **VF** £75 ($110) / **EF** £250 ($375)

9054 A. Rev. P M TR P III COS P P S C, Felicitas stg. l., holding long caduceus and cornucopiae. Cf. RIC 149b. C 126. Hunter, p. lxxxvii. *[Rome, AD 246].*
 F £32 ($50) / **VF** £80 ($120) / **EF** £265 ($400)

9055 Similar, but with rev. legend P M TR P IIII COS II P P S C. Cf. RIC 150b. C 139. Hunter, p. lxxxvii. *[Rome, AD 247].* **F** £30 ($45) / **VF** £75 ($110) / **EF** £250 ($375)

9056 Similar, but with rev. type Philip, togate, seated l. on curule chair, holding globe and short sceptre. RIC 151b. C 143. Hunter 59. *[Rome, AD 247].*
 F £35 ($52) / **VF** £85 ($130) / **EF** £285 ($425)

9057 Similar, but with obv. legend B. RIC 151a. C 142. Hunter, p. lxxxix. *[Rome, AD 247].*
 F £40 ($60) / **VF** £100 ($150) / **EF** £300 ($450)

9058 A. Rev. P M TR P V COS III P P S C, Felicitas stg. l., as 9054. RIC 153b. C 150. Hunter, p. lxxxix. *[Rome, AD 248].* **F** £32 ($50) / **VF** £80 ($120) / **EF** £265 ($400)

9059 Similar, but with rev. type Philip seated l., as 9056. RIC 154c. C 153. Hunter, p. lxxxix. *[Rome, AD 248].* **F** £35 ($52) / **VF** £85 ($130) / **EF** £285 ($425)

9060 Similar, but with obv. legend B. RIC 154b. C 152. Hunter, p. lxxxix. *[Rome, AD 248].*
 F £40 ($60) / **VF** £100 ($150) / **EF** £300 ($450)

9061 Bronze as. A. Rev. SAECVLARES AVGG S C, cippus (column) inscribed COS / III in two lines. RIC 162b. C 196. Hunter 115. *[Rome, AD 248].*
F £35 ($52) / **VF** £85 ($130) / **EF** £285 ($425)
This type and the next belong to the extensive series, in all metals, commemorating the celebration in AD 248 of the thousandth anniversary of Rome's founding (see also nos. 8911–12, 8956–63, 8984, 9000, 9010–15, 9031, 9034–5 and 9052, and under Otacilia Severa and Philip II).

9062 A. Rev. SAECVLVM NOVVM S C, hexastyle temple containing seated statue of Roma. Cf. RIC 163b. C 203. Hunter, p. xc. *[Rome, AD 248].*
F £45 ($65) / **VF** £110 ($160) / **EF** £320 ($475)
This is a simplified depiction of the temple of Roma, part of Hadrian's remarkable double-temple of Venus and Roma completed under Antoninus Pius in AD 141. Its most recent appearance had been on Severan coins issued in AD 206 (see no. 7199 in Vol. II). See also nos. 8912, 8963, 9015 and 9035, and under Otacilia Severa and Philip II.

9063 A. Rev. SALVS AVG S C, Salus stg. l., feeding snake arising from altar and holding rudder. Cf. RIC 187b. C 207. Cf. Hunter 77. *[Rome, AD 244–5].*
F £30 ($45) / **VF** £75 ($110) / **EF** £250 ($375)

9064 A. Rev. — Salus stg. r., feeding snake held in her arms. Cf. RIC 186b. C 212. Hunter, p. lxxxviii. *[Rome, AD 244–5].* F £30 ($45) / **VF** £75 ($110) / **EF** £250 ($375)

9065 A. Rev. VICTORIA AVG S C, Victory advancing r., holding wreath and palm. Cf. RIC 191b. C 229. Hunter 80. *[Rome, AD 244–5].* F £30 ($45) / **VF** £75 ($110) / **EF** £250 ($375)

9066 Similar, but Victory advancing l. RIC 192b. C 233. Hunter, p. lxxxviii. *[Rome, AD 244–5].*
F £30 ($45) / **VF** £75 ($110) / **EF** £250 ($375)

9067 A. Rev. VOTIS / DECENNA / LIBVS / S C in four lines within laurel-wreath. RIC 195b. C 247. Hunter 86. *[Rome, AD 244].* F £60 ($90) / **VF** £150 ($225) / **EF** £450 ($675)

Alexandrian Coinage

9068 Billon tetradrachm. A K M IOV ΦΙΛΙΠΠΟC EV CEB, laur. and cuir. bust r. Rev. Athena seated l., holding Nike and resting on spear, shield at side, L — A (= regnal year 1) in field. Dattari 4866. BMCG 1951. Cologne 2697. Milne 3500. *[AD 244].*
F £16 ($25) / **VF** £55 ($80)

9069 Obv. Similar. Rev. Bust of Nilus r., crowned with lotus, cornucopiae before, L A (= regnal year 1) behind. Dattari 4900. BMCG —. Cologne —. Milne 3518. *[AD 244].*
F £20 ($30) / **VF** £60 ($90)

9070 — Rev. Bust of Sarapis r., wearing modius, L — A (= regnal year 1) in field. Dattari 4907. BMCG —. Cologne —. Milne —. *[AD 244].* F £25 ($40) / **VF** £65 ($100)

9071 — Rev. Laur. bust of Zeus r., L — A (= regnal year 1) in field. Dattari 4926. BMCG 1940. Cologne 2703. Milne 3499. *[AD 244].* F £16 ($25) / **VF** £55 ($80)

9072 — Rev. Dikaiosyne (= Aequitas) stg. l., holding scales and cornucopiae, L A (= regnal year 1) before. Dattari 4869. BMCG 1954. Cologne 2698. Milne 3503. *[AD 244].*
F £16 ($25) / **VF** £55 ($80)

9073 **Billon tetradrachm.** Obv. As 9068. Rev. Homonoia (= Concordia) stg. l., r. hand
 extended, holding double cornucopiae in l., L A (= regnal year 1) before. Dattari 4884.
 BMCG 1958. Cologne 2699. Milne 3507. *[AD 244].* **F** £16 ($25) / **VF** £55 ($80)

9074 — Rev. Nike (= Victory) advancing l., holding wreath with both hands, palm over r.
 shoulder, L A (= regnal year 1) before. Dattari —. BMCG 1962. Cologne —. Milne —.
 [AD 244]. **F** £20 ($30) / **VF** £60 ($90)

9075 — Rev. Bust of Athena r., wearing crested Corinthian helmet and aegis, L B (= regnal year
 2) before. Dattari 4863. BMCG/Christiansen 3228. Cologne —. Milne 3528. *[AD 244–5].*
 F £25 ($40) / **VF** £65 ($100)

9076 — Rev. Athena stg. r., resting on sceptre and holding Nike, shield at feet to r., L — B
 (= regnal year 2) in field. Dattari 4864. BMCG 1950. Cologne 2707. Milne 3529.
 [AD 244–5]. **F** £16 ($25) / **VF** £55 ($80)

9077 — Rev. Bust of Isis l., wearing disk and plumes, knot on breast, L — B (= regnal year 2) in
 field. Cf. Dattari 4888 ('bust of Isis right'). BMCG 1982. Cologne —. Milne —.
 [AD 244–5]. **F** £25 ($40) / **VF** £65 ($100)

9078 — Rev. Nike (= Victory) advancing r., holding wreath and palm, L B (= regnal year 2)
 before. Dattari 4890. BMCG 1964. Cologne 2711. Milne 3543. *[AD 244–5].*
 F £16 ($25) / **VF** £55 ($80)

9079 — Rev. Tyche (= Fortuna) stg. l., holding rudder and cornucopiae, L B (= regnal year 2)
 before. Dattari 4920. BMCG 1972. Cologne 2714. Milne 3546. *[AD 244–5].*
 F £16 ($25) / **VF** £55 ($80)

9080 — Rev. Eagle stg. r., palm transversely in background, L — B (= regnal year 2) in field.
 Dattari 4938. BMCG 1998. Cologne 2704. Milne 3566. *[AD 244–5].*
 F £16 ($25) / **VF** £55 ($80)

9081 — Rev. Asklepios stg. l., holding patera over altar and resting on snake-entwined staff, L Γ
 (= regnal year 3) before. Dattari 4861. BMCG 1953 var. Cologne —. Milne 3586.
 [AD 245–6]. **F** £25 ($40) / **VF** £65 ($100)

9082 — Rev. Rad. bust of Helios r., L — Γ (= regnal year 3) in field. Dattari 4876. BMCG 1948
 var. Cologne —. Milne —. *[AD 245–6].* **F** £20 ($30) / **VF** £60 ($90)

9083 — Rev. Conjoined busts r. of Helios, rad., and Selene, with large lunar crescent before, L Γ
 (= regnal year 3) behind. Dattari 4878. BMCG —. Cologne —. Milne —. *[AD 245–6].*
 F £30 ($45) / **VF** £75 ($110)

9084 — Rev. Nilus reclining l., holding reed and cornucopiae, l. arm resting on hippopotamus r.
 below, crocodile r. in ex., L Γ (= regnal year 3) before. Dattari 4901. BMCG 1986. Cologne
 —. Milne 3629. *[AD 245–6].* **F** £20 ($30) / **VF** £60 ($90)

9085 — Rev. Sarapis stg. facing, hd. r., wearing modius and resting on sceptre held in r. hand, L
 — Γ (= regnal year 3) in field. Dattari —. BMCG/Christiansen 3242. Cologne 2721. Milne
 3617. *[AD 245–6].* **F** £20 ($30) / **VF** £60 ($90)

9086 — Rev. Sarapis seated l., wearing modius, his r. hand outstretched, holding sceptre held in
 l., Kerberos at his feet, little Nike on back of throne, L — Γ (= regnal year 3) in field.
 Dattari 4913. BMCG 1981. Cologne —. Milne 3623. *[AD 245–6].*
 F £20 ($30) / **VF** £60 ($90)

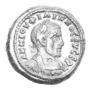

9085

9087 **Billon tetradrachm.** — Rev. Conjoined busts r. of Sarapis, wearing modius, and Isis, wearing disk and plumes, knot on breast, L Γ (= regnal year 3) behind. Dattari 4915. BMCG —. Cologne —. Milne —. *[AD 245–6].* **F** £32 ($50) / **VF** £80 ($120)

9088 — Rev. Bust of Selene r., large lunar crescent before, L Γ (= regnal year 3) behind. Dattari 4918 var. (year 1). BMCG/Christiansen 3227. Cologne —. Milne —. *[AD 245–6].*
F £30 ($45) / **VF** £75 ($110)

9089 — Rev. Bust of Zeus Ammon r., with ram's horn, crowned with horns and disk, L — Γ (= regnal year 3) in field. Dattari 4930. BMCG 1943. Cologne —. Milne 3613. *[AD 245–6].* **F** £25 ($40) / **VF** £65 ($100)

9090 — Rev. Nike (= Victory) advancing r., hd. l., wings open, holding wreath and palm, L — Γ (= regnal year 3) in field. Dattari 4894. Cf. BMCG/Christiansen 3238. Cologne —. Milne —. *[AD 245–6].* **F** £25 ($40) / **VF** £65 ($100)

9091

9091 Α Κ Μ ΙΟΥ ΦΙΛΙΠΠΟC ΕΥ CE (or similar), laur., dr. and cuir. bust r. Rev. Alexandria, sometimes turreted, stg. l., holding bust of Sarapis and resting on sceptre, L — Δ (= regnal year 4) in field. Dattari 4856–7. BMCG 1988. Cologne 2726. Milne 3683. *[AD 246–7].* **F** £20 ($30) / **VF** £60 ($90)

9092 Obv. Similar. Rev. Ares stg. facing, hd. l., holding Nike in r. hand and spear and shield with Medusa hd. in l., L Δ (= regnal year 4) to l. Dattari 4860. BMCG —. Cologne —. Milne 3647. *[AD 246–7].* **F** £30 ($45) / **VF** £75 ($110)

9093 — Rev. Athena stg. facing, hd. l., holding Nike and resting on spear, shield at feet, L — Δ (= regnal year 4) in field. Dattari 4865 var. BMCG —. Cologne —. Milne 3646. *[AD 246–7].* **F** £25 ($40) / **VF** £65 ($100)

9094 — Rev. Nilus seated l. on rocks, l. hand resting on hippotamus r., holding reed and cornucopiae containing little wreath-bearing genius, L Δ (= regnal year 4) before. Dattari 4902. BMCG 1985. Cologne —. Milne —. *[AD 246–7].* **F** £20 ($30) / **VF** £60 ($90)

9095 **Billon tetradrachm.** Obv. As 9068. Rev. Conjoined busts r. of Nilus, crowned with lotus, and Euthenia (= Abundantia), crowned with corn, cornucopiae before, L Δ (= regnal year 4) behind. Dattari 4904. Cf. BMCG/Christiansen 3244 (misdescribed). Cologne —. Milne 3678. *[AD 246–7].* **F** £30 ($45) / **VF** £75 ($110)

9096 — Rev. Nilus seated l., holding cornucopiae and reed, crocodile at side, facing Euthenia (= Abundantia) stg. r., holding wreath, L Δ (= regnal year 4) in ex. Dattari —. BMCG —. Cologne —. Milne —. Curtis 1361. *[AD 246–7].* **F** £65 ($100) / **VF** £170 ($250)

9097 — Rev. Roma (?), in military attire, stg. l., resting on sceptre and holding parazononium, L — Δ (= regnal year 4) in field. Dattari 4906. BMCG —. Cologne —. Milne —. *[AD 246–7].* **F** £32 ($50) / **VF** £80 ($120)

9098 — Rev. Bust of Sarapis Pantheos r., combining the attributes of Ammon (ram's horn), Asklepios and Poseidon (serpent-staff combined with trident), Helios (rad. crown), Nilus (lotus headdress and cornucopiae) and Sarapis himself (modius), L — Δ (= regnal year 4) in field. Dattari 4916–17. BMCG 1945. Cologne 2732. Milne 3639–42. *[AD 246–7].*
F £32 ($50) / **VF** £80 ($120)

Coins of this complex type may exhibit different combinations of attributes, some of which include the club of Heracles.

9099 — Rev. Dikaiosyne (= Aequitas) seated l., holding scales and cornucopiae, L Δ (= regnal year 4) before. Dattari 4872. BMCG 1956. Cologne —. Milne 3649. *[AD 246–7].*
F £25 ($40) / **VF** £65 ($100)

9100 — Rev. Elpis (= Spes) advancing l., holding flower and lifting skirt, L — Δ (= regnal year 4) in field. Dattari 4873. BMCG 1957. Cologne 2727. Milne 3650. *[AD 246–7].*
F £16 ($25) / **VF** £55 ($80)

9101 — Rev. Homonoia (= Concordia) seated l., r. hand extended, holding double cornucopiae in l., L Δ (= regnal year 4) before. Dattari —. BMCG —. Cologne —. Milne 3660. *[AD 246–7].*
F £25 ($40) / **VF** £65 ($100)

9102 — Rev. Winged bust of Nike (= Victory) r., L — Δ (= regnal year 4) in field. Dattari —. BMCG 1961. Cologne —. Milne —. *[AD 246–7].* **F** £25 ($40) / **VF** £65 ($100)

9103 — Rev. Nike (= Victory) stg. r., placing shield with Gorgon's hd. on column and holding palm in l., L · Δ (= regnal year 4) above and to r. Dattari 4897. BMCG 1971 var. Cologne —. Milne 3666. *[AD 246–7].* **F** £20 ($30) / **VF** £60 ($90)

9104 — Rev. Nike (= Victory) enthroned l., holding wreath and palm, L Δ (= regnal year 4) before. Dattari 4898. BMCG 1969. Cologne 2731. Milne 3668. *[AD 246–7].*
F £16 ($25) / **VF** £55 ($80)

9105 — Rev. Trophy, with two captives seated at base, L — Δ (= regnal year 4) in field. Dattari — (but in his collection) = BMCG/Christiansen 3251. Cologne —. Milne —. *[AD 246–7].*
F £40 ($60) / **VF** £100 ($150)

9106 — Rev. Alexandria, wearing elephant's skin headdress, stg. facing, hd. l., holding ears of corn and vexillum, L — E (= regnal year 5) in field. Dattari 4854. BMCG 1987. Cologne —. Milne (Supplement) 3732a. *[AD 247–8].* **F** £20 ($30) / **VF** £60 ($90)

9107 — Rev. Nike (= Victory) advancing r., holding wreath with both hands and palm over l. shoulder with r., L E (= regnal year 5) before. Dattari 4896. BMCG 1967. Cologne 2740. Milne 3709. *[AD 247–8].* **F** £16 ($25) / **VF** £55 ($80)

9108 **Billon tetradrachm.** — Rev. Tyche (= Fortuna) reclining l. on couch, holding rudder, L E (= regnal year 5) above. Dattari 4925. BMCG 1978. Cologne 2741. Milne 3713. *[AD 247–8].* **F** £16 ($25) / **VF** £55 ($80)

9109 — Rev. Eagle stg. l., hd. r., holding wreath in beak, L — E (= regnal year 5) in field. Dattari 4936. BMCG 1995. Cologne 2733. Milne 3733. *[AD 247–8].* **F** £16 ($25) / **VF** £55 ($80)

9110 A K M IOV ΦIΛIΠΠOC EV C (or similar), laur. and cuir. bust r. Rev. Similar to previous, but eagle's wings are spread, L — Ϛ regnal year 6) in lower field. Dattari 4939. BMCG 1997. Cologne 2746. Milne 3772. *[AD 248–9].* **F** £16 ($25) / **VF** £55 ($80)

9111 Obv. Similar. Rev. Philip on horseback r., his r. hand raised, holding sceptre in l., L Ϛ regnal year 6) behind. Dattari 4852. BMCG —. Cologne —. Milne —. *[AD 248–9].* **F** £65 ($100) / **VF** £170 ($250)

9112 — Rev. Nike (= Victory) seated l. on cuirass, holding wreath and palm, shield on ground behind, L Ϛ regnal year 6) before. Dattari 4899. BMCG 1970. Cologne —. Milne —. *[AD 248–9].* **F** £25 ($40) / **VF** £65 ($100)

9113 Obv. Similar, but laur., dr. and cuir. bust r. Rev. Alexandria, turreted, stg. l., her r. hand raised, holding sceptre in l., L — Z (= regnal year 7) in field. Dattari 4855. BMCG 1991. Cologne 2758. Milne —. *[AD 249].* **F** £30 ($45) / **VF** £75 ($110)

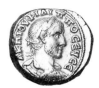

9114

9114 — Rev. Bust of Hermanubis r., wearing modius, taenia and lotus-petal, combined caduceus and palm-branch before, L Z (= regnal year 7) behind. Dattari 4883. BMCG —. Cologne —. Milne —. *[AD 249].* **F** £32 ($50) / **VF** £80 ($120)

9115 **Bronze hemidrachm** (31–33 mm. diam). A K M IOV ΦIΛIΠΠOC EV C (or similar), laur., dr. and cuir. bust r. Rev. Alexandria, turreted, holding hd. of Sarapis, as 9091, L — E (= regnal year 5) in field. Dattari 4940. BMCG 2001. Cologne —. Milne (Supplement) 3744a. *[AD 248].* **F** £115 ($175) / **VF** £265 ($400)

NB This exceptional issue of large Alexandrian bronzes is to be associated with the celebration in AD 248 of Rome's thousandth anniversary.

9116 Obv. Similar. Rev. Rad. bust of Helios r., L — E (= regnal year 5) in field. Dattari 4943. BMCG —. Cologne 2744. Milne —. *[AD 248].* **F** £115 ($175) / **VF** £265 ($400)

9117 — Rev. Conjoined busts of Sarapis and Isis, as 9087, L — E (= regnal year 5) in field. Dattari 4948. BMCG —. Cologne —. Milne —. *[AD 248].* **F** £130 ($200) / **VF** £300 ($450)

9118 **Bronze hemidrachm** Obv. As 9115. Rev. Semasia on horseback galloping r., wearing elephant's skin headdress, holding palm, L — E (= regnal year 5) below. Dattari 4949. BMCG —. Cologne —. Milne —. *[AD 248].* **F** £130 ($200) / **VF** £300 ($450)

9119 — Rev. Tyche (= Fortuna) reclining l. on couch, holding rudder, L E (= regnal year 5) above. Dattari 4951. BMCG/Christiansen 3251B. Cologne —. Milne 3743. *[AD 248].*
 F £115 ($175) / **VF** £265 ($400)

9120 — Rev. Eagle stg. r., holding wreath in beak, palm transversely in background, L — E (= regnal year 5) in field. Dattari 4957. Cf. BMCG/Christiansen 3252. Cologne 2742. Milne —. *[AD 248].* **F** £100 ($150) / **VF** £230 ($350)

9121 — Rev. Serpent Agathodaemon l., enfolding caduceus, facing Uraeus snake r., with sistrum, palm in ex., L ϛ regnal year 6) above. Dattari 4955. BMCG —. Cologne —. Milne —. *[AD 248].* **F** £130 ($200) / **VF** £300 ($450)

9122 — Rev. Harpocrates, as a child, squatting l. on lotus supported by Uraeus snake, his r. hand raised to mouth, holding lotus flower in l., palm-branch to r., L ϛ regnal year 6) to l. Dattari 4852. BMCG —. Cologne —. Milne —. *[AD 248].* **F** £130 ($200) / **VF** £300 ($450)

9123 — Rev. Zeus seated l., holding patera and sceptre, eagle at feet, little Nike on back of throne, palm behind, L — ϛ regnal year 6) in field. Dattari —. BMCG 1999. Cologne —. Milne —. *[AD 248].* **F** £115 ($175) / **VF** £265 ($400)

9124 — Rev. Zeus, holding patera and sceptre, reclining l. on back of eagle l., its hd. r. and wings spread, palm behind, L ϛ regnal year 6) before. Dattari 4953. BMCG —. Cologne —. Milne —. *[AD 248].* **F** £130 ($200) / **VF** £300 ($450)

9125 — Rev. Bust of Zeus Ammon r., as 9089, palm before, L — ϛ regnal year 6) in field. Dattari 4954. BMCG —. Cologne —. Milne —. *[AD 248].*
 F £130 ($200) / **VF** £300 ($450)

9126 — Rev. Elpis (= Spes) advancing l., holding flower and lifting skirt, palm before, L ϛ regnal year 6) behind. Dattari 4941. BMCG —. Cologne —. Milne —. *[AD 248].*
 F £115 ($175) / **VF** £265 ($400)

9127 — Rev. Homonoia (= Concordia) stg. l., r. hand extended, holding double cornucopiae in l., palm before, L ϛ regnal year 6) behind. Dattari 4946. BMCG/Christiansen 3251A. Cologne 2755. Milne 3778. *[AD 248].* **F** £100 ($150) / **VF** £230 ($350)

9128 — Rev. Nike (= Victory) advancing r., holding wreath and palm, palm behind, L ϛ regnal year 6) before. Dattari 4947. BMCG 2000. Cologne 2756. Milne —. *[AD 248].*
 F £100 ($150) / **VF** £230 ($350)

9129 — Rev. Tyche (= Fortuna) stg. l., holding rudder and cornucopiae, palm behind, L ϛ regnal year 6) before. Dattari 4950. BMCG —. Cologne 2757. Milne 3779. *[AD 248].*
 F £100 ($150) / **VF** £230 ($350)

9130 — Rev. Eagle stg. l., hd. r., holding wreath in beak, palm before, L ϛ regnal year 6) behind. Dattari 4956. BMCG 2002. Cologne 2753. Milne 3781. *[AD 248].*
 F £100 ($150) / **VF** £230 ($350)

For other local coinages of Philip I, see *Greek Imperial Coins & Their Values*, pp. 371–82.

PHILIP I AND OTACILIA SEVERA

9131 **Silver antoninianus.** IMP M IVL PHILIPPVS AVG, rad., dr. and cuir. bust of Philip I r. Rev. MARCIA OTACIL SEVERA AVG, diad. and dr. bust of Otacilia Severa r., crescent behind shoulders. RIC *Philip I* 39. RSC 2. Hunter, p. xc. *[Rome, AD 245].*
VF £1,000 ($1,500) / EF £2,000 ($3,000)

PHILIP I WITH OTACILIA SEVERA AND PHILIP II

9134

9132 **Silver antoninianus.** IMP M IVL PHILIPPVS AVG, rad., dr. and cuir. bust of Philip I r. Rev. DE PIA MATRE PIVS FILIVS, laur., dr. and cuir. bust of Philip II r. facing diad. and dr. bust of Otacilia Severa l. RIC *Philip I* 30. RSC 1. Hunter, p. xc. *[Rome, AD 247].*
VF £2,000 ($3,000) / EF £4,000 ($6,000)

9133 Obv. Similar. Rev. PIETAS AVGG, bare-headed, dr. and cuir. bust of Philip II r. facing diad. and dr. bust of Otacilia Severa l. RIC *Philip I* 43b. RSC 4. Hunter, p. lxxxviii. *[Rome, AD 245].*
VF £1,500 ($2,250) / EF £3,000 ($4,500)

9134 **Silver denarius.** Similar, but Philip I laur. instead of rad. RIC *Philip I* 43b. RSC 4. Hunter, p. lxxxviii. *[Rome, AD 245].*
VF £1,850 ($2,750) / EF £3,650 ($5,500)

NB See also no. 9342.

PHILIP I AND PHILIP II

9135 **Silver antoninianus.** M IVL PHILIPPVS AVG M IVL PHILIPPVS N C, rad., dr. and cuir. busts of Philip I and Philip II face to face, crowned by Victory between them. Rev. LIBERALITAS AVGG II, Liberalitas stg. l., holding abacus and cornucopiae. RIC *Philip I* 56. RSC 8. Hunter, p. xci. *[Rome, AD 245].*
VF £1,650 ($2,500) / EF £3,300 ($5,000)

9136 IMP PHILIPPVS AVG, rad., dr. and cuir. bust of Philip I r. Rev. Similar to obv., but bust of Philip II. RIC *Philip I* 68. RSC 4. Hunter —. *[Rome, AD 247].*
VF £1,175 ($1,750) / EF £2,300 ($3,500)

Issues of Philip I in honour of his deified father Julius Marinus

Little is known of Philip's father beyond the fact that he was a native of Arabia Trachonitis and was a chieftain who had attained Roman equestrian rank. The date of his death is uncertain, but his memory was honoured by his son immediately upon the latter's accession in ad 244. The family's home town was renamed Philippopolis and a temple was erected there honouring the new deity as well as various other members of the emperor's family. This was commemorated by an issue of bronze coinage in the name of 'ΘΕΩ ΜΑΡΙΝΩ' at Philippopolis, specimens of which are now very rare.

9137 Æ **30** of Philippopolis in Arabia. ΘΕΩ ΜΑΡΙΝΩ, bare-headed bust of Julius Marinus r.,
 supported by eagle facing, hd. l., its wings spread. Rev. ΦΙΛΙΠΠΟΠΟΛΙΤΩΝ ΚΟΛΩΝΙΑC
 S C, Roma seated l., holding eagle supporting two small figures and resting on spear, shield
 at side. C 1. Spijkerman (The Coins of the Decapolis and Provincia Arabia) p. 260, 1.
 [AD 244]. F £1,500 ($2,250) / VF £3,000 ($4,500)
 The two small figures on rev. may imply that both of Philip's parents were deified.

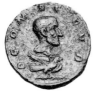

9138

9138 Æ **23,** same mint. Obv. Similar, but the eagle is to r. Rev. — (sometimes without S C),
 Roma stg. l., holding patera and spear, shield on ground behind. BMCG (Arabia,
 Mesopotamia and Persia) p. 42, 2. Spijkerman (*The Coins of the Decapolis and Provincia
 Arabia*) p. 260, 2. *[AD 244].* F £825 ($1,250) / VF £1,650 ($2,500)

9139 Similar, but obv. as 9137, and without S C on rev. BMCG (Arabia, Mesopotamia and
 Persia) p. 42, 1. Spijkerman (*The Coins of the Decapolis and Provincia Arabia*) —.
 [AD 244]. F £1,000 ($1,500) / VF £2,000 ($3,000)

OTACILIA SEVERA

9177

*Marcia Otacilia Severa was the wife of Philip I, though very little is known of the biographical
details of her life. She may have been of noble Roman birth, as suggested by her name, though if so
we can only speculate on how she came to marry the son of an Arab chieftain. She gave birth to
their only son, the younger Philip, about seven years before her husband's accession to the throne
and was accorded the title of Augusta early in the reign. She enjoyed a generous share of the
imperial coinage, with one of the six officinae of the Rome mint being assigned to the production of
issues in her name. Antioch also struck antoniniani for her, though these are by no means common.
Otacilia's ultimate fate is shrouded in mystery. She was in Rome at the time of her husband's defeat
by Decius in AD 249, but it is unclear whether she was murdered by the praetorians at this time or
merely permitted to retire into private life.*

There are three principal varieties of obverse legend and two varieties of obverse type:

A. M OTACIL SEVERA AVG
B. MARCIA OTACIL SEVERA AVG
C. OTACIL SEVERA AVG

a. Diademed and draped bust of Otacilia Severa right.
b. Diademed and draped bust of Otacilia Severa right, crescent behind shoulders.

RIC references are to the coinage of Philip I.

9140 **Gold aureus.** Aa. Rev. CONCORDIA AVGG, Concordia seated l., holding patera and double cornucopiae. RIC 125a. C 2. Hunter 3. *[Rome, AD 245]*.
VF £4,000 ($6,000) / **EF** £10,000 ($15,000)

9141 Ba. Rev. PIETAS AVG, Pietas stg. l., r. hand raised, holding box of incense in l., sometimes with child at feet. RIC 120a, 122a. C 29, 36. Cf. Hunter, p. xci. *[Rome, AD 244–5]*.
VF £4,000 ($6,000) / **EF** £10,000 ($15,000)

9142 Ba. Rev. PVDICITIA AVG, Pudicitia seated l., drawing veil from face and holding transverse sceptre. RIC 123a. C 51. Hunter, p. xci. *[Rome, AD 244–5]*.
VF £4,000 ($6,000) / **EF** £10,000 ($15,000)

9143 Ca. Rev. SAECVLARES AVGG, hippotamus stg. r. RIC 116a. Cf. C 62. Hunter, p. xcii. *[Rome, AD 248]*. VF £5,300 ($8,000) / **EF** £13,500 ($20,000)
This and the following two types belong to the extensive series, in all metals, commemorating the celebration in AD 248 of the thousandth anniversary of Rome's founding (see also nos. 9160, 9170–71, 9176–7 and 9187–8, and under Philip I and Philip II).

9144 Ca. Rev. — cippus (column), uninscribed. RIC 117. Cf. C 67. Hunter, p. xcii. *[Rome, AD 248]*. VF £5,300 ($8,000) / **EF** £13,500 ($20,000)

9145 Ca. Rev. SAECVLVM NOVVM, hexastyle temple containing seated statue of Roma. RIC 117. Cf. C 67. Hunter, p. xcii. *[Rome, AD 248]*. VF £5,300 ($8,000) / **EF** £13,500 ($20,000)
This is a simplified depiction of the temple of Roma, part of Hadrian's remarkable double-temple of Venus and Roma completed under Antoninus Pius in AD 141. Its most recent appearance had been on Severan coins issued in AD 206 (see no. 7199 in Vol. II). See also under Philip I and Philip II.

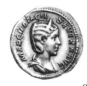

9146 9147

9146 Ba. Rev. SECVRIT ORBIS, Securitas seated l., at ease, her hd. propped on l. hand and holding sceptre in r. RIC 124a, 142a. C 73. Hunter, p. xci. *[Rome, AD 244–5]*.
VF £4,000 ($6,000) / **EF** £10,000 ($15,000)

9147 **Silver antoninianus.** Ab. Rev. CONCORDIA AVGG, Concordia seated l., holding patera and double cornucopiae. RIC 125c. RSC 4. Hunter 4. *[Rome, AD 245–7]*.
VF £16 ($25) / **EF** £45 ($65)

9148 Similar, but with obv. legend B. RIC 119b. RSC 9. Hunter, p. xci. *[Rome, AD 245]*.
VF £20 ($30) / **EF** £50 ($75)

9149 Similar to 9147, but Concordia holds single cornucopiae and has altar at feet. RIC 126. RSC 17. Hunter, p. xci. *[Rome, AD 247]*. VF £20 ($30) / **EF** £50 ($75)

9150 As previous, but with obv. legend C. RIC 129. RSC 16. Hunter 7. *[Rome, AD 247]*.
VF £20 ($30) / **EF** £50 ($75)

9151 MARC OTACI SEVERA AVG, b. Rev. FECVNDITAS TEMPORVM, Tellus seated l., holding corn-ears and cornucopiae, child stg. at her feet, another in background. Cf. RIC 132. Cf. RSC 18. Cf. Hunter, p. xcii. *[Antioch, AD 247]*. VF £300 ($450) / **EF** £600 ($900)

9152 **Silver antoninianus.** Ab. Rev. IVNO CONSERVAT (or CONSERVATRIX), Juno stg. l., holding patera and sceptre. RIC 127, 128. RSC 20, 21. Hunter 6 and p. xci. *[Rome, AD 245–7].* **VF** £20 ($30) / **EF** £50 ($75)

9153 Bb. Rev. PIETAS AVG, Pietas stg. l., r. hand raised, holding box of incense in l. RIC 120b. RSC 30. Hunter 1. *[Rome, AD 244–5].* **VF** £20 ($30) / **EF** £50 ($75)

9154 Similar, but with altar at Pietas' feet. RIC 121. RSC 34. Hunter, p. xci. *[Rome, AD 244–5].* **VF** £20 ($30) / **EF** £50 ($75)

9155 Similar, but with child instead of altar. RIC 122b. RSC 37. Hunter, p. xci. *[Rome, AD 244–5].* **VF** £20 ($30) / **EF** £50 ($75)

9156 9158

9156 Obv. As 9151. Rev. PIETAS AVG N, Pietas stg. l., holding globe and transverse sceptre, child at feet. Cf. RIC 134. Cf. RSC 42a. Cf. Hunter, p. xcii. *[Antioch, AD 247–8].*
 VF £30 ($45) / **EF** £80 ($120)

9157 Cb. Rev. PIETAS AVGG, type as 9154, officina mark Δ (= 4) in field. RIC 115. RSC 39. Hunter, p. xcii. *[Rome, AD 248].* **VF** £23 ($35) / **EF** £55 ($85)

9158 Cb. Rev. PIETAS AVGVSTAE, type as 9153. RIC 130. RSC 43. Hunter 8. *[Rome, AD 247].*
 VF £16 ($25) / **EF** £45 ($65)

9159 9160

9159 Bb. Rev. PVDICITIA AVG, Pudicitia seated, as 9142. RIC 123c. RSC 53. Hunter 2. *[Rome, AD 244–5].* **VF** £16 ($25) / **EF** £45 ($65)

9160 Cb. Rev. SAECVLARES AVGG, hippotamus stg. r., officina mark IIII (= 4) in ex. RIC 130. RSC 43. Hunter 8. *[Rome, AD 248].* **VF** £30 ($45) / **EF** £80 ($120)
 This type belongs to the extensive series, in all metals, commemorating the celebration in AD 248 of the thousandth anniversary of Rome's founding (see also nos. 9143–5, 9170–71, 9176–7 and 9187–8, and under Philip I and Philip II).

9161 **Silver denarius.** As 9140 (rev. CONCORDIA AVGG, Concordia seated). RIC 125b. RSC 3.
 Hunter, p. xci. *[Rome, AD 245].* **VF** £2,500 ($3,750) / **EF** £5,000 ($7,500)

9162 As 9142 (rev. PVDICITIA AVG, Pudicitia seated). RIC 123b. RSC 52. Hunter, p. xci.
 [Rome, AD 244–5]. **VF** £2,500 ($3,750) / **EF** £5,000 ($7,500)

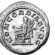

9163

9163 **Silver quinarius.** Ba. Rev. CONCORDIA AVGG, Concordia seated l., holding patera and
 double cornucopiae. RIC 119a. RSC 8. Hunter, p. xci. *[Rome, AD 245].*
 VF £2,000 ($3,000) / **EF** £4,000 ($6,000)

9164

9164 **Bronze sestertius.** Ba. Rev. CONCORDIA AVGG S C, as previous. RIC 203a. C 10. Hunter
 14. *[Rome, AD 245–7].* **F** £32 ($50) / **VF** £80 ($120) / **EF** £265 ($400)

9165 Similar, but with obv. legend C. RIC 203e. C 5. Hunter 21. *[Rome, AD 247].*
 F £38 ($55) / **VF** £95 ($140) / **EF** £300 ($450)

9166 Ba. Rev. PIETAS AVG S C, Pietas stg. l., r. hand raised, holding box of incense in l. RIC 205a.
 C 31. Hunter, p. xci. *[Rome, AD 244–5].* **F** £38 ($55) / **VF** £95 ($140) / **EF** £300 ($450)

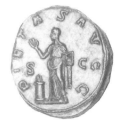

9167

9167 Ba. Rev. PIETAS AVGG S C, similar, but with altar at Pietas' feet. RIC 198a. C 40. Hunter
 25. *[Rome, AD 245].* **F** £38 ($55) / **VF** £95 ($140) / **EF** £300 ($450)

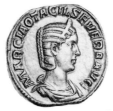
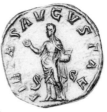

9168

9168 **Bronze sestertius.** Ba. Rev. PIETAS AVGVSTAE S C, type as 9166. RIC 208a. C 46. Hunter
23. *[Rome, AD 245–7].* **F** £32 ($50) / **VF** £80 ($120) / **EF** £265 ($400)

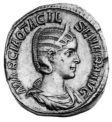
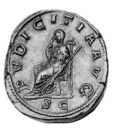

9169

9169 Ba. Rev. PVDICITIA AVG S C, Pudicitia seated l., drawing veil from face and holding
transverse sceptre. RIC 209a. C 55. Hunter, p. xci. *[Rome, AD 244–5].*
 F £32 ($50) / **VF** £80 ($120) / **EF** £265 ($400)

9170 Ba. Rev. SAECVLARES AVGG S C, hippopotamus stg. r. RIC 200a. C 65. Hunter 26. *[Rome,
AD 248].* **F** £48 ($70) / **VF** £115 ($175) / **EF** £350 ($525)
*This type and the next belong to the extensive series, in all metals, commemorating the
celebration in AD 248 of the thousandth anniversary of Rome's founding (see also nos.
9143–5, 9160, 9176–7 and 9187–8, and under Philip I and Philip II).*

9171 Ba. Rev. — cippus (column), uninscribed. RIC 202a. C 68. Hunter 28. *[Rome, AD 248].*
 F £55 ($80) / **VF** £130 ($200) / **EF** £400 ($600)

9172 **Bronze dupondius.** Bb. Rev. CONCORDIA AVGG S C, Concordia seated, as 9163. RIC
203c. C 12. Hunter, p. xci. *[Rome, AD 245–7].*
 F £40 ($60) / **VF** £100 ($150) / **EF** £300 ($450)

9173 Bb. Rev. PIETAS AVG S C, Pietas stg., as 9166. RIC 205c. C 33. Hunter, p. xci. *[Rome, AD
244–5].* **F** £40 ($60) / **VF** £100 ($150) / **EF** £300 ($450)

9174 Similar, but with rev. legend PIETAS AVGVSTAE S C. RIC 208c. C 48. Hunter, p. xcii.
[Rome, AD 245–7]. **F** £40 ($60) / **VF** £100 ($150) / **EF** £300 ($450)

9175 Bb. Rev. PVDICITIA AVG S C, Pudicitia seated, as 9169. RIC 209c. C 57. Hunter, p. xci.
[Rome, AD 244–5]. **F** £40 ($60) / **VF** £100 ($150) / **EF** £300 ($450)

9174

9176 **Bronze dupondius.** Bb. Rev. SAECVLARES AVGG S C, cippus, as 9171. RIC 202c. C 70.
Hunter, p. xcii. *[Rome, AD 248].* F £48 ($70) / **VF** £115 ($175) / **EF** £350 ($525)
*This type and the next belong to the extensive series, in all metals, commemorating the
celebration in AD 248 of the thousandth anniversary of Rome's founding (see also nos.
9143–5, 9160, 9170–71 and 9187–8, and under Philip I and Philip II).*

9177 Similar, but with obv. legend C. RIC 202d. C —. Hunter 29. *[Rome, AD 248].*
 F £48 ($70) / **VF** £115 ($175) / **EF** £350 ($525)

9178 **Bronze as.** Ba. Rev. CONCORDIA AVGG S C, Concordia seated, as 9163 Cf. RIC 203b. C
11. Hunter 17. *[Rome, AD 245–7].* F £32 ($50) / **VF** £85 ($130) / **EF** £285 ($425)

9179 Similar, but with obv. type diad. and dr. bust l. RIC 203d. C 13. Hunter —. *[Rome,
AD 245–7].* F £100 ($150) / **VF** £230 ($350) / **EF** £665 ($1,000)

9180 Similar to 9178, but with obv. legend C. Cf. RIC 203f. C 6. Hunter —. *[Rome, AD 247].*
 F £40 ($60) / **VF** £100 ($150) / **EF** £300 ($450)

9181 Ba. Rev. PIETAS AVG S C, Pietas stg. l., r. hand raised, holding box of incense in l.,
sometimes with altar at feet. RIC 205b, 206. C 32, 35. Hunter, p. xci. *[Rome, AD 244–5].*
 F £38 ($55) / **VF** £95 ($140) / **EF** £300 ($450)

9182 Similar, but with PIETAS AVGG S C (altar at Pietas' feet). RIC 198b. C 41. Hunter, p. xcii.
[Rome, AD 245]. F £38 ($55) / **VF** £95 ($140) / **EF** £300 ($450)

9183 Similar, but with PIETAS AVGVSTAE S C (without altar). RIC 208b. C 47. Hunter 24.
[Rome, AD 245–7]. F £32 ($50) / **VF** £85 ($130) / **EF** £285 ($425)

9184 Ba. Rev. PVDICITIA AVG S C, Pudicitia seated l., drawing veil from face and holding
transverse sceptre. RIC 209b. C 56. Hunter, p. xci. *[Rome, AD 244–5].*
 F £38 ($55) / **VF** £95 ($140) / **EF** £300 ($450)

 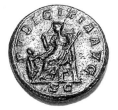

9185

9185 Ba. Rev. — similar, but with child at feet of Pudicitia. RIC 210. C 59. Hunter, p. xci.
[Rome, AD 244–5]. F £55 ($80) / **VF** £130 ($200) / **EF** £400 ($600)

9186 **Bronze as.** B (but OTACILIA), diad. and dr. bust l. Rev. PVDICITIA AVG S C, as previous, but also with female figure stg. behind Pudicitia, holding cornucopiae. RIC 211. C 60. Hunter, p. xci. *[Rome, AD 244–5].* **F** £200 ($300) / **VF** £500 ($750) / **EF** £1,500 ($2,250)

9187 Ba. Rev. MILIARIVM SAECVLVM S C, cippus (column), uninscribed. RIC 199b. C 26. Hunter, p. xcii. *[Rome, AD 248].* **F** £60 ($90) / **VF** £150 ($225) / **EF** £450 ($675)
 This type and the next belong to the extensive series, in all metals, commemorating the celebration in AD 248 of the thousandth anniversary of Rome's founding (see also nos. 9143–5, 9160, 9170–71 and 9176–7, and under Philip I and Philip II).

9188 Similar, but with rev. legend SAECVLARES AVGG S C. RIC 202b. C 69. Cf. Hunter 30. *[Rome, AD 248].* **F** £48 ($70) / **VF** £115 ($175) / **EF** £350 ($525)

Alexandrian Coinage

9189 **Billon tetradrachm.** M ωT CEOVHPA CE M CTPA, diad. and dr. bust r. Rev. Dikaiosyne (= Aequitas) stg. l., holding scales and cornucopiae, L A (= regnal year 1) before. Dattari —. BMCG 2009. Cologne —. Milne —. *[AD 244].* **F** £40 ($60) / **VF** £100 ($150)

9190 Obv. Similar. Rev. Athena stg. r., resting on sceptre and holding Nike, shield at feet to r., L — B (= regnal year 2) in field. Dattari 4967. BMCG —. Cologne —. Milne —. *[AD 244–5].* **F** £40 ($60) / **VF** £100 ($150)

9191 — Rev. Rad. bust of Helios r., L — B (= regnal year 2) in field. Dattari 4978. BMCG —. Cologne 2761. Milne 3527. *[AD 244–5].* **F** £38 ($55) / **VF** £95 ($140)

9192 — Rev. Bust of Isis l., wearing disk and plumes, knot on breast, L — B (= regnal year 2, sometimes retrograde) in field. Cf. Dattari 4985–6 ('Isis bust right'). BMCG 2029. Cologne —. Milne 3559. *[AD 244–5].* **F** £50 ($75) / **VF** £115 ($175)

9193 — Rev. Bust of Nilus r., crowned with lotus, cornucopiae before, L B (= regnal year 2) behind. Dattari 4992. BMCG 2031. Cologne —. Milne —. *[AD 244–5].*
 F £40 ($60) / **VF** £100 ($150)

9194 — Rev. Bust of Sarapis r., wearing modius, L — B (= regnal year 2) in field. Dattari 4996. BMCG —. Cologne —. Milne —. *[AD 244–5].* **F** £40 ($60) / **VF** £100 ($150)

9195 — Rev. Eagle stg. r., palm transversely in background, L — B (= regnal year 2) in field. Dattari 5010. BMCG 2037. Cologne 2759. Milne 3570. *[AD 244–5].*
 F £32 ($50) / **VF** £85 ($130)

9196 — Rev. Asklepios stg. l., holding patera over altar and resting on snake-entwined staff, L Γ (= regnal year 3) before. Dattari 4961. BMCG —. Cologne —. Milne 3588. *[AD 245–6].*
 F £38 ($55) / **VF** £95 ($140)

9197 — Rev. Athena seated l., holding Nike and resting on spear, shield at side, L — Γ (= regnal year 3) in field. Dattari 4968. BMCG —. Cologne —. Milne 3584. *[AD 245–6].*
 F £40 ($60) / **VF** £100 ($150)

9198 — Rev. Bust of Hermanubis r., wearing modius, taenia and lotus-petal, combined caduceus and palm-branch before, L Γ (= regnal year 3) behind. Dattari 4981. BMCG 2030 var. (year 2). Cologne —. Milne —. *[AD 245–6].* **F** £45 ($65) / **VF** £110 ($160)

9199 **Billon tetradrachm.** — Rev. Hermanubis stg. r., wearing modius, holding caduceus and palm, jackal at his feet behind, L — Γ (= regnal year 3) in field. Dattari 4982. BMCG —. Cologne —. Milne —. *[AD 245–6].* **F** £50 ($75) / **VF** £115 ($175)

9200 — Rev. Nilus reclining l., holding reed and cornucopiae, l. arm resting on hippopotamus r. below, crocodile r. in ex., L Γ (= regnal year 3) before. Dattari —. BMCG —. Cologne —. Milne —. Emmett 3560. *[AD 245–6].* **F** £45 ($65) / **VF** £110 ($160)

9201 — Rev. Sarapis stg. facing, hd. r., wearing modius and resting on sceptre held in r. hand, L — Γ (= regnal year 3) in field. Dattari 4998. BMCG 2027. Cologne 2766. Milne 3620. *[AD 245–6].* **F** £32 ($50) / **VF** £85 ($130)

9202 — Rev. Sarapis seated l., wearing modius, his r. hand outstretched, holding sceptre held in l., Kerberos at his feet, little Nike on back of throne, L — Γ (= regnal year 3) in field. Dattari 4999. BMCG 2028 var. Cologne 2767. Milne 3625 var. *[AD 245–6].* **F** £38 ($55) / **VF** £95 ($140)

9203 — Rev. Conjoined busts r. of Sarapis, wearing modius, and Isis, wearing disk and plumes, knot on breast, L — Γ (= regnal year 3) in field. Dattari 5000. BMCG —. Cologne —. Milne —. *[AD 245–6].* **F** £50 ($75) / **VF** £115 ($175)

9204 — Rev. Bust of Selene r., large lunar crescent before, L Γ (= regnal year 3) behind. Dattari —. BMCG —. Cologne —. Milne —. Curtis 1388. *[AD 245–6].* **F** £45 ($65) / **VF** £110 ($160)

9205 — Rev. Laur. but of Zeus r., L — Γ (= regnal year 3) in field. Dattari 5006. BMCG 2003. Cologne —. Milne 3574. *[AD 245–6].* **F** £38 ($55) / **VF** £95 ($140)

9206 — Rev. Bust of Zeus Ammon r., with ram's horn, crowned with horns and disk, L — Γ (= regnal year 3) in field. Dattari 5007. BMCG 2005. Cologne —. Milne 3614. *[AD 245–6].* **F** £40 ($60) / **VF** £100 ($150)

9207

9207 — Rev. Homonoia (= Concordia) stg. l., r. hand extended, holding double cornucopiae in l., L Γ (= regnal year 3) before. Dattari 4984. BMCG 2020. Cologne —. Milne 3595. *[AD 245–6].* **F** £32 ($50) / **VF** £85 ($130)

9208 — Rev. Nike (= Victory) advancing r., holding wreath and palm, L Γ (= regnal year 3) before. Dattari 4990. BMCG 2023. Cologne —. Milne 3600. *[AD 245–6].* **F** £32 ($50) / **VF** £85 ($130)

9209 — Rev. Similar, but Nike looks back and her wings are open r., L — Γ (= regnal year 3) in field. Dattari 4991. BMCG —. Cologne —. Milne —. *[AD 245–6].* **F** £40 ($60) / **VF** £100 ($150)

9210 **Billon tetradrachm.** Obv. As 9189. Rev. Tyche (= Fortuna) stg. l., holding rudder and cornucopiae, L Γ (= regnal year 3) before. Dattari 5002. BMCG 2025. Cologne —. Milne 3606. *[AD 245–6]*. **F** £32 ($50) / **VF** £85 ($130)

9211 — Rev. Tyche (= Fortuna) reclining l. on couch, holding rudder, L Γ (= regnal year 3) above. Dattari 5004. BMCG —. Cologne 2768. Milne 3611. *[AD 245–6]*.
F £40 ($60) / **VF** £100 ($150)

9212 — Rev. Eagle stg. l., hd. r., holding wreath in beak, L — Γ (= regnal year 3) in field. Dattari 5009. BMCG 2036. Cologne 2763. Milne 3635. *[AD 245–6]*. **F** £32 ($50) / **VF** £85 ($130)

9213 9215

9213 — Rev. Bust of Alexandria l., wearing close-fitting turreted cap, L — Δ (= regnal year 4) in field. Dattari 4958 var. BMCG 2032. Cologne 2769. Milne 3681. *[AD 246–7]*.
F £40 ($60) / **VF** £100 ($150)

9214 — Rev. Alexandria stg. l., holding bust of Sarapis and resting on sceptre, L — Δ (= regnal year 4) in field. Dattari —. BMCG —. Cologne —. Milne —. Emmett 3537. *[AD 246–7]*.
F £45 ($65) / **VF** £110 ($160)

9215 — Rev. Bust of Athena r., wearing crested Athenian helmet and holding spear before her, L — Δ (= regnal year 4) in field. Dattari 4965. BMCG —. Cologne —. Milne —. *[AD 246–7]*. **F** £45 ($65) / **VF** £110 ($160)

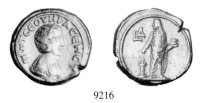

9216

9216 — Rev. Eusebeia (= Pietas) stg. l., sacrificing over altar and holding box of incense, L Δ (= regnal year 4) before. Dattari 4976. BMCG 2014. Cologne 2770. Milne 3654. *[AD 246–7]*. **F** £32 ($50) / **VF** £85 ($130)

9217 — Rev. Winged bust of Nike (= Victory) r., L — Δ (= regnal year 4) in field. Dattari 4987. BMCG 2021. Cologne 2771. Milne 3661. *[AD 246–7]*. **F** £38 ($55) / **VF** £95 ($140)

9218 M ωT CEOVHPA CE M CEB, diad. and dr. bust r. Rev. Half-length figure of Alexandria l., wearing turreted cap, r. hand raised, holding sceptre in l., L — E (= regnal year 5) in field. Dattari 4960. BMCG 2033 var. Cologne —. Milne 3727 var. *[AD 247–8]*.
F £50 ($75) / **VF** £115 ($175)

9219 **Billon tetradrachm.** Obv. Similar. Rev. Half-length figure of Roma facing, hd. l., helmeted and in military attire, r. hand raised, holding sceptre in l., L E (= regnal year 5) before. Dattari 4994. BMCG —. Cologne —. Milne 3726. *[AD 247–8].* **F** £50 ($75) / **VF** £115 ($175)

9220 — Rev. Dikaiosyne (= Aequitas) seated l., holding scales and cornucopiae, L — E (= regnal year 5) in field. Dattari 4973. BMCG 2011. Cologne 2772. Milne 3694. *[AD 247–8].*
F £32 ($50) / **VF** £85 ($130)

9221

9221 — Rev. Athena stg. l., holding Nike and resting on shield, L — Ϛ regnal year 6) in field. Dattari 4966. BMCG 2008. Cologne —. Milne 2749. *[AD 248–9].*
F £38 ($55) / **VF** £95 ($140)

9222 — Rev. Elpis (= Spes) advancing l., holding flower and lifting skirt, L — Ϛ regnal year 6) in field. Dattari 4985. BMCG 2013. Cologne —. Milne —. *[AD 248–9].*
F £38 ($55) / **VF** £95 ($140)

9223 — Rev. Conjoined busts r. of Helios, rad., and Selene, with large lunar crescent before, L Z (= regnal year 7) behind. Dattari 4980. BMCG/Christiansen 3253. Cologne —. Milne —. *[AD 249].* **F** £45 ($65) / **VF** £110 ($160)

9224 — Rev. Roma stg. l., r. hand raised, holding sceptre in l., L Z (= regnal year 7) before. Dattari 4995. BMCG —. Cologne —. Milne —. *[AD 249].* **F** £40 ($60) / **VF** £100 ($150)

9225 — Rev. Eirene (= Pax) stg. l., holding corn-ears and caduceus, L Z (= regnal year 7) before. Dattari 4974. Cf. BMCG 2012. Cologne 2781. Milne 3782. *[AD 249].*
F £38 ($55) / **VF** £95 ($140)

9226 **Bronze hemidrachm** (31–33 mm. diam). M ωT CEOVHPA CE M CEB, diad. and dr. bust r. Rev. Conjoined busts r. of Sarapis, wearing modius, and Isis, wearing disk and plumes, knot on breast, L — E (= regnal year 5) in field. Dattari —. BMCG —. Cologne 2775. Milne —. *[AD 248].* **F** £130 ($200) / **VF** £300 ($450)

NB This exceptional issue of large Alexandrian bronzes is to be associated with the celebration in AD 248 of Rome's thousandth anniversary.

9227 Obv. Similar. Rev. Homonoia (= Concordia) stg. l., r. hand extended, holding double cornucopiae in l., L — E (= regnal year 5) in field. Dattari —. BMCG —. Cologne —. Milne 3742. *[AD 248].* **F** £115 ($175) / **VF** £265 ($400)

9228 — Rev. Tyche (= Fortuna) reclining l. on couch, holding rudder, L E (= regnal year 5) above. Dattari —. BMCG —. Cologne 2776. Milne —. *[AD 248].*
F £115 ($175) / **VF** £265 ($400)

9229 **Bronze hemidrachm** Obv. As 9226. Rev. Serpent Agathodaemon l., enfolding caduceus, facing Uraeus snake r., with sistrum, palm in ex., L Ϛ regnal year 6) above. Dattari 5014. BMCG/Christiansen 3256. Cologne 2778. Milne —. *[AD 248].*
F £130 ($200) / **VF** £300 ($450)

9230 — Rev. Alexandria, turreted, stg. l., holding bust of Sarapis and resting on sceptre, palm before, L Ϛ regnal year 6) behind. Dattari 5011. BMCG —. Cologne —. Milne —. *[AD 248].*
F £115 ($175) / **VF** £265 ($400)

9231 — Rev. Sarapis enthroned l., wearing modius, his r. hand outstretched, holding sceptre held in l., Kerberos at his feet, palm behind, L Ϛ regnal year 6) before. Dattari —. BMCG —. Cologne 2779. Milne —. *[AD 248].*
F £115 ($175) / **VF** £265 ($400)

9232 — Rev. Nike (= Victory) advancing r., holding wreath and palm, palm behind, L Ϛ regnal year 6) before. Dattari —. BMCG —. Cologne —. Milne —. Emmett 3576. *[AD 248].*
F £115 ($175) / **VF** £265 ($400)

9233 — Rev. Tyche (= Fortuna) stg. l., holding rudder and cornucopiae, palm behind, L Ϛ regnal year 6) before. Dattari 5013. BMCG 2038. Cologne 2780. Milne 3780. *[AD 248].*
F £100 ($150) / **VF** £230 ($350)

9234 — Rev. Eagle stg. l., hd. r., holding wreath in beak, palm before, L Ϛ regnal year 6) behind. Dattari 5015. BMCG —. Cologne —. Milne —. *[AD 248].* F £115 ($175) / **VF** £265 ($400)

For other local coinages of Otacilia Severa, see *Greek Imperial Coins & Their Values*, pp. 382–9.

PHILIP II
Jul./Aug. AD 247–Sep. 249

9283

Marcus Julius Severus Philippus, the son of Philip I and Otacilia Severa, was born about AD 237, some years before his father's accession to the throne on the downfall of Gordian III. The 7-year-old son of the new emperor was immediately granted the junior imperial rank of Caesar and this he retained for the following three years. He seems to have accompanied his father during the campaigns of AD 245–7 against the Quadi and the Carpi on the northern frontier and on their return to Rome to celebrate a triumph the boy was rewarded by advancement to the rank of Augustus and co-emperor with his father. When their regime was threatened two years later by the revolt of Decius the two Philips marched together against the usurper, only to perish in battle at Verona. An alternative version of the story is that the younger Philip survived the battle but was brought back to Rome where he was put to death by the praetorians.

Philip II's coinage is divided into two main groups, those issued between AD 244 and 247, when he bore the title of Caesar, and those issued after his elevation to the rank of Augustus. The former are all from the mint of Rome, but after he became co-emperor with his father he also shared in the issue of antoniniani from Antioch. During this latter period he uses the same obverse legends as his father and differentiation on some Syrian issues may sometimes be confusing, though the younger

features of Philip II's portrait are generally discernible. The officina marks on the 'Saeculares' antoniniani issued at Rome in AD 248 reveal that, like his mother, Philip II was assigned one of the six officinae to produce issues in his name.

There are three principal varieties of obverse legend, the first as Caesar, the other two as Augustus:

A. M IVL PHILIPPVS CAES
B. IMP M IVL PHILIPPVS AVG
C. IMP PHILIPPVS AVG

Issues as Caesar under Philip I, AD 244–247

9235 **Gold aureus.** A, bare-headed and dr. bust r. Rev. PIETAS AVGVSTOR, sprinkler, simpulum, jug, knife, and lituus (emblems of the priestly colleges). Cf. RIC 215, note. Cf. C 30 (misdescribed). Hunter 2. *[Rome, AD 245–6].* **VF** £5,000 ($7,500) / **EF** £12,000 ($18,000)

9236 Obv. Similar. Rev. PRINCIPI IVVENT, Philip II, in military attire, stg. l., holding globe and resting on spear. Cf. RIC 218a. C 46. Hunter, p. xciii. *[Rome, AD 245–6].*
 VF £4,000 ($6,000) / **EF** £10,000 ($15,000)

9237 — Rev. — Philip II, in military attire, stg. r., holding transverse spear and globe. RIC 216a. C 52. Hunter 4. *[Rome, AD 245–6].* **VF** £4,000 ($6,000) / **EF** £10,000 ($15,000)

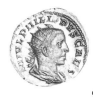

9238 9240

9238 **Silver antoninianus.** A, rad. and dr. bust r. Rev. IOVI CONSERVAT, Jupiter stg. l., holding thunderbolt and sceptre. RIC 213. RSC 13. Hunter 1. *[Rome, AD 245–6].*
 VF £20 ($30) / **EF** £50 ($75)

9239 Obv. Similar. Rev. PIETAS AVGVSTOR, priestly emblems, as 9235. RIC 215. RSC 32. Hunter 3. *[Rome, AD 245–6].* **VF** £20 ($30) / **EF** £50 ($75)

9240 Obv. Similar. Rev. PRINCIPI IVVENT, Philip II stg. l., as 9236. Cf. RIC 218d. RSC 48. Hunter 8. *[Rome, AD 245–6].* **VF** £16 ($25) / **EF** £45 ($65)

9241 Similar, but with captive seated at Philip's feet. Cf. RIC 219. RSC 57. Hunter 10. *[Rome, AD 246–7].* **VF** £20 ($30) / **EF** £50 ($75)

9242 Obv. Similar. Rev. PRINCIPI IVVENT, Philip II stg. r., as 9237. RIC 216c. RSC 54. Hunter 5. *[Rome, AD 245–6].* **VF** £16 ($25) / **EF** £45 ($65)

9243 Similar, but in background soldier stands beside Philip, sometimes resting on spear. RIC 217. RSC 58, 59. Hunter 7. *[Rome, AD 246–7].* **VF** £33 ($50) / **EF** £80 ($120)

9244 Obv. Similar. Rev. PRINCIPI IVVENTVTIS, Philip II, in military attire, stg. l., holding standard and spear. RIC 220b. RSC 61. Hunter, p. xciii. *[Rome, AD 246–7].*
 VF £23 ($35) / **EF** £55 ($85)

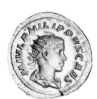

9243

9245 **Silver antoninianus.** Obv. Similar. Rev. SPES PVBLICA, Spes advancing l., holding flower and lifting skirt. RIC 221. RSC 84. Hunter 11. *[Rome, AD 245–6]*.
VF £25 ($40) / **EF** £65 ($100)

9246 **Silver denarius.** As 9236 (rev. PRINCIPI IVVENT, Philip II stg. l.). Cf. RIC 218b. RSC 47a. Hunter, p. xciii. *[Rome, AD 245]*. **VF** £2,500 ($3,750) / **EF** £5,000 ($7,500)

9247 As 9237 (rev. PRINCIPI IVVENT, Philip II stg. r.). RIC 216b. RSC 53. Hunter, p. xciii. *[Rome, AD 245]*. **VF** £2,500 ($3,750) / **EF** £5,000 ($7,500)

9248 **Silver quinarius.** As 9236 (rev. PRINCIPI IVVENT, Philip II stg. l.). Cf. RIC 218c. RSC 47. Hunter, p. xciii. *[Rome, AD 245]*. **VF** £1,650 ($2,500) / **EF** £3,300 ($5,000)

9249

9249 **Bronze sestertius.** A, bare-headed and dr. bust r. Rev. PRINCIPI IVVENT S C, Philip II stg. l., as 9236. RIC 256a. C 49. Hunter 14. *[Rome, AD 245–6]*.
F £32 ($50) / **VF** £80 ($120) / **EF** £265 ($400)

9250

9250 Obv. Similar. Rev. — Philip II stg. r., as 9237. RIC 255a. C 55. Hunter 12. *[Rome, AD 245–6]*. **F** £32 ($50) / **VF** £80 ($120) / **EF** £265 ($400)

9251

9251 **Bronze sestertius.** — Rev. PRINCIPI IVVENTVTIS S C, Philip II stg. l., as 9244. RIC 258a. C 62. Hunter 18 var. *[Rome, AD 246–7].* **F** £38 ($55) / **VF** £95 ($140) / **EF** £300 ($450)

9252 Similar, but with obv. bust to l. RIC 258c. C 65. Hunter —. *[Rome, AD 246–7].*
 F £200 ($300) / **VF** £500 ($750) / **EF** £1,500 ($2,250)

9253 **Bronze dupondius** or **as.** As 9249. RIC 256b. C 50. Hunter 16. *[Rome, AD 245–6].*
 F £32 ($50) / **VF** £85 ($130) / **EF** £285 ($425)

9254 As 9250. RIC 255b. C 56. Hunter, p. xciii. *[Rome, AD 245–6].*
 F £32 ($50) / **VF** £85 ($130) / **EF** £285 ($425)

9255 As 9251. RIC 258b. C 63. Hunter 19. *[Rome, AD 246–7].*
 F £32 ($50) / **VF** £85 ($130) / **EF** £285 ($425)

For the Alexandrian issues of Philip II as Caesar, see nos. 9294–9317.

Issues as Augustus, AD 247–249

9256 **Gold aureus.** C, laur., dr. and cuir. bust r. Rev. PAX AETERNA, Pax stg. l., holding olive-branch and transverse sceptre. RIC 231a. C 21. Hunter, p. xciii. *[Rome, AD 247].*
 VF £5,000 ($7,500) / **EF** £12,000 ($18,000)

9257 Obv. Similar. Rev. SAECVLARES AVGG, cippus (column) inscribed COS / II in two lines. RIC 225. C 77. Hunter, p. xciii. *[Rome, AD 248].*
 VF £5,300 ($8,000) / **EF** £13,500 ($20,000)
 This type belongs to the extensive series, in all metals, commemorating the celebration in AD 248 of the thousandth anniversary of Rome's founding (see also nos. 9275, 9283–4, 9288 and 9291–2, and under Philip I and Otacilia Severa).

9258 **Silver antoninianus.** B, rad., dr. and cuir. bust r. Rev. AEQVITAS AVG, Aequitas stg. l., holding scales and cornucopiae. RIC —. RSC — (but cf. C 1). Hunter —. *[Antioch, AD 247].* **VF** £40 ($60) / **EF** £100 ($150)
 This type has been recorded also with the emperor's bust to left.

9259 Similar, but with AEQVITAS AVGG. RIC 240a. RSC 1. Hunter, p. xciv. *[Antioch, AD 247].*
 VF £25 ($40) / **EF** £65 ($100)

9260 Similar, but with obv. type rad. and cuir. bust l. RIC 240b. RSC 2. Hunter, p. xciv. *[Antioch, AD 247].* **VF** £50 ($75) / **EF** £100 ($150)

9258 9259

9261 **Silver antoninianus.** Obv. As 9258. Rev. AETERNIT IMPER, Sol advancing l., r. hand
 raised, holding whip in l. Cf. RIC 226. RSC 6. Hunter 21. *[Rome, AD 247]*.
 VF £16 ($25) / **EF** £45 ($65)

9262 9265

9262 — Rev. CONCORDIA AVGG, Concordia seated l., holding patera and cornucopiae. RIC —.
 RSC —. Hunter 39. *[Antioch, AD 247]*. VF £25 ($40) / **EF** £65 ($100)

9263 Similar, but with obv. type rad. and cuir. bust l. RIC 241. RSC 8. Hunter, p. xciv. *[Antioch,
 AD 247]*. VF £50 ($75) / **EF** £100 ($150)

9264 Obv. As previous. Rev. FELI / CITAS / IMPP in three lines within laurel-wreath. RIC 242.
 RSC 11. Hunter, p. xciv. *[Antioch, AD 247]*. VF £65 ($100) / **EF** £130 ($200)

9265 C, rad., dr. and cuir. bust r. Rev. LIBERALITAS AVGG III, Philip I and Philip II seated l. on
 curule chairs side by side, their r. hands extended, Philip I also holding short sceptre. RIC
 230. RSC 17. Hunter 23. *[Rome, AD 247]*. VF £20 ($30) / **EF** £50 ($75)

9266 9269

9266 — — Rev. PAX AETERNA, Pax stg., as 9256. RIC 231c. RSC 23. Hunter 24. *[Rome,
 AD 247]*. VF £16 ($25) / **EF** £45 ($65)

9267 Similar, but with obv. legend B. RIC 227. RSC 24. Hunter 22. *[Rome, AD 247]*.
 VF £16 ($25) / **EF** £45 ($65)

9268 Obv. As previous. Rev. P M TR P IIII COS P P, Felicitas stg. l., holding long caduceus and
 cornucopiae. RIC 232. RSC 33a. Hunter, p. xciii. *[Antioch, AD 247]*.
 VF £25 ($40) / **EF** £65 ($100)

9269 **Silver antoninianus.** Similar, but with rev. legend P M TR P VI COS P P. RIC 235. RSC 38.
 Hunter, p. xciv. *[Antioch, AD 249].* **VF** £23 ($35) / **EF** £60 ($90)

9270 Similar, but with obv. type rad., dr. and cuir. bust l. RIC 235. RSC 39. Hunter, p. xciv.
 [Antioch, AD 249]. **VF** £50 ($75) / **EF** £100 ($150)

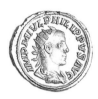

 9271 9275

9271 Obv. As 9258. Rev. P M TR P VI COS P P, Philip II, togate, stg. l., sacrificing over tripod-
 altar and holding short sceptre. RIC 236. RSC 40. Hunter, p. xciv. *[Antioch, AD 249].*
 VF £25 ($40) / **EF** £65 ($100)

9272 — Rev. — lion walking l. RIC 239. RSC 43. Hunter 38. *[Antioch, AD 249].*
 VF £50 ($75) / **EF** £100 ($150)

9273 Similar, but with obv. type rad., dr. and cuir. bust l., and on rev. lion is walking r. RIC 238.
 RSC 42. Hunter, p. xciv. *[Antioch, AD 249].* **VF** £80 ($120) / **EF** £170 ($250)

9274 B, rad. and cuir. bust l. Rev. **ROMAE AETERNAE**, Roma seated l., holding Victory and spear,
 shield at side. RIC 243. RSC 71. Hunter, p. xciv. *[Antioch, AD 247].*
 VF £60 ($90) / **EF** £115 ($175)

9275 Obv. As 9265. Rev. **SAECVLARES AVGG**, elk stg. or walking l., officina mark III (= 3) in ex.
 RIC 224. RSC 72. Hunter 26. *[Rome, AD 248].* **VF** £30 ($45) / **EF** £80 ($120)
 *This type belongs to the extensive series, in all metals, commemorating the celebration in
 AD 248 of the thousandth anniversary of Rome's founding (see also nos. 9257, 9283–4,
 9288 and 9291–2, and under Philip I and Otacilia Severa). The animal on reverse has
 traditionally been identified as a goat, but cf. John Twente in 'The Celator', Jan. 2002,
 p. 38. There seems little likelihood of the common goat having being featured as one of the
 exotic animals in the arena, whereas the northern European elk (North American moose)
 would have been a most suitable candidate.*

9276 B, rad., dr. and cuir. bust l. Rev. **SAECVLVM NOVVM**, hexastyle temple containing seated
 statue of Roma. RIC 244. RSC 81. Hunter, p. xciv. *[Rome, AD 248].*
 VF £65 ($100) / **EF** £130 ($200)
 *This is a simplified depiction of the temple of Roma, part of Hadrian's remarkable double-
 temple of Venus and Roma completed under Antoninus Pius in AD 141. Its most recent
 appearance had been on Severan coins issued in AD 206 (see no. 7199 in Vol. II). See also
 under Philip I and Otacilia Severa.*

9277 Obv. As 9265. Rev. **VIRTVS AVGG**, Mars, naked, advancing r., carrying spear and trophy
 over l. shoulder, officina mark Γ (= 3) in field. RIC 223. RSC 88. Hunter 25. *[Rome,
 AD 248].* **VF** £23 ($35) / **EF** £55 ($85)

9278 **Silver quinarius.** As 9256 (rev. **PAX AETERNA**, Pax stg.). RIC 231b. RSC 22. Hunter,
 p. xciii. *[Rome, AD 247].* **VF** £1,650 ($2,500) / **EF** £3,300 ($5,000)

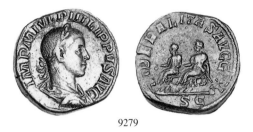

9279

9279 **Bronze sestertius.** B, laur., dr. and cuir. bust r. Rev. LIBERALITAS AVGG III S C, Philip I and Philip II seated l. on curule chairs , as 9265. RIC 267a. C 18. Hunter 29. *[Rome, AD 247].*
 F £40 ($60) / **VF** £100 ($150) / **EF** £300 ($450)

9280

9280 Obv. Similar. Rev. PAX AETERNA S C, Pax stg., as 9256. Cf. RIC 268a. C 27. Hunter 30. *[Rome, AD 247].* **F** £35 ($52) / **VF** £85 ($130) / **EF** £285 ($425)

9281 Similar, but with obv. legend C. RIC 268c. C 25. Hunter 31. *[Rome, AD 247].*
 F £35 ($52) / **VF** £85 ($130) / **EF** £285 ($425)

9282 Obv. As 9279. Rev. P M TR P IIII COS II P P S C, Philip II, togate, seated l. on curule chair, holding globe and short sceptre. RIC 262a. C 36. Hunter 28. *[Rome, AD 247].*
 F £48 ($70) / **VF** £115 ($175) / **EF** £350 ($525)

9283 — Rev. SAECVLARES AVGG S C, elk walking l. RIC 264a. Cf. C 73. Hunter 34. *[Rome, AD 248].* **F** £48 ($70) / **VF** £115 ($175) / **EF** £350 ($525)
 This type and the next belong to the extensive series, in all metals, commemorating the celebration in AD 248 of the thousandth anniversary of Rome's founding (see also nos. 9257, 9275, 9288 and 9291–2, and under Philip I and Otacilia Severa). For the identification of the animal depicted on this type, see note following no. 9275.

9284 — Rev. — cippus (column) inscribed COS / II in two lines. RIC 265a. C 78. Hunter 35. *[Rome, AD 248].* **F** £48 ($70) / **VF** £115 ($175) / **EF** £350 ($525)

9285 — Rev. VIRTVS AVGG S C, Mars advancing, as 9277, but no officina mark in field. RIC 263. C 89. Hunter 32. *[Rome, AD 248].* **F** £45 ($65) / **VF** £110 ($160) / **EF** £320 ($475)

9286 **Bronze dupondius.** C, rad., dr. and cuir. bust r. Rev. P M TR P IIII COS II P P S C, Philip II seated on curule chair, as 9282. RIC 262b. C 37. Hunter, p. xciii. *[Rome, AD 247].*
 F £55 ($80) / **VF** £130 ($200) / **EF** £400 ($600)

9287 **Bronze dupondius.** B, type as previous. Rev. **SAECVLARES AVGG S C**, inscribed cippus
 (column), as 9284. RIC 265c. C 80. Hunter, p. xciii. *[Rome, AD 248].*
 F £55 ($80) / **VF** £130 ($200) / **EF** £400 ($600)

9288 **Bronze as.** B, laur., dr. and cuir. bust r. Rev. **MILIARIVM SAECVLVM S C**, inscribed cippus
 (column), as previous. Cf. RIC 271 (**COS III** on column). Cf. C 20. Hunter 33. *[Rome, AD
 248].* **F** £55 ($80) / **VF** £130 ($200) / **EF** £400 ($600)
 *This type belongs to the extensive series, in all metals, commemorating the celebration in
 AD 248 of the thousandth anniversary of Rome's founding (see also nos. 9257, 9275,
 9283–4 and 9291–2, and under Philip I and Otacilia Severa).*

9289 Obv. Similar. Rev. **PAX AETERNA S C**, Pax stg., as 9256. Cf. RIC 268b. C 28. Hunter,
 p. xciii. *[Rome, AD 247].* **F** £38 ($55) / **VF** £95 ($140) / **EF** £300 ($450)

9290 Similar, but with obv. legend C. RIC 268d. C 26. Hunter, p. xciii. *[Rome, AD 247].*
 F £38 ($55) / **VF** £95 ($140) / **EF** £300 ($450)

9291 Obv. As 9288. Rev. **SAECVLARES AVGG S C**, elk walking l. RIC 264b. Cf. C 74. Hunter,
 p. xciii. *[Rome, AD 248].* **F** £50 ($75) / **VF** £125 ($185) / **EF** £365 ($550)
 *This type and the next belong to the extensive series, in all metals, commemorating the
 celebration in AD 248 of the thousandth anniversary of Rome's founding (see also nos.
 9257, 9275, 9283–4 and 9288, and under Philip I and Otacilia Severa). For the
 identification of the animal depicted on this type, see note following no. 9275.*

9292 — Rev. — inscribed cippus (column), as 9284. RIC 265b. C 79. Hunter 36. *[Rome, AD 248].*
 F £50 ($75) / **VF** £125 ($185) / **EF** £365 ($550)

9293 — Rev. **VOTIS** / **DECENNA** / **LIBVS** / **S C** in four lines within laurel-wreath. RIC 269. C 90.
 Hunter, p. xciii. *[Rome, AD 247].* **F** £65 ($100) / **VF** £170 ($250) / **EF** £500 ($750)

Alexandrian Coinage

As Caesar

9294 **Billon tetradrachm.** M IOY ΦΙΛΙΠΠΟC K CEB (or similar), bare-headed, dr. and cuir. bust r.
 Rev. Athena stg. r., resting on sceptre and holding Nike, shield at feet to r., L — B (= regnal
 year 2) in field. Dattari 5020 var. (year 3). BMCG —. Cologne —. Milne 3530.
 [AD 244–5]. **F** £38 ($55) / **VF** £95 ($140)

9295 Obv. Similar. Rev. Athena seated l., holding Nike and resting on spear, shield at side, L — B
 (= regnal year 2) in field. Dattari 5021. BMCG/Christiansen 3259. Cologne —. Milne
 3534. *[AD 244–5].* **F** £32 ($50) / **VF** £85 ($130)

9296 — Rev. Bust of Selene r., large lunar crescent before, L B (= regnal year 2) behind. Dattari
 5039. BMCG/Christiansen 3258 var. (year 3). Cologne —. Milne —. *[AD 244–5].*
 F £40 ($60) / **VF** £100 ($150)

9297 — Rev. Nike (= Victory) advancing r., holding wreath and palm, L B (= regnal year 2)
 before. Dattari 5032. BMCG 2045. Cologne 2783. Milne 3545. *[AD 244–5].*
 F £30 ($45) / **VF** £80 ($120)

9298 — Rev. Rev. Eagle stg. r., palm transversely in background, L — B (= regnal year 2) in
 field. Dattari 5051. BMCG —. Cologne —. Milne 3572. *[AD 244–5].*
 F £38 ($55) / **VF** £95 ($140)

9297

9299 **Billon tetradrachm.** Obv. As 9294. Rev. Asklepios stg. l., holding patera over altar and resting on snake-entwined staff, L Γ (= regnal year 3) before. Dattari 5018. BMCG —. Cologne —. Milne 3589. *[AD 245–6]*. **F** £38 ($55) / **VF** £95 ($140)

9300 — Rev. Rad. bust of Helios r., L — Γ (= regnal year 3) in field. Dattari 5025. BMCG/Christiansen 3257. Cologne —. Milne —. *[AD 245–6]*.
 F £32 ($50) / **VF** £85 ($130)

9301 — Rev. Conjoined busts r. of Helios, rad., and Selene, with large lunar crescent before, L Γ (= regnal year 3) behind. Dattari 5026. BMCG 2042. Cologne —. Milne 3579. *[AD 245–6]*. **F** £45 ($65) / **VF** £110 ($160)

9302 — Rev. Bust of Hermanubis r., wearing modius, taenia and lotus-petal, combined caduceus and palm-branch before, L Γ (= regnal year 3) behind. Dattari 5027 var. (year 2). BMCG — . Cologne —. Milne —. Emmett 3591. *[AD 245–6]*. **F** £45 ($65) / **VF** £110 ($160)

9303 — Rev. Bust of Nilus r., crowned with lotus, cornucopiae before, L Γ (= regnal year 3) behind. Dattari 5034. BMCG —. Cologne —. Milne 3628. *[AD 245–6]*.
 F £40 ($60) / **VF** £100 ($150)

9304 — Rev. Sarapis stg. facing, hd. r., wearing modius and resting on sceptre held in r. hand, L — Γ (= regnal year 3) in field. Dattari 5036. BMCG 2049. Cologne —. Milne 3622. *[AD 245–6]*. **F** £30 ($45) / **VF** £80 ($120)

9305 — Rev. Sarapis seated l., wearing modius, his r. hand outstretched, holding sceptre held in l., Kerberos at his feet, little Nike on back of throne, L Γ (= regnal year 3) before. Dattari 5037. BMCG —. Cologne —. Milne —. *[AD 245–6]*. **F** £38 ($55) / **VF** £95 ($140)

9306 — Rev. Conjoined busts r. of Sarapis, wearing modius, and Isis, wearing disk and plumes, knot on breast, L Γ (= regnal year 3) behind. Dattari 5038. BMCG —. Cologne —. Milne 3616. *[AD 245–6]*. **F** £50 ($75) / **VF** £115 ($175)

9307 — Rev. Laur. bust of Zeus r., L — Γ (= regnal year 3) in field. Dattari 5047. BMCG 2039. Cologne 2789. Milne 3575. *[AD 245–6]*. **F** £30 ($45) / **VF** £80 ($120)

9308 — Rev. Bust of Zeus Ammon r., with ram's horn, crowned with horns and disk, L — Γ (= regnal year 3) in field. Dattari 5048. BMCG 2040. Cologne 2785. Milne 3615. *[AD 245–6]*. **F** £32 ($50) / **VF** £85 ($130)

9309 — Rev. Dikaiosyne stg. l., holding scales and cornucopiae, L Γ (= regnal year 3) before. Dattari 5023 var. (year 2). BMCG/Christiansen 3261. Cologne 2787. Milne 3607. *[AD 245–6]*. **F** £38 ($55) / **VF** £95 ($140)

9310 — Rev. Homonoia (= Concordia) stg. l., r. hand extended, holding double cornucopiae in l., L Γ (= regnal year 3) before. Dattari 5031. BMCG 2044. Cologne 2786. Milne 3596. *[AD 245–6]*. **F** £30 ($45) / **VF** £80 ($120)

9311 **Billon tetradrachm.** — Rev. Tyche (= Fortuna) stg. l., holding rudder and cornucopiae, L
Γ (= regnal year 3) before. Dattari 5043. BMCG 2047. Cologne —. Milne —. *[AD 245–6].*
F £30 ($45) / **VF** £80 ($120)

9312 — Rev. Tyche (= Fortuna) reclining l. on couch, holding rudder, L Γ (= regnal year 3)
above. Dattari 5045. BMCG —. Cologne 2788. Milne 3612. *[AD 245–6].*
F £32 ($50) / **VF** £85 ($130)

9313 — Rev. Eagle stg. l., hd. r., holding wreath in beak, L — Γ (= regnal year 3) in field.
Dattari 5050. BMCG 2051. Cologne 2784. Milne 3638. *[AD 245–6].*
F £30 ($45) / **VF** £80 ($120)

9314 M IOY ΦIΛIΠΠOC K CEB (or similar), bare-headed and cuir. bust r. Rev. Hermanubis stg. r.,
wearing modius, holding caduceus and palm, jackal at his feet behind, L — Δ (= regnal
year 4) in field. Dattari 5029. BMCG 2050. Cologne 2790. Milne 3676. *[AD 246–7].*
F £45 ($65) / **VF** £110 ($160)

9315 Obv. Similar. Rev. Triptolemos in car drawn r. by two winged serpents,scattering seed
from bag on l. arm, L Δ (= regnal year 4) before. Dattari 5041. BMCG 2041. Cologne —.
Milne 3643. *[AD 246–7].* **F** £50 ($75) / **VF** £115 ($175)

9316 — Rev. Tyche (= Fortuna) seated l., holding rudder and cornucopiae, L Δ (= regnal year 4)
before. Dattari 5044. BMCG 2048. Cologne 2793. Milne 3672. *[AD 246–7].*
F £30 ($45) / **VF** £80 ($120)

9317

9317 — Rev. Philip II on horseback pacing r., his r. hand raised, holding sceptre in l., L — Δ
(= regnal year 4) in field. Dattari 5016. BMCG 2052. Cologne 2791. Milne 3687.
[AD 246–7]. **F** £55 ($80) / **VF** £130 ($200)

As Augustus

9318 **Billon tetradrachm.** A K M IOY ΦIΛIΠΠOC EY CE, laur. and cuir. bust r. Rev. Tyche seated,
as 9316, L Δ (= regnal year 4) before. Dattari —. BMCG —. Cologne —. Milne 3689.
[AD 247]. **F** £40 ($60) / **VF** £100 ($150)

9319 A K M IOY ΦIΛIΠΠOC E (or EY or EY C or EY CE), laur., dr. and cuir. bust r. Rev.
Hermanubis stg. with jackal, as 9314, L — E (= regnal year 5) in field. Dattari 5054.
BMCG 2062. Cologne 2796. Milne 3722–3. *[AD 247–8].* **F** £45 ($65) / **VF** £110 ($160)

9320 Obv. Similar. Rev. Nilus reclining l., holding reed and cornucopiae, l. arm resting on
hippopotamus r. below, crocodile r. in ex., L — E (= regnal year 5) before. Dattari 5059.
BMCG 2064. Cologne —. Milne 3724–5. *[AD 247–8].* **F** £32 ($50) / **VF** £85 ($130)

9321 — Rev. Bust of Sarapis l., wearing modius, L E (= regnal year 5) before. Dattari 5060.
BMCG 2061. Cologne —. Milne —. *[AD 247–8].* **F** £38 ($55) / **VF** £95 ($140)

9322 **Billon tetradrachm.** Obv. As 9319. Rev. Tyche (= Fortuna) reclining on couch, as 9312, L
E (= regnal year 5) above. Dattari —. BMCG 2060. Cologne —. Milne —. *[AD 247–8]*.
F £40 ($60) / **VF** £100 ($150)

9323 — Rev. Homonoia (= Concordia) seated l., r. hand extended, holding double cornucopiae
in l., L E (= regnal year 5) before. Dattari 5057. BMCG 2059. Cologne 2799–2800. Milne
3706–7. *[AD 247–8]*. F £30 ($45) / **VF** £80 ($120)

9324 — Rev. Laur. bust of Zeus r., L — ϛ regnal year 6) in field. Dattari 5062. BMCG 2054.
Cologne 2804. Milne 3745–6. *[AD 248–9]*. F £30 ($45) / **VF** £80 ($120)

9325 — Rev. Zeus seated l., holding patera and sceptre, eagle at feet, L — ϛ regnal year 6) in
field. Dattari 5064. BMCG —. Cologne —. Milne —. *[AD 248–9]*.
F £32 ($50) / **VF** £85 ($130)

9326 — Rev. Zeus, holding patera and short sceptre, reclining l. on back of eagle l., hd. r., its
wings spread, L — ϛ regnal year 6) in field. Dattari 5065. BMCG —. Cologne —. Milne —.
[AD 248–9]. F £40 ($60) / **VF** £100 ($150)

9327 — Rev. Ares stg. l., resting on sceptre and holding parazonium, L — Z (= regnal year 7) in
field. Dattari 5052. BMCG —. Cologne —. Milne —. *[AD 249]*.
F £45 ($65) / **VF** £110 ($160)

9328 — Rev. Bust of Nilus r., crowned with lotus, cornucopiae before containing little genius
holding wreath, L — Z (= regnal year 7) in field. Dattari 5058. BMCG 2063. Cologne —.
Milne —. *[AD 249]*. F £40 ($60) / **VF** £100 ($150)

9329 **Bronze hemidrachm** (31–33 mm. diam). A K M ΙΟΥ ΦΙΛΙΠΠΟC EY (or EY C or EY CE or EY
CEB), laur., dr. and cuir. bust r. Rev. Bust of Athena l., wearing crested Corinthian helmet
and aegis, palm behind, L E (= regnal year 5) before. Dattari —. BMCG —. Cologne 2801.
Milne —. *[AD 248]*. F £130 ($200) / **VF** £300 ($450)

NB This exceptional issue of large Alexandrian bronzes is to be associated with the
celebration in AD 248 of Rome's thousandth anniversary.

9330 Obv. Similar. Rev. Conjoined busts r. of Sarapis, wearing modius, and Isis, wearing disk
and plumes, knot on breast, L — E (= regnal year 5) in field. Dattari 5068. BMCG —.
Cologne —. Milne —. *[AD 248]*. F £130 ($200) / **VF** £300 ($450)

9331 — Rev. Homonoia (= Concordia) stg. l., r. hand extended, holding double cornucopiae in
l., palm before, L E (= regnal year 5) behind. Dattari 2802 var. (without palm on rev).
BMCG 2067 var. (year 6) Cologne 2802. Milne 3744. *[AD 248]*.
F £100 ($150) / **VF** £230 ($350)

9332 — Rev. Serpent Agathodaemon l., enfolding caduceus, facing Uraeus snake r., with
sistrum, palm in ex., L ϛ regnal year 6) above. Dattari —. BMCG —. Cologne 2805. Milne
—. *[AD 248]*. F £130 ($200) / **VF** £300 ($450)

9333 — Rev. Alexandria, turreted, stg. l., holding bust of Sarapis and resting on sceptre, palm
before, L ϛ regnal year 6) behind. Dattari —. BMCG 2068. Cologne —. Milne —.
[AD 248]. F £115 ($175) / **VF** £265 ($400)

9334 — Rev. Asklepios stg. l., holding patera over altar and resting on snake-entwined staff,
palm behind, L ϛ regnal year 6) before. Dattari —. BMCG 2066. Cologne —. Milne —.
[AD 248]. F £115 ($175) / **VF** £265 ($400)

9335 **Bronze hemidrachm** — Rev. Zeus seated l., holding patera and sceptre, eagle at feet, little Nike on back of throne, palm behind, L — Ϛ regnal year 6) in field. Dattari —. BMCG 2065. Cologne —. Milne —. *[AD 248].* **F** £115 ($175) / **VF** £265 ($400)

9336 — Rev. Zeus, holding patera and sceptre, reclining l. on back of eagle l., its hd. r. and wings spread, palm behind, L Ϛ regnal year 6) before. Dattari —. BMCG —. Cologne —. Milne —. Emmett 3628. *[AD 248].* **F** £130 ($200) / **VF** £300 ($450)

9337 — Rev. Bust of Zeus Ammon r., with ram's horn, crowned with horns and disk, palm before, L — Ϛ regnal year 6) in field. Dattari 5070. BMCG —. Cologne 2806. Milne —. *[AD 248].* **F** £115 ($175) / **VF** £265 ($400)

9338 — Rev. Elpis (= Spes) advancing l., holding flower and lifting skirt, palm before, L — Ϛ (= regnal year 6) in field. Dattari 5066. BMCG —. Cologne —. Milne —. *[AD 248].* **F** £115 ($175) / **VF** £265 ($400)

9339 — Rev. Tyche (= Fortuna) stg. l., holding rudder and cornucopiae, palm behind, L Ϛ regnal year 6) before. Dattari —. BMCG —. Cologne —. Milne —. *[AD 248].* **F** £115 ($175) / **VF** £265 ($400)

9340 — Rev. Tyche (= Fortuna) reclining l. on couch, holding rudder, palm in ex., L Ϛ regnal year 6) above. Dattari 5069. BMCG —. Cologne —. Milne —. *[AD 248].* **F** £115 ($175) / **VF** £265 ($400)

9341 — Rev. Eagle stg. l., hd. r., holding wreath in beak, palm before, L Ϛ regnal year 6) behind. Dattari 5071. BMCG —. Cologne —. Milne —. *[AD 248].* **F** £115 ($175) / **VF** £265 ($400)

For other local coinages of Philip II, see *Greek Imperial Coins & Their Values*, pp. 390–99.

PHILIP II WITH PHILIP I AND OTACILIA SEVERA

9342 **Silver antoninianus.** IMP M IVL PHILIPPVS AVG, rad., dr. and cuir. bust of Philip II r. Rev. AVG PATRI AVG MATRI, laur., dr. and cuir. bust of Philip I r. facing diad. and dr. bust of Otacilia Severa l. RIC *Philip I* 30. RSC 1. Hunter, p. xc. *[Rome, AD 247].*
 VF £2,000 ($3,000) / **EF** £4,000 ($6,000)

NB See also no. 9132. A silver multiple (32 mm., 24.94 gm.) exists in Vienna, obv. M IVL PHILIPPVS NOBIL CAES, bare-headed and dr. bust of Philip II r., rev. CONCORDIA AVGVSTORVM, confronted busts of Philip I and Otacilia, as 9342 (RSC 2, Gnecchi I, p. 49, 1, RIC 222).

PACATIAN
ca. AD 248–249

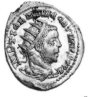

9347

Towards the end of AD 248, following the lavish celebrations in Rome on the occasion of the city's thousandth anniversary, two serious revolts broke out against the regime of Philip I and II in widely separated regions of the Empire. In Cappadocia and northern Syria the uprising was headed by a certain Jotapian, whilst on the northern frontier in Moesia Tiberius Claudius Marinus Pacatianus was proclaimed emperor by the mutinous Danubian legions. Greatly alarmed by these threats to his authority, Philip sent the general Decius to confront the northern rebels. He would have done better to have dealt with the emergency himself, for on the approach of Decius the rebels murdered their recently elevated leader and transferred their allegiance to the man sent against them. Gaius Messius Quintus Decius later claimed he had tried to decline the dubious honour, which may or may not be true, but despite its brevity the revolt of Pacatian led indirectly to the downfall of Philip and his son and the accession of Trajan Decius.

The coinage of Pacatian is composed entirely of silver antoniniani which are overstruck on the coins of earlier emperors. They are usually attributed to the Danubian mint of Viminacium which had recently become a colonia under Gordian III.

 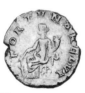

9343 9345

9343 **Silver antoninianus.** IMP TI CL MAR PACATIANVS P F AVG, rad., dr. and cuir. bust r. Rev. CONCORDIA MILITVM, Concordia seated l., holding patera and double cornucopiae. RIC 1b. RSC 1. Hunter, p. xciv. *[Viminacium, AD 248–9].*
　　　　　　　　　　　　　　　　F £1,000 ($1,500) / **VF** £2,300 ($3,500) / **EF** £5,000 ($7,500)

9344 Obv. Similar. Rev. FIDES MILITVM, Fides Militum stg. l. between two standards, holding two more, one in each hand. RIC 3. RSC 4. Cf. Hunter, p. xciv. *[Viminacium, AD 248–9].*
　　　　　　　　　　　　　　　　F £1,000 ($1,500) / **VF** £2,500 ($3,750) / **EF** £5,300 ($8,000)

9345 — Rev. FORTVNA REDVX, Fortuna seated l., holding rudder and cornucopiae, wheel below seat. RIC —. RSC —. Hunter 1. *[Viminacium, AD 248–9].*
　　　　　　　　　　　　　　　　F £1,000 ($1,500) / **VF** £2,500 ($3,750) / **EF** £5,300 ($8,000)

9346 Similar, but without P F in obv. legend. RIC 4. RSC 5. Hunter, p. xciv. *[Viminacium, AD 248–9].*　　　　　　　　**F** £1,000 ($1,500) / **VF** £2,300 ($3,500) / **EF** £5,000 ($7,500)

9347 Obv. As previous. Rev. PAX AETERNA, Pax stg. l., holding olive-branch and transverse sceptre. RIC 5. RSC 6a. Cf. Hunter 2. *[Viminacium, AD 248–9].*
　　　　　　　　　　　　　　　　F £1,000 ($1,500) / **VF** £2,500 ($3,750) / **EF** £5,300 ($8,000)

9348 Similar, but obv. as 9343. RIC 5. RSC 6b. Cf. Hunter 2. *[Viminacium, AD 248–9].*
　　　　　　　　　　　　　　　　F £1,000 ($1,500) / **VF** £2,300 ($3,500) / **EF** £5,000 ($7,500)

9349 **Silver antoninianus.** Obv. As 9346. Rev. ROMAE AETER AN MIL ET PRIMO, Roma seated l., holding Victory and spear, shield below seat. Cf. RIC 6 (MILL for MIL on rev). Cf. RSC 7. Cf. Hunter, p. xciv. *[Viminacium, AD 248–9].*
<div align="right">**F** £2,000 ($3,000) / **VF** £5,000 ($7,500) / **EF** £10,000 ($15,000)</div>
Although the reverse legend is always quoted with "MILL" instead of "MIL" Cohen's illustration clearly shows the shorter abbreviation. This remarkable type establishes beyond doubt the precise date of Pacatian's revolt — "to the thousand and first year of Eternal Rome".

JOTAPIAN
ca. AD 248–249

9350

The revolt in northern Syria and Cappadocia against Philip I and II seems to have occurred at about the same time as Pacatian's uprising on the Danubian frontier. Little is known of its leader, Marcus Fulvius Rufus Iotapianus, but it appears to have been in response to the oppressive administration in the East of the emperor's brother Priscus. But whatever its cause the rebellion of Jotapian was of short duration, probably ending in the early part of AD 249 when the usurper was murdered by his own soldiers. Perhaps the eastern legions quickly became aware of their leader's incompetence and feared the retribution of the imperial government.

The extremely rare coinage of Jotapian is of antoniniani only, all having Victory as their reverse type. The mint is quite uncertain, though presumably it was located somewhere in northern Syria or Cappadocia.

9350 **Silver antoninianus.** IM C M F RV IOTAPIANVS (or similar), rad. and cuir. bust r. Rev. VICTORIA AVG, Victory advancing l., holding wreath and palm. Cf. RIC 2c. RSC 2. Hunter, p. xcv. *[Syria or Cappadocia, AD 248–9].*
<div align="right">**F** £2,000 ($3,000) / **VF** £5,000 ($7,500) / **EF** £10,000 ($15,000)</div>

9351 Similar, but with Victory advancing r. RIC 1. RSC 3. Hunter, p. xcv. *[Syria or Cappadocia, AD 248–9].* **F** £2,300 ($3,500) / **VF** £6,000 ($9,000) / **EF** £12,000 ($18,000)

TRAJAN DECIUS
Sep. AD 249-Jun./Jul. 251

9366

Gaius Messius Quintus Decius, of noble Italian ancestry on his mother's side, was born probably in the final decade of the 2nd century in the Pannonian village of Budalia near Sirmium. He achieved senatorial rank and probably served as governor of both Nearer Spain and Lower Moesia, though the epigraphic record is not entirely clear on this point. He was city prefect of Rome in the latter part of Philip's reign and counselled the emperor not to abdicate when provincial rebellions broke out in the latter part of AD 248. He was then appointed to the command of the Danubian legions, the loyalty of which was suspect in the aftermath of Pacatian's revolt.

Having achieved success against the Gothic invaders of the region the inevitable result was Decius' proclamation as emperor by his troops. Although reputedly reluctant to accept the honour he nevertheless advanced against Philip's forces in northern Italy and defeated the emperor and his son at Verona (September 249). Confirmed by the senate the following month, Decius was honoured by his former colleagues with the illustrious additional name of Trajan, the emperor who, a century and a half before, had added Dacia to the territory of the Empire and who had always maintained excellent relations with the senate. The principal theme of Trajan Decius' 21-month reign was reverence for Rome's illustrious past and a desire to restore the old virtues which had made her great. In this connection he issued a remarkable series of silver antoniniani commemorating eleven of the imperial 'Divi' (deified emperors) from Augustus to Severus Alexander, even though the latter had in fact never received official recognition as a god. A byproduct of this promotion of the imperial cult was a rigorous persecution of the Christians in which Pope Fabian, amongst many others, was martyred. However, barbarian pressure on the Empire's northern frontier remained relentless and the Danube was crossed by the Goths, under Kniva, whilst the Carpi attacked Dacia. Leaving the future emperor Valerian in charge in Rome Decius and his elder son Herennius Etruscus (appointed Caesar in the summer of AD 250) advanced against the invaders. The emperor achieved some initial success, which was marked by the further elevation of Etruscus to full imperial status, but he failed in his attempt to prevent the Goths from devastating Thrace. His plan was to confront the barbarians on their return home laden with booty, but due to recklessness, possibly on the part of the general Trebonianus Gallus, the resulting battle was an unmitigated disaster for Rome. For the first time in the history of the Empire an emperor of Rome fell in combat against a foreign enemy. Decius' son, the recently promoted Herennius Etruscus, also perished and the remnants of the Roman army proclaimed Trebonianus Gallus emperor in succession to the fallen rulers.

The coinage of this short reign is of considerable interest. Much emphasis was placed on the commemoration of the Danubian provinces of the two Pannonias (Inferior and Superior) and Dacia as well as "the Spirit of the Army of Illyricum". A remarkable innovation was the introduction of a large double sestertius. This was distinguished by the emperor's radiate bust and a corresponding crescent behind the empress's shoulders on coins of Herennia Etruscilla. The double sestertius was abandoned by Decius' immediate successors though it was revived a decade later by the Gallic usurper Postumus. Decius also struck an enigmatic small bronze coin which is usually described as a semis, though this denomination had not been issued since Hadrianic times. In addition to the coinage of Trajan Decius himself issues were made in the names of his wife Herennia Etruscilla, his elder son Herennius Etruscus (first as Caesar, then as Augustus) and his younger son Hostilian who was made Caesar late in AD 250. There are later issues of Hostilian on which he is accorded the rank of Augustus, but these belong to the reign of Decius' successor Trebonianus Gallus.

As under his predecessors, Rome was the principal mint for the production of coinage throughout the reign of Trajan Decius. The only coins which can assuredly be given to a provincial minting establishment are antoniniani with dots or numerals below the obverse bust or in the exergue on reverse. As this system of officina differentiation was also employed on the tetradrachms of Antioch it seems safe to attribute these scarce antoniniani to the Syrian capital.

There are six varieties of obverse legend:

A. IMP C M Q TRAIANVS DECIVS AVG
B. IMP CAE TRA DEC AVG
C. IMP CAE TRA DECIVS AVG
D. IMP CAES C MESS Q DECIO TRAI AVG
E. IMP CAES C MESS TRAI Q DECIO AVG
F. IMP TRAIANVS DECIVS AVG

The normal obverse type for antoniniani, double sestertii and dupondii is radiate bust of Trajan Decius right. All other denominations have laureate bust right. The bust of Trajan Decius is usually depicted draped and cuirassed, though the drapery is sometimes only slightly indicated on the left shoulder giving the portrait the appearance of being cuirassed only.

9352 **Gold aureus.** A. Rev. ABVNDANTIA AVG, Abundantia stg. r., emptying cornucopiae held with both hands. RIC 10a. C 1. Hunter, p. xcvii. *[Rome, AD 250–51].*
VF £1,000 ($1,500) / **EF** £3,000 ($4,500)

NB Under Trajan Decius the weight of the aureus declined to an average level of 4.19 grams, though individual specimens may vary considerably.

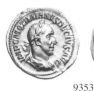

9353 9357

9353 A. Rev. ADVENTVS AVG, Trajan Decius on horseback pacing l., his r. hand raised, holding sceptre in l. RIC 11a. C 3. Hunter 5. *[Rome, AD 250].*
VF £1,100 ($1,650) / **EF** £3,300 ($5,000)

9354 F. Rev. DACIA, Dacia stg. l., holding Dacian standard surmounted by wolf's hd. (*draco*). RIC 2a. C 12. Hunter, p. xcvi. *[Rome, AD 249].* **VF** £1,350 ($2,000) / **EF** £4,000 ($6,000) *The staff held by the personification of the province of Dacia has traditionally been described as "surmounted by ass's head". I am indebted to Mr. Alexandru Marian of Romania for the correct identification of the 'draco', the Dacian battle standard which was decorated with a wolf's head and the tail of a 'dragon'.*

9355 A. Rev. DACIA FELIX, Dacia stg. l., holding Roman standard. RIC 14a. C 31. Hunter, p. xcvii. *[Rome, AD 251].* **VF** £1,500 ($2,250) / **EF** £4,300 ($6,500)

9356 A. Rev. GEN ILLVRICI, Genius of Illyricum stg. l., holding patera and cornucopiae. RIC 15a. Cf. C 70. Hunter, p. xcvii. *[Rome, AD 251].* **VF** £1,850 ($2,750) / **EF** £5,000 ($7,500)

9357 A. Rev. GENIVS EXERC ILLVRICIANI, Genius of the Army of Illyricum stg. l., holding patera and cornucopiae, standard behind. RIC 16a. C 48. Hunter 9. *[Rome, AD 250–51].*
VF £1,250 ($1,850) / **EF** £3,700 ($5,500)

9358 Similar, but with obv. legend F and EXERCITVS for EXERC on rev. RIC 4a. C 62. Hunter, p. xcvi. *[Rome, AD 249].* **VF** £1,350 ($2,000) / **EF** £4,000 ($6,000)

9359 F. Rev. PANNONIAE, Pannonia stg. facing, hd. r., her r. hand raised, holding legionary eagle in l. RIC —. C —. Hunter —. *[Rome, AD 249].*
VF £2,300 ($3,500) / **EF** £6,000 ($9,000)

9360 A. Rev. — the two Pannoniae stg. side by side, their hds. turned away from one another, each raising r. hand, the one on r. holding standard, the other with standard beside her to l. RIC 21a. C 85. Hunter 15. *[Rome, AD 250–51].* **VF** £1,250 ($1,850) / **EF** £3,700 ($5,500)

9361 A. Rev. VBERITAS AVG, Uberitas stg. l., holding cow's udder (?) and cornucopiae. RIC 28. C 104. Hunter 19. *[Rome, AD 250–51].* **VF** £1,000 ($1,500) / **EF** £3,000 ($4,500)

9362 F. Rev. VICTORIA AVG, Victory advancing l., holding wreath and palm. RIC 7a. C 108. Hunter, p. xcvi. *[Rome, AD 249].* **VF** £1,250 ($1,850) / **EF** £3,700 ($5,500)

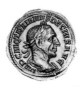

9361 9362

9363 **Gold aureus.** Similar, but with obv. legend A. RIC 29a. C 107. Hunter, p. xcvii. *[Rome,*
 AD 250–51]. **VF** £1,100 ($1,650) / **EF** £3,300 ($5,000)

9364 **Silver antoninianus.** A. Rev. **ABVNDANTIA AVG**, Abundantia emptying cornucopiae, as
 9352. RIC 10b. RSC 2. Hunter 14. *[Rome, AD 250–51].* **VF** £14 ($20) / **EF** £32 ($50)

 NB Under Trajan Decius the fineness of the antoninianus ranges from about 47% at the
 outset of the reign down to only 41% in some subsequent issues. The average weight also
 declines, from about 4 grams down to 3.60 grams.

9365 F. Rev. **ADVENTVS AVG**, Trajan Decius on horseback, as 9353. RIC 1b. RSC 6. Hunter 2.
 [Rome, AD 249]. **VF** £16 ($25) / **EF** £45 ($65)

9366 Similar, but with obv. legend A. RIC 11b. RSC 4. Hunter 6. *[Rome, AD 250].*
 VF £15 ($22) / **EF** £38 ($55)

9367 A (sometimes with dots below bust). Rev. **AEQVITAS AVG** (sometimes **AVGG**), Aequitas
 stg. l., holding scales and cornucopiae. RIC 44–5. RSC 9–9b. Hunter, p. xcviii. *[Antioch,*
 AD 250–51]. **VF** £25 ($40) / **EF** £65 ($100)

9368

9368 A. Rev. **DACIA**, Dacia stg. l., holding Dacian standard surmounted by wolf's hd. (*draco*).
 RIC 12b. RSC 16. Hunter 7. *[Rome, AD 250–51].* **VF** £15 ($22) / **EF** £38 ($55)
 See note following no. 9354.

9369 B. Rev. — Dacia stg. l., holding Roman standard. RIC 36a. RSC 25. Hunter, p. xcviii.
 [Rome, AD 251]. **VF** £22 ($35) / **EF** £55 ($85)

9370 Similar, but with obv. legend C. RIC 36b. RSC 26. Hunter, p. xcviii. *[Rome, AD 251].*
 VF £22 ($35) / **EF** £55 ($85)

9371 B. Rev. **DACIA FELIX**, type as previous. RIC 37b. RSC 33. Hunter 21. *[Rome, AD 251].*
 VF £20 ($30) / **EF** £50 ($75)

9372 A. Rev. **GEN ILLVRICI**, Genius of Illyricum stg., as 9356. RIC 15b. RSC 46. Hunter,
 p. xcvii. *[Rome, AD 251].* **VF** £16 ($25) / **EF** £45 ($65)

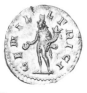

9371 9372

9373 **Silver antoninianus.** Similar, but with obv. legend B. RIC 38a. RSC 43. Hunter 23.
[Rome, AD 251]. **VF** £20 ($30) / **EF** £50 ($75)

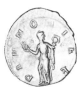

9374 9376

9374 A. Rev. GENIVS EXERC (sometimes EXERCITVS) ILLVRICIANI, Genius of the Army of
Illyricum stg. l., holding patera and cornucopiae, standard behind. RIC 16c, 18. RSC 49,
64. Hunter 11. *[Rome, AD 250–51]*. **VF** £15 ($22) / **EF** £38 ($55)

9375 Similar (with EXERC), but the standard is to l. of Genius who is sacrificing at altar. RIC 17b.
RSC 56. Hunter 10. *[Rome, AD 250]*. **VF** £16 ($25) / **EF** £45 ($65)

9376 F. Rev. PANNONIAE, Pannonia stg. facing, hd. r., her r. hand raised, holding standard in l.
RIC 5. RSC 79. Hunter, p. xcvi. *[Rome, AD 249]*. **VF** £16 ($25) / **EF** £45 ($65)

9377 Similar, but with obv. legend A. RIC 20. RSC 80. Hunter 12. *[Rome, AD 250]*.
VF £16 ($25) / **EF** £45 ($65)

9378 9380

9378 A. Rev. — the two Pannoniae with two standards, as 9360. RIC 21b. RSC 86. Hunter 16.
[Rome, AD 250–51]. **VF** £15 ($22) / **EF** £38 ($55)

9379 A. Rev. — the two Pannoniae stg. facing each other, clasping r. hands, standard in
background between them. RIC 26. RSC 81. Hunter, p. xcvii. *[Rome, AD 251]*.
VF £16 ($25) / **EF** £45 ($65)

9380 Similar, but with obv. legend B. RIC 41a. RSC 82. Hunter 24. *[Rome, AD 251]*.
VF £20 ($30) / **EF** £50 ($75)

9381 9384

9381 **Silver antoninianus.** F. Rev. **PAX AVGVSTI**, Pax stg. l., holding olive-branch and transverse
 sceptre. RIC 6. RSC 91. Hunter 3. *[Rome, AD 249].* **VF** £16 ($25) / **EF** £45 ($65)

9382 A (sometimes with dot or dots below bust). Rev. **PVDICITIA AVG**, Pudicitia seated l.,
 drawing veil from face and holding transverse sceptre. RIC 46. RSC 98, 98a. Hunter 58.
 [Antioch, AD 250–51]. **VF** £32 ($50) / **EF** £80 ($120)

9383 Obv. Similar. Rev. **ROMAE AETERNAE**, Roma seated l., holding Victory and spear, shield at
 side. RIC 47. RSC 99. Hunter, p. xcviii. *[Antioch, AD 250–51].*
 VF £32 ($50) / **EF** £80 ($120)

9384 A. Rev. **VBERITAS AVG**, Uberitas stg., as 9361. RIC 28b. RSC 105. Hunter 20. *[Rome,*
 AD 250–51]. **VF** £14 ($20) / **EF** £32 ($50)

9385 Similar, but with **VERITAS** (*sic*) for **VBERITAS**. RIC 28b, note. RSC 106. Hunter 59.
 [Antioch, AD 250–51]. **VF** £25 ($40) / **EF** £65 ($100)

9386 F. Rev. **VICTORIA AVG**, Victory advancing, as 9362. RIC 7c. RSC 111. Hunter, p. xcvi.
 [Rome, AD 249]. **VF** £16 ($25) / **EF** £40 ($60)

9387

9387 Similar, but with obverse legend A. RIC 29c. RSC 113a. Hunter 13. *[Rome, AD 250].*
 VF £14 ($20) / **EF** £32 ($50)

9388 C. Rev. **VICTORIA GERMANICA**, Trajan Decius on horseback pacing l., his r. hand raised,
 holding sceptre in l., preceded by Victory walking l., holding wreath and palm. Cf. RIC 43.
 RSC 122. Hunter 26. *[Rome, AD 251].* **VF** £130 ($200) / **EF** £300 ($450)

9389 F. Rev. **VIRTVS AVG**, Virtus seated l. on cuirass, holding branch and sceptre (or spear).
 RIC 8. RSC 123. Hunter 4. *[Rome, AD 249].* **VF** £16 ($25) / **EF** £45 ($65)

9390 A. Rev. **VOTIS / DECEN / NALI / BVS** in four lines within laurel-wreath. RIC 29c. RSC 113a.
 Hunter 13. *[Rome, AD 250].* **VF** £170 ($250) / **EF** £400 ($600)

9391 **Silver denarius.** As 9357 (rev. **GENIVS EXERC ILLVRICIANI**, Genius with standard). Cf.
 RIC 16b. RSC 51b. Hunter, p. xcvii. *[Rome, AD 250–51].*
 VF £2,500 ($3,750) / **EF** £5,000 ($7,500)

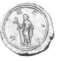

9392

9392 **Silver quinarius.** A. Rev. DACIA, Dacia stg. l., holding Dacian standard surmounted by wolf's hd. (*draco*). RIC 12a. RSC 17. Hunter, p. xcvi. *[Rome, AD 250–51].*

VF £750 ($1,100) / EF £1,500 ($2,250)

See note following no. 9354.

9393 A (but second M omitted). Rev. GENIVS EXERC ILLVRICIANI, Genius sacrificing, as 9375. RIC 17a. RSC 58. Hunter, p. xcvii. *[Rome, AD 250].*

VF £750 ($1,100) / EF £1,500 ($2,250)

9394 A. Rev. VICTORIA AVG, Victory advancing l., as 9362. RIC 29b. RSC 112a. Hunter, p. xcvii. *[Rome, AD 250].*

VF £750 ($1,100) / EF £1,500 ($2,250)

9395

9395 **Bronze double sestertius.** A. Rev. FELICITAS SAECVLI S C, Felicitas stg. l., holding long caduceus and cornucopiae. RIC 115a-c. C 39, 40. Hunter 46. *[Rome, AD 250].*

F £200 ($300) / VF £600 ($900) / EF £2,700 ($4,000)

9396 A. Rev. LIBERALITAS AVG S C, Trajan Decius and Herennius Etruscus seated l. on curule chairs atop platform, Liberalitas stg. l. before them, holding abacus and cornucopiae, citizen mounting steps of platform about to receive largess. RIC 122. C 74. Hunter, p. xcvii. *[Rome, AD 250].* F £800 ($1,200) / VF £2,700 ($4,000) / EF £8,000 ($12,000)

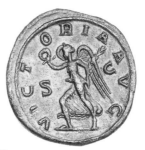

9397

9397 **Bronze double sestertius.** A. Rev. VICTORIA AVG S C, Victory advancing l., holding
wreath and palm. RIC 126a-c. C 114, 115. Hunter, p. xcvii. *[Rome, AD 250].*
F £200 ($300) / VF £600 ($900) / EF £2,700 ($4,000)

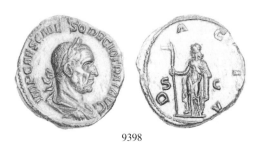

9398

9398 **Bronze sestertius.** D. Rev. DACIA S C, Dacia stg. l., holding Dacian standard surmounted
by wolf's hd. (*draco*). RIC 101a, b. C 22. Hunter, p. xcvi. *[Rome, AD 249].*
F £38 ($55) / VF £95 ($140) / EF £300 ($450)
See note following no. 9354.

9399 Similar, but with obv. legend A. RIC 112a, b. C 18. Hunter 32. *[Rome, AD 250–51].*
F £32 ($50) / VF £80 ($120) / EF £265 ($400)

9400 Similar, but Dacia holds Roman instead of Dacian standard. RIC 113a, b. C 28. Hunter,
p. xcvii. *[Rome, AD 251].* F £38 ($55) / VF £95 ($140) / EF £300 ($450)

9401 Similar, but with rev. legend DACIA FELIX S C. RIC 114a, b. C 35. Hunter 45. *[Rome,
AD 251].* F £38 ($55) / VF £95 ($140) / EF £300 ($450)

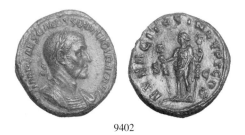

9402

9402 D. Rev. EXERCITVS INLVRICVS S C, Fides Militum stg. l., holding standard in each hand.
RIC 102a, b. C 37. Hunter, p. xcvi. *[Rome, AD 249].*
F £65 ($100) / VF £170 ($250) / EF £500 ($750)

9403 A. Rev. GEN ILLVRICI S C, Genius of Illyricum stg. l., holding patera and cornucopiae.
RIC 116a, b. C 47. Hunter 48. *[Rome, AD 251].*
F £38 ($55) / VF £95 ($140) / EF £300 ($450)

9404 A. Rev. GENIVS EXERC (sometimes EXERCITVS) ILLVRICIANI S C, Genius of the Army of
Illyricum stg. l., holding patera and cornucopiae, standard behind. RIC 117a-b, 119a-b.
C 53, 66. Hunter 34. *[Rome, AD 250–51].* F £32 ($50) / VF £80 ($120) / EF £265 ($400)

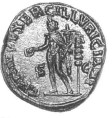

9404

9405 **Bronze sestertius.** E. Rev. — (EXERC), similar, but the standard is to l. of Genius who is sacrificing at altar. RIC 104a, b. C 59. Hunter, p. xcvi. *[Rome, AD 249]*.

 F £38 ($55) / **VF** £95 ($140) / **EF** £300 ($450)

9406

9406 A. Rev. **LIBERALITAS AVG S C**, Trajan Decius seated l. on curule chair atop platform, accompanied by officer stg. behind, Liberalitas stg. l. before him, holding abacus and cornucopiae, citizen mounting steps of platform about to receive largess. RIC 121. C 75. Hunter — (but cf. 53). *[Rome, AD 250]*.

 F £100 ($150) / **VF** £250 ($375) / **EF** £750 ($1,100)

9407

9407 A. Rev. **PANNONIAE S C**, the two Pannoniae stg. side by side, their hds. turned away from one another, each raising r. hand, the one on r. holding standard, the other with standard beside her to l. RIC 124a. C 87. Hunter 54. *[Rome, AD 250–51]*.

 F £32 ($50) / **VF** £80 ($120) / **EF** £265 ($400)

9408 D. Rev. **PAX AVGVSTI S C**, Pax stg. l., holding olive-branch and transverse sceptre. RIC 107a, b. C 94, 95. Hunter 28. *[Rome, AD 249]*.

 F £38 ($55) / **VF** £95 ($140) / **EF** £300 ($450)

9409

9409 **Bronze sestertius.** D. Rev. VICTORIA AVG S C, Victory advancing l., holding wreath and palm. RIC 108a. C 120. Hunter, p. xcvi. *[Rome, AD 249].*
F £38 ($55) / **VF** £95 ($140) / **EF** £300 ($450)

9410 Similar, but with obv. legend A. RIC 126d. C 117. Hunter 40. *[Rome, AD 250].*
F £32 ($50) / **VF** £80 ($120) / **EF** £265 ($400)

9411

9411 A. Rev. VIRTVS AVG S C, Virtus seated l. on cuirass, holding branch and sceptre (or spear). RIC 127. C 124. Hunter, p. xcvii. *[Rome, AD 250].*
F £38 ($55) / **VF** £95 ($140) / **EF** £300 ($450)

9412 D. Rev. VOTIS / DECENNA / LIBVS / S C in four lines within laurel-wreath. RIC 110a. C 130. Hunter 31. *[Rome, AD 249].* F £60 ($90) / **VF** £150 ($225) / **EF** £450 ($675)

9413 **Bronze dupondius.** A. Rev. DACIA S C, Dacia stg. l., holding Dacian standard surmounted by wolf's hd. (*draco*). RIC 112e, f. C 20. Hunter 33. *[Rome, AD 250–51].*
F £40 ($60) / **VF** £100 ($150) / **EF** £320 ($475)
See note following no. 9354.

9414 Similar, but Dacia holds Roman instead of Dacian standard. RIC —. C —. Hunter 43. *[Rome, AD 251].* F £55 ($80) / **VF** £130 ($200) / **EF** £400 ($600)

9415 A. Rev. GENIVS EXERC ILLVRICIANI S C, Genius of the Army of Illyricum stg. l., holding patera and cornucopiae, standard behind. RIC 117d, e. C 55. Hunter 36. *[Rome, AD 250–51].* F £40 ($60) / **VF** £100 ($150) / **EF** £320 ($475)

9416 Similar, but the standard is to l. of Genius who is sacrificing at altar. RIC 118c. C 61. Hunter, p. xcvii. *[Rome, AD 250].* F £45 ($65) / **VF** £110 ($160) / **EF** £330 ($500)

9415 9428

9417 **Bronze dupondius.** Similar to 9415, but with obv. legend D and EXERCITVS for EXERC on rev. RIC 105c. C 68. Hunter, p. xcvi. *[Rome, AD 249].*
 F £45 ($65) / **VF** £110 ($160) / **EF** £330 ($500)

9418 A. Rev. LIBERALITAS AVG S C, Liberalitas stg. l., holding abacus and cornucopiae. RIC 120c. C 72. Hunter 49. *[Rome, AD 250].* F £38 ($55) / **VF** £95 ($140) / **EF** £300 ($450)

9419 A. Rev. PANNONIAE S C, the two Pannoniae stg., as 9407. RIC 124d. C 89. Hunter, xcvii. *[Rome, AD 250–51].* F £40 ($60) / **VF** £100 ($150) / **EF** £320 ($475)

9420 D. Rev. VICTORIA AVG S C, Victory advancing l., as 9409. RIC 108b. C 121. Hunter, p. xcvi. *[Rome, AD 249].* F £45 ($65) / **VF** £110 ($160) / **EF** £330 ($500)

9421 **Bronze as.** As 9398 (obv. D, rev. DACIA S C, Dacia with wolf's hd. standard). RIC 101c. C 23. Hunter, p. xcvi. *[Rome, AD 249].* F £40 ($60) / **VF** £100 ($150) / **EF** £320 ($475)

9422 Similar, but with obv. legend A. RIC 112c, d. C 19. Hunter, p. xcvi. *[Rome, AD 250–51].*
 F £38 ($55) / **VF** £95 ($140) / **EF** £300 ($450)

9423 Similar, but Dacia holds Roman instead of Dacian standard. RIC 113c, d. C 29. Hunter, p. xcvii. *[Rome, AD 251].* F £40 ($60) / **VF** £100 ($150) / **EF** £320 ($475)

9424 Similar, but with rev. legend DACIA FELIX S C. RIC 114c. C 36. Hunter, p. xcvii. *[Rome, AD 251].* F £55 ($80) / **VF** £130 ($200) / **EF** £400 ($600)

9425 As 9402 (rev. EXERCITVS INLVRICVS, Fides Militum stg.). RIC 102c, d. C 38. Hunter 27. *[Rome, AD 249].* F £60 ($90) / **VF** £150 ($225) / **EF** £450 ($675)

9426 A. Rev. GENIVS EXERC ILLVRICIANI S C, Genius of the Army of Illyricum stg. l., holding patera and cornucopiae, standard behind. RIC 117c. C 54. Hunter 38. *[Rome, AD 250–51].*
 F £38 ($55) / **VF** £95 ($140) / **EF** £300 ($450)

9427 Similar, but the standard is to l. of Genius who is sacrificing at altar. RIC 118b. C 60. Hunter 39. *[Rome, AD 250].* F £40 ($60) / **VF** £100 ($150) / **EF** £320 ($475)

9428 A. Rev. LIBERALITAS AVG S C, Liberalitas stg., as 9418. RIC 120a, b. C 71. Hunter 52. *[Rome, AD 250].* F £38 ($55) / **VF** £95 ($140) / **EF** £300 ($450)

9429 As 9407 (rev. PANNONIAE S C, the two Pannoniae stg.). RIC 124b, c. C 88. Hunter, p. xcvii. *[Rome, AD 250–51].* F £38 ($55) / **VF** £95 ($140) / **EF** £300 ($450)

9430 A. Rev. VICTORIA AVG S C, Victory advancing l., as 9409. RIC 126e, f. C 118. Hunter 41. *[Rome, AD 250].* F £38 ($55) / **VF** £95 ($140) / **EF** £300 ($450)

9431 D. Rev. VIRTVS AVG S C, Virtus seated on cuirass, as 9411. RIC 109b. C 128. Hunter, p. xcvi. *[Rome, AD 249].* F £40 ($60) / **VF** £100 ($150) / **EF** £320 ($475)

9432 **Bronze as.** E. Rev. VOTIS / DECENNA / LIBVS / S C in four lines within laurel-wreath. RIC 110c. C 132. Hunter, p. xcvi. *[Rome, AD 249].*
F £60 ($90) / **VF** £150 ($225) / **EF** £450 ($675)

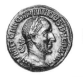

9433

9433 **Bronze semis.** A. Rev. S C, Mars stg. l., resting on shield and spear. RIC 128. C 102. Hunter 55. *[Rome, AD 250].* **F** £25 ($40) / **VF** £65 ($100) / **EF** £230 ($350)

NB This enigmatic revival of an obscure *aes* denomination has occasioned some scholarly debate. As its issue appears to be linked with the new double sestertius it has been suggested that Trajan Decius was attempting to counter inflation by readjusting the Augustan monetary system to take into account the new reality of reduced weight standards and metallic fineness. David Vagi (*Coinage and History of the Roman Empire*, Vol. I, p. 335) has even suggested that the new 'semis' should in fact be regarded as an as on a greatly reduced weight standard. If this is so then the experiment was quickly abandoned as in subsequent issues the as reverted to its old standard and the double sestertius ceased to be produced.

Alexandrian Coinage

9434 **Billon tetradrachm.** A K Γ M K TPAIANOC ΔEKIOC EV (or similar), laur., dr. and cuir. bust r. Rev. Alexandria, turreted, stg. l., her r. hand raised, holding sceptre in l., L — A (= regnal year 1) in field. Dattari 5072. BMCG 2082. Cologne 2809. Milne 3808. *[AD 249–50].*
F £30 ($45) / **VF** £75 ($110)

9435 Obv. Similar. Rev. Asklepios stg. l., holding patera over altar and resting on snake-entwined staff, L — A (= regnal year 1) in field. Dattari 5073. BMCG 2072. Cologne 2811. Milne 3791. *[AD 249–50].* **F** £32 ($50) / **VF** £80 ($120)

9436 — Rev. Athena seated l., holding Nike and sceptre, L — A (= regnal year 1) in field. Dattari 5075. BMCG 2071. Cologne 2812. Milne 3788. *[AD 249–50].*
F £25 ($40) / **VF** £65 ($100)

9437 — Rev. Bust of Hermanubis r., wearing modius, taenia and lotus-petal, combined caduceus and palm-branch before, L A (= regnal year 1) behind. Dattari 5080. BMCG 2081. Cologne —. Milne 3806. *[AD 249–50].* **F** £38 ($55) / **VF** £95 ($140)

9438 — Rev. Bust of Isis r., wearing disk and plumes, knot on breast, L — A (= regnal year 1) in field. Dattari —. BMCG —. Cologne —. Milne —. Emmett 3641. *[AD 249–50].*
F £45 ($65) / **VF** £110 ($160)

9439 — Rev. Rev. Sarapis stg. facing, hd. r., wearing modius and resting on sceptre held in r. hand, L — A (= regnal year 1) in field. Dattari 5087. BMCG 2079. Cologne 2814. Milne 3802. *[AD 249–50].* **F** £25 ($40) / **VF** £65 ($100)

9440 **Billon tetradrachm.** Similar, but with obv. legend A K Γ M K ΔEKIOC TPAIANOC EV. Dattari 5088. BMCG —. Cologne —. Milne 3786. *[AD 249]*. **F** £32 ($50) / **VF** £85 ($130)

9441 Obv. As 9434. Rev. Bust of Zeus Ammon r., with ram's horn, crowned with horns and disk, L — A (= regnal year 1) in field. Dattari 5093. BMCG 2069. Cologne —. Milne 3800. *[AD 249–50]*. **F** £30 ($45) / **VF** £75 ($110)

9442 — Rev. Nike (= Victory) advancing r., holding wreath and palm, L — A (= regnal year 1) in field. Dattari 5083. BMCG 2076. Cologne 2813. Milne 3797. *[AD 249–50]*.
 F £25 ($40) / **VF** £65 ($100)

9443 — Rev. Nike (= Victory) seated l. on cuirass, holding wreath and palm, L A (= regnal year 1) before. Dattari 5086. BMCG —. Cologne —. Milne —. *[AD 249–50]*.
 F £32 ($50) / **VF** £85 ($130)

9444 — Rev. Eagle stg. l., hd. r., wings closed, holding wreath in beak, L — A (= regnal year 1) in field. Dattari 5096. BMCG 2083. Cologne 2808. Milne 3812. *[AD 249–50]*.
 F £25 ($40) / **VF** £65 ($100)

9445 Similar, but obv. legend as 9440. Dattari 5097. BMCG —. Cologne —. Milne 3787. *[AD 249]*. **F** £32 ($50) / **VF** £85 ($130)

9446 A K Γ M K TPAIANOC ΔEKIOC EV (or similar), laur. and cuir. bust r. Rev. Rad. bust of Helios r., L — B (= regnal year 2) in field. Dattari 5079. BMCG 2070. Cologne —. Milne 3817. *[AD 250–51]*. **F** £30 ($45) / **VF** £75 ($110)

9447 Obv. Similar. Rev. Sarapis seated l., wearing modius, his r. hand outstretched, holding sceptre held in l., Kerberos at his feet, little Nike on back of throne, L — B (= regnal year 2) in field. Dattari 5089. BMCG —. Cologne —. Milne 3832. *[AD 250–51]*.
 F £32 ($50) / **VF** £85 ($130)

9448 — Rev. Laur. bust of Zeus r., L — B (= regnal year 2) in field. Dattari 5092. BMCG —. Cologne —. Milne —. *[AD 250–51]*. **F** £32 ($50) / **VF** £85 ($130)

9449 — Rev. Dikaiosyne (= Aequitas) seated l., holding scales and cornucopiae, L — B (= regnal year 2) in field. Dattari 5076. BMCG 2073. Cologne 2818. Milne 3819. *[AD 250–51]*.
 F £25 ($40) / **VF** £65 ($100)

9450 — Rev. Eirene (= Pax) stg. l., holding olive-branch and transverse sceptre, L — B (= regnal year 2) in field. Dattari 5077. BMCG/Christiansen 3271. Cologne —. Milne 3821. *[AD 250–51]*. **F** £30 ($45) / **VF** £75 ($110)

9451 — Rev. Elpis (= Spes) advancing l., holding flower and lifting skirt, L — B (= regnal year 2) in field. Dattari 5078. BMCG 2074. Cologne 2819. Milne 3823. *[AD 250–51]*.
 F £25 ($40) / **VF** £65 ($100)

9452 — Rev. Homonoia (= Concordia) seated l., her r. hand raised, holding double cornucopiae in l., L — B (= regnal year 2) in field. Dattari 5082. BMCG 2075. Cologne —. Milne 3827. *[AD 250–51]*. **F** £25 ($40) / **VF** £65 ($100)

9453 — Rev. Tyche (= Fortuna) reclining l. on couch, holding rudder, L B (= regnal year 2) above. Dattari 5090. BMCG 2078. Cologne —. Milne —. *[AD 250–51]*.
 F £32 ($50) / **VF** £85 ($130)

208 MILITARY ANARCHY AND ECONOMIC COLLAPSE, AD 235–270

9454 **Billon tetradrachm.** Obv. As 9446. Rev. Eagle stg. l., hd. r., wings open, holding wreath in beak, L B (= regnal year 2) before. Dattari 5098. BMCG 2086. Cologne 2817. Milne 3835. *[AD 250–51].* **F** £25 ($40) / **VF** £65 ($100)

9455

9455 — Rev. Trophy with two captives seated back to back at base, L — B (= regnal year 2) in field. Dattari 5095. BMCG 2087. Cologne —. Milne 3838. *[AD 250–51].*
 F £32 ($50) / **VF** £85 ($130)

For other local coinages of Trajan Decius, see *Greek Imperial Coins & Their Values*, pp. 399–405.

TRAJAN DECIUS WITH HERENNIA ETRUSCILLA, HERENNIUS ETRUSCUS AND HOSTILIAN

9456 **Silver antoninianus.** IMP C M Q TRAIANVS DECIVS AVG, rad., dr. and cuir. bust of Trajan Decius r. Rev. CONCORDIA AVGG, diad. and dr. bust of Herennia Etruscilla r., crescent behind shoulders, facing conjoined rad. and dr. busts of Herennius Etruscus and Hostilian l. RIC *Trajan Decius* 31. RSC 1. Hunter, p. xcvii. *[Rome, AD 250].*
 VF £2,000 ($3,000) / **EF** £4,000 ($6,000)

TRAJAN DECIUS WITH HERENNIUS ETRUSCUS AND HOSTILIAN

9457 **Silver antoninianus.** Obv. As 9456. Rev. PIETAS AVGG, dr. busts of Herennius Etruscus and Hostilian face to face. RIC *Trajan Decius* 32. RSC 1a. Hunter, p. xcvii. *[Rome, AD 250].* **VF** £2,000 ($3,000) / **EF** £4,000 ($6,000)

RIC and RSC both cite the specimen in the De Quelen Sale (Paris, 1888), lot 1594, but unfortunately neither describes whether the two princes are bare-headed or radiate.

Issues of Trajan Decius in honour of the Imperial 'Divi'

This remarkable series of antoniniani omits the name of the issuing authority, though the denomination, metal quality and style plainly call for a mid-3rd century date. An attribution to the reign of Trajan Decius (AD 249–251) was convincingly demonstrated by Harold Mattingly in an article published in 1949 in the Numismatic Chronicle ("The Coins of the 'Divi' issued by Trajan Decius", pp. 75 ff). By honouring the memory of the best of the imperial Divi these coins fit neatly into the pattern of Decius' policy of reviving the old Roman virtues at a time of national crisis. On stylistic grounds the series was formerly associated with Decius' later issues (with obbreviated

obverse legends) which were assigned to a newly opened mint at Mediolanum (Milan). However, the weight of evidence, including numerous die links between the so-called 'Milan' coinage of Decius and his earlier Roman issues, now points to the production of the 'Divi' series by a single officina of the Rome mint. There are two reverse types, one featuring the eagle of Jupiter which bore the new god aloft to his place in the heavens, the other a large altar symbolizing the worship of the imperial deity. The selection of deified rulers commemorated on this coinage throws an interesting light on the verdict of history as it was viewed by mid-3rd century Roman society. Eleven Divi were honoured by Decius, including one who was never formally deified (Severus Alexander), and another (Commodus) whose consecration was carried out for purely political reasons some years after his death. Some of the omissions are equally enigmatic by modern standards. The following rulers received deification and were honoured with commemorative coinage at the time their deaths but are ignored on Decius' series: Julius Caesar, Claudius, Lucius Verus, Pertinax, and Caracalla.

In order to avoid unnecessary repetition in the following listing the two reverse types are described merely as "eagle" and "altar". The full descriptions are: eagle standing standing right, head left, wings open; and altar-enclosure with double panelled door, flames rising from the top of the altar, sometimes the horns also visible on either side.

All RIC references are to the coinage of Trajan Decius.

9458　**Silver antoninianus.** DIVO AVGVSTO, rad. hd. of **Augustus** r. Rev. CONSECRATIO, eagle. RIC 77. C Augustus 577. Hunter 1. [Rome, AD 250–51].
VF £100 ($150) / **EF** £200 ($300)

9459

9460

9459　Obv. Similar. Rev. — altar. RIC 78. C *Augustus* 578. Hunter 2, 3. *[Rome, AD 250–51].*
VF £80 ($120) / **EF** £170 ($250)

9460　DIVO VESPASIANO, rad. hd. of **Vespasian** r. Rev. CONSECRATIO, eagle. RIC 79. RSC *Vespasian* 651. Hunter 5. *[Rome, AD 250–51].*　**VF** £80 ($120) / **EF** £170 ($250)

9461　Obv. Similar. Rev. — altar. RIC 80. RSC *Vespasian* 652. Hunter 7, 8. *[Rome, AD 250–51].*
VF £80 ($120) / **EF** £170 ($250)

 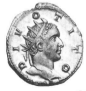

9461

9462

9462　DIVO TITO, rad. hd. of **Titus** r. Rev. CONSECRATIO, eagle. RIC 81a. RSC *Titus* 404. Hunter 10. *[Rome, AD 250–51].*　**VF** £90 ($135) / **EF** £185 ($275)

9463 **Silver antoninianus.** Similar, but Titus' bust is dr. and cuir. RIC 81b. RSC *Titus* —.
Hunter 11. *[Rome, AD 250–51].* **VF** £110 ($160) / **EF** £220 ($325)

9464 Obv. As previous. Rev. CONSECRATIO, altar. RIC 82a. Cf. RSC *Titus* 406. Hunter, p. ciii.
[Rome, AD 250–51]. **VF** £110 ($160) / **EF** £220 ($325)

 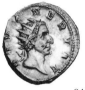

9465 9466

9465 Obv. As 9462. Rev. As previous. RIC 81b. RSC *Titus* 405. Hunter 12. *[Rome, AD 250–51].*
VF £90 ($135) / **EF** £185 ($275)

9466 DIVO NERVAE, rad. hd. of **Nerva** r. Rev. CONSECRATIO, eagle. RIC 83a. RSC *Nerva* 152.
Hunter, p. ciii. *[Rome, AD 250–51].* **VF** £100 ($150) / **EF** £200 ($300)

9467 Similar, but NERVE for NERVAE. RIC 83b. RSC *Nerva* —. Hunter, p. ciii. *[Rome,
AD 250–51].* **VF** £115 ($175) / **EF** £230 ($350)

9468 9470

9468 Obv. As previous. Rev. CONSECRATIO, altar. RIC 84a. RSC *Nerva* —. Hunter, p. ciii.
[Rome, AD 250–51]. **VF** £115 ($175) / **EF** £230 ($350)

9469 Obv. As 9466. Rev. As previous. RIC 84b. RSC *Nerva* 153. Hunter 14. *[Rome,
AD 250–51].* **VF** £100 ($150) / **EF** £200 ($300)

9470 DIVO TRAIANO, rad. hd. of **Trajan** r., sometimes with light drapery on l. shoulder. Rev.
CONSECRATIO, eagle. RIC 85a, b. RSC *Trajan* 666. Hunter, p. ciii. *[Rome, AD 250–51].*
VF £90 ($135) / **EF** £185 ($275)

9471 Obv. Similar. Rev. — altar (sometimes not lighted). RIC 86a, b and note. RSC *Trajan*
664–5. Hunter 15, 16. *[Rome, AD 250–51].* **VF** £80 ($120) / **EF** £170 ($250)

9472 DIVO HADRIANO, rad. hd. of **Hadrian** r. Rev. CONSECRATIO, eagle. RIC 87. RSC *Hadrian*
1509. Hunter 18. *[Rome, AD 250–51].* **VF** £150 ($225) / **EF** £300 ($450)

9473 Obv. Similar. Rev. — altar. RIC 88. RSC *Hadrian* 1510. Hunter, p. ciii. *[Rome,
AD 250–51].* **VF** £150 ($225) / **EF** £300 ($450)

9471 9473

9474 9475

9474 **Silver antoninianus.** DIVO PIO, rad. hd. of **Antoninus Pius** r. Rev. CONSECRATIO, eagle. RIC 89. RSC *Antoninus Pius* 1188. Hunter 20. *[Rome,* AD *250–51].*
 VF £90 ($135) / **EF** £185 ($275)

9475 Obv. Similar. Rev. — altar. RIC 90. RSC *Antoninus Pius* 1189. Hunter 23, 24. *[Rome,* AD *250–51].* **VF** £80 ($120) / **EF** £170 ($250)

9476 9478

9476 DIVO MARCO, rad. hd. of **Marcus Aurelius** r. Rev. CONSECRATIO, eagle. RIC 91a. RSC *Marcus Aurelius* 1056. Hunter 25. *[Rome,* AD *250–51].* **VF** £130 ($200) / **EF** £265 ($400)

9477 Similar, but obv. legend DIVO MARCO ANTONINO. RIC 91b. RSC *Marcus Aurelius* 1057. Hunter 26. *[Rome,* AD *250–51].* **VF** £130 ($200) / **EF** £265 ($400)

9478 Obv. As previous. Rev. CONSECRATIO, altar. RIC 92a. RSC *Marcus Aurelius* 1058. Hunter, p. ciii. *[Rome,* AD *250–51].* **VF** £130 ($200) / **EF** £265 ($400)

9479 Obv. As 9476. Rev. As previous. RIC 92b. RSC *Marcus Aurelius* 1059. Hunter, p. ciii. *[Rome,* AD *250–51].* **VF** £130 ($200) / **EF** £265 ($400)

9480 DIVO COMMODO, rad. hd. of **Commodus** r., sometimes with light drapery on l. shoulder. Rev. CONSECRATIO, eagle. RIC 93. RSC *Commodus* 1009. Hunter 27. *[Rome,* AD *250–51].* **VF** £90 ($135) / **EF** £185 ($275)

9481 Obv. Similar. Rev. — altar. RIC 94. RSC *Commodus* 1010. Hunter 28. *[Rome,* AD *250–51].* **VF** £90 ($135) / **EF** £185 ($275)

9480 9482

9482 **Silver antoninianus.** DIVO SEVERO, rad. hd. of **Septimius Severus** r. Rev. CONSECRATIO,
eagle. RIC 95. RSC *Septimius Severus* 799. Hunter 29. *[Rome, AD 250–51].*
 VF £100 ($150) / **EF** £200 ($300)

9483 Obv. Similar. Rev. — altar. RIC 96. RSC *Septimius Severus* 800. Hunter 31. *[Rome,
AD 250–51].* **VF** £100 ($150) / **EF** £200 ($300)

9484 9485

9484 DIVO ALEXANDRO, rad. hd. of **Severus Alexander** r., usually with light drapery on l.
shoulder. Rev. CONSECRATIO, eagle. RIC 97. RSC *Severus Alexander* 599. Hunter 32.
[Rome, AD 250–51]. **VF** £90 ($135) / **EF** £185 ($275)

9485 Obv. Similar. Rev. — altar. RIC 98. RSC *Severus Alexander* 597, 598. Hunter 34. *[Rome,
AD 250–51].* **VF** £90 ($135) / **EF** £185 ($275)

HERENNIA ETRUSCILLA

9494

*Little is known of the life and origins of Herennia Cupressenia Etruscilla though her name suggests
that, like her husband, she was of noble Italian ancestry. She was the mother of Decius' two sons,
Herennius Etruscus and Hostilian. The name Cupressenia never appears on her Roman coinage
but it was used at Alexandria and some other eastern mints. Like her predecessor as empress it
seems likely that Etruscilla was assigned one of the six officinae of the Rome mint. Double sestertii
were also struck in her name, though no semisses are known. In addition to her main coinage a
wide variety of antoninianus types was struck at Antioch, though specimens are scarce today. As on
her husband's coinage, the Antiochene issues of the empress frequently bear officina marks in the
form of dots or numerals below the obverse bust. Following the deaths of her husband and elder*

son Etruscilla was treated with honour by his successor. Her younger son even ruled as joint emperor with Trebonianus Gallus for a brief period and during this time it seems likely that her coinage remained in issue. With a surviving empress from the previous regime Gallus' own wife Baebiana was unable to assume imperial rank and in consequence no coinage was ever issued in her name. With the downfall of Gallus in AD 253 Etruscilla's subsequent fate is unknown, but presumably she would have retired into private life.

There are two principal varieties of obverse legend. The shorter form is employed on the gold and silver denominations, the longer on bronzes:

A. HER ETRVSCILLA AVG
B. HERENNIA ETRVSCILLA AVG

There are two varieties of obverse type. These appear to have a chronological significance, that with a plait carried up the back of the head being the earlier. Antoniniani, double sestertii and dupondii also have a crescent behind the shoulders:

a. Diademed and draped bust of Herennia Etruscilla right, the hair carried up back of head in a plait.
b. Diademed and draped bust of Herennia Etruscilla right, the hair ridged in waves.

RIC references are to the coinage of Trajan Decius.

9486 **Gold aureus.** Ab. Rev. FECVNDITAS AVG, Fecunditas stg. l., her r. hand extended to child stg. at her feet, holding cornucopiae in l. RIC 55a. C —. Hunter, p. xcix. *[Rome, AD 250–51].* **VF** £2,500 ($3,750) / **EF** £6,300 ($9,500)

9487 Similar, but with obv. legend HER ETRVSC AVG. RIC 61. C 7. Hunter, p. xcix, note 1. *[Rome, AD 251].* **VF** £2,700 ($4,000) / **EF** £6,700 ($10,000)

 9488 9489

9488 Aa. Rev. PVDICITIA AVG, Pudicitia stg. l., drawing veil from face and holding transverse sceptre. RIC 58a. C 16. Hunter —. *[Rome, AD 250].*
 VF £2,300 ($3,500) / **EF** £6,000 ($9,000)

9489 Ab. Rev. — Pudicitia seated l., drawing veil from face and holding transverse sceptre. RIC 59a. C 18. Hunter 9 var. (different hair style). *[Rome, AD 250–51].*
 VF £2,150 ($3,250) / **EF** £5,700 ($8,500)

9490 **Silver antoninianus.** Ab (sometimes with dots below bust). Rev. ADVENTVS AVG, Trajan Decius on horseback pacing l., his r. hand raised, holding sceptre in l. RIC 62. RSC 2–2b. Hunter, p. xcix. *[Antioch, AD 250].* **VF** £40 ($60) / **EF** £100 ($150)

9491 Obv. Similar. Rev. AEQVITAS AVG (sometimes AVGG), Aequitas stg. l., holding scales and cornucopiae. RIC 63, 64. RSC 3–3d. Hunter, p. xcix. *[Antioch, AD 250–51].*
 VF £32 ($50) / **EF** £80 ($120)

9492 Ab. Rev. FECVNDITAS AVG (sometimes AVGG), Fecunditas and child, as 9486. RIC 55b, 56. RSC 8, 11. Hunter 1. *[Rome, AD 250–51].* **VF** £20 ($30) / **EF** £50 ($75)

9490 9491

9493 9495

9493 **Silver antoninianus.** Ab. Rev. IVNO REGINA, Juno stg. l., holding patera and sceptre, peacock at feet. RIC 57. RSC 14. Hunter 3. *[Rome, AD 251].* **VF** £20 ($30) / **EF** £50 ($75)

9494 Ab. Rev. PVDICITIA AVG, Pudicitia stg., as 9488. RIC 58b. RSC 17. Hunter 4. *[Rome, AD 250–51].* **VF** £16 ($25) / **EF** £45 ($65)

9495 Aa. Rev. — Pudicitia seated, as 9489. RIC 59b. RSC 19. Hunter 10. *[Rome, AD 250].* **VF** £16 ($25) / **EF** £45 ($65)

9496 Ab (sometimes with numeral below bust). Rev. As previous. RIC 65. RSC 19a, b. Hunter, p. xcix. *[Antioch, AD 250–51].* **VF** £32 ($50) / **EF** £80 ($120)

9497 Ab (sometimes with dots or numeral below bust). Rev. ROMAE AETERNAE, Roma seated l., holding Victory and spear, shield at side. RIC 66. RSC 27, 27a. Hunter, p. xcix. *[Antioch, AD 250–51].* **VF** £32 ($50) / **EF** £80 ($120)

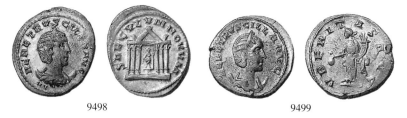

9498 9499

9498 Obv. Similar. Rev. SAECVLVM NOVVM, hexastyle temple containing seated statue of Roma. RIC 67. RSC 28–29a. Hunter, p. xcix. *[Antioch, AD 250–51].*
 VF £40 ($60) / **EF** £100 ($150)
 This is a revival of a type issued two years before as part of the celebration of Rome's millennium (see no. 8963).

9499 — Rev. VBERITAS AVG, Uberitas stg. l., holding cow's udder (?) and cornucopiae. RIC 68. RSC 31–31c. Hunter 24. *[Antioch, AD 250–51].* **VF** £32 ($50) / **EF** £80 ($120)

9500 **Silver antoninianus.** Similar, but with VERITAS (*sic*) for VBERITAS. RIC 69. RSC 32, 32a. Hunter, p. xcix. *[Antioch, AD 250–51].* **VF** £32 ($50) / **EF** £80 ($120)

9501 Ab (sometimes with dots below bust). Rev. VICTORIA AVG, Victory advancing l., holding wreath and palm. RIC 70. RSC 34–34b. Hunter, p. xcix. *[Antioch, AD 250–51].* **VF** £32 ($50) / **EF** £80 ($120)

9502 **Bronze double sestertius.** Ba. Rev. PVDICITIA AVG S C, Pudicitia seated l., drawing veil from face and holding transverse sceptre. RIC 136a. C 21. Hunter, p. xcix. *[Rome, AD 250].* **F** £500 ($750) / **VF** £1,650 ($2,500) / **EF** £6,000 ($9,000)

9503 **Bronze sestertius.** Bb. Rev. CONCORDIA AVG S C, Concordia seated l., holding patera and cornucopiae. RIC 132. C 4. Hunter, p. xcix. *[Rome, AD 250–51].* **F** £48 ($70) / **VF** £115 ($175) / **EF** £350 ($525)
Cohen (6) notes a variety of this type with rev. ending **AVGG** *and Concordia holding a double cornucopiae.*

9504 Bb. Rev. FECVNDITAS AVG (sometimes AVGG) S C, Fecunditas stg. l., her r. hand extended to child stg. at her feet, holding cornucopiae in l. RIC 134a, 135a. C 9, 12. Hunter 12. *[Rome, AD 250–51].* **F** £45 ($65) / **VF** £110 ($165) / **EF** £330 ($500)

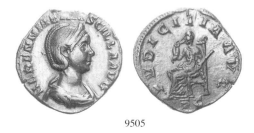

9505

9505 Ba. Rev. PVDICITIA AVG S C, Pudicitia seated, as 9502. RIC 136b. C 22. Hunter 16. *[Rome, AD 250].* **F** £40 ($60) / **VF** £100 ($150) / **EF** £300 ($450)

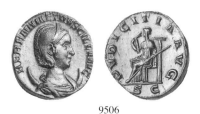

9506

9506 **Bronze dupondius.** Ba. Rev. As previous. RIC 136d. C 24. Hunter 19. *[Rome, AD 250].* **F** £38 ($55) / **VF** £95 ($140) / **EF** £285 ($425)

9507 **Bronze as.** As 9504 (rev. FECVNDITAS AVG or AVGG, Fecunditas and child). RIC 134b, 135b. C 10, 13. Hunter 13. *[Rome, AD 250–51].* **F** £38 ($55) / **VF** £95 ($140) / **EF** £285 ($425)

9508 As 9505 (rev. PVDICITIA AVG, Pudicitia seated). RIC 136c. C 23. Hunter 22. *[Rome, AD 250].* **F** £38 ($55) / **VF** £95 ($140) / **EF** £285 ($425)

See also no. 9456.

Alexandrian Coinage

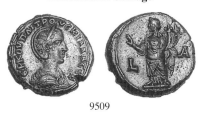

9509

9509 **Billon tetradrachm.** ЄΡ ΚΟΥΠ ΑΙΤΡΟΥCΚΙΛΛΑ CЄΒ (or similar), diad. and dr. bust r. Rev. Homonoia (= Concordia) stg. l., her r. hand raised, holding double cornucopiae in l., L — A (= regnal year 1) in field. Dattari 5102. BMCG 2091. Cologne 2121. Milne 3794. *[AD 249–50].* **F** £50 ($75) / **VF** £115 ($175)

9510 Obv. Similar. Rev. Tyche (= Fortuna) stg. l., holding rudder and cornucopiae, L — A (= regnal year 1) in field. Dattari 5103. BMCG 2093. Cologne 2123. Milne 3799. *[AD 249–50].* **F** £50 ($75) / **VF** £115 ($175)

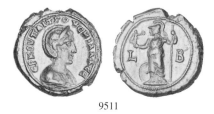

9511

9511 — Rev. Athena stg. l., holding Nike and resting on sceptre, shield at side, L — B (= regnal year 2) in field. Dattari 5099. BMCG 2088. Cologne 2825. Milne 3818. *[AD 250–51].* **F** £50 ($75) / **VF** £115 ($175)

9512 — Rev. Eusebeia (= Pietas) stg. facing, hd. l., sacrificing over altar and holding box of incense, L B (= regnal year 2) to l. Dattari 5100. BMCG 2090. Cologne —. Milne 3825. *[AD 250–51].* **F** £50 ($75) / **VF** £115 ($175)

For other local coinages of Herennia Etruscilla, see *Greek Imperial Coins & Their Values*, pp. 405–9.

HERENNIUS ETRUSCUS
early summer AD 251

9518

Quintus Herennius Etruscus Messius Decius was the elder son of Trajan Decius and Herennia Etruscilla and was born probably in the mid-230s. He appears to have been given the rank of Caesar by his father in the summer of AD 250 and to have accompanied Decius to the northern frontier region on the fateful campaign against the Gothic invaders. His further elevation to Augustus and co-emperor seems to have taken place only shortly before the disastrous battle in which both emperors perished (June or July AD 251).

Issues as Caesar under Trajan Decius, AD 250–251

9513 **Gold aureus.** Q HER ETR MES DECIVS NOB C, bare-headed and dr. bust r. Rev. PIETAS
AVGG, Mercury stg. l., holding purse and caduceus. RIC 142a. Cf. C 10 (inaccurately
described). Hunter, p. c. *[Rome, AD 251]*. **VF** £6,700 ($10,000) / **EF** £16,500 ($25,000)

9514 Obv. Similar. Rev. PRINCIPI IVVENTVTIS, Herennius Etruscus, in military attire, stg. l.,
holding baton and transverse spear. RIC 147a. C 25. Hunter, p. c. *[Rome, AD 250–51]*.
VF £5,500 ($8,000) / **EF** £13,500 ($20,000)

9515 Similar, but prince holds standard and rests on spear. RIC 148a. C 32. Hunter, p. c. *[Rome,
AD 250–51]*. **VF** £6,000 ($9,000) / **EF** £15,000 ($22,500)

9516 **Silver antoninianus.** HEREN ETRV MES QV DECIVS CAESAR, rad. and dr. bust r. (with dots
below). Rev. ADVENTVS AVG, Trajan Decius or Herennius Etruscus on horseback pacing
l., his r. hand raised, holding sceptre in l. RIC 156. RSC 1. Hunter, p. c. *[Antioch, AD 250]*.
VF £80 ($120) / **EF** £200 ($300)

9517 Obv. Similar, but sometimes TRV (*sic*) for ETRV (sometimes with dots below bust). Rev.
AEQVITAS AVG, Aequitas stg. l., holding scales and cornucopiae (sometimes with dot in
ex.). RIC 157. RSC 2–2d. Hunter, p. c. *[Antioch, AD 250–51]*.
VF £65 ($100) / **EF** £170 ($250)

9518 Q HER ETR MES DECIVS NOB C, rad. and dr. bust r. Rev. CONCORDIA AVGG, clasped r.
hands. RIC 138. RSC 4. Hunter 1. *[Rome, AD 251]*. **VF** £32 ($50) / **EF** £80 ($120)

9519 Obv. As 9517 (sometimes with dot below bust). Rev. PANNONIAE, Pannonia stg. facing,
hd. r., holding helmet and standard. RIC 158. RSC 9, 9a. Hunter, p. c. *[Antioch, AD 250]*.
VF £75 ($110) / **EF** £185 ($275)

9520 9521

9520 Obv. As 9518. Rev. PIETAS AVGG, Mercury stg. l., holding purse and caduceus. RIC 142b.
RSC 11. Hunter 4. *[Rome, AD 251]*. **VF** £32 ($50) / **EF** £80 ($120)

9521 — Rev. PIETAS AVGVSTORVM, sprinkler, simpulum, jug, patera and lituus (emblems of
the priestly colleges). Cf. RIC 143. RSC 14. Hunter 7. *[Rome, AD 250–51]*.
VF £32 ($50) / **EF** £80 ($120)

9522 — Rev. PRINCIPI IVVENTVTIS, Apollo seated l., holding laurel-branch and resting l. arm on
lyre. RIC 146. RSC 24a. Hunter 9. *[Rome, AD 251]*. **VF** £32 ($50) / **EF** £80 ($120)
Rarer varieties of this type have abbreviated forms of the rev. legend — PRINC IVVENT *or*
PRINC IVVENTVTIS.

9523 — Rev. — Herennius Etruscus, in military attire, stg. l., holding baton and transverse
spear. RIC 147c. RSC 26. Hunter 13. *[Rome, AD 250–51]*. **VF** £32 ($50) / **EF** £80 ($120)

9522 9523

9524 **Silver antoninianus.** Similar, but prince holds standard and rests on spear. RIC 148b. RSC
33. Hunter, p. c. *[Rome, AD 250–51].* **VF** £40 ($60) / **EF** £100 ($150)

9525 Obv. As 9516 (sometimes with dots below bust). Rev. PVDICITIA AVG, Pudicitia seated l.,
drawing veil from face and holding transverse sceptre. RIC 159. RSC 35, 35a. Hunter, p. c.
[Antioch, AD 250–51]. **VF** £65 ($100) / **EF** £170 ($250)

9526

9526 Obv. As 9518. Rev. SPES PVBLICA, Spes advancing l., holding flower and lifting skirt. RIC
149. RSC 38. Hunter 2. *[Rome, AD 250–51].* **VF** £32 ($50) / **EF** £80 ($120)

9527 Obv. As 9516 (sometimes with dot below bust). Rev. VBERITAS AVG, Uberitas stg. l.,
holding cow's udder (?) and cornucopiae. RIC 160. RSC 40, 40a. Hunter, p. c. *[Antioch,
AD 250–51].* **VF** £65 ($100) / **EF** £170 ($250)

9528 Obv. As 9516, but sometimes ETR for ETRV (with dot or dots below bust). Rev. VICTORIA
AVG, Victory advancing l., holding wreath and palm. RIC 161. RSC 40b-c. Hunter, p. c.
[Antioch, AD 250–51]. **VF** £65 ($100) / **EF** £170 ($250)

9529 **Silver denarius.** Obv. As 9513. Rev. PRINC IVVENT, Apollo seated, as 9522. RIC 144a.
RSC 20a. Hunter, p. c. *[Rome, AD 251].* **VF** £3,000 ($4,500) / **EF** £6,000 ($9,000)

9530 **Silver quinarius.** Obv. As 9513. Rev. PRINCIPI IVVENTVTIS, Herennius Etruscus in
military attire, as 9523. RIC 147b. RSC 27. Hunter, p. c. *[Rome, AD 250–51].*
 VF £1,175 ($1,750) / **EF** £2,300 ($3,500)

9531 **Bronze sestertius.** Q HER ETR MES DECIVS NOB C, bare-headed and dr. (or dr. and cuir.)
bust r. Rev. PIETAS AVGG S C, Mercury stg. l., holding purse and caduceus. RIC 167a. C
12. Hunter 14. *[Rome, AD 251].* **F** £80 ($120) / **VF** £200 ($300) / **EF** £600 ($900)

9532 Obv. Similar. Rev. PIETAS AVGVSTORVM S C, priestly emblems, similar to 9521. RIC
168a. C 15. Hunter 19. *[Rome, AD 250–51].*
 F £80 ($120) / **VF** £200 ($300) / **EF** £600 ($900)

9533 — Rev. PRINCIPI IVVENTVTIS S C, Apollo seated, as 9522. Cf. RIC 169a. Cf. C 23. Hunter
21. *[Rome, AD 251].* **F** £80 ($120) / **VF** £200 ($300) / **EF** £600 ($900)

9531

9532

9534

9534 **Bronze sestertius.** — Rev. — Herennius Etruscus, in military attire, stg. l., holding baton and transverse spear. RIC 171a. C 28. Hunter 22. *[Rome, AD 250–51].*
F £65 ($100) / **VF** £170 ($250) / **EF** £500 ($750)

9535 Similar, but prince holds standard and rests on spear. RIC 172. C 34. Hunter, p. c. *[Rome, AD 250–51].*
F £80 ($120) / **VF** £200 ($300) / **EF** £600 ($900)

9536 **Bronze dupondius** or **as.** As 9531 (rev. PIETAS AVGG S C, Mercury stg.). RIC 167b. C 13. Hunter 15. *[Rome, AD 251].*
F £80 ($120) / **VF** £200 ($300) / **EF** £600 ($900)

9537 As 9533 (rev. PRINCIPI IVVENTVTIS S C, Apollo seated). Cf. RIC 169b. Cf. C 24. Hunter, p. c. *[Rome, AD 251].*
F £100 ($150) / **VF** £230 ($350) / **EF** £750 ($1,100)

9538 As 9534 (rev. PRINCIPI IVVENTVTIS S C, Herennius Etruscus stg.). RIC 171b. C 29. Hunter, p. c. *[Rome, AD 250–51].*
F £100 ($150) / **VF** £230 ($350) / **EF** £750 ($1,100)

For the Alexandrian issues of Herennius Etruscus as Caesar, see nos. 9543–7.

Issues as Augustus, AD 251

9539 **Gold aureus.** IMP C Q HER ETR MES DECIO AVG, laur., dr. and cuir. bust r. Rev. PRINC
 IVVENT, Apollo seated l., holding laurel-branch and resting l. arm on lyre. RIC 153a. C 18.
 Hunter, p. c. *[Rome]*. **VF** £8,000 ($12,000) / **EF** £20,000 ($30,000)

9540 **Silver antoninianus.** Similar, but emperor's bust is rad. instead of laur. RIC 153b. RSC
 19. Hunter, p. c. *[Rome]*. **VF** £170 ($250) / **EF** £400 ($600)

9541 9544

9541 Obv. As previous. Rev. VICTORIA GERMANICA, Victory advancing r., holding wreath and
 palm. RIC 154. RSC 41. Hunter 24. *[Rome]*. **VF** £130 ($200) / **EF** £330 ($500)

9542 Obv. Similar, but DECIVS instead of DECIO. Rev. VOTIS DECENNALIBVS within laurel-
 wreath. RIC 155b. RSC 42a. Hunter, p. c. *[Rome]*. **VF** £200 ($300) / **EF** £500 ($750)

Alexandrian Coinage

9543 **Billon tetradrachm.** K EPE ETP MEC ΔEKIOC KAIC (or KAICA), bare-headed and cuir. bust
 r. Rev. Roma (?), helmeted, stg. l., r. hand raised, holding sceptre in l., L — A (= regnal
 year 1) in field. Dattari —. BMCG/Christiansen 3275. Cologne —. Milne —. *[AD 250]*.
 F £130 ($200) / **VF** £330 ($500)
 This extremely rare issue indicates that Herennius Etruscus was raised to the rank of
 Caesar before the end of August AD 250.

9544 Similar, but with regnal date L B (= year 2) in rev. field to l. Dattari 5105. BMCG 2095.
 Cologne 2826. Milne 3833. *[AD 250–51]*. **F** £55 ($85) / **VF** £130 ($200)

9545 Obv. As previous. Rev. Laur. bust of Zeus r., L — B (= regnal year 2) in field. Dattari —.
 BMCG —. Cologne —. Milne —. Curtis 1450A. *[AD 250–51]*.
 F £65 ($100) / **VF** £170 ($250)

9546 — Rev. Herennius Etruscus, in military attire, galloping r., thrusting downwards with spear
 held in r. hand at prostrate enemy beneath horse, L B (= regnal year 2) behind. Dattari 5104.
 BMCG —. Cologne —. Milne —. *[AD 250–51]*. **F** £100 ($150) / **VF** £230 ($350)

9547 — Rev. Eagle stg. l., hd. r., wings open, holding wreath in beak, L B (= regnal year 2)
 before. Dattari —. BMCG 2097. Cologne —. Milne —. *[AD 250–51]*.
 F £65 ($100) / **VF** £170 ($250)

For other local coinages of Herennius Etruscus, see *Greek Imperial Coins & Their Values*,
pp. 409–12.

HOSTILIAN
summer–Nov. AD 251

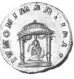

9581

Gaius Valens Hostilianus Messius Quintus was the younger son of Trajan Decius and Herennia Etruscilla and was born probably in the late 230s. He received the the rank of Caesar late in AD 250 and remained behind in Rome when his father and elder brother Herennius Etruscus left the capital to confront the Goths, who had crossed the Danubian frontier and invaded Rome's Balkan provinces. Following their deaths in the disastrous battle of Abrittus, in which both emperors perished (June or July AD 251), Hostilian was left as the only surviving male representative of the imperial family. The new emperor, Trebonianus Gallus, who had been proclaimed by the army following Abrittus, elevated the young Hostilian to the rank of Augustus and co-emperor, whilst his own son, Volusian, had to be content with the junior position of Caesar. However, after only three or four months of joint rule Hostilian fell victim to the plague which was raging in the capital and was replaced as co-emperor by Volusian.

Issues as Caesar under Trajan Decius, AD 250–251

9548 **Gold aureus.** C VALENS HOSTIL MES QVINTVS N C, bare-headed and dr. bust r. Rev. MARTI PROPVGNATORI, Mars advancing r., carrying spear and shield. RIC 177a. C 14. Hunter, p. ci. *[Rome, AD 251].* **VF** £6,700 ($10,000) / **EF** £16,500 ($25,000)

9549 Obv. Similar. Rev. PIETAS AVGG, Mercury stg. l., holding purse and caduceus. RIC 178a. Cf. C 19. Hunter, p. ci. *[Rome, AD 251].* **VF** £6,700 ($10,000) / **EF** £16,500 ($25,000)

9550 — Rev. PRINCIPI IVVENTVTIS, Hostilian, in military attire, stg. l., holding standard and resting on spear. RIC 181b. C 33. Hunter, p. ci. *[Rome, AD 250–51].*
 VF £6,000 ($9,000) / **EF** £15,000 ($22,500)

9551 Similar, but VALES for VALENS and prince holds baton and transverse spear. RIC 183a. C 37 var. Hunter, p. ci. *[Rome, AD 250–51].* **VF** £6,000 ($9,000) / **EF** £15,000 ($22,500)

NB See also no. 9578.

9552 **Silver antoninianus.** C OVL OSTIL MES COVINTVS CAESAR, rad. and dr. bust r. (with dots or numeral below). Rev. ADVENTVS AVG, Trajan Decius on horseback pacing l., his r. hand raised, holding sceptre in l. RIC 193. RSC 2, 2a. Hunter, p. ci. *[Antioch, AD 250].*
 VF £120 ($180) / **EF** £300 ($450)

9553 C OVAL OSTIL MES COVINTVS CAESAR, rad. and dr. bust r. (sometimes with dot below). Rev. AEQVITAS AVG, Aequitas stg. l., holding scales and cornucopiae . RIC 194a, b. RSC 4b, c. Hunter, p. ci. *[Antioch, AD 250–51].* **VF** £100 ($150) / **EF** £250 ($375)

9554 C VAL HOS MES QVINTVS N C, rad. and dr. bust r. Rev. CONCORDIA AVGG, clasped r. hands. RIC 174a. RSC 5. Hunter, p. ci. *[Rome, AD 251].* **VF** £65 ($100) / **EF** £170 ($250)

9555 Obv. Similar. Rev. MAR (or MARS) PROP (or PROPVG), Mars advancing r., carrying spear and shield. RIC 175a, 176a. RSC 11, 12. Hunter 1. *[Rome, AD 251].*
 VF £65 ($100) / **EF** £170 ($250)

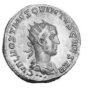

9556 9557

9556 **Silver antoninianus.** C VALENS HOSTIL MES QVINTVS N C, rad. and dr. bust r. Rev. MARTI
 PROPVGNATORI, Mars advancing, as previous. RIC 177b. RSC 15. Hunter 3. *[Rome,
 AD 251].* **VF** £60 ($90) / **EF** £150 ($225)

9557 C VAL HOST MES QVINTVS CAESAR, rad. and dr. bust r. (with three dots below). Rev.
 PANNONIAE, Pannonia stg. facing, hd. r., holding helmet and standard. RIC 195. Cf. RSC
 17. Hunter, p. ci. *[Antioch, AD 250].* **VF** £120 ($180) / **EF** £300 ($450)

9558 Obv. As 9554. Rev. PIETAS AVGG, Mercury stg. l., holding purse and caduceus. RIC 178b.
 RSC 20. Hunter, p. ci. *[Rome, AD 251].* **VF** £65 ($100) / **EF** £170 ($250)

9559 Obv. As 9556. Rev. PIETAS AVGVSTORVM, simpulum, sprinkler, jug, patera and lituus
 (emblems of the priestly colleges). Cf. RIC 179. RSC 25. Hunter, p. ci. *[Rome,
 AD 250–51].* **VF** £65 ($100) / **EF** £170 ($250)

9560 — Rev. PRINCIPI IVVENTVTIS, Apollo seated l., holding laurel-branch and resting l. arm on
 lyre. RIC 180. RSC 30. Hunter, p. ci. *[Rome, AD 251].* **VF** £65 ($100) / **EF** £170 ($250)

9561

9561 — Rev. — Hostilian, in military attire, stg. l., holding standard and resting on spear. RIC
 181d. RSC 34. Hunter 4. *[Rome, AD 250–51].* **VF** £55 ($80) / **EF** £130 ($200)

9562 — Rev. — Hostilian, in military attire, stg. l., holding baton and transverse spear. RIC
 183e. RSC 38. Hunter, p. ci. *[Rome, AD 250–51].* **VF** £65 ($100) / **EF** £170 ($250)

9563 Obv. As 9553 (sometimes with dots or numeral below bust). Rev. PVDICITIA AVG,
 Pudicitia seated l., drawing veil from face and holding transverse sceptre. RIC 196. RSC
 43–43c. Hunter, p. ci. *[Antioch, AD 250–51].* **VF** £100 ($150) / **EF** £250 ($375)

9564 — (with dots below bust). Rev. ROMAE AETERNAE, Roma seated l., holding Victory and
 spear, shield at side. RIC 198b, c. RSC 46a, b. Hunter, p. ci. *[Antioch, AD 250–51].*
 VF £110 ($165) / **EF** £265 ($400)

9565 — — Rev. As previous, but ROMAE AETERNAE AVG. RIC 197 var. RSC 52 var. Hunter 15.
 [Antioch, AD 250–51]. **VF** £110 ($165) / **EF** £265 ($400)

9566 **Silver antoninianus.** — (with dot or dots or numeral below bust). Rev. SAECVLVM
NOVVM, hexastyle temple containing seated statue of Roma. RIC 199a-c. RSC 54–54c.
Hunter, p. ci. *[Antioch, AD 250–51].* **VF** £120 ($180) / **EF** £300 ($450)
*This is a revival of a type issued two years before as part of the celebration of Rome's
millennium (see no. 8963).*

9567 Obv. As 9556. Rev. SPES PVBLICA, Spes advancing l., holding flower and lifting skirt. RIC
184b. RSC 61. Hunter, p. ci. *[Rome, AD 250–51].* **VF** £65 ($100) / **EF** £170 ($250)

9568 Obv. As 9553 (with dot or dots or numeral below bust). Rev. VBERITAS AVG, Uberitas stg.
l., holding cow's udder (?) and cornucopiae. RIC 200b-d. RSC 63a-c. Hunter, p. ci.
[Antioch, AD 250–51]. **VF** £100 ($150) / **EF** £250 ($375)

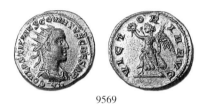

9569

9569 Obv. As 9552 (with numeral below bust). Rev. VICTORIA AVG, Victory advancing l.,
holding wreath and palm. RIC 201. RSC 65. Hunter, p. ci. *[Antioch, AD 250–51].*
VF £100 ($150) / **EF** £250 ($375)

9570 Obv. As 9554. Rev. VICTORIA GERMANICA, Victory advancing l., holding wreath and
palm. RIC 185. RSC 70. Hunter, p. ci. *[Rome, AD 251].* **VF** £120 ($180) / **EF** £300 ($450)

9571 **Silver quinarius.** C VALENS HOSTIL MES QVINTVS N C, bare-headed and dr. bust r. Rev.
PRINCIPI IVVENTVTIS, Hostilian, in military attire, stg. l., holding baton and transverse
spear. RIC 183c. RSC 39a. Hunter, p. ci. *[Rome, AD 250–51].*
VF £1,350 ($2,000) / **EF** £2,700 ($4,000)

9572 **Bronze sestertius.** Obv. Similar. Rev. PIETAS AVGG S C, Mercury stg. l., holding purse and
caduceus. RIC 213. Cf. C 23. Hunter 7. *[Rome, AD 251].*
F £100 ($150) / **VF** £230 ($350) / **EF** £665 ($1,000)

9573

9573 — Rev. PRINCIPI IVVENTVTIS (or PRINC IVVENT) S C, Apollo seated l., holding laurel-
branch and resting l. arm on lyre. RIC 214, 215a. C 27, 31. Hunter 8. *[Rome, AD 251].*
F £100 ($150) / **VF** £230 ($350) / **EF** £665 ($1,000)

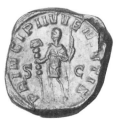

9574

9574 **Bronze sestertius.** Obv. As 9571. Rev. PRINCIPI IVVENTVTIS S C, Hostilian, in military
attire, stg. l., holding standard and resting on spear. RIC 216a. C 35. Hunter 12. *[Rome,
AD 250–51].* **F** £100 ($150) / **VF** £230 ($350) / **EF** £665 ($1,000)

9575 Similar, but on rev. Hostilian raises r. hand to touch the nearer of two standards on l. RIC
218a. Cf. C 41. Hunter, p. ci. *[Rome, AD 250–51].*
 F £115 ($175) / **VF** £265 ($400) / **EF** £800 ($1,200)

9576 **Bronze dupondius** or **as.** As 9573 (unabbreviated rev. legend). RIC 215b. C 32. Hunter
10. *[Rome, AD 251].* **F** £115 ($175) / **VF** £265 ($400) / **EF** £800 ($1,200)

9577 As 9575. RIC 218b. C —. Hunter, p. ci. *[Rome, AD 251].*
 F £130 ($200) / **VF** £300 ($450) / **EF** £900 ($1,350)

For the Alexandrian issues of Hostilian as Caesar, see nos. 9598–9600.

Issues as Augustus, AD 251 (with Trebonianus Gallus)

There are two principal varieties of obv. legend:

A. IMP CAE C VAL HOS MES QVINTVS AVG
B. C OVAL OSTIL MES COVINTVS AVG

*The obv. type is laur. and dr. bust of Hostilian r. on aurei, sestertii and asses, and rad. and dr. bust r.
on antoniniani and dupondii. Occasionally the bust appears to be cuir. also.*

9578 **Gold aureus.** G VALE QVT M OSTILIAN N C. Rev. PROVIDENTIA AVG, Providentia stg. l.,
holding globe and transverse sceptre. RIC —. C —. Hunter —. NAC Auction 24, Zürich, 5
Dec. 2002, lot 185. *[Rome].* **VF** £8,000 ($12,000) / **EF** £20,000 ($30,000)
*This extremely rare and enigmatic type would appear to belong to the confused period
following the deaths in battle of Trajan Decius and Herennius Etruscus when it was
uncertain what the attitude of the new emperor, Trebonianus Gallus, would be to the
surviving son of his predecessor. Hostilian is shown with the laureate bust of an emperor
while the somewhat confused obverse legend still only accords him the junior rank of
Caesar. This obverse has also been noted on an aureus with reverse as 9550 (cf. RIC 181,
note).*

9579 **Silver antoninianus.** B (sometimes with dots or numeral below bust). Rev. AEQVITAS
AVG, Aequitas stg., as 9553. RIC 202. RSC 3–3b. Hunter, p. cii. *[Antioch].*
 VF £120 ($180) / **EF** £300 ($450)

9580 **Silver antoninianus.** A. Rev. CONCORDIA AVGG, clasped r. hands. RIC 186. RSC 7.
Hunter, p. cii. *[Rome]*. **VF** £130 ($200) / **EF** £330 ($500)

9581 A. Rev. IVNONI MARTIALI, Juno, with peacock at feet, seated facing within circular
distyle shrine with domed roof. RIC 190. RSC 8. Hunter 1. *[Rome]*.
 VF £130 ($200) / **EF** £330 ($500)
*A similar type was also issued at Antioch. The precise location of this shrine has been
disputed by scholars, though most would like to place it in the Campus Martius where
there were three temples dedicated to Juno. Hill, however, in "The Monuments of Ancient
Rome as Coin Types", pp. 17–18, prefers to place it in the Campus Martialis, a small area
at the foot of the Caelian Hill situated close to the Porta Caelimontana in the Servian
Wall. (See also under Trebonianus Gallus and Volusian).*

9582 B (sometimes with dot, dots or numeral below bust). Rev. PVDICITIA AVG, Pudicitia
seated l., drawing veil from face and holding transverse sceptre. RIC 203. RSC 43d-h.
Hunter, p. cii. *[Antioch]*. **VF** £120 ($180) / **EF** £300 ($450)

9583 B (sometimes with dots below bust). Rev. ROMAE AETERNAE, Roma seated l., holding
Victory and spear, shield at side. RIC 204. RSC 45, 45a. Hunter, p. cii. *[Antioch]*.
 VF £120 ($180) / **EF** £300 ($450)

9584 Obv. As previous. Rev. SAECVLVM NOVVM, hexastyle temple containing seated statue of
Roma. RIC 205. RSC 55a, b. Hunter, p. cii. *[Antioch]*. **VF** £130 ($200) / **EF** £330 ($500)
*This is a revival of a type issued three years before as part of the celebration of Rome's
millennium (see no. 8963).*

 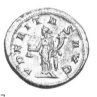

9585 9587

9585 A. Rev. SECVRITAS AVGG, Securitas stg. facing, hd. l., legs crossed, r. hand on hd., resting
l. arm on column. RIC 191a. RSC 57. Hunter, p. cii. *[Rome]*.
 VF £120 ($180) / **EF** £300 ($450)

9586 Similar, but with obv. legend IMP C MES QVINTVS AVG. RIC 191b. Cf. RSC 58. Hunter,
p. cii. *[Rome]*. **VF** £150 ($225) / **EF** £365 ($550)

9587 B (with dots or numeral below bust). Rev. VBERITAS AVG, Uberitas stg. l., holding cow's
udder (?) and cornucopiae. RIC 207. RSC 64, 64a. Hunter, p. cii. *[Antioch]*.
 VF £120 ($180) / **EF** £300 ($450)

9588 B (with dots below bust). Rev. VICTORIA AVG, Victory advancing l., holding wreath and
palm. RIC 208. RSC 66. Hunter, p. cii. *[Antioch]*. **VF** £120 ($180) / **EF** £300 ($450)

9589 B (sometimes OVL for OVAL, with dot, dots or numeral below bust). Rev. As previous, but
Victory stands r. on globe. RIC 209. RSC 67–67c. Hunter, p. cii. *[Antioch]*.
 VF £120 ($180) / **EF** £300 ($450)

9589

9590 **Bronze sestertius.** A. Rev. PROVIDENTIA AVG S C, Providentia stg. l., holding globe and transverse sceptre. RIC 221a. C 42. Hunter, p. cii. *[Rome]*.
F £150 ($225) / **VF** £365 ($550) / **EF** £1,100 ($1,650)

9591 A. Rev. QVINTO FELIX S C, Pax stg. l., holding olive-branch and transverse sceptre. RIC 222. C 44. Hunter, p. cii. *[Rome]*. **F** £300 ($450) / **VF** £800 ($1,200) / **EF** £2,300 ($3,500)

9592 A. Rev. SALVS AVGVS S C, Salus stg. l., feeding snake arising from altar and holding sceptre. RIC 224. C 56. Hunter, p. cii. *[Rome]*.
F £130 ($200) / **VF** £330 ($500) / **EF** £1,000 ($1,500)

9593 A. Rev. SECVRITAS AVGG S C, Securitas stg. facing, hd. r., legs crossed, r. hand on hd., resting l. arm on column. Cf. RIC 225. C 60. Hunter 3. *[Rome]*.
F £120 ($180) / **VF** £300 ($450) / **EF** £900 ($1,350)

9594 A. Rev. VOTIS / DECENNA / LIBVS / S C in four lines within laurel-wreath. RIC 226. C 71. Hunter 4. *[Rome]*. **F** £200 ($300) / **VF** £500 ($750) / **EF** £1,500 ($2,250)

9595 **Bronze dupondius.** A. Rev. PROVIDENTIA AVG S C, Providentia stg., as 9590. RIC —. C —. Hunter 2. *[Rome]*. **F** £200 ($300) / **VF** £500 ($750) / **EF** £1,500 ($2,250)

9596 **Bronze as.** A. Rev. PIETAS AVGVST S C, Pietas stg. l., sacrificing over altar and holding sceptre. RIC 220. C 24. Hunter, p. cii. *[Rome]*.
F £170 ($250) / **VF** £430 ($650) / **EF** £1,350 ($2,000)

9597 As 9590 (rev. PROVIDENTIA AVG S C, Providentia stg.). RIC 221b. C —. Hunter, p. cii. *[Rome]*. **F** £170 ($250) / **VF** £430 ($650) / **EF** £1,350 ($2,000)

Alexandrian Coinage

9598 **Billon tetradrachm.** Γ OVAΛ OCTIΛ MEC KVINTOC K, bare-headed, dr. and cuir. bust r. Rev. Roma (?), helmeted, stg. l., r. hand raised, holding sceptre in l., L B (= regnal year 2) before. Dattari —. BMCG —. Cologne 2829. Milne —. *[AD 250–51]*.
F £100 ($150) / **VF** £230 ($350)

9599 — — Rev. Laur. bust of Zeus r., L — B (= regnal year 2) in field. Dattari 5109. BMCG 2098. Cologne 2830. Milne 3816. *[AD 250–51]*. **F** £80 ($120) / **VF** £200 ($300)

9600 — — Rev. Eirene (= Pax) stg. l., holding olive-branch and caduceus, L B (= regnal year 2) before. Dattari 5108. BMCG 2099. Cologne 2828. Milne (Supplement) 3822a. *[AD 250–51]*. **F** £90 ($135) / **VF** £215 ($325)

For other local coinages of Hostilian, see *Greek Imperial Coins & Their Values*, pp. 412–14.

TREBONIANUS GALLUS
Jun./Jul. AD 251–Jul./Aug. 253

9605

Little is known of the early life of Gaius Vibius Trebonianus Gallus other than that he belonged to an old Etruscan family from Perusia and was born about AD 206. After entering the Senate he held the consulship early in the reign of Philip I and five years later (AD 250) was appointed by Trajan Decius to the vital governorship of Moesia. Here he achieved some success against the barbarian invaders of his province and the following year he was given a high command in the ill-fated campaign led by Decius and his elder son Herennius Etruscus which culminated in a catastrophic defeat at the hands of the Goths. It was rumoured that Trebonianus Gallus had contributed to this unprecedented disaster by failing to bring up reinforcements, but the story may be based on nothing more than malicious gossip. Whatever the truth of the matter Gallus was proclaimed emperor by the troops immediately following the deaths of Decius and Etruscus and he rapidly concluded a peace with the Goths which, as was only to be expected under the circumstances, was highly unfavourable to the Romans. He then returned to Rome where he promoted the surviving younger son of Decius, the Caesar Hostilian, to the rank of co-emperor and made his own son, Volusian, Caesar in Hostilian's place. His wife Baebiana was not made Augusta as Decius' widow, Herennia Etruscilla, was still living. Considering the brevity of Gallus' reign it is remarkable how many misfortunes it encompassed: Rome was ravaged by the plague, one of its early victims being the young co-emperor Hostilian (November 251); the Empire's eastern provinces were attacked by the Sasanid Persians under Shapur I who even captured and sacked the great Syrian metropolis of Antioch; and in the north the Goths continued their inroads in search of plunder, penetrating even into Asia Minor and reaching as far south as Ephesus. Trebonianus Gallus and his son Volusian (who had succeeded Hostilian as co-emperor late in 251) appeared incapable of action in the face of these military setbacks and it is scarcely surprising that when Aemilian, governor of Lower Moesia, inflicted a severe defeat on the Goths north of the Danube he was immediately proclaimed emperor by his troops. Faced with this threat Gallus and Volusian summoned the distinguished general Valerian, who was on the Upper Rhine, to come to their assistance. However, before Valerian could become a factor in the situation the soldiers of Gallus and Volusian, realizing their position was hopeless in the face of Aemilian's overwhelming military force, took matters into their own hands and murdered the unfortunate co-emperors just north of Rome.

Numismatically, the principal interest of this reign lies in the introduction of a heavier gold denomination as part of the regular coinage issued concurrently with the traditional aureus. The heavy coin is usually given the designation 'binio', indicating a double denomination, and this is borne out by the radiate crown worn by the emperor. However, surviving specimens are usually only about 60% heavier than the aureus and we may suspect that gold was now being weighed as a normal feature of transactions rather than being accepted at the value fixed by the government. During this reign the coinage in the name of Trebonianus Gallus was supplemented initially by issues for the co-emperor Hostilian and the Caesar Volusian, and later for Volusian as Augustus in quantities equal to his father.

Rome continued to be the principal mint throughout this reign and was supplemented, as under Decius, by antoniniani from Antioch distinguished by dots or numerals indicating the responsible officina. Attempts have been made to identify a second provincial mint which produced silver coinage with a more abbreviated form of obverse legend than the regular products of Rome (IMP C C VIB instead of IMP CAE C VIB). Both Milan and Viminacium have been proposed as the source of these coins and it is also possible that they represent a separate issue from Rome itself. In the following listings they are described as 'uncertain mint'.

There are four principal varieties of obverse legend:

A. IMP C C VIB TREB GALLVS AVG
B. IMP C C VIB TREB GALLVS P F AVG
C. IMP CAE C VIB TREB GALLVS AVG
D. IMP CAES C VIBIVS TREBONIANVS GALLVS AVG

The normal obverse type for binios, antoniniani and dupondii is radiate bust of Trebonianus Gallus right. All other denominations have laureate bust right. The emperor's bust is usually depicted draped and cuirassed, though on some Antiochene issues the drapery is only slightly indicated on the left shoulder giving the portrait the appearance of being cuirassed only.

9601 **Gold binio.** C. Rev. ANNONA AVGG, Annona stg. r., l. foot on prow, holding rudder and corn-ears. RIC 4. C —. Hunter, p. cv. *[Rome, AD 253].*
VF £2,700 ($4,000) / EF £6,700 ($10,000)

NB The weight of the radiate binio averages about 5.8 grams and that of the laureate aureus about 3.65 grams.

9602 C. Rev. APOLL SALVTARI, Apollo stg. l., holding lustral branch and resting on lyre set on rock. RIC 5. C —. Hunter, p. cv. *[Rome, AD 252].*
VF £3,300 ($5,000) / EF £8,300 ($12,500)
This unusual reverse type doubtless represents an appeal to the god of healing for deliverance from the pestilence which was afflicting Rome (see also nos. 9615, 9627, 9665 and 9685, and under Volusian).

9603 C. Rev. CONCORDIA AVGG, Concordia stg. l., holding patera and double cornucopiae. RIC 6. C 28. Hunter 13. *[Rome, AD 252].* VF £2,700 ($4,000) / EF £6,700 ($10,000)

9604 Similar, but Concordia seated l. and with star in rev. field. RIC 7. C 25. Hunter, p. cv. *[Rome, AD 252].* VF £2,700 ($4,000) / EF £6,700 ($10,000)

9605 C. Rev. FELICITAS PVBLICA, Felicitas stg. l., holding long caduceus and cornucopiae. RIC 8. C 36. Hunter, p. cv. *[Rome, AD 251–2].* VF £2,700 ($4,000) / EF £6,700 ($10,000)

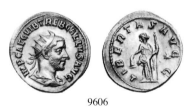

9606

9606 C. Rev. LIBERTAS AVGG, Libertas stg. l., holding pileus and sceptre, star in field. RIC 10. C 62 var. Hunter, p. cv. *[Rome, AD 252].* VF £2,700 ($4,000) / EF £6,700 ($10,000)

9607 Similar, but Libertas rests on column, her legs are crossed and the sceptre is transverse. RIC 11. C 66. Hunter, p. cv. *[Rome, AD 252].* VF £2,700 ($4,000) / EF £6,700 ($10,000)

9608 C. Rev. PIETAS AVGG, Pietas stg. facing, hd. l., raising both hands, star in field. RIC 12 var. C 82 var. Hunter, p. cv, note 3. *[Rome, AD 252].*
VF £2,700 ($4,000) / EF £6,700 ($10,000)

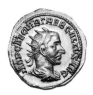

9608

9609 **Gold binio.** C. Rev. P M TR P IIII COS II, Trebonianus Gallus, togate, stg. l., sacrificing over
 tripod-altar and holding short sceptre. RIC —. C —. Hunter —. *[Rome, AD 253]*.
 VF £3,300 ($5,000) / **EF** £8,300 ($12,500)
 As Hostilian was co-emperor at the commencement of the reign the tribunician dates of
 Trebonianus Gallus would appear to continue those of Trajan Decius (see also no. 9620).

9610 C. Rev. **SALVS AVGG**, Salus stg. r., feeding snake held in her arms. RIC 13. C 113. Hunter,
 p. cvi. *[Rome, AD 252]*. **VF** £2,700 ($4,000) / **EF** £6,700 ($10,000)

9611 **Gold aureus.** C. Rev. **ADVENTVS AVG**, Trebonianus Gallus on horseback pacing l., his r.
 hand raised, holding sceptre in l. RIC 14. C 1. Hunter, p. cv. *[Rome, AD 251]*.
 VF £1,850 ($2,750) / **EF** £5,000 ($7,500)

9612 C. Rev. **AEQVITAS AVGG**, Aequitas stg. l., holding scales and cornucopiae. RIC 16. C 8.
 Hunter, p. cv. *[Rome, AD 253]*. **VF** £1,500 ($2,250) / **EF** £4,300 ($6,500)

9613 C. Rev. **AETERNITAS AVGG**, Aeternitas stg. l., holding phoenix on globe and lifting skirt.
 RIC 17. C 12. Hunter, p. cv. *[Rome, AD 253]*. **VF** £1,850 ($2,750) / **EF** £5,000 ($7,500)

9614 C. Rev. **ANNONA AVGG**, Annona stg., as 9601. RIC 18. C 16. Hunter 18. *[Rome, AD 253]*.
 VF £1,500 ($2,250) / **EF** £4,300 ($6,500)

9615 C. Rev. **APOLL SALVTARI**, Apollo stg., as 9602. RIC 19. C 19. Hunter, p. cv. *[Rome,*
 AD 252]. **VF** £1,850 ($2,750) / **EF** £5,000 ($7,500)
 See note following no. 9602.

9616 C. Rev. **CONCORDIA AVGG**, Concordia stg., as 9603. RIC 19A. C —. Hunter, p. cv.
 [Rome, AD 252]. **VF** £1,500 ($2,250) / **EF** £4,300 ($6,500)

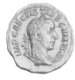

9617

9617 C. Rev. **LIBERTAS AVGG**, Libertas stg. l., holding pileus and sceptre. RIC 20. C 60. Hunter,
 p. cv. *[Rome, AD 251–2]*. **VF** £1,500 ($2,250) / **EF** £4,300 ($6,500)

 NB Cohen 61 records a 'gold quinarius' of this type which may or may not exist as a
 separate denomination.

9618 **Gold aureus.** Similar, but Libertas rests on column, her legs are crossed and the sceptre is transverse. RIC 21. C —. Hunter, p. cv. *[Rome, AD 252].*
 VF £1,650 ($2,500) / **EF** £4,700 ($7,000)

9619 C. Rev. **PIETAS AVGG**, Pietas stg. facing, hd. l., raising both hands. RIC 22. C 83. Hunter, p. cv. *[Rome, AD 251–2].* **VF** £1,500 ($2,250) / **EF** £4,300 ($6,500)

9620 C. Rev. **P M TR P IIII COS II**, Trebonianus Gallus, togate, stg. l., holding branch and short sceptre. RIC 1. C 92. Hunter, p. civ. *[Rome, AD 253].*
 VF £1,850 ($2,750) / **EF** £5,000 ($7,500)
See note following no. 9609.

9621 C. Rev. **PROVIDENTIA AVG**, Providentia stg. l., holding globe and transverse sceptre. RIC 23. C 101. Hunter, p. cv. *[Rome, AD 251].* **VF** £1,850 ($2,750) / **EF** £5,000 ($7,500)

9622 **Silver antoninianus.** B. Rev. **ADVENTVS AVG**, Trebonianus Gallus on horseback, as 9611. RIC 79. RSC 2–3e. Hunter 56. *[Antioch, AD 251–2].* **VF** £22 ($35) / **EF** £55 ($85)

NB Under Trebonianus Gallus the fineness of the antoninianus is generally around 35% whilst the average weight is about 3.40 grams. The Antiochene antoniniani exhibit a wide variety of mint marks (usually dots or numerals on one or both sides) and no attempt is made in these listings to describe them individually. In AD 253 Antioch was captured and sacked by the Persians.

 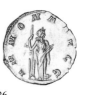

 9623 9626

9623 B. Rev. **AEQVITAS AVG**, Aequitas stg. l., holding scales and cornucopiae. RIC 80. RSC 6–6k. Hunter 52–3. *[Antioch, AD 251].* **VF** £16 ($25) / **EF** £40 ($60)

9624 Similar, but **AEQVITAS AVGG**. RIC 81. RSC 9–9f. Hunter, p. cvi. *[Antioch, AD 251–2].*
 VF £16 ($25) / **EF** £40 ($60)

9625 C. Rev. **AETERNITAS AVGG**, Aeternitas stg., as 9613. RIC 30. RSC 13. Hunter 17. *[Rome, AD 253].* **VF** £20 ($30) / **EF** £50 ($75)

9626 C. Rev. **ANNONA AVGG**, Annona stg., as 9601. RIC 31. RSC 17. Hunter 19. *[Rome, AD 253].* **VF** £16 ($25) / **EF** £40 ($60)

9627 C. Rev. **APOLL SALVTARI**, Apollo stg., as 9602. RIC 32. RSC 20. Hunter 21. *[Rome, AD 252].* **VF** £20 ($30) / **EF** £50 ($75)
See note following no. 9602.

9628 B. Rev. **FELICITAS PVBL**, Felicitas stg. l., holding long caduceus and cornucopiae. RIC 82. RSC 34–34q. Hunter, p. cvi. *[Antioch, AD 251–2].* **VF** £16 ($25) / **EF** £40 ($60)

9629 C. Rev. **FELICITAS PVBLICA**, as previous, but sometimes with star in field. RIC 33–4. RSC 37, 37a. Hunter 4, 6. *[Rome, AD 251–2].* **VF** £16 ($25) / **EF** £40 ($60)

9627 9629

9630 **Silver antoninianus.** C. Rev. — Felicitas stg. l., resting on column and holding short
 caduceus and tranverse sceptre. Cf. RIC 34A. RSC 41. Hunter 15. *[Rome, AD 252]*.
 VF £16 ($25) / **EF** £40 ($60)

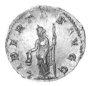

9631 9634

9631 A. Rev. **IVNO MARTIALIS**, Juno seated l., holding corn-ears and transverse sceptre. RIC
 69. RSC 46. Hunter 49. *[Uncertain mint, AD 252]*. **VF** £20 ($30) / **EF** £50 ($75)
 This reverse type occurs also at the mint of Antioch.

9632 C. Rev. **IVNONI MARTIALI**, Juno, with peacock at feet, seated facing within circular distyle
 shrine with domed roof. RIC 54. RSC 49. Hunter, p. cv. *[Rome, AD 252]*.
 VF £85 ($125) / **EF** £170 ($250)
 *The precise location of this shrine has been disputed by scholars, though most would like
 to place it in the Campus Martius where there were three temples dedicated to Juno. Hill,
 however, in "The Monuments of Ancient Rome as Coin Types", pp. 17–18, prefers to place
 it in the Campus Martialis, a small area at the foot of the Caelian Hill situated close to the
 Porta Caelimontana in the Servian Wall. (See also nos. 9671–2 and 9689, and under
 Hostilian and Volusian).*

9633 C. Rev. **LIBERALITAS AVGG**, Liberalitas stg. l., holding abacus and cornucopiae. RIC 36.
 RSC 56. Hunter, p. cv. *[Rome, AD 252]*. **VF** £25 ($40) / **EF** £65 ($100)

9634 C. Rev. **LIBERTAS AVGG**, Libertas stg. l., holding pileus and sceptre, sometimes with star in
 field. RIC 37–8. RSC 63, 63a. Hunter 8. *[Rome, AD 251–2]*. **VF** £16 ($25) / **EF** £40 ($60)

9635 Similar, but Libertas rests on column, her legs are crossed and the sceptre is transverse.
 RIC 39. RSC 67. Hunter, p. cv. *[Rome, AD 252]*. **VF** £16 ($25) / **EF** £40 ($60)

9636 A. Rev. **LIBERTAS PVBLICA**, Libertas stg. l., holding pileus and transverse sceptre. RIC 70.
 RSC 68. Hunter 50. *[Uncertain mint, AD 252]*. **VF** £16 ($25) / **EF** £40 ($60)

9637 B. Rev. **MARTEM PROPVGNATOREM**, Mars advancing r., carrying transverse spear and
 shield. RIC 84. RSC 70. Hunter 59. *[Antioch, AD 251]*. **VF** £20 ($30) / **EF** £50 ($75)

9638 C. Rev. **MARTI PACIFERO**, Mars hurrying l., holding olive-branch and spear. RIC 40. RSC
 71. Hunter 22. *[Rome, AD 251]*. **VF** £22 ($35) / **EF** £55 ($85)
 This reverse type occurs also at the mint of Antioch.

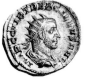

9638 9643

9639 **Silver antoninianus.** A. Rev. PAX AETERNA, Pax stg. l., holding olive-branch and
 transverse sceptre. RIC 71. RSC 76. Hunter 51. *[Uncertain mint, AD 252–3].*
 VF £16 ($25) / **EF** £40 ($60)

9640 C. Rev. PAX AVGG, as previous. RIC 55. RSC 77. Hunter 9. *[Rome, AD 251–2].*
 VF £16 ($25) / **EF** £40 ($60)

9641 B. Rev. PAX AVGVS, as previous. RIC 86. RSC 80–80k. Hunter 60. *[Antioch, AD 252].*
 VF £20 ($30) / **EF** £50 ($75)

9642 C. Rev. PIETAS AVGG, Pietas stg. facing, hd. l., raising both hands, sometimes with star in
 field. RIC 41–2. RSC 84, 84a. Hunter 10, 12. *[Rome, AD 251–2].*
 VF £16 ($25) / **EF** £40 ($60)

9643 A. Rev. — similar, but with altar at Pietas' feet (no star in field). RIC 71. RSC 76. Hunter
 51. *[Uncertain mint, AD 252–3].* **VF** £16 ($25) / **EF** £40 ($60)

9644 9648

9644 C. Rev. PROVIDENTIA AVG, Providentia stg. l., holding globe and sceptre (usually
 transverse). RIC 43. RSC 102. Hunter, p. cv. *[Rome, AD 251].*
 VF £22 ($35) / **EF** £55 ($85)

9645 Similar, but PROVIDENTIA AVGG. RIC 44 and note. RSC 103, 103a. Hunter 3. *[Rome,
 AD 251].* **VF** £20 ($30) / **EF** £50 ($75)

9646 B. Rev. PVDICITIA AVG, Pudicitia seated l., drawing veil from face and holding transverse
 sceptre. RIC 88. RSC 104–104c. Hunter, p. cvi. *[Antioch, AD 251].*
 VF £20 ($30) / **EF** £50 ($75)

9647 B. Rev. ROMAE AETERNAE AVG, Roma seated l., holding Victory and spear, shield at side.
 RIC 89. RSC 107–108p. Hunter, p. cvi. *[Antioch, AD 251–2].* **VF** £20 ($30) / **EF** £50 ($75)

9648 B. Rev. SAECVLVM (or SAECVLLVM) NOVVM, hexastyle temple containing seated statue of
 Roma. RIC 90, 91. RSC 110–110r, 111–111f. Hunter 54. *[Antioch, AD 251–2].*
 VF £22 ($35) / **EF** £55 ($85)
 This is a revival of a type issued four years before as part of the celebration of Rome's
 millennium (see no. 8963).

9649 **Silver antoninianus.** C. Rev. SALVS AVGG, Salus stg. l., feeding snake arising from altar
and holding sceptre. RIC 46a. RSC 117. Hunter, p. cvi. *[Rome, AD 253].*
VF £20 ($30) / **EF** £50 ($75)

9650 Similar, but with obv. legend GALLVS PIVS AVG. RIC 46b. RSC 118. Hunter, p. cvi, note 2.
[Rome, AD 253]. VF £150 ($225) / **EF** £300 ($450)

9651 As 9649, but with SALVS AVGVS. RIC 47. RSC 121. Hunter, p. cv. *[Rome, AD 251].*
VF £22 ($35) / **EF** £55 ($85)

9652 B. Rev. VBERITAS AVG, Uberitas stg. l., holding cow's udder (?) and cornucopiae. RIC 92.
RSC 125–125r. Hunter, p. cvi. *[Antioch, AD 251–2].* VF £16 ($25) / **EF** £40 ($60)

 9653 9656

9653 B. Rev. VICTORIA AVG, Victory advancing l., holding wreath and palm. RIC 93. RSC
126–126n. Hunter 55. *[Antioch, AD 251–2].* VF £16 ($25) / **EF** £40 ($60)

9654 B. Rev. — Victory stg. r. on globe, holding wreath and palm. RIC 94. RSC 127b. Hunter,
p. cvi. *[Antioch, AD 251].* VF £22 ($35) / **EF** £55 ($85)

9655 As 9653, but Victory advancing r. RIC 95. RSC 127, 127a. Hunter, p. cvi. *[Antioch,
AD 251].* VF £20 ($30) / **EF** £50 ($75)

9656 C. Rev. VICTORIA AVGG, Victory stg. l., holding wreath and palm. RIC 48a. RSC 128.
Hunter 23. *[Rome, AD 253].* VF £16 ($25) / **EF** £40 ($60)

9657 Similar, but with obv. legend GALLVS PIVS AVG. RIC 48b. RSC 129. Hunter, p. cvi, note 3.
[Rome, AD 253]. VF £150 ($225) / **EF** £300 ($450)

9658 A. Rev. VIRTVS AVGG, Virtus stg. r., resting on spear and shield. RIC 76. RSC 133. Hunter
48. *[Uncertain mint, AD 252].* VF £20 ($30) / **EF** £50 ($75)

9659 C. Rev. VOTIS / DECENNA / LIBVS in three lines within laurel-wreath. RIC 49. RSC 136.
Hunter, p. cv. *[Rome, AD 251].* VF £150 ($225) / **EF** £300 ($450)

9660 **Silver quinarius.** IMP C GALLVS AVG. Rev. FELICITAS PVBLICA, Felicitas stg. l., holding
long caduceus and cornucopiae. RIC 27. RSC 39. Hunter, p. cv. *[Rome, AD 251–2].*
VF £665 ($1,000) / **EF** £1,350 ($2,000)

9661 Similar, but Felicitas rests on column and holds short caduceus and transverse sceptre. Cf.
RIC 29. RSC 42. Hunter, p. cv. *[Rome, AD 252].* VF £665 ($1,000) / **EF** £1,350 ($2,000)

9662 A. Rev. IVNO MARTIALIS, Juno seated l., holding corn-ears and transverse sceptre. RIC
78. RSC 48. Hunter, p. cvi. *[Uncertain mint, AD 252].*
VF £750 ($1,100) / **EF** £1,500 ($2,250)

9663 **Bronze sestertius.** D. Rev. AEQVITAS AVGG S C, Aequitas stg. l., holding scales and cornucopiae. RIC 101. C 10. Hunter, p. cv. *[Rome, AD 253].*
F £40 ($60) / **VF** £100 ($150) / **EF** £300 ($450)

9664 D. Rev. AETERNITAS AVGG S C, Aeternitas stg. l., holding phoenix on globe and lifting skirt. RIC 102. C 14. Hunter, p. cv. *[Rome, AD 253].*
F £40 ($60) / **VF** £100 ($150) / **EF** £300 ($450)

9665 D. Rev. APOLL (or APOLLO) SALVTARI S C, Apollo stg. l., holding lustral branch and resting on lyre set on rock. RIC 103, 104a. C 21. Hunter 41. *[Rome, AD 252].*
F £40 ($60) / **VF** £100 ($150) / **EF** £300 ($450)
See note following no. 9602.

9666 D. Rev. CONCORDIA AVGG S C, Concordia stg. l., holding patera and double cornucopiae. RIC 105a. C 30. Hunter 37. *[Rome, AD 252].*
F £32 ($50) / **VF** £85 ($130) / **EF** £265 ($400)

9667 Similar, but Concordia seated l. RIC 106a. C 26. Hunter, p. cv. *[Rome, AD 252].*
F £32 ($50) / **VF** £85 ($130) / **EF** £265 ($400)

9668 D. Rev. FELICITAS PVBLICA S C, Felicitas stg. l., holding long caduceus and cornucopiae. RIC 107. C 40. Hunter, p. cv. *[Rome, AD 251–2].*
F £32 ($50) / **VF** £85 ($130) / **EF** £265 ($400)

9669 Similar, but Felicitas rests on column and holds short caduceus and transverse sceptre. RIC 108a. C 43. Hunter 38. *[Rome, AD 252].* F £32 ($50) / **VF** £85 ($130) / **EF** £265 ($400)

9670 D. Rev. IVNONI MARTIALI S C, Juno seated l., holding corn-ears and globe. RIC 109. Cf. C 52. Hunter, p. cv. *[Rome, AD 252].* F £40 ($60) / **VF** £100 ($150) / **EF** £300 ($450)

9671 D. Rev. — Juno seated facing within circular distyle shrine with domed roof. RIC 110a. C 50. Hunter, p. cv. *[Rome, AD 252].* F £55 ($80) / **VF** £130 ($200) / **EF** £400 ($600)
See note following no. 9632.

9672 Similar, but the shrine is tetrastyle and Juno has peacock at her feet. RIC 112. C 54. Hunter 25. *[Rome, AD 252].* F £55 ($80) / **VF** £130 ($200) / **EF** £400 ($600)

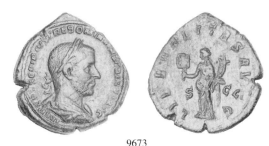

9673

9673 D. Rev. LIBERALITAS AVGG S C, Liberalitas stg. l., holding abacus and cornucopiae. RIC 113. C 57. Hunter 43. *[Rome, AD 252].* F £32 ($50) / **VF** £85 ($130) / **EF** £265 ($400)

9674 D. Rev. LIBERTAS AVGG S C, Libertas stg. l., holding pileus and sceptre. RIC 114a. Cf. C 64. Hunter 31. *[Rome, AD 251–2].* F £32 ($50) / **VF** £85 ($130) / **EF** £265 ($400)

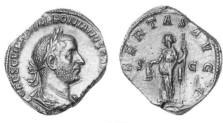

9674

9675 **Bronze sestertius.** D. Rev. PAX AVGG S C, Pax stg. l., holding olive-branch and transverse
 sceptre. RIC 115a. C 78. Hunter 33. *[Rome, AD 251–2].*
 F £32 ($50) / **VF** £85 ($130) / **EF** £265 ($400)

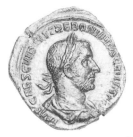

9676

9676 D. Rev. PIETAS AVGG S C, Pietas stg. facing, hd. l., raising both hands, sometimes with
 altar at feet. RIC 116a, 117a. C 86, 89. Hunter 34. *[Rome, AD 251–2].*
 F £32 ($50) / **VF** £85 ($130) / **EF** £265 ($400)

9677

9677 D. Rev. ROMAE AETERNAE S C, Roma seated l., holding Victory and spear, shield at side.
 Roma seated l., holding Victory and spear, shield at side. RIC 120. C 106. Hunter 27.
 [Rome, AD 251]. **F** £40 ($60) / **VF** £100 ($150) / **EF** £300 ($450)

9678 D. Rev. SALVS AVGG S C, Salus stg. r., feeding snake held in her arms. RIC 121a. C 115.
 Hunter, p. cvi. *[Rome, AD 252].* **F** £32 ($50) / **VF** £85 ($130) / **EF** £265 ($400)

9679 Similar, but Salus stg. l., feeding snake arising from altar and holding sceptre. RIC 122a. C
 119. Hunter 44. *[Rome, AD 253].* **F** £32 ($50) / **VF** £85 ($130) / **EF** £265 ($400)

9680 **Bronze sestertius.** D. Rev. SECVRITAS AVGG S C, Securitas stg. facing, hd. r., legs crossed, r. hand on hd., resting l. arm on column. RIC 124. C 124. Hunter 28. *[Rome, AD 251].*
F £40 ($60) / **VF** £100 ($150) / **EF** £300 ($450)

9681 D. Rev. VICTORIA AVGG S C, Victory stg. l., holding wreath and palm. Cf. RIC 125. C 130. Hunter, p. cvi. *[Rome, AD 253].* F £32 ($50) / **VF** £85 ($130) / **EF** £265 ($400)

9682 D. Rev. VIRTVS AVGG S C, Virtus stg. l., resting on shield and spear. RIC 126a. C 134. Hunter 39. *[Rome, AD 251–2].* F £32 ($50) / **VF** £85 ($130) / **EF** £265 ($400)

9683 D. Rev. VOTIS / DECENNA / LIBVS · S C in four lines within laurel-wreath. RIC 127a. C 137. Hunter 29. *[Rome, AD 251].* F £65 ($100) / **VF** £170 ($250) / **EF** £500 ($750)

9684 **Bronze dupondius.** C. Rev. As previous. RIC 127c. C —. Hunter 30. *[Rome, AD 251].*
F £130 ($200) / **VF** £300 ($450) / **EF** £900 ($1,350)

9685 **Bronze as.** C. Rev. APOLLO SALVTARI S C, Apollo stg., as 9665. RIC 104b. C 22. Hunter 42. *[Rome, AD 252].* F £40 ($60) / **VF** £100 ($150) / **EF** £300 ($450)
See note following no. 9602.

9686 C. Rev. CONCORDIA AVGG S C, Concordia stg., as 9666. RIC 105b. C 31. Hunter, p. cv. *[Rome, AD 252].* F £40 ($60) / **VF** £100 ($150) / **EF** £300 ($450)

9687 C. Rev. — Concordia seated, as 9667. RIC 106b. C 27. Hunter, p. cv. *[Rome, AD 252].*
F £40 ($60) / **VF** £100 ($150) / **EF** £300 ($450)

9688 C. Rev. FELICITAS PVBLICA S C Felicitas resting on column, as 9669. RIC 108b. C —. Hunter, p. cv. *[Rome, AD 252].* F £40 ($60) / **VF** £100 ($150) / **EF** £300 ($450)

9689 C. Rev. IVNONI MARTIALI S C, Juno in distyle shrine, as 9671. RIC 110b. C 51. Hunter 26. *[Rome, AD 252].* F £65 ($100) / **VF** £170 ($250) / **EF** £500 ($750)
See note following no. 9632.

9690 C. Rev. LIBERTAS AVGG S C, Libertas stg., as 9674. RIC 114c. C 65. Hunter 32. *[Rome, AD 251–2].* F £40 ($60) / **VF** £100 ($150) / **EF** £300 ($450)
This type is also known with obv. legend D (RIC 114b).

9691 C. Rev. PAX AVGG S C, Pax stg., as 9675. RIC 115b. C 79. Hunter, p. cv. *[Rome, AD 251–2].* F £40 ($60) / **VF** £100 ($150) / **EF** £300 ($450)

9692 C. Rev. PIETAS AVGG S C, Pietas stg., sometimes with altar at feet, as 9676. RIC 116c, 117b. C 87, 90. Hunter 35. *[Rome, AD 251–2].*
F £40 ($60) / **VF** £100 ($150) / **EF** £300 ($450)

9693 C. Rev. SALVS AVGG S C, Salus holding snake, as 9678. RIC 121b. C 116. Hunter, p. cvi. *[Rome, AD 252].* F £40 ($60) / **VF** £100 ($150) / **EF** £300 ($450)

9694 C. Rev. — Salus at altar, as 9679. RIC 122b. C 120. Hunter, p. cvi. *[Rome, AD 253].*
F £40 ($60) / **VF** £100 ($150) / **EF** £300 ($450)

9695 Similar, but rev. legend SALVS AVGVS S C. RIC 123. C 122. Hunter, p. cv. *[Rome, AD 251].*
F £55 ($80) / **VF** £130 ($200) / **EF** £400 ($600)

9696 **Bronze as.** C. Rev. VIRTVS AVGG S C, Virtus stg., as 9682. RIC 126b. C 135. Hunter 40. *[Rome, AD 251–2].* **F** £40 ($60) / **VF** £100 ($150) / **EF** £300 ($450)

9697 C. Rev. VOTIS / DECENNA / LIBVS ˙ S C in wreath, as 9683. RIC 127b. C 138. Hunter, p. cv. *[Rome, AD 251].* **F** £80 ($120) / **VF** £200 ($300) / **EF** £600 ($900)

Alexandrian Coinage

9698

9698 **Billon tetradrachm.** A K Γ OVIB TPEB ΓAΛΛOC EV CEB, laur., dr. and cuir. bust r. Rev. Alexandria, turreted, stg. l., her r. hand raised, holding sceptre in l., L — Γ (= regnal year 3) in field. Dattari 5110. BMCG —. Cologne 2832. Milne 3856. *[AD 252–3].* **F** £32 ($50) / **VF** £85 ($130)

9699 Obv. Similar. Rev. Laur. bust of Asklepios r., snake-entwined staff before, L Γ (= regnal year 3) behind. Dattari 5111. BMCG 2101. Cologne 2833. Milne 3842. *[AD 252–3].* **F** £38 ($55) / **VF** £95 ($140)

9700 — Rev. Athena seated l., holding Nike and resting on sceptre, cuirass at side, L Γ (= regnal year 3) before. Dattari 5112. Cf. BMCG 2100. Cologne 2834. Milne —. *[AD 252–3].* **F** £32 ($50) / **VF** £85 ($130)

9701 — Rev. Rad. bust of Helios r., L — Γ (= regnal year 3) in field. Dattari —. BMCG —. Cologne —. Milne 3839. *[AD 252–3].* **F** £38 ($55) / **VF** £95 ($140)

9702 — Rev. Bust of Sarapis r., wearing modius, L — Γ (= regnal year 3) in field. Dattari 5117. BMCG —. Cologne —. Milne —. *[AD 252–3].* **F** £40 ($60) / **VF** £100 ($150)

9703 — Rev. Sarapis, wearing modius, walking l., his r. hand raised, holding sceptre in l., L — Γ (= regnal year 3) in field. Dattari 5118. BMCG 2105. Cologne 2838. Milne 3852. *[AD 252–3].* **F** £30 ($45) / **VF** £80 ($120)

9704 — Rev. Bust of Selene r., large lunar crescent before, L Γ (= regnal year 3) behind. Dattari —. BMCG —. Cologne 2840. Milne 3840. *[AD 252–3].* **F** £40 ($60) / **VF** £100 ($150)

9705 — Rev. Laur. bust of Zeus r., L — Γ (= regnal year 3) in field. Dattari 5120. BMCG —. Cologne —. Milne —. *[AD 252–3].* **F** £40 ($60) / **VF** £100 ($150)

9706 — Rev. Dikaiosyne (= Aequitas) seated l., holding scales and cornucopiae, L — Γ (= regnal year 3) in field. Dattari 5113. BMCG 2102. Cologne 2835. Milne 3844. *[AD 252–3].* **F** £30 ($45) / **VF** £80 ($120)

9707 — Rev. Eirene (= Pax) stg. l., holding olive-branch and sceptre, L Γ (= regnal year 3) before. Dattari 5114. BMCG 2103. Cologne —. Milne 3845. *[AD 252–3].* **F** £30 ($45) / **VF** £80 ($120)

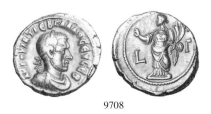

9708

9708 **Billon tetradrachm.** Obv. As 9698. Rev. Homonoia (= Concordia) stg. l., r. hand
extended, holding double-cornucopiae in l., L — Γ (= regnal year 3) in field. Dattari 5115.
BMCG 2104. Cologne 2836. Milne 3847. *[AD 252–3].* **F** £30 ($45) / **VF** £80 ($120)

9709 — Rev. Nike (= Victory) advancing r., holding wreath and palm, L — Γ (= regnal year 3) in
field. Dattari 5116. BMCG —. Cologne 2837. Milne 3849. *[AD 252–3].*
F £30 ($45) / **VF** £80 ($120)

9710 — Rev. Tyche (= Fortuna) stg. l., holding rudder and cornucopiae, L — Γ (= regnal year 3)
in field. Dattari 5119. BMCG —. Cologne —. Milne 3850. *[AD 252–3].*
F £38 ($55) / **VF** £95 ($140)

9711 — Rev. Eagle stg. r., wings open, holding wreath in beak, palm transversely in
background, L Γ (= regnal year 3) before. Dattari 5121. BMCG 2106. Cologne 2831. Milne
3858. *[AD 252–3].* **F** £30 ($45) / **VF** £80 ($120)

For other local coinages of Trebonianus Gallus, see *Greek Imperial Coins & Their Values*, pp. 414–19.

VOLUSIAN
Nov. AD 251–Jul./Aug. 253

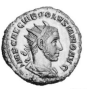 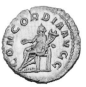

9743

*Gaius Vibius Afinius Gallus Vendumnianus Volusianus was the son of Trebonianus Gallus and
Baebiana. His date of birth is uncertain but from his coin portraits it would appear to have been in
the middle years of the reign of Severus Alexander, probably the late AD 220s. Soon after his
father's accession to imperial power in the summer of AD 251 Volusian was granted the junior rank
of Caesar, the position of co-emperor being bestowed on the younger Hostilian, the surviving son
of Trajan Decius. On the death of Hostilian, probably in November of the same year, Volusian took
his place as co-emperor, thus averting what would inevitably have developed into a fatal rivalry
between the two young men. The joint reign of father and son lasted until the summer of AD 253
when both were murdered by their own soldiers on the approach of Aemilian, a rival claimant to
the imperial throne.*

*Volusian's coinage is divided into two main groups, those issued between the summer and
November of AD 251, when he bore the title of Caesar, and those issued after his elevation to the
rank of Augustus. The former are all from the mint of Rome, but after he became co-emperor with
his father he also shared in the issue of antoniniani from Antioch and from the 'uncertain mint'
mentioned in the introduction to the coinage of Trebonianus Gallus. An interesting feature of the
coinage of Volusian is the exclusive rendering at the mint of Rome (and frequently at Antioch) of
his name in the dative case 'Volusiano'.*

There are four principal varieties of obverse legend, the first as Caesar, the other three as Augustus:

A. C VIBIO VOLVSIANO CAES
B. IMP C C VIB VOLVSIANVS AVG
C. IMP C V AF GAL VEND VOLVSIANO (or VOLVSIANVS) AVG
D. IMP CAE C VIB VOLVSIANO AVG

The normal obverse type for binios, antoniniani and dupondii is radiate bust of Volusian right. All other denominations have laureate bust right. The emperor's bust is usually depicted draped and cuirassed, though sometimes the cuirass is only slightly indicated or may even be absent on some dies. On his rare issues as Caesar Volusian's head is bare on all denominations other than the antoninianus on which he appears radiate.

Issues as Caesar under Trebonianus Gallus and Hostilian, summer-Nov. AD 251

9712 **Gold aureus.** A. Rev. PRINCIPI IVVENTVTIS, Volusian, in military attire, stg. l., holding baton and resting on spear. RIC 129. C 98. Hunter, p. cvii. *[Rome]*.
 VF £4,000 ($6,000) / **EF** £10,000 ($15,000)

 NB Cohen 99 records a 'gold quinarius' of this type which may or may not exist as a separate denomination.

9713 **Silver antoninianus.** A. Rev. As previous. RIC 134. RSC 100. Hunter, p. cvii. *[Rome]*.
 VF £150 ($225) / **EF** £300 ($450)

9714 **Bronze sestertius.** A. Rev. PRINCIPI IVVENTVTIS S C, as 9712. RIC 241. C 103. Hunter 1. *[Rome]*. **F** £115 ($175) / **VF** £265 ($400) / **EF** £800 ($1,200)

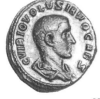

 9715 9716

9715 **Bronze dupondius** or **as.** A. Rev. PAX AVGG S C, Pax stg. l., holding olive-branch and transverse sceptre. RIC 240. C 76. Hunter, p. cvii. *[Rome]*.
 F £80 ($120) / **VF** £200 ($300) / **EF** £600 ($900)

9716 A. Rev. VOTIS / DECENNA / LIBVS / S C in four lines within laurel-wreath. RIC 243. C 141. Hunter, p. cvii. *[Rome]*. **F** £100 ($150) / **VF** £230 ($350) / **EF** £665 ($1,000)

Issues as Augustus, AD 251–253

9717 **Gold binio.** D. Rev. AEQVITAS AVGG, Aequitas stg. l., holding scales and cornucopiae. RIC 142. C 7. Hunter, p. cvii. *[Rome, AD 253].* **VF** £2,700 ($4,000) / **EF** £6,700 ($10,000)

9718 D. Rev. CONCORDIA AVGG, Concordia stg. l., holding patera and double cornucopiae. RIC 143. C 19. Hunter 16. *[Rome, AD 252].* **VF** £2,700 ($4,000) / **EF** £6,700 ($10,000)

9719 Similar, but Concordia seated l. and sometimes with star in field. RIC 144–5. C 24. Hunter, p. cvii. *[Rome, AD 251–2].* **VF** £2,700 ($4,000) / **EF** £6,700 ($10,000)

9720 Similar, but Concordia holds single cornucopiae and has altar at feet. RIC 146. C 28. Hunter, p. cvii. *[Rome, AD 251–2].* **VF** £2,700 ($4,000) / **EF** £6,700 ($10,000)

9721 D. Rev. LIBERTAS AVGG, Libertas stg. l., holding pileus and sceptre. RIC 148. C 54. Hunter, p. cvii. *[Rome, AD 251–2].* **VF** £2,700 ($4,000) / **EF** £6,700 ($10,000)

9722 Similar, but Libertas rests on column, her legs are crossed and the sceptre is transverse. RIC 149. C 57. Hunter, p. cvii. *[Rome, AD 252].*
 VF £2,700 ($4,000) / **EF** £6,700 ($10,000)

9723 D. Rev. PIETAS AVGG, Pietas stg. facing, hd. l., raising both hands, star in field. RIC 150. C 82. Hunter, p. cvii. *[Rome, AD 252].* **VF** £2,700 ($4,000) / **EF** £6,700 ($10,000)

9724 Similar, but with altar at Pietas' feet (no star in field). RIC 151. C —. Hunter, p. cvii. *[Rome, AD 252].* **VF** £2,700 ($4,000) / **EF** £6,700 ($10,000)

 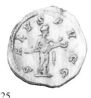 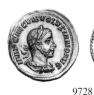 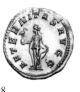

9725 9728

9725 D. Rev. SALVS AVGG, Salus stg. r., feeding snake held in her arms. RIC 152. C 117. Hunter, p. cviii. *[Rome, AD 252].* **VF** £2,700 ($4,000) / **EF** £6,700 ($10,000)

9726 D. Rev. VIRTVS AVGG, Virtus stg. l., resting on shield and spear . RIC —. C —. Hunter —. *[Rome, AD 251–2].* **VF** £2,700 ($4,000) / **EF** £6,700 ($10,000)

9727 **Gold aureus.** D. Rev. AEQVITAS AVGG, Aequitas stg., as 9717. RIC 153. C 6. Hunter, p. cvii. *[Rome, AD 253].* **VF** £1,850 ($2,750) / **EF** £5,000 ($7,500)

9728 D. Rev. AETERNITAS AVGG, Aeternitas stg. l., holding phoenix on globe and lifting skirt. RIC 154. C 10. Hunter, p. cvii. *[Rome, AD 253].*
 VF £2,000 ($3,000) / **EF** £5,300 ($8,000)

9729 D. Rev. ANNONA AVGG, Annona stg. r., l. foot on prow, holding rudder and corn-ears. RIC —. C —. Hunter —. *[Rome, AD 253].* **VF** £2,300 ($3,500) / **EF** £6,000 ($9,000)

9730 **Gold aureus.** D. Rev. IVNONI MARTIALI, Juno seated facing within circular distyle (sometimes tetrastyle) shrine with domed roof. RIC 155–6. C 40. Hunter, p. cvii. *[Rome, AD 252].* **VF** £2,700 ($4,000) / **EF** £6,700 ($10,000)
The precise location of this shrine has been disputed by scholars, though most would like to place it in the Campus Martius where there were three temples dedicated to Juno. Hill, however, in "The Monuments of Ancient Rome as Coin Types", pp. 17–18, prefers to place it in the Campus Martialis, a small area at the foot of the Caelian Hill situated close to the Porta Caelimontana in the Servian Wall. (See also nos. 9750, 9787–8 and 9807–8, and under Trebonianus Gallus and Hostilian).

9731 C (VOLVSIANO), two dots behind head. Rev. LIBERTAS AVGG, Libertas stg. facing, hd. l., her legs crossed, holding pileus and transverse sceptre and resting on column. RIC 227. C 56. Hunter, p. cvii. *[Antioch, AD 252].* **VF** £3,300 ($5,000) / **EF** £8,300 ($12,500)

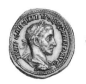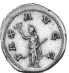

9732

9732 D. Rev. PAX AVGG, Pax stg. l., holding olive-branch and transverse sceptre. RIC 157. C 69. Hunter, p. cvii. *[Rome, AD 251–2].* **VF** £1,850 ($2,750) / **EF** £5,000 ($7,500)

9733 D. Rev. PIETAS AVGG, Pietas stg. facing, hd. l., raising both hands. RIC 158. C 83. Hunter, p. cvii. *[Rome, AD 251–2].* **VF** £1,850 ($2,750) / **EF** £5,000 ($7,500)

NB Cohen 84 records a 'gold quinarius' of this type which may or may not exist as a separate denomination.

9734 D. Rev. PRINCIPI IVVENTVTIS, Volusian, in military attire, stg. l., holding standard and spear. RIC 159. C 105. Hunter —. *[Rome, AD 251].* **VF** £2,000 ($3,000) / **EF** £5,300 ($8,000)

9735 D. Rev. SALVS AVGG, Salus holding snake, as 9725. RIC 160. C —. Hunter, p. cviii. *[Rome, AD 252].* **VF** £2,000 ($3,000) / **EF** £5,300 ($8,000)

9736 D. Rev. VICTORIA AVGG, Victory stg. l., holding wreath and palm. RIC 161. C 130. Hunter, p. cviii. *[Rome, AD 253].* **VF** £1,850 ($2,750) / **EF** £5,000 ($7,500)

9737 D. Rev. VIRTVS AVGG, Virtus stg., as 9726. RIC 162. C 134. Hunter, p. cvii. *[Rome, AD 251–2].* **VF** £1,850 ($2,750) / **EF** £5,000 ($7,500)

9738 **Silver antoninianus.** B. Rev. ADVENTVS AVG, Volusian on horseback pacing l., his r. hand raised, holding sceptre in l. RIC 214. RSC 1. Hunter, p. cviii. *[Antioch, AD 252].* **VF** £22 ($35) / **EF** £55 ($85)

9739 C (VOLVSIANO). Rev. AEQVITAS AVG, Aequitas stg. l., holding scales and cornucopiae. RIC 225. RSC 5. Hunter 49 var. *[Antioch, AD 251–2].* **VF** £16 ($25) / **EF** £40 ($60)

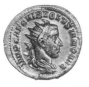
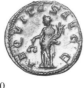

9740 9742

9740 **Silver antoninianus.** D. Rev. AEQVITAS AVGG, as previous. RIC 166. RSC 8. Hunter 20.
 [Rome, AD 253]. **VF** £16 ($25) / **EF** £40 ($60)

9741 D. Rev. APOLL SALVTARI, Apollo stg. l., holding lustral branch and resting on lyre set on
 rock. RIC 188. RSC 14. Hunter, p. cvii. *[Rome, AD 252].* **VF** £22 ($35) / **EF** £60 ($90)
 *This unusual reverse type doubtless represents an appeal to the god of healing for
 deliverance from the pestilence which was afflicting Rome (see also nos. 9783 and 9803,
 and under Trebonianus Gallus).*

9742 D. Rev. CONCORDIA AVGG, Concordia stg. l., holding patera and double cornucopiae.
 RIC 167. RSC 20. Hunter 17. *[Rome, AD 252].* **VF** £16 ($25) / **EF** £40 ($60)

9743

9743 Similar, but Concordia seated l. and sometimes with star in field. RIC 168–9. RSC 25, 25a.
 Hunter 6. *[Rome, AD 251–2].* **VF** £16 ($25) / **EF** £40 ($60)

9744 Similar, but Concordia holds single cornucopiae and has altar at feet. RIC 170. RSC 29.
 Hunter, p. cvii. *[Rome, AD 251–2].* **VF** £25 ($40) / **EF** £65 ($100)

9745 B. Rev. FELICITAS AVG, Felicitas stg. l., holding long caduceus and cornucopiae. RIC 216.
 RSC 30a, b. Hunter, p. cix. *[Antioch, AD 252].* **VF** £22 ($35) / **EF** £55 ($85)

9746 Similar, but with rev. legend FELICITAS PVBL. RIC 205. RSC 32. Hunter 46. *[Uncertain
 mint, AD 252].* **VF** £16 ($25) / **EF** £40 ($60)
 This reverse type occurs also at the mint of Antioch.

9747 D. Rev. Felicitas stg. l., resting on column and holding short caduceus and tranverse sceptre.
 RIC 188A. RSC 34. Hunter, p. cvii. *[Rome, AD 252].* **VF** £20 ($30) / **EF** £50 ($75)

9748 B. Rev. IVNO MARTIALIS, Juno seated l., holding corn-ears and transverse sceptre. RIC
 209. RSC 38. Hunter, p. cviii. *[Uncertain mint, AD 252].* **VF** £22 ($35) / **EF** £55 ($85)
 This reverse type occurs also at the mint of Antioch.

9749 D. Rev. IVNONI MARTIALI, similar, but Juno holds globe instead of sceptre. RIC 177. RSC
 39. Hunter, p. cviii. *[Rome, AD 252].* **VF** £25 ($40) / **EF** £65 ($100)

9750 9755

9750 **Silver antoninianus.** D. Rev. — Juno seated facing within circular distyle (sometimes tetrastyle) shrine with domed roof, sometimes with star in field. RIC 171–6. RSC 40a-45, 48, 48a. Hunter 8–10. *[Rome, AD 252].* **VF** £65 ($100) / **EF** £130 ($200) *See note following no. 9730.*

9751 D. Rev. LIBERALITAS AVGG, Liberalitas stg. l., holding abacus and cornucopiae. RIC 178. RSC 49. Hunter, p. cviii. *[Rome, AD 252–3].* **VF** £25 ($40) / **EF** £65 ($100)

9752 D. Rev. LIBERTAS AVGG, Libertas stg. l., holding pileus and sceptre. RIC 189. RSC 55. Hunter, p. cvii. *[Rome, AD 251–2].* **VF** £20 ($30) / **EF** £50 ($75)

9753 Similar, but Libertas rests on column, her legs are crossed and the sceptre is transverse. RIC 190. RSC 58. Hunter, p. cvii. *[Rome, AD 252].* **VF** £20 ($30) / **EF** £50 ($75)

9754 B. Rev. LIBERTAS PVBLICA, Libertas stg. l., holding pileus and transverse sceptre. RIC 210. RSC 59. Hunter, p. cviii. *[Uncertain mint, AD 252].* **VF** £20 ($30) / **EF** £50 ($75)

9755 B. Rev. MARTEM PROPVGNATOREM, Mars advancing r., carrying transverse spear and shield. RIC 219. RSC 60. Hunter, p. cix. *[Antioch, AD 251–2].*
 VF £20 ($30) / **EF** £50 ($75)

9756 C (VOLVSIANO). Rev. MARTI PACIFERO, Mars hurrying l., holding olive-branch and spear. RIC 228. RSC 61, 61a. Hunter, p. cviii. *[Antioch, AD 251–2].*
 VF £22 ($35) / **EF** £55 ($85)

9757 B. Rev. PAX AETERNA, Pax stg. l., holding olive-branch and transverse sceptre. RIC 211. RSC 66. Hunter, p. cviii. *[Uncertain mint, AD 252–3].* **VF** £20 ($30) / **EF** £50 ($75)

9758 D. Rev. PAX AVGG, as previous, but sometimes with star in field. RIC 179, 180. RSC 70, 71. Hunter 11, 12. *[Rome, AD 251–2].* **VF** £16 ($25) / **EF** £40 ($60)

9759 C (VOLVSIANO). Rev. PAX AVGVS, as 9757. RIC 230a. RSC 78–78g. Hunter, p. cviii. *[Antioch, AD 252].* **VF** £20 ($30) / **EF** £50 ($75)

9760 D. Rev. PIETAS AVGG, Pietas stg. facing, hd. l., raising both hands, sometimes with star in field. RIC 191, 192. RSC 85, 85a. Hunter, p. cvii. *[Rome, AD 251–2].*
 VF £20 ($30) / **EF** £50 ($75)

9761 Similar, but with altar at Pietas' feet (no star in field). RIC 182. RSC 88. Hunter 19. *[Rome, AD 252].* **VF** £16 ($25) / **EF** £40 ($60)

9762 D. Rev. P M TR P IIII COS II, Volusian, togate, stg. l., holding branch and short sceptre. RIC 140. RSC 92. Hunter 2. *[Rome, AD 253].* **VF** £16 ($25) / **EF** £40 ($60) *As Hostilian was co-emperor at the commencement of the reign of Trebonianus Gallus the tribunician dates of both Gallus and Volusian would appear to continue those of Trajan Decius (see also the following and nos. 9792–3).*

9761 9762

9763 9769

9763 **Silver antoninianus.** Similar, but Volusian sacrifices over altar instead of holding branch.
 RIC 141. RSC 94. Hunter 3. *[Rome, AD 253].* **VF** £16 ($25) / **EF** £40 ($60)

9764 D. Rev. **PRINCIPI IVVENTVTIS**, Volusian, in military attire, stg. l., holding baton and resting
 on spear. RIC 183. RSC 101. Hunter 5. *[Rome, AD 251].* **VF** £25 ($40) / **EF** £65 ($100)

9765 D. Rev. **PROVIDENTIA AVGG**, Providentia stg. l., holding globe and sceptre . RIC 193.
 RSC 108. Hunter, p. cvii. *[Rome, AD 251–2].* **VF** £22 ($35) / **EF** £55 ($85)

9766 C (**VOLVSIANO**). Rev. **PVDICITIA AVGG**, Pudicitia seated l., drawing veil from face and
 holding transverse sceptre. RIC 233a. RSC 110a-c. Hunter, p. cviii. *[Antioch, AD 251–2].*
 VF £20 ($30) / **EF** £50 ($75)

9767 B. Rev. **ROMAE AETERNAE AVG**, Roma seated l., holding Victory and spear, shield at side.
 RIC 221. RSC 113–113b. Hunter, p. cix. *[Antioch, AD 251–2].*
 VF £20 ($30) / **EF** £50 ($75)

9768 C (**VOLVSIANO**). Rev. **SAECVLVM** (sometimes **SAECVLLVM**) **NOVVM**, hexastyle temple
 containing seated statue of Roma. RIC 235, 236a. RSC 114e, 115–115j. Hunter, p. cviii.
 [Antioch, AD 251–2]. **VF** £22 ($35) / **EF** £55 ($85)
 *This is a revival of a type issued four years before as part of the celebration of Rome's
 millennium (see no. 8963).*

9769 D. Rev. **SALVS AVGG**, Salus stg. r., feeding snake held in her arms. RIC 184. RSC 118.
 Hunter 22. *[Rome, AD 252].* **VF** £16 ($25) / **EF** £40 ($60)

9770 **VOLVSIANVS PIVS F AVG.** Rev. — Salus stg. l., feeding snake arising from altar and
 holding sceptre. Cf. RIC 185A. RSC 119a. Hunter, p. cviii, note 2. *[Rome, AD 253].*
 VF £150 ($225) / **EF** £300 ($450)

9771 D. Rev. **SALVS AVGVS**, as previous. RIC 185. RSC 122. Hunter, p. cvii. *[Rome, AD 251].*
 VF £22 ($35) / **EF** £55 ($85)

9772 **Silver antoninianus.** C (VOLVSIANO). Rev. VBERITAS AVG, Uberitas stg. l., holding cow's udder (?) and cornucopiae. RIC 237a. RSC 125–125f. Hunter 48. *[Antioch, AD 251–2].* **VF** £16 ($25) / **EF** £40 ($60)

9773 — Rev. VICTORIA AVG, Victory advancing l., holding wreath and palm. RIC 238. RSC 127–127e. Hunter, p. cviii. *[Antioch, AD 251–2].* **VF** £16 ($25) / **EF** £40 ($60)

9774 — Rev. — Victory stg. r. on globe, holding wreath and palm. RIC 239a. RSC 126–126d. Hunter, p. cviii. *[Antioch, AD 251].* **VF** £22 ($35) / **EF** £55 ($85)

9775 D. Rev. VICTORIA AVGG, Victory stg. l., holding wreath and palm. RIC 194. RSC 131. Hunter, p. cviii. *[Rome, AD 253].* **VF** £20 ($30) / **EF** £50 ($75)

9776

9776 B. Rev. VIRTVS AVGG, Virtus stg. r., resting on spear and shield. RIC 206. RSC 133. Hunter 47. *[Uncertain mint, AD 252].* **VF** £16 ($25) / **EF** £40 ($60)

9777 Similar, but Virtus stands l., resting on shield and spear. RIC —. RSC —. Hunter 45. *[Uncertain mint, AD 252].* **VF** £25 ($40) / **EF** £65 ($100)

9778 D. Rev. As last, but sometimes with star in field. RIC 186–7. RSC 135, 135a. Hunter 14. *[Rome, AD 251–2].* **VF** £16 ($25) / **EF** £40 ($60)

9779 **Silver quinarius.** IMP C VOLVSIANO AVG. Rev. FELICITAS PVBLICA, Felicitas stg. l., holding long caduceus and cornucopiae. RIC 165. RSC 33a. Hunter, p. cvii. *[Rome, AD 251–2].* **VF** £1,200 ($1,800) / **EF** £2,300 ($3,500)

9780 — Rev. SALVS AVGG, Salus stg. r., feeding snake held in her arms. RIC p. 182, 208B. RSC 119. Hunter, p. cviii. *[Rome, AD 252].* **VF** £1,200 ($1,800) / **EF** £2,300 ($3,500) *RIC and Hunter consider that this type and the next may belong to the 'uncertain mint' rather than to Rome. This seems more likely to be true in the case of no. 9781.*

9781 B. Rev. VIRTVS AVGG, Virtus stg. r., as 9776. RIC p. 182, 208A. RSC 133a. Hunter, p. cviii. *[Uncertain mint, AD 252].* **VF** £1,200 ($1,800) / **EF** £2,300 ($3,500)

9782 **Bronze sestertius.** D. Rev. AEQVITAS AVGG S C, Aequitas stg. l., holding scales and cornucopiae. RIC 246. C 9. Hunter 42. *[Rome, AD 253].* **F** £32 ($50) / **VF** £85 ($130) / **EF** £265 ($400)

9783 D. Rev. APOLLO (or APOLL) SALVTARI S C, Apollo stg. l., holding lustral branch and resting on lyre set on rock. RIC 247, 248a. C 15. Hunter, p. cvii. *[Rome, AD 252].* **F** £40 ($60) / **VF** £100 ($150) / **EF** £300 ($450)

See note following no. 9741.

9782

9784 **Bronze sestertius.** D. Rev. CONCORDIA AVGG S C, Concordia stg. l., holding patera and double cornucopiae. RIC 249a. C 21. Hunter 34. *[Rome, AD 252].*
 F £32 ($50) / **VF** £85 ($130) / **EF** £265 ($400)

9785 Similar, but Concordia seated l. RIC 250a. C 26. Hunter 28. *[Rome, AD 252].*
 F £32 ($50) / **VF** £85 ($130) / **EF** £265 ($400)

9786

9786 D. Rev. FELICITAS PVBLICA S C, Felicitas stg. l., resting on column and holding short caduceus and tranverse sceptre. RIC 251a. C 35. Hunter 39. *[Rome, AD 252].*
 F £32 ($50) / **VF** £85 ($130) / **EF** £265 ($400)

9787 D. Rev. IVNONI MARTIALI S C, Juno seated facing within circular distyle shrine with domed roof. RIC 253a. C 46. Hunter 30. *[Rome, AD 252].*
 F £55 ($80) / **VF** £130 ($200) / **EF** £400 ($600)
 See note following no. 9730.

9788 Similar, but the shrine is tetrastyle. RIC 252a. C 41. Hunter, p. cvii. *[Rome, AD 252].*
 F £55 ($80) / **VF** £130 ($200) / **EF** £400 ($600)

9789 D. Rev. LIBERALITAS AVGG S C, Liberalitas stg. l., holding abacus and cornucopiae. RIC 254a. C 50. Hunter 43. *[Rome, AD 252].* **F** £40 ($60) / **VF** £100 ($150) / **EF** £300 ($450)

9790 D. Rev. PAX AVGG S C, Pax stg. l., holding olive-branch and transverse sceptre. RIC 256a. C 74. Hunter 32. *[Rome, AD 251–2].* **F** £32 ($50) / **VF** £85 ($130) / **EF** £265 ($400)

9791 D. Rev. PIETAS AVGG S C, Pietas stg. facing, hd. l., raising both hands, sometimes with altar at feet. RIC 257. C 87. Hunter 41. *[Rome, AD 251–2].*
 F £32 ($50) / **VF** £85 ($130) / **EF** £265 ($400)

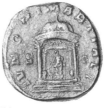

9788

9790

9792 **Bronze sestertius.** D. Rev. P M TR P IIII COS II P P S C, Volusian, togate, stg. l., holding branch and short sceptre. RIC 244. C 97. Hunter 24. *[Rome, AD 253]*.
 F £40 ($60) / **VF** £100 ($150) / **EF** £300 ($450)
See note following no. 9762.

9793 Similar, but Volusian sacrifices over altar instead of holding branch. RIC 245. C 96. Hunter 26. *[Rome, AD 253]*. F £40 ($60) / **VF** £100 ($150) / **EF** £300 ($450)

9794 D. Rev. PRINCIPI IVVENTVTIS S C, Volusian, in military attire, stg. l., holding baton and resting on spear. RIC 259. C 102. Hunter, p. cvii. *[Rome, AD 251]*.
 F £50 ($75) / **VF** £115 ($175) / **EF** £350 ($525)

9795 D. Rev. SALVS AVGG, Salus stg. r., feeding snake held in her arms. RIC 260a. C 120. Hunter 44. *[Rome, AD 252]*. F £32 ($50) / **VF** £85 ($130) / **EF** £265 ($400)

9796 D. Rev. SECVRITAS AVGG S C, Securitas stg. facing, hd. r., legs crossed, r. hand on hd., resting l. arm on column. RIC 261. C 124. Hunter, p. cvii. *[Rome, AD 251]*.
 F £50 ($75) / **VF** £115 ($175) / **EF** £350 ($525)

9797 D. Rev. VICTORIA AVGG S C, Victory stg. l., holding wreath and palm. RIC 262. C 132. Hunter, p. cviii. *[Rome, AD 253]*. F £40 ($60) / **VF** £100 ($150) / **EF** £300 ($450)

9798 D. Rev. VIRTVS AVGG S C, Virtus stg. l., resting on shield and spear. RIC 263a. C 136. Hunter, p. cvii. *[Rome, AD 251–2]*. F £32 ($50) / **VF** £85 ($130) / **EF** £265 ($400)

9799 D. Rev. VOTIS / DECENNA / LIBVS ' S C in four lines within laurel-wreath. RIC 264. C 140. Hunter 27. *[Rome, AD 251]*. F £65 ($100) / **VF** £170 ($250) / **EF** £500 ($750)

9800 **Bronze dupondius.** D. Rev. CONCORDIA AVGG S C, Concordia stg., as 9784. RIC 249c. C 23. Hunter, p. cvii. *[Rome, AD 252]*. F £80 ($120) / **VF** £200 ($300) / **EF** £600 ($900)

9801 **Bronze dupondius.** D. Rev. PAX AVGG S C, Pax stg., as 9790. RIC 256c. C —. Hunter, p. cvii. *[Rome, AD 251–2].* F £80 ($120) / **VF** £200 ($300) / **EF** £600 ($900)

9802 D. Rev. PIETAS AVGG S C, Pietas stg. facing, hd. l., raising both hands, altar at feet. RIC 258b. C —. Hunter, p. cvii. *[Rome, AD 251–2].*
 F £80 ($120) / **VF** £200 ($300) / **EF** £600 ($900)

9803 **Bronze as.** As 9783 (rev. APOLLO SALVTARI S C, Apollo stg.). RIC 248b. C 16. Hunter, p. cvii. *[Rome, AD 252].* F £50 ($75) / **VF** £115 ($175) / **EF** £350 ($525)
 See note following no. 9741.

 9804 9806

9804 D. Rev. CONCORDIA AVGG S C, Concordia stg. l., holding patera and double cornucopiae. RIC 249b. C 22. Hunter 36. *[Rome, AD 252].*
 F £40 ($60) / **VF** £100 ($150) / **EF** £300 ($450)

9805 Similar, but Concordia seated l. RIC 250b. C 27. Hunter, p. cvii. *[Rome, AD 252].*
 F £40 ($60) / **VF** £100 ($150) / **EF** £300 ($450)

9806 As 9786 (rev. FELICITAS PVBLICA S C, Felicitas resting on column). RIC 251b. C 36. Hunter 40. *[Rome, AD 252].* F £40 ($60) / **VF** £100 ($150) / **EF** £300 ($450)

9807 D. Rev. IVNONI MARTIALI S C, Juno seated facing within circular distyle shrine with domed roof. RIC 253b. C —. Hunter, p. cvii. *[Rome, AD 252].*
 F £55 ($80) / **VF** £130 ($200) / **EF** £400 ($600)
 See note following no. 9730.

9808 Similar, but the shrine is tetrastyle. RIC 252b. C 42. Hunter 31. *[Rome, AD 252].*
 F £55 ($80) / **VF** £130 ($200) / **EF** £400 ($600)

9809 As 9789 (rev. LIBERALITAS AVGG S C, Liberalitas stg.). RIC 254b. C 51. Hunter, p. cviii. *[Rome, AD 252].* F £50 ($75) / **VF** £115 ($175) / **EF** £350 ($525)

9810 As 9790 (rev. PAX AVGG S C, Pax stg.). RIC 256b. C 75. Hunter, p. cvii. *[Rome, AD 251–2].* F £40 ($60) / **VF** £100 ($150) / **EF** £300 ($450)

9811 D. Rev. PIETAS AVGG S C, as 9802. RIC 258a. C 89. Hunter, p. cvii. *[Rome, AD 251–2].*
 F £40 ($60) / **VF** £100 ($150) / **EF** £300 ($450)

9812 As 9795 (rev. SALVS AVGG S C, Salus holding snake). RIC 260b. C 121. Hunter, p. cviii. *[Rome, AD 252].* F £40 ($60) / **VF** £100 ($150) / **EF** £300 ($450)

9813 As 9798 (rev. VIRTVS AVGG S C, Virtus stg.). RIC 263b. C 137. Hunter, p. cvii. *[Rome, AD 251–2].* F £40 ($60) / **VF** £100 ($150) / **EF** £300 ($450)

Alexandrian Coinage

9814 **Billon tetradrachm.** Α Κ Γ ΑΦ ΓΑΛ Β ΒΟΛΟVCΙΑΝΟC ΕV C, laur., dr. and cuir. bust r. Rev. Alexandria, turreted, stg. l., her r. hand raised, holding sceptre in l., L — Γ (= regnal year 3) in field. Dattari 5123. BMCG —. Cologne —. Milne 3857. *[AD 252–3].*
F £38 ($55) / **VF** £95 ($140)

9815

9815 Obv. Similar. Rev. Laur. bust of Asklepios r., snake-entwined staff before, L Γ (= regnal year 3) behind. Dattari 5124. BMCG 2109. Cologne 2842. Milne 3843. *[AD 252–3].*
F £32 ($50) / **VF** £85 ($130)

9816 — Rev. Rad. bust of Helios r., L — Γ (= regnal year 3) in field. Dattari 5127. BMCG 2107. Cologne 2843. Milne (Supplement) 3839a. *[AD 252–3].* F £32 ($50) / **VF** £85 ($130)

9817 — Rev. Bust of Sarapis r., wearing modius, L — Γ (= regnal year 3) in field. Dattari 5129. BMCG —. Cologne 2845. Milne —. *[AD 252–3].* F £38 ($55) / **VF** £95 ($140)

9818 — Rev. Sarapis, wearing modius, walking l., his r. hand raised, holding sceptre in l., L — Γ (= regnal year 3) in field. Dattari 5130. BMCG 2113. Cologne 2846. Milne 3855. *[AD 252–3].* F £30 ($45) / **VF** £80 ($120)

9819 — Rev. Bust of Selene r., large lunar crescent before, L Γ (= regnal year 3) behind. Dattari 5131. BMCG 2108. Cologne —. Milne 3841. *[AD 252–3].* F £32 ($50) / **VF** £85 ($130)

9820 — Rev. Laur. bust of Zeus r., L — Γ (= regnal year 3) in field. Dattari 5133. BMCG —. Cologne —. Milne —. *[AD 252–3].* F £40 ($60) / **VF** £100 ($150)

9821 — Rev. Dikaiosyne (= Aequitas) seated l., holding scales and cornucopiae, L — Γ (= regnal year 3) in field. Dattari 5125. BMCG 2110. Cologne —. Milne —. *[AD 252–3].*
F £38 ($55) / **VF** £95 ($140)

9822 — Rev. Eirene (= Pax) stg. l., holding olive-branch and sceptre, L Γ (= regnal year 3) before. Dattari 5126. BMCG 2111. Cologne —. Milne 3846. *[AD 252–3].*
F £32 ($50) / **VF** £85 ($130)

9823 — Rev. Homonoia (= Concordia) stg. l., r. hand extended, holding double-cornucopiae in l., L — Γ (= regnal year 3) in field. Dattari 5128. BMCG —. Cologne —. Milne 3848. *[AD 252–3].* F £38 ($55) / **VF** £95 ($140)

9824 — Rev. Nike (= Victory) advancing r., holding wreath and palm, L — Γ (= regnal year 3) in field. Dattari —. BMCG —. Cologne —. Milne —. Emmett 3686. *[AD 252–3].*
F £38 ($55) / **VF** £95 ($140)

9825 — Rev. Tyche (= Fortuna) stg. l., holding rudder and cornucopiae, L — Γ (= regnal year 3) in field. Dattari 5132. BMCG 2112. Cologne 2847. Milne 3851. *[AD 252–3].*
F £30 ($45) / **VF** £80 ($120)

9824

9826 **Billon tetradrachm.** Obv. As 9814. Rev. Eagle stg. r., wings open, holding wreath in beak, palm transversely in background, L Γ (= regnal year 3) before. Dattari 5134. BMCG 2114. Cologne 2841. Milne —. *[AD 252–3]*. **F** £30 ($45) / **VF** £80 ($120)

For other local coinages of Volusian, see *Greek Imperial Coins & Their Values*, pp. 419–23.

<div align="center">

AEMILIAN
Jul./Aug.–Oct. AD 253

</div>

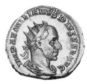

9846

The reign of Marcus Aemilius Aemilianus, a native of Mauretania, seems to have spanned no more than about three months during the second half of the year AD 253. The absence of any Alexandrian coinage dated 'year 1' is a clear indication that his recognition there only just preceded the end of the Alexandrian year on August 28th. Having been proclaimed emperor by his troops in Moesia he quickly invaded Italy in order to confront the forces of Trebonianus Gallus and Volusian. There does not appear to have been a military engagement as the usurper advanced on the capital as the numerically inferior forces of the joint emperors quickly realized that they were no match for the seasoned frontier legions which were confronting them. In consequence, Gallus and Volusian were murdered by their own men and Aemilian entered Rome unopposed, quickly receiving recognition of his new status from the Senate. However, the emperor Aemilian had little time to make his mark on history as yet another military commander was about to make a bid for the imperial throne. Shortly before their overthrow Gallus and Volusian had summoned the distinguished general Valerian to come to their assistance from his base on the Rhine. Too late to affect the outcome of the contest with Aemilian, Valerian now posed as the avenger of the slain emperors and continued his advance on Rome. History now repeated itself as the soldiers of Aemilian, believing they were facing a superior rival, deserted the cause of their commander as soon as the two armies met near Spoleto in Umbria. Aemilian was assassinated and Valerian quickly thereafter took possession of the capital and the throne, thus bringing to an end the catastrophic cycle of emperors being confronted by successful frontier commanders which had begun just four years before with Decius' overthrow of the two Philips.

His brief period of power gave Aemilian little opportunity to effect much change in the imperial coinage, though the distinctive nature of many of his reverse types would seem to betray some personal interest in the currency on the part of the emperor. The gold binio, issued so extensively under Trebonianus Gallus and Volusian, was not a feature of Aemilian's coinage, though had he been given more time the radiate piece may well have been coined. In addition to coinage in his own name Aemilian also struck an extremely limited issue of antoniniani in the name of his wife, Cornelia Supera.

Rome remained the principal mint under Aemilian. Neither the 'uncertain mint' of Gallus and Volusian nor the Syrian metropolis of Antioch coined in his name, though the latter may have been

temporarily inoperative because of the Persian invasion. There was, however, a secondary mint for antoniniani whose products were of distinctive style and with types and legends varying from Rome. The location of this establishment is quite uncertain, though somewhere in the Balkan area would appear to be a logical choice. At any rate it seems to have been in a region where Aemilian was well known as it includes his praenomen Marcus and nomen Aemilius which never appear on the coinage of Rome. In the following listing these are described as 'uncertain mint'.

There are three varieties of obverse legend:

A. IMP AEMILIANVS PIVS FEL AVG
B. IMP CAES AEMILIANVS P F AVG
C. IMP M AEMIL AEMILIANVS P F AVG

The normal obverse type for antoniniani and dupondii is radiate bust of Aemilian right. All other denominations have laureate bust right. As usual, the emperor's bust is depicted draped and cuirassed with his right shoulder advanced.

9827 **Gold aureus.** A. Rev. DIANAE VICTRI, Diana stg. l., holding arrow and bow. RIC 2a. C 9. Hunter, p. cxi. *[Rome]*. **VF** £20,000 ($30,000) / **EF** £42,500 ($65,000)

 NB The weight of the aureus averages about 3.4 grams.

9828 A. Rev. ERCVL VICTORI, Hercules stg. r., resting on club and holding bow, lion's skin on l. arm. RIC 3a. Cf. C 12. Hunter, p. cxi. *[Rome]*. **VF** £20,000 ($30,000) / **EF** £42,500 ($65,000)

9829 A. Rev. MARTI PACIF, Mars advancing l., extending olive-branch and holding spear and shield. RIC 5a. Cf. C 21. Hunter, p. cxi. *[Rome]*. **VF** £20,000 ($30,000) / **EF** £42,500 ($65,000)

9830 9831

9830 **Silver antoninianus.** A. Rev. APOL CONSERVAT, Apollo stg. l., holding laurel-branch and resting on lyre usually set on rock. RIC 1. RSC 2. Hunter 8. *[Rome]*. **VF** £80 ($120) / **EF** £200 ($300)

9831 A. Rev. DIANAE VICTRI, Diana stg., as 9827. RIC 2b. RSC 10. Hunter 9. *[Rome]*. **VF** £80 ($120) / **EF** £200 ($300)

9832 A. Rev. ERCVL VICTORI, Hercules resting on club, as 9828. RIC 3b. RSC 13. Hunter 10. *[Rome]*. **VF** £80 ($120) / **EF** £200 ($300)

9833 A. Rev. IOVI CONSERVAT, Jupiter stg. l., holding thunderbolt and sceptre, small figure of emperor at feet to l. RIC 4. RSC 16. Hunter 11. *[Rome]*. **VF** £80 ($120) / **EF** £200 ($300)

9834 Similar, but with obv. legend B. RIC 14. RSC 17. Hunter, p. cxi. *[Rome]*. **VF** £90 ($135) / **EF** £215 ($325)

 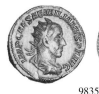

9833 9835

9835 **Silver antoninianus.** Obv. As previous. Rev. MARTI PACIF, Mars advancing, as 9829. RIC
 15. RSC 23. Hunter, p. cxi. *[Rome]*. **VF** £90 ($135) / **EF** £215 ($325)

9836 Similar, but with obv. legend A. RIC 5b. RSC 22. Hunter 12. *[Rome]*.
 VF £80 ($120) / **EF** £200 ($300)

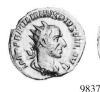 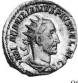

9837 9838

9837 A. Rev. MARTI PROPVGT, Mars stg. l., resting on shield and spear. RIC 6. RSC 25. Hunter
 18. *[Rome]*. **VF** £80 ($120) / **EF** £200 ($300)

9838 A. Rev. PACI AVG, Pax stg. facing, hd. l., legs crossed, holding olive-branch and
 transverse sceptre and resting on column. RIC 8. RSC 26. Hunter 13. *[Rome]*.
 VF £80 ($120) / **EF** £200 ($300)

9839 C. Rev. PAXS AVG, Pax advancing l., holding olive-branch and transverse sceptre. RIC 23.
 RSC 31. Hunter, p. cxi. *[Uncertain mint]*. **VF** £130 ($200) / **EF** £330 ($500)

9840 A. Rev. P M TR P I P P, Aemilian, in military attire, stg. l., sacrificing over altar (usually
 tripod) and holding spear, standard set in ground to l. Cf. RIC 7. RSC 32. Hunter 7.
 [Rome]. **VF** £100 ($150) / **EF** £230 ($350)
 *The remarkably unorthodox form 'TR P I' occurs only on the coinage of this reign. See also
 the following and nos. 9857 and 9863.*

 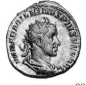

9841 9842

9841 Similar, but with obv. legend B. RIC 16. RSC 33. Hunter 1. *[Rome]*.
 VF £100 ($150) / **EF** £230 ($350)

9842 **Silver antoninianus.** A. Rev. ROMAE AETERN, Roma stg. l., holding phoenix on globe and transverse spear, her l. arm resting on shield behind. RIC 9. RSC 41. Hunter 15. *[Rome]*.
VF £80 ($120) / **EF** £200 ($300)

9843 A. Rev. SPES PVBLICA, Spes advancing l., holding flower and lifting skirt. RIC 10. RSC 47. Hunter 16. *[Rome]*.
VF £80 ($120) / **EF** £200 ($300)

 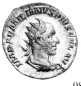

9844 9849

9844 Similar, but with obv. legend B. RIC 20. RSC 48. Hunter, p. cxi. *[Rome]*.
VF £90 ($135) / **EF** £215 ($325)

9845 Obv. As previous. Rev. VICTORIA AVG, Victory advancing l., holding wreath and palm. RIC 21. RSC 52. Hunter 5. *[Rome]*.
VF £90 ($135) / **EF** £215 ($325)

9846 Similar, but with obv. legend A. RIC 11. RSC 53. Hunter, p. cxi. *[Rome]*.
VF £80 ($120) / **EF** £200 ($300)

9847 Similar, but with obv. legend C. RIC 24. RSC 57a. Hunter, p. cxi. *[Uncertain mint]*.
VF £130 ($200) / **EF** £330 ($500)

9848 Similar, but with rev. type winged Nemesis stg. l., wheel at feet. RIC 25. RSC 58. Hunter, p. cxi. *[Uncertain mint]*.
VF £130 ($200) / **EF** £330 ($500)

9849 A. Rev. VIRTVS AVG, Virtus stg. l., r. foot on helmet, holding olive-branch and spear. RIC 12. RSC 60. Hunter 17. *[Rome]*.
VF £80 ($120) / **EF** £200 ($300)

9850 Similar, but with obv. legend B. RIC 22. RSC 59. Hunter 6. *[Rome]*.
VF £90 ($135) / **EF** £215 ($325)

9851 Similar, but with obv. legend C and rev. type Hercules stg. r. (or l.), resting on club and holding bow, lion's skin on arm. RIC 26. RSC 63, 63a. Hunter, p. cxi. *[Uncertain mint]*.
VF £130 ($200) / **EF** £330 ($500)

9852

9852 A. Rev. VOTIS / DECENNA / LIBVS in three lines within laurel-wreath. RIC 13. RSC 64. Hunter, p. cxi. *[Rome]*.
VF £120 ($180) / **EF** £300 ($450)

9853 **Bronze sestertius.** B. Rev. APOL CONSERVAT S C, Apollo resting on lyre, as 9830. RIC 43. C 3. Hunter, p. cxi. *[Rome]*.
F £230 ($350) / **VF** £600 ($900) / **EF** £1,850 ($2,750)

9853

9854 **Bronze sestertius.** B. Rev. ERCVL VICTORI S C, Hercules resting on club, as 9828. RIC 44. C 14. Hunter, p. cxi. *[Rome].* **F** £230 ($350) / **VF** £600 ($900) / **EF** £1,850 ($2,750)

9855 B. Rev. IOVI CONSERVAT (or CONSERVATORI) S C, Jupiter protecting emperor, as 9833. RIC 45–6. C 18, 20. Hunter 20. *[Rome].*
 F £230 ($350) / **VF** £600 ($900) / **EF** £1,850 ($2,750)

9856 A. Rev. PACI AVG S C, Pax resting on column, as 9838. RIC 37. C 27. Hunter, p. cxi. *[Rome].* **F** £230 ($350) / **VF** £600 ($900) / **EF** £1,850 ($2,750)

9857

9857 A. Rev. P M TR P I P P S C, Aemilian sacrificing, as 9840. Cf. RIC 47a. C 36. Cf. Hunter, p. cxi. *[Rome].* **F** £230 ($350) / **VF** £600 ($900) / **EF** £1,850 ($2,750) *See note following no. 9840.*

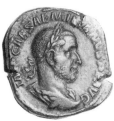

9858

9858 B. Rev. SPES PVBLICA S C, Spes advancing, as 9843. RIC 51a. C 49. Hunter 21. *[Rome].*
 F £200 ($300) / **VF** £500 ($750) / **EF** £1,650 ($2,500)

9859 B. Rev. VICTORIA AVG S C, Victory advancing, as 9845. RIC 52. C 56. Hunter 23. *[Rome].* **F** £200 ($300) / **VF** £500 ($750) / **EF** £1,650 ($2,500)

9860 **Bronze sestertius.** B. Rev. VIRTVS AVG S C, Virtus holding olive-branch, as 9849. RIC 53. C 62. Hunter 24. *[Rome]*. **F** £200 ($300) / **VF** £500 ($750) / **EF** £1,650 ($2,500)

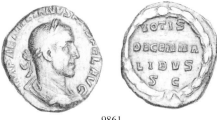

9861

9861 A. Rev. VOTIS / DECENNA / LIBVS / S C in four lines within laurel-wreath. RIC 42a. C 65. Hunter, p. cxi. *[Rome]*. **F** £265 ($400) / **VF** £665 ($1,000) / **EF** £2,000 ($3,000)

9862 Similar, but with obv. legend B. RIC 54a. C 67. Hunter 25. *[Rome]*.
 F £265 ($400) / **VF** £665 ($1,000) / **EF** £2,000 ($3,000)

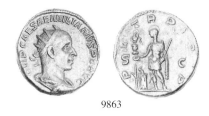

9863

9863 **Bronze dupondius.** B. Rev. P M TR P I P P S C, Aemilian sacrificing, as 9840. RIC 47b. C 37. Hunter, p. cxi. *[Rome]*. **F** £230 ($350) / **VF** £600 ($900) / **EF** £1,850 ($2,750)
See note following no. 9840.

9864 B. Rev. SPES PVBLICA S C, Spes advancing, as 9843. RIC 51c. C —. Hunter, p. cxi. *[Rome]*.
 F £230 ($350) / **VF** £600 ($900) / **EF** £1,850 ($2,750)

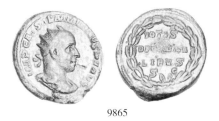

9865

9865 B. Rev. Votive legend in wreath, as 9861. RIC 54b. C 68. Hunter 26. *[Rome]*.
 F £265 ($400) / **VF** £665 ($1,000) / **EF** £2,000 ($3,000)

9866 **Bronze as.** B. Rev. As 9864. RIC 51b. C 50. Hunter 22. *[Rome]*.
 F £220 ($325) / **VF** £525 ($800) / **EF** £1,650 ($2,500)

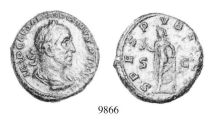

9866

Alexandrian Coinage

9867 **Billon tetradrachm.** A K M AIMA (*sic*) AIMIΛIAIVON (*sic*) EVC EVT CEB, laur. and cuir. bust r. Rev. Alexandria, turreted, stg. l., her r. hand raised, holding sceptre in l., L — B (= regnal year 2) in field. Dattari —. BMCG 2119. Cologne —. Milne (Supplement) 3863a. *[After 29 August].* **F** £120 ($180) / **VF** £300 ($450)

9868 Obv. Similar. Rev. Athena seated l., holding Nike and resting on sceptre, shield at side, L B (= regnal year 2) before. Dattari 5135. BMCG 2116. Cologne —. Milne —. *[After 29 August].* **F** £110 ($165) / **VF** £285 ($425)

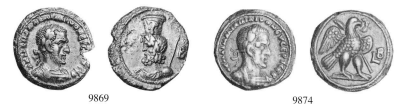

9869 9874

9869 — Rev. Bust of Sarapis l., wearing modius, sceptre behind l. shoulder, L — B (= regnal year 2) in field. Dattari —. BMCG 2118. Cologne —. Milne —. *[After 29 August].* **F** £120 ($180) / **VF** £300 ($450)

9870 — Rev. Laur. bust of Zeus r., L — B (= regnal year 2) in field. Dattari 5138. BMCG 2115. Cologne —. Milne —. *[After 29 August].* **F** £120 ($180) / **VF** £300 ($450)

9871 — Rev. Homonoia (= Concordia) stg. l., r. hand extended, holding double-cornucopiae in l., L — B (= regnal year 2) in field. Dattari 5136. BMCG —. Cologne —. Milne —. *[After 29 August].* **F** £120 ($180) / **VF** £300 ($450)

9872 — Rev. Nike (= Victory) advancing r., holding wreath and palm, L — B (= regnal year 2) in field. Dattari 5137. BMCG 2117. Cologne —. Milne —. *[After 29 August].* **F** £110 ($165) / **VF** £285 ($425)

9873 — Rev. Eagle stg. l., hd. r., holding wreath in beak, L — B (= regnal year 2) in field. Dattari 5141. BMCG 2120. Cologne 2848. Milne 3862. *[After 29 August].* **F** £100 ($150) / **VF** £265 ($400)

9874 — Rev. Eagle stg. r., wings open, holding wreath in beak, palm transversely in background, L B (= regnal year 2) before. Dattari 5139. BMCG 2121. Cologne —. Milne 3863. *[After 29 August].* **F** £100 ($150) / **VF** £265 ($400)

For other local coinages of Aemilian, see *Greek Imperial Coins & Their Values*, pp. 424–5.

CORNELIA SUPERA

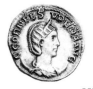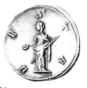

9876

History records nothing of Gaia Cornelia Supera though the numismatic evidence clearly points to her identification as the consort of the ephemeral emperor Aemilian. Her Roman coinage comprises antoniniani of two types, both of considerable rarity, especially that of the uncertain Balkan (?) mint.

9875 **Silver antoninianus.** COR SVPERA AVG, diad. and dr. bust r., crescent behind shoulders. Rev. IVNONI AVG, Juno seated l., holding flower and infant in swaddling clothes. RIC 31. RSC 3. Hunter, p. cxii. *[Uncertain mint].* **VF** £4,000 ($6,000) / **EF** £8,000 ($12,000)

9876 C CORNEL SVPERA AVG, as previous. Rev. VESTA, Vesta stg. l., holding patera and transverse sceptre. RIC 30. RSC 5. Hunter 1. *[Rome].*
 VF £3,350 ($5,000) / **EF** £6,700 ($10,000)

There is no Alexandrian coinage in the name of Cornelia Supera. For her local issues see *Greek Imperial Coins & Their Values*, p. 425.

SILBANNACUS
Oct. AD 253

New light has recently been shed on the mysterious usurpation of Marius (or Marcius) Silbannacus by the discovery near Paris of a second specimen of his coinage (published by Sylviane Estiot in Revue Numismatique 151, 1996, pp. 105–17, "L'Empereur Silbannacus: un Second Antoninien"). Although from the same obverse die as the formerly unique antoninianus in the British Museum, found in Lorraine, this piece has a different reverse type which is virtually identical to an issue of Aemilian (see no. 9837). The tentative conclusion which has been drawn from this is that the otherwise unknown Silbannacus may have been a senior officer of Aemilian who was left behind in Rome when the emperor marched north to confront his rival Valerian. On the murder of Aemilian Silbannacus would then have made a brief grasp at power before being removed from office by the forces of Valerian as soon as the new emperor entered the capital. Under the proposed circumstances Silbannacus' reign could not have lasted longer than a couple of weeks, thus accounting for the extreme rarity of his coinage. The Gallic provenance of the two known examples may be explained by the movement of troops from Rome to the Rhine frontier under Gallienus in AD 254.

9877 **Silver antoninianus.** IMP MAR SILBANNACVS AVG, rad. and cuir. bust r. Rev. MARTI PROPVGT, Mars stg. l., resting on shield and spear. RIC —. RSC —. Hunter —. *[Rome].*
 (Unique)

9878 Obv. As previous. Rev. VICTORIA AVG, Mercury stg. l., holding Victory and caduceus. RIC 1. RSC 1. Hunter, p. xcv. *[Rome].* *(Unique)*

URANIUS ANTONINUS
AD 253–254

9880

The usurpation of L. Julius Aurelius Sulpicius Uranius Antoninus took place in the Syrian city of Emesa shortly after the invasion of the province in AD 252–3 by the Sasanid Persians under Shapur I. Antioch was attacked and captured at this time but the assault on Emesa was repulsed under the leadership of Sampsigeramus, the high-priest of the sun-god Elah-Gabal. There is no historical record of a usurper named Uranius Antoninus at this time but it seems reasonable to assume that he and Sampsigeramus were one and the same person. The high-priest may well have adopted the name Antoninus in honour of the emperor Elagabalus, who held the same office in Emesa prior to his accession, and some of his tetradrachm types also include the dynastic name Severus ('ΣΕΟVΗΡΟΣ') in their obverse inscriptions. On the arrival of Valerian in Syria in 254 Roman authority was quickly re-established in the province and Uranius Antoninus' regime was brought to an end, either voluntarily or by force.

The interesting coinage of Uranius Antoninus comprises Roman gold aurei and silver and billon tetradrachms and bronzes with Greek inscriptions. A denarius has also been recorded sharing a reverse die with an aureus, though it appears doubtful whether this really represents a distinct issue (Paris, published by G. le Rider in BSFN 1962, pp. 143f, 'Un denier d'Uranius Antonin, acquis récemment par le Cabinet des Medailles'). Emesa seems to have been the only mint, though one tetradrachm type has the characteristics of an Antiochene issue and may be evidence of a brief extension of Uranius' authority in Syria. An intriguing feature of the coinage is the omission of imperial titles on the aurei, while both 'AVTOK' (= IMPERATOR) and 'CEB' (= AVGVSTVS) are prominent on the Greek issues.

In the following listing Cohen's references are to his Volume IV, pp. 503–4. He placed them following the coinage of Severus Alexander on the basis of a confused reference by the early 6th century Greek historian Zosimus to two pretenders, Antoninus and Uranius, during the reign of the last of the Severan emperors.

9879 **Gold aureus.** L IVL AVR SVLP VRA ANTONINVS, laur., dr. and cuir. bust r. Rev. CONSERVATOR AVG, draped and ornamented conical stone of Elah-Gabal between two parasols. Baldus 47–8. RIC 1. Cohen 1. Hunter, p. cx. *[Emesa, AD 253–4].*
VF £16,500 ($25,000) / **EF** £40,000 ($60,000)

NB Usually weighing between 5.5 and 6 grams, the aurei of this reign are the equivalent of the binios of Trebonianus Gallus and Volusian.

9880 Obv. As previous. Rev. — slow quadriga drawn l. by horses, the car surmounted by the conical stone of Elah-Gabal ornamented with eagle and flanked by two parasols. Baldus 69–70. RIC 2. Cohen —. Hunter, p. cx. *[Emesa, AD 253–4].*
VF £15,000 ($22,500) / **EF** £33,500 ($50,000)
The reverse types of this and the next are copied from the coinage of Elagabalus issued three and a half decades before (see nos. 7465 and 7467).

9881 Similar, but with obv. L IVL AVR SVLP ANTONINVS (LP ligatured), laur., dr. and cuir. bust l. Baldus 85–7. RIC 2. Cohen 2. Hunter, p. cx. *[Emesa, AD 253–4].*
VF £15,000 ($22,500) / **EF** £33,500 ($50,000)

9882 Obv. As previous. Rev. FECVNDITAS AVG, Fecunditas-Fortuna stg. l., holding rudder and cornucopiae. Baldus 83. RIC 3. Cohen —. Hunter, p. cx, note 1. *[Emesa, AD 253–4].*
VF £8,000 ($12,000) / **EF** £20,000 ($30,000)

9882

9883 **Gold aureus.** Similar, but with obv. as 9879. Baldus 57–67, 73–4. RIC 3. Cohen 3. Hunter, p. cx. *[Emesa, AD 253–4].* **VF** £6,700 ($10,000) / **EF** £16,500 ($25,000)

9884 — Rev. **FORTVNA PEDVIX** (*sic*), Fortuna seated l., holding rudder and cornucopiae, wheel below seat. Baldus 68, 72, 76–81. Cf. RIC 4. Cohen —. Hunter, p. cx. *[Emesa, AD 253–4].* **VF** £8,000 ($12,000) / **EF** £20,000 ($30,000)

9885 — Rev. **MINERVA VICTRIX**, Minerva stg. facing, hd. l., holding spear in extended r. hand and circular shield in l. Baldus 51–2. RIC 5. Cohen 4. Hunter, p. cx. *[Emesa, AD 253–4].* **VF** £10,000 ($15,000) / **EF** £23,500 ($35,000)
This reverse type is very similar to an Antiochene denarius of Pescennius Niger issued in AD 193 (see no. 6118 = RSC 54a).

9886 Obv. As 9881. Rev. **P M TR P XVIIII COS IIII P P**, rad. lion walking r. Baldus 84. RIC 6. Cohen —. Cf. Hunter, p. cx. *[Emesa, AD 253–4].* **VF** £12,000 ($18,000) / **EF** £26,500 ($40,000)
This is copied from the coinage of Caracalla of AD 216, though on the prototypes the lion is to left and holds a thunderbolt in its jaws.

9887 — Rev. **SAECVLARES AVGG**, cippus (column) inscribed **COS / I** in two lines. Baldus 88–9. RIC 7. Cohen —. Hunter, p. cx. *[Emesa, AD 253–4].* **VF** £12,000 ($18,000) / **EF** £26,500 ($40,000)
*This is copied from the coinage of Philip commemorating the celebration in AD 248 of the thousandth anniversary of Rome's founding. On the prototypes the cippus is inscribed **COS III** (Philip I) or **COS II** (Philip II).*

9888 Obv. As 9879. Rev. **SOL ELAGABALVS**, conical stone of Elah-Gabal set on altar, the baetyl ornamented with eagle and flanked by two parasols, jug below altar which is flanked by two candelabra. Baldus 53–4. RIC 8. Cohen —. Cf. Hunter, p. cx. *[Emesa, AD 253–4].* **VF** £18,500 ($27,500) / **EF** £43,500 ($65,000)
For other depictions of the sacred stone of the Emesan sun-god on the coinage of this reign, see nos. 9879–81. Needless to say, all are inspired by the coinage of the emperor Elagabalus (AD 218–222).

9889 — Rev. **VICTORIA AVG**, Victory advancing l., holding wreath and palm. Baldus 49–50. RIC 9. Cohen —. Hunter, p. cx. *[Emesa, AD 253–4].* **VF** £8,000 ($12,000) / **EF** £20,000 ($30,000)

9890 Similar, but Victory is stg. l. Baldus 55–6. RIC —. Cohen —. Hunter —. *[Emesa, AD 253–4].* **VF** £8,000 ($12,000) / **EF** £20,000 ($30,000)

9891 Similar, but with obv. as 9881. Baldus 91. RIC —. Cohen —. Hunter —. *[Emesa, AD 253–4].* **VF** £10,000 ($15,000) / **EF** £23,500 ($35,000)

9892 **Gold aureus.** Obv. As 9881. Rev. VICTORIA AVG, Victory advancing r., holding wreath and palm. Baldus 90. RIC, p. 206. Cohen —. Hunter, p. cx. *[Emesa, AD 253–4].*
VF £10,000 ($15,000) / **EF** £23,500 ($35,000)

9893 **Silver denarius.** As 9883 (rev. FECVNDITAS AVG, Fecunditas-Fortuna stg.). Baldus 71. RIC —. Cohen —. Hunter, p. cx, note 2 (but referring to the wrong type). *[Emesa, AD 253–4].* (*Unique*)
This may be nothing more than a trial-striking in silver.

As the authority of Uranius Antoninus never extended to Egypt there were no Alexandrian billon tetradrachms struck in his name. For his provincial currency in silver, billon and bronze issued at Emesa and possibly also at Antioch, see *Greek Imperial Coins & Their Values*, p. 426

<div align="center">

VALERIAN

Oct. AD 253–summer 260

9917

</div>

Born in the final decade of the 2nd century, the senator Publius Licinius Valerianus was of a distinguished Roman family and had wide experience both as an administrator and a general. He held the consulship during the reign of Severus Alexander and in AD 250 was placed in charge of affairs in Rome during the absence of Trajan Decius on the northern frontier. He subsequently held an important military command on the Rhine and in 253 was summoned by Trebonianus Gallus to Rome to assist the emperor against the usurper Aemilian. He was not in time to prevent the downfall of Gallus and Volusian but continued his advance on the capital in order to challenge Aemilian for the throne. Aemilian was murdered by his own men and Valerian entered Rome where he received senatorial recognition of his new imperial status. His son Gallienus was quickly nominated as co-emperor and the two new rulers set about facing the challenges of foreign invasion with which they were immediately confronted. Gallienus was given responsibility for the defence of the northern frontier and in 254 set out for Gaul where he established his headquarters. Valerian took responsibility for the defence of the eastern provinces where both Asia Minor and Syria were under serious threat, the former from the Goths, who now for the first time were using ships to cross the Black Sea, the latter from the Sasanids under Shapur who were threatening invasion yet again. The Goths also ravaged Thrace, penetrating as far as Thessalonica which they failed to take. All in all the situation was probably more critical than that faced by any previous imperial regime and unfortunately it could not be effectively contained by Valerian and Gallienus. Disaster struck in the summer of AD 260 when Valerian, who had previously been successful in his efforts to drive the Sasanids out of the eastern provinces, found his position weakened by the effects of the plague on his army. Accordingly, he decided to attempt to negotiate peace terms with Shapur and a meeting was arranged between the two leaders. Valerian was treacherously attacked during the conference and carried off in captivity to Persia, the first Roman emperor ever to fall into the hands of a foreign power. How long he survived this event is unclear, but he was certainly not treated honourably by his captors who inflicted a series of humiliations on him. Death must have come as a merciful release to the imperial prisoner. With the Empire on the brink of collapse Gallienus was now left as sole emperor to face what was surely Rome's darkest hour.

The extraordinary circumstances of this reign resulted in an unprecedented decline in the quality of the imperial coinage, especially the antoniniani, and a proliferation of provincial mints to serve the needs of armies which were constantly engaged on campaign in the frontier regions. The mint of Rome, though still important, was beginning to lose its primacy in the production of currency and even the striking of gold denominations was now delegated to provincial establishments. The process would take another four decades to run its full course but its true

beginnings can be dated to the 7-year joint reign of Valerian and his son. Gallienus' activities in Gaul led to the opening of an important mint in the region, and although its precise location has long remained controversial Cologne would appear to be the most likely candidate. A second western mint seems also to have been active for a while. This may have been located in the Balkans (Viminacium?) and perhaps represents a continuation of the issues of the 'uncertain mint' which had struck for Trebonianus Gallus and Volusian. A new mint at Milan would appear to date from late in the joint reign, about AD 259. In the East, Antioch was active until about AD 255 when it was succeeded by another mint of uncertain location. It has been proposed that this second Asian mint was established at Cyzicus, but this now appears unlikely and probably another site in Syria is to be preferred. A field-mint may also have been active during the course of Valerian's eastern campaigns. The entire picture is complex and confusing but the one certain fact is that there was a major decentralization of currency production during the joint reign of Valerian and Gallienus and this set the pattern for the Roman imperial coinage throughout the remainder of its history.

In addition to coins in his own name and that of his co-emperor Gallienus Valerian struck issues for various other members of the imperial family. These include his wife Mariniana, who appears to have died prior to his accession to the throne and is honoured with a posthumous coinage; his daughter-in-law Salonina, wife of Gallienus; his elder grandson Valerian Junior, Caesar AD 256–8; and his younger grandson Saloninus, Caesar AD 258–60.

There are seven principal varieties of obverse legend:

A. IMP C P LIC VALERIANVS AVG
B. IMP C P LIC VALERIANVS P F AVG
C. IMP VALERIANVS AVG
D. IMP VALERIANVS P AVG
E. IMP VALERIANVS P F AVG
F. IMP VALERIANVS PIVS AVG
G. VALERIANVS P F AVG

The normal obverse type for binios, antoniniani and dupondii is radiate bust of Valerian right. All other denominations have laureate bust right. The emperor's bust is usually depicted draped and cuirassed, but sometimes is cuirassed only.

9894 **Gold binio.** A. Rev. AETERNITAS AVGG, Valerian, rad. and in long robes, advancing r., his r. hand raised, holding globe in l. RIC 30, 273. C 6. Hunter, p. xxxiii. *[Uncertain Syrian mint, AD 255–6].* **VF** £3,300 ($5,000) / **EF** £8,000 ($12,000)

 NB The weight of the radiate binio averages about 5.4 grams and that of the laureate aureus about 3.00 grams. Weights are extremely variable and doubtless coins of this metal were always weighed as part of a transaction.

9895 D. Rev. FIDES MILITVM, Fides Militum stg. facing, hd. r., holding vexillum and transverse standard. RIC —. C —. Hunter —. *[Viminacium, AD 253–5].* **VF** £3,300 ($5,000) / **EF** £8,000 ($12,000)

9896 A. Rev. P M TR P III COS III P P, Valerian, togate, stg. r., sacrificing over tripod-altar and holding eagle-tipped sceptre. RIC 29. C 161. Hunter, pp. xxxiii, xxxix. *[Uncertain Syrian mint, AD 255].* **VF** £3,300 ($5,000) / **EF** £8,000 ($12,000)

9897 **Gold aureus.** D. Rev. AETERNIT (or AETERNITAS) AVGG, Sol stg. l., his r. hand raised, holding globe in l. RIC 228–9. C —. Hunter, p. xxxvii. *[Viminacium, AD 253–5].* **VF** £1,650 ($2,500) / **EF** £4,300 ($6,500)

9898 B. Rev. ANNONA AVGG, Annona stg. l., holding corn-ears and cornucopiae, modius at feet. RIC 31. C 12. Hunter, p. xxxiv. *[Rome, AD 255–8].* **VF** £1,350 ($2,000) / **EF** £3,700 ($5,500)

9899 **Gold aureus.** B. Rev. APOLINI CONSERVA, Apollo stg. l., holding laurel-branch and resting on lyre set on rock. RIC 32. C 16. Hunter, p. xxxiv. *[Rome, AD 255–8]*.
VF £1,500 ($2,250) / **EF** £4,000 ($6,000)

9900 G. Rev. DEO VOLKANO, tetrastyle temple containing Vulcan stg. l., holding hammer and tongs, anvil at feet. RIC 1. C (Valerian Junior) 1. Hunter, p. xxxvii. *[Cologne, AD 259–60]*.
VF £2,700 ($4,000) / **EF** £6,700 ($10,000)

9901 B. Rev. FELICITAS AVGG, Felicitas stg. l., holding long caduceus and cornucopiae. RIC 34. C 52. Hunter, p. xxxiv. *[Rome, AD 255–8]*. VF £1,350 ($2,000) / **EF** £3,700 ($5,500)

9902 A. Rev. FIDES MILITVM, Fides Militum stg. l., holding two standards. RIC 35. C 64. Hunter, p. xxxiv. *[Rome, AD 253–5]*. VF £1,350 ($2,000) / **EF** £3,700 ($5,500)

9902 9903

9903 B. Rev. IOVI CONSERVAT (or CONSERVATORI), Jupiter stg. l., holding thunderbolt and sceptre. RIC 38. C 82 var. Hunter, p. xxxv. *[Rome, AD 255–8]*.
VF £1,350 ($2,000) / **EF** £3,700 ($5,500)

9904 A. Rev. LAETITIA AVGG, Laetitia stg. l., holding wreath and anchor. RIC 41. C 100. Hunter, p. xxxiii. *[Rome, AD 253–5]*. VF £1,350 ($2,000) / **EF** £3,700 ($5,500)

9905 B. Rev. LIBERALITAS AVGG, Liberalitas stg. l., holding abacus and cornucopiae. RIC 43. C 104 var. Hunter, p. xxxv. *[Rome, AD 255]*. VF £1,500 ($2,250) / **EF** £4,000 ($6,000)

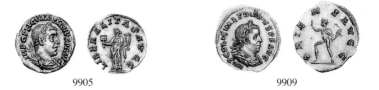

9905 9909

9906 Similar, but with rev. legend LIBERALITAS AVGG III. RIC 44. C 118. Hunter, p. xxxv. *[Rome, AD 256]*. VF £1,650 ($2,500) / **EF** £4,300 ($6,500)

9907 Similar, but with rev. type Valerian and Gallienus seated l. on curule chairs, their r. hands extended, officer stg. between them. RIC 45. C 124. Hunter, p. xxxv. *[Rome, AD 256]*.
VF £2,000 ($3,000) / **EF** £5,300 ($8,000)
On some specimens the central figure appears also to be seated and perhaps represents the Caesar Valerian Junior.

9908 G. Rev. ORIENS AVGG, Sol stg. l., his r. hand raised, holding globe in l. RIC 2. C (Valerian Junior) 4. Hunter, p. xxxvii. *[Cologne, AD 257–9]*.
VF £1,850 ($2,750) / **EF** £5,000 ($7,500)

9909 **Gold aureus.** B. Rev. — similar, but Sol holds whip in l. and sometimes is advancing. RIC
 46. C 133. Hunter, p. xxxv. *[Rome, AD 255–8].* **VF** £1,350 ($2,000) / **EF** £3,700 ($5,500)

 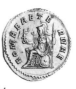

 9910 9914

9910 B. Rev. **PAX AVGG**, Pax advancing l., holding olive-branch and sceptre. RIC 48. C 148.
 Hunter, p. xxxv. *[Rome, AD 255–8].* **VF** £1,350 ($2,000) / **EF** £3,700 ($5,500)

9911 A. Rev. **P M TR P II COS P P**, Virtus stg. l., resting on shield and spear. RIC 27. C 158.
 Hunter, p. xxxviii. *[Antioch, AD 254].* **VF** £1,650 ($2,500) / **EF** £4,300 ($6,500)

9912 B. Rev. **PROVIDENTIA AVGG**, Providentia stg. l., holding rod and cornucopiae, globe at
 feet. RIC 49. C —. Hunter, p. xxxv. *[Rome, AD 255–8].*
 VF £1,500 ($2,250) / **EF** £4,000 ($6,000)

9913 B. Rev. **RESTITVTOR ORBIS**, Valerian, in military attire, stg. l., raising turreted kneeling
 female figure and holding spear. RIC 50. C 181. Hunter, p. xxxv. *[Rome, AD 255–8].*
 VF £1,500 ($2,250) / **EF** £4,000 ($6,000)

9914 A. Rev. **ROMAE AETERNAE**, Roma seated l., holding Victory and spear, shield at side. RIC
 275. C 191. Hunter 6. *[Uncertain Syrian mint, AD 255–6].*
 VF £1,500 ($2,250) / **EF** £4,000 ($6,000)

9915 A. Rev. **VICTORIA AVGG**, Victory advancing r., holding wreath and palm. RIC 52. C 217.
 Hunter, p. xxxiii. *[Uncertain Syrian mint, AD 255–6].*
 VF £1,500 ($2,250) / **EF** £4,000 ($6,000)

9916 A. Rev. — Victory stg. l., resting on shield and holding palm. RIC 53. C 220, 225. Hunter,
 p. xxxiv. *[Rome, AD 253–5].* **VF** £1,350 ($2,000) / **EF** £3,700 ($5,500)

9917 A. Rev. **VICTORIAE AVGG**, Victory in galloping biga r., holding whip. RIC 276. C 239.
 Hunter, p. xxxix. *[Uncertain Syrian mint, AD 255–6].*
 VF £2,000 ($3,000) / **EF** £5,300 ($8,000)

9918 B. Rev. **VIRTVS AVGG**, Virtus stg. l., resting on shield and spear. RIC 56. C 261. Hunter,
 p. xxxv. *[Rome, AD 255–8].* **VF** £1,350 ($2,000) / **EF** £3,700 ($5,500)

9919 Similar, but with obv. legend G. RIC 3. C 260. Hunter, p. xxxvii. *[Cologne, AD 257–9].*
 VF £1,850 ($2,750) / **EF** £5,000 ($7,500)

9920 **Billon antoninianus.** A. Rev. **AEQVITAS AVGG**, Aequitas stg. l., holding scales and
 cornucopiae. RIC 278. RSC 3. Hunter 67. *[Antioch, AD 254–5].*
 VF £14 ($20) / **EF** £30 ($45)

NB Under Valerian the fineness of the antoninianus declined precipitately from about 35%
at the commencement of the reign down to a mere 15% in AD 260. In consequence,
henceforth in this catalogue all antoniniani are described as billon rather than silver.

9921 **Billon antoninianus.** As 9894 (rev. **AETERNITAS AVGG**, Valerian advancing r.). RIC 66. RSC 7. Hunter, p. xxxiii. *[Uncertain Syrian mint,* AD *255–6].* **VF** £20 ($30) / **EF** £45 ($65)

9922 A Rev. **AETERNITATI AVGG**, Saturn stg. r., holding scythe. RIC 210. RSC 8. Hunter, p. xxxviii. *[Antioch,* AD *254–5].* **VF** £25 ($40) / **EF** £60 ($90)

9923 D. Rev. — Sol stg. l., his r. hand raised, holding globe in l. RIC 232. RSC 10. Hunter, p. xxxvii. *[Viminacium,* AD *253–5].* **VF** £14 ($20) / **EF** £30 ($45)

9924 C. Rev. **ANNONA AVGG**, Annona stg. l., holding corn-ears and cornucopiae, modius at feet. RIC 70. RSC 15. Hunter, p. xxxvi. *[Rome,* AD *258–60].* **VF** £14 ($20) / **EF** £30 ($45)

9925 A. Rev. **APOLINI CONSERVA**, Apollo stg. l., holding laurel-branch and resting on lyre set on rock. RIC 71. RSC 18. Hunter, p. xxxiv. *[Rome,* AD *253–5].*
 VF £16 ($25) / **EF** £38 ($55)

9926

9926 A. Rev. **APOLINI PROPVG**, Apollo stg. r., drawing bow. RIC 74. RSC 25. Hunter 8. *[Rome,* AD *253–5].* **VF** £16 ($25) / **EF** £38 ($55)

9927 A. Rev. **CONCORDIA AVGG**, Concordia stg. l., holding patera and double cornucopiae. RIC 80. RSC 31. Hunter, p. xxxiii. *[Rome,* AD *253–5].* **VF** £14 ($20) / **EF** £30 ($45)

9928 B. Rev. — similar, but Concordia seated. RIC 79. RSC 32. Hunter, p. xxxv. *[Rome,* AD *255–8].* **VF** £14 ($20) / **EF** £30 ($45)

9929 D. Rev. **CONCOR** (or **CONCORDIA**) **EXERC** (or **EXERCITI**), Concordia stg. l., sacrificing at altar and holding cornucopiae. RIC 233, 234. RSC 36, 42. Hunter, p. xxxvii. *[Viminacium,* AD *253–5].* **VF** £14 ($20) / **EF** £30 ($45)

9930 D. Rev. **CONCOR LEGG**, Concordia seated l., holding patera and double cornucopiae. RIC 236. RSC 44. Hunter, p. xxxvii. *[Viminacium,* AD *253–5].* **VF** £23 ($35) / **EF** £50 ($75)

9931 A. Rev. **CONCORDIA MILIT**, Concordia Militum stg. l., holding two standards. RIC 238. RSC 47. Hunter 4. *[Rome,* AD *253–5].* **VF** £14 ($20) / **EF** £30 ($45)

9932 C. Rev. **CONSERVAT** (or **CONSERVT**) **AVGG**, Apollo resting on lyre, as 9925, officina mark Q (= 4) in field or in ex. RIC 84. RSC 48. Hunter, p. xxxvi. *[Rome,* AD *258–60].*
 VF £16 ($25) / **EF** £38 ($55)

9933 B. Rev. — similar, but Diana stands beside Apollo drawing arrow from her quiver and holding bow, officina mark Q (= 4) in ex. RIC 85. RSC 50. Hunter, p. xxxv. *[Rome,* AD *258–60].* **VF** £32 ($50) / **EF** £75 ($110)

9934 G. Rev. **DEO VOLKANO**, tetrastyle temple containing Vulcan stg. l., holding hammer and tongs, sometimes with anvil at feet. RIC 5. RSC 50c-d. Hunter 56, 58. *[Cologne,* AD *259–60].* **VF** £25 ($40) / **EF** £60 ($90)

9935 **Billon antoninianus.** A. Rev. DIANA LVCIFERA, Diana stg. r., holding torch with both hands. RIC 212. RSC 51. Hunter, p. xxxviii. *[Antioch, AD 254–5].* **VF** £23 ($35) / **EF** £50 ($75)

9936 B. Rev. FELICITAS AVGG, Felicitas stg. l., holding long caduceus and cornucopiae. RIC 87. RSC 53. Hunter, p. xxxv. *[Rome, AD 255–8].* **VF** £14 ($20) / **EF** £30 ($45)

9937 A. Rev. FELICITAS SAECVLI, Diana advancing r., holding torch with both hands. RIC 213. RSC 61. Hunter, p. xxxviii. *[Antioch, AD 254–5].* **VF** £20 ($30) / **EF** £45 ($65)

9938 A. Rev. FIDES MILITVM, Fides Militum stg. l., holding two standards. RIC 89. RSC 65. Hunter 10. *[Rome, AD 253–5].* **VF** £14 ($20) / **EF** £30 ($45)

 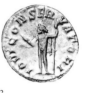

9939 9943

9939 D. Rev. — Fides Militum stg. facing, hd. r., holding vexillum and transverse standard. Cf. RIC 241. RSC 71. Cf. Hunter, p. xxxvii. *[Viminacium, AD 253–5].*
VF £14 ($20) / **EF** £30 ($45)

9940 C. Rev. FORTVNA REDVX, Fortuna stg. l., holding rudder and cornucopiae, officina mark S (= 2) in field. RIC 91. RSC 76a. Hunter, p. xxxvi. *[Rome, AD 258–60].*
VF £14 ($20) / **EF** £30 ($45)

9941 A. Rev. — Mercury stg. l., holding purse and caduceus. RIC 214. RSC 75. Hunter 65. *[Antioch, AD 254–5].* **VF** £23 ($35) / **EF** £50 ($75)

9942 F. Rev. GALLIENVS CVM EXERC SVO, Jupiter stg. l., holding Victory and sceptre, atop large altar or cippus inscribed IOVI / VIC / TORI in three lines. RIC 7. RSC 77. Hunter 51. *[Cologne, AD 257].* **VF** £38 ($55) / **EF** £80 ($120)

9943 A. Rev. IOVI CONSERVATORI, Jupiter stg. l., holding thunderbolt and sceptre. RIC 92. RSC 94. Hunter 12. *[Rome, AD 253–5].* **VF** £14 ($20) / **EF** £30 ($45)

9944 B. Rev. LAETITIA AVGG, Laetitia stg. l., holding wreath and anchor. RIC 216. RSC 102. Hunter, p. xxxviii. *[Antioch, AD 253–4].* **VF** £14 ($20) / **EF** £30 ($45)

9945 D. Rev. LIBERALITAS AVGG, Liberalitas stg. l., holding abacus and cornucopiae. RIC 243. RSC 106. Hunter, p. xxxvii. *[Viminacium, AD 255].* **VF** £14 ($20) / **EF** £30 ($45)

9946 B. Rev. — similar, but Liberalitas seated. RIC 101. RSC 113. Hunter 28. *[Rome, AD 255].*
VF £20 ($30) / **EF** £45 ($65)

9947 B. Rev. LIBERALITAS AVGG II, type as 9945. RIC 103. RSC 116. Hunter, p. xxxv. *[Rome, AD 255].* **VF** £16 ($25) / **EF** £38 ($55)

9948 Similar, but LIBERALITAS AVGG III. RIC 104. RSC 119. Hunter 29. *[Rome, AD 256].*
VF £16 ($25) / **EF** £38 ($55)

9949 **Billon antoninianus.** B. Rev. LIBERALITAS AVGG III, Valerian and Gallienus seated l. on curule chairs, their r. hands extended, officer stg. between them. Cf. RIC 105 (*rev. type misdescribed*). Cf. RSC 124a (*rev. type misdescribed*). Hunter, p. xxxv. *[Rome, AD 256]*.
VF £45 ($65) / EF £100 ($150)

9950

9950 B. Rev. ORIENS AVGG, Sol stg. l., his r. hand raised, holding whip in l. RIC 106. RSC 135. Hunter 31. *[Rome, AD 255–8]*. VF £16 ($25) / EF £38 ($55)

9951 G. Rev. — similar, but Sol holds globe instead of whip. RIC 13. RSC 140b. Hunter 60. *[Cologne, AD 257–9]*. VF £16 ($25) / EF £38 ($55)

9952 Similar, but Sol advances l. and holds whip instead of globe. RIC 12. RSC 143a. Hunter 53. *[Cologne, AD 257–9]*. VF £16 ($25) / EF £38 ($55)

9953 A. Rev. PACATORI ORBIS, Jupiter seated l., holding patera and sceptre, eagle at feet. RIC 218. RSC 145. Hunter, p. xxxviii. *[Antioch, AD 254–5]*. VF £20 ($30) / EF £45 ($65)

9954 B. Rev. PAX AVGG (or AVGVSTI), Pax stg. l., holding olive-branch and transverse sceptre. RIC 109, 111. RSC 149, 151. Hunter, p. xxxv. *[Rome, AD 255–8]*.
VF £14 ($20) / EF £30 ($45)

9955 B. Rev. PIETAS AVGG, Valerian and Gallienus stg. facing each other, sacrificing over altar between them, one holding eagle-tipped sceptre, the other parazonium (on later issues with wreath, with or without central dot, or star in field). RIC 285. RSC 152. Hunter 73. *[Uncertain Syrian mint, AD 256–8, 258–60]*. VF £16 ($25) / EF £38 ($55)

9956 A. Rev. PIETATI AVGG, Pietas-Securitas stg. l., holding sceptre and resting on column. RIC 219. RSC 155. Hunter, p. xxxviii. *[Antioch, AD 254–5]*. VF £16 ($25) / EF £38 ($55)

9957 A. Rev. P M TR P II COS P P, Valerian, togate, stg. l., sacrificing over altar and holding short sceptre. RIC 207. RSC 159a. Hunter, p. xxxviii. *[Antioch, AD 254]*.
VF £16 ($25) / EF £38 ($55)

9958 A. Rev. P M TR P II COS II P P, Jupiter stg., as 9943. RIC 141. RSC 156. Hunter 1. *[Rome, AD 254]*. VF £14 ($20) / EF £30 ($45)

9959 B. Rev. P M TR P III COS III P P, Valerian, togate, seated l. on curule chair, holding globe and sceptre. RIC 142b. RSC 163. Hunter, p. xxxiv. *[Rome, AD 255]*.
VF £23 ($35) / EF £50 ($75)

9960 B. Rev. P M TR P IIII COS III P P, Sol advancing, as 9952. Cf. RIC 142. RSC 164. Hunter, p. xxxiv. *[Rome, AD 256]*. VF £20 ($30) / EF £45 ($65)

9961 B. Rev. P M TR P V COS IIII P P, Valerian seated, as 9959. Cf. RIC 142c. RSC 166. Hunter, p. xxxiv. *[Rome, AD 257]*. VF £20 ($30) / EF £45 ($65)

9962 9968

9962 **Billon antoninianus.** C. Rev. — Valerian and Gallienus stg. facing each other, resting on shields between them behind which are two upright spears. RIC 277. RSC 169. Hunter 70. *[Eastern field-mint, AD 257].* **VF** £20 ($30) / **EF** £45 ($65)
This reverse type is similar to, and presumably was inspired by, the aureus and denarius reverse type of Augustus depicting his two grandsons, Gaius and Lucius Caesars (see Volume I, nos. 1578 and 1597). See also nos. 9986 and 10318.

9963 D. Rev. PROVID AVGG, Providentia stg. l., holding rod and standard, globe at feet. RIC 247. RSC 173. Hunter, p. xxxvii. *[Viminacium, AD 253–5].* **VF** £16 ($25) / **EF** £38 ($55)

9964 B. Rev. PROVIDENTIA AVGG, similar, but holding cornucopiae instead of standard. RIC 113. RSC 175. Hunter, p. xxxv. *[Rome, AD 255–8].* **VF** £14 ($20) / **EF** £30 ($45)

9965 C. Rev. RELIGIO AVGG, Diana stg. l., drawing arrow from quiver and holding bow, officina mark P (= 1) or Q (= 4) in field. RIC 115. RSC 177, 177a. Hunter, p. xxxvi. *[Rome, AD 258–60].* **VF** £25 ($40) / **EF** £60 ($90)

9966 A. Rev. RESTITVT GENER HVMANI, Valerian, rad. and in long robes, advancing r., his r. hand raised, holding globe in l. RIC 220. RSC 179. Hunter, p. xxxviii. *[Antioch, AD 254–5].* **VF** £23 ($35) / **EF** £50 ($75)

9967 B. Rev. RESTITVT ORIENTIS, turreted female figure stg. r., presenting wreath to Valerian, in military attire, stg. l., resting on spear held in l. hand (on later issues with wreath, with or without central dot, or star in field). RIC 287. RSC 189, 190. Hunter 75. *[Uncertain Syrian mint, AD 256–8, 258–60].* **VF** £16 ($25) / **EF** £38 ($55)

9968 B. Rev. RESTITVTOR ORBIS, Valerian, in military attire, stg. l., raising turreted female figure kneeling r. and resting on spear. RIC 117. RSC 183. Hunter 23. *[Rome, AD 255–8].* **VF** £16 ($25) / **EF** £38 ($55)

9969 A. Rev. RESTITVTORI ORBIS, Jupiter seated l., holding patera and sceptre, eagle at feet. RIC 119. RSC 180. Hunter, p. xxxiii. *[Rome, AD 253–5].* **VF** £16 ($25) / **EF** £38 ($55)

9970 A. Rev. ROMAE AETERNAE, Roma seated l., holding Victory and spear, shield at side. RIC 221. RSC 192, 192a. Hunter 7. *[Antioch, AD 254–5].* **VF** £16 ($25) / **EF** £38 ($55)

9971 D. Rev. SAECVLI (or SECVLI) FELICITAS, Felicitas stg. l., holding caduceus and cornucopiae. RIC 249. RSC 194, 195. Hunter, p. xxxvii. *[Viminacium, AD 253–5].* **VF** £16 ($25) / **EF** £38 ($55)

9972 D. Rev. SALVS AVG, Salus stg. r., feeding snake held in her arms. RIC 251. RSC 200. Cf. Hunter, p. xxxvii. *[Viminacium, AD 253].* **VF** £20 ($30) / **EF** £45 ($65)

9973 E. Rev. SALVS AVGG, as previous. RIC 252. RSC 202a. Hunter 61. *[Viminacium, AD 255–7].* **VF** £16 ($25) / **EF** £38 ($55)

9974 **Billon antoninianus.** D. Rev. SALVS AVGG, Salus stg. l., feeding snake arising from altar and holding sceptre. RIC 254. RSC 196. Hunter, p. xxxvii. *[Viminacium, AD 253–5].*
VF £14 ($20) / **EF** £30 ($45)

9975 Similar, but with rev. legend SALVS PVBLICA. RIC 255. RSC 203. Hunter, p. xxxvii. *[Viminacium, AD 253–5].* VF £16 ($25) / **EF** £38 ($55)

9976 C. Rev. SECVRIT PERPET, Securitas stg. facing, hd. l., holding sceptre and resting on column. RIC 256. RSC 204. Hunter 64. *[Milan, AD 259–60].*
VF £16 ($25) / **EF** £38 ($55)

9977 Similar, but with obv. legend F or G. Cf. RIC 17, 19. RSC 206, 207a. Hunter, p. xxxvi. *[Cologne, AD 257, 257–60].* VF £16 ($25) / **EF** £38 ($55)

9978 D. Rev. SPES PVBLICA, Spes advancing l., holding flower and lifting skirt. RIC 257. RSC 208. Hunter 62. *[Viminacium, AD 253–5].* VF £14 ($20) / **EF** £30 ($45)

9979 D. Rev. TEMPORVM FELICITAS, Felicitas stg., as 9971. RIC 259. RSC 211. Hunter, p. xxxvii. *[Viminacium, AD 253–5].* VF £16 ($25) / **EF** £38 ($55)

9980 A. Rev. VENVS VICTRIX, Venus stg. l., holding helmet and transverse sceptre and resting on shield. RIC 222. RSC 212. Hunter, p. xxxviii. *[Antioch, AD 254–5].*
VF £23 ($35) / **EF** £50 ($75)

9981 E. Rev. VICT AVGG, Victory stg. l., holding wreath and palm, captive at feet. RIC 260. RSC 214b. Hunter, p. xxxvii. *[Viminacium, AD 255–7].* VF £20 ($30) / **EF** £45 ($65)

9982 E. Rev. VICT PART, as previous. RIC 262. RSC 255. Hunter, p. xxxvii. *[Viminacium, AD 257].* VF £23 ($35) / **EF** £50 ($75)

9983 G. Rev. VICT PARTICA, Victory advancing r. or l., holding wreath and palm, treading down captive. RIC 22. RSC 255b, c. Hunter, p. xxxvii. *[Cologne, AD 257–9].*
VF £25 ($40) / **EF** £60 ($90)

9984 A. Rev. VICTORIA AVGG, Victory stg. l., resting on shield and holding palm. RIC 127. RSC 221. Hunter, p. xxxiv. *[Rome, AD 253–5].* VF £14 ($20) / **EF** £30 ($45)

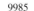
9985 9989

9985 A. Rev. — Victory stg. l., holding wreath and palm. RIC 125. RSC 230. Hunter 14. *[Rome, AD 253–5].* VF £14 ($20) / **EF** £30 ($45)

9986 E. Rev. — similar, but Victory stands on globe. RIC 288. RSC 236. Hunter, p. xxxix. *[Eastern field-mint, AD 255–7].* VF £16 ($25) / **EF** £38 ($55)
Like nos. 9962 and 10318 this reverse also revives an Augustan type (see Volume I, no. 1552).

9987 **Billon antoninianus.** A. Rev. VICTORIA EXERCIT, as 9985. RIC 131. RSC 244. Hunter, p. xxxiii. *[Rome, AD 253–5]*. **VF** £16 ($25) / **EF** £38 ($55)

9988 B. Rev. VICTORIA GERM, Victory and captive, as 9981. RIC 132. RSC 248. Cf. Hunter, p. xxxv. *[Rome, AD 255]*. **VF** £20 ($30) / **EF** £45 ($65)

9989 IMP P LIC VALERIANO AVG. Rev. VICTORIA GERMANICA, Victory stg. l., resting on shield and holding palm, captive at feet. RIC 264. RSC 253. Hunter, p. xxxviii. *[Viminacium, AD 253]*. **VF** £23 ($35) / **EF** £50 ($75)

9990 A. Rev. VICTORIAE AVGG, Virtus stg. r., resting on spear and shield. RIC 225. RSC 241. Hunter 66. *[Antioch, AD 254–5]*. **VF** £23 ($35) / **EF** £50 ($75)

9991 B. Rev. VICTORIAE AVGG IT GERM, Victory stg. l., holding wreath and palm, captive at feet. RIC 130. RSC 242. Cf. Hunter, p. xxxv. *[Rome, AD 255]*.
 VF £20 ($30) / **EF** £45 ($65)

 9992 9995

9992 Obv. As 9989. Rev. VIRTVS AVG, Virtus stg. l., holding Victory and resting on shield, spear propped against l. arm. RIC 266. RSC 257 = 278a. Hunter, p. xxxviii. *[Viminacium, AD 253]*. **VF** £20 ($30) / **EF** £45 ($65)

9993 A. Rev. VIRTVS AVGG, Virtus stg. l., resting on shield and holding spear. RIC 133. RSC 263. Hunter 19. *[Rome, AD 253–5]*. **VF** £14 ($20) / **EF** £30 ($45)

9994 Similar, but with obv. legend D. RIC 271. RSC 265. Hunter 63. *[Viminacium, AD 253–5]*.
 VF £16 ($25) / **EF** £38 ($55)

9995 B. Rev. — Valerian and Gallienus stg. facing each other, Valerian holding sceptre and globe, Gallienus holding Victory and transverse spear. RIC 293. RSC 276. Hunter 76. *[Uncertain Syrian mint, AD 256–8]*. **VF** £16 ($25) / **EF** £38 ($55)

 9996

9996 A. Rev. VOTA ORBIS, two Victories stg. facing each other, attaching shield inscribed S C to palm-tree. RIC 294. RSC 280. Hunter 72. *[Uncertain Syrian mint, AD 255–6]*.
 VF £23 ($35) / **EF** £55 ($85)

9997 **Billon antoninianus.** A. Rev. VOTIS / DECENNA / LIBVS in three lines within laurel-wreath. RIC 139. RSC 282. Hunter, p. xxxiii. *[Rome, AD 253].* **VF** £60 ($90) / **EF** £130 ($200)

9998 **Billon denarius.** A. Rev. IOVI CONSERVATORI, Jupiter stg. l., holding thunderbolt and sceptre. RIC 143. RSC 92. Hunter, p. xxxiv. *[Rome, AD 253–5].*
F £130 ($200) / **VF** £330 ($500) / **EF** £800 ($1,200)

9999 B. Rev. ORIENS AVGG, Sol stg. l., his r. hand raised, holding whip in l. RIC 144. RSC 134. Hunter, p. xxxv. *[Rome, AD 255–8].* **F** £130 ($200) / **VF** £330 ($500) / **EF** £800 ($1,200)

10000 A. Rev. VICTORIAE AVGG, Victory in galloping biga r., holding whip. RIC 145. RSC 240. Hunter, p. xxxiii. *[Rome, AD 253–5].* **F** £150 ($225) / **VF** £365 ($550) / **EF** £800 ($1,200)

10001 **Billon quinarius.** B. Rev. IOVI CONSERVAT, as 9998. RIC 146. RSC 90. Hunter, p. xxxv. *[Rome, AD 255–8].* **F** £120 ($180) / **VF** £265 ($400) / **EF** £665 ($1,000)

10002 Similar, but obv. legend A and CONSERVATORI instead of CONSERVAT. RIC 147. RSC 93. Hunter, p. xxxiv. *[Rome, AD 253–5].* **F** £120 ($180) / **VF** £265 ($400) / **EF** £665 ($1,000)

10003 A. Rev. ORIENS AVGG, as 9999. RIC 148. RSC 136. Hunter, p. xxxv, note 2. *[Rome, AD 253–5].* **F** £120 ($180) / **VF** £265 ($400) / **EF** £665 ($1,000)

10004 B. Rev. RESTITVTOR ORBIS, Valerian raising kneeling female, as 9968. RIC 149. RSC 182. Hunter, p. xxxv. *[Rome, AD 255–8].* **F** £130 ($200) / **VF** £300 ($450) / **EF** £750 ($1,100)

10005 C. Rev. SECVRIT PERPET, Securitas resting on column, as 9976. RIC 25. RSC 207. Hunter, p. xxxviii. *[Milan, AD 259–60].* **F** £130 ($200) / **VF** £300 ($450) / **EF** £750 ($1,100)

10006 A. Rev. VICTORIA AVGG, Victory stg. l., holding wreath and palm. RIC 150. RSC 231a. Hunter, p. xxxiv. *[Rome, AD 253–5].* **F** £120 ($180) / **VF** £265 ($400) / **EF** £665 ($1,000)

10007 Similar, but rev. legend VICTORIA GERM and Victory has seated captive at feet. RIC —. RSC —. Hunter 18. *[Rome, AD 253–5].*
F £130 ($200) / **VF** £300 ($450) / **EF** £750 ($1,100)

10008 **Bronze sestertius.** B. Rev. APOLINI CONSERVA S C, Apollo stg. l., holding laurel-branch and resting on lyre set on rock. RIC 152. C 22. Hunter 43. *[Rome, AD 255–8].*
F £55 ($80) / **VF** £130 ($200) / **EF** £400 ($600)

10009 A. Rev. APOLLINI PROPVG S C, Apollo stg. r., drawing bow. RIC 153. C 27. Hunter, p. xxxiv. *[Rome, AD 253–5].* **F** £60 ($90) / **VF** £150 ($225) / **EF** £450 ($675)

10010 A. Rev. CONCORDIA EXERCIT S C, Concordia stg. l., holding patera and double cornucopiae. RIC 155. C 40. Hunter, p. xxxiv. *[Rome, AD 253–5].*
F £55 ($80) / **VF** £130 ($200) / **EF** £400 ($600)

10011 B. Rev. FELICITAS AVGG S C, Felicitas stg. l., holding long caduceus and cornucopiae. RIC 157. C 58. Hunter, p. xxxv. *[Rome, AD 255–8].*
F £55 ($80) / **VF** £130 ($200) / **EF** £400 ($600)

10012 A. Rev. FIDES MILITVM S C, Fides Militum stg. l., holding two standards. RIC 160. C 70. Hunter, p. xxxiv. *[Rome, AD 253–5].* **F** £55 ($80) / **VF** £130 ($200) / **EF** £400 ($600)

10013 A. Rev. IOVI CONSERVA S C, Jupiter stg. l., holding thunderbolt and sceptre. RIC 162. C 84. Hunter 41. *[Rome, AD 253–5].* **F** £55 ($80) / **VF** £130 ($200) / **EF** £400 ($600)

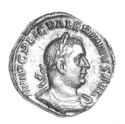

10012

10014 **Bronze sestertius.** Similar, but obv. legend B and IOVI CONSERVATORI S C on rev. Cf.
 RIC 163. C 95. Hunter, p. xxxv. *[Rome, AD 255–8]*.
 F £55 ($80) / **VF** £130 ($200) / **EF** £400 ($600)

10015 A. Rev. LIBERALITAS AVGG S C, Liberalitas stg. l., holding abacus and cornucopiae. RIC 164.
 C 110. Hunter 45 var. *[Rome, AD 255]*. F £55 ($80) / **VF** £130 ($200) / **EF** £400 ($600)

10016 A. Rev. MARTI PACIF S C, Mars advancing l., holding olive-branch in r. hand and shield
 and spear in l. RIC 169. C 125. Hunter, p. xxxiii. *[Rome, AD 253–5]*.
 F £65 ($100) / **VF** £170 ($250) / **EF** £500 ($750)

10017

10017 B. Rev. ORIENS AVGG S C, Sol stg. l., his r. hand raised, holding whip in l. RIC 170. C 137.
 Hunter 49. *[Rome, AD 255–8]*. F £60 ($90) / **VF** £150 ($225) / **EF** £450 ($675)

10018 B. Rev. P M TR P V COS IIII P P S C, Valerian, togate, seated l. on curule chair, holding globe
 and sceptre. RIC 151. C 167. Hunter, p. xxxiv. *[Rome, AD 257]*.
 F £65 ($100) / **VF** £170 ($250) / **EF** £500 ($750)

10019 B. Rev. RESTITVTOR ORBIS S C, Valerian, in military attire, stg. l., raising turreted female
 figure kneeling r. and resting on spear. RIC 171. C 186. Hunter 46. *[Rome, AD 255–8]*.
 F £65 ($100) / **VF** £170 ($250) / **EF** £500 ($750)

10020 A. Rev. SALVS AVGG S C, Salus stg. l., feeding snake arising from altar and holding
 sceptre. Cf. RIC 173. C 198. Hunter, p. xxxiv. *[Rome, AD 253–5]*.
 F £60 ($90) / **VF** £150 ($225) / **EF** £450 ($675)

10021 A. Rev. VESTA S C, Vesta stg. l., holding patera and transverse sceptre. RIC 175. C 214.
 Hunter, p. xxxiii. *[Rome, AD 253–5]*. F £60 ($90) / **VF** £150 ($225) / **EF** £450 ($675)

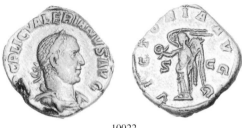

10022

10022 **Bronze sestertius.** A. Rev. VICTORIA AVGG S C, Victory stg. (or advancing) l., holding
wreath and palm. RIC 177. C 219, 234. Hunter, p. xxxiv. *[Rome, AD 253–5].*
 F £55 ($80) / **VF** £130 ($200) / **EF** £400 ($600)

10023

10023 Similar, but obv. legend B and Victory stg. l., resting on shield and holding palm. RIC 180.
C 226. Hunter 47. *[Rome, AD 253–5].* F £55 ($80) / **VF** £130 ($200) / **EF** £400 ($600)

10024 B. Rev. VICTORIA GERM S C, Victory stg. l., holding wreath and palm, sometimes with
captive at feet. RIC 181. C 246, 249. Hunter, p. xxxv. *[Rome, AD 255].*
 F £65 ($100) / **VF** £170 ($250) / **EF** £500 ($750)

10025

10025 A. Rev. VIRTVS AVGG S C, Virtus stg. l., resting on shield and holding spear. RIC 182. C
269. Hunter 39. *[Rome, AD 253–5].* F £55 ($80) / **VF** £130 ($200) / **EF** £400 ($600)

10026 A. Rev. VOTIS / DECENNA / LIBVS / S C in four lines within laurel-wreath. RIC 184. C 283.
Hunter 35. *[Rome, AD 253].* F £80 ($120) / **VF** £200 ($300) / **EF** £600 ($900)

10026

10027 **Bronze dupondius.** A. Rev. LIBERALITAS AVGG S C, Liberalitas stg., as 10015. RIC 185. C 112. Hunter, p. xxxiv. *[Rome, AD 255].*
F £120 ($180) / **VF** £300 ($450) / **EF** £800 ($1,200)

10028 B. Rev. ORIENS AVGG S C, Sol stg., as 10017. RIC 187. C 139. Hunter, p. xxxv. *[Rome, AD 255–8].*
F £120 ($180) / **VF** £300 ($450) / **EF** £800 ($1,200)

10029 **Bronze as.** As 10008 (rev. APOLINI CONSERVA S C, Apollo resting on lyre). RIC 190. C 23. Hunter 44. *[Rome, AD 255–8].*
F £60 ($90) / **VF** £150 ($225) / **EF** £450 ($675)

10030 As 10010 (rev. CONCORDIA EXERCIT S C, Concordia stg.). RIC 191. C 41. Hunter, p. xxxiv. *[Rome, AD 253–5].*
F £60 ($90) / **VF** £150 ($225) / **EF** £450 ($675)

10031 As 10011 (rev. FELICITAS AVGG S C, Felicitas stg.). RIC 193. C 59. Hunter 42. *[Rome, AD 255–8].*
F £60 ($90) / **VF** £150 ($225) / **EF** £450 ($675)

10032 As 10014 (rev. IOVI CONSERVATORI S C, Jupiter stg.). RIC 195. C 96. Hunter, p. xxxv. *[Rome, AD 255–8].*
F £60 ($90) / **VF** £150 ($225) / **EF** £450 ($675)

10033 As 10015 (rev. LIBERALITAS AVGG S C, Liberalitas stg.). RIC 196. C 111. Hunter, p. xxxiv. *[Rome, AD 255].*
F £60 ($90) / **VF** £150 ($225) / **EF** £450 ($675)

10034 As 10017 (rev. ORIENS AVGG S C, Sol stg., holding whip). RIC 198. C 138. Hunter, p. xxxv. *[Rome, AD 255–8].*
F £60 ($90) / **VF** £150 ($225) / **EF** £450 ($675)

10035 As 10018 (rev. P M TR P V COS IIII P P S C, Valerian seated). Cf. RIC 189. C 168. Hunter, p. xxxiv. *[Rome, AD 257].*
F £65 ($100) / **VF** £170 ($250) / **EF** £500 ($750)

10036 As 10020 (rev. SALVS AVGG S C, Salus stg. at altar). RIC — (omitted in error). C 199. Hunter, p. xxxiv. *[Rome, AD 253–5].*
F £60 ($90) / **VF** £150 ($225) / **EF** £450 ($675)

10037 As 10022 (rev. VICTORIA AVGG S C, Victory stg., holding wreath). RIC 200. C 235. Hunter 38. *[Rome, AD 253–5].*
F £60 ($90) / **VF** £150 ($225) / **EF** £450 ($675)

10038 Similar, but Victory resting on shield. RIC 201. C 229. Hunter, p. xxxiv. *[Rome, AD 253–5].*
F £60 ($90) / **VF** £150 ($225) / **EF** £450 ($675)

10039 As 10024 (rev. VICTORIA GERM S C, Victory stg. with captive at feet). RIC 203. C 250. Hunter 50. *[Rome, AD 255].*
F £65 ($100) / **VF** £170 ($250) / **EF** £500 ($750)

10040 As 10025 (rev. VIRTVS AVGG S C, Virtus resting on shield). RIC 204. C 270. Hunter 40. *[Rome, AD 253–5].*
F £55 ($80) / **VF** £130 ($200) / **EF** £400 ($600)

10041 As 10026 (rev. votive legend in wreath). RIC 206. C 284. Hunter 36. *[Rome, AD 253].*
F £80 ($120) / **VF** £200 ($300) / **EF** £600 ($900)

Alexandrian Coinage

10042 **Billon tetradrachm.** A K Π ΛΙ OVAΛEPIANOC EV EV C, laur., dr. and cuir. bust r. Rev. Alexandria, turreted, stg. l., her r. hand raised, holding sceptre in l., L — A (= regnal year 1) in field. Dattari 5142. BMCG 2138. Cologne 2851. Milne 3871. *[AD 253–4].*
F £16 ($25) / **VF** £48 ($70)

10043 Obv. Similar. Rev. Tyche (= Fortuna) reclining l. on couch, holding rudder, L A (= regnal year 1) above. Dattari 5175. BMCG 2136. Cologne —. Milne —. *[AD 253–4].*
F £20 ($30) / **VF** £55 ($80)

10044 — Rev. Rev. Eagle stg. l., hd. r., its wings closed, holding wreath in beak, L — A (= regnal year 1) in field. Dattari 5183. BMCG 2142. Cologne 2849. Milne 3873. *[AD 253–4].*
F £14 ($20) / **VF** £40 ($60)

10045

10045 Obv. Similar, but bust laur. and cuir. r. Rev. Nike (= Victory) stg. facing, hd. l., holding wreath and palm, L B (= regnal year 2) in field to l. Dattari 5162. BMCG —. Cologne —. Milne 3882. *[AD 254–5].*
F £16 ($25) / **VF** £48 ($70)

10046 — Rev. Eirene (= Pax) stg. l., holding olive-branch and sceptre, L Γ (= regnal year 3) before. Dattari 5150. BMCG 2126. Cologne 2859. Milne 3888. *[AD 255–6].*
F £14 ($20) / **VF** £40 ($60)

10047 — Rev. Elpis (= Spes) advancing l., holding flower and lifting skirt, L — Γ (= regnal year 3) in field. Dattari 5153. BMCG/Christiansen 3279. Cologne 2860. Milne 3897. *[AD 255–6].*
F £14 ($20) / **VF** £40 ($60)

10048 — Rev. Homonoia (= Concordia) seated l., her r. hand raised, holding double cornucopiae in l., L Γ (= regnal year 3) before. Dattari 5161. BMCG 2130. Cologne 2861. Milne 3905. *[AD 255–6].*
F £14 ($20) / **VF** £40 ($60)

10049 — Rev. Eagle, as 10044, but its wings open, L — Γ (= regnal year 3) in field. Dattari 5189. BMCG 2144. Cologne 2857. Milne 3914. *[AD 255–6].* **F** £14 ($20) / **VF** £40 ($60)

10050 — Rev. Rad. bust of Helios r., L — Δ (= regnal year 4) in field. Dattari 5155. BMCG 2124. Cologne 2863. Milne 3918. *[AD 256–7].* **F** £16 ($25) / **VF** £48 ($70)

10051 — Rev. Homonoia, as 10048, but stg. instead of seated, L — Δ (= regnal year 4) in field. Dattari 5158. BMCG 2128. Cologne 2864. Milne 3923. *[AD 256–7].*
F £14 ($20) / **VF** £40 ($60)

10052 — Rev. Nike (= Victory) advancing r., holding wreath and palm, L — Δ (= regnal year 4) in field. Dattari 5165. BMCG 2132. Cologne 2866. Milne 3931. *[AD 256–7].*
F £14 ($20) / **VF** £40 ($60)

10053 **Billon tetradrachm.** — Rev. Tyche (= Fortuna) seated l., holding rudder and cornucopiae, L Δ (= regnal year 4) before. Dattari 5174. BMCG 2135. Cologne 2867. Milne 3936. *[AD 256–7].* **F** £14 ($20) / **VF** £40 ($60)

10054 — Rev. Alexandria, turreted, stg. l., holding small hd. of Sarapis and resting on sceptre, L — E (= regnal year 5) in field. Dattari 5192. BMCG 2139. Cologne 2869. Milne 3976. *[AD 257–8].* **F** £16 ($25) / **VF** £48 ($70)

10055 — Rev. Zeus seated l., holding patera and sceptre, eagle at feet, Nike r. on back of throne, L — E (= regnal year 5) in field. Dattari —. BMCG —. Cologne —. Milne 3965. *[AD 257–8]* . **F** £20 ($30) / **VF** £55 ($80)

10056 — Rev. Nike (= Victory) seated l. on cuirass, holding wreath and palm, L E (= regnal year 5) before. Dattari 5209. BMCG —. Cologne 2870. Milne 3966. *[AD 257–8].* **F** £16 ($25) / **VF** £48 ($70)

10057 — Rev. Tyche (= Fortuna) stg. l., holding rudder and cornucopiae, L — E (= regnal year 5) in field. Dattari 5211. BMCG 2134. Cologne 2871. Milne 3970. *[AD 257–8].* **F** £14 ($20) / **VF** £40 ($60)

10058 Obv. As 10042. Rev. Bust of Sarapis l., wearing modius, sceptre over l. shoulder, L — Ϛ regnal year 6) in field. Dattari 5172. BMCG —. Cologne 2875. Milne 3997. *[AD 258–9].* **F** £22 ($35) / **VF** £60 ($90)

10059 — Rev. Laur. bust of Zeus r., L — Ϛ regnal year 6) in field. Dattari 5179. BMCG 2122. Cologne 2876. Milne 3991. *[AD 258–9].* **F** £16 ($25) / **VF** £48 ($70)

10060 — Rev. Athena seated l., holding Nike and resting on sceptre, shield with Gorgon's hd. at side, L — Z (= regnal year 7) in field. Dattari 5148. BMCG 2125. Cologne —. Milne 4017. *[AD 259–60].* **F** £16 ($25) / **VF** £48 ($70)

10061 — Rev. Conjoined busts l. of Sarapis, wearing modius, sceptre over l. shoulder, and Isis, wearing disk and plumes, knot on breast, L — Z (= regnal year 7) in field. Dattari —. BMCG —. Cologne —. Milne — Emmett 3719. *[AD 259–60].* **F** £25 ($40) / **VF** £65 ($100)

10062 — Rev. Eagle stg. l., wings open, holding wreath in beak, L H (= regnal year 8) before. Dattari 5190. BMCG —. Cologne —. Milne 4050. *[AD 260].* **F** £22 ($35) / **VF** £60 ($90)

For other local coinages of Valerian, see *Greek Imperial Coins & Their Values*, pp. 427–38.

VALERIAN AND GALLIENUS

10063 **Billon denarius.** CONCORDIA AVGVSTORVM, laur., dr. and cuir. busts of Valerian r. and
Gallienus l., face to face. Rev. LIBERALITAS AVGVSTORVM, Liberalitas stg. l., holding
abacus and cornucopiae. RIC 3. RSC 9. Hunter, p. xl. *[Rome, AD 253].* (*Unique?*)

10064 **Bronze dupondius (?).** Similar, but with rev. legend LIBERALITAS AVGG III S C. RIC 7.
Cohen 8. Hunter, p. xl. *[Rome, AD 256].* (*Extremely rare*)
This may be a small medallion rather than a dupondius.

Issues of Valerian in honour of Diva Mariniana

*Mariniana is presumed to have been the wife of Valerian and mother of Gallienus, though the
evidence is solely numismatic. Confirmation of the date of her coinage is provided by a provincial
bronze of Viminacium in Moesia Superior which was struck in the 15th year of that city's colonial
era (AD 253–4). The scarcity of her Roman denominations would indicate that they all belong to
this same period of issue. As her coinage is entirely posthumous and her name lacks the title of
Augusta it must be assumed that she died prior to her husband's elevation to imperial status.*

* Although all types are attributed to Rome in the following listing there is a possibility that
another mint, possibly Viminacium, may have been active in the production of Mariniana's
coinage. Some issues (usually those lacking the diadem on the obverse portrait) appear to be
stylistically distinctiveand may represent a provincial issue.*

10065 **Gold aureus.** DIVAE MARINIANAE, diad., veiled and dr. bust of Mariniana r. Rev.
CONSECRATIO, peacock stg. facing, hd. l., its tail in splendour. RIC 1. C 1. Hunter, p. xl.
[Rome, AD 253–4]. **VF** £10,000 ($15,000) / **EF** £23,500 ($35,000)

10066 Obv. Similar, but without diad. Rev. — peacock flying r., bearing on its back seated figure
of Mariniana l., her r. hand raised, holding sceptre in l. RIC 2. Cf. C 13 (incomplete
description). Hunter, p. xl. *[Rome, AD 253–4].*
VF £10,000 ($15,000) / **EF** £23,500 ($35,000)

10067

10067 **Billon antoninianus.** Similar to 10065, but on obv. crescent behind empress's shoulders
and sometimes without diad. RIC 3. RSC 2, 3. Hunter 3, 5. *[Rome, AD 253–4].*
VF £65 ($100) / **EF** £170 ($250)

10068 Similar, but peacock's hd. is turned to r. and sometimes with mint mark V in rev. field. RIC
4 and note. RSC 4–6. Hunter 4. *[Rome, AD 253–4].* **VF** £65 ($100) / **EF** £170 ($250)

10069 Obv. As 10067 (with diad.). Rev. CONSECRATIO, peacock walking r., its tail in splendour.
RIC 5. RSC 11. Hunter, p. xl. *[Rome, AD 253–4].* **VF** £75 ($110) / **EF** £185 ($275)

10070 — (usually without diad.). Rev. — peacock flying r., as 10066. RIC 6. RSC 16, 18. Hunter 1.
[Rome, AD 253–4]. **VF** £65 ($100) / **EF** £170 ($250)

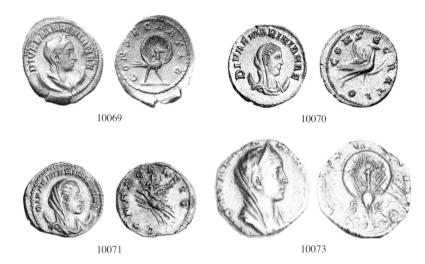

10069 10070

10071 10073

10071 **Billon antoninianus.** Similar, but peacock flying l. and empress seated r. RIC 6. RSC 14.
 Hunter, p. xl. *[Rome, AD 253–4].* **VF** £75 ($110) / **EF** £185 ($275)

10072 **Billon quinarius.** Obv. As 10066. Rev. CONSECRATIO, as previous. Cf. RIC 8. RSC 17.
 Hunter, p. xl. *[Rome, AD 253–4].* **F** £400 ($600) / **VF** £1,000 ($1,500)

10073 **Bronze sestertius.** As 10065, but also with S C on rev. Cf. RIC 9 var. (obv. misdescribed). C
 7 var. Hunter 8. *[Rome, AD 253–4].* **F** £200 ($300) / **VF** £500 ($750) / **EF** £1,500 ($2,250)

10074 Obv. As 10065. Rev. As 10069, but also with S C on rev. Cf. RIC 10. C 12. Hunter 9.
 [Rome, AD 253–4]. **F** £230 ($350) / **VF** £550 ($850) / **EF** £1,650 ($2,500)

10075 **Bronze dupondius.** Obv. As 10067 (without diad.). Rev. CONSECRATIO S C, peacock stg.
 facing, hd. r., its tail in splendour. RIC —. C 9. Hunter, p. xl. *[Rome, AD 253–4].*
 F £200 ($300) / **VF** £500 ($750) / **EF** £1,500 ($2,250)

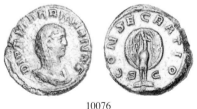

10076

10076 **Bronze as.** Obv. As 10066. Rev. — as previous. RIC 11. C 10. Hunter 6. *[Rome, AD
 253–4].* **F** £130 ($200) / **VF** £365 ($550) / **EF** £1,000 ($1,500)

10077 — Rev. — peacock flying l., carrying empress, as 10071. RIC 12. C 15. Hunter, p. xl.
 [Rome, AD 253–4]. **F** £170 ($250) / **VF** £430 ($650) / **EF** £1,175 ($1,750)

There is no Alexandrian coinage in the name of Mariniana. For a local issue from Viminacium, see
Greek Imperial Coins & Their Values, p. 438.

GALLIENUS
Oct. AD 253–Sep. 268

10152

Publius Licinius Egnatius Gallienus, son of Valerian and Mariniana, was born about AD 218 and was thus in his mid-thirties at the time his father elevated him to the rank of co-emperor. He was given responsibility for the defenceof the northern frontier from the Rhine to the Danube and seems to have achieved a fair degree of success against a number of the Empire's principal adversaries in this region, notably the Franks and the Alamanni. In AD 256 Gallienus' elder son, Valerian Junior, was given the rank of Caesar and on the young man's death two years later he was succeeded in this office by his younger brother, Saloninus. The year 260 was catastrophic for the regime of Valerian and Gallienus: not only was the older emperor captured by the Persians but in the West the usurper Postumus besieged Saloninus in Cologne and, following the fall of the city, put him to death. Postumus founded an independent 'Gallic Empire' which was to remain autonomous for fourteen years under a succession of rulers. After the abortive rebellion of Macrian, a staff officer of Valerian, much of the East came under the effective rule of king Odaenathus of Palmyra who successfully defended his territory against the Persians. Now left as sole emperor of a rapidly disintegrating state Gallienus was faced with his sternest challenge. During his eight remaining years he tried valiantly to hold the Empire together, fighting successfully against a succession of minor usurpers and endeavouring to implement vital military reforms. These included the exclusion of senators from military commands and the creation of a field army and a highly mobile elite cavalry force. These important reforms laid the foundations for the Empire's recovery in the following decades but a hostile tradition gives Gallienus little credit for being the true architect of the resurgence of Roman power. Gallienus himself was not destined to achieve the reunification of the Empire and many of the western provinces remained under the control of Postumus, whilst in the East the 'Palmyrene Empire' continued to hold sway. Shortly after achieving a great victory over a horde of Gothic invaders, who had attacked the Balkans and central Greece, Gallienus was obliged to return to northern Italy to put down the rebellion of his most trusted general, Aureolus. Whilst he was besieging the usurper in Milan Gallienus was assassinated by a group of his staff officers which included the future emperors Claudius II and Aurelian (late summer, AD 268). A highly cultured man and a friend of the celebrated philosopher Plotinus, it was the ill luck of Gallienus to have to devote most of his efforts to virtually continous warfare, a misfortune which he shared with the philosopher-emperor Marcus Aurelius a century before.

The coinage of Gallienus falls into two main periods. During the joint reign with his father Valerian (AD 253–260) the pattern of issues mirrors that of the older emperor and where appropriate the reverse legend endings are in the plural (AVGG = Augustorum). After Valerian's capture Gallienus' period of sole rule (AD 260–268) saw a number of changes in the monetary system. The weights of the gold coinage became even more unstable and there was a steep decline in the aureus from about 3 grams to just over 1 gram. There appears to have been much experimentation with the gold denominations but no effective reform was accomplished. The billon antoninianus continued its catastrophic decline and by the end of the reign the silver content had sunk to a minute 2.5%. With the antoninianus itself now reduced to little more than a small bronze coin there was little point in continuing the production of the larger aes denominations (sestertius, dupondius and as) and these ceased quite early in the sole reign. Rome maintained its position as the principal mint but issues from provincial establishments continued to grow in importance. Cologne was lost to Gallienus at the beginning of his sole reign through the usurpation of Postumus, the founder of an independent western state. Postumus continued to use it as his principal mint and produced there a coinage which maintained much higher standards than those of the contemporary issues of Gallienus and included a large output of aes. The mint of Milan, opened towards the end of the joint reign (circa AD 259), now assumed greater importance for Gallienus, especially as the city had been chosen as the base for Gallienus' new mobile field army.

In the militarily important region of the Balkans a mint which was to have a long history was set up by Gallienus in AD 262. It was located at Siscia in Pannonia Superior at the confluence of the rivers Savus and Colapis and served as a fleet station. A possible second Balkan mint at Sirmium in Pannonia Inferior was also an important fleet station. In the East the situation was very confused because of the temporary collapse of Roman power in the region following the capture of Valerian. The uncertain Syrian mint continued striking briefly for Gallienus until it was taken over by the usurpers Macrian and Quietus. Then, in AD 263, Antioch was reopened and produced a substantial coinage throughout the remaining half decade of the reign. A late addition to the eastern mints produced distinctive antoniniani with S P Q R in the exergue. The location of this mint has been the subject of much scholarly debate. Ephesus, Smyrna, Cyzicus, and Tripolis in Phrygia have all been proposed but the question remains to be resolved. Cyzicus is perhaps the most likely on the evidence of the coins of Gallienus' successor, Claudius II. In the following listing the products of this mint have been designated as "uncertain Asia Minor mint".

In addition to issues in his own name Gallienus, during his sole reign, continued production of the coinage in the name of his wife Cornelia Salonina which had commenced early in the joint reign.

There are seven principal varieties of obverse legend:

A. GALLIENVS AVG
B. GALLIENVS P F AVG
C. IMP C P LIC GALLIENVS AVG
D. IMP C P LIC GALLIENVS P F AVG
E. IMP GALLIENVS AVG
F. IMP GALLIENVS P AVG
G. IMP GALLIENVS P F AVG

The normal obverse type for binios, antoniniani and dupondii is radiate head or bust of Gallienus right. Other denominations have laureate head or bust right. The emperor's bust is usually depicted draped and/or cuirassed. Many other varieties of obverse type exist and these are described in full.

RIC and Hunter have two separate listings for the coinage of Gallienus, one for the issues of his joint reign with Valerian, the other for those of his sole reign. For issues up to AD 260 the RIC numbers refer to the listing commencing on p. 68, and the Hunter numbers refer to the listing commencing on p. 13. For issues from AD 260–268 the RIC listing commences on p. 130 and the Hunter listing on p. 38. The 'legionary' antoniniani of Gallienus, issued at Milan early in the sole reign (260–61), are listed in RIC on pp. 92–7 under the joint reign, while in Hunter they have a separate listing on pp. 36–7.

10078 **Gold binio.** A, rad. hd. l. Rev. **ADVENTVS AVG**, Gallienus on horseback riding l., his r. hand raised, holding spear in l. RIC 22. C 13. Hunter, p. lix. *[Rome, AD 261–2].*
 VF £2,500 ($3,750) / **EF** £6,000 ($9,000)

NB During the joint reign (AD 253–60) the weight of the radiate binio averaged about 5.40 grams and that of the laureate aureus about 3.00 grams. In the sole reign (AD 260–68) the binio declined to about 4.50 grams, whilst the aureus fell from 2.50 grams to just over 1.00 gram. About AD 266 a separate class of gold coins was introduced characterized by a reed-crowned portrait of the emperor. Initially weighing about 6.00 grams these also had declined to little more than a gram by the end of the reign. An extensive range of gold multiples ('medallions') is known for this reign, ranging in weight from about 7.00 grams to over 49.00 grams.

10079 C. Rev. **AETERNITAS AVGG**, Gallienus, rad. and in long robes, advancing r., his r. hand raised, holding globe in l. RIC 69. C 49. Hunter, p. xli. *[Uncertain Syrian mint, AD 255–6].*
 VF £2,700 ($4,000) / **EF** £6,700 ($10,000)

10080 **Gold binio.** A. Rev. DIANA FELIX, Diana stg. r., holding spear and bow, hound at feet. RIC 444. C 172. Cf. Hunter, p. lix (Rome). *[Milan, AD 264–5].*
VF £2,500 ($3,750) / **EF** £6,000 ($9,000)

10081 A. Rev. FID MILITVM, Fides Militum stg. l., holding two standards. RIC 43. C 278. Hunter, p. lx. *[Rome, AD 261–2].*
VF £2,300 ($3,500) / **EF** £5,300 ($8,000)

10082 B. Rev. FIDE / I EQVI / TVM in three lines within laurel-wreath. RIC 33. C 212. Hunter, p. lviii. *[Rome, AD 260–61].*
VF £2,500 ($3,750) / **EF** £6,000 ($9,000)

10083 A. Rev. FIDEI PRAET, Genius of the Praetorians stg. l., holding patera and cornucopiae, standard to r. RIC 36. C 214. Hunter, p. lx. *[Rome, AD 262–3].*
VF £2,500 ($3,750) / **EF** £6,000 ($9,000)

10084 A. Rev. — legionary eagle between two standards. RIC 37. C 215. Hunter, p. lx. *[Rome, AD 262–3].*
VF £2,700 ($4,000) / **EF** £6,700 ($10,000)

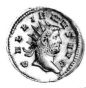

10085

10085 A. Rev. FIDES / MILI / TVM in three lines within laurel-wreath. RIC 41. C 256 var. Hunter, p. lx. *[Rome, AD 261].*
VF £2,500 ($3,750) / **EF** £6,000 ($9,000)

10086 A. Rev. FORTVNA REDVX, Fortuna seated l., holding rudder and cornucopiae. Cf. RIC 43 (Rome, rev. misdescribed). C 278. Hunter, p. lxvi. *[Milan, AD 264–5].*
VF £2,300 ($3,500) / **EF** £5,300 ($8,000)

10087 A. Rev. IOVI VLTORI, Jupiter advancing to front, looking r., thunderbolt in raised r. hand, l. at side, officina mark S (= 2) in l. field. RIC 52. C 401. Hunter, p. lx. *[Rome, AD 261].*
VF £2,300 ($3,500) / **EF** £5,300 ($8,000)

10088 A. Rev. LIBERAL AVG, Liberalitas stg. l., holding abacus and cornucopiae, officina mark P (= 1) in l. field. RIC 55. C 561. Hunter, p. lx. *[Rome, AD 261].*
VF £2,300 ($3,500) / **EF** £5,300 ($8,000)

10089 A, cuir. bust l., wearing rad. helmet and holding spear and shield. Rev. MARTI PROPVGNAT, Mars advancing r., spearing enemy at his feet and holding shield. RIC 57. C 624. Hunter, p. lxiii. *[Rome, AD 263].* VF £3,000 ($4,500) / **EF** £8,000 ($12,000)

10090 A. Rev. ORIENS AVG, Sol stg. l., raising r. hand and holding whip in l., officina mark P (= 1) in ex. RIC 448. C 683. Hunter, p. lxvi. *[Milan, AD 264–5].*
VF £2,300 ($3,500) / **EF** £5,300 ($8,000)

10091 E. Rev. PIETAS AVG, Pietas stg. l., both hands raised, altar at feet, officina mark P (= 1) in ex. RIC 449. C 782. Hunter, p. lxvii. *[Milan, AD 262–3].*
VF £2,300 ($3,500) / **EF** £5,300 ($8,000)

10092 C. Rev. P M TR P III COS II P P, Gallienus, togate, stg. r., sacrificing over tripod-altar and holding eagle-tipped sceptre. RIC —. C —. Hunter —. *[Uncertain Syrian mint, AD 255–6].*
VF £3,000 ($4,500) / **EF** £8,000 ($12,000)

10092

10093 **Gold binio.** A, rad. hd. l. Rev. VICT GAL AVG III, Victory advancing r., holding wreath and palm. RIC 75. C 1039. Cf. Hunter, p. lxi. *[Rome, AD 261–2]*.
VF £2,500 ($3,750) / **EF** £6,000 ($9,000)

10094 A. Rev. VICTORIA AVG III, Victory advancing l., holding wreath and palm, officina mark T (= 3) in l. field. RIC 84. C 1116. Hunter, p. lxi. *[Rome, AD 261–2]*.
VF £2,300 ($3,500) / **EF** £5,300 ($8,000)

10095 C. Rev. VICTORIA AVGG, Victory stg. l., holding wreath and palm. Cf. RIC 94, C 1137, and Hunter, p. xlii, for the aureus of this type. *[Rome, AD 253–5]*.
VF £2,700 ($4,000) / **EF** £6,700 ($10,000)

10096 A, rad. hd. l. Rev. VIRT GALLIENI AVG, Gallienus galloping r., spearing fallen enemy on ground below horse. RIC 88. C 1202. Hunter, p. lxi. *[Rome, AD 261–2]*.
VF £2,700 ($4,000) / **EF** £6,700 ($10,000)

10097 10099

10097 A. Rev. VIRTVS AVG, Mars stg. l., holding globe and resting on sceptre, officina mark P (= 1) in r. field. RIC 90. C 1220. Hunter, p. lxi. *[Rome, AD 261–2]*.
VF £2,300 ($3,500) / **EF** £5,300 ($8,000)

10098 A, rad. hd. l. Rev. VIRTVS AVGVSTI, Hercules stg. r., r. hand on hip, l. holding club wrapped in lion's skin set on rock. RIC 91. C 1314. Hunter 35. *[Rome, AD 261–2]*. **VF** £2,500 ($3,750) / **EF** £6,000 ($9,000)

10099 A. Rev. VOT / X / ET / XX in four lines within laurel-wreath. RIC 95. C 1354. Hunter, p. lxi. *[Rome, AD 262–3]*. VF £2,700 ($4,000) / **EF** £6,700 ($10,000)

10100 A. Rev. VOTIS / DECENNA / LIB in three lines within laurel-wreath. RIC 92. Cf. C 1337. Hunter 37. *[Rome, AD 262–3]*. VF £2,700 ($4,000) / **EF** £6,700 ($10,000)

10101 A. Rev. VO / TIS / X in three lines within laurel-wreath. RIC 93. C —. Hunter, p. lxi. *[Rome, AD 262–3]*. VF £2,700 ($4,000) / **EF** £6,700 ($10,000)

10102 **Gold aureus.** E, laur. half-length bust r. Rev. ABVNDANTIA AVG, Abundantia stg. r., emptying cornucopiae. RIC 97. C 3. Hunter, p. lxii. *[Rome, AD 265–6]*.
VF £825 ($1,250) / **EF** £2,300 ($3,500)

NB The latest issues of this denomination frequently weigh little more than 1.00 gram and are often referred to in catalogues as 'gold quinarii'.

10103 **Gold aureus.** A. Rev. **ADVENTVS AVG**, Gallienus on horseback riding l., his r. hand raised, holding spear in l. RIC 22. C 12. Hunter, p. lix. *[Rome, AD 262]*.
VF £1,200 ($1,800) / **EF** £2,300 ($4,500)

10104 A. Rev. **AEQVITAS AVG**, Aequitas stg. l., holding scales and cornucopiae. RIC 23. C 21. Hunter, p. lix. *[Rome, AD 261–2]*. VF £800 ($1,200) / **EF** £2,000 ($3,000)

10105 A. Rev. **AETERNITAS AVG**, Sol stg. l., raising r. hand and holding globe in l. RIC 24, 99. C 37, 43. Hunter 53. *[Rome, AD 264–6]*.
VF £665–800 ($1,000–1,200) / **EF** £1,650–2,000 ($2,500–3,000)

10106 D. Rev. **APOLINI CONSERVA**, Apollo stg. l., holding laurel-branch and resting on lyre set on rock. RIC —. C —. Hunter, p. xlii. *[Rome, AD 255–7]*.
VF £1,200 ($1,800) / **EF** £2,300 ($4,500)

10107 A. Rev. **CLEMENTIA TEMP**, Clementia stg. l., holding sceptre and resting on column. RIC 100. C 101. Hunter, p. lix. *[Rome, AD 265–6]*. VF £750 ($1,100) / **EF** £1,850 ($2,750)

10108

10108 C. Rev. **CONCORDIA EXERCIT**, Concordia stg. l., holding patera and cornucopiae (sometimes double). RIC 70. C 130. Hunter, p. xli. *[Rome, AD 253–5]*.
VF £1,000 ($1,500) / **EF** £2,700 ($4,000)

10109 Similar, but with rev. legend **CONCORDIA MILIT**. RIC 71. C —. Hunter, p. xli. *[Rome, AD 253–5]*. VF £1,000 ($1,500) / **EF** £2,700 ($4,000)

10110 Similar, but Concordia holds two standards. RIC 72. C 135. Hunter, p. xli. *[Rome, AD 253–5]*. VF £825 ($1,250) / **EF** £2,300 ($3,500)

10111 A, laur. and cuir. bust l. Rev. **DEO AVGVSTO**, laur. hd. of Augustus r. RIC 28. C 148. Hunter, p. lxv. *[Rome?, AD 263–4]*. VF £4,000 ($6,000) / **EF** £10,000 ($15,000)
It is possible that this remarkable type commemorates the 250th anniversary of the death and deification of Augustus in AD 14.

10112 D. Rev. **FELICITAS AVGG**, Felicitas stg. l., holding long caduceus and cornucopiae. RIC 73. C 194. Hunter, p. xlii. *[Rome, AD 255–7]*. VF £825 ($1,250) / **EF** £2,300 ($3,500)

10113 **GALLIENVS GER AVG**, bare hd. r. Rev. **FELICITATI AVGVSTI**, galley rowed l., standard at prow, steersman in stern. Cf. RIC 32 (omitting **GER**). C 207. Cf. Hunter, p. lxv. *[Rome?, AD 263–4]*. VF £4,000 ($6,000) / **EF** £10,000 ($15,000)
Another remarkable type which appears to revive a reverse of Hadrian whose death had occurred a century and a quarter before.

10114 **Gold aureus.** A. Rev. FIDES MILIT, Fides Militum stg. l., holding two standards. RIC 39. C 228. Hunter, p. lx. *[Rome, AD 261–2].* **VF** £800 ($1,200) / **EF** £2,000 ($3,000)

10115 Similar, but with FIDES MILITVM and on obverse Gallienus wears lion's skin headdress. Cf. RIC 39. C 233. Hunter, p. lx. *[Rome, AD 261–3].* **VF** £2,300 ($3,500) / **EF** £5,000 ($7,500)

10116 Similar, but with normal obv. type and on rev. Fides Militum holds standard and sceptre, sometimes with officina mark H (= 8) or N (=9) in field. RIC 102. C 243. Hunter, p. lix. *[Rome, AD 265–6].* **VF** £750 ($1,100) / **EF** £1,850 ($2,750)

10117 E. Rev. FORTVNA REDVX, Fortuna stg. l., holding rudder and cornucopiae. RIC 103. C 268. Hunter, p. lvi. *[Rome, AD 265–6].* **VF** £750 ($1,100) / **EF** £1,850 ($2,750)

10118 A. Rev. GENIVS AVG, Genius stg. l., holding patera and cornucopiae, standard to r. RIC —. C —. Hunter, p. lx. *[Rome, AD 265–6].* **VF** £800 ($1,200) / **EF** £2,000 ($3,000)

10119 A. Rev. INDVLGENT AVG, Indulgentia seated l., holding branch and sceptre. Cf. RIC 106. C 324. Hunter, p. lxii. *[Rome, AD 265–6].* **VF** £750 ($1,100) / **EF** £1,850 ($2,750)

10120 10123

10120 C. Rev. IOVI CONSERVA (or CONSERVATORI), Jupiter stg. l., holding thunderbolt and sceptre. RIC 76, 77. C 349, 368. Hunter, p. xli. *[Rome, AD 253–5].*
 VF £825 ($1,250) / **EF** £2,300 ($3,500)

10121 A. Rev. IOVI PROPVGNATOR, Jupiter advancing to front, looking r., thunderbolt in raised r. hand, l. at side. RIC 108. C 385. Hunter —. *[Rome, AD 265–6].*
 VF £750 ($1,100) / **EF** £1,850 ($2,750)

10122 A. Rev. IOVI STATORI, Jupiter stg. facing, hd. r., holding sceptre and thunderbolt. Cf. RIC 109. C 393. Hunter, p. lxiii. *[Rome, AD 265–6].* **VF** £750 ($1,100) / **EF** £1,850 ($2,750)

10123 A. Rev. LAETITIA AVG, Laetitia stg. l., holding wreath and anchor. RIC 54 var. C —. Hunter, p. lx. *[Rome, AD 261–2].* **VF** £800 ($1,200) / **EF** £2,000 ($3,000)

10124 D. Rev. LAETITIA AVGG, as previous. RIC 80. C 434. Hunter, p. xlii. *[Rome, AD 255–7].*
 VF £825 ($1,250) / **EF** £2,300 ($3,500)

10125 Similar, but with obv. legend IMP GALLIENVS P F AVG GERM. RIC 81. C 433. Hunter, p. xliii. *[Rome, AD 258–60].* **VF** £1,000 ($1,500) / **EF** £2,700 ($4,000)

10126 D. Rev. LIBERALITAS AVGG III, Liberalitas stg. l., holding abacus and cornucopiae. RIC 83. C 578. Hunter, p. xliii. *[Rome, AD 256].* **VF** £1,000 ($1,500) / **EF** £2,700 ($4,000)

10127 D. Rev. — Valerian and Gallienus seated l. on curule chairs, their r. hands extended, officer stg. between them. RIC 84. C 583. Hunter, p. xliii. *[Rome, AD 256].*
 VF £1,500 ($2,250) / **EF** £4,000 ($6,000)

10128 **Gold aureus.** C. Rev. LIBERTAS AVGG, Libertas stg. l., holding pileus and sceptre. RIC 85. Cf. C 597. Hunter, p. xli. *[Rome, AD 253–5].* **VF** £825 ($1,250) / **EF** £2,300 ($3,500)

10129 A. Rev. MARTI PACIFERO, Mars stg. l., holding olive-branch and resting on shield, spear propped against l. arm. RIC 56, 112. C 615–16. Hunter, p. lxiii. *[Rome, AD 264–6].*
VF £665–800 ($1,000–1,200) / **EF** £1,650–2,000 ($2,500–3,000)

10130 GALLIENVM AVG P R. Rev. OB CONSERVAT SALVT, Salus stg. r., feeding snake held in her arms. RIC 59. C 671. Hunter, p. lx. *[Rome, AD 264].*
VF £3,300 ($5,000) / **EF** £8,300 ($12,500)

10131 A. Rev. OB LIBERTAT REC, Libertas stg., as 10128. RIC 61. C 677. Hunter, p. lx. *[Rome, AD 264].* **VF** £2,700 ($4,000) / **EF** £6,700 ($10,000)

10132 10155

10132 A. Rev. ORIENS AVG, Sol advancing l., raising r. hand and holding whip in l. RIC 62. C 697. Hunter, p. lxiii. *[Rome, AD 264–6].*
VF £665–800 ($1,000–1,200) / **EF** £1,650–2,000 ($2,500–3,000)

10133 A. Rev. PAX AVG, Pax stg. l., holding olive-branch and sceptre, sometimes with officina mark V (= 5) in field . RIC 63. C 724, 726. Hunter, p. lx. *[Rome, AD 261–2].*
VF £800 ($1,200) / **EF** £2,000 ($3,000)

10134 Similar, but Pax advancing l. and without officina mark in rev. field. RIC 115. C 740. Hunter, p. lx. *[Rome, AD 265–6].* **VF** £665 ($1,000) / **EF** £1,650 ($2,500)

10135 A. Rev. PAX PVBLICA, Pax seated l., holding olive-branch and sceptre. RIC 64. Cf. C 772. Hunter, p. lxii. *[Rome, AD 263].* **VF** £825 ($1,250) / **EF** £2,300 ($3,500)

10136 C. Rev. P M TR P III COS II P P, Gallienus, togate, stg. r., sacrificing over tripod-altar and holding eagle-tipped sceptre. RIC —. C —. Hunter —. *[Uncertain Syrian mint, AD 255].*
VF £2,300 ($3,500) / **EF** £5,000 ($7,500)

10137 A, laur. hd. l. Rev. PROVID AVG, Providentia stg. l., holding globe and transverse sceptre. RIC 65. C 858. Hunter, p. lx. *[Rome, AD 261–2].* **VF** £800 ($1,200) / **EF** £2,000 ($3,000)

10138 A. Rev. PROVIDENTIA AVG, Providentia stg. l., holding rod and cornucopiae, globe at feet. RIC 116. C 879. Hunter, p. lx. *[Rome, AD 265–6].* **VF** £665 ($1,000) / **EF** £1,650 ($2,500)

10139 IMP GALLIENVS P F AVG G M. Rev. RESTITVTOR ORBIS, Gallienus, in military attire, stg. l., raising turreted kneeling female figure and holding spear. Cf. RIC 91. C 910. Hunter, p. xliv. *[Rome, AD 257–8].* **VF** £1,200 ($1,800) / **EF** £2,300 ($4,500)

10140 C. Rev. ROMAE AETERNAE, Roma seated l., holding Victory and spear, shield at side. RIC 432. C 916. Hunter, p. xli. *[Uncertain Syrian mint, AD 255–6].*
VF £1,200 ($1,800) / **EF** £2,300 ($4,500)

10141 **Gold aureus.** A. Rev. SECVRIT PERPET, Securitas stg. facing, hd. l., her legs crossed, holding sceptre and resting on column. Cf. RIC 69, 118. C 959. Hunter 76. *[Rome, AD 264–6].* **VF** £665–800 ($1,000–1,200) / **EF** £1,650–2,000 ($2,500–3,000)

10142 A. Rev. SOLI INVICTO, Sol stg. l., raising r. hand and holding globe in l. RIC 119. C 986. Hunter, p. lx. *[Rome, AD 265–6].* **VF** £665 ($1,000) / **EF** £1,650 ($2,500)

10143 A. Rev. VBERITAS AVG, Uberitas stg. l., holding cow's udder (?) and cornucopiae. RIC 120. C 1007. Hunter, p. lxiii. *[Rome, AD 265–6].* **VF** £665 ($1,000) / **EF** £1,650 ($2,500)

10144 B, laur. and cuir. bust l., holding spear and shield. Rev. VICT GERMANICA, Victory advancing l., holding wreath and palm. RIC 2. C 1046. Hunter, p. xlv. *[Cologne, AD 257–60].* **VF** £1,500 ($2,250) / **EF** £4,300 ($6,500)

10145 Similar, but Victory treads down German captive and holds trophy instead of palm. RIC 3. C 1057. Hunter, p. xlv. *[Cologne, AD 257–60].* **VF** £1,500 ($2,250) / **EF** £4,300 ($6,500)

10146 A. Rev. VICTORIA AET, Victory stg. l., holding wreath and palm. RIC 123. C 1069. Hunter, p. lxiii. *[Rome, AD 265–6].* **VF** £665 ($1,000) / **EF** £1,650 ($2,500)

10147 Similar, but rev. legend ends AVG instead of AET. RIC 126. C 1074. Hunter, p. lxi. *[Rome, AD 265–6].* **VF** £665 ($1,000) / **EF** £1,650 ($2,500)

10148 A. Rev. VICTORIA AVG, Gallienus, in military attire, stg. l., holding globe and transverse sceptre, crowned by Victory stg. l. behind him, holding palm. RIC 127. C 1110. Hunter —. *[Rome, AD 265–6].* **VF** £800 ($1,200) / **EF** £2,000 ($3,000)

10149 A. Rev. VICTORIA AVG III, Victory advancing l., holding wreath and palm. RIC 84. C 1117. Hunter, p. lxi. *[Rome, AD 261–2].* **VF** £800 ($1,200) / **EF** £2,000 ($3,000)

10150 C. Rev. VICTORIA AVGG, Victory stg. l., resting on shield and holding palm. RIC 93. C 1142. Hunter, p. xlii. *[Rome, AD 253–5].* **VF** £825 ($1,250) / **EF** £2,300 ($3,500)

10151 IMP GALLIENVS P F AVG GERM. Rev. VICTORIA GERM (or GERMANICA), Victory stg. l., holding wreath and palm, captive at feet. RIC 96, 97. Cf. C 1158. Hunter, p. xliv. *[Rome, AD 257–8].* **VF** £1,250 ($1,850) / **EF** £3,300 ($5,000)

10152 A. Rev. VIRTVS AVG, bust of Gallienus, as Mars, l., wearing crested helmet. RIC 89. C 1212. Hunter, p. lxi. *[Rome, AD 262–3].* **VF** £3,300 ($5,000) / **EF** £8,300 ($12,500)

10153 A. Rev. — Mars stg. l., holding globe and resting on sceptre. RIC 90. C 1219. Hunter, p. lxi. *[Rome, AD 261–2].* **VF** £800 ($1,200) / **EF** £2,000 ($3,000)

10154 IMP GALLIENVS P F AVG GERM. Rev. VIRTVS AVGG, Mars advancing r., carrying spear and trophy. RIC 102. C 1271. Hunter, p. xliv. *[Rome, AD 257–8].*
 VF £1,000 ($1,500) / **EF** £2,700 ($4,000)

10155 C. Rev. — Virtus stg. l., resting on shield and spear. Cf. RIC 99. C 1286–7. Hunter, p. xlii. *[Rome, AD 253–5].* **VF** £825 ($1,250) / **EF** £2,300 ($3,500)

10156 **'Reed-crowned' gold.** A, hd. l., crowned with reeds. Rev. FIDES MIL, Fides stg. l., holding two standards. RIC 38. C 226. Hunter, p. lviii. *[Rome or Siscia, AD 267–8].*
 VF £1,500 ($2,250) / **EF** £4,000 ($6,000)

NB This intriguing group of gold issues, characterized by the curious crown of reeds worn by the emperor, appears to belong late in the reign, probably commencing in AD 266.

Another curious feature is the seemingly feminine dative singular form of the emperor's name (GALLIENAE AVGVSTAE) appearing on the initial issues, though this is perhaps better explained as a vocative acclamation of the emperor (cf. J.P.C. Kent, "Gallienae Augustae" in *Numismatic Chronicle* 1973, pp. 64–8). The weights of this short series are extremely variable, suggesting a system of different denominations as well as an overall decline during the period of issue. Kent regarded the entire coinage as being a product of the Rome mint, while Göbl divided it between Rome and Siscia. See also nos. 10439 and 10442.

10157 A, hd. r., crowned with reeds. Rev. MARTI PROPVNATORI (*sic*), Mars advancing r., holding olive-branch and shield. RIC 58. C —. Hunter, p. lviii. *[Rome or Siscia, AD 267–8].*
VF £2,000 ($3,000) / **EF** £5,000 ($7,500)

10158 Obv. As 10156. Rev. P M T P VII COS P P, Gallienus, in military attire, stg. facing, holding spear and parazonium, between two reclining river gods, each holding reed. Cf. RIC 18. Cf. C 828. Cf. Hunter, p. lviii. *[Rome or Siscia, AD 267–8].*
VF £4,000 ($6,000) / **EF** £10,000 ($15,000)
The unusual reverse type may refer to a Roman victory on the banks of a river, perhaps at its confluence with another stream. The numeral 'VII' in the reverse legend probably refers to the emperor's seventh consulship in AD 266. See also no. 10322.

10159 GALLIENAE AVGVSTAE, hd. l., crowned with reeds. Rev. VBIQVE PAX, Victory in galloping biga r., holding whip. RIC 74. C 1015. Hunter, p. lviii. *[Rome, AD 266–7].*
VF £3,300 ($5,000) / **EF** £8,300 ($12,500)

10160 Similar, but with obv. legend B. RIC 72. C 1018. Hunter, p. lviii. *[Rome, AD 267].*
VF £1,500 ($2,250) / **EF** £4,000 ($6,000)

10161 Similar, but with obv. legend A. RIC 73. C 1018. Hunter, p. lviii. *[Rome, AD 267–8].*
VF £1,250 ($1,850) / **EF** £3,300 ($5,000)

10162 Obv. As 10159. Rev. VICTORIA AVG, Gallienus, in military attire, stg. l., holding globe and transverse sceptre, crowned by Victory stg. l. behind him, holding palm. RIC 82. C 1111. Hunter, p. lviii. *[Rome, AD 266–7].*
VF £2,300–3,300 ($3,500–5,000) / **EF** £6,000–8,300 ($9,000–12,500)

10163

10163 Similar, but with obv. legend B. RIC 81. C 1112. Hunter, p. lviii. *[Rome, AD 267].*
VF £1,500–2,000 ($2,250–3,000) / **EF** £4,000–5,000 ($6,000–7,500)

10164 **Billon antoninianus.** A. Rev. ABVNDANTIA AVG, Abundantia stg. r., emptying cornucopiae, usually with officina mark B (= 2) in field. RIC 157. RSC 5–6. Hunter 51–2. *[Rome, AD 265–7].* **VF** £8 ($12) / **EF** £23 ($35)

NB The sole reign of Gallienus (AD 260–68) witnessed a catastrophic decline in the fineness of the alloy from which the antoniniani were struck, from 15% at the outset, to 5% by 266, and ultimately a mere 2.5% by the time of the emperor's death. Therefore, as in the case of Valerian, all antoniniani are described as billon rather than silver in this catalogue.

10165 **Billon antoninianus.** A. Rev. — River-god (Caystrus?) reclining l., holding reed and resting on urn from which water flows, S P Q R below. RIC 625. RSC 8, 8a. Hunter, p. lxxi. *[Uncertain Asia Minor mint, AD 268].* **VF** £65 ($100) / **EF** £200 ($300)
The officinae of this mint are distinguished by the appearance of one or two dots below the obverse bust.

10166 A. Rev. **ADVENTVS AVG**, Gallienus, in military attire, riding l., his r. hand raised, holding spear in l. RIC 463. RSC 15, 15a. Hunter, p. lxvi. *[Milan, AD 264–5].*
VF £20 ($30) / **EF** £55 ($85)

10167 A. Rev. **AEQVITAS AVG**, Aequitas stg. l., holding scales and cornucopiae, sometimes with officina mark Q (= 4) or VI (= 6) in field. RIC 159 var. RSC 24, 24a, 25. 25a. Hunter 7, 8. *[Rome, AD 261–2].* **VF** £8 ($12) / **EF** £23 ($35)

10168 Similar, but sometimes with **AEQVTAS** (*sic*) for **AEQVITAS** and with star in rev. field or in ex. RIC 627. RSC 24b, 30. Hunter, p. lxix. *[Antioch, AD 264].* **VF** £8 ($12) / **EF** £23 ($35)

10169 A. Rev. **AETERN** (or **AETERNITAS**) **AVG**, Sol stg. l., r. hand raised, holding globe in l., mint mark **MT** in ex. or officina mark **T** (= 3) in field. RIC 465a, 466. RSC 35, 38a. Hunter, pp. lxvi, lxvii. *[Milan, AD 267–8].* **VF** £8 ($12) / **EF** £23 ($35)

10170 A. Rev. **AETERNITAS AVG**, Saturn stg. r., holding scythe (?), P XV (= TR P XV) in ex. RIC 606. RSC 44–44b. Hunter, p. lxx. *[Antioch, AD 267].* **VF** £14 ($20) / **EF** £45 ($65)

10171

10171 A, rad. and cuir. bust l. Rev. — she-wolf stg. r., suckling Romulus and Remus. RIC 628 var. RSC 47. Hunter, p. lxix. *[Antioch, AD 265–6].* **VF** £16 ($25) / **EF** £50 ($75)

10172 A. Rev. **AETERNITATI AVG**, Sol stg. l., as 10169. RIC 630. RSC 51b. Hunter, p. lxix. *[Antioch, AD 264].* **VF** £8 ($12) / **EF** £23 ($35)

10173 A. Rev. **ANNONA AVG**, Annona stg. r., l. foot on prow, holding rudder and corn-ears, sometimes with officina mark Q (= 4) or V (= 5) in field or in ex. RIC 161. RSC 55–55e. Hunter, p. lix. *[Rome, AD 261–2].* **VF** £8 ($12) / **EF** £23 ($35)

10174 A. Rev. — Annona stg. l., holding corn-ears and anchor (or cornucopiae), modius at feet, sometimes with officina mark Q (= 4) in field or in ex. RIC 162. RSC 56–60a. Hunter 10. *[Rome, AD 261–2].* **VF** £8 ($12) / **EF** £23 ($35)

10175 **IMP GALLIENVS P F AVG GERM**. Rev. **APOLINI CONSERVA**, Apollo stg. l., holding laurel-branch and resting on lyre set on rock. RIC 126. RSC 64. Hunter, p. xliii. *[Rome, AD 257–8].* **VF** £12 ($18) / **EF** £38 ($55)

10176 C. Rev. **APOLINI PROPVG**, Apollo stg. r., drawing bow. RIC 128. RSC 71. Hunter, p. xli. *[Rome, AD 253–5].* **VF** £12 ($18) / **EF** £38 ($55)

10177 **Billon antoninianus.** A. Rev. APOLLINI CONS AVG, centaur walking r., drawing bow, officina mark Z (= 7) or H (= 8) in ex. RIC 163. RSC 72. Hunter 95. *[Rome, AD 267–8].*
 VF £14 ($20) / **EF** £45 ($65)

10178 A. Rev. — centaur walking l., holding globe and rudder (?), officina mark Z (= 7), H (= 8), N (= 9) or I (= 10) in ex. RIC 164. RSC 73–74a. Hunter 97–9. *[Rome, AD 267–8].*
 VF £14 ($20) / **EF** £45 ($65)

10179 A. Rev. — griffin walking r., officina mark Δ (= 4) in ex. RIC 166. RSC 75. Hunter, p. lxiv. *[Rome, AD 267–8].* VF £12 ($18) / **EF** £38 ($55)

10180 Similar, but griffin walking l. RIC 166. RSC 76. Hunter 101. *[Rome, AD 267–8].*
 VF £12 ($18) / **EF** £38 ($55)

10181 A. Rev. APOLLI (or APOLLINI) PAL, Apollo stg. l., holding patera or globe and sceptre, S P Q R in ex. RIC 631. RSC 86–87a. Hunter, p. lxxi. *[Uncertain Asia Minor mint, AD 268].*
 VF £32 ($50) / **EF** £100 ($150)

10182 A. Rev. APOLLO CONSER, Apollo stg. l., holding laurel-branch and mantle. RIC 468. RSC 89. Hunter 151. *[Milan, AD 264–5].* VF £10 ($15) / **EF** £30 ($45)

10183 A. Rev. — (or CONSERV or CONSERVA), Apollo stg. facing, hd. r., r. hand resting on hd., l. holding lyre set on altar with drapery. RIC 467. RSC 91–3. Hunter 152. *[Milan, AD 264–5].* VF £10 ($15) / **EF** £30 ($45)

10184 A. Rev. BONAE FORTVNAE, Fortuna stg. l., holding rudder and cornucopiae. RIC 469. RSC 96. Hunter, p. lxv. *[Milan, AD 264–5].* VF £10 ($15) / **EF** £30 ($45)

10185 A. Rev. BON (or BONVS) EVEN (or EVENTVS) AVG, Bonus Eventus stg. l., holding patera and corn-ears, altar at feet, sometimes with mint and officina marks M T (= 3rd officina) in ex. RIC 470. RSC 98–9, 100. Hunter, p. lxvii. *[Milan, AD 264–5].*
 VF £10 ($15) / **EF** £30 ($45)

10186 A. Rev. COHH PRAET VI (or VII) P VI (or VII) F, rad. lion walking r. RIC 370, 372. RSC 104–5, 111–12. Hunter, p. 37, 18. *[Milan, AD 260–61].* VF £85 ($125) / **EF** £230 ($350)
 This forms part of the extensive 'legionary' series of Gallienus (see nos. 10252–75) issued early in his sole reign at Milan, the base of the recently established field army commanded by Aureolus. The units honoured were the Praetorian Cohort and the seventeen legions which had furnished detachments for the field army. The numerals 'VI' and 'VII' appearing in the reverse legends may refer to the victories achieved by Aureolus over the usurpers Ingenuus and Regalian.

10187 A. Rev. CONCOR AVG, Concordia seated l., holding patera and cornucopiae, mint and officina marks M T (= 3rd officina) in ex. RIC 471. RSC 116. Hunter 172. *[Milan, AD 267–8].* VF £8 ($12) / **EF** £23 ($35)

10188 F. Rev. CONCOR MIL, Concordia stg. l., holding patera and cornucopiae. RIC 377. RSC 118. Hunter 60. *[Viminacium, AD 253–5].* VF £12 ($18) / **EF** £38 ($55)

10189 C. Rev. CONCORDIA AVGG, clasped r. hands. RIC 131. RSC 125. Hunter 2. *[Rome, AD 253–5].* VF £16 ($25) / **EF** £50 ($75)

10190 C. Rev. CONCORDIA EXERC (or EXERCIT), as 10188, but double cornucopiae. RIC 132. RSC 129–131a. Hunter 3. *[Rome, AD 253–5].* VF £10 ($15) / **EF** £30 ($45)

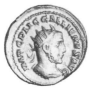

10190 10200

10191 **Billon antoninianus.** F. Rev. CONCORDIAE MILITVM, as 10188. RIC 379. RSC 137. Hunter, p. xlvi. *[Viminacium, AD 253–5].* **VF** £12 ($18) / **EF** £38 ($55)

10192 A. Rev. CONSERVAT PIETAT, Gallienus, in military attire, stg. l., extending hand to female figure kneeling before him and holding sceptre, officina mark XII (= 12) in field or in ex. RIC 171a. RSC 144. Hunter, p. lxiii. *[Rome, AD 265–7].* **VF** £20 ($30) / **EF** £55 ($85)

10193 A. Rev. CONSERVATOR AVG, Aesculapius stg. facing, hd. l., holding snake-entwined staff. RIC 632. RSC 140. Hunter 208. *[Antioch, AD 265–6].* **VF** £14 ($20) / **EF** £45 ($65)

10194 A. Rev. COS IIII P P, Gallienus, togate, in slow quadriga l., holding branch. Cf. RIC 150. Cf. RSC 146. Hunter 6. *[Rome, AD 261].* **VF** £85 ($125) / **EF** £230 ($350)

10195 B, rad. and cuir. bust l., holding spear and shield. Rev. DEO MARTI, Mars stg. l. in tetrastyle temple, resting on shield and spear. Cf. RIC 10. RSC 150. Hunter 46–7. *[Cologne, AD 259–60].* **VF** £22 ($35) / **EF** £65 ($100)

10196 E. Rev. DIANA FELIX, Diana advancing r., drawing arrow from quiver and holding bow, hound at feet. RIC 380. RSC 169a. Hunter 62. *[Milan, AD 259–60].*
 VF £16 ($25) / **EF** £50 ($75)

10197 A. Rev. — Diana stg. r., holding spear and bow, hound at feet. RIC 473. RSC 173. Hunter, p. lxvi. *[Milan, AD 264–5].* **VF** £14 ($20) / **EF** £45 ($65)

10198 C. Rev. DIANA LVCIFERA, Diana stg. r., holding torch with both hands. RIC 290. RSC 177. Hunter, p. xlvii. *[Antioch, AD 254–5].* **VF** £14 ($20) / **EF** £45 ($65)

10199 E. Rev. DIANAE CONS AVG, doe stg. or walking r. (or l.), looking back, officina mark ε (= 5) in ex. RIC 176. RSC 153, 155. Hunter 91, 94. *[Rome, AD 267–8].*
 VF £10 ($15) / **EF** £30 ($45)

10200 A. Rev. — antelope stg. or walking r. (or l.), officina mark Γ (= 3), X, XI or XII (= 10, 11 or 12) in ex. RIC 181. RSC 162, 165, 167, 167a. Hunter 102, 135, 137. *[Rome, AD 267–8].*
 VF £10 ($15) / **EF** £30 ($45)

10201 A. Rev. — stag stg. or walking r. (or l.), sometimes looking back, officina mark X, XI or XII (= 10, 11 or 12) in ex. RIC 179. RSC 157–8, 160. Hunter 130, 132. *[Rome, AD 267–8].*
 VF £10 ($15) / **EF** £30 ($45)

10202 A. Rev. FELICI AET, Felicitas stg. l., holding caduceus and resting on column. RIC 185. RSC 180. Hunter 183. *[Siscia, AD 262–5].* **VF** £10 ($15) / **EF** £30 ($45)

10203 A. Rev. FELICI AVG, Felicitas stg. l., holding caduceus and cornucopiae. RIC 565. RSC 181. Hunter, p. lxviii. *[Siscia, AD 262–5].* **VF** £10 ($15) / **EF** £30 ($45)

10204 **Billon antoninianus.** A. Rev. FELICIT AVG, Felicitas stg. r., holding caduceus or sceptre and globe, officina mark P, S or T (= 1, 2 or 3) in field. RIC 188–9. RSC 183, 185a. Cf. Hunter, p. lix. *[Rome, AD 261–2].* **VF** £8 ($12) / **EF** £23 ($35)

10205 A. Rev. — Felicitas stg. l., holding caduceus and sceptre, officina marks as previous, but sometimes in ex. RIC 191. RSC 186. Hunter, p. lxi. *[Rome, AD 261–2].*
 VF £8 ($12) / **EF** £23 ($35)

10206 C. Rev. FELICIT DEORVM, as previous, but no officina mark. RIC 133. RSC 191. Hunter, p. xli. *[Rome, AD 253–5].* **VF** £12 ($18) / **EF** £38 ($55)

10207 A. Rev. FELICIT PVBL, Felicitas seated l., holding caduceus and cornucopiae, officina mark T (= 3) in ex. RIC 192. RSC 192–3. Hunter 43–4. *[Rome, AD 263–4].*
 VF £8 ($12) / **EF** £23 ($35)

10208 D. Rev. FELICITAS AVGG, Felicitas stg. l., holding caduceus and cornucopiae. RIC 135. RSC 195. Hunter, p. xlii. *[Rome, AD 255–7].* **VF** £10 ($15) / **EF** £30 ($45)

10209 C. Rev. FELICITAS SAECVLI, Diana advancing r., holding torch with both hands. RIC 291. RSC 206a. Hunter, p. xlvii. *[Antioch, AD 254–5].* **VF** £16 ($25) / **EF** £50 ($75)

10210 A. Rev. FID MILITVM, Fides Militum stg. l., holding two standards. Cf. RIC 475. RSC 209. Hunter, p. lxv. *[Milan, AD 262–3].* **VF** £10 ($15) / **EF** £30 ($45)

10211 A. Rev. FIDEI PRAET, legionary eagle between two standards. RIC 568. RSC 216–17. Hunter, p. lx. *[Rome, AD 262–3].* **VF** £14 ($20) / **EF** £45 ($65)

10212 A. Rev. FIDES AVG, Mercury stg. l., holding purse and caduceus, P XV (= TR P XV) in ex. RIC 607. RSC 219a, b. Hunter, p. lxx. *[Antioch, AD 267].* **VF** £12 ($18) / **EF** £38 ($55)

10213 A. Rev. FIDES EXERC VIII, Fides Militum stg. facing, hd. r., holding legionary eagle and transverse standard, officina mark P (= 1) in field. Cf. RIC 478. RSC 220–21. Hunter 155. *[Milan, AD 262–3].* **VF** £12 ($18) / **EF** £38 ($55)

10214 A. Rev. FIDES MILIT, Fides Militum stg. l., holding standard and transverse sceptre, mint and officina marks M P (= 1st officina) in ex. RIC 481. RSC 229. Hunter, p. lxvii. *[Milan, AD 265–6].* **VF** £12 ($18) / **EF** £38 ($55)

10215 C. Rev. FIDES MILITVM, Fides Militum, as 10210. RIC 137. RSC 236–7. Hunter, p. xli. *[Rome, AD 253–5].* **VF** £10 ($15) / **EF** £30 ($45)

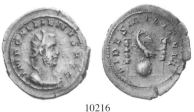

10216

10216 E. Rev. — eagle stg. l., hd. r., on globe flanked by two standards, holding wreath in beak. RIC 13. RSC 249. Hunter 48 var. *[Cologne, AD 257].* **VF** £16 ($25) / **EF** £50 ($75)

10217 **Billon antoninianus.** A. Rev. FIDES / MILI / TVM in three lines within laurel-wreath. RIC 570. RSC 257. Cf. Hunter, p. lx. *[Siscia, AD 262–5].* **VF** £30 ($45) / **EF** £80 ($120)

10218 E. Rev. FORT REDVX, Fortuna seated l., holding rudder and cornucopiae, mint and officina marks M S (= 2nd officina) in ex. RIC 483. RSC 261. Hunter 178. *[Milan, AD 266].*
VF £10 ($15) / **EF** £30 ($45)

10219 A. Rev. FORTVNA REDVX, similar, but Fortuna stg., sometimes with officina mark S (= 2) in ex. RIC 193. RSC 269–70. Hunter, p. lxi. *[Rome, AD 262–3].*
VF £8 ($12) / **EF** £23 ($35)

10220 A. Rev. — Fortuna stg. l., holding caduceus and cornucopiae, VII C (= COS VII) in ex. RIC 613. RSC 277. Hunter 203–5. *[Antioch, AD 266–7].* **VF** £12 ($18) / **EF** £38 ($55)

10221 A. Rev. GENIO AVG, Genius stg. l., holding patera and cornucopiae, altar at feet. RIC 197. RSC 289. Hunter, p. lxii. *[Rome, AD 262–3].* **VF** £10 ($15) / **EF** £30 ($45)

10222 A. Rev. GENIV (or GENIVS) AVG, similar, but without altar and with standard to r., sometimes with officina mark Q, V, or VI (= 4, 5, or 6) in field or in ex. RIC 197. RSC 291 and 291a, 297 and 297a. Hunter, p. lxii. *[Rome, AD 262–3].* **VF** £10 ($15) / **EF** £30 ($45)

10223 E. Rev. GERMAN MAX TER, two captives seated at foot of trophy. RIC —. RSC 305a. Hunter, p. xlv, note 3. *[Cologne, AD 257].* **VF** £30 ($45) / **EF** £80 ($120)

10224 B. Rev. GERMANICVS MAX V, as previous. RIC 18. RSC 308. Hunter 49–50. *[Cologne, AD 257–8].* **VF** £16 ($25) / **EF** £50 ($75)

10225

10225 Similar, but with obv. type rad. and cuir. bust l., holding spear and shield. RIC 18. RSC 310. Hunter 51. *[Cologne, AD 257–8].* **VF** £20 ($30) / **EF** £55 ($85)

10226 G. Rev. As 10223, but with legend GERMANICVS MAXIMVS. Cf. RIC 382. Cf. RSC 306, 306a. Cf. Hunter, p. xlv. *[Cologne, AD 257].* **VF** £22 ($35) / **EF** £65 ($100)

10227 A. Rev. HERCVLI CONS AVG, lion prowling l., officina mark A (= 1) in ex. RIC 201. RSC 316. Hunter 104. *[Rome, AD 267–8].* **VF** £30 ($45) / **EF** £80 ($120)

10228 Similar, but with rev. type wild boar running r., officina mark ε (= 5) in ex. RIC 202. RSC 317. Hunter, p. lxv. *[Rome, AD 267–8].* **VF** £20 ($30) / **EF** £55 ($85)

10229 A. Rev. INDVLG AVG, Spes advancing l., holding flower and lifting skirt, officina mark Δ (= 4) in ex. RIC 204. RSC 322, 322b. Hunter, p. lxii. *[Rome, AD 264–6].*
VF £12 ($18) / **EF** £38 ($55)

10230 A. Rev. INDVLGENT AVG, Indulgentia seated l., holding branch and sceptre, officina mark P (= 1) in ex. RIC 205. RSC 326–7. Hunter 45. *[Rome, AD 263–4].*
VF £10 ($15) / **EF** £30 ($45)

10231 **Billon antoninianus.** A. Rev. INDVLGENTIA AVG, Indulgentia stg. facing, hd. l., legs crossed, holding rod and cornucopiae and resting on column, wheel at feet, officina mark XI (= 11) in field. RIC 206. RSC 331–2. Hunter 83. *[Rome, AD 264–6].*
VF £12 ($18) / EF £38 ($55)

10232 A. Rev. INVICTO (or INVICTVS) AVG, Sol stg. l., raising r. hand and holding whip in l., S P Q R in ex. RIC 640. RSC 336, 338a. Hunter, p. lxxi. *[Uncertain Asia Minor mint, AD 268].*
VF £20 ($30) / EF £55 ($85)

10233 A. Rev. INVICTVS, similar, but Sol advancing l., star in l. field. RIC 639. RSC 337. Hunter, p. lxix. *[Antioch, AD 264].*
VF £16 ($25) / EF £50 ($75)

10234 A. Rev. IO CANTAB, Jupiter stg. l., holding thunderbolt and sceptre. RIC 573. RSC 339. Hunter, p. lxviii. *[Siscia, AD 262–4].*
VF £45 ($65) / EF £115 ($175)
The reason for the appearance on this Siscian issue of a type dedicated to the Spanish deity Jupiter Cantabrorum ("Jupiter of the Cantabri") remains a mystery. The Cantabri were a coastal and mountain people of northwest Spain and were finally conquered by the Romans between 26 and 19 BC in campaigns led by Augustus and Agrippa. It may be speculated that there was a military unit serving at Siscia which was originally raised in the region of the Cantabri.

10235 A. Rev. IOVI CONS AVG, goat walking l., officina mark S (= 6) in ex. RIC 207. RSC 342. Hunter 110. *[Rome, AD 267–8].*
VF £10 ($15) / EF £30 ($45)

10236 Similar, but goat walking r. RIC 207. RSC 344. Hunter 105. *[Rome, AD 267–8].*
VF £10 ($15) / EF £30 ($45)

10237 C. Rev. IOVI CONSERVA, Jupiter stg. l., holding thunderbolt and sceptre. RIC 143. RSC 351. Hunter 5. *[Rome, AD 253–5].*
VF £10 ($15) / EF £30 ($45)

10238 A, rad. and cuir. bust l. Rev. — similar, but with eagle at Jupiter's feet and with officina mark S (= 2) in field. RIC 486 var. RSC 358. Hunter, p. lxvi. *[Milan, AD 264–5].*
VF £12 ($18) / EF £38 ($55)

10239 A. Rev. IOVI CONSERVA or CONSERVAT, Jupiter seated l., holding Victory and sceptre, officina mark P (= 1) in field or in ex. RIC 487. RSC 360, 367. Hunter, p. lxvi. *[Milan, AD 264–5].*
VF £12 ($18) / EF £38 ($55)

10240 A. Rev. IOVI CONSERVAT or CONSERVATORI, Jupiter stg. l., holding globe and sceptre, P XV (= TR P XV) in ex. RIC 608. Cf. RSC 362, 376. Hunter 199. *[Antioch, AD 267].*
VF £12 ($18) / EF £38 ($55)

10241 C. Rev. IOVI CONSERVATORI, as 10237, but with small figure of Gallienus at Jupiter's feet. RIC 143. RSC 377. Hunter, p. xli. *[Rome, AD 253–5].* VF £14 ($20) / EF £45 ($65)

10242 D. Rev. — Gallienus, in military attire, stg. r., resting on spear and receiving globe from Jupiter stg. l., resting on sceptre, wreath in upper field. RIC 440. RSC 378. Hunter, p. xlviii. *[Uncertain Syrian mint, AD 258–60].* VF £14 ($20) / EF £45 ($65)

10243 A. Rev. IOVI PATRI, Jupiter stg. r., looking back, holding thunderbolt and sceptre, palm-branch in ex. RIC 642. RSC 381. Hunter, p. lxix. *[Antioch, AD 265].*
VF £14 ($20) / EF £45 ($65)

10244 A. Rev. IOVI PROPVGNAT, Jupiter advancing l., looking back, holding thunderbolt, officina mark X, XI or IX (= 10 or 11) in field. RIC 214. RSC 382a. Hunter 85. *[Rome, AD 264–6].* VF £8 ($12) / EF £23 ($35)

10245 **Billon antoninianus.** A. Rev. IOVI STATORI, Jupiter stg. facing, hd. r., holding sceptre and thunderbolt, star in field or in ex. RIC 645. RSC 394. Hunter, p. lxix. *[Antioch, AD 264]*.
VF £10 ($15) / EF £30 ($45)

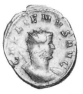

10246 10253

10246 F. Rev. IOVI VICTORI, large cippus inscribed IMP / C E S (= *imperator cum exercitu suo*, "the emperor with his army") surmounted by Jupiter stg. l., holding Victory and sceptre. RIC 21. RSC 398. Hunter 43. *[Cologne, AD 257]*.
VF £20 ($30) / EF £55 ($85)

10247 E. Rev. IOVI VLTORI, Jupiter advancing, as 10244, officina mark S or V (= 2 or 5) in field. RIC 220. RSC 404. Hunter, p. lvii. *[Rome, AD 260–61]*.
VF £8 ($12) / EF £23 ($35)

10248 A. Rev. IOVIS STATOR, Jupiter stg. facing, as 10245, sometimes with officina mark S (= 6) in field. RIC 216. RSC 388, 388a. Hunter 64–5. *[Rome, AD 264–6]*.
VF £8 ($12) / EF £23 ($35)

10249 A. Rev. IVBENTVS (or LVBENTVS) AVG, Gallienus, in military attire, stg. l., holding Victory and spear, VII C (= COS VII) in ex. RIC 615. RSC 415. Hunter, p. lxx. *[Antioch, AD 266–7]*.
VF £14 ($20) / EF £45 ($65)

10250 A. Rev. LAETITIA AVG, Laetitia stg. l., holding wreath and anchor, officina mark P or V (= 1 or 5) in field. RIC 226. RSC 424. Hunter 15. *[Rome, AD 262–3]*.
VF £8 ($12) / EF £23 ($35)

10251 C. Rev. LAETITIA AVGG, as previous, but no officina mark. RIC 144. RSC 437, 437a. Cf. Hunter 7. *[Rome, AD 253–5]*.
VF £10 ($15) / EF £30 ($45)

10252 A. Rev. LEG I ADI VI P VI F, capricorn r. RIC 315. RSC 446–7. Hunter 3. *[Milan, AD 260–61]*.
VF £85 ($125) / EF £230 ($350)
This and the following 23 types belong to the extensive 'legionary' series of Gallienus which was issued early in his sole reign at Milan, the base of the recently established field army commanded by Aureolus. The units honoured were the Praetorian Cohort and the seventeen legions which had furnished detachments for the field army. The numerals 'VI' and 'VII' appearing in the reverse legends may refer to the victories achieved by Aureolus over the usurpers Ingenuus and Regalian. See also no. 10186.

NB Coins of this series tend to be weakly struck.

10253 Similar, but with rev. type Pegasus springing r. RIC 317. RSC 451. Hunter, p. liii. *[Milan, AD 260–61]*.
VF £95 ($140) / EF £265 ($400)

10254 A. Rev. LEG I ITAL VI P VI F, boar at bay r. RIC 320. RSC 455–6. Hunter 6. *[Milan, AD 260–61]*.
VF £85 ($125) / EF £230 ($350)

10255 A. Rev. LEG I ITAL VII P VII F, hippocamp r. RIC 321. RSC 458. Hunter 8. *[Milan, AD 260–61]*.
VF £95 ($140) / EF £265 ($400)

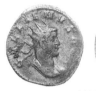

10256 10262

10256 **Billon antoninianus.** A. Rev. LEG I MIN VI P VI F, Minerva stg. l., holding Victory, spear and shield. RIC 322. RSC 459, 459a. Hunter, p. liii. *[Milan, AD 260–61].*
VF £110 ($160) / EF £300 ($450)

10257 A. Rev. LEG II ADI (or AD) VI P VI F, Pegasus springing r. RIC 324. RSC 465. Hunter 9. *[Milan, AD 260–61].* VF £85 ($125) / EF £230 ($350)

10258 A, rad. hd. l. Rev. LEG II CL ADI VI P VI F, capriorn r. RIC 327. RSC 470. Hunter, p. liv. *[Milan, AD 260–61].* VF £95 ($140) / EF £265 ($400)

10259 A. Rev. LEG II ITAL VI P VI F, as previous. RIC 328. RSC 471. Hunter, p. liv. *[Milan, AD 260–61].* VF £90 ($135) / EF £250 ($375)

10260 A. Rev. — she-wolf stg. l., suckling Romulus and Remus. RIC 329. RSC 472. Hunter, p. liv. *[Milan, AD 260–61].* VF £100 ($150) / EF £285 ($425)

10261 A. Rev. LEG II PART VI P VI F, centaur walking l., holding globe and club. RIC 334. RSC 480. Hunter 11. *[Milan, AD 260–61].* VF £85 ($125) / EF £230 ($350)

10262 A. Rev. — centaur prancing r., r. hand raised, holding club in l. RIC 336. RSC 483. Hunter, p. liv. *[Milan, AD 260–61].* VF £85 ($125) / EF £230 ($350)

10263 A, rad. bust l., holding spear and shield. Rev. LEG III ITAL VI P VI F, stork walking r. RIC 339. RSC 489. Hunter 12 var. *[Milan, AD 260–61].* VF £110 ($160) / EF £300 ($450)

10264 A. Rev. LEG III ITAL VII P VII F, as previous. RIC 341. RSC 496. Hunter, p. liv. *[Milan, AD 260–61].* VF £95 ($140) / EF £265 ($400)

10265 A. Rev. LEG IIII FL VI P VI F, lion leaping r. RIC 343. RSC 500. Hunter 13. *[Milan, AD 260–61].* VF £85 ($125) / EF £230 ($350)

10266 A. LEG V MAC VII P VII F, Victory stg. r., holding wreath and palm, eagle at feet. RIC 345a. RSC 506. Hunter, p. liv. *[Milan, AD 260–61].* VF £110 ($160) / EF £300 ($450)

10267 A. Rev. LEG VII CL VI P VI F, bull stg. r. RIC 348. RSC 510. Hunter, p. liv. *[Milan, AD 260–61].* VF £85 ($125) / EF £230 ($350)

10268 Similar, but rev. legend LEG VIII AVG VI P VI F. RIC 353. RSC 522. Hunter 14. *[Milan, AD 260–61].* VF £85 ($125) / EF £230 ($350)

10269 Similar, but rev. legend LEG X GEM VI P VI F. RIC 357. RSC 529. Hunter 15. *[Milan, AD 260–61].* VF £85 ($125) / EF £230 ($350)

10270 A. Rev. LEG XI CL VI P VI F, Neptune stg. r., holding trident and dolphin. RIC 359. RSC 535, 535a. Hunter, p. liv. *[Milan, AD 260–61].* VF £110 ($160) / EF £300 ($450)

 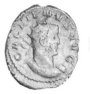

10271 10273

10271 **Billon antoninianus.** A. Rev. LEG XIII GEM VI P VI F, Victory stg. r., holding wreath and
 palm, lion l. at feet. RIC 360. RSC 537. Hunter 16. *[Milan, AD 260–61].*
 VF £95 ($140) / **EF** £265 ($400)

10272 A. Rev. LEG XIIII GEM VI P VI F, capricorn r. RIC 361. RSC 540. Hunter, p. liv. *[Milan,
 AD 260–61].* VF £85 ($125) / **EF** £230 ($350)

10273 Similar, but with rev. legend LEG IIXX (or XXII) VI P VI F. RIC 362, 366. RSC 542–542a,
 551. Hunter, p. liv. *[Milan, AD 260–61].* VF £85 ($125) / **EF** £230 ($350)

10274 Similar, but with rev. legend LEG IIXX VII P VII F. RIC 363. RSC 545. Hunter17. *[Milan,
 AD 260–61].* VF £90 ($135) / **EF** £250 ($375)

10275 A. Rev. LEG XXX VLP VI P VI F, Neptune stg. r., as 10270. RIC 368. RSC 553–4. Hunter,
 p. liv. *[Milan, AD 260–61].* VF £110 ($160) / **EF** £300 ($450)

10276 A. Rev. LIBERAL AVG, Liberalitas stg. l., holding abacus and cornucopiae, officina mark P,
 S, T or Q (= 1, 2, 3 or 4) in field. RIC 227. RSC 562–563a. Hunter 17–18. *[Rome,
 AD 262–3].* VF £8 ($12) / **EF** £23 ($35)

10277 F. Rev. LIBERALITAS AVGG, similar, but no officina mark. RIC 385. RSC 566, 566a.
 Hunter, p. xlvi. *[Viminacium, AD 255].* VF £14 ($20) / **EF** £30 ($45)

10278 D. Rev. — Valerian and Gallienus seated l. on curule chairs, their r. hands extended, officer
 stg. between them. RIC 150. RSC 571b. Hunter 17. *[Rome, AD 255].*
 VF £45 ($65) / **EF** £100 ($150)

10279 D. Rev. LIBERALITAS AVGG III, Liberalitas stg., as 10277. RIC 151. RSC 579, 579a. Hunter
 18. *[Rome, AD 256].* VF £12 ($18) / **EF** £38 ($55)

10280 D. Rev. — Valerian and Gallienus seated, as 10278. RIC —. RSC 584. Hunter, p. xliii.
 [Rome, AD 256]. VF £45 ($65) / **EF** £100 ($150)

10281 A. Rev. LIBERO P CONS AVG, panther walking l. (or r.), officina mark B (= 2) in ex. RIC
 230. RSC 586, 587, 591. Hunter 112. *[Rome, AD 267–8].* VF £10 ($15) / **EF** £30 ($45)

10282 A. Rev. LIBERT AVG, Libertas stg. facing, hd. l., legs crossed, holding pileus and transverse
 sceptre and resting l. arm on column, officina mark S (= 2) in field. RIC 232. RSC
 593–594a. Cf. Hunter, p. lx. *[Rome, AD 262–3].* VF £8 ($12) / **EF** £23 ($35)

10283 A. Rev. LIBERTAS AVG, Libertas stg. l., holding pileus and transverse sceptre, officina mark
 XI (= 11) in field. RIC 233. RSC 596. Hunter 87. *[Rome, AD 264–6].*
 VF £8 ($12) / **EF** £23 ($35)

10284 A. Rev. LVNA LVCIF, Diana as Luna stg. r., holding flaming torch with both hands, P XV
 (= TR P XV) in ex. RIC 609. RSC 599–600a. Hunter 200. *[Antioch, AD 267].*
 VF £12 ($18) / **EF** £38 ($55)

10285 **Billon antoninianus.** A. Rev. MARS AVG, Mars stg.r., resting on spear and shield, S P Q R in ex. RIC 647. RSC 604. Hunter, p. lxxi. *[Uncertain Asia Minor mint, AD 268].*
VF £14 ($20) / EF £45 ($65)

10286

10286 A. Rev. MARS VICTOR, Mars advancing r., holding transverse spear and shield, branch in ex. RIC 649. RSC 605. Hunter, p. lxix. *[Antioch, AD 265].* VF £12 ($18) / EF £38 ($55)

10287 A. Rev. MARTI PACIFE, Mars, in military attire, stepping l., presenting olive-branch and holding spear, shield on l. arm behind him, officina mark P (= 1) in field. RIC 492. RSC 611. Hunter 159. *[Milan, AD 264–5].* VF £10 ($15) / EF £30 ($45)

10288 A. Rev. MARTI PACIFERO, Mars, in military attire, stg. l., holding olive-branch and resting on shield, spear propped against l.arm, officina mark A, H, N or X (= 1, 8, 9 or 10) in field. RIC 236. RSC 617–618c. Hunter 67. *[Rome, AD 264–6].* VF £8 ($12) / EF £23 ($35)

10289 A. Rev. MERCVRIO CONS AVG, hippocamp r., officina mark H (= 8) below. RIC 242. RSC 631. Hunter 118–19. *[Rome, AD 267–8].* VF £20 ($30) / EF £55 ($85)

10290 A. Rev. MINERVA AVG, Minerva stg. r., resting on spear and shield, branch in ex. RIC 651. RSC 632–3. Hunter, p. lxix. *[Antioch, AD 265].* VF £12 ($18) / EF £38 ($55)

10291 Similar, but Minerva stg. l., resting on shield and spear, VII C (= COS VII) in ex. RIC 617. RSC 634. Hunter, p. lxx. *[Antioch, AD 266–7].* VF £12 ($18) / EF £38 ($55)

10292 A. Rev. NEPTVNO CONS AVG, hippocamp r. (rarely l.), officina mark N (= 9) below. RIC 245–6. RSC 667–8, 669a. Hunter 121, 123. *[Rome, AD 267–8].*
VF £14 ($20) / EF £45 ($65)

10293 Similar, but with rev. type capricorn r., officina mark S (= 6) below. RIC 245. RSC 670. Hunter 120. *[Rome, AD 267–8].* VF £16 ($25) / EF £50 ($75)

10294 A. Rev. OB REDDIT LIBERT, Libertas stg. l., holding pileus and transverse sceptre. RIC 247. RSC 681. Hunter, p. lx. *[Rome, AD 264].* VF £45 ($65) / EF £115 ($175)

10295 A. Rev. ORIENS AVG, Sol stg. l., raising r. hand and holding whip in l., usually with officina mark P or S (= 1 or 2) in ex. RIC 494. RSC 685–7. Hunter 167. *[Milan, AD 264–5].*
VF £8 ($12) / EF £23 ($35)

10296 Similar, but Sol holds globe instead of whip. RIC 495. RSC 690–691a. Hunter 166. *[Milan, AD 264–5].* VF £8 ($12) / EF £23 ($35)

10297 As 10295, but Sol advancing l., usually with officina mark Z (= 7) in field. RIC 249. RSC 699–700a. Hunter 72. *[Rome, AD 264–6].* VF £8 ($12) / EF £23 ($35)

10298 **Billon antoninianus.** D. Rev. ORIENS AVG, turreted female figure stg. r., presenting
wreath to Gallienus, in military attire, stg. l., resting on spear held in l. hand, sometimes
with wreath in upper field. Cf. RIC 445. RSC 705, 705a. Hunter 71. *[Uncertain Syrian
mint, AD 260].*					**VF** £16 ($25) / **EF** £50 ($75)

10299 A. Rev. PAX AETERNA AVG, Pax stg. l., holding olive-branch and transverse sceptre,
officina mark Δ (= 4) in field. RIC 253. RSC 718. Hunter 75. *[Rome, AD 264–6].*
VF £8 ($12) / **EF** £23 ($35)

10300 A. Rev. PAX AVG, Pax stg., as previous, mint and officina marks S — I (= Siscia, 1st
officina) in field. RIC 575. RSC 727a. Hunter 184. *[Siscia, AD 266–7].*
VF £10 ($15) / **EF** £30 ($45)

10301 A. Rev. — similar, but Pax advancing l., officina mark S (= 2) in field. RIC 501 var. RSC
741a var. Cf. Hunter 25. *[Milan, AD 264–5].*			**VF** £8 ($12) / **EF** £23 ($35)

10302 A. Rev. — similar, but Pax seated l., no mint or officina mark. RIC 258. RSC 746–7.
Hunter 23–4. *[Rome, AD 262–3].*				**VF** £8 ($12) / **EF** £23 ($35)

10303 C. Rev. PAX AVGG, Pax stg. l., holding olive-branch and transverse sceptre. RIC 155. RSC
754. Hunter 9. *[Rome, AD 253–5].*				**VF** £10 ($15) / **EF** £30 ($45)

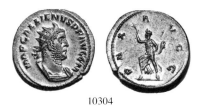

10304

10304 IMP GALLIENVS P F AVG G M. Rev. — similar, but Pax advancing l. RIC 157. RSC 765,
765a. Hunter, p. xliii. *[Rome, AD 257–8].*			**VF** £12 ($18) / **EF** £38 ($55)

10305 A. Rev. PAX AVGVSTI, as previous, but also with officina mark S (= 2) in field. RIC 502.
RSC 766. Hunter 161. *[Milan, AD 264–5].*			**VF** £8 ($12) / **EF** £23 ($35)

10306 A. Rev. PAX FVNDATA, two captives seated on ground on either side of trophy, sometimes
with branch in ex. RIC 652. RSC 769, 769a. Hunter 197. *[Antioch, AD 265].*
VF £12 ($18) / **EF** £38 ($55)

10307 A. Rev. PAX PVBLICA, Pax seated l., holding olive-branch and transverse sceptre, officina
mark V (= 5) in ex. RIC 260. RSC 773a. Hunter 46. *[Rome, AD 262–3].*
VF £10 ($15) / **EF** £30 ($45)

10308 A. Rev. PERPETVITATI AVG, Perpetuitas stg. facing, hd. l., holding globe and transverse
sceptre and resting l. arm on column, officina mark P (= 1) in field. RIC 504. RSC 777a,
778a. Hunter, p. lxvi. *[Milan, AD 264–5].*			**VF** £12 ($18) / **EF** £38 ($55)

10309 F. Rev. PIET SAECVLI, goat of Amalthea stg. r., suckling the infant Jupiter. Cf. RIC 394.
RSC 781. Cf. Hunter, p. xlvi. *[Viminacium, AD 253–5].* **VF** £45 ($65) / **EF** £130 ($200)

10310 **Billon antoninianus.** A. Rev. PIETAS AVG, Pietas stg. l. at lighted altar, both hands raised, officina mark P or S (= 1 or 2) in field or in ex., or mint and officina marks M P (= 1st officina) in ex. RIC 507. RSC 786. Hunter 162. *[Milan, AD 264–6].* **VF** £8 ($12) / **EF** £23 ($35)

10311 A. Rev. — Gallienus, veiled, stg. l., sacrificing over tripod-altar and holding transverse sceptre, VII C (= COS VII) in ex. RIC 618. RSC 788. Hunter, p. lxx. *[Antioch, AD 266–7].*
VF £12 ($18) / **EF** £38 ($55)

10312 D. Rev. PIETAS AVGG, Valerian and Gallienus stg. facing each other, sacrificing over altar between them, one holding eagle-tipped sceptre, the other parazonium (on later issues with wreath, with or without central dot, or star in field). RIC 447. RSC 792, 792a. Hunter 68. *[Uncertain Syrian mint, AD 256–8, 258–60].* **VF** £16 ($25) / **EF** £38 ($55)

10313 C. Rev. PIETATI AVGG, Pietas-Securitas stg. l., holding sceptre and resting on column. RIC 295. RSC 795. Hunter, p. xlvii. *[Antioch, AD 254–5].* **VF** £16 ($25) / **EF** £38 ($55)

10314 C. Rev. P M TR P II COS P P, Virtus stg. l., resting on shield and spear. RIC 115. RSC 797. Hunter, p. xl. *[Rome, AD 254].* **VF** £10 ($15) / **EF** £30 ($45)

10315 C. Rev. — Gallienus, togate, stg. l., sacrificing over altar and holding short sceptre. RIC 287. RSC 798a. Hunter, p. xlvii. *[Antioch, AD 254].* **VF** £16 ($25) / **EF** £38 ($55)

10316 D. Rev. P M TR P IIII COS III P P, Sol advancing l., his r. hand raised, holding whip in l. RIC 119. RSC 806. Hunter13. *[Rome, AD 256].* **VF** £16 ($25) / **EF** £38 ($55)

10317 B. Rev. P M TR P V COS III, Mars advancing r., carrying spear and trophy. RIC 5. RSC 807. Hunter, p. xlv. *[Cologne, AD 257].* **VF** £20 ($30) / **EF** £55 ($85)

10318 E. Rev. P M TR P V COS IIII P P, Valerian and Gallienus stg. facing each other, resting on shields between them behind which are two upright spears. RIC 435. RSC 815. Hunter, p. xlvii. *[Eastern field-mint, AD 257].* **VF** £20 ($30) / **EF** £45 ($65)
This reverse type is similar to, and presumably was inspired by, the aureus and denarius reverse type of Augustus depicting his two grandsons, Gaius and Lucius Caesars (see Volume I, nos. 1578 and 1597). See also nos. 9962 and 9986.

10319 E. Rev. P M TR P VII COS, Gallienus, togate, stg. l., sacrificing over tripod-altar and holding short sceptre. RIC 308. RSC 819. Hunter, p. xlvi. *[Milan, AD 259].*
VF £12 ($18) / **EF** £38 ($55)

10320 E. Rev. — Gallienus, togate, seated l. on curule chair, holding globe and sceptre. RIC 312. RSC 824b. Hunter, p. xlvi. *[Milan, AD 259].* **VF** £14 ($20) / **EF** £45 ($65)

10321 F. Rev. — Gallienus in triumphal quadriga l., holding branch, crowned by Victory stg. behind him. RIC 313. RSC 827. Hunter, p. xlvi. *[Milan, AD 259].*
VF £60 ($90) / **EF** £170 ($250)

10322 A. Rev. P M TR P VII COS P P, Gallienus, in military attire, stg. facing, holding spear and parazonium, between two reclining river gods, each holding reed. RIC 549. RSC 829. Hunter, p. lxviii. *[Rome or Siscia, AD 267–8].* **VF** £85 ($125) / **EF** £230 ($350)
The unusual reverse type may refer to a Roman victory on the banks of a river, perhaps at its confluence with another stream. The numeral 'VII' in the reverse legend probably refers to the emperor's seventh consulship in AD 266. See also no. 10158.

10323 B. Rev. P M TR P VII COS IIII P P, Mars advancing, as 10317. RIC 8. RSC 831. Hunter, p. xlv. *[Cologne, AD 259].* **VF** £16 ($25) / **EF** £50 ($75)

10324 **Billon antoninianus.** A. Rev. P M TR P VIIII COS IIII P P, Gallienus sacrificing, as 10319. RIC 153. RSC 835. Hunter, p. lix. *[Rome, AD 261].* **VF** £12 ($18) / **EF** £38 ($55)

10325 A, cuir. bust l., wearing rad. helmet and holding spear and shield. Rev. P M TR P X COS IIII P P, Gallienus in triumphal quadriga l., holding sceptre. RIC 154. Cf. RSC 837. Hunter, p. lix. *[Rome, AD 262].* **VF** £85 ($125) / **EF** £230 ($350)

10326 B. Rev. P M TR P XII COS V P P, Serapis stg. l., wearing modius, raising r. hand and holding sceptre in l. RIC 600. RSC 839. Hunter, p. lxix. *[Antioch, AD 264].* **VF** £12 ($18) / **EF** £38 ($55)

10327 A. Rev. P M TR P XIII around, C VI P P in ex., rad. lion walking l., sometimes with bull's hd. between paws, branch in ex. RIC 602. RSC 843–4. Hunter 193 var. *[Antioch, AD 265].* **VF** £14 ($20) / **EF** £45 ($65)

10328 A. Rev. P M TR P XV P P around, VII C in ex., Neptune stg. l., r. foot on prow, holding trident. RIC 603. RSC 848–9. Hunter 198. *[Antioch, AD 267].* **VF** £12 ($18) / **EF** £38 ($55)

10329 A. Rev. P M TR P XVI COS VII, Gallienus, in military attire, stg. l., holding globe and resting on sceptre or spear, sometimes with star or officina mark P (= 1) in field. RIC 550. RSC 851, 852–852c. Cf. Hunter, p. lix. *[Siscia, AD 268].* **VF** £12 ($18) / **EF** £38 ($55)

10330 A. Rev. PROVI AVG, Providentia stg. l., holding rod and cornucopiae, globe at feet, officina mark N or X (= 9 or 10) in field. RIC 267. RSC 854a, 855b. Hunter, pp. lxiii-lxiv. *[Rome, AD 265–7].* **VF** £8 ($12) / **EF** £23 ($35)

10331 A. Rev. PROVID AVG, Providentia stg. l., holding globe and transverse sceptre, mint and officina marks M P (= 1st officina) in ex. RIC 508a. RSC 859a. Hunter 171. *[Milan, AD 265–6].* **VF** £10 ($15) / **EF** £30 ($45)

10332 A. Rev. — Providentia stg. l., holding rod and sceptre, globe at feet, P — II (= *Pannonia Secunda*) in field. RIC 580. RSC 864a. Hunter, p. lxviii. *[Sirmium?, AD 265].* **VF** £10 ($15) / **EF** £30 ($45)

10333 F. Rev. PROVID AVGG, Providentia stg. l., holding rod and standard, globe at feet. Cf. RIC 395. RSC 870. Hunter 61. *[Milan, AD 259–60].* **VF** £14 ($20) / **EF** £45 ($65)

10334 A. Rev. PROVIDEN AVG, Providentia stg., as 10330, but nothing in field. RIC 580. RSC 872. Cf. Hunter, p. lxviii. *[Siscia, AD 267–8].* **VF** £8 ($12) / **EF** £23 ($35)

10335 A. Rev. PROVIDENT AVG, Providentia stg., as 10331, but with officina mark P (= 1) in field, nothing in ex. RIC 270. RSC 874a. Hunter 27. *[Rome, AD 261–3].* **VF** £8 ($12) / **EF** £23 ($35)

10336

10336 A. Rev. PROVIDENTIA AVG, Mercury stg. l., holding purse and caduceus. RIC 653 var. RSC 875, 876. Hunter 211. *[Antioch, AD 265].* **VF** £12 ($18) / **EF** £38 ($55)

10337 **Billon antoninianus.** A. Rev. PROVIDENTIA AVG, Providentia stg., as 10330, but also resting on column and with officina mark S (= 2) in field. RIC 510. RSC 880. Hunter, p. lxvi. *[Milan, AD 264–5].* **VF** £10 ($15) / **EF** £30 ($45)

10338 D. Rev. PROVIDENTIA AVGG, Providentia stg., as 10330, but nothing in field. RIC 159. RSC 888. Hunter 27. *[Rome, AD 255–7].* **VF** £10 ($15) / **EF** £30 ($45)

10339 B. Rev. RESTIT GALLIAR, Gallienus, in military attire, stg. l., holding spear and raising turreted female figure kneeling r., holding cornucopiae. RIC 29. RSC 895. Hunter 44 var. *[Cologne, AD 257–8].* **VF** £20 ($30) / **EF** £55 ($85)

10340 C. Rev. RESTITVT GENER HVMANI, Gallienus, rad. and in long robes, advancing r., his r. hand raised, holding globe in l. RIC 296. RSC 901. Cf. Hunter, p. xlvii. *[Antioch, AD 254–5].* **VF** £23 ($35) / **EF** £50 ($75)

10341 C. Rev. RESTITVT ORIENTIS, turreted female figure stg. r., presenting wreath to Gallienus, in military attire, stg. l., resting on spear held in l. hand, one or two dots in ex. RIC 448. RSC 902a-b. Hunter, p. xlvii. *[Uncertain Syrian mint, AD 255–6].* **VF** £14 ($20) / **EF** £45 ($65)

10342 D. Rev. RESTITVTOR ORBIS, Valerian, in military attire, stg. l., raising turreted female figure kneeling r. and resting on spear. RIC 164. RSC 911b. Hunter, p. xlii. *[Rome, AD 255–7].* **VF** £14 ($20) / **EF** £45 ($65)

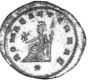

10343

10343 A. Rev. ROMAE AETERNAE, Roma seated l., holding Victory and spear, shield at side, star in ex. RIC 655. RSC 919. Hunter, p. lxix. *[Antioch, AD 264].* **VF** £10 ($15) / **EF** £30 ($45)

10344 D. Rev. — Roma seated, as previous, but she presents the Victory to Gallienus stg. r. before her, star or wreath in field above. RIC 449. RSC 921, 921a. Hunter 73. *[Uncertain Syrian mint, AD 258–60].* **VF** £14 ($20) / **EF** £45 ($65)

10345 A. Rev. SAECVLARES AVG, stag stg. r., branch in ex. RIC 656. RSC 923–4. Hunter 195. *[Antioch, AD 265].* **VF** £14 ($20) / **EF** £45 ($65)

10346 A. Rev. SALVS AVG, Apollo stg. l., holding laurel-branch, tripod to r., P XV (= TR P XV) in ex. RIC 610. RSC 927, 927a. Hunter, p. lxx. *[Antioch, AD 267].* **VF** £12 ($18) / **EF** £38 ($55)

10347 E. Rev. — Aesculapius stg. l., holding snake-entwined staff, mint and officina marks M P (= 1st officina) in ex. RIC 511b. RSC 928–9. Hunter 181. *[Milan, AD 265–6].* **VF** £12 ($18) / **EF** £38 ($55)

10348 A. Rev. — Salus stg. r., feeding snake held in her arms, officina mark XII (= 12) in field. RIC 274a. RSC 932b. Hunter, p. lxiv. *[Rome, AD 265–7].* **VF** £8 ($12) / **EF** £23 ($35)

10349 **Billon antoninianus.** A. Rev. — Salus stg. l., feeding snake arising from altar and holding sceptre, mint and officina marks **S I** (= 1st officina) in field. RIC 581. RSC 934. Hunter, p. lxviii. *[Siscia, AD 266–7].* **VF** £10 ($15) / **EF** £30 ($45)

10350 A. Rev. — Salus seated l., feeding snake arising from altar, officina mark **P** (= 1) in field. RIC 275. RSC 935. Hunter, p. lx. *[Rome, AD 261–3].* **VF** £10 ($15) / **EF** £30 ($45)

10351 F. Rev. **SALVS AVGG**, Salus stg. r., as 10348, but nothing in field. RIC 399. RSC 936–7. Hunter, p. xlvi. *[Milan, AD 259–60].* **VF** £12 ($18) / **EF** £38 ($55)

10352 Similar, but on rev. Salus is stg. l., as 10349. RIC 397. RSC 940–41. Hunter, p. xlvi. *[Milan, AD 259–60].* **VF** £12 ($18) / **EF** £38 ($55)

10353 E. Rev. **SALVS ITAL**, rad. female figure stg. r., offering fruits wrapped in her dress to Gallienus, in military attire, stg. l., raising r. hand and holding transverse spear in l. RIC 400. RSC 943. Hunter, p. xlvi. *[Milan, AD 259–60].* **VF** £85 ($125) / **EF** £230 ($350)

10354 As 10352, but with rev. legend **SALVS PVBLICA**. RIC 401. RSC 944. Hunter, p. xlvi. *[Milan, AD 259–60].* **VF** £12 ($18) / **EF** £38 ($55)

10355 A. Rev. **SECVR TEMPO**, Securitas stg. facing, hd. l., her legs crossed, holding sceptre and resting l. arm on column, mint and officina marks **M S** (= 2nd officina) in ex. RIC 513. RSC 949. Hunter, p. lxvii. *[Milan, AD 265–6].* **VF** £10 ($15) / **EF** £30 ($45)

10356 A. Rev. **SECVRIT** (or **SECVRT**) **AVG**, similar, but Securitas has r. hand on hd. instead of holding sceptre, and with officina mark **VI** (= 6) in field. RIC 277. RSC 951. Hunter 28. *[Rome, AD 261–3].* **VF** £8 ($12) / **EF** £23 ($35)

10357 A. Rev. **SECVRIT ORBIS**, Securitas seated l., holding sceptre and resting l. hand on hd., officina mark **T** (= 3) or **VI** (= 6) in ex. RIC 278. RSC 953–4. Hunter 47–50. *[Rome, AD 261–3].* **VF** £8 ($12) / **EF** £23 ($35)

10358 A. Rev. — Securitas seated l., holding caduceus and cornucopiae, officina mark **T** (= 3) in ex. RIC 279. RSC 956–7. Hunter, p. lxii. *[Rome, AD 261–3].* **VF** £10 ($15) / **EF** £30 ($45)

10359 A. Rev. **SECVRIT PERPET**, Securitas resting on column, as 10355, but with officina mark **H** (= 8) in field. RIC 280. RSC 961a, 962a. Hunter 77–9. *[Rome, AD 265–7].*
 VF £8 ($12) / **EF** £23 ($35)

10360 A. Rev. **SECVRIT** (or **SECVRITAS**) **PVBL**, Securitas seated, as 10357. RIC 281. RSC 974, 974a. Hunter, p. lxii. *[Rome, AD 261–3].* **VF** £10 ($15) / **EF** £30 ($45)

10361 A. Rev. **SISCIA AVG**, turreted city-goddess of Siscia, both hands raised, seated l. above the banks of a river (the Savus) in the waters of which the river-god swims l. RIC 582. RSC 976–977b. Hunter 186. *[Siscia, AD 262].* **VF** £200 ($300) / **EF** £500 ($750)
 This rare type clearly identifies Siscia, in Pannonia Superior, as the location of the new Balkan mint established by Gallienus in AD 262. For a later version of the type, see under Probus (no. 12037).

10362 A. Rev. **SOLI CONS AVG**, Pegasus springing r. (or l.), about to take flight, officina mark **A** (= 1), **H** (= 8) or **N** (= 9) in ex. RIC 283–4. RSC 979, 979a, 981. Hunter 127. *[Rome, AD 267–8].* **VF** £12 ($18) / **EF** £38 ($55)

10363 A. Rev. — bull stg. r., officina mark **XI** (= 11) in ex. RIC 285. RSC 983. Hunter 142. *[Rome, AD 267–8].* **VF** £14 ($20) / **EF** £45 ($65)

10364 **Billon antoninianus.** A. Rev. SOLI INVICTO, Sol stg. l., raising r. hand and holding whip in l. RIC 658. RSC 987. Hunter 212. *[Antioch, AD 265].* **VF** £10 ($15) / **EF** £30 ($45)

10365 A. Rev. — similar, but Sol stands facing, hd. l., wears long robe and holds globe in l., VII C or P XV in ex. RIC 611, 620. RSC 989–989b. Hunter 201. *[Antioch, AD 266–7].*
VF £10 ($15) / **EF** £30 ($45)

10366 F. Rev. SPES PVBLICA, Spes advancing l., holding flower and lifting skirt. RIC 403. RSC 990–92. Hunter, p. xlvi. *[Milan, AD 259–60].* **VF** £14 ($20) / **EF** £45 ($65)

10367 B. Rev. S P Q R OPTIMO PRINCIPI in laurel-wreath. RIC 659. RSC 998. Hunter, p. lxix. *[Antioch, AD 263–4].* **VF** £30 ($45) / **EF** £80 ($120)

10368 A. Rev. VBERITAS (or VBERTAS) AVG, Uberitas stg. l., holding cow's udder (?) and cornucopiae, officina mark ε (= 5) in field. Cf. RIC 585. RSC 1008, 1014. Hunter 80. *[Rome, AD 265–7].* **VF** £8 ($12) / **EF** £23 ($35)

10369 A. Rev. VENER VICTRIX, Venus stg. l., holding helmet and transverse sceptre and resting on shield, S P Q R in ex. RIC 660. RSC 1020. Hunter, p. lxxi. *[Uncertain Asia Minor mint, AD 268].* **VF** £12 ($18) / **EF** £38 ($55)

10370 Similar, but with rev. legend VENERI VICTRICI and without S P Q R. RIC 660. RSC 1021. Hunter, p. lxx. *[Antioch, AD 265].* **VF** £10 ($15) / **EF** £30 ($45)

10371 Similar, but with rev. legend VENVS VICTRIX and officina mark N (= 9) in field. RIC 289. RSC 1024. Hunter —. *[Rome, AD 265–7].* **VF** £8 ($12) / **EF** £23 ($35)

10372 A. Rev. VESTA, Vesta stg. l., holding simpulum and transverse sceptre, officina mark P (= 1) or Q (= 4) in ex. RIC 290. RSC 1027a. Hunter —. *[Rome, AD 261–3].*
VF £10 ($15) / **EF** £30 ($45)

10373 E. Rev. VIC GALL AVG III, Victory advancing l., holding wreath and palm, officina mark T (= 3) in field. Cf. RIC 296. Cf. RSC 1041. Cf. Hunter, p. lvi. *[Rome, AD 260–61].*
VF £14 ($20) / **EF** £45 ($65)

10374 10377

10374 A. Rev. VICT GAL AVG, three Victories stg. side by side, each holding wreath and palm, sometimes with officina mark V (= 5) in ex. RIC 294. RSC 1032–3. Hunter, p. lxii. *[Rome, AD 261–3].* **VF** £22 ($35) / **EF** £65 ($100)

10375 Similar, but with rev. legend VICT GAL AVG III. RIC 295. RSC 1035, 1035a, 1037. Cf. Hunter, p. lxvi. *[Rome, AD 261–3].* **VF** £22 ($35) / **EF** £65 ($100)

10376 G. Rev. VICT GERM, Victory advancing l., holding wreath and palm, captive at feet. RIC 404. RSC 1045. Hunter, p. xlv. *[Viminacium, AD 257].* **VF** £23 ($35) / **EF** £50 ($75)

10377 **Billon antoninianus.** B, rad. and cuir. bust l., holding spear and shield. Rev. VICT GERMANICA, Victory advancing r., holding wreath and trophy. RIC 42. RSC 1055. Hunter, p. xlv. *[Cologne, AD 257–8].* **VF** £22 ($35) / **EF** £65 ($100)

10378 B. Rev. — similar, but Victory advances l. and tramples on German captive at her feet. RIC 44. RSC 1060. Cf. Hunter 56. *[Cologne, AD 257–8].* **VF** £20 ($30) / **EF** £55 ($85)

10379 B. Rev. — similar to 10377, but Victory stands on globe between two German captives. RIC 49. RSC 1062. Cf. Hunter 54. *[Cologne, AD 257–8].* **VF** £20 ($30) / **EF** £55 ($85)

10380 A. Rev. VICTORIA AET, Victory stg. l., holding wreath and palm, S — P (= *Secunda Pannonia*) in field. RIC 586. RSC 1071a, 1072a. Hunter 187. *[Sirmium?, AD 265].*
 VF £10 ($15) / **EF** £30 ($45)

10381 A. Rev. VICTORIA AVG, type as previous, but with officina mark Z (= 7) in field. Cf. RIC 299. RSC 1075b. Hunter —. *[Rome, AD 265–7].* **VF** £8 ($12) / **EF** £23 ($35)

10382 A. Rev. — Victory advancing l., placing shield on pedestal, S P Q R in ex. RIC 665. RSC 1085, 1085a. Hunter, p. lxxi. *[Uncertain Asia Minor mint, AD 268].*
 VF £20 ($30) / **EF** £55 ($85)

10383 E. Rev. — Victory stg. l., attaching shield, inscribed III, to palm-tree. RIC 521. RSC 1087. Hunter —. *[Milan, AD 262–3].* **VF** £14 ($20) / **EF** £45 ($65)

10384 A. Rev. — Victory advancing l., holding wreath and palm, star in field or in ex. RIC 663. RSC 1094b-c, e, h. Hunter 191. *[Antioch, AD 264].* **VF** £10 ($15) / **EF** £30 ($45)

10385 A. Rev. — Victory advancing l., holding open wreath with both hands over shield set on base, VII C (= COS VII) in ex. RIC 622. RSC 1106, 1106a. Hunter, p. lxx. *[Antioch, AD 266–7].* **VF** £12 ($18) / **EF** £38 ($55)
 This is a revival of a Severan type issued in AD 199/200 (see Vol. II, nos. 6333, 6368 and 6381).

10386 D. Rev. — Victory stg. l., holding palm and presenting wreath to Gallienus, in military attire, stg. r., holding spear, star or wreath in field above. Cf. RIC 450. RSC 1109a, b. Cf. Hunter, p. xlviii. *[Uncertain Syrian mint, AD 260].* **VF** £14 ($20) / **EF** £45 ($65)

10387 A. Rev. VICTORIA AVG III, Victory advancing l., holding wreath and palm, officina mark T (= 3) in field. RIC 305. RSC 1118a, 1119a. Hunter 31. *[Rome, AD 261–3].*
 VF £10 ($15) / **EF** £30 ($45)

10388 A. Rev. VICTORIA AVG VII, Victory stg. l., holding wreath and palm, sometimes with captive at feet. RIC 526. RSC 1132–3. Hunter, p. lxvi. *[Milan, AD 262–3].*
 VF £10 ($15) / **EF** £30 ($45)

10389 Similar, but with rev. legend VICTORIA AVG VIII and sometimes with officina mark S (= 2) in field. RIC 527. RSC 1135–1135b. Hunter, p. lxvi. *[Milan, AD 262–3].*
 VF £10 ($15) / **EF** £30 ($45)

10390 C. Rev. VICTORIA AVGG, Victory stg. (sometimes advancing) l., holding wreath and palm. RIC 170, 172. RSC 1138, 1154. Hunter, p. xlii. *[Rome, AD 253–5].*
 VF £10 ($15) / **EF** £30 ($45)

10391 **Billon antoninianus.** E. Rev. VICTORIA AVGG, Victory hovering to front, hd. l., between
two shields, holding open wreath with both hands. RIC 405. RSC 1148. Hunter 63 var.
(obv. hd. l.). *[Milan, AD 259–60].* VF £12 ($18) / EF £38 ($55)
*This is a revival of a type issued in AD 220/21 under Elagabalus (see Volume II, nos. 7535
and 7554). See also no. 10492, and under Aurelian (no. 11619), Tacitus (no. 11820), and
Probus (no. 11929).*

10392 10401

10392 IMP GALLIENVS P F AVG GERM. Rev. VICTORIA GERM, Victory stg. l., holding wreath and
palm, captive at feet. RIC 175. RSC 1162. Hunter 21. *[Rome, AD 257–8].*
 VF £14 ($20) / EF £45 ($65)

10393 E. Rev. VICTORIA GERMAN, Victory stg. r., holding palm and presenting wreath to Gallienus,
in military attire, stg. l., holding globe and spear, star in field above. RIC 452. RSC 1173a.
Cf. Hunter, p. xlviii. *[Eastern field-mint, AD 257–8].* VF £23 ($35) / EF £50 ($75)

10394 B. Rev. VICTORIA GERMANICA, Victory, holding wreath and trophy, stg. r. on globe
between two German captives. RIC 51. RSC 1181. Hunter, p. xlv. *[Cologne, AD 257–8].*
 VF £20 ($30) / EF £55 ($85)

10395 IMP GALLIENVS P F AVG G M. Rev. VICTORIA G M, Victory and captive, as 10392. Cf. RIC
176. RSC 1187. Hunter, p. xliv. *[Rome, AD 257–8].* VF £14 ($20) / EF £45 ($65)

10396 — Rev. — two captives seated at foot of trophy. RIC 177. RSC 1189. Hunter —. *[Rome,
AD 257–8].* VF £23 ($35) / EF £50 ($75)

10397 C. Rev. VICTORIAE AVGG, soldier stg. r., holding spear and resting on shield. RIC 300.
RSC 1196. Hunter, p. xlvii. *[Antioch, AD 254–5].* VF £14 ($20) / EF £45 ($65)

10398 D. Rev. VICTORIAE AVGG IT GERM, Victory and captive, as 10392. Cf. RIC 178. RSC
1198, 1198a. Hunter 19. *[Rome, AD 257].* VF £14 ($20) / EF £45 ($65)

10399 A, cuir. bust l., wearing rad. helmet and holding spear and shield. Rev. VIRT GALLIENI
AVG, Gallienus galloping r., spearing fallen enemy. RIC 529. RSC 1205a. Hunter , p. lxvi.
[Milan, AD 262–3]. VF £30 ($45) / EF £80 ($120)

10400 B. Rev. — Gallienus, in military attire, advancing r., holding spear and shield and
trampling down enemy. RIC 54. RSC 1206. Hunter 57. *[Cologne, AD 257–8].*
 VF £20 ($30) / EF £55 ($85)

10401 A. Rev. VIRTVS AVG, Mars stg. l., sometimes with foot on helmet, holding globe and
resting on spear, officina mark P or Q (= 1 or 4) in field. RIC 317. RSC 1221a and c,
1225a. Hunter 32. *[Rome, AD 261–2].* VF £8 ($12) / EF £23 ($35)

10402 A. Rev. — Virtus stg. l., resting on shield and spear, star in field or ex. RIC 668. RSC
1236d, 1237, 1237b-c, and e. Hunter, p. lxix. *[Antioch, AD 266–7].*
 VF £10 ($15) / EF £30 ($45)

10403 **Billon antoninianus.** Similar, but Virtus stg. r., and with P XV (= TR P XV) in ex.. RIC 612.
RSC 1245, 1245a. Hunter 202. *[Antioch, AD 266–7].* **VF** £12 ($18) / **EF** £38 ($55)

10404 A. Rev. VIRTVS AVG, Hercules stg. facing, hd. l., resting on club and holding apple, VII C
(= COS VII) in ex. Cf. RIC 623. RSC 1250, 1250a. Hunter, p. lxx. *[Antioch, AD 266–7].*
VF £14 ($20) / **EF** £45 ($65)

10405 Similar, but Hercules holds laurel-branch in r. hand and club and lion's skin in l., nothing
in ex. RIC 328. RSC 1253. Hunter, p. lxi. *[Rome, AD 262–3].*
VF £12 ($18) / **EF** £38 ($55)

10406 A. Rev. VIRTVS AVG, Gallienus, in military attire, stg. r., holding transverse spear and
globe, palm-branch in ex. RIC 670. RSC 1256–8. Hunter 196. *[Antioch, AD 265].*
VF £12 ($18) / **EF** £38 ($55)

10407 A. Rev. — Gallienus, in military attire, stg. l., holding globe and spear, female figure
kneeling before him, captive seated behind. RIC 323. RSC 1265–1265b. Cf. Hunter, p. lxi.
[Rome, AD 262–3]. **VF** £22 ($35) / **EF** £65 ($100)

10408 10411

10408 D. Rev. —Gallienus stg. r., holding transverse spear and receiving Victory from Roma stg.
l., resting on shield, spear propped against l. arm, star or wreath in field above. RIC 457.
RSC 1266. Cf. Hunter, p. xlviii. *[Uncertain Syrian mint, AD 260].*
VF £14 ($20) / **EF** £45 ($65)

10409 IMP GALLIENVS P F AVG GERM. Rev. VIRTVS AVGG, military figure (Gallienus?)
advancing r., carrying transverse spear and trophy over l. shoulder. RIC 186. RSC 1272.
Hunter 22. *[Rome, AD 257–8].* **VF** £12 ($18) / **EF** £38 ($55)

10410 IMP GALLIENVS P F AVG G M. Rev. — Virtus stg. r., resting on spear and shield. RIC 183.
RSC 1276. Cf. Hunter, p. xliv. *[Rome, AD 257–8].* **VF** £12 ($18) / **EF** £38 ($55)

10411 C. Rev. — similar, but Virtus stg. l. RIC 181. RSC 1288. Hunter 10. *[Rome, AD 253–5].*
VF £10 ($15) / **EF** £30 ($45)

10412 G. Rev. — Gallienus, in military attire, stg. l., holding spear with both hands, standard to
right. RIC 407. RSC 1306. Hunter, p. xlv. *[Milan, AD 259].* **VF** £14 ($20) / **EF** £45 ($65)

10413 B. Rev. — Gallienus, in military attire, stg. r., holding spear and standard. RIC 58. RSC
1309, 1309a. Hunter 58. *[Cologne, AD 257–8].* **VF** £14 ($20) / **EF** £45 ($65)

10414 C. Rev. — Valerian and Gallienus, both in military attire, stg. facing each other, one
resting on spear and holding globe, the other holding Victory and transverse spear. RIC
455. RSC 1311. Hunter, p. xlvii. *[Uncertain Syrian mint, AD 255–6].*
VF £14 ($20) / **EF** £45 ($65)

10414 10415

10415 **Billon antoninianus.** A. Rev. VIRTVS AVGVSTI, Hercules stg. r., r. hand on hip, l. resting
 on club with lion's skin set on rock, star in field or in ex. RIC 673. RSC 1320a. Hunter
 192. *[Antioch, AD 264]*. **VF** £12 ($18) / **EF** £38 ($55)

10416 A. Rev. — Mars stg. l., foot on helmet, holding branch and spear, officina mark X or XII
 (= 10 or 12) in field. RIC —. RSC 1322. Hunter, p. lxiv. *[Rome, AD 261–2]*.
 VF £10 ($15) / **EF** £30 ($45)

10417

10417 A, rad. bust r., wearing lion's skin headdress. Rev. VIRTVS FALERI, club between quiver
 and lion's skin on l., and vase and bow on r. RIC 596. RSC 1326. Hunter, p. lxi. *[Rome,
 AD 262–3]*. **VF** £200 ($300) / **EF** £500 ($750)
 *This interesting type pays tribute to Gallienus' origins in the Etruscan town of Falerii,
 perhaps on the occasion of the tenth anniversary of his reign .*

10418 A. Rev. VIRTVTI AVG, two captives seated at foot of trophy, S P Q R in ex. RIC 675. RSC
 1331, 1331a. Hunter, p. lxxi. *[Uncertain Asia Minor mint, AD 268]*.
 VF £30 ($45) / **EF** £80 ($120)

10419 A. Rev. VOTA DECENNALIA (or DECENALIA), Victory stg. r., inscribing shield attached to
 palm-tree. RIC 333. RSC 1332–1332c. Hunter, p. lxi. *[Rome, AD 262–3]*.
 VF £22 ($35) / **EF** £65 ($100)

10420 C. Rev. VOTA ORBIS, two Victories stg. facing each other, attaching shield inscribed S C to
 palm-tree. RIC 459. RSC 1335–1335b. Hunter 67. *[Uncertain Syrian mint, AD 255–6]*.
 VF £20 ($30) / **EF** £55 ($85)

10421 A. Rev. VOTIS DECENNALIB (or DECENNALIBVS) in laurel-wreath. RIC 334. RSC
 1338–1339a. Hunter 38–40. *[Rome, AD 262–3]*. **VF** £20 ($30) / **EF** £55 ($85)

10422 A. Rev. VOTIS X in laurel-wreath. RIC 598. RSC 1350–51. Hunter, p. lxi. *[Rome,
 AD 262–3]*. **VF** £22 ($35) / **EF** £65 ($100)

10423 Similar, but with VOT (or VOTIS) X ET XX in laurel-wreath. RIC 599. RSC 1355. Hunter,
 p. lxi. *[Rome, AD 262–3]*. **VF** £32 ($50) / **EF** £95 ($140)

10424 10430

10424 **Billon denarius.** E. Rev. ABVNDANTIA AVG, Abundantia stg. r., emptying cornucopiae. RIC 346. RSC 4. Hunter, p. lxii. *[Rome, AD 265–7].* **VF** £85 ($125) / **EF** £230 ($350)

NB The much rarer denarii are distinguishable from the antoniniani by their smaller size and the laurel-wreath worn by the emperor in place of the radiate crown.

10425 A. Rev. AEQVITAS AVG, Aequitas stg. l., holding scales and cornucopiae. RIC 347. RSC 23a. Hunter, p. lix. *[Rome, AD 261–2].* **VF** £85 ($125) / **EF** £230 ($350)

10426 E. Rev. AETERNITAS AVG, Sol stg. l., r. hand raised, holding globe in l. RIC 348. RSC 42. Hunter, p. lxii. *[Rome, AD 265–7].* **VF** £85 ($125) / **EF** £230 ($350)

10427 A, laur., dr. and cuir. bust l. Rev. — she-wolf stg. r., suckling Romulus and Remus. Cf. RIC 349 and 677. RSC 48. Hunter, p. lxix. *[Rome and/or Antioch, AD 265].*
VF £100 ($150) / **EF** £300 ($450)

10428 F. Rev. BONAE FORTVNAE, Fortuna stg. l., holding rudder and cornucopiae. RIC 412. RSC 97a. Hunter, p. xlvi. *[Milan, AD 259–60].* **F** £85 ($125) / **VF** £200 ($300) **EF** £500 ($750)

10429 A. Rev. FELICIT AVG, Felicitas stg. l., holding caduceus and sceptre. RIC 350. RSC 188. Hunter, p. lxi. *[Rome, AD 261–2].* **VF** £85 ($125) / **EF** £230 ($350)

10430 E. Rev. FIDES MILITVM, Fides Militum stg. l., holding standard and sceptre. RIC — (cf. 366). RSC — (cf. 245). Hunter — (cf. p. lxii). *[Rome, AD 265–7].*
VF £95 ($140) / **EF** £265 ($400)
Although this type is normally catalogued as a quinarius, following Cohen's possibly erroneous decsription of his nos. 244 and 245, it seems more likely to exist only as a denarius.

10431 E. Rev. FORTVNA REDVX, Fortuna stg. l., holding rudder on globe and cornucopiae. RIC 352. RSC 276. Hunter, p. lxi. *[Rome, AD 260–61].* **VF** £85 ($125) / **EF** £230 ($350)

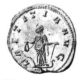

10432 10434

10432 A. Rev. LAETITIA AVG, Laetitia stg. l., holding wreath and anchor, galley beneath her feet. RIC —. RSC —. Hunter —. *[Rome, AD 261–2].* **VF** £100 ($150) / **EF** £300 ($450)

10433 E. Rev. MARTI PACIFERO, Mars, in military attire, stg. l., holding olive-branch and resting on shield, spear propped against l. arm. RIC 353. RSC 619. Hunter, p. lxiii. *[Rome, AD 265–7].* **VF** £95 ($140) / **EF** £265 ($400)

10434 **Billon denarius.** E. Rev. ORIENS AVG, Sol advancing l., raising r. hand and holding whip in l. RIC 354 var. RSC 698 var. Hunter, p. lxiii. *[Rome, AD 265–7].*
VF £85 ($125) / **EF** £230 ($350)

10435 C. Rev. PROVIDENTIA AVGG, Providentia stg. l., holding rod and cornucopiae and resting on column, globe at feet. Cf. RIC 188. RSC 890. Hunter, p. xliii. *[Rome, AD 253–5].*
F £115 ($175) / **VF** £265 ($400) **EF** £665 ($1,000)

10436 E. Rev. SECVRIT PERPET, Securitas stg. facing, hd. l., her legs crossed, holding sceptre and resting l. arm on column. RIC 355. RSC 964. Hunter, p. lxiii. *[Rome, AD 265–7].*
VF £85 ($125) / **EF** £230 ($350)

10437 B, laur. hd. l. Rev. TRIB POT VIII COS III, Mars, holding spear and shield, descending r. through the air to Rhea Silvia, who reclines l. asleep on ground, her hd. propped on l. hand. RIC 345. RSC 1005. Hunter, p. lvii. *[Rome, AD 260].*
VF £500 ($750) / **EF** £1,000 ($1,500)
This is a revival of a type issued 120 years before under Antoninus Pius (see Volume II, nos. 4030 and 4315).

10438 E. Rev. VBERTAS AVG, Uberitas stg. l., holding cow's udder (?) and cornucopiae. RIC 358. RSC 1013. Hunter, p. lvii. *[Rome, AD 260–61].* VF £85 ($125) / **EF** £230 ($350)

10439 GALLIENAE AVGVSTAE, hd. l., crowned with reeds. Rev. VBIQVE PAX, Victory in galloping biga r., holding whip. RIC 359. RSC 1016. Hunter, p. lviii. *[Rome, AD 266–7].*
VF £825 ($1,250) / **EF** £1,650 ($2,500)

10440 E. Rev. VICTORIA AET, Victory stg. l., holding wreath and palm. RIC 361. RSC 1073. Hunter, p. lxi. *[Rome, AD 260–61].* VF £85 ($125) / **EF** £230 ($350)

10441 A. Rev. VICTORIA AVG, Victory advancing l., holding wreath and palm. RIC 362. RSC 1093. Hunter, p. lxi. *[Rome, AD 260–61].* VF £85 ($125) / **EF** £230 ($350)

10442 B, hd. l., crowned with reeds. Rev. — Gallienus, in military attire, stg. l., holding globe and transverse sceptre, crowned by Victory stg. l. behind him, holding palm. RIC 363. RSC 1113. Hunter, p. lviii. *[Rome, AD 267].* VF £300 ($450) / **EF** £665 ($1,000)

10443 A. Rev. VIRTVS AVG, bust of Gallienus, as Mars, l., wearing crested helmet. Cf. RIC 364 (misdescribed). RSC 1214. Hunter, p. lxi. *[Rome, AD 262–3].*
VF £500 ($750) / **EF** £1,000 ($1,500)

10444 A, laur. hd. l. Rev. VIRTVS AVGVSTI, Hercules stg. r., r. hand on hip, l. resting on club with lion's skin set on rock. RIC 678. RSC 1317. Hunter, p. lxix. *[Antioch, AD 264].*
VF £95 ($140) / **EF** £265 ($400)

10445 **Billon quinarius.** B. Rev. GERMANICVS MAX V, two captives seated at foot of trophy. RIC 60. RSC 315. Hunter, p. xlv. *[Cologne, AD 257–8].*
F £115 ($175) / **VF** £300 ($450) **EF** £750 ($1,100)

10446 A. Rev. INDVLGENT (or INDVLGENTIA) AVG, Indulgentia seated l., holding branch and sceptre. RIC 368. RSC 325, 330. Hunter, p. lxii. *[Rome, AD 263–4].*
VF £200 ($300) / **EF** £500 ($750)

10447 C. Rev. IOVI CONSERVATORI, Jupiter stg. l., holding thunderbolt and sceptre. RIC 189. RSC 371. Hunter, p. xli. *[Rome, AD 253–5].* **F** £100 ($150) / **VF** £265 ($400) **EF** £600 ($900)

10448 **Billon quinarius.** A. Rev. LIBERAL AVG, Liberalitas stg. l., holding abacus and cornucopiae. RIC 369. RSC 564. Hunter, p. lxii. *[Rome, AD 261–2].*
VF £200 ($300) / **EF** £500 ($750)

10449 E. Rev. MARTI PACIFERO, Mars, in military attire, stg. l., holding olive-branch and resting on shield, spear propped against l.arm. RIC 370. RSC 620. Hunter — . *[Rome, AD 265–7].*
VF £200 ($300) / **EF** £500 ($750)

10450 C. Rev. PAX AVGG, Pax stg. l., holding olive-branch and transverse sceptre. RIC 190. RSC 755. Hunter, p. xlii. *[Rome, AD 253–5].* **F** £100 ($150) / **VF** £265 ($400) **EF** £600 ($900)

10451 A. Rev. SALVS AVG, Salus seated l., feeding snake arising from altar. RIC 542a. RSC 935a. Cf. Hunter, p. lx. *[Rome, AD 263–4].* VF £200 ($300) / **EF** £500 ($750)

10452 A. Rev. SECVRIT PERPET, Securitas stg. facing, hd. l., her legs crossed, holding sceptre and resting l. arm on column. RIC 372. RSC 960. Hunter, p. lxiii. *[Rome, AD 265–7].*
VF £200 ($300) / **EF** £500 ($750)

10453 B, laur. and cuir. bust l., holding spear and shield. Rev. VICT GERMANICA, Victory advancing l., holding wreath and trophy, trampling down German captive at her feet. RIC 62. RSC 1058. Cf. Hunter, p. xlv. *[Cologne, AD 257–8].*
F £115 ($175) / **VF** £300 ($450) **EF** £750 ($1,100)

10454 Similar, but with obv. type laur. bust r., and on reverse Victory stands r. on globe between two German captives. RIC 61. RSC 1064. Hunter, p. xlv. *[Cologne, AD 257–8].*
F £115 ($175) / **VF** £300 ($450) **EF** £750 ($1,100)

10455 A. Rev. VICTORIA AVG, Victory advancing l., holding wreath and palm. RIC 375. RSC 1096, 1096a. Hunter, p. lxi. *[Rome, AD 261–3].* VF £200 ($300) / **EF** £500 ($750)

10456 D. Rev. VICTORIA AVGG, Victory stg. l., holding wreath and palm. RIC 192. RSC 1139. Hunter, p. xlii. *[Rome, AD 255–7].* **F** £100 ($150) / **VF** £265 ($400) **EF** £600 ($900)

10457 Similar, but with obv. legend C, and on reverse Victory rests on shield and holds palm. RIC 193. RSC 1142a. Hunter, p. xlii. *[Rome, AD 253–5].*
F £100 ($150) / **VF** £265 ($400) **EF** £600 ($900)

10458 C. Rev. VICTORIA GERM, Victory stg. l., holding wreath and palm, captive at feet. RIC 194. RSC 1166. Hunter, p. xlii. *[Rome, AD 253–5].*
F £120 ($180) / **VF** £300 ($450) **EF** £665 ($1,000)

10459 Obv. As 10453. Rev. VIRT GALLIENI AVG, Gallienus, in military attire, advancing r., holding spear and shield and trampling down enemy. RIC 64. RSC 1207a. Hunter, p. xlv. *[Cologne, AD 257–8].* **F** £115 ($175) / **VF** £300 ($450) **EF** £750 ($1,100)

10460 A. Rev. VIRTVS AVG, Virtus stg. l., resting on shield and spear. RIC 379. RSC 1233. Hunter, p. lxi. *[Rome, AD 261–3].* VF £200 ($300) / **EF** £500 ($750)

10461 E. Rev. — Mars (?), in military attire, stg. l., holding globe and resting on spear. Cf. RIC 380. Cf. RSC 1260. Hunter, p. lvii. *[Rome, AD 260–61].* VF £200 ($300) / **EF** £500 ($750)

10462 D. Rev. VIRTVS AVGG, Mars advancing r., carrying spear and trophy. RIC 197. RSC 1271a. Hunter, p. xliii. *[Rome, AD 255–7].*
F £100 ($150) / **VF** £265 ($400) **EF** £600 ($900)

10463 **Billon quinarius.** Similar, but with rev. type as 10460. RIC 199. RSC 1283. Hunter, p. xliii. *[Rome, AD 255–7].* **F** £100 ($150) / **VF** £265 ($400) **EF** £600 ($900)

10464 **Bronze sestertius.** IMP GALLIENVS P F AVG GERM. Rev. ANNONA AVGG S C, Annona stg. l., holding corn-ears and cornucopiae, modius at feet. RIC 204. C 62. Hunter, p. xliii. *[Rome, AD 257–8].* **F** £100 ($150) / **VF** £230 ($350) / **EF** £665 ($1,000)

10465 D. Rev. APOLINI CONSERVA S C, Apollo stg. l., holding laurel-branch and resting on lyre set on rock. RIC 205. C 67. Hunter, p. xlii. *[Rome, AD 255–7].*
 F £55 ($80) / **VF** £130 ($200) / **EF** £400 ($600)

10466

10466 C. Rev. CONCORDIA AVGG S C, clasped r. hand. RIC 208. C 126. Hunter, p. xli. *[Rome, AD 253–5].* **F** £65 ($100) / **VF** £170 ($250) / **EF** £500 ($750)

10467

10467 C. Rev. CONCORDIA EXERCIT S C, Concordia stg. l., holding patera and double cornucopiae. RIC 209. C 132. Hunter 24. *[Rome, AD 253–5].*
 F £55 ($80) / **VF** £130 ($200) / **EF** £400 ($600)

10468 D. Rev. FELICITAS AVGG S C, Felicitas stg. l., holding caduceus and cornucopiae. RIC 211. C 203. Hunter, p. xlii. *[Rome, AD 255–7].* **F** £55 ($80) / **VF** £130 ($200) / **EF** £400 ($600)

10469 C. Rev. FIDES MILITVM S C, Fides Militum stg. l., holding standard in each hand. RIC 213. C 239. Hunter 29. *[Rome, AD 253–5].* **F** £55 ($80) / **VF** £130 ($200) / **EF** £400 ($600)

10470 G. Rev. GENIVS AVG S C, Genius stg. l., holding patera and cornucopiae, standard to r. RIC 383 var. C 303 var. Hunter 147. *[Rome, AD 260–61].*
 F £80 ($120) / **VF** £200 ($300) / **EF** £600 ($900)

10471 C. Rev. IOVI CONSERVA S C, Jupiter stg. l., holding thunderbolt and sceptre. RIC 215. C 355. Cf. Hunter, p. xli. *[Rome, AD 253–5].*
 F £55 ($80) / **VF** £130 ($200) / **EF** £400 ($600)

10471

10472 **Bronze sestertius.** G. Rev. IOVI CONSERVATORI S C, as previous. RIC 384. C 373. Hunter, p. xliii. *[Rome, AD 258–61].* **F** £65 ($100) / **VF** £170 ($250) / **EF** £500 ($750)

10473 G. Rev. IOVI VLTORI S C, Jupiter advancing l., thrusting thunderbolt held in r. hand. RIC 385. C 414. Cf. Hunter, p. lvii. *[Rome, AD 258–61].*
F £80 ($120) / **VF** £200 ($300) / **EF** £600 ($900)

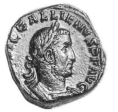

10474

10474 D. Rev. LIBERALITAS AVGG S C, Liberalitas stg. l., holding abacus and cornucopiae. RIC 221. C 572. Hunter 36. *[Rome, AD 255–7].*
F £55 ($80) / **VF** £130 ($200) / **EF** £400 ($600)

10475 C. Rev. MARTI PACIF S C, Mars, in military attire, advancing l., presenting olive-branch held in r. hand and holding spear and shield in l. RIC 225. C 610. Hunter 26. *[Rome, AD 253–5].* **F** £65 ($100) / **VF** £170 ($250) / **EF** £500 ($750)

10476 B. Rev. MONETA AVG, the three Monetae stg. l., side by side, each holding scales and cornucopiae and with pile of metal at her feet. RIC 388. C 653. Hunter —. *[Rome, AD 261–3].* **F** £130 ($200) / **VF** £300 ($450) / **EF** £900 ($1,350) *It is possible that pieces of this type and the next may be small medallions rather than sestertii (cf. RIC p. 86, note 1).*

10477 Similar, but with obv. legend G and rev. legend MONETA AVGG. RIC 227. C 664. Hunter —. *[Rome, AD 258–60].* **F** £130 ($200) / **VF** £300 ($450) / **EF** £900 ($1,350)

10478 IMP GALLIENVS P F AVG GERM. Rev. ORIENS AVGG S C, Sol stg. l., raising r. hand and holding globe in l. RIC 229. C 709. Hunter, p. xliv. *[Rome, AD 257–8].*
F £65 ($100) / **VF** £170 ($250) / **EF** £500 ($750)

10479 Similar, but Sol holds whip instead of globe. Cf. RIC 229. C 711. Hunter, p. xliii. *[Rome, AD 257–8].* **F** £65 ($100) / **VF** £170 ($250) / **EF** £500 ($750)

10480 **Bronze sestertius.** G. Rev. PAX AVG S C, Pax stg. l., holding olive-branch and transverse sceptre. RIC 390. C 734. Hunter, p. lvii. *[Rome, AD 260–61].*

F £65 ($100) / **VF** £170 ($250) / **EF** £500 ($750)

10481

10481 C. Rev. PAX AVGG S C, as previous. RIC 231. C 759. Hunter 32. *[Rome, AD 253–5].*

F £55 ($80) / **VF** £130 ($200) / **EF** £400 ($600)

10482 Obv. As 10478. Rev. P M TR P V COS III P P S C, Gallienus, togate, seated l. on curule chair, holding globe and sceptre. Cf. RIC 201. Cf. C 809. Hunter, p. xliii. *[Rome, AD 257].*

F £130 ($200) / **VF** £300 ($450) / **EF** £900 ($1,350)

10483 — Rev. RESTITVTOR ORBIS S C, Gallienus, in military attire, stg. l., raising turreted female figure kneeling r. and resting on spear. RIC 236. C 913. Hunter 39. *[Rome, AD 257–8].*

F £100 ($150) / **VF** £230 ($350) / **EF** £665 ($1,000)

10484 C. Rev. SECVRITAS AVGG S C, Securitas stg. facing, hd. r., legs crossed, r. hand on hd., holding sceptre and resting on column. RIC 237. C 970. Hunter, p. xlii. *[Rome, AD 253–5].*

F £60 ($90) / **VF** £150 ($225) / **EF** £450 ($675)

10485 D. Rev. SECVRITAS ORBIS S C, Securitas seated l., holding sceptre, her hd. propped on l. hand. Cf. RIC 240. C 973. Cf. Hunter, p. xliii. *[Rome, AD 255–7].*

F £60 ($90) / **VF** £150 ($225) / **EF** £450 ($675)

10486 B. Rev. S P Q R OPTIMO PRINCIPI in laurel-wreath. RIC 393 var. C 1000. Cf. Hunter, p. xliv. *[Rome, AD 261–3].* **F** £110 ($160) / **VF** £265 ($400) / **EF** £800 ($1,200)

10487 E, laur. and cuir. bust l. Rev. VICTORIA AVG S C, Victory advancing l., holding wreath and palm. RIC 395 var. C 1103. Hunter 149. *[Rome, AD 260–61].*

F £80 ($120) / **VF** £200 ($300) / **EF** £600 ($900)

10488 G. Rev. — Victory stg. r., l. foot on helmet, inscribing III on shield attached to palm-tree. RIC 396. C 1089. Hunter 148. *[Rome, AD 260–61].*

F £80 ($120) / **VF** £200 ($300) / **EF** £600 ($900)

10489 E. Rev. VICTORIA AVG III S C, Victory advancing, as 10487. RIC 398. C 1123. Hunter, p. lvii. *[Rome, AD 260–61].* **F** £65 ($100) / **VF** £170 ($250) / **EF** £500 ($750)

10490 C. Rev. VICTORIA AVGG S C, Victory stg. l., holding wreath and palm. RIC 243. C 1140. Hunter, p. xlii. *[Rome, AD 253–5].* **F** £55 ($80) / **VF** £130 ($200) / **EF** £400 ($600)

10491 D. Rev. — Victory stg. l., resting on shield and holding palm. RIC 242. C 1144. Hunter, p. xlii. *[Rome, AD 255–7].* **F** £55 ($80) / **VF** £130 ($200) / **EF** £400 ($600)

10492 **Bronze sestertius.** D. Rev. — Victory hovering to front, hd. l., between two shields, holding open wreath with both hands. RIC 421. C 1153. Hunter, p. xliii. *[Rome, AD 255–7].* **F** £65 ($100) / **VF** £170 ($250) / **EF** £500 ($750) *See note following no. 10391.*

10493 IMP GALLIENVS P F AVG GERM. Rev. VICTORIA GERM S C, Victory stg. l., holding wreath and palm, German captive seated at feet. RIC 245. C 1167. Hunter, p. xliv. *[Rome, AD 257–8].* **F** £65 ($100) / **VF** £170 ($250) / **EF** £500 ($750)

10494 E. Re. VIRTVS AVG S C, Mars (?), in military attire, stg. l., holding globe and resting on spear. RIC 405. C 1226. Hunter, p. lvii. *[Rome, AD 260–61].* **F** £65 ($100) / **VF** £170 ($250) / **EF** £500 ($750)

10495 C. Rev. VIRTVS AVGG S C, Virtus stg. l., resting on shield and spear. RIC 248. C 1293, 1295. Hunter 33. *[Rome, AD 253–5].* **F** £55 ($80) / **VF** £130 ($200) / **EF** £400 ($600)

10496 C. Rev. VOTIS / DECENNA / LIBVS / S C in four lines within laurel-wreath. RIC 250. C 1342. Hunter 27. *[Rome, AD 253].* **F** £80 ($120) / **VF** £200 ($300) / **EF** £600 ($900)

NB For the GENIVS P R / INT VRB S C bronze issues of Gallienus, frequenty referred to as the 'Interregnum Coinage', see nos. 10596–8.

10497 **Bronze dupondius.** D. Rev. APOLINI CONSERVA S C, Apollo resting on lyre, as 10465. RIC 251. C 68. Hunter, p. xlii. *[Rome, AD 255–7].* **F** £100 ($150) / **VF** £265 ($400) / **EF** £800 ($1,200)

10498 C. Rev. CONCORDIA AVGG S C, clasped r. hands. RIC 252. C 128. Hunter, p. xli. *[Rome, AD 253–5].* **F** £115 ($175) / **VF** £300 ($450) / **EF** £900 ($1,350)

10499 C. Rev. CONCORDIA EXERCIT S C, Concordia stg., as 10467. RIC 253. C —. Hunter, p. xli. *[Rome, AD 253–5].* **F** £100 ($150) / **VF** £265 ($400) / **EF** £800 ($1,200)

10500 D. Rev. FELICITAS AVGG S C, Felicitas stg., as 10468. RIC 254. C —. Hunter, p. xlii. *[Rome, AD 255–7].* **F** £100 ($150) / **VF** £265 ($400) / **EF** £800 ($1,200)

10501 C. Rev. LIBERALITAS AVGG S C, Liberalitas stg., as 10474. Cf. RIC 255. C —. Hunter, p. xli. *[Rome, AD 253–5].* **F** £100 ($150) / **VF** £265 ($400) / **EF** £800 ($1,200)

10502 G. Rev. PAX AVG S C, Pax stg. l., holding olive-branch and transverse sceptre. Cf. RIC 409. C 736. Hunter, p. lvii. *[Rome, AD 260–61].* **F** £115 ($175) / **VF** £300 ($450) / **EF** £900 ($1,350)

10503 Similar, but with obv. legend C and PAX AVGG S C on rev. RIC 256. C —. Hunter, p. xlii. *[Rome, AD 253–5].* **F** £100 ($150) / **VF** £265 ($400) / **EF** £800 ($1,200)

10504 C. Rev. VIRTVS AVGG S C, Virtus stg., as 10495. RIC 257. C 1296. Hunter, p. xlii. *[Rome, AD 253–5].* **F** £100 ($150) / **VF** £265 ($400) / **EF** £800 ($1,200)

10505 C. Rev. VOTIS / DECENNA / LIBVS / S C in four lines within laurel-wreath. RIC 258. C 1344. Hunter, p. xli. *[Rome, AD 253].* **F** £130 ($200) / **VF** £330 ($500) / **EF** £1,000 ($1,500)

10506 **Bronze as.** C. Rev. ADVENTVS AVGG, Valerian and Gallienus on horseback l., preceded by Victory, holding wreath and palm, and followed by soldier, holding spear and shield, standards in background. RIC 260. C 18. Hunter, p. xli. *[Rome, AD 253].* **F** £150 ($225) / **VF** £400 ($600) / **EF** £1,350 ($2,000) *The lack of S C on reverse suggests that this piece may be a small medallion rather than an as.*

10507 **Bronze as.** E, laur. hd. r., small Pegasus r. below. Rev. **ALACRITATI AVG**, Pegasus springing r. RIC 414. C 54. Hunter, p. lvi. *[Rome, AD 260–61].*
F £185 ($275) / **VF** £500 ($750) / **EF** £1,650 ($2,500)
*The Hunter Catalogue gives obverse legend **GALLIENVS AVG** in which case the date would be slighly later, circa AD 262–3.*

10508 D. Rev. **APOLLINI CONSERVA S C**, Apollo resting on lyre, as 10465. RIC 262. C 84. Hunter, p. xlii. *[Rome, AD 255–7].* **F** £55 ($80) / **VF** £130 ($200) / **EF** £400 ($600)

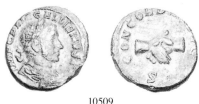

10509

10509 C. Rev. **CONCORDIA AVGG S C**, clasped r. hand. RIC 264. C 127. Hunter 23. *[Rome, AD 253–5].* **F** £65 ($100) / **VF** £170 ($250) / **EF** £500 ($750)

10510 As 10467 (rev. **CONCORDIA EXERCIT S C**, Concordia stg.). RIC 265. C 133. Hunter 25 var. *[Rome, AD 253–5].* **F** £55 ($80) / **VF** £130 ($200) / **EF** £400 ($600)

10511 As 10468 (rev. **FELICITAS AVGG S C**, Felicitas stg.). RIC 266. C 204. Hunter, p. xlii. *[Rome, AD 255–7].* **F** £55 ($80) / **VF** £130 ($200) / **EF** £400 ($600)

10512 E. Rev. **FIDES MILITVM S C**, Fides Militum stg. l., holding standard in each hand. RIC 267. C 241. Cf. Hunter, p. lx. *[Rome, AD 260–61].*
F £65 ($100) / **VF** £170 ($250) / **EF** £500 ($750)

10513 A, laur. hd. l. Rev. **FIDES MILITVM** in laurel-wreath. RIC 267. C 241. Cf. Hunter, p. lx. *[Rome, AD 262–3].* **F** £100 ($150) / **VF** £230 ($350) / **EF** £665 ($1,000)

10514 E. Rev. **INDVLGENT AVG S C**, Indulgentia seated l., holding branch and sceptre. Cf. RIC 418. C 328 var. Cf. Hunter, p. lxii. *[Rome, AD 260–61].*
F £65 ($100) / **VF** £170 ($250) / **EF** £500 ($750)

10515 A. Rev. **IOVI VLTORI S C**, Jupiter advancing to front, looking r., thunderbolt in raised r. hand, l. at side. RIC 420. C 411. Hunter, p. lx. *[Rome, AD 261–2].*
F £65 ($100) / **VF** £170 ($250) / **EF** £500 ($750)

10516 **IMP GALLIENVS PIVS FELIX AVG.** Rev. **LAETITIA AVG S C**, Laetitia stg. l., holding wreath and anchor. RIC 421. C 432. Hunter, p. lvii. *[Rome, AD 260–61].*
F £65 ($100) / **VF** £170 ($250) / **EF** £500 ($750)

10517 D. Rev. **LIBERALITAS AVGG III S C**, Liberalitas stg. l., holding abacus and cornucopiae. RIC 272. Cf. C 582 (misdescribed). Hunter, p. xliii. *[Rome, AD 256].*
F £65 ($100) / **VF** £170 ($250) / **EF** £500 ($750)

10518 A. Rev. **MARTI PACIFERO S C**, Mars, in military attire, stg. l., holding olive-branch and resting on shield, spear propped against l.arm. RIC 422. C 621. Hunter, p. lxiii. *[Rome, AD 261–2].* **F** £80 ($120) / **VF** £200 ($300) / **EF** £600 ($900)

10519 **Bronze as.** GALLIENVM AVG P R. Rev. OB CONSERVATIONEM SALVTIS, Salus stg. r., feeding snake held in her arms. Cf. RIC 423. C 674. Cf. Hunter, p. lx. *[Rome, AD 264].*
 F £185 ($275) / **VF** £500 ($750) / **EF** £1,650 ($2,500)

10520 GALLIENVM AVG SENATVS, laur. and dr. bust l. Rev. OB LIBERTATEM RECEPTAM, Libertas stg. l., holding pileus and transverse sceptre. RIC 424. C 679. Hunter, p. lx. *[Rome, AD 264].* F £185 ($275) / **VF** £500 ($750) / **EF** £1,650 ($2,500)

10521 IMP GALLIENVS P F AVG GERM. Rev. ORIENS AVGG S C, Sol stg. l., raising r. hand and holding whip in l. RIC 273. C 712. Hunter, p. xliii. *[Rome, AD 257–8].*
 F £65 ($100) / **VF** £170 ($250) / **EF** £500 ($750)

10522 A. Rev. PAX AVG S C, Pax stg. l., holding olive-branch and transverse sceptre. RIC 428. C 737. Hunter, p. lx. *[Rome, AD 261–2].* F £65 ($100) / **VF** £170 ($250) / **EF** £500 ($750)

10523 Obv. As 10521. Rev. PAX AVGG S C, as previous. RIC 275. C 761. Hunter, p. xliii. *[Rome, AD 257–8].* F £65 ($100) / **VF** £170 ($250) / **EF** £500 ($750)

10524 Obv. As 10520, but wearing imperial mantle. Rev. P M TR P XII COS VI P P, Gallienus in slow quadriga l., holding eagle-tipped sceptre. Cf. RIC 412. C 841. Hunter 145. *[Rome, AD 264].* F £185 ($275) / **VF** £500 ($750) / **EF** £1,650 ($2,500)

10525 B. Rev. SECVRIT ORBIS S C, Securitas seated l., holding sceptre, her hd. propped on l. hand. RIC 432. C 955. Hunter, p. lix. *[Rome, AD 261–2].*
 F £80 ($120) / **VF** £200 ($300) / **EF** £600 ($900)

10526 A. Rev. SECVRITAS AVG, Securitas stg. facing, hd. l., her legs crossed, holding sceptre and resting l. arm on column. RIC 431. C 967. Hunter, p. lx. *[Rome, AD 261–2].*
 F £65 ($100) / **VF** £170 ($250) / **EF** £500 ($750)

10527 B. Rev. VICTORIA AVG III, Victory advancing l., holding wreath and palm. Cf. RIC 434. C 1126. Hunter, p. lix. *[Rome, AD 261–2].* F £65 ($100) / **VF** £170 ($250) / **EF** £500 ($750)

10528 As 10491 (rev. VICTORIA AVGG S C, Victory resting on shield). RIC 280. C 1145. Hunter, p. xlii. *[Rome, AD 255–7].* F £55 ($80) / **VF** £130 ($200) / **EF** £400 ($600)

10529 G. Rev. VICTORIA GERM S C, Victory stg. l., holding wreath and palm, German captive at feet. RIC 436. C 1171. Hunter 146. *[Rome, AD 260–61].*
 F £80 ($120) / **VF** £200 ($300) / **EF** £600 ($900)

10530 As 10494 (rev. VIRTVS AVG S C, Mars (?) stg. l., with globe and spear). RIC 439. C 1227. Hunter, p. lvii. *[Rome, AD 260–61].* F £65 ($100) / **VF** £170 ($250) / **EF** £500 ($750)

10531 As 10495 (rev. VIRTVS AVGG S C, Virtus stg. l.). RIC 286. C 1294. Hunter 35. *[Rome, AD 253–5].* F £55 ($80) / **VF** £130 ($200) / **EF** £400 ($600)

10532 As 10496 (rev. VOTIS DECENNALIBVS S C in laurel-wreath). RIC — (omitted in error). C 1343. Hunter 28. *[Rome, AD 253].* F £80 ($120) / **VF** £200 ($300) / **EF** £600 ($900)

10533 Similar, but with obv. legend E. RIC 441. C 1347. Hunter 150. *[Rome, AD 261].*
 F £80 ($120) / **VF** £200 ($300) / **EF** £600 ($900)

For the so-called 'Interregnum Coinage' of Gallienus, see nos. 10596–8.

Alexandrian Coinage

10534 **Billon tetradrachm.** A K Π ΛI OV ΓΑΛΛIHNOC (or ΓΑΛIHNOC) EV EV C, laur., dr. and
cuir. bust r. Rev. Alexandria, turreted, stg. l., her r. hand raised, holding sceptre in l., L — A
(= regnal year 1) in field. Dattari 5191. BMCG 2216. Cologne —. Milne 3872.
[AD 253–4]. **F** £14 ($20) / **VF** £40 ($60) / **EF** £80 ($120)

10535 Obv. Similar. Rev. Elpis (= Spes) advancing l., holding flower and lifting skirt, L — A
(= regnal year 1) in field. Dattari 5198. BMCG 2178. Cologne 2881. Milne 3868.
[AD 253–4]. **F** £10 ($15) / **VF** £32 ($50) / **EF** £65 ($100)

10536

10536 — Rev. Eagle stg. l., hd. r., its wings closed, holding wreath in beak, L — A (= regnal year
1) in field. Dattari 5218. BMCG 2217. Cologne 2880. Milne 3874. *[AD 253–4].*
F £10 ($15) / **VF** £32 ($50) / **EF** £65 ($100)

10537 — Rev. Nike (= Victory) advancing r., holding wreath with both hands, palm over l.
shoulder, L — B (= regnal year 2) in field. Dattari —. BMCG —. Cologne —. Milne —.
Emmett 3737 = Curtis 1533. *[AD 254–5].* **F** £25 ($40) / **VF** £65 ($100) / **EF** £130 ($200)

10538 — Rev. Laur bust of Zeus r., L — Γ (= regnal year 3) in field. Dattari 5215. BMCG 2151.
Cologne 2890. Milne 3886. *[AD 255–6].* **F** £15 ($22) / **VF** £50 ($75) / **EF** £100 ($150)

10539 — Rev. Eirene (= Pax) stg. l., holding olive-branch and sceptre, L Γ (= regnal year 3)
before. Dattari 5197. BMCG 2176. Cologne 2885. Milne 3895. *[AD 255–6].*
F £10 ($15) / **VF** £32 ($50) / **EF** £65 ($100)

10540 — Rev. Homonoia (= Concordia) seated l., her r. hand raised, holding double cornucopiae
in l., L Γ (= regnal year 3) before. Dattari 5204. BMCG 2189. Cologne 2887. Milne 3907.
[AD 255–6]. **F** £10 ($15) / **VF** £32 ($50) / **EF** £65 ($100)

10541 — Rev. Nike (= Victory) stg. facing, hd. l., wings open, holding wreath and palm, L Γ (=
regnal year 3) in field to l. Dattari 5205. BMCG —. Cologne 2888. Milne 3912.
[AD 255–6]. **F** £10 ($15) / **VF** £32 ($50) / **EF** £65 ($100)

10542 — Rev. Similar to 10536, but the eagle's wings are open, L — Γ (= regnal year 3) in field.
Dattari 5224. BMCG 2218. Cologne 2884. Milne 3917. *[AD 255–6].*
F £10 ($15) / **VF** £32 ($50) / **EF** £65 ($100)

10543 — Rev. Rad. bust of Helios r., L — Δ (= regnal year 4) in field. Dattari 5200. BMCG 2155.
Cologne 2892. Milne 3920. *[AD 256–7].* **F** £15 ($22) / **VF** £50 ($75) / **EF** £100 ($150)

10544 — Rev. Tyche (= Fortuna) seated l., holding rudder and cornucopiae, L Δ (= regnal year 4)
before. Dattari 5212. BMCG 2201. Cologne 2895. Milne 3939. *[AD 256–7].*
F £10 ($15) / **VF** £32 ($50) / **EF** £65 ($100)

10545 **Billon tetradrachm.** A K Π ΛΙ OV ΓΑΛΛΙΑΝΟC (*sic*) EV EV C, laur., dr. and cuir. bust r.
Rev. Nike seated l. on cuirass, holding wreath and palm, L E (= regnal year 5) before.
Dattari 5168. BMCG 2197. Cologne —. Milne 3967. *[AD 257–8].*
 F £10 ($15) / **VF** £32 ($50) / **EF** £65 ($100)

10546 Obv. Similar. Rev. Nike (= Victory) advancing r., holding wreath and palm, L — ϛ regnal
year 6) in field. Dattari —. BMCG 2194. Cologne —. Milne 3995. *[AD 258–9].*
 F £10 ($15) / **VF** £32 ($50) / **EF** £65 ($100)

10547 — Rev. Alexandria, turreted, stg. l., holding bust of Sarapis r. in r. hand and sceptre in l., L
— Z (= regnal year 7) in field. Dattari 5194. BMCG —. Cologne 2903. Milne 4028.
[AD 259–60]. F £14 ($20) / **VF** £40 ($60) / **EF** £80 ($120)

10548 AYT K Π ΛΙΚ ΓΑΛΛΙΗΝΟC CEB, laur. and cuir. bust r. Rev. Eagle stg. l., its wings open,
holding wreath in beak, L H (= regnal year 8) before. Dattari 5290. BMCG 2232. Cologne
—. Milne 4061. *[AD 260–61].* F £10 ($15) / **VF** £32 ($50) / **EF** £65 ($100)

10549 Obv. Similar. Rev. Asklepios stg. l., sacrificing from patera over altar and resting on snake-
entwined staff, L Θ (= regnal year 9) before. Dattari 5227. BMCG 2174. Cologne —.
Milne —. *[AD 261–2].* F £15 ($22) / **VF** £50 ($75) / **EF** £100 ($150)

10550 — Rev. Conjoined busts r. of Sarapis, wearing modius, and Isis, wearing disk and plumes,
L — Θ (= regnal year 9) in field. Dattari 5263. BMCG —. Cologne —. Milne —.
[AD 261–2]. F £32 ($50) / **VF** £80 ($120) / **EF** £170 ($250)

10551 — Rev. Dikaiosyne (= Aequitas) stg. l., holding scales and double-cornucopiae, L — Θ
(= regnal year 9) in field. Dattari —. BMCG 2175. Cologne —. Milne —. *[AD 261–2].*
 F £20 ($30) / **VF** £60 ($90) / **EF** £115 ($175)

10552

10552 — Rev. Eagle stg. l., its wings closed, holding wreath in beak, palm-branch transversely in
background, L — HA (= regnal year 9) in field. Dattari 5287. BMCG —. Cologne 2906.
Milne 4063. *[AD 261–2].* F £14 ($20) / **VF** £40 ($60) / **EF** £80 ($120)

10553 — Rev. Athena seated l., holding Nike and resting on sceptre, shield with Gorgon's hd. at
side, L behind, ENATOV (= regnal year 9) before. Dattari 5230. BMCG 2169. Cologne —.
Milne 4067. *[AD 261–2].* F £14 ($20) / **VF** £40 ($60) / **EF** £80 ($120)

10554 — Rev. Bust of Sarapis l., wearing ornamented modius, sceptre and L behind, ENATOV (=
regnal year 9) before. Dattari 5260. BMCG 2208. Cologne 2911. Milne 4069. *[AD 261–2].*
 F £20 ($30) / **VF** £60 ($90) / **EF** £115 ($175)

10555 — Rev. Trophy, at base of which two captives seated on r., one on l., L to r., ENATOV
(= regnal year 9) to l. Dattari 5274. BMCG 2239. Cologne 2912. Milne 4073. *[AD 261–2].*
 F £32 ($50) / **VF** £80 ($120) / **EF** £170 ($250)

10556 AYT K Π ΛΙΚ ΓΑΛΛΙΗΝΟC CEB, laur., dr. and cuir. bust r. Rev. Bust of Isis r., wearing disk
and plumes, L — I (= regnal year 10) in field. Dattari —. BMCG 2212. Cologne —. Milne
—. *[AD 262–3].* F £32 ($50) / **VF** £80 ($120) / **EF** £170 ($250)

10557 **Billon tetradrachm.** Obv. Similar. Rev. Bust of Nilus l., crowned with lotus, cornucopiae at l. shoulder, L I (= regnal year 10) before. Dattari —. BMCG —. Cologne —. Milne —. Emmett 3825 = Curtis 1613A. *[AD 262–3].* **F** £45 ($65) / **VF** £50 ($150) / **EF** £200 ($300)

10558 — Rev. Nilus reclining l., L I (= regnal year 10) in field. Dattari —. BMCG —. Cologne —. Milne —. Emmett 3826 (ANS). *[AD 262–3].*
F £45 ($65) / **VF** £50 ($150) / **EF** £200 ($300)

10559 — Rev. Bust of Sarapis Pantheos r., combining the attributes of various deities, including Helios (rad. crown) as well as Sarapis himself (modius), L I (= regnal year 10) in field. Dattari —. BMCG/Christiansen 3297. Cologne —. Milne —. Emmett 3833 (ANS). *[AD 262–3].* **F** £45 ($65) / **VF** £50 ($150) / **EF** £200 ($300)

10560 — Rev. Gallienus on horseback r., L I (= regnal year 10) in field. Dattari —. BMCG/Christiansen 3321. Cologne —. Milne —. *[AD 262–3].*
F £50 ($75) / **VF** £115 ($175) / **EF** £230 ($350)

10561 — Rev. L I (= regnal year 10) within laurel-wreath. Dattari —. BMCG —. Cologne —. Milne —. Emmett 3839. *[AD 262–3].* **F** £45 ($65) / **VF** £50 ($150) / **EF** £200 ($300)
This type and the next commemorate the 10th anniversary of Gallienus' reign.

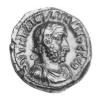

10562

10562 — Rev. ΔEKA / ETHPI / C KV / PIOV in four lines within laurel-wreath, L I (= regnal year 10) below. Cf. Dattari 5273. BMCG 2240. Cologne 2915. Milne 4081. *[AD 262–3].*
F £20 ($30) / **VF** £60 ($90) / **EF** £115 ($175)

10563 — Rev. Ares, in military attire, stg. r., resting on spear and shield, trophy before him with two captives seated at base, L IA (= regnal year 11) in ex. Dattari 5226. BMCG 2172. Cologne —. Milne (Supplement) 4097a. *[AD 263–4].*
F £32 ($50) / **VF** £80 ($120) / **EF** £170 ($250)

10564 — Rev. Canopus of Osiris l., L IA (= regnal year 11) in field. Dattari —. BMCG —. Cologne —. Milne —. Emmett 3799. *[AD 263–4].*
F £45 ($65) / **VF** £50 ($150) / **EF** £200 ($300)

10565 — Rev. Sarapis, as fountain-god, stg. l., dipping simpulum into bowl at his feet, water-spout in form of lion's head to l., palm to r., L — IA (= regnal year 11) in field. Dattari 5262. BMCG —. Cologne —. Milne —. *[AD 263–4].*
F £45 ($65) / **VF** £50 ($150) / **EF** £200 ($300)

10566 — Rev. Statue of Sarapis stg. facing on pedestal, his r. hand raised , holding sceptre in l., between facing stg. figures of Ares on l., hd. r., wearing military attire and resting on spear and shield, and Nike on r., hd. l., holding wreath and palm, L IA (= regnal year 11) in ex. Dattari —. BMCG 2211. Cologne 2918. Milne 4097. *[AD 263–4].*
F £45 ($65) / **VF** £50 ($150) / **EF** £200 ($300)

10567 **Billon tetradrachm.** — Rev. Dikaiosyne seated l., holding scales and cornucopiae, L IA (= regnal year 11) before. Dattari —. BMCG —. Cologne —. Milne —. Emmett 3801. *[AD 263–4].* **F** £25 ($40) / **VF** £65 ($100) / **EF** £130 ($200)

10568 — Rev. Tyche (= Fortuna) stg. l., holding rudder and cornucopiae, L IA (retrograde = regnal year 11) before. Dattari 5267. BMCG 2200. Cologne 2919. Milne 4092. *[AD 263–4].* **F** £10 ($15) / **VF** £32 ($50) / **EF** £65 ($100)

10569 — Rev. Tyche (= Fortuna) reclining l. on couch, holding rudder, L IA (= regnal year 11) before. Dattari —. BMCG 2203. Cologne —. Milne —. *[AD 263–4].*
 F £14 ($20) / **VF** £40 ($60) / **EF** £80 ($120)

10570

10570 — Rev. Eagle stg. r., its wings open, holding wreath in beak, L IA (= regnal year 11) before. Dattari 5289. BMCG 2234. Cologne 2916. Milne 4095. *[AD 263–4].*
 F £10 ($15) / **VF** £32 ($50) / **EF** £65 ($100)

10571 ΑΥΤ Κ Π ΛΙΚ ΓΑΛΛΙΗΝΟC CEB, laur. and cuir. bust r. Rev. Athena stg. facing, hd. l., resting on sceptre and shield with Gorgon's hd., L IB (= regnal year 12) to l., palm to r. Dattari 5228. BMCG 2166. Cologne 2922. Milne 4098. *[AD 264–5].*
 F £14 ($20) / **VF** £40 ($60) / **EF** £80 ($120)

10572 Obv. Similar. Rev. Homonoia (= Concordia) seated l., r. hand raised, holding double cornucopiae in l., L IB (= regnal year 12) before, palm behind. Dattari 5249. Cf. BMCG 2190. Cologne 2923. Milne 4107. *[AD 264–5].*
 F £14 ($20) / **VF** £40 ($60) / **EF** £80 ($120)

10573 — Rev. Nike (= Victory) advancing r., holding wreath and palm, L IB (= regnal year 12) before, palm behind. Dattari —. BMCG —. Cologne 2924. Milne —. *[AD 264–5].*
 F £20 ($30) / **VF** £60 ($90) / **EF** £115 ($175)

10574 — Rev. Tyche (= Fortuna) seated l., holding rudder and cornucopiae, L IB (= regnal year 12) before, palm behind. Dattari 5268. BMCG 2202. Cologne 2925. Milne 4108. *[AD 264–5].* **F** £14 ($20) / **VF** £40 ($60) / **EF** £80 ($120)

10575 — Rev. Eagle stg. facing, hd. l., supporting open laurel-wreath on its outspread wings, L IB (= regnal year 12) above eagle's hd., palm to r. Dattari 5291. BMCG 2237. Cologne 2921. Milne 4110. *[AD 264–5].* **F** £14 ($20) / **VF** £40 ($60) / **EF** £80 ($120)

10576 ΑΥΤ Κ Π ΛΙΚ ΓΑΛΛΙΗΝΟC CEB, laur., dr. and cuir. bust r. Rev. Eirene (= Pax) stg. l., holding olive-branch and transverse sceptre, L IΓ (= regnal year 13) before, palm behind. Dattari 5236. BMCG 2177. Cologne 2929. Milne 4114. *[AD 265–6].*
 F £10 ($15) / **VF** £32 ($50) / **EF** £65 ($100)

10577 **Billon tetradrachm.** Obv. Similar. Rev. Eagle stg. r., its wings closed, holding wreath in beak, palm-branch transversely in background, L — IΓ (= regnal year 13) in field. Dattari 5288. BMCG 2236. Cologne 2928. Milne 4119. *[AD 265–6].*
F £10 ($15) / **VF** £32 ($50) / **EF** £65 ($100)

10578 Obv. As 10571. Rev. Bust of Sarapis r., wearing ornamented modius, palm before., L / I – Δ (= regnal year 14) in field. Dattari 5261. BMCG 2209. Cologne 2940. Milne 4141. *[AD 266–7].*
F £15 ($22) / **VF** £50 ($75) / **EF** £100 ($150)

10579 — Rev. Bust of Selene r., wearing taenia, large lunar crescent and palm before, L IΔ (= regnal year 14) behind. Cf. Dattari 5264 (palm omitted). BMCG 2161. Cologne 2941. Milne 4125. *[AD 266–7].*
F £15 ($22) / **VF** £50 ($75) / **EF** £100 ($150)

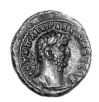

10580

10580 — Rev. Homonoia (= Concordia) stg. l., r. hand raised, holding double cornucopiae in l., L IΔ (= regnal year 14) before, palm behind. Dattari 5246. BMCG 2186. Cologne 2937. Milne 4136. *[AD 266–7].*
F £10 ($15) / **VF** £32 ($50) / **EF** £65 ($100)

10581 — Rev. Nike (= Victory) advancing r., holding wreath with both hands, palm diagonally in background, L IΔ (= regnal year 14) before. Cf. Dattari 5254 (L IA). BMCG 2196. Cologne 2938. Milne 4137. *[AD 266–7].*
F £14 ($20) / **VF** £40 ($60) / **EF** £80 ($120)

10582 — Rev. Eagle stg. l., hd. r., its wings closed, holding wreath in beak, palm to r., L IΔ (= regnal year 14) to l. Dattari 5283. BMCG 2227. Cologne 2932. Milne 4145. *[AD 266–7].*
F £10 ($15) / **VF** £32 ($50) / **EF** £65 ($100)

10583 Obv. As 10576. Rev. Serpent Agathodaemon r., wearing skhent, palm before, L IE (= regnal year 15) behind. Dattari 5275. BMCG 2238. Cologne 2945. Milne 4192. *[AD 267–8].*
F £20 ($30) / **VF** £60 ($90) / **EF** £115 ($175)

10584 Obv. As 10571. Rev. Athena seated l., holding Nike and resting on sceptre, cuirass at side, palm behind, L / IE (= regnal year 15) before. Dattari 5232. BMCG 2171. Cologne 2946. Milne 4159. *[AD 267–8].*
F £14 ($20) / **VF** £40 ($60) / **EF** £80 ($120)

10585 Obv. As 10576. Rev. Canopus of Osiris r., palm before, L IE (= regnal year 15) behind. Dattari 5235. BMCG 2215. Cologne 2947. Milne 4185. *[AD 267–8].*
F £20 ($30) / **VF** £60 ($90) / **EF** £115 ($175)

10586 Obv. As 10571. Rev. Harpocrates of Pelusium, wearing hemhem crown, stg. facing, hd. r., holding branch and pomegranate, dancing figure of Paniskos at his feet to l., palm to r., L I LI–E (= regnal year 15) in field. Dattari 5237. BMCG 2213. Cologne 2948. Milne 4173. *[AD 267–8].*
F £32 ($50) / **VF** £80 ($120) / **EF** £170 ($250)

10587 — Rev. Rad. bust of Helios r., palm before, L–IE (= regnal year 15) in field. Dattari 5235. BMCG 2215. Cologne 2947. Milne 4185. *[AD 267–8].*
F £15 ($22) / **VF** £50 ($75) / **EF** £100 ($150)

10588 **Billon tetradrachm.** — Rev. Hermes stg. l., resting r. hand on hip and holding caduceus in
l., palm behind, L I / E (= regnal year 15) before. Dattari —. BMCG 2173. Cologne —.
Milne 4160. *[AD 267–8].* **F** £20 ($30) / **VF** £60 ($90) / **EF** £115 ($175)

10589 — Rev. Poseidon stg. l., r. foot on dolphin, holding uncertain object in r. hand and resting
on trident held in l., palm behind, L I / E (= regnal year 15) before. Dattari —. BMCG 2173.
Cologne —. Milne 4160. *[AD 267–8].* **F** £20 ($30) / **VF** £60 ($90) / **EF** £115 ($175)

10590 Obv. As 10576. Rev. Nike (= Victory) advancing l., holding wreath and palm, LI—E
(= regnal year 15) in field. Dattari 5257. BMCG 2195. Cologne 2951. Milne 4183.
[AD 267–8]. **F** £14 ($20) / **VF** £40 ($60) / **EF** £80 ($120)

10591 Obv. As 10571. Rev. Two Nikai stg. facing each other, holding between them shield
inscribed L IE (= regnal year 15), palm in ex. Dattari 5258. BMCG 2198. Cologne 2952.
Milne 4168. *[AD 267–8].* **F** £15 ($22) / **VF** £50 ($75) / **EF** £100 ($150)

10592 — Rev. Eagle stg. r., hd. l., its wings closed, holding wreath in beak, palm to l., L IE (=
regnal year 15) to right. Dattari 5285. BMCG 2230. Cologne 2942. Milne 4175.
[AD 267–8]. **F** £10 ($15) / **VF** £32 ($50) / **EF** £65 ($100)

10593

10593 **Bronze hemidrachm** (28–32 mm. diam). Obv. As 10571. Rev. Eirene (= Pax) stg. l.,
holding olive-branch and transverese sceptre, palm behind, L IB (= regnal year 12) before.
Dattari 5292. BMCG —. Cologne 2927. Milne —. *[AD 264–5].*
F £130 ($200) / **VF** £300 ($450)

NB This exceptional issue of large bronzes all belongs to the twelfth regnal year of
Gallienus (August 264 to August 265). Like the similar issues of Severus Alexander and
Philip I it is undoubtedly commemorative, though the precise occasion being celebrated is
difficult to determine.

10594 — Rev. Homonoia (= Concordia) stg. l., r. hand raised, holding double cornucopiae in l.,
palm behind, L IB (= regnal year 12) before. Dattari 5293. BMCG —. Cologne —. Milne —.
[AD 264–5]. **F** £130 ($200) / **VF** £300 ($450)

10595 — Rev. Eagle stg. l., hd. r., its wings closed, holding wreath in beak, palm to l., L IB (=
regnal year 12) to r. Dattari 5294. BMCG 2241. Cologne 2926. Milne 4112. *[AD 264–5].*
F £120 ($180) / **VF** £265 ($400)

For other local coinages of Gallienus, see *Greek Imperial Coins & Their Values*, pp. 438–49.

THE 'INT VRB' COINAGE OF GALLIENUS

This enigmatic series of aes, comprising two denominations (possibly double sestertii and sestertii), has been variously interpreted as belonging to the sole reign of Gallienus or to the possible interregnum between the assassination of Aurelian and the accession of Tacitus in AD 275. As the head of the Genius of the Roman People normally bears a marked resemblance to the later portraits of Gallienus, and the fabric and metrology of the coins themselves are more appropriate to the 260s than the 270s, it seems possible that they were produced in anticipation of Gallienus' triumphal entry into the City of Rome (INTROITVS VRBIS or INTRATA VRBE) in 268, following his victory over the Herulians and Goths at Naqssus in the Balkans. With the emperor's murder outside Milan, where he was besieging the rebel general Aureolus, the reason for the coinage disappeared and production would have been abruptly terminated. For a detailed study of this series, see the article by David Yonge "The So-Called Interregnum Coinage" (Numismatic Chronicle 1979, pp. 47–60 and plates 8–11).

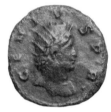

10596

10596 **Bronze double sestertius?** GENIVS P R, rad. bust of the Genius of the Roman People r., wearing mural crown, sometimes with light drapery on l. shoulder, the facial features usually resembling Gallienus. Rev. INT VRB above and below S C, all within laurel-wreath. RIC, p. 361, 2–3. C Gallienus 334–5. Hunter, p. 65, 1. [Rome, AD 268].
F £170 ($250) / VF £430 ($650)

10597 Similar, but without INT VRB on rev. RIC —. C *Gallienus* 946–7. Hunter —. *[Rome, AD 268].*
F £200 ($300) / VF £500 ($750)

10598 **Bronze sestertius?** As 10596, but Genius is laur. instead of rad. RIC, p. 361, 1. C *Gallienus* 333. Hunter, p. 65, 2. *[Rome, AD 268].*
F £200 ($300) / VF £500 ($750)

GALLIENUS AND SALONINA

The occasion for these exceptional issues may have been the celebration of Gallienus' decennalia or tenth anniversary of rule.

10599 **Gold binio.** CONCORDIA AVGG, conjoined dr. busts r. of Gallienus, rad., and Salonina, diad. and with crescent behind shoulders. Rev. LAETITIA AVG, Laetitia stg. l., holding wreath and anchor. RIC p. 191, 1. C —. Cf. Hunter, p. lxxi. [Rome, AD 262–3].
VF £10,000 ($15,000) / EF £20,000 ($30,000)

10600 Obv. Similar. Rev. VICT GAL AVG, three Victories stg. side by side, each holding wreath and palm, RIC p. 191, 3. Cf. C 14. Cf. Hunter, pp. lxxi-lxxii. *[Rome, AD 262–3].*
VF £10,000 ($15,000) / EF £20,000 ($30,000)

10601 **Gold aureus.** CONCORDIA AVGG, laur. and cuir. bust of Gallienus l., facing diad. and dr. bust of Salonina r. Rev. SALONINA AVG, diad. and dr. bust of Salonina r. RIC p. 191, 2. C 10. Cf. Hunter, pp. lxxi-lxxii. *[Rome, AD 262–3].* VF £8,000 ($12,000) / EF £16,500 ($25,000)

10602 **Billon antoninianus.** GALLIENVS AVG, rad. hd. r. Rev. SALONINA AVG, diad. and dr. bust r., crescent behind shoulders. RIC p. 191, 4. RSC 11. Hunter, p. lxxii. *[Rome, AD 262–3].*
VF £500 ($750) / EF £1,000 ($1,500)

10603 **Billon denarius.** Obv. As 10599. Rev. FELICITATIS, Victory seated l., Salonina (?) and two children at her feet, another child by chair. RIC p. 191, 6. RSC 5a. Cf. Hunter, p. lxxi. *[Rome, AD 262–3].*
VF £1,200 ($1,800) / EF £2,300 ($3,500)
As the first six letters of the rev. legend on the specimen of this type in the British Museum are not legible there would seem to be a possibility that the correct reading is PIETATIS and the seated figure is Pietas rather than Victory.

Issues of Valerian and Gallienus in honour of Divus Valerian Junior

Following the death in AD 258 of Gallienus' elder son, the Caesar P. Cornelius Licinius Valerianus, a small commemorative coinage was issued in honour of his deification. He was, in fact, the only member of his family to be ranked among the gods.

10604 **Gold aureus.** DIVO CAES VALERIANO, bare-headed and dr. bust of Valerian Junior r. Rev. CONSECRATIO, eagle stg. l., hd. r. Cf. RIC 7. C —. Hunter, p. li. [Rome, AD 258].
VF £6,700 ($10,000) / EF £16,500 ($25,000)

10605

10605 **Billon antoninianus.** DIVO VALERIANO CAES, rad. and dr. bust of Valerian Junior r. Rev. CONSACRATIO, as previous. RIC 8. RSC 2. Hunter, p. li. *[Cologne, AD 258].*
VF £22 ($35) / EF £65 ($100)

10606 10608

10606 Obv. Similar. Rev. — Valerian Junior, his r. hand raised and holding sceptre in l., seated l. on back of eagle soaring r. RIC 9. RSC 5. Hunter 7. *[Cologne, AD 258].*
VF £30 ($45) / EF £80 ($120)

10607 — Rev. — pyramidal crematorium of four storeys, with garlanded base, surmounted by prince in quadriga facing. RIC 10. RSC 6. Hunter, p. li. *[Cologne, AD 258].*
VF £38 ($55) / EF £100 ($150)

10608 DIVO CAES VALERIANO, rad., dr. and cuir. bust of Valerian Junior r. Rev. CONSECRATIO, altar-enclosure with double panelled door, horns visible above on either side , flames rising from top of altar. RIC 24. RSC 13. Hunter 2. *[Rome, AD 258].*
VF £22 ($35) / EF £65 ($100)

10609 **Billon quinarius.** DIVO CAES VALERIANO, bare hd. of Valerian Junior r. Rev. CONSECRATIO, eagle, as 10604. RIC 31. RSC 10. Hunter, p. li. *[Rome, AD 258].*
F £200 ($300) / **VF** £500 ($750)

10610 **Bronze sestertius.** DIVO CAES VALERIANO, bare-headed, dr. and cuir. bust r. Rev. CONSECRATIO S C, similar to 10607, but the crematorium has five storeys. RIC 35. C (Saloninus) 17. Hunter 6. *[Rome, AD 258].*
F £200 ($300) / **VF** £500 ($750)

10611 **Bronze dupondius** or **as.** Similar, but with obv. type bare head of Valerian Junior r. RIC 43. C (Saloninus) 18. Hunter, p. li. *[Rome, AD 258].*
F £170 ($250) / **VF** £400 ($600)

10612 DIVO CAESARI VALERIANO, bare head of Valerian Junior r. Rev. CONSECRATIO, eagle bearing prince aloft, as 10606. Cf. RIC 41, 42. C (Saloninus) 11. Hunter, p. li. *[Rome, AD 258].*
F £170 ($250) / **VF** £400 ($600)

For the lifetime issues of Valerian Junior struck while he was Caesar under Valerian and Gallienus (AD 256–8), see nos. 10727–49.

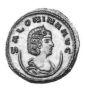

SALONINA

10625

Cornelia Salonina, known also as Chrysogone ('begotten of gold') was of Greek origin and had been married to Gallienus since early in the reign of Gordian III. She was the mother of the Caesars Valerian Junior and Saloninus, both of whom were destined to perish during their parents' lifetimes. Salonina's Alexandrian coinage commences only during regnal year three (AD 255–6) and this may be the date of her elevation to the rank of Augusta. A woman of sophistication and learning, she and her husband were both members of the philosopher Plotinus' circle of intellectuals in Rome and it is possible that she also had Christian sympathies. In AD 268 the empress was probably a witness to her husband's murder during the siege of Milan and her subsequent fate is unknown. An extensive coinage was issued in Salonina's name, both during the joint reign of Valerian and Gallienus and throughout the period of her husband's sole rule. It was on a larger scale than for any empress since the time of Julia Domna, wife of Septimius Severus.
There are three principal varieties of obverse legend. The more abbreviated forms are generally employed on the gold and billon denominations, the longest on bronzes:

A. CORN SALONINA AVG
B. CORNELIA SALONINA AVG
C. SALONINA AVG

The normal obverse type is diademed and draped bust of Salonina right. Antoniniani and dupondii also have a crescent behind the shoulders.
* RIC and Hunter have two separate listings for the coinage of Salonina, one for the issues of the period of the joint reign of Valerian and Gallienus, the other for those of the period of her husband's sole reign. For issues up to AD 260 the RIC numbers refer to the listing commencing on p. 108, and the Hunter numbers refer to the listing commencing on p. 24. For issues from AD 260–268 the RIC listing commences on p. 192 and the Hunter listing on p. 60.*

10613 **Gold aureus.** C. Rev. DEAE SEGETIAE, Dea Segetia, nimbate, stg. facing in tetrastyle temple, both hands raised. RIC 1. C 35. Hunter, p. xlix. *[Cologne, AD 259–60]*.
VF £5,000 ($7,500) / **EF** £10,000 ($15,000)
Segetia was a goddess of crops and fertility.

10614 C. Rev. FECVNDITAS AVG, Fecunditas stg. r., holding child on l. arm and extending r. hand to another child at her feet. RIC 15. C 42. Hunter, p. xlix. *[Rome, AD 257–60]*.
VF £2,700 ($4,000) / **EF** £6,000 ($9,000)
This type is often described as a 'quinarius' because the published specimens have tended to be of lower than average weight. It is almost certainly an aureus.

10615

10615 C. Rev. FELICITAS PVBLICA, Felicitas seated l., holding caduceus and cornucopiae. RIC 2. C 49. Hunter, p. xlix. *[Cologne, AD 257–9]*. VF £2,700 ($4,000) / **EF** £6,000 ($9,000)

10616 A. Rev. IVNO REGINA, Juno stg. l., holding patera and transverse sceptre. Cf. RIC 10 (misdescribed). C 57. Hunter 3. *[Rome, AD 256–7]*.
VF £2,800 ($4,250) / **EF** £6300 ($9,500)

10617 C. Rev. PIETAS AVGG, Pietas seated l., extending r. hand to two children at her feet and resting on sceptre held in l., a third child stg. beside her. RIC 11. C —. Hunter, p. xlix. *[Rome, AD 257–60]*. VF £3,000 ($4,500) / **EF** £6,700 ($10,000)

10618 A. Rev. VENERI GENETRICI, Venus stg. l., holding apple and sceptre. RIC 56. C 111. Hunter, p. xlix. *[Uncertain Syrian mint, AD 256–7]*.
VF £2,800 ($4,250) / **EF** £6300 ($9,500)

10619 C. Rev. VENVS FELIX, Venus seated l., extending r. hand to child at her feet and holding transverse sceptre in l. Cf. RIC 3. Cf. C 114. Hunter, p. xlix. *[Cologne, AD 257–9]*.
VF £2,800 ($4,250) / **EF** £6300 ($9,500)

10620 C. Rev. VENVS GENETRIX, Venus stg. l., holding apple and sceptre, Cupid at feet. RIC 12. C 119. Hunter, p. xlix. *[Rome, AD 257–60]*. VF £2,700 ($4,000) / **EF** £6,000 ($9,000)

10621 C. Rev. VENVS VICTRIX, Venus stg. l., holding helmet and spear. RIC 13. C 128. Hunter, p. xlix. *[Rome, AD 257–60]*. VF £3,000 ($4,500) / **EF** £6,700 ($10,000)

10622 C. Rev. — Venus stg. r., her back turned towards spectator, holding apple and palm and resting on column. Cf. RIC 4. Cf. C 133. Cf. Hunter 25 ('gold quinarius'). *[Cologne, AD 257–9]*. VF £2,800 ($4,250) / **EF** £6300 ($9,500)

10623 A. Rev. VESTA, Vesta stg. l., holding patera and transverse sceptre. RIC 14. C 136. Hunter, p. xlviii. *[Rome, AD 256–7]*. VF £2,800 ($4,250) / **EF** £6300 ($9,500)

10624 Similar, but with obv. legend C and on rev. Vesta is seated. RIC —. C —. Hunter, p. lxxii. *[Rome, AD 260–62]*. VF £3,000 ($4,500) / **EF** £6,700 ($10,000)

10625 **Billon antoninianus.** C. Rev. AEQVITAS AVG, Aequitas stg. l., holding scales and cornucopiae, crescent in l. field, VII C (= COS VII) in ex. RIC 87. Cf. RSC 4. Hunter 34. *[Antioch, AD 266–7].* **VF** £12 ($18) / **EF** £38 ($55)

10626 C. Rev. AVG (or AVGVSTA) IN PACE, Salonina, as Pax, seated l., holding olive-branch downwards and transverse sceptre, officina mark P (= 1) in field or in ex. RIC 58, 60. RSC 17, 20a-b. Hunter 25, 27 var. *[Milan, AD 262–3].* **VF** £45 ($65) / **EF** £100 ($150) *This type has been rather fancifully interpreted as a reference to the empress's possible Christian leanings.*

10627 C. Rev. CERERI AVG, Ceres seated l., holding corn-ears and torch. RIC 90. RSC 22. Hunter, p. lxxiii. *[Antioch, AD 265].* **VF** £20 ($30) / **EF** £55 ($85)

10628 C. Rev. CONCOR AVG, Concordia seated l., holding patera and double cornucopiae. RIC 71 var. RSC 24. Cf. Hunter 30. *[Siscia, AD 267–8].* **VF** £10 ($15) / **EF** £30 ($45)

10629 C. Rev. CONCORD AET, similar, but with mint and officina marks R P (= 1st officina) in ex. RIC 2. RSC 25. Hunter 7. *[Rome, AD 263–4].* **VF** £10 ($15) / **EF** £30 ($45)

10630 10633

10630 A. Rev. CONCORDIA AVGG, Gallienus, togate, stg. r., clasping hands with Salonina stg. l., sometimes with wreath or star in upper field. RIC 63. RSC 31, 31a. Hunter 33. *[Uncertain Syrian mint, AD 258–60].* **VF** £14 ($20) / **EF** £45 ($65)

10631 C. Rev. DEAE SEGETIAE, goddess stg. in tetrastyle temple, as 10613. RIC 5. RSC 36. Hunter 21. *[Cologne, AD 259–60].* **VF** £25 ($40) / **EF** £75 ($110)

10632 C. Rev. DIANAE CONS AVG, doe walking r., officina mark Δ (= 4) in ex. RIC 3. RSC 37a. Hunter, p. lxxii. *[Rome, AD 267–8].* **VF** £14 ($20) / **EF** £45 ($65)

10633 C. Rev. FECVNDITAS AVG, Fecunditas stg. l., extending r. hand to child stg. at her feet and holding cornucopiae in l., sometimes with officina mark Δ (= 4) in field or in ex. RIC 5. RSC 39–39b. Hunter 14, 15. *[Rome, AD 265–7].* **VF** £10 ($15) / **EF** £30 ($45)

10634 Similar, but Fecunditas stands r., holding child on l. arm and extending r. hand to another child at her feet, officina mark Δ. RIC 26. RSC 44a. Hunter 8. *[Rome, AD 257–60].* **VF** £12 ($18) / **EF** £38 ($55)

10635 C. Rev. FELICIT PVBL, Felicitas stg. facing, hd. l., her legs crossed, holding caduceus and resting on column. RIC 61. RSC 51. Hunter 24. *[Milan, AD 262–3].* **VF** £10 ($15) / **EF** £30 ($45)

10636 C. Rev. FELICITAS PVBLICA, Felicitas seated, as 10615. RIC 5. RSC 50. Hunter 22. *[Cologne, AD 257–9].* **VF** £12 ($18) / **EF** £38 ($55)

10637 C. Rev. FORTVNA AVG, Fortuna stg. l., holding patera and cornucopiae, altar at feet, S P Q R in ex. RIC 91. RSC 51d. Hunter, p. lxxiv. *[Uncertain Asia Minor mint, AD 268].* **VF** £16 ($25) / **EF** £50 ($75)

10638 **Billon antoninianus.** C. Rev. IVNO AVG, Juno seated l., holding flower and child in
 swaddling clothes, mint and officina marks M S (= 2nd officina) in ex. RIC 62. RSC 55.
 Hunter 28. *[Milan, AD 265–6].* **VF** £10 ($15) / **EF** £30 ($45)

10639 C. Rev. IVNO CONSERVAT, Juno stg. l., holding patera and sceptre, peacock at feet,
 officina mark N (= 9) in field. Cf. RIC 11. RSC 56. Hunter 18. *[Rome, AD 265–7].*
 VF £10 ($15) / **EF** £30 ($45)

10640 10647

10640 C. Rev. IVNO REGINA, similar, but without peacock and no officina mark. RIC 29. RSC
 60. Hunter 6. *[Rome, AD 257–60].* **VF** £12 ($18) / **EF** £38 ($55)

10641 Similar, but with peacock at Juno's feet, and with star or crescent in field or star in ex. RIC
 92. RSC 67b. Hunter, pp. lxxiii-lxxiv. *[Antioch, AD 264].* **VF** £12 ($18) / **EF** £38 ($55)

10642 C. Rev. IVNO VICTRIX, as 10640. RIC 31. RSC 68. Hunter, p. xlix. *[Rome, AD 257–60].*
 VF £12 ($18) / **EF** £38 ($55)

10643 A (sometimes COR for CORN). Rev. IVNONI CONS AVG, doe walking r. (or l.), officina
 mark Δ (= 4) in ex. RIC 14, 16. RSC 69–69a, 70–70a. Hunter 21. *[Rome, AD 267–8].*
 VF £14 ($20) / **EF** £45 ($65)

10644 C. Rev. LVNA LVCIF, Luna in galloping biga l. RIC 63 (Milan). RSC 73b. Hunter, p. lxxiii.
 [Siscia, AD 262–4]. **VF** £75 ($110) / **EF** £30 ($250)

10645 C. Rev. PIETAS AVG, Pietas stg. l., her r. hand raised, holding box of incense in l., officina
 mark P (= 1) in field or in ex. RIC 22. RSC 77. Hunter 3. *[Rome, AD 260–62].*
 VF £10 ($15) / **EF** £30 ($45)

10646 C. Rev. — similar, but Pietas is sacrificing over altar, and sometimes with mint mark S — I
 in field, or with officina mark II (= 2) in field or in ex. RIC 79. RSC 79, 79a. Hunter 31 and
 p. lxxiii. *[Siscia, AD 267–8].* **VF** £10 ($15) / **EF** £30 ($45)

10647 C. Rev. PIETAS AVGG, Pietas seated l., extending r. hand to two children at her feet and
 resting on sceptre held in l., sometimes a third child stg. beside her. RIC 35, 59. RSC 84,
 84a. Hunter 9. *[Rome, AD 257–60].* **VF** £12 ($18) / **EF** £38 ($55)

10648 C. Rev. PVDICITIA, Pudicitia stg. l., drawing veil from face and holding transverse sceptre,
 sometimes with officina mark Q (= 4) or VI (= 6) in field. RIC 24. RSC 92, 92a. Hunter 5.
 [Rome, AD 260–62]. **VF** £10 ($15) / **EF** £30 ($45)

10649 Similar, but Pudicitia seated and the officina mark in ex. RIC 25. RSC 94, 94a. Hunter
 8–10. *[Rome, AD 263–4].* **VF** £10 ($15) / **EF** £30 ($45)
 A rarer variety has the legend **PVDICITIAM.**

10650 C. Rev. PVDICITIA AVG, Pudicitia seated, as previous, mint mark SI in ex. RIC 82. RSC
 99a. Hunter, p. lxxiii. *[Siscia, AD 266–7].* **VF** £10 ($15) / **EF** £30 ($45)

10651 **Billon antoninianus.** C. Rev. ROMAE AETERNAE, Roma seated l., shield at side, holding spear and presentingVictory to Gallienus stg. r. before her, star or wreath in field above. RIC 67. RSC 103a. Hunter 35–6. *[Uncertain Syrian mint, AD 258–60].*
VF £16 ($25) / EF £50 ($75)

10652

10652 C. Rev. SALVS AVG, Salus stg. r., feeding snake held in her arms. Cf. RIC 88. RSC 105. Cf. Hunter, p. lxxiv. *[Antioch, AD 265].* VF £12 ($18) / EF £38 ($55)

10653 A. Rev. VENERI GENETRICI, Venus stg. l., holding apple and sceptre. RIC 61. RSC 110, 111a. Hunter, p. xlix. *[Uncertain Syrian mint, AD 256–7].* VF £14 ($20) / EF £45 ($65)
A rarer variety has the legend VENEREM GENETRICEM.

10654 C. Rev. VENVS AVG, Venus stg. l., holding helmet and transverse spear and resting on shield at her side, P XV (= TR P XV) in ex. RIC 86. RSC 113. Hunter 33. *[Antioch, AD 267].*
VF £12 ($18) / EF £38 ($55)

10655 C. Rev. VENVS FELIX, Venus seated l., extending r. hand to child (or Cupid) at her feet and holding transverse sceptre in l. Cf. RIC 7. RSC 115. Hunter 24. *[Cologne, AD 257–9].*
VF £12 ($18) / EF £38 ($55)

10656 C. Rev. — Venus stg. r., holding sceptre and child (or Cupid), sometimes with officina mark P (= 1) in field. Cf. RIC 65. Cf. RSC 117, 117a. Hunter, p. lxxiii. *[Milan, AD 262–3].*
VF £10 ($15) / EF £30 ($45)

10657 C. Rev. VENVS GENETRIX, Venus stg. l., holding apple and sceptre, Cupid at feet, officina mark S (= 2) or VI (= 6) in field. RIC 30. RSC 121a. Hunter, p. lxxii. *[Rome, AD 260–62].*
VF £10 ($15) / EF £30 ($45)

10658 C. Rev. VENVS VICT, similar, but Venus holds helmet instead of apple and with officina mark P (= 1) in field or in ex. RIC 66. RSC 126a, b. Hunter, p. lxxiii. *[Milan, AD 262–3].*
VF £10 ($15) / EF £30 ($45)

10659 C. Rev. — Venus stg. l., holding helmet and transverse spear and resting on shield, mint and officina marks M S (= 2nd officina) in ex. RIC 67. RSC 127a. Hunter. p. lxxiii. *[Milan, AD 265–6].* VF £10 ($15) / EF £30 ($45)

10660 C. Rev. VENVS VICTRIX, Venus stg. l., holding helmet (or apple) and sceptre, shield (or small figure) at feet, sometimes with officina mark VI or IV (= 6) or H (= 8) in field. RIC 31. RSC 129a, cf. 130a-132. Hunter 20. *[Rome, AD 260–62, 265–7].*
VF £10 ($15) / EF £30 ($45)

10661 C. Rev. — Venus stg. l., holding apple and palm and resting on shield. Cf. RIC 37 (misdescribed, see pl. IV, 55). RSC 130. Hunter 30. *[Rome and Cologne, AD 257–9].*
VF £12 ($18) / EF £38 ($55)

10662 **Billon antoninianus.** C. Rev. — Venus stg. r., her back turned towards spectator, holding apple (or helmet) and palm and resting on column. Cf. RIC 8. RSC 134. Hunter, p. xlix. *[Cologne, AD 257–9]*. **VF** £14 ($20) / **EF** £45 ($65)

10663 A. Rev. VESTA, Vesta stg. l., holding patera and transverse sceptre. RIC 39. RSC 137. Hunter 1. *[Rome, AD 256–7]*. **VF** £14 ($20) / **EF** £45 ($65)

10664 C. Rev. — Vesta seated l., holding Palladium and transverse sceptre. RIC 9 (rev. misdescribed). RSC 142. Hunter 26. *[Cologne, AD 257–9]*. **VF** £12 ($18) / **EF** £38 ($55)

10665 C. Rev. — similar, but holding patera instead of Palladium, and with officina mark Q (= 4) in field or in ex. RIC 32. RSC 143. Hunter 11. *[Rome, AD 263–4]*. **VF** £10 ($15) / **EF** £30 ($45)

10666 A. Rev. VESTA AETERNA, Vesta stg. l., holding Palladium and sceptre. Cf. RIC 71. Cf. RSC 146. Hunter, p. xlix. *[Uncertain Syrian mint, AD 256–7]*. **VF** £14 ($20) / **EF** £45 ($65)

10667 C. Rev. VESTA FELIX, Vesta stg. l., as 10663, officina mark S (= 2) in field or in ex. RIC 69. Cf. RSC 147. Hunter 26. *[Milan, AD 263–4]*. **VF** £10 ($15) / **EF** £30 ($45)

10668 **Billon denarius.** C. Rev. CONCORD AET, Concordia seated l., holding patera and double cornucopiae. RIC 34. RSC 26. Hunter, p. lxxii. *[Rome, AD 263–4]*. **VF** £100 ($150) / **EF** £265 ($400)

NB The much rarer denarii are distinguishable from the antoniniani by their smaller size and the absence of a crescent behind the empress's shoulders on the obverse.

10669 C. Rev. FECVNDITAS AVG, Fecunditas stg. l., extending r. hand to child stg. at her feet and holding cornucopiae in l. RIC 35. RSC 41a. Hunter, p. lxxii. *[Rome, AD 265–7]*. **VF** £100 ($150) / **EF** £265 ($400)

10670 C. Rev. PVDICITIA, Pudicitia stg. l., drawing veil from face and holding transverse sceptre. RIC 38. RSC 92c. Hunter, p. lxxii. *[Rome, AD 260–62]*. **VF** £100 ($150) / **EF** £265 ($400)

10671 **Billon quinarius.** C. Rev. FECVNDITAS AVG, Fecunditas stg. r., holding child on left arm and extending r. hand to another child at her feet. RIC 42 (sole reign). RSC 43. Hunter, p. xlix. *[Rome, AD 257–60]*. **F** £115 ($175) / **VF** £265 ($400) **EF** £665 ($1,000)

10672 C. Rev. IVNO REGINA, Juno stg. l., holding patera and sceptre. RIC 40. RSC 61. Hunter, p. xlviii. *[Rome, AD 257–60]*. **F** £115 ($175) / **VF** £265 ($400) **EF** £665 ($1,000)

10673 C. Rev. PIETAS AVGG, Pietas seated l., extending r. hand to two children at her feet and resting on sceptre held in l., a third child stg. beside her. RIC 41. RSC 85. Hunter 11. *[Rome, AD 257–60]*. **F** £115 ($175) / **VF** £265 ($400) **EF** £665 ($1,000)

10674 C. Rev. PVDICITIA (sometimes PVDICITIAM), Pudicitia seated l., drawing veil from face and holding transverse sceptre. RIC 43. RSC 95, 95a. Hunter, p. lxxii. *[Rome, AD 263–4]*. **VF** £230 ($350) / **EF** £600 ($900)

10675 C. Rev. VENVS GENETRIX, Venus stg. l., holding apple and sceptre, Cupid at feet. RIC 42. RSC 120. Hunter, p. xlix. *[Rome, AD 257–60]*. **F** £115 ($175) / **VF** £265 ($400) **EF** £665 ($1,000)

10676 A. Rev. VESTA, Vesta stg. l., holding patera and sceptre (or torch). RIC 43. RSC 141, 141a. Hunter, p. xlviii. *[Rome, AD 256–7]*. **F** £115 ($175) / **VF** £265 ($400) **EF** £665 ($1,000)

10677 **Billon quinarius.** C. Rev. VESTA, Vesta seated l., holding patera and transverse sceptre. RIC 45. RSC 144. Hunter 13. *[Rome, AD 263–4].* **VF** £230 ($350) / **EF** £600 ($900)

10678 **Bronze sestertius.** B. Rev. FECVNDITAS AVG S C (sometimes C S), Fecunditas stg. r., as 10671. Cf. RIC 45. C 45. Cf. Hunter 16. *[Rome, AD 256–60].*
 F £75 ($110) / **VF** £185 ($275) / **EF** £525 ($800)

10679

10679 B. Rev. IVNO REGINA S C, Juno stg. l., as 10672. RIC 46. Cf. C 62. Hunter 13. *[Rome, AD 256–60].* **F** £75 ($110) / **VF** £185 ($275) / **EF** £525 ($800)

10680 B. Rev. PIETAS AVGG S C, Pietas seated l., as 10673. RIC 47. C 86. Cf. Hunter 17 (rev. altered by tooling). *[Rome, AD 256–60].* **F** £75 ($110) / **VF** £185 ($275) / **EF** £525 ($800)

10681 B. Rev. PVDICITIA (or PVDICITIA AVG) S C, Pudicitia seated l., as 10674. RIC 46–7. C 96, 100. Cf. Hunter, p. lxxii. *[Rome, AD 263–4].*
 F £75 ($110) / **VF** £185 ($275) / **EF** £525 ($800)

10682 B. Rev. VENVS GENETRIX S C, Venus stg. l., as 10675. RIC 42. C 122. Hunter, p. xlix. *[Rome, AD 256–60].* **F** £75 ($110) / **VF** £185 ($275) / **EF** £525 ($800)

10683 B. Rev. VESTA S C, Vesta seated l., as 10677. RIC 48. C 145. Hunter 23. *[Rome, AD 263–4].* **F** £75 ($110) / **VF** £185 ($275) / **EF** £525 ($800)

10684

10684 **Bronze dupondius.** B. Rev. IVNO REGINA S C, Juno stg. l., as 10672. Cf. RIC 49. C 64. Hunter, p. xlviii. *[Rome, AD 257–60].* **F** £100 ($150) / **VF** £230 ($350) / **EF** £665 ($1,000)

NB This denomination may be distinguished from the asses by the crescent appearing behind the empress's shoulders on the obverse.

10685 **Bronze dupondius.** A. Rev. VENVS GENETRIX S C, Venus stg. l., as 10675. RIC 50. C 124.
 Hunter, p. xlix. *[Rome, AD 256–7].* **F** £100 ($150) / **VF** £230 ($350) / **EF** £665 ($1,000)

10686 **Bronze as.** B. Rev. FECVNDITAS AVG S C, Fecunditas stg. r., as 10671. Cf. RIC 51. C 46.
 Cf. Hunter, p. xlix. *[Rome, AD 256–60].* **F** £60 ($90) / **VF** £150 ($225) / **EF** £465 ($700)

10687 B. Rev. IVNO REGINA S C, Juno stg. l., as 10672. RIC 53. Cf. C 63. Hunter 14. *[Rome,
 AD 256–60].* **F** £60 ($90) / **VF** £150 ($225) / **EF** £465 ($700)

10688 B. Rev. PIETAS AVGG S C, Pietas seated l., as 10673. RIC 54. C 87. Hunter 18. *[Rome,
 AD 256–60].* **F** £60 ($90) / **VF** £150 ($225) / **EF** £465 ($700)

10689 B. Rev. PVDICITIA S C, Pudicitia stg. l., drawing veil from face and holding transverse
 sceptre. RIC 51. C 93. Hunter, p. lxxii. *[Rome, AD 260–62].*
 F £60 ($90) / **VF** £150 ($225) / **EF** £465 ($700)

10690 B. Rev. VENVS GENETRIX S C, Venus stg. l., as 10675, but with officina mark Q (= 4) or VI
 (= 6) in ex.. RIC 55 (joint reign). C 123. Hunter, p. xlix and note 3. *[Rome, AD 260–62].*
 F £60 ($90) / **VF** £150 ($225) / **EF** £465 ($700)

10691 C. Rev. VESTA FELIX, Vesta seated l., as 10677, but with officina mark S (= 2) in exergue.
 RIC 56. C 148. Hunter, p. lxxii. *[Rome, AD 263–4].*
 F £75 ($110) / **VF** £185 ($275) / **EF** £525 ($800)

Alexandrian Coinage

10692 **Billon tetradrachm.** KOPNHΛIA CAΛWNEINA CEB, diademed and dr. bust r. Rev. Laur.
 bust of Zeus r., L — Γ (= regnal year 3) in field. Dattari 5315. BMCG —. Cologne 2956.
 Milne —. *[AD 255–6].* **F** £20 ($30) / **VF** £60 ($90) / **EF** £115 ($175)

10693

10693 Obv. Similar. Rev. Elpis (= Spes) advancing l., holding flower and lifting skirt, L — Γ
 (= regnal year 3) in field. Dattari 5302. BMCG —. Cologne —. Milne 3904. *[AD 255–6].*
 F £14 ($20) / **VF** £40 ($60) / **EF** £80 ($120)

10694 — Rev. Homonoia (= Concordia) seated l., her r. hand raised, holding double cornucopiae
 in l., L Γ (= regnal year 3) before. Dattari 5305. BMCG 2256. Cologne 2955. Milne 3908.
 [AD 255–6]. **F** £14 ($20) / **VF** £40 ($60) / **EF** £80 ($120)

10695 — Rev. Nike (= Victory) stg. facing, hd. l., wings open, holding wreath and palm, L Γ
 (= regnal year 3) in field to l. Dattari 5306. BMCG —. Cologne —. Milne —. *[AD 255–6].*
 F £15 ($22) / **VF** £50 ($75) / **EF** £100 ($150)

10696 **Billon tetradrachm.** Obv. As 10692. Rev. Rad. bust of Helios r., L — Δ (= regnal year 4) in field. Dattari 5303. BMCG 2243. Cologne 2959. Milne 3921. *[AD 256–7].*
F £15 ($22) / **VF** £50 ($75) / **EF** £100 ($150)

10697 — Rev. Homonoia (= Concordia) stg. l., r. hand raised, holding double cornucopiae in l., L — Δ (= regnal year 4) in field. Dattari 5304. BMCG 2255. Cologne 2960. Milne 3929. *[AD 256–7].*
F £10 ($15) / **VF** £32 ($50) / **EF** £65 ($100)

10698 — Rev. Nike (= Victory) advancing r., holding wreath and palm, L — Δ (= regnal year 4) in field. Dattari 5307. BMCG 2259. Cologne 2961. Milne 3934. *[AD 256–7].*
F £14 ($20) / **VF** £40 ($60) / **EF** £80 ($120)

10699 — Rev. Tyche (= Fortuna) seated l., holding rudder and cornucopiae, L Δ (= regnal year 4) before. Dattari 5314. BMCG 2265. Cologne 2962. Milne 3940. *[AD 256–7].*
F £14 ($20) / **VF** £40 ($60) / **EF** £80 ($120)

10700 — Rev. Eagle stg. l., hd. r., its wings closed, holding wreath in beak, L — Δ (= regnal year 4) in field. Dattari 5319. BMCG 2272. Cologne 2957. Milne 3962. *[AD 256–7].*
F £10 ($15) / **VF** £32 ($50) / **EF** £65 ($100)

10701 — Rev. Bust of Sarapis l., wearing ornamented modius, sceptre behind, L — E (= regnal year 5) in field. Dattari 5312. BMCG —. Cologne —. Milne —. *[AD 257–8].*
F £20 ($30) / **VF** £60 ($90) / **EF** £115 ($175)

10702 — Rev. Zeus seated l., holding patera and sceptre, eagle at feet, Nike r. on back of throne, L — E (= regnal year 5) in field. Dattari 5318. BMCG —. Cologne —. Milne —. *[AD 257–8]* .
F £15 ($22) / **VF** £50 ($75) / **EF** £100 ($150)

10703 — Rev. Nike (= Victory) seated l. on cuirass, holding wreath and palm, L E (= regnal year 5) before. Dattari 5310. BMCG —. Cologne —. Milne 3968. *[AD 257–8].*
F £15 ($22) / **VF** £50 ($75) / **EF** £100 ($150)

10704 — Rev. Alexandria, turreted, stg. l., holding bust of Sarapis r. in r. hand and sceptre in l., L — Ϛ regnal year 6) in field. Dattari 5298. BMCG 2270. Cologne —. Milne 4003. *[AD 258–9].*
F £14 ($20) / **VF** £40 ($60) / **EF** £80 ($120)

10705 — Rev. Athena seated l., holding Nike and resting on sceptre, shield with Gorgon's hd. at side, L — Z (= regnal year 7) in field. Dattari 5300. BMCG 2244. Cologne —. Milne 4018. *[AD 259–60].*
F £14 ($20) / **VF** £40 ($60) / **EF** £80 ($120)

10706 — Rev. Eagle stg. l., its wings open, holding wreath in beak, L H (= regnal year 8) before. Dattari 5324. BMCG 2277. Cologne —. Milne 4052. *[AD 260–61].*
F £14 ($20) / **VF** £40 ($60) / **EF** £80 ($120)

10707 — Rev. Dikaiosyne (= Aequitas) seated l., holding scales and cornucopiae, L IA (= regnal year 11) before. Dattari 5330. BMCG 2248. Cologne 2966. Milne 4087. *[AD 263–4].*
F £10 ($15) / **VF** £32 ($50) / **EF** £65 ($100)

10708 — Rev. Homonoia (= Concordia) seated l., as 10694, but with date L IA (= regnal year 11) before. Dattari 5335. BMCG 2258. Cologne 2967. Milne 4088. *[AD 263–4].*
F £10 ($15) / **VF** £32 ($50) / **EF** £65 ($100)

10709 — Rev. Athena seated left, as 10705, but sometimes without Gorgon's hd. on shield and with date L IB (= regnal year 12) before, palm behind. Dattari 5327. BMCG 2245. Cologne 2968. Milne 4101. *[AD 264–5].*
F £10 ($15) / **VF** £32 ($50) / **EF** £65 ($100)

10710 **Billon tetradrachm.** — Rev. Eirene (= Pax) stg. l., holding olive-branch and transverse sceptre, L / IB (= regnal year 12) behind, palm before. Dattari 5331. BMCG 2250. Cologne 2969. Milne 4102. *[AD 264–5]*. **F** £10 ($15) / **VF** £32 ($50) / **EF** £65 ($100)

10711 — Rev. Elpis (= Spes) advancing l., as 10693, but with date L / IB (= regnal year 12) behind and palm before. Dattari 5332. BMCG 2251. Cologne 2970. Milne 4105. *[AD 264–5]*.
F £10 ($15) / **VF** £32 ($50) / **EF** £65 ($100)

10712 — Rev. Dikaiosyne (= Aequitas) stg. l., holding scales and cornucopiae, L / IΓ (= regnal year 13) before, palm behind. Dattari 5328. BMCG 2246. Cologne 2974. Milne 4113. *[AD 265–6]*. **F** £10 ($15) / **VF** £32 ($50) / **EF** £65 ($100)

10713 — Rev. Eagle stg. l., hd. r., as 10700, but with date L IΓ (= regnal year 13) behind and palm before. Dattari 5347. BMCG 2276. Cologne 2973. Milne 4122. *[AD 265–6]*.
F £10 ($15) / **VF** £32 ($50) / **EF** £65 ($100)

10714 — Rev. Bust of Isis r., wearing disk and plumes, L / I—Δ (= regnal year 14) in field, palm before. Dattari 5336. BMCG 2268. Cologne 2980. Milne 4142. *[AD 266–7]*.
F £15 ($22) / **VF** £50 ($75) / **EF** £100 ($150)

 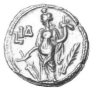

10715

10715 — Rev. Tyche (= Fortuna) stg. l., holding rudder and cornucopiae, L IΔ (= regnal year 14) before, palm behind. Dattari —. BMCG 2263. Cologne 2981. Milne 4139. *[AD 266–7]*.
F £10 ($15) / **VF** £32 ($50) / **EF** £65 ($100)

10716 — Rev. Tyche (= Fortuna) reclining l. on couch, holding rudder, L IΔ (= regnal year 14) above, palm in ex. Cf. Dattari 5342. BMCG 2266. Cologne 2982. Milne 4140. *[AD 266–7]*.
F £10 ($15) / **VF** £32 ($50) / **EF** £65 ($100)

10717 — Rev. Eagle stg. l., wings open, as 10706, but with date L IΔ (= regnal year 14) before and palm behind. Dattari 5345. BMCG 2278. Cologne 2977. Milne 4151. *[AD 266–7]*.
F £14 ($20) / **VF** £40 ($60) / **EF** £80 ($120)

10718 — Rev. Alexandria, turreted, stg. l., raising r. hand and holding sceptre in l., L / IE (= regnal year 15) before, palm behind. Dattari 5325. BMCG —. Cologne —. Milne 4174. *[AD 267–8]*. **F** £15 ($22) / **VF** £50 ($75) / **EF** £100 ($150)

10719 — Rev. Bust of Isis l., wearing disk and plumes, E—I / L (= regnal year 15) in field, palm before. Dattari —. BMCG 2269. Cologne 2987. Milne 4172. *[AD 267–8]*.
F £20 ($30) / **VF** £60 ($90) / **EF** £115 ($175)

10720 — Rev. Conjoined busts r. of Nilus, crowned with lotus, cornucopiae at r. shoulder, and Euthenia (= Abundantia), crowned with corn, L IE (= regnal year 15) behind, palm before. Cf. Dattari 5337. BMCG —. Cologne 2988. Milne —. *[AD 267–8]*.
F £32 ($50) / **VF** £80 ($120) / **EF** £170 ($250)

10721 **Billon tetradrachm.** Obv. As 10692. Rev. Sarapis seated l., wearing modius, his r. hand outstretched, holding sceptre held in l., Kerberos at his feet, little Nike on back of throne, L I—E (= regnal year 15) in field, palm behind. Dattari —. Cf. BMCG/Christiansen 3330. Cologne 2989. Milne 4184. *[AD 267–8].* **F** £20 ($30) / **VF** £60 ($90) / **EF** £115 ($175)

10722 — Rev. Eagle stg. l., its wings closed, holding wreath in beak, palm-branch transversely in background, L I—E (= regnal year 15) in field. Cf. Dattari 5343. BMCG 2281. Cologne 2985. Milne 4182. *[AD 267–8].* **F** £10 ($15) / **VF** £32 ($50) / **EF** £65 ($100)

10723 — Rev. Eagle stg. r., its wings open, holding wreath in beak, L IE (= regnal year 15) before, palm behind. Dattari 5346. BMCG 2280. Cologne 2983. Milne 4189. *[AD 267–8].* **F** £10 ($15) / **VF** £32 ($50) / **EF** £65 ($100)

10724 **Bronze hemidrachm** (28–32 mm. diam). KOPNHΛIA CAΛWNEINA CEB, diademed and dr. bust r. Rev. Homonoia (= Concordia) stg. l., r. hand raised, holding double cornucopiae in l., sometimes with altar at feet, L IB (= regnal year 12) before, palm behind. Dattari 5348–9. BMCG —. Cologne 2971. Milne —. *[AD 264–5].* **F** £130 ($200) / **VF** £300 ($450) *See note following no. 10593.*

10725 Obv. Similar. Rev. Tyche (= Fortuna) stg. l., holding rudder and cornucopiae, L IB (= regnal year 12) before, palm behind. Dattari —. BMCG —. Cologne 2972. Milne —. *[AD 264–5].* **F** £150 ($225) / **VF** £330 ($500)

10726 — Rev. Eagle stg. r., hd. l., its wings closed, holding wreath in beak, L IB (= regnal year 12) behind, palm before. Dattari 5350. BMCG 2282. Cologne —. Milne —. *[AD 264–5].* **F** £130 ($200) / **VF** £300 ($450)

For other local coinages of Salonina, see *Greek Imperial Coins & Their Values*, pp. 449–55.

VALERIAN JUNIOR
Caesar under Valerian and Gallienus, AD 256–258

10733

P. Cornelius Licinius (or Licinius Cornelius) Valerianus, the elder son of Gallienus and Salonina, was elevated to the junior imperial rank of Caesar in the late summer or autumn of AD 256 (Alexandrian regnal year 4 of Valerian and Gallienus). Thus, for the only time in Roman history three generations of the same family exercised imperial power simultaneously. Valerian Caesar joined his father on the Rhine/Danube frontier and they jointly commanded the Roman forces until the sudden death of the young prince, probably in the spring or summer of AD 258 (Alexandrian regnal year 5). Devastated by this unexpected loss, Gallienus issued a posthumous coinage in his son's honour and elevated the young man's brother Saloninus to be Caesar in his place.

Cohen's listings for the coinages of Valerian Junior and his younger brother Saloninus are quite confused. A number of the types that he gave to Valerian Junior are now attributed to the young prince's grandfather, the emperor Valerian, while most now attributed to Valerian Junior Cohen gave to Saloninus.

10727 **Gold aureus.** VALERIANVS CAES, bare-headed and dr. bust r. Rev. IOVI CRESCENTI, infant Jupiter seated facing on goat stg. r., his r. hand raised. RIC 1. C (Saloninus) 25. Hunter, p. li. *[Cologne, AD 257–8].* **VF** £6,700 ($10,000) / **EF** £16,500 ($25,000)

10728 **Gold aureus.** VALERIANVS NOBIL CAES, bare-headed, dr. and cuir. bust r. rev. PRINC IVVENTVTIS, Valerian Jr., in military attire, stg. l., holding baton and transverse spear, two standards set in ground to r. RIC 44. C (Saloninus) 65. Hunter 14. *[Uncertain Syrian mint, AD 256–8].* **VF** £6,000 ($9,000) / **EF** £15,000 ($22,500)

10729 P C L VALERIANVS NOB CAES, bare-headed and dr. bust r. Rev. PRINCIPI IVVENTVTIS, Valerian Jr., in military attire, stg. l., holding standard and resting on spear. RIC 11. C (Saloninus) 79. Hunter, p. l. *[Rome, AD 257–8].* **VF** £5,300 ($8,000) / **EF** £13,500 ($20,000)

10730 **Billon antoninianus.** VALERIANVS NOBIL CAES, rad. and dr. bust r. Rev. FIDES MILITVM, legionary eagle between two standards. RIC 46. RSC 24. Hunter 13. *[Uncertain Syrian mint, AD 256–8].* **VF** £32 ($50) / **EF** £95 ($140)

 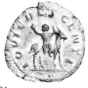

10731 10732

10731 VALERIANVS CAES, rad. and dr. bust r. Rev. IOVI CRESCENTI, infant Jupiter on goat, as 10727. RIC 3. RSC 26. Hunter 9. *[Cologne, AD 257–8].* **VF** £30 ($45) / **EF** £80 ($120)

10732 Similar, but with obv. legend P LIC VALERIANVS CAES. RIC 13. RSC 29a. Hunter, p. l. *[Rome, AD 256–7].* **VF** £30 ($45) / **EF** £80 ($120)

10733 P C L VALERIANVS NOB CAES, rad. and dr. bust r. Rev. PIETAS AVGG, lituus, knife, patera, jug, simpulum and sprinkler (emblems of the priestly colleges). RIC 20. RSC 50. Hunter 5. *[Rome, AD 257–8].* **VF** £22 ($35) / **EF** £65 ($100)

10734 Obv. As 10731. Rev. PRINC IVVENTVTIS, prince and standards, as 10728. RIC 5. RSC 66. Hunter, p. li. *[Cologne, AD 257–8].* **VF** £22 ($35) / **EF** £65 ($100)

10735 Obv. As 10730. Rev. — Valerian Jr., in military attire, stg. l., crowning trophy and resting on shield, spear propped against l. arm. RIC 49. RSC 67. Hunter 15. *[Uncertain Syrian mint, AD 256–8].* **VF** £30 ($45) / **EF** £80 ($120)

10736 Obv. As 10733, but dr. and cuir. Rev. PRINCIPI IVVENT, Valerian Jr., in military attire, stg. l., holding globe and resting on spear. RIC 23. Cf. RSC 70. Hunter, p. l. *[Rome, AD 257–8].* **VF** £22 ($35) / **EF** £65 ($100)

10737 P LIC COR VALERIANVS CAES, rad. and dr. bust r. Rev. PRINCIPI IVBENTVTIS, prince crowning trophy, as 10735. RIC 50. RSC 78. Cf. Hunter, p. li. *[Eastern field-mint, AD 256–8].* **VF** £30 ($45) / **EF** £80 ($120)

10738 Obv. As 10736. Rev. PRINCIPI IVVENTVTIS, prince holding standard, as 10729, but sometimes sceptre for spear. RIC 23. RSC 81. Hunter 6. *[Rome, AD 257–8].* **VF** £22 ($35) / **EF** £65 ($100)

10739 Obv. As 10737. Rev. — Valerian Jr., in military attire, stg. l., holding baton and transverse spear. RIC 51. RSC 84. Hunter, p. li. *[Eastern field-mint, AD 256–8].* **VF** £30 ($45) / **EF** £80 ($120)

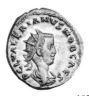

10738 10742

10740 **Billon antoninianus.** Obv. As 10730. Rev. SPES PVBLICA, Spes advancing l., holding flower and lifting skirt. RIC 52. RSC 92. Hunter, p. li. *[Uncertain Syrian mint, AD 256–8].*
 VF £30 ($45) / **EF** £80 ($120)

10741 Obv. As 10737. Rev. VICTORIA GERMAN, Victory stg. r., holding palm and presenting wreath to Valerian II, in military attire, stg. l., holding globe and resting on spear. RIC 53. RSC 96. Hunter, p. li. *[Eastern field-mint, AD 256–8].* **VF** £55 ($80) / **EF** £150 ($225)

10742 Similar, but with rev. legend VICTORIA PART. RIC 54. RSC 97. Hunter 11. *[Eastern field-mint, AD 256–8].* **VF** £45 ($65) / **EF** £115 ($175)

10743 **Billon denarius.** As 10729 (rev. PRINCIPI IVVENTVTIS, prince holding standard). RIC 29. RSC 80a. Hunter, p. l. *[Rome, AD 257–8].* **F** £250 ($375) / **VF** £600 ($900)

10744 **Billon quinarius.** As previous. RIC 30. RSC 80. Hunter, p. l. *[Rome, AD 257–8].*
 F £200 ($300) / **VF** £500 ($750)

10745 **Bronze sestertius.** Obv. As 10729. Rev. PIETAS AVGVSTORVM S C, priestly emblems, as 10733. RIC 33. C (Saloninus) 58. Hunter, p. l. *[Rome, AD 257–8].*
 F £200 ($300) / **VF** £500 ($750)

10746 — Rev. PRINCIPI IVVENT S C, prince holding standard, as 10729. RIC 34. C (Saloninus) 75. Hunter, p. l. *[Rome, AD 257–8].* **F** £170 ($250) / **VF** £430 ($650)

10747

10747 **Bronze dupondius** or as. Obv. As 10729. Rev. PIETAS AVGG, priestly emblems, as 10733. RIC 36. C (Saloninus) 55. Hunter 7. *[Rome, AD 257–8].* **F** £150 ($225) / **VF** £365 ($550)

10748 — Rev. PRINC IVVENTVTIS (or PRINCIPI IVVENT S C), prince holding standard, as 10729. RIC 37, 38. C (Saloninus) 68, 76. Hunter, p. l. *[Rome, AD 257–8].*
 F £150 ($225) / **VF** £365 ($550)

10749 P LIC VALERIANVS CAES, bare-headed and dr. bust r. Rev. PRINCIPI IVVENT S C, prince holding globe, as 10736. RIC 39. C (Saloninus) 71. Hunter, p. l. *[Rome, AD 256–7].*
 F £150 ($225) / **VF** £365 ($550)

For the posthumous coinage of Valerian Junior issued in AD 258, see nos. 10604–12.

Alexandrian Coinage

10750 **Billon tetradrachm.** Π ΛΙΚ ΚΟΡ ΟΥΑΛΕΡΙΑΝΟϹ ΚΑΙϹ ϹΕΒ, bare-headed, dr. and cuir. bust r. Rev. Rad. bust of Helios r., L — Δ (= regnal year 4) in field. Dattari (Saloninus) 5355. BMCG (Saloninus) 2283. Cologne 2992. Milne 3922. *[AD 256–7].*
F £38 ($55) / VF £95 ($140)

10751

10751 Obv. Similar. Rev. Homonoia (= Concordia) stg. l., r. hand raised, holding double cornucopiae in l., L — Δ (= regnal year 4) in field. Cf. Dattari (Saloninus) 5358 (year 3 in error?). BMCG (Saloninus) 2284. Cologne 2993. Milne 3930. *[AD 256–7].*
F £30 ($45) / VF £80 ($120)

10752 — Rev. Nike (= Victory) advancing r., holding wreath and palm, L — Δ (= regnal year 4) in field. Dattari (Saloninus) 5360. BMCG/Christiansen 3337. Cologne 2994. Milne 3935. *[AD 256–7].*
F £30 ($45) / VF £80 ($120)

10753 — Rev. Tyche (= Fortuna) seated l., holding rudder and cornucopiae, L Δ (= regnal year 4) before. Dattari (Saloninus) 5369. BMCG —. Cologne 2996. Milne 3941. *[AD 256–7].*
F £38 ($55) / VF £95 ($140)

10754 — Rev. Eagle stg. l., hd. r., its wings closed, holding wreath in beak, L — Δ (= regnal year 4) in field. Dattari (Saloninus) 5373. BMCG (Saloninus) 2293. Cologne 2991. Milne 3964. *[AD 256–7].*
F £30 ($45) / VF £80 ($120)

10755 — Rev. Alexandria, turreted, stg. l., holding bust of Sarapis r. in r. hand and sceptre in l., L — E (= regnal year 5) in field. Dattari (Saloninus) 5351. BMCG (Saloninus) 2290. Cologne 2998. Milne 3981. *[AD 257–8].*
F £38 ($55) / VF £95 ($140)

10756 — Rev. Bust of Sarapis l., wearing ornamented modius, sceptre behind, L — E (= regnal year 5) in field. Dattari (Saloninus) 5365. BMCG (Saloninus) 2287 var. (year 4). Cologne 2999. Milne 3975. *[AD 257–8].*
F £40 ($60) / VF £110 ($160)

10757 — Rev. Zeus seated l., holding patera and sceptre, eagle at feet, Nike r. on back of throne, L — E (= regnal year 5) in field. Dattari (Saloninus) 5372. BMCG —. Cologne —. Milne —. *[AD 257–8].*
F £45 ($65) / VF £115 ($175)

10758 — Rev. Nike (= Victory) seated l. on cuirass, holding wreath and palm, L E (= regnal year 5) before. Dattari (Saloninus) 5363. BMCG —. Cologne —. Milne —. *[AD 257–8].*
F £45 ($65) / VF £115 ($175)

10759 — Rev. Tyche (= Fortuna) stg. l., holding rudder and cornucopiae, L — E (= regnal year 5) in field. Dattari (Saloninus) 5368. BMCG/Christiansen 3338. Cologne 3000. Milne 3974. *[AD 257–8].*
F £30 ($45) / VF £80 ($120)

For other local coinages of Valerian Junior, see *Greek Imperial Coins & Their Values*, pp. 437–8, 449 and 455–7.

SALONINUS
summer AD 260

10765

P. Licinius Cornelius Saloninus Valerianus, the younger son of Gallienus and Salonina, was born about AD 242 and succeeded to the rank of Caesar on the death of his elder brother, Valerian Junior, in the spring or summer of AD 258 (Alexandrian regnal year 5 of Valerian and Gallienus). Gallienus instructed his youthful heir to set up his headquarters at Cologne (Colonia Agrippinensis), the command-centre of the Rhine frontier, where he was assisted by the praetorian prefect Silvanus and (from 259) Postumus, governor of Upper and Lower Germany. Two years later (summer AD 260), at the time of a serious German incursion into the western provinces, Postumus was proclaimed emperor by his troops and proceeded to besiege Saloninus, now promoted to the senior imperial rank of Augustus, in Cologne. At about the same time the emperor Valerian was taken prisoner in the East by the Sasanid ruler Shapur and this cataclysmic event may have motivated Postumus in his rebellion. After a brief siege Cologne was captured by the rebels and Saloninus and Silvanus were both put to death. Postumus now established an independent western state, comprising Gaul, Britain and Spain (the 'Gallic Empire'), which was destined to endure for 14 years.

Most of the coinage of Saloninus was struck during his two years as Caesar. His very rare coinage as Augustus belongs to the short siege of Cologne by Postumus in the summer of AD 260 and provides strong evidence that the Gallic mint established in 257 was located in that city.

Issues as Caesar under Valerian and Gallienus, AD 258–260

10760 **Gold aureus.** SALON VALERIANVS CAES, bare-headed and dr. bust r. Rev. PIETAS AVG, lituus, knife, jug, simpulum and sprinkler (emblems of the priestly colleges). RIC 4. C 42. Hunter, p. lii. *[Cologne, AD 258–60].* **VF** £6,700 ($10,000) / **EF** £16,500 ($25,000)

10761 LIC COR SAL VALERIANVS N CAES, bare-headed and dr. bust r. Rev. PIETAS AVGG, lituus, knife, patera, jug, simpulum and sprinkler (emblems of the priestly colleges), sometimes order reversed. RIC 17, 21. C 48, 44. Hunter, p. lii. *[Rome, AD 258–60].*
VF £6,000 ($9,000) / **EF** £15,000 ($22,500)

10762 Obv. As previous. Rev. PRINCIPI IVVENTVTIS, Saloninus, in military attire, stg. l., holding standard and resting on sceptre or spear. RIC 19. C 82. Hunter, p. lii. *[Rome, AD 258–60].*
VF £6,000 ($9,000) / **EF** £15,000 ($22,500)

10763 Obv. As 10760. Rev. — similar, but prince holds baton instead of standard, trophy with shields at base behind. RIC 20. Cf. C 86. Hunter, p. lii. *[Cologne, AD 258–60].*
VF £6,700 ($10,000) / **EF** £16,500 ($25,000)

10764 **Billon antoninianus.** SAL VALERIANVS CS, rad. and dr. bust r. Rev. ADVENTVS AVGG, Saloninus on horseback riding l., his r. hand raised and holding holding spear in l. RIC 6. RSC 1. Hunter, p. lii. *[Viminacium/Milan, AD 258–60].* **VF** £90 ($135) / **EF** £250 ($375)

10765 P COR SAL VALERIANVS CAES, rad. and dr. bust r. Rev. DII NVTRITORES, Jupiter stg. l., resting on sceptre and presenting Victory to Saloninus stg. r. in military attire. RIC 35. RSC 21. Hunter 11. *[Eastern field-mint, AD 258].* **VF** £40 ($60) / **EF** £120 ($180)
This unusual reverse honours the 'nourishing gods' and although only Jupiter is depicted it is implied that all of them had joined in nurturing the young heir to the throne.

10766 **Billon antoninianus.** LIC COR SAL VALERIANVS N CAES, rad. and dr. bust r. Rev. PAX AVGG, Pax stg. l., holding olive-branch and transverse sceptre. RIC 25. RSC 39. Hunter, p. lii. *[Rome, AD 258–60].* **VF** £30 ($45) / **EF** £95 ($140)

10767

10767 SALON VALERIANVS CAES, rad. and dr. bust r. rev. PIETAS AVG, priestly emblems, as 10760. RIC 9. RSC 41. Hunter 8. *[Cologne, AD 258–60].* **VF** £30 ($45) / **EF** £80 ($120)

10768 10770

10768 Obv. As 10766. Rev. PIETAS AVGG, priestly emblems, as 10761. RIC 26. RSC 49. Hunter, p. lii. *[Rome, AD 258–60].* **VF** £30 ($45) / **EF** £80 ($120)

10769 — Rev. PRINC IVVENT, Saloninus with standard, as 10762. RIC 27. RSC 60. Hunter 1. *[Rome, AD 258–60].* **VF** £30 ($45) / **EF** £80 ($120)

10770 Obv. As 10764. Rev. — Saloninus, in military attire, stg. l., holding baton and transverse spear, one or two standards behind. RIC 10. RSC 61, 62. Hunter 9, 10. *[Viminacium/Milan, AD 258–60].* **VF** £30 ($45) / **EF** £95 ($140)

10771

10771 Obv. As 10766. Rev. — Saloninus, in miltary attire, stg. l., holding globe and resting on spear, captive seated at feet, officina mark P (= 1) or S (= 2) in field. Cf. RIC 28 (misdescribed). RSC 63. Hunter 2, 4. *[Rome, AD 260].* **VF** £30 ($45) / **EF** £95 ($140)

10772 Obv. As 10764. Rev. — Saloninus, in military attire, stg. l., holding baton and transverse spear, trophy with two captives at base before. RIC 11. RSC 642. Hunter, p. lii. *[Viminacium/Milan, AD 258–60].* **VF** £38 ($55) / **EF** £110 ($160)

10773 **Billon antoninianus.** Obv. As 10767. Rev. PRINCIPI IVVENTVTIS, Saloninus with trophy and shields behind, as 10763. RIC 12. RSC 87. Hunter, p. lii. *[Cologne, AD 258–60].*
VF £30 ($45) / EF £95 ($140)

10774 — Rev. SPES PVBLICA, Spes advancing l., holding flower and lifting skirt. Cf. RIC 13 (Spes r.). RSC 93. Hunter, p. lii. *[Cologne, AD 258–60].* VF £30 ($45) / EF £80 ($120)

10775 10778

10775 SALON VALERIANVS NOB CAES, rad. and dr. bust r. Rev. — Saloninus, in military attire, stg. r., holding sceptre in l. hand and extending r. to receive flower from Spes advancing l. before him, lifting her skirt behind, sometimes with star or wreath in field above. RIC 36. RSC 95, 95a. Hunter 12. *[Uncertain Syrian mint, AD 258–60].*
VF £30 ($45) / EF £95 ($140)

10776 **Billon quinarius.** LIC COR SAL VALERIANVS N CAES, bare-headed and dr. bust r. Rev. PRINCIPI IVVENTVTIS, Saloninus, in military attire, stg. l., holding standard in each hand. Cf. RIC 31 (misdescribed). RSC 85. Hunter —. *[Rome, AD 258–60].*
F £200 ($300) / VF £500 ($750)

10777 **Bronze sestertius.** Obv. Similar, but sometimes also cuir. Rev. PRINCIPI IVVENTVTIS, Saloninus, in miltary attire, stg. l., holding globe and resting on spear, captive seated at feet. RIC 32. C 89. Hunter 5. *[Rome, AD 258–60].* F £200 ($300) / VF £500 ($750)

10778 **Bronze dupondius** or **as.** Obv. As. 10776. Rev. As previous, but with S C in field and sometimes officina mark P (= 1) in ex. RIC 34. C 90. Hunter 6. *[Rome, AD 258–60].*
F £170 ($250) / VF £400 ($600)

Issues as Augustus, AD 260

10779 **Gold aureus.** IMP SALON VALERIANVS AVG, laur. and dr. bust r. Rev. FELICITAS AVGG, Felicitas stg. l., holding caduceus and cornucopiae. RIC 1. C 22. Hunter, p. lii. *[Cologne, AD 260].* (*Unique?*)

10780 **Billon antoninianus.** Similar, but emperor's hd. is rad. instead of laur. RIC —. RSC 23a. Hunter, p. lii. *[Cologne, AD 260].* VF £400 ($600) / EF £800 ($1200)

10781 Obv. As previous. Rev. SPES PVBLICA, as 10774. RIC 14. RSC 94. Hunter, p. lii. *[Cologne, AD 260].* VF £400 ($600) / EF £800 ($1200)

Alexandrian Coinage

10782 **Billon tetradrachm.** ΠΟ ΛΙ ΚΟΡ CA ΟΥΑΛΕΡΙΑΝΟC Κ CEB, bare-headed, dr. and cuir. bust r. Rev. Alexandria, turreted, stg. l., holding bust of Sarapis r. in r. hand and sceptre in l., L — E (= regnal year 5) in field. Dattari —. BMCG 2291. Cologne —. Milne —. *[AD 258]*.
F £45 ($65) / **VF** £115 ($175)

10783 Obv. Similar. Rev. Eagle stg. l., hd. r., its wings closed, holding wreath in beak, L — E (= regnal year 5) in field. Dattari 5375. BMCG 2295. Cologne 3001. Milne 3990. *[AD 258]*.
F £38 ($55) / **VF** £95 ($140)

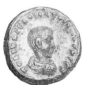

10784 10790

10784 — Rev. Alexandria holding bust of Sarapis, as 10782, L — Ϛ regnal year 6) in field. Dattari 5352. BMCG/Christiansen 3342. Cologne 3003. Milne 4004. *[AD 258–9]*.
F £38 ($55) / **VF** £95 ($140)

10785 — Rev. Bust of Sarapis l., wearing ornamented modius, sceptre behind, L — Ϛ regnal year 6) in field. Dattari 5366. BMCG 2288. Cologne —. Milne 3998. *[AD 258–9]*.
F £38 ($55) / **VF** £95 ($140)

10786 — Rev. Laur. bust of Zeus r., L — Ϛ regnal year 6) in field. Dattari 5370. BMCG —. Cologne 3004. Milne —. *[AD 258–9]*.
F £38 ($55) / **VF** £95 ($140)

10787 Obv. Similar, but ΟΥΑΛΕΡΙΑΝΟC for ΟΥΑΛΕΡΙΑΝΟC. Rev. Athena seated l., holding Nike and resting on sceptre, shield with Gorgon's hd. at side, L — Z (= regnal year 7) in field. Dattari 5354. BMCG —. Cologne 3008. Milne —. *[AD 259–60]*.
F £40 ($60) / **VF** £110 ($160)

10788 — Rev. Conjoined busts l. of Sarapis, wearing modius, sceptre over l. shoulder, and Isis, wearing disk and plumes, knot on breast, L — Z (= regnal year 7) in field. Dattari 5367. BMCG 2289. Cologne 3010 var. Milne 4023 var. *[AD 259–60]*.
F £40 ($60) / **VF** £110 ($160)

10789 — Rev. Nike (= Victory) advancing r., holding wreath and palm, L — Z (= regnal year 7) in field. Dattari 5362. BMCG 2286. Cologne 3009. Milne 4021. *[AD 259–60]*.
F £30 ($45) / **VF** £80 ($120)

10790 — Rev. Eagle stg. l., hd. r., as 10783, L — Z (= regnal year 7) in field. Dattari 5377. BMCG 2297. Cologne 3005. Milne 4047. *[AD 259–60]*. F £30 ($45) / **VF** £80 ($120)

10791 — Rev. Rad. bust of Helios r., L — H (= regnal year 8) in field. Dattari 5356. BMCG —. Cologne —. Milne —. *[AD 260]*. F £50 ($75) / **VF** £130 ($200)

10792 — Rev. Homonoia (= Concordia) stg .l., r. hand raised, holding double cornucopiae in l., L — H (= regnal year 8) in field. Dattari —. BMCG —. Cologne —. Milne —. Emmett 3779. *[AD 260]*.
F £50 ($75) / **VF** £130 ($200)

10793 **Billon tetradrachm.** Obv. As 10787. Rcv. Nike (= Victory) stg. facing, hd. l., wings open, holding wreath and palm, L H (= regnal year 8) to left. Dattari 5359. BMCG —. Cologne —. Milne —. *[AD 260].* **F** £50 ($75) / **VF** £130 ($200)

10794 — Rev. Eagle stg. l., its wings open, holding wreath in beak, L H (= regnal year 8) before. Dattari 5377 *bis*. BMCG 2298. Cologne —. Milne —. *[AD 260].*
 F £45 ($65) / **VF** £115 ($175)

For other local coinages of Saloninus, see *Greek Imperial Coins & Their Values*, pp. 457–8.

<div align="center">

MACRIAN
summer AD 260–early summer 261

10799

</div>

Titus Fulvius Junius Macrianus came to power in the period of confusion following the treacherous capture of Valerian by the Persian monarch Shapur. His elevation, together with that of his younger brother Quietus, was secured by their father Macrian who was disbarred from imperial office himself through lameness. The elder Macrian had assumed control of the leaderless Roman legions in the East in partnership with the praetorian prefect Callistus (nicknamed Ballista) who had succeeded in halting the westward Persian advance into Asia Minor. After consolidating their power in Syria, Egypt and Asia Minor the two Macriani marched west, presumably to challenge Gallienus, while Quietus and Ballista remained in Syria to look after the eastern frontier. Disaster overcame the Macriani in the Balkans where they were defeated and slain by Gallienus' general Domitian, a lieutenant of Aureolus, commander of the elite mobile field army based in Milan.

Only two mints operated in the production of Macrian's Roman coinage. The principal establishment was the one set up by Valerian about AD 255 to take over the operations of Antioch following that mint's temporary closure. Its precise location is unknown and it is referred to in this catalogue as 'uncertain Syrian mint'. Much scarcer antoniniani of cruder style are generally attributed to Emesa which had previously been active less than a decade before during the usurpation of Uranius Antoninus.

The standard obverse legend is IMP C FVL MACRIANVS P F AVG *and the emperor's bust is shown cuirassed to right, with light drapery on the left shoulder. On the antoniniani he wears a radiate crown and on the extremely rare aurei he has a wreath of laurel. The reverses are as follows:*

10795 **Gold aureus.** CONSERVATRICI AVGG, Diana stg. r., drawing arrow from quiver at her shoulder and holding bow in l., stag at her feet, star in l. field. Cf. RIC 1. C 3. Hunter, p. lxxv. *[Uncertain Syrian mint].* **VF** £23,500 ($35,000) / **EF** £56,500 ($85,000)

10796 ROMAE AETERNAE, Roma seated l., holding Victory and resting on sceptre or spear, shield at side. RIC 2. C 10. Hunter, p. lxxv. *[Uncertain Syrian mint].*
 VF £23,500 ($35,000) / **EF** £56,500 ($85,000)

10797 VICTORIA AVGG, Victory advancing r., holding wreath and palm. RIC 3. C 14. Hunter, p. lxxv. *[Uncertain Syrian mint].* **VF** £23,500 ($35,000) / **EF** £56,500 ($85,000)

10798 **Billon antoninianus.** AEQVTAS (*sic*) AVGG, Aequitas stg. l., holding scales and cornucopiae, sometimes with star in l. field. RIC 5. RSC 1, 1b. Hunter 1. *[Uncertain Syrian mint].* **VF** £55 ($85) / **EF** £170 ($250)

10798

10799 **Billon antoninianus.** APOLINI CONSERVA, Apollo stg. facing, hd. l., holding laurel-branch and resting on lyre sometimes set on small rock, sometimes with star in l. field. RIC 6. RSC 2, 2a. Hunter, p. lxxv. *[Uncertain Syrian mint].* **VF** £55 ($85) / **EF** £170 ($250)

10800 FORT REDVX, Fortuna seated l., holding rudder and cornucopiae, sometimes with wheel at feet or below seat, sometimes with star in l. field, with or without dot in ex. RIC 7. RSC 5–5b. Hunter, p. lxxv. *[Uncertain Syrian mint].* **VF** £85 ($125) / **EF** £230 ($350)

10801 10803

10801 INDVLGENTIAE AVG, Indulgentia seated l., holding patera and short sceptre, sometimes with star in l. field, with or without dot in ex. RIC 8. RSC 6, 6a. Hunter 2. *[Uncertain Syrian mint].* **VF** £55 ($85) / **EF** £170 ($250)

10802 Similar, but of cruder style and sometimes with crescent and star in l. and r. field. RIC —.RSC —. Hunter, p. lxxv. *[Emesa].* **VF** £65 ($100) / **EF** £200 ($300)

10803 IOVI CONSERVATORI, Jupiter seated l., holding patera and resting on sceptre, eagle at feet, sometimes with star in l. field. RIC 9. RSC 8, 8a. Hunter, p. lxxv. *[Uncertain Syrian mint].* **VF** £55 ($85) / **EF** £170 ($250)

10804 Similar, but of cruder style and sometimes with crescent and star in l. and r. field. RIC —.RSC —. Hunter, p. lxxv. *[Emesa].* **VF** £65 ($100) / **EF** £200 ($300)

10805 MARTI PROPVGNATORI, Mars advancing r., carrying spear and shield, sometimes with star in l. or r. field, with or without dot in ex. RIC 10. RSC 9, 9a. Hunter, p. lxxv. *[Uncertain Syrian mint].* **VF** £85 ($125) / **EF** £230 ($350)

10806 PIETAS AVG, Mercury stg. l., holding purse and caduceus, sometimes with dot in ex. RIC —. Cf. RSC 10a. Cf. Hunter, p. lxxv. *[Emesa].* **VF** £85 ($125) / **EF** £230 ($350)

10807 ROMAE AETERNAE, Roma seated l., as 10796, sometimes with star in l. field, with or without two dots in ex., or with two dots alone. RIC 11. RSC 11–11b. Hunter 3, 5. *[Uncertain Syrian mint].* **VF** £55 ($85) / **EF** £170 ($250)

10808 Similar, but of cruder style and sometimes with three dots in ex. RIC —.RSC —. Hunter, p. lxxv. *[Emesa].* **VF** £65 ($100) / **EF** £200 ($300)

10807 10809

10809 **Billon antoninianus.** SOL INVICTO, Sol stg. l., raising r. hand and holding globe in l., sometimes with star in l. field. RIC 12. RSC 12, 12a. Hunter 8. *[Uncertain Syrian mint].*
VF £55 ($85) / **EF** £170 ($250)

10810 Similar, but of cruder style and sometimes with two dots in ex. RIC —. RSC —. Hunter, p. lxxv. *[Emesa].* VF £65 ($100) / **EF** £200 ($300)

10811 10814

10811 SPES PVBLICA, Spes advancing l., holding flower and lifting skirt, sometimes with star in l. field. RIC 13. RSC 13, 13a. Hunter 9. *[Uncertain Syrian mint].*
VF £55 ($85) / **EF** £170 ($250)

10812 VICTORIA AVGG, Victory advancing r., holding wreath and palm. RIC 14. RSC 15. Hunter, p. lxxv. *[Uncertain Syrian mint].* VF £65 ($100) / **EF** £200 ($300)

10813 — Victory stg. l. on globe, holding wreath and palm. RIC —. RSC —. Hunter, p. lxxv. *[Emesa].* VF £85 ($125) / **EF** £230 ($350)

Alexandrian Coinage

10814 **Billon tetradrachm.** A K T Φ IOYN MAKPIANOC E CEB, laur. and cuir. bust r. Rev. Homonoia (= Concordia) stg .l., r. hand raised, holding double cornucopiae in l., L A (= regnal year 1) before. Dattari 5378. BMCG 2300. Cologne 3012. Milne 4053. *[AD 260–61].* F £48 ($70) / **VF** £115 ($175)

10815 10816

10815 **Billon tetradrachm.** Obv. Similar. Rev. Nike (= Victory) stg. facing, hd. l., wings open, holding wreath and palm, L A (= regnal year 1) to left. Dattari 5379. BMCG —. Cologne —. Milne —. *[AD 260–61].* **F** £55 ($80) / **VF** £130 ($200)

10816 — Rev. Eagle stg. l., its wings open, holding wreath in beak, L A (= regnal year 1) before. Dattari 5380. BMCG 2301. Cologne 3011. Milne 4056. *[AD 260–61].*
 F £48 ($70) / **VF** £115 ($175)

For other local coinages of Macrian, see *Greek Imperial Coins & Their Values*, pp. 458–9.

QUIETUS
summer AD 260–late summer 261

10823

Titus Fulvius Junius Quietus was the younger son of Macrian, the officer who took control of the Roman army in the East after the capture of Valerian by the Sasanid Persians. Quietus and his elder brother Macrian were both proclaimed emperors by their father, the elder Macrian being disbarred from imperial office through lameness. When the two Macriani invaded Europe to challenge Gallienus for the Roman throne Quietus and the praetorian prefect Callistus (nicknamed Ballista) were left in Syria to guard the eastern frontier. However, the Macriani were defeated and slain in the Balkans by one of Gallienus' generals and Quietus and Ballista were left with gravely weakened forces in the East where they tried during the summer of AD 261 to maintain their cause. But their position was soon threatened by Odaenathus, ruler of the desert city of Palmyra (Tadmor), who, acting as Gallienus' lieutenant in the East, challenged Quietus and Ballista and besieged them in Emesa. The usurpers were eventually murdered by the Emesan citizens and Odaenathus, rewarded as a loyal ally of Gallienus in the East, was granted the imposing title corrector totius Orientis ('administrator of the whole east').

The coinage of Quietus followed a parallel course to that of his brother, though his issues from Emesa, which was his last stronghold, are naturally a little more plentiful than those in the name of Macrian. Surprisingly for an eastern coinage, bronze asses were issued in the name of Quietus. None have so far been recorded for Macrian, though a specimen may one day come to light.

The standard obverse legend is IMP C FVL QVIETVS P F AVG *and the emperor's bust is shown to right, draped or draped and cuirassed. On the antoniniani he wears a radiate crown and on the extremely rare aurei and asses he has a wreath of laurel. The reverses are as follows:*

10817 **Gold aureus.** VICTORIA AVGG, Victory advancing r., holding wreath and palm. RIC 1. C 15. Hunter, p. lxxvi. *[Uncertain Syrian mint].* **VF** £26,500 ($40,000) / **EF** £66,500 ($100,000)

10818 **Billon antoninianus.** AEQVTAS (*sic*) AVGG, Aequitas stg. l., holding scales and cornucopiae, sometimes with star in l. field, with or without dot in ex. RIC 2. RSC 1b-d. Hunter 1. *[Uncertain Syrian mint].* **VF** £55 ($85) / **EF** £170 ($250)

10819 APOLINI CONSERVA, Apollo stg. facing, hd. l., holding laurel-branch and resting on lyre sometimes set on small rock, sometimes with star in l. field. RIC 3. RSC 4, 4a. Hunter, p. lxxvi. *[Uncertain Syrian mint].* **VF** £55 ($85) / **EF** £170 ($250)

10820 FORT REDVX, Fortuna seated l., holding rudder and cornucopiae, sometimes with wheel at feet or below seat, sometimes with star in field, with or without dot in ex. RIC 4. RSC 5. Hunter, p. lxxvi. *[Uncertain Syrian mint].* **VF** £85 ($125) / **EF** £230 ($350)

10819

10821 **Billon antoninianus.** INDVLGENTIAE AVG, Indulgentia seated l., holding patera and short sceptre, sometimes with star in l. field, with or without one or two dots in ex. RIC 5. RSC 6–6b. Hunter 2. *[Uncertain Syrian mint].* **VF** £55 ($85) / **EF** £170 ($250)

10822 Similar, but of cruder style and sometimes with crescent and star in l. and r. field. RIC —.RSC —. Hunter, p. lxxvi. *[Emesa].* **VF** £65 ($100) / **EF** £200 ($300)

10823 IOVI CONSERVATORI, Jupiter seated l., holding patera and resting on sceptre, eagle at feet, sometimes with star in l. field. RIC 6. RSC 8, 8a. Hunter, p. lxxvi. *[Uncertain Syrian mint].* **VF** £55 ($85) / **EF** £170 ($250)

10824 Similar, but of cruder style and sometimes with crescent and star in l. and r. field. RIC —.RSC —. Hunter, p. lxxvi. *[Emesa].* **VF** £65 ($100) / **EF** £200 ($300)

10825 MARTI PROPVGNATORI, Mars advancing r., carrying spear and shield, sometimes with star in r. field, with or without dot in ex. RIC 7. RSC 9. Hunter, p. lxxvi. *[Uncertain Syrian mint].* **VF** £85 ($125) / **EF** £230 ($350)

10826 PIETAS AVG, Mercury stg. l., holding purse and caduceus, sometimes with dot in ex. RIC 8. RSC 10a. Cf. Hunter, p. lxxvi. *[Emesa].* **VF** £85 ($125) / **EF** £230 ($350)

10827 10829

10827 ROMAE AETERNAE, Roma seated l., holding Victory and resting on sceptre or spear, shield at side, sometimes with star in l. field, with or without one or two dots in ex., or with two dots alone. RIC 9. RSC 11–11b. Hunter 3. *[Uncertain Syrian mint].*
 VF £55 ($85) / **EF** £170 ($250)

10828 Similar, but of cruder style and sometimes with three dots in ex. RIC —.RSC —. Hunter, p. lxxvi. *[Emesa].* **VF** £65 ($100) / **EF** £200 ($300)

10829 SOL INVICTO, Sol stg. l., raising r. hand and holding globe in l., sometimes with star in l. field. RIC 10. RSC 12, 12a. Hunter 4. *[Uncertain Syrian mint].*
 VF £55 ($85) / **EF** £170 ($250)

10830 Similar, but of cruder style and sometimes with crescent and star in l. and r. field, or with two dots in ex. RIC 10. RSC 12b. Hunter, p. lxxvi. *[Emesa].*
 VF £65 ($100) / **EF** £200 ($300)

QUIETUS 347

10830 10831

10831 **Billon antoninianus.** SPES PVBLICA, Spes advancing l., holding flower and lifting skirt,
sometimes with star in l. field. RIC 11. RSC 14, 14a. Hunter 5. *[Uncertain Syrian mint].*
VF £55 ($85) / **EF** £170 ($250)

10832 VICTORIA AVGG, Victory advancing r., holding wreath and palm. Cf. RIC 12
(misdescribed). RSC 16. Hunter, p. lxxvi. *[Uncertain Syrian mint].*
VF £65 ($100) / **EF** £200 ($300)

10833 — Victory stg. l. on globe, holding wreath and palm. Cf. RIC 12 (misdescribed). Cf. RSC
16a (misdescribed). Hunter, p. lxxvi. *[Emesa].* VF £85 ($125) / **EF** £230 ($350)

10834 **Bronze as.** AEQVTAS (*sic*) AVGG, Aequitas stg. l., holding scales and cornucopiae. RIC
13. C 2. Hunter, p. lxxvi. *[Uncertain Syrian mint].* (*Extremely rare*)

Alexandrian Coinage

 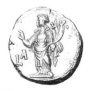

10835 10838

10835 **Billon tetradrachm.** A K T Φ IOYN KOVHTOC E CEB, laur., dr. and cuir. bust r. Rev.
Homonoia (= Concordia) stg .l., r. hand raised, holding double cornucopiae in l., L A
(= regnal year 1) before. Dattari 5381. BMCG 2302. Cologne —. Milne 4054.
[AD 260–61]. F £48 ($70) / **VF** £115 ($175)

10836 Obv. Similar. Rev. Nike (= Victory) stg. facing, hd. l., wings open, holding wreath and
palm, L A (= regnal year 1) to left. Dattari —. BMCG 2304. Cologne —. Milne —.
[AD 260–61]. F £55 ($80) / **VF** £130 ($200)

10837 — Rev. Tyche (= Fortuna) reclining l. on couch, holding rudder, L A (= regnal year 1)
above. Dattari —. BMCG —. Cologne —. Milne —. Emmett 3791. *[AD 260–61].*
F £60 ($90) / **VF** £150 ($225)

10838 — Rev. Eagle stg. l., its wings open, holding wreath in beak, L A (= regnal year 1) before.
Dattari 5382. BMCG 2305. Cologne 3013. Milne 4057. *[AD 260–61].*
F £48 ($70) / **VF** £115 ($175)

For another local issue of Quietus, see *Greek Imperial Coins & Their Values*, p. 459.

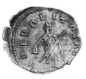

REGALIAN
autumn AD 260

10843

Publius Cornelius Regalianus was a native of Dacia and claimed to be a descendant of Decebalus, the celebrated Dacian king who was defeated by Trajan in AD 106. His brief tenure of imperial power came in the aftermath of the revolt against Gallienus of Ingenuus, governor of Pannonia, in the summer of 260. Ingenuus' uprising was of short duration and he appears not to have produced any coinage. However, his defeat by Gallienus' general Aureolus did not extinguish the flames of rebellion and the soldiers proclaimed Regalian emperor in place of their fallen leader. Regalian managed to produce an emergency coinage of antoniniani, mostly overstruck on coins of earlier 3rd century emperors, and even issued some in the name of his wife Sulpicia Dryantilla. All were probably minted at his headquarters at Carnuntum and their poor style clearly betrays the hand of an inexperienced die-engraver. The rebellion finally collapsed, probably late in the year 260, when Gallienus defeated his rival and reestablished imperial control in the Balkan region.

The obverse legend is IMP C P C REGALIANVS AVG *and the emperor's bust is radiate and draped to right. Because of careless overstriking the details may be obscure and portions of the undertype are frequently visible. The reverses are as follows:*

10839 **Silver or billon antoninianus.** AEQVITAS AVGG, Aequitas stg. l., holding scales and double cornucopiae. RIC —. RSC —. Cf. Hunter, p. lxxvi. Göbl, type G. *[Carnuntum].*
F £1,350 ($2,000) / **VF** £3,000 ($4,500) / **EF** £6,700 ($10,000)

10840 **CONCORDIA AVGG**, Regalian and Dryantilla stg. facing each other, altar between them. RIC 2. RSC 1a. Hunter, p. lxxvi. Göbl, type B. *[Carnuntum].*
F £1,350 ($2,000) / **VF** £3,000 ($4,500) / **EF** £6,700 ($10,000)

10841 — clasped r. hands. RIC —. RSC —. Hunter, p. lxxvi. Göbl, type E. *[Carnuntum].*
F £1,350 ($2,000) / **VF** £3,000 ($4,500) / **EF** £6,700 ($10,000)

10842 **IOVI CONSER** (or **CONSERVA**), Jupiter stg. l., holding thunderbolt and sceptre. RIC 4. RSC 2. Hunter, p. lxxvii. Göbl, type D. *[Carnuntum].*
F £1,350 ($2,000) / **VF** £3,000 ($4,500) / **EF** £6,700 ($10,000)

10843 **LIBERALITAS AVGG**, Libertas (*sic*) stg. l., holding pileus and transverse sceptre. RIC 5, 6. RSC 2a, 3. Hunter, p. lxxvii. Göbl, type L. *[Carnuntum].*
F £1,350 ($2,000) / **VF** £3,000 ($4,500) / **EF** £6,700 ($10,000)

10844

10844 **ORIENS AVGG**, Sol stg. l., r. hand raised and holding whip in l. RIC 7. RSC 4a. Cf. Hunter 1–2. Göbl, type K. *[Carnuntum].*
F £1,200 ($1,800) / **VF** £2,700 ($4,000) / **EF** £6,000 ($9,000)

10845 **Silver or billon antoninianus.** PROVIDENTIA AVGG, Annona stg. l., holding corn-ears and
cornucopiae, modius at feet. RIC 8. RSC 5. Hunter, p. lxxvii. Göbl, type A. *[Carnuntum]*.
 F £1,350 ($2,000) / **VF** £3,000 ($4,500) / **EF** £6,700 ($10,000)

10846 VIRTVS AVGG, Virtus stg. l., resting on shield and spear. RIC —. RSC —. Hunter,
p. lxxvii. Göbl, type H. *[Carnuntum]*.
 F £1,350 ($2,000) / **VF** £3,000 ($4,500) / **EF** £6,700 ($10,000)

DRYANTILLA

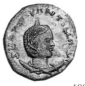

10847

*Sulpicia Dryantilla, wife of Regalian, was the daughter of Claudia Ammiana Dryantilla and the
prominent Severan senator Sulpicius Pollio. It is remarkable that she was accorded such a
prominent share of the usurper's brief coinage.*

 Her obverse legend is SVLP DRYANTILLA AVG *and her bust is shown diademed and draped to
right, with a crescent behind the shoulders. As in the case of her husband's coinage, careless
overstriking usually renders the details of the types obscure and portions of the undertype are
frequently visible. The reverses are as follows:*

10847 **Silver or billon antoninianus.** AEQVITAS AVGG, Aequitas stg., as 10839. RIC 1. RSC 1
bis. Hunter, p. lxxvii. Göbl, type D. *[Carnuntum]*.
 F £1,350 ($2,000) / **VF** £3,000 ($4,500) / **EF** £6,700 ($10,000)

10848 IVNO REGINA, Juno stg. l., holding patera (?) and sceptre. Cf. RIC 2. Cf. RSC 1–3. Hunter,
p. lxxvii. Göbl, type A. *[Carnuntum]*.
 F £1,200 ($1,800) / **VF** £2,700 ($4,000) / **EF** £6,000 ($9,000)

10849 Similar, but with rev. legend IVNONI REGINE. Cf. RIC 2, and note. RSC 1–3 var. Hunter,
p. lxxvii. Göbl, type B. *[Carnuntum]*.
 F £1,200 ($1,800) / **VF** £2,700 ($4,000) / **EF** £6,000 ($9,000)

10850 Similar, but with rev. legend IVNONI REDINE. Cf. RIC 2, and note. RSC 1–3 var. (Cohen 1).
Hunter, p. lxxvii. Göbl, type C. *[Carnuntum]*.
 F £1,200 ($1,800) / **VF** £2,700 ($4,000) / **EF** £6,000 ($9,000)

10851 PROVIDENTIA AVGG, Annona with modius at feet, as 10845. RIC —. RSC —. Hunter,
p. lxxvii. Göbl, type E. *[Carnuntum]*.
 F £1,350 ($2,000) / **VF** £3,000 ($4,500) / **EF** £6,700 ($10,000)

POSTUMUS
summer AD 260–spring 269

10975

The remarkably successful usurpation of Marcus Cassianius Latinius Postumus began in the summer of AD 260 when the governor of Upper and Lower Germany was proclaimed emperor by his troops at the time of a serious barbarian incursion. Saloninus, the teenage son of Gallienus, was obviously regarded as being unequal to the task of defending the western provinces and was besieged by Postumus in Cologne. On the fall of the city the unfortunate youth was executed together with the praetorian prefect Silvanus. Deeply preoccupied by the eastern crisis resulting from Valerian's capture by the Persians, and with additional troubles in the Balkans, Gallienus was unable to confront the new western usurper who proceeded to extend his authority over Gaul, Britain and Spain. The 'Gallic Empire' of Postumus and his successors was destined to endure for 14 years, a testament to the temporary weakness of the central government brought on by the successive military catastrophies and failed economic policies of the preceding decades. Postumus proved himself highly effective in countering the barbarian threat in the West and eventually Gallienus seems to have accepted the status quo, though only after an abortive attempt to overthrow the usurper between 263 and 265. Postumus' star still seemed to be in the ascendant as late as AD 268 when Gallienus' general Aureolus, who was based in Milan, rebelled against the emperor and invited Postumus to invade Italy. Aureolus even struck coins in Postumus' name, but the usurper did not respond to the general's overtures and shortly thereafter Aureolus was besieged by Gallienus in Milan, a war which was to prove fatal to them both. Early in the following year (269) Postumus faced rebellion himself when Ulpius Cornelius Laelianus seized power in Mainz (Moguntiacum) and was proclaimed emperor by his soldiers. Laelian maintained himself for several months before Postumus laid siege to Mainz and quickly ended the uprising. However, the victor's refusal to allow his troops to pillage the captured city led to his own assassination and to a period of instability in the hitherto secure Gallic Empire.

Postumus' coinage is of considerable interest. In addition to the many attractive and unusual types, he also succeeded in maintaining consistently higher standards of weight and metal purity than those achieved by Gallienus. His aurei average at least 5.50 grams, much higher than those of the Central Empire, and his antoniniani, although still heavily debased, generally contain almost double the percentage of silver content. The aes coinage is also remarkable, both in its volume and its variety. Considerable quantities of radiate double sestertii were struck in addition to sestertii, though large scale production of forgeries soon led to the cessation of regular issues, possibly as early as AD 262/3. Mint attributions for the coinage of the Gallic Empire continue to be problematic. Cologne, established by Valerian and Gallienus about AD 257, appears to have remained the principal mint under Postumus, though the usurper's capital was at Trier (Augusta Treverorum) and this, as well as Lyon (Lugdunum), have both been proposed as alternative locations. The case for Cologne is certainly strengthened by coins bearing the reverse legends COL CL AGRIP COS IIII and C C A A COS IIII and those with the mint mark C A. Cologne has, therefore, been retained as the primary mint attribution for the purposes of this catalogue, though future evidence may shed more light on this controversial question. The brief issue in Postumus' name produced by Aureolus at Milan in 268 has already been mentioned, though it should be borne in mind that the Gallic emperor never gained possesstion of this Italian city.

The following are the principal forms of obverse legend, other varieties being given in full:

A. IMP C M CASS LAT POSTVMVS P F AVG
B. IMP C POSTVMVS P F AVG
C. POSTVMVS AVG
D. POSTVMVS PIVS AVG
E. POSTVMVS PIVS FELIX AVG

The normal obverse type for antoniniani and double sestertii is radiate bust of Postumus right, draped or cuirassed or draped and cuirassed. Other denominations have a laureate bust instead of the radiate crown and sometimes the head alone is shown, without drapery or armour, especially on the gold. Rarer varieties of obverse type exist and these are described in full.

NB For the sake of clarity the coinage of the Gallic emperors Postumus to Tetricus (AD 260–274) will be catalogued in sequence, even though the series extends through the reigns of the three immediate successors of Gallienus in the Central Empire — Claudius II (268–270), Quintillus (270), and Aurelian (270–75).

10852 **Gold aureus.** B. Rev. AETERNITAS AVG, Postumus, in military attire, stg. l., resting on spear, crowned by Hercules stg. l. behind him, holding club and lion's skin. RIC 17. C 4. Hunter 7. Schulte 8. *[Cologne, AD 261].* **VF** £5,500 ($8,000) / **EF** £13,500 ($20,000)

 NB As noted above, the aurei of Postumus generally average about 5.50 grams and are even heavier in the closing stages of the reign.

10853 B, laur. and cuir. bust l. Rev. — three rad. and dr. busts of Sol, the one in centre facing, the other two face to face. RIC 18. C 5. Hunter, p. lxxxvii. Schulte 16–17. *[Cologne, AD 261].* **VF** £8,000 ($12,000) / **EF** £20,000 ($30,000)
 This type is clearly inspired by the dynastic aureus of Septimius Severus struck 60 years before with the facing bust of Julia Domna between confronted busts of her two sons, Caracalla and Geta (see Vol. II, no. 6511). The symbolism on this occasion is unclear, but perhaps is connected with the three provinces of Gallia Comata (the Tres Galliae), Aquitania, Lugdunensis, and Belgica.

10854 D. Rev. ANNONA AVG, Annona stg. l., holding corn-ears and cornucopiae, modius at feet. Cf. RIC 19. Cf. C 7. Cf. Hunter, p. lxxxix. Schulte 98. *[Cologne, AD 264].* **VF** £4,000 ($6,000) / **EF** £10,000 ($15,000)

10855 E, conjoined laur. busts r. of Postumus and Hercules. Rev. CLARITAS AVG, conjoined busts r. of Sol, rad., and Luna, with small crescent on hd. and larger one behind shoulders. RIC 260. C 12. Hunter, p. xc. Schulte 115–17. *[Cologne, AD 266].* **VF** £10,000 ($15,000) / **EF** £23,500 ($35,000)

10856 Obv. As previous. Rev. COMITI AVG, Postumus and Hercules busts, as obv. RIC 261. C 15. Hunter, p. xc. Schulte 113. *[Cologne, AD 266].* **VF** £10,000 ($15,000) / **EF** £23,500 ($35,000)

10857 — Rev. CONSERVATORES AVG, conjoined busts r. of Apollo, laur. and with quiver at shoulder, and Diana with bow before. RIC 263. C 26. Hunter 44. Schulte 112. *[Cologne, AD 266].* **VF** £10,000 ($15,000) / **EF** £23,500 ($35,000)

10858 — Rev. — conjoined busts r. of Mars, helmeted and with features of Postumus, and Victory, holding wreath and palm. RIC 262. C 23. Hunter, p. xc. Schulte 119. *[Cologne, AD 266].* **VF** £10,000 ($15,000) / **EF** £23,500 ($35,000)

10859 — Rev. CONSERVATORI AVG, conjoined laur. busts l. of Postumus and Jupiter, thunderbolt before. Cf. RIC 264. C 28. Hunter, p. xc. Schulte 114. *[Cologne, AD 266].* **VF** £10,500 ($16,000) / **EF** £26,500 ($40,000)

10860 — Rev. FELICITAS AVG, conjoined busts r. of Victory, laur. and winged and holding wreath and palm, and Felicitas, diad. and holding olive-branch. RIC 267. C 45. Hunter, p. xc. Schulte 108–10. *[Cologne, AD 266].* **VF** £10,000 ($15,000) / **EF** £23,500 ($35,000)

10861 **Gold aureus.** C, laur. bust l., with lion's skin at l. shoulder, holding club over r. shoulder. Rev. FELICITAS AVG, as previous. RIC 268. C 46. Hunter, p. xc, note 2. Schulte 111. *[Cologne, AD 266].* **VF** £10,000 ($15,000) / **EF** £23,500 ($35,000)

10862 B. Rev. — laur. hds. of Hercules r. and Postumus l., face to face. RIC 266. C 43. Cf. Hunter, p. lxxxvii. Schulte 22. *[Cologne, AD 266].*
VF £10,500 ($16,000) / **EF** £26,500 ($40,000)

10863 E, conjoined laur. busts l. of Postumus and Hercules. Rev. FELICITAS TEMP, galley travelling l. over waves, with rowers and standard. RIC 269. C 54. Hunter, p. xc. Schulte 158. *[Cologne, AD 268].* **VF** £10,500 ($16,000) / **EF** £26,500 ($40,000)

10864 D, laur. and rad. hd. r. Rev. FIDES EXERCITVS, four standards, one surmounted by legionary eagle. RIC 270. C 64. Hunter, p. lxxxix. Schulte 101. *[Cologne, AD 265–6].*
VF £5,500 ($8,000) / **EF** £13,500 ($20,000)

10865 B. Rev. HERC (or HERCVLI) DEVSONIENSI, Hercules stg. r., resting on club and holding bow, lion's skin over l. arm. RIC 20, 21. C 90. Cf. Hunter, p. lxxxvii. Schulte 3, 4. *[Cologne, AD 260].* **VF** £4,000 ($6,000) / **EF** £10,000 ($15,000)
This interesting legend refers to the cult of Hercules at Deuso (modern Deutz) on the Rhine which still forms the eastern bridgehead of Cologne (see also the following two and nos. 10871, 10944–5, 11008–9, 11042–4, 11083–5, and 11107).

10866 B. Rev. — Hercules stg. r., r. hand on hip, l. resting on club with lion's skin. RIC —. C —. Hunter —. Schulte 37. *[Cologne, AD 262].* **VF** £5,500 ($8,000) / **EF** £13,500 ($20,000)

10867 Similar, but obv. C, helmeted and cuir. bust l. RIC —. C —. Hunter — (but cf. p. lxxxvii, note 3). Schulte 38. *[Cologne, AD 262].* **VF** £6,700 ($10,000) / **EF** £16,500 ($25,000)

10868 E, conjoined laur. busts r. of Postumus and Hercules, the emperor also rad. Rev. HERCVLI ARGIVO, Hercules advancing l., wielding his club to attack the Hydra of Lerna. Cf. RIC 341 and C 110 for billon denarii of this type. Hunter, p. xc. Schulte 125. *[Cologne, AD 268].* **VF** £12,000 ($18,000) / **EF** £30,000 ($45,000)

10869 Obv. Similar, but emperor not rad. Rev. HERCVLI AVG, Hercules stg. facing, discharging his bow towards the Stymphalian birds, two of which appear to r. RIC 271. C 112. Hunter, p. xc. Schulte 136. *[Cologne, AD 268].* **VF** £12,000 ($18,000) / **EF** £30,000 ($45,000)

10870 Obv. As 10863. Rev. HERCVLI CRETENSI, Hercules running r., subduing the Cretan bull. Cf. RIC 272. Cf. C 114. Hunter, p. xc. Schulte 137. *[Cologne, AD 268].*
VF £12,000 ($18,000) / **EF** £30,000 ($45,000)

10871 C, helmeted and cuir. bust l. Rev. HERCVLI DEVSONIENSI, laur. hd. of Hercules r. RIC 22. C 115. Hunter, p. lxxxix. Schulte 77. *[Cologne, AD 263].*
VF £8,000 ($12,000) / **EF** £20,000 ($30,000)
See note following no. 10865 (see also nos. 10866–7, 10944–5, 11008–9, 11042–4, 11083–5, and 11107).

10872 Obv. As 10863. Rev. HERCVLI ERVMANTINO, Hercules stg. r., carrying the wild Erymanthian boar. RIC —. C —. Hunter, p. xc. Schulte 133. *[Cologne, AD 268].*
VF £12,000 ($18,000) / **EF** £30,000 ($45,000)

10873 B. Rev. HERCVLI INVICTO, Hercules stg. l., strangling the Nemean lion, club on ground. RIC 23. C 125. Hunter, p. lxxxvii. Schulte 36. *[Cologne, AD 262].*
VF £10,500 ($16,000) / **EF** £26,500 ($40,000)

10874 **Gold aureus.** Similar, but with obv. as 10871. RIC 24. C 126. Hunter, p. lxxxix. Schulte 40. *[Cologne, AD 262].* **VF** £10,500 ($16,000) / **EF** £26,500 ($40,000)

10875 Obv. As 10855. Rev. **HERCVLI LIBYCO**, Hercules wrestling the African giant Antaeus who he raises from the ground. RIC 273. C 128. Hunter, p. xc. Schulte 150. *[Cologne, AD 268].*
VF £13,500 ($20,000) / **EF** £33,500 ($50,000)

10876 — Rev. **HERCVLI NEMAEO**, Hercules strangling lion, as 10873. RIC 274. C 131. Hunter, p. xc. Schulte 120–21. *[Cologne, AD 268].* **VF** £10,500 ($16,000) / **EF** £26,500 ($40,000)

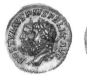

10877

10877 Similar, but with obv. as 10863. RIC —. C —. Hunter, p. xc. Schulte 123. *[Cologne, AD 268].* **VF** £10,500 ($16,000) / **EF** £26,500 ($40,000)

10878 C, rad., dr. and cuir. bust three-quarter face to r. Rev. **HERCVLI THRACIO**, Hercules r., overcoming the man-eating horses of Diomedes, king of the Bistones. RIC 275. C 138. Hunter, p. lxxxix. Schulte 138. *[Cologne, AD 268].*
VF £23,500 ($35,000) / **EF** £56,500 ($85,000)

10879 D. Rev. **INDVLG PIA POSTVMI AVG**, Postumus seated l. on curule chair, kneeling suppliant at his feet. RIC 276. C 145. Hunter, p. lxxxix. Schulte 91–5. *[Cologne, AD 263–4].*
VF £5,500 ($8,000) / **EF** £13,500 ($20,000)

10880 Similar, but with obv. C, bare-headed and cuir. bust three-quarter face to l. RIC 277. C 146. Hunter, p. lxxxix. Schulte 96. *[Cologne, AD 263–4].*
VF £20,000 ($30,000) / **EF** £50,000 ($75,000)

10881 B. Rev. **INVICTO AVG**, rad. and cuir. bust of Postumus l., holding sceptre over r. shoulder. RIC 25. C 147. Hunter, p. lxxxvii. Schulte 28–9. *[Cologne, AD 261].*
VF £8,000 ($12,000) / **EF** £20,000 ($30,000)

10882 B, laur. and cuir. bust l. Rev. **LAETITIA AVG**, galley travelling l. over waves, with four rowers. RIC 26. C 166. Hunter, p. lxxxvii. Schulte 23. *[Cologne, AD 261].*
VF £6,700 ($10,000) / **EF** £16,500 ($25,000)

10883 B. Rev. **LIBERALITAS AVG**, Postumus seated l. on curule chair atop platform, accompanied by lictor stg. behind, Liberalitas stg. l. before him, holding abacus and cornucopiae, citizen mounting steps of platform about to receive largess. RIC 27. C 188. Hunter, p. lxxxvii. Schulte 31. *[Cologne, AD 262].* **VF** £8,000 ($12,000) / **EF** £20,000 ($30,000)

10884 B. Rev. **MINER FAVTR**, Minerva hurrying l., offering olive-branch held in extended in r. hand and holding spear and shield in l. RIC 29. C 194. Hunter, p. lxxxvii. Schulte 41–2. *[Cologne, AD 262].* **VF** £5,500 ($8,000) / **EF** £13,500 ($20,000)
The unusual title Fautrix *('Favourable') appeared on the Roman coinage only during the reign of Postumus (see also no. 10961).*

10885 **Gold aureus.** B. Rev. NEPT COMITI, Neptune stg. l., r. foot on prow, holding dolphin and trident. RIC 30. C 204. Hunter, p. lxxxvii. Schulte 32–5. *[Cologne, AD 262].*
VF £4,000 ($6,000) / **EF** £10,000 ($15,000)

10886

10886 Obv. As 10882. Rev. ORIENS AVG, Sol in galloping quadriga l., his r. hand raised, holding whip in l. RIC —. C —. Hunter, p. lxxxvii. Schulte 18A var. (obv. bust r.). *[Cologne, AD 261].* VF £8,000 ($12,000) / **EF** £20,000 ($30,000)
This type appears to have been inspired by the coinage of Caracalla's sole reign (see Vol. II, nos. 6721 and 6843).

10887 Obv. As 10879. Rev. PIETAS AVG, Pietas stg. l. between two children, holding two more in her arms. RIC 279. C 229. Hunter, p. lxxxix. Schulte 106. *[Cologne, AD 265–6].*
VF £4,000 ($6,000) / **EF** £10,000 ($15,000)

10888 Obv. As 10871. Rev. P M G M T P COS III P P, two captives seated back to back at foot of trophy. RIC 3. Cf. C 232. Hunter, p. lxxxviii. Schulte 43–6. *[Cologne, AD 263].*
VF £6,700 ($10,000) / **EF** £16,500 ($25,000)

10889 Obv. As 10879. Rev. P M T P COS IIII P P, Postumus in slow quadriga l., holding branch. RIC 257. C 234. Hunter, p. lxxxviii. Schulte 107. *[Cologne, AD 267].*
VF £8,000 ($12,000) / **EF** £20,000 ($30,000)

10890 D. Rev. P M T P IMP V COS III P P, Postumus, in military attire, stg. l., sacrificing over altar with child at his side and citizen stg. l. behind, two Vestal Virgins stg. r. facing the emperor on opposite side of the altar, accompanied by child, domed temple of Vesta in background. Cf. RIC 9. Cf. C 236. Cf. Hunter, p. lxxxviii. Schulte 78. *[Cologne, AD 263].*
VF £10,500 ($16,000) / **EF** £26,500 ($40,000)

10891 B. Rev. P M TR P COS P P, rad. lion walking l., holding thunderbolt in its mouth. RIC 1. C 237. Hunter, p. lxxxvii. Schulte 25–7. *[Cologne, AD 260].*
VF £6,700 ($10,000) / **EF** £16,500 ($25,000)
Another type inspired by the coinage of Caracalla's sole reign (see Vol. II, nos. 6774, 6844 and 7002).

10892 B. Rev. P M TR P COS II P P, Mars (or emperor), in military attire, stg. l., holding globe and resting on spear. RIC 2. C 240. Hunter, p. lxxxvii. Schulte 6, 7. *[Cologne, AD 261].*
VF £5,500 ($8,000) / **EF** £13,500 ($20,000)

10893 B. Rev. P M TR P III COS III P P, Postumus, togate, stg. l., sacrificing over tripod-altar and holding short sceptre. RIC 4. C 270. Hunter, p. lxxxvii. Schulte 39. *[Cologne, AD 262].*
VF £5,500 ($8,000) / **EF** £13,500 ($20,000)

10894 Obv. As 10871. Rev. P M TR P IIII COS III P P, Mars, naked, walking r., carrying transverse spear and trophy over l. shoulder. RIC 6. C 271. Hunter, p. lxxxvii. Schulte 56. *[Cologne, AD 263].* VF £6,700 ($10,000) / **EF** £16,500 ($25,000)

POSTUMUS 355

10895 **Gold aureus.** D, laur. hd. l. Rev. P M TR P VI COS III P P, Postumus, togate, stg. l., clasping r. hands with Roma seated r. on cuirass, holding sceptre in l., shield in background behind Roma. Cf. RIC 10. Cf. C 277. Cf. Hunter, p. lxxxviii. Schulte 97. *[Cologne, AD 264–5]*.
VF £8,000 ($12,000) / **EF** £20,000 ($30,000)

10896 D, laur. hd. r., sometimes also rad. Rev. P M TR P VII COS III P P, Postumus, togate, stg. l., sacrificing over altar and holding short sceptre, Mercury stg. facing on l., hd. r., holding purse and caduceus. Cf. RIC 13, 255. C 279, 280. Hunter, p. lxxxviii. Schulte 99, 100. *[Cologne, AD 265–6]*.
VF £6,700 ($10,000) / **EF** £16,500 ($25,000)

10897 D, conjoined laur. heads r. of Postumus and Hercules. Rev. P M TR P X COS V P P, half-length laur. bust of winged Victory r., inscribing with r. hand VO / XX on shield held before her. Cf. RIC 258. Cf. C 284. Hunter, p. lxxxviii. Schulte 162. *[Cologne, AD 269]*.
VF £10,000 ($15,000) / **EF** £23,500 ($35,000)

10898 D. Rev. P M TR P IMP V COS III P P, Postumus, togate, seated l. on curule chair, holding globe and short sceptre. RIC 7. C 287. Hunter, p. lxxxviii. Schulte 62–70. *[Cologne, AD 263]*.
VF £5,500 ($8,000) / **EF** £13,500 ($20,000)

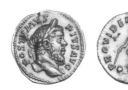

10899

10899 D. Rev. PROVIDENTIA AVG, Providentia stg. facing, hd. l., legs crossed, resting on column and holding rod and cornucopiae, globe at feet. RIC 32. C 300. Hunter 6. Schulte 58–61. *[Cologne, AD 263]*.
VF £4,000 ($6,000) / **EF** £10,000 ($15,000)

10900 D. Rev. QVINQVENNALES POSTVMI AVG, Victory stg. r., l. foot on rock (?), inscribing X (sometimes VOT / X) on shield set on l. knee. RIC 34. C 308. Hunter, p. lxxxix. Schulte 80–88. *[Cologne, AD 264]*.
VF £5,500 ($8,000) / **EF** £13,500 ($20,000)

10901 D. Rev. ROMAE AETERNAE, Roma seated l. on throne, holding Palladium and resting on sceptre or spear. Cf. RIC 36. Cf. C 327. Cf. Hunter, p. lxxxix. Cf. Schulte 48–53A. *[Cologne, AD 263]*.
VF £4,000 ($6,000) / **EF** £10,000 ($15,000)

10902 B. Rev. — helmeted and dr. bust of Roma r. RIC —. C —. Hunter —. Schulte 24. *[Cologne, AD 261]*.
VF £10,000 ($15,000) / **EF** £23,500 ($35,000)

10903 D, laur. and rad. hd. r. Rev. SALVS EXERCITI, Aesculapius stg. facing, hd. l., holding snake-entwined staff, globe at feet to r. RIC — (cf. p. 368, note 2). C 347. Hunter, p. lxxxix. Schulte 102. *[Cologne, AD 265]*.
VF £8,000 ($12,000) / **EF** £20,000 ($30,000)

10904 Obv. As previous. Rev. SALVS POSTVMI AVG, Salus stg. r., feeding snake held in her arms, facing Aesculapius stg., as previous. Cf. RIC 281. Cf. C 349. Cf. Hunter, p. lxxxix. Schulte 103. *[Cologne, AD 265]*.
VF £8,000 ($12,000) / **EF** £20,000 ($30,000)

10905 Similar, but with obv. as 10878. RIC —. C —. Hunter —. Schulte 104. *[Cologne, AD 265]*.
VF £23,500 ($35,000) / **EF** £56,500 ($85,000)

10906 **Gold aureus.** D. Rev. SERAPI COMITI AVG, Serapis stg. l., his r. hand raised, holding transverse sceptre in l., ship in background to l. RIC 282. C 359. Hunter, p. lxxxix. Schulte 105. *[Cologne, AD 265].* **VF** £6,700 ($10,000) / **EF** £16,500 ($25,000)

10907 B. Rev. SPES PVBLICA, Spes advancing l., holding flower and lifting skirt. RIC —. C —. Cf. Hunter, p. lxxxviii. Schulte 21. *[Cologne, AD 261].*
VF £5,500 ($8,000) / **EF** £13,500 ($20,000)

10908 E, conjoined laur. busts r. of Postumus and Hercules. Rev. TRIB POT X COS V P P, Postumus in slow quadriga l., holding branch. RIC —. C —. Hunter, p. lxxxviii. Schulte 161a. *[Cologne, AD 269].* **VF** £10,000 ($15,000) / **EF** £23,500 ($35,000)

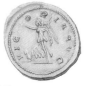

10909 10912

10909 D. Rev. VIC GERM P M TR P V COS III P P, Postumus, in military attire, stg. l., holding globe and spear, crowned by Victory stg. l. behind him, holding palm in l. RIC 14. C 369. Hunter, p. lxxxviii. Schulte 75. *[Cologne, AD 263].* **VF** £5,500 ($8,000) / **EF** £13,500 ($20,000)

10910 Similar, but with obv. C, helmeted and cuir. bust l. RIC 15. C 367. Hunter, p. lxxxviii. Schulte 72. *[Cologne, AD 263].* **VF** £6,700 ($10,000) / **EF** £16,500 ($25,000)

10911 Obv. As previous. Rev. VICT COMES AVG, Postumus, in military attire, on horseback moving r., Victory running r. before, looking back leading horse by bridle. RIC —. C —. Cf. Hunter, p. lxxxix. Schulte 55. *[Cologne, AD 263].*
VF £10,500 ($16,000) / **EF** £26,500 ($40,000)

10912 B. Rev. VICTORIA AVG, Victory advancing l., holding wreath and palm, seated captive at feet. Cf. RIC 39. Cf. C 374. Hunter, p. lxxxviii. Schulte 1. *[Cologne, AD 260].*
VF £4,000 ($6,000) / **EF** £10,000 ($15,000)

10913 Similar, but with obv. VIRTVS POSTVMI AVG, helmeted and cuir. bust r. RIC 40. C 375. Hunter, p. lxxxviii, note 5. Schulte 10. *[Cologne, AD 261].*
VF £5,500 ($8,000) / **EF** £13,500 ($20,000)

10914

10914 B. Rev. VICTORIA AVG, Victory in galloping biga r., holding whip. RIC 42. C 397. Hunter, p. lxxxviii. Schulte 14. *[Cologne, AD 261].* **VF** £5,500 ($8,000) / **EF** £13,500 ($20,000)
A type probably derived from the coinage of Septimius Severus (see Vol. II, nos. 6240 and 6379).

10915 **Gold aureus.** Similar, but with obv. as 10913. RIC 43. C 398. Hunter, p. lxxxviii, note 5. Schulte 11. *[Cologne, AD 261].* **VF** £5,500 ($8,000) / **EF** £13,500 ($20,000)

10916 IMP POSTVMVS AVG, rad., dr. and cuir. bust r. Rev. VIRTVS EQVIT, Mars advancing r., holding transverse spear and shield, officina mark T (= 3) in ex. RIC 369. C 440. Hunter, p. xcv. Schulte 164. *[Milan, AD 268].* **VF** £6,700 ($10,000) / **EF** £16,500 ($25,000) *This was issued by Gallienus' general Aureolus who had revolted and transferred his allegiance to Postumus (see also nos. 10929–31, 10937–8, 10968, 10986, 10994, and 11001–2).*

10917 D. Rev. VIRTVS EXERCITVS, pile of military arms and armour. RIC 44. C 444. Hunter, p. lxxxix. Schulte, p. 172, f. *[Cologne, AD 265].* **VF** £10,000 ($15,000) / **EF** £23,500 ($35,000) *This type would appear to be modelled on an aureus of Marcus Aurelius celebrating his German victories (see Vol. II, no. 4855).*

10918 B. Rev. VIRTVS POSTVMI AVG, helmeted and cuir. bust of Postumus r. RIC 45. C 447. Hunter, p. lxxxviii. Schulte 19–20. *[Cologne, AD 261].* **VF** £8,000 ($12,000) / **EF** £20,000 ($30,000)

10919 Similar, but with obv. POSTVMVS P F AVG, laur. and cuir. bust l., r. hand raised. RIC 46. C 448. Hunter, p. lxxxviii, note 6. Schulte 9. *[Cologne, AD 261].* **VF** £10,000 ($15,000) / **EF** £23,500 ($35,000)

10920 E, conjoined laur. busts r. of Postumus and Hercules. Rev. VIRTVTI AVG, conjoined busts r. of Postumus, laur., and Mars, helmeted. RIC 283. C 451. Hunter, p xc. Schulte 118. *[Cologne, AD 266].* **VF** £10,000 ($15,000) / **EF** £23,500 ($35,000)

10921 B. Rev. VOT PVBL, slow quadriga three-quarter face to l., Postumus accompanied by Victory in the car, both stg. to l., the emperor holding branch and sceptre, Victory holding palm, the horses flanked by figures of Mars and Virtus, the heads of three citizens in background. RIC —. C —. Hunter —. Schulte 30. *[Cologne, AD 262].* **VF** £12,000 ($18,000) / **EF** £30,000 ($45,000)

10922 **Gold quinarius.** B. Rev. P M TR P COS III P P, lion walking r. RIC 47. C 265. Hunter, p. lxxxvii. Schulte Q4. *[Cologne, AD 262].* **VF** £5,500 ($8,000) / **EF** £13,500 ($20,000)

10923 C, helmeted and cuir. bust l. Rev. PROVIDENTIA AVG, Providentia stg. l., holding globe and transverse sceptre. RIC 49. C 294. Hunter, p. lxxxix. Schulte Q5–7. *[Cologne, AD 263–4].* **VF** £5,500 ($8,000) / **EF** £13,500 ($20,000)

10924 Obv. As previous. Rev. QVINQVENNALES AVG, Victory stg. r., l. foot on rock (?), inscribing V / Q on shield set on l. knee. Cf. RIC 50. Cf. C 306. Hunter, p. lxxxix. Schulte Q9A. *[Cologne, AD 264].* **VF** £5,500 ($8,000) / **EF** £13,500 ($20,000)

10925 Similar, but with obv. type bare-headed and cuir. bust three-quarter face to l. Cf. RIC 51. Cf. C 307. Hunter, p. lxxxix, note 3. Schulte Q9. *[Cologne, AD 264].* **VF** £10,000 ($15,000) / **EF** £23,500 ($35,000)

10926 **Billon antoninianus.** B. Rev. CASTOR, Castor stg. l. beside horse, holding spear. RIC 297. RSC 8a. Hunter, p. xc. *[Cologne, AD 268].* **VF** £130 ($200) / **EF** £330 ($500) *This type was derived from the coinage of Geta, younger son of Septimius Severus, which was itself derived from the coinage of Commodus (see Vol. II, nos. 5611, 7152 and 7169). See also nos. 11004 and 11746.*

NB Although seriously debased, the 'silver' coinage of this reign consistently maintained higher standards of metal quality than the contemporary issues of Gallienus in the Central Empire, with purity ranging from 20% down to 15% throughout much of the reign. Even in the final year of Postumus' reign, when the silver content plummetted to 5% or less, it was still significantly better than the contemporary issues of Gallienus and his successor Claudius II.

10927 **Billon antoninianus.** B. Rev. C C A A COS IIII, Moneta stg. l., holding scales and cornucopiae. RIC 285. RSC 11. Hunter, p. lxxxix. *[Cologne, AD 267–8].*
VF £200 ($300) / EF £500 ($750)
This rare and important issue provides clear evidence of the mint responsible for its production — Colonia Claudia Agrippina Augusta, modern Cologne. The colony was founded by Claudius in AD 50 and was named after his wife, the younger Agrippina (see also the following and no. 10956).

10928 Similar, but with rev. legend COL CL AGRIP COS IIII. RIC 286 var. RSC 14a. Hunter, p. lxxxix. *[Cologne, AD 267–8].* VF £250 ($375) / EF £600 ($900)

10929 IMP POSTVMVS AVG. Rev. CONCORD AEQVIT (*sic*), Fortuna stg. l., r. foot on prow, holding patera and rudder on globe, sometimes with officina mark S (= 2) in ex. RIC 371. RSC 18–18b. Hunter 141. *[Milan, AD 268].* VF £20 ($30) / EF £45 ($65)
This was issued by Gallienus' general Aureolus who had revolted and transferred his allegiance to Postumus (see also the following two and nos. 10916, 10937–8, 10968, 10986, 10994, and 11001–2).

10930 Similar, but with rev. legend CONCORD EQVIT. RIC 373. RSC 19–19b. Hunter, p. xcv. *[Milan, AD 268].* VF £20 ($30) / EF £45 ($65)

10931 Similar, but with CONCORD EQVITVM and obv. legend B. RIC 374. RSC 21, 21a. Hunter, p. xciv. *[Milan, AD 268].* VF £20 ($30) / EF £45 ($65)

10932 B. Rev. COS IIII, Victory stg. r., holding wreath and palm. RIC 287. RSC 31, 31a. Hunter 42. *[Cologne, AD 267–8].* VF £16 ($25) / EF £38 ($55)

10933 Similar, but with COS V. RIC 288. RSC 32, 32a. Hunter, p. lxxxix. *[Cologne, AD 269].*
VF £16 ($25) / FF £38 ($55)

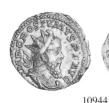

10934 10944

10934 B. Rev. DIANAE LVCIFERAE or LVCIFERE (*sic*), Diana stepping r., quiver at shoulder, holding lighted torch with both hands, sometimes with stag at feet. RIC 299. RSC 33–4. Hunter 47. *[Cologne, AD 265–8].* VF £16 ($25) / EF £38 ($55)

10935 B. Rev. DIANAE REDVCI, Diana advancing r., looking back, holding bow and leading stag. RIC 300. RSC 35. Hunter 48. *[Cologne, AD 265–8].* VF £65 ($100) / EF £170 ($250)

10936 B. Rev. FELICITAS AVG, Felicitas stg. l., holding long caduceus and cornucopiae. RIC 58. RSC 39, 39a. Hunter 49. *[Cologne, AD 265–8].* VF £14 ($20) / EF £30 ($45)

10937 **Billon antoninianus.** IMP POSTVMVS AVG. Rev. FIDES AEQVIT (*sic*), Fides seated l., holding patera and standard, sometimes with officina mark P (= 1) in ex. RIC 376. RSC 57, 57a. Hunter 142. *[Milan, AD 268].* **VF** £20 ($30) / **EF** £45 ($65)
See note following no. 10929 (see also the following and nos. 10916, 10930–31, 10968, 10986, 10994, and 11001–2).

10938 Similar, but with rev. legend FIDES EQVIT and sometimes with obv. legend B. RIC 377–8. RSC 59–60a. Hunter 143. *[Milan, AD 268].* **VF** £20 ($30) / **EF** £45 ($65)

10939 B. Rev. FIDES EXERCITVS, four standards, including one legionary eagle. RIC 303. RSC 65. Hunter 55. *[Cologne, AD 265–8].* **VF** £23 ($35) / **EF** £50 ($75)

10940 B. Rev. FIDES MILITVM, Fides Militum stg. l., holding standard in each hand. RIC 59. RSC 67, 67a. Hunter 9. *[Cologne, AD 260–65].* **VF** £14 ($20) / **EF** £30 ($45)

10941 B. Rev. FORTVNA AVG, Fortuna stg. l., holding rudder and cornucopiae. RIC 60. RSC 80. Hunter 56. *[Cologne, AD 265–8].* **VF** £14 ($20) / **EF** £30 ($45)

10942 Similar, but Fortuna seated l. RIC 61. RSC 81. Hunter, p. xci. *[Cologne, AD 265–8].* **VF** £16 ($25) / **EF** £38 ($55)

10943 B. Rev. FORTVNA REDVX, distyle shrine, with domed roof, containingFortuna seated l, holding rudder and cornucopiae, wheel at side. RIC 62. RSC 83. Hunter 13. *[Cologne, AD 260–65].* **VF** £55 ($80) / **EF** £130 ($200)

10944 B. Rev. HERC DEVSONIENSI, Hercules stg. r., resting on club and holding bow, lion's skin over l. arm. RIC 64. RSC 91, 91a. Hunter 14. *[Cologne, AD 260–65].* **VF** £16 ($25) / **EF** £38 ($55)
This interesting legend refers to the cult of Hercules at Deuso (modern Deutz) on the Rhine which still forms the eastern bridgehead of Cologne (see also the following and nos. 10865–7, 10871, 11008–9, 11042–4, 11083–5, and 11107).

10945 10946

10945 B. Rev. — tetrastyle temple containing Hercules stg. l., resting on club and holding lion' skin. RIC 66. RSC 98, 98a. Hunter, p. lxxxvii. *[Cologne, AD 260–65].* **VF** £23 ($35) / **EF** £55 ($85)

10946 B. Rev. HERC PACIFERO, Hercules stg. l., holding olive-branch, club and lion's skin. RIC 67. RSC 101, 101a. Hunter 17. *[Cologne, AD 260–65].* **VF** £14 ($20) / **EF** £30 ($45)

10947 B. Rev. HERCVLI MAGVSANO, Hercules stg. r., r. hand on hip, l. resting on club with lion's skin set on rock. RIC 68. RSC 129, 129a. Hunter, p. lxxxvii. *[Cologne, AD 260–65].* **VF** £130 ($200) / **EF** £300 ($450)
The unusual title 'Hercules of Magusa' on this rare type refers to a town on the Moselle in German territory which was under Postumus' control (see also no. 11046).

10948 **Billon antoninianus.** B. Rev. HERCVLI ROMANO AVG, bow, club and quiver. RIC 306. RSC 136, 136a. Hunter, p. xci. *[Cologne, AD 268].* **VF** £40 ($60) / **EF** £100 ($150) *This is a revival of a reverse type originally featured on the coinage of Commodus in AD 192 (see Vol. II, nos. 5585, 5645, and 5753).*

10949 Similar, but with obv. C, rad. bust l., with lion's skin at l. shoulder, holding club over r. shoulder. RIC 307. RSC 137. Hunter, p. xci, note 1. *[Cologne, AD 268].* **VF** £100 ($150) / **EF** £230 ($350)

10950 B. Rev. IMP X COS V, Victory stg. r., holding wreath and palm. RIC 289. RSC 144, 144a. Hunter 43. *[Cologne, AD 269].* **VF** £16 ($25) / **EF** £38 ($55)

10951 B. Rev. INTERNVTIVS (*sic*) DEORVM, Mercury stg. facing, hd. r., holding purse and caduceus. RIC —. RSC 145a. Cf. Hunter, p. xci. *[Cologne, AD 265].*
VF £200 ($300) / **EF** £500 ($750)
This rare type perhaps makes reference to a diplomatic exchange following the termination of hostilities between Postumus and Gallienus in 265 (cf. Carson, "Coins of the Roman Empire", p. 112 and note 13. The legend should read INTERNVNTIVS DEORVM).

10952 B. Rev. IOVI CONSERVAT (or CONSERVATORI), Jupiter stg. l., holding thunderbolt and sceptre, small figure (of Postumus?) at feet. RIC 308. RSC 151–2. Hunter, p. xci. *[Cologne, AD 265–8].* **VF** £23 ($35) / **EF** £50 ($75)

10953 10958

10953 B. Rev. IOVI PROPVGNAT (or PROPVGNATORI), Jupiter advancing l., looking back, holding thunderbolt and eagle (?). RIC 70, 72. RSC 153, 153a and 155, 155a. Hunter 19. *[Cologne, AD 260–65].* **VF** £14 ($20) / **EF** £30 ($45)

10954 B. Rev. IOVI STATORI, Jupiter stg. facing, hd. r., holding sceptre and thunderbolt. RIC 309. RSC 159, 159a. Hunter 57. *[Cologne, AD 265–8].* **VF** £14 ($20) / **EF** £30 ($45)

10955 B. Rev. IOVI VICTORI, Jupiter advancing l., looking back, holding thunderbolt and transverse spear (or sceptre) over l. shoulder. RIC 311. RSC 161, 161a. Hunter, p. xci. *[Cologne, AD 267–8].* **VF** £16 ($25) / **EF** £38 ($55)

10956 Similar, but with mint mark C — A (= *Colonia Agrippina*) in field. RIC 311, note 1. RSC 163. Hunter, p. xci. *[Cologne, AD 267–8].* **VF** £200 ($300) / **EF** £500 ($750) *See also nos. 10927–8.*

10957 Similar to 10955, but with seven stars in rev. field and eagle between legs of Jupiter. RIC 311a. RSC 162, 162a. Hunter, p. xci. *[Cologne, AD 267–8].*
VF £50 ($75) / **EF** £130 ($200)

10958 **Billon antoninianus.** B. Rev. LAETITIA AVG, galley travelling l. over waves, with rowers and steersman. RIC 73. RSC 167, 167a. Hunter 20. *[Cologne, AD 260–65].*
VF £16 ($25) / **EF** £38 ($55)
This refers to the importance of naval power in the Gallic Empire and perhaps even to an imperial visit to Britain in the early years of Postumus' reign (see also nos. 11049 and 11087).

10959 B. Rev. MARS VICTOR, Mars stg. l., resting on shield and spear. RIC 312. RSC 191. Hunter, p. xci. *[Cologne, AD 265–8].* VF £23 ($35) / **EF** £55 ($85)

10960 B. Rev. MERCVRIO FELICI, Mercury stg., as 10951. RIC 313. RSC 192. Hunter 59. *[Cologne, AD 265–8].* VF £23 ($35) / **EF** £50 ($75)

10961 B. Rev. MINER FAVTR, Minerva hurrying l., offering olive-branch held in extended in r. hand and holding spear and shield in l. RIC 74. RSC 195, 195a. Hunter 23. *[Cologne, AD 262].* VF £16 ($25) / **EF** £38 ($55)
See note following no. 10884.

10962 10963

10962 B. Rev. MONETA AVG, Moneta stg. l., holding scales and cornucopiae. RIC 75. RSC 199, 199a. Hunter 60. *[Cologne, AD 262–5].* VF £14 ($20) / **EF** £30 ($45)
This common type is indicative of Postumus' concern for his coinage which consistently surpassed that of Gallienus in weight, metal quality, and standards of engraving and execution.

10963 B. Rev. NEPTVNO REDVCI, Neptune stg. l., holding dolphin and long trident, sometimes with forepart of ship at feet. RIC 76. RSC 205–206a. Hunter 24. *[Cologne, AD 260–65].*
VF £16 ($25) / **EF** £38 ($55)

10964 10966

10964 B. Rev. ORIENS AVG, Sol advancing l., r. hand raised, holding whip in l., sometimes with P in l. field. RIC 316. RSC 213–213d. Hunter 66, 96. *[Cologne, AD 265–8].*
VF £14 ($20) / **EF** £30 ($45)

10965 B. Rev. PACATOR ORBIS, rad. and dr. bust of Sol r. RIC 317. RSC 214a, b. Hunter 68. *[Cologne, AD 265–8].* VF £65 ($100) / **EF** £170 ($250)

10966 **Billon antoninianus.** B. Rev. PAX AVG, Pax advancing l., holding olive-branch and sceptre. RIC 78. RSC 220. Hunter 27. *[Cologne, AD 260–65].***VF** £14 ($20) / **EF** £30 ($45)

10967 B. Rev. — (or AVGVSTI), Pax stg. l., holding olive-branch and transverse sceptre, sometimes with P in l. field or V in l. field and star in r. RIC 318. RSC 215a-c, 227 and 227a. Hunter 70, 97. *[Cologne, AD 265–8].* **VF** £14 ($20) / **EF** £30 ($45)

10967 10969

10968 B. Rev. PAX EQVITVM, as previous, sometimes with officina mark T (= 3) in ex. RIC 381. RSC 228–228b. Hunter, p. xcv. *[Milan, AD 268].* **VF** £20 ($30) / **EF** £45 ($65)
See note following no. 10929 (see also nos. 10916, 10930–31, 10937–8, 10986, 10994, and 11001–2).

10969 B. Rev. PIETAS AVG, Pietas stg. l. between two children, holding two more in her arms. RIC 320. RSC 230, 230a. Hunter 73. *[Cologne, AD 265–8].* **VF** £16 ($25) / **EF** £38 ($55)

10970 B. Rev. P M TR P COS I P P, Postumus, in military attire, stg. l., holding globe and resting on spear. RIC 53. RSC 239, 239a. Hunter, p. lxxxvii. *[Cologne, AD 260].*
VF £32 ($50) / **EF** £80 ($120)

10971 Similar, but COS II. RIC 54. RSC 243, 243a. Hunter 1. *[Cologne, AD 261].*
VF £14 ($20) / **EF** £30 ($45)

10972 Similar, but COS III. RIC 55. RSC 261, 261a. Hunter 3. *[Cologne, AD 262].*
VF £16 ($25) / **EF** £38 ($55)

10973 B. Rev. P M TR P III COS III P P, Mars, naked, advancing r., carrying transverse spear and trophy over l. shoulder. RIC 56. RSC 269. Hunter, p. lxxxvii. *[Cologne, AD 262].*
VF £16 ($25) / **EF** £38 ($55)

10974

10974 Similar, but TR P IIII. RIC 57. Cf. RSC 273, 273a. Hunter 4. *[Cologne, AD 263].*
VF £16 ($25) / **EF** £38 ($55)

10975 B. Rev. P M TR P VIIII COS IIII P P, bow, club, and quiver (sometimes flat, sometimes cylindrical). RIC 291. RSC 281, 283, 283a. Hunter, p. lxxxviii. *[Cologne, AD 268].*
VF £40 ($60) / **EF** £100 ($150)

10976 **Billon antoninianus.** Similar, but with obv. as 10949. RIC 292. RSC 282. Hunter 41. *[Cologne, AD 268].* **VF** £100 ($150) / **EF** £230 ($350)

10977 B. Rev. **P M TR P X COS V P P**, Victory stg. r., l. foot on globe or helmet, inscribing **VO XX** on shield set on l. knee. RIC 295. RSC 285. Hunter, p. lxxxix. *[Cologne, AD 269].* **VF** £32 ($50) / **EF** £80 ($120)

10978 B. Rev. — Postumus (?), togate, stg. l., holding branch and sceptre. RIC 294. RSC 286. Hunter, p. lxxxix. *[Cologne, AD 269].* **VF** £23 ($35) / **EF** £55 ($85)

10979 10983

10979 B. Rev. **PROVIDENTIA AVG**, Providentia stg. l., holding globe and transverse sceptre. RIC 80, 323. RSC 295, 295a. Hunter 75. *[Cologne, AD 265–8].* **VF** £14 ($20) / **EF** £30 ($45)

10980 B. Rev. — Providentia stg. facing, hd. l., legs crossed, resting on column and holding rod and cornucopiae, globe at feet. RIC 81. RSC 303. Hunter, p. lxxxviii. *[Cologne, AD 260–65].* **VF** £16 ($25) / **EF** £38 ($55)

10981 B. Rev. **REST** (or **RESTIT** or **RESTITVTOR**) **GALLIAR** (or **GALLIARVM**), Postumus, in military attire, stg. l., sometimes with foot on captive, resting on spear and raising kneeling figure of Gallia r., sometimes turreted, holding cornucopiae. RIC 82. RSC 311–319. Hunter, p. xci. *[Cologne, AD 265–8].* **VF** £40 ($60) / **EF** £100 ($150)

10982 B. Rev. **REST** (or **RESTIT** or **RESTITVTOR**) **ORBIS**, similar, but Postumus stands r. and the female figure, who represents the world, kneels l. RIC 324. RSC 323–326. Hunter, p. xci. *[Cologne, AD 265–8].* **VF** £32 ($50) / **EF** £80 ($120)

10983 B. Rev. **SAECVLI FELICITAS**, Postumus, in military attire, stg. r., holding transverse spear and globe. RIC 325. RSC 83, 325. Hunter 79. *[Cologne, AD 265–8].* **VF** £14 ($20) / **EF** £30 ($45)

10984 B. Rev. **SAECVLO FRVGIFERO**, winged caduceus. RIC 84. RSC 333, 333a. Hunter 82. *[Cologne, AD 265–8].* **VF** £23 ($35) / **EF** £50 ($75)

10985 B. Rev. **SALVS AVG**, Aesculapius stg. facing, hd. l., holding snake-entwined staff, sometimes with globe at feet to r. RIC 86. RSC 336, 336a. Hunter 85, 86. *[Cologne, AD 265–8].* **VF** £20 ($30) / **EF** £45 ($65)

10986 Similar, but with officina mark P (= 1) in ex. RIC 382. RSC 336b, c. Hunter, p. xcv. *[Milan, AD 268].* **VF** £20 ($30) / **EF** £45 ($65)
See note following no. 10929 (see also nos. 10916, 10930–31, 10937–8, 10968, 10994, and 11001–2).

10987 B. Rev. — Salus stg. l., feeding snake arising from altar and holding rudder. RIC 85. RSC 339, 339a. Hunter 28. *[Cologne, AD 260–65].* **VF** £14 ($20) / **EF** £30 ($45)

10988 B. Rev. **SALVS EXERCITI**, Aesculapius with snake-entwined staff, as 10985. RIC 327. RSC 348b. Hunter, p. xci. *[Cologne, AD 265–8].* **VF** £20 ($30) / **EF** £45 ($65)

10989 10991

10989 **Billon antoninianus.** B. Rev. SALVS POSTVMI AVG, Salus stg. r., feeding snake held in her
 arms. RIC 328. RSC 350, 350a. Hunter 90. *[Cologne, AD 265–8].*
 VF £20 ($30) / **EF** £45 ($65)

10990 A. Rev. SALVS PROVINCIARVM, river-god (the Rhine), sometimes horned, reclining l.,
 resting r. hand on boat and holding anchor in l., l. arm resting on urn. Cf. RIC 87 (this obv.
 legend omitted in error). C 352–3 (omitted in error in RSC). Hunter 39–40. *[Cologne,
 AD 260].* **VF** £65 ($100) / **EF** £170 ($250)
 *This rare issue is one of the earliest of the reign and must date to the period immediately
 following Postumus' capture of Cologne and the execution of Gallienus' son Saloninus.
 Cologne was the command-centre for the Rhine frontier region. See also no. 11026.*

10991 Similar, but with obv. legend B. RIC 87. RSC 355a, b. Hunter, p. lxxxviii. *[Cologne,
 AD 260].* **VF** £40 ($60) / **EF** £100 ($150)

10992 10998

10992 B. Rev. SERAPI COMITI AVG, Serapis stg. l., raising r. hand and holding transverse sceptre
 in l., sometimes with ship at feet to l. RIC 329. RSC 358–360a. Hunter 91–2. *[Cologne,
 AD 265–8].* **VF** £20 ($30) / **EF** £45 ($65)

10993 B. Rev. SPEI PERPETVAE, Spes advancing l., holding flower and lifting skirt. RIC 88. RSC
 361, 361a. Hunter, p. lxxxviii. *[Cologne, AD 260–65].* **VF** £23 ($35) / **EF** £50 ($75)

10994 B. Rev. SPES PVBLICA, as previous, sometimes with officina mark P (= 1) in ex. RIC 384.
 RSC 363, 363a. Hunter, p. xcv. *[Milan, AD 268].* **VF** £23 ($35) / **EF** £50 ($75)
 *See note following no. 10929 (see also nos. 10916, 10930–31, 10937–8, 10968, 10986,
 and 11001–2).*

10995 B. Rev. VBERTAS (or VBERITAS) AVG, Uberitas stg. l., holding cow's udder (?) and
 cornucopiae. RIC 330. RSC 365–366a. Hunter 93. *[Cologne, AD 265–8].*
 VF £14 ($20) / **EF** £30 ($45)

10996 B. Rev. VICTORIA AVG, Victory advancing l., holding wreath and palm, sometimes with
 captive at feet. RIC 89–90. RSC 377, 377a, 390. Hunter 30. *[Cologne, AD 260–65].*
 VF £14 ($20) / **EF** £30 ($45)

10997 **Billon antoninianus.** B. Rev. VIRTVS AVG, Hercules stg. r., resting on club and holding bow, lion's skin over l. arm. RIC 92. RSC 418, 418a. Hunter, p. lxxxviii. *[Cologne, AD 260–65].* **VF** £20 ($30) / **EF** £45 ($65)
The B.M. has a rarer variety on which Hercules holds four apples instead of bow (RSC 418b).

10998 B. Rev. — Mars or Virtus, naked, stg. r., resting on spear and shield. RIC 93. RSC 419, 419a. Hunter 32. *[Cologne, AD 260–65].* **VF** £14 ($20) / **EF** £30 ($45)

10999 B. Rev. — Postumus, in military attire, advancing r., holding spear and shield, sometimes with captive at feet. RIC 331. RSC 427–428a. Hunter, p. xci. *[Cologne, AD 265–8].* **VF** £16 ($25) / **EF** £38 ($55)

11000 B. Rev. — Postumus, in military attire, stg. l., holding spear and resting r. hand on trophy with two captives at base. RIC 332. RSC 434. Hunter, p. xci. *[Cologne, AD 265–8].* **VF** £65 ($100) / **EF** £170 ($250)

11001 IMP POSTVMVS AVG. Rev. VIRTVS EQVIT, Mars or soldier advancing r., holding transverse spear and shield, sometimes with officina mark T (= 3) in ex. RIC 388. Cf. RSC 441 (rev. misdescribed). Hunter 144. *[Milan, AD 268].* **VF** £20 ($30) / **EF** £45 ($65)
See note following no. 10929 (see also the following and nos. 10916, 10930–31, 10937–8, 10968, 10986, and 10994).

11002 B. Rev. VIRTVS EQVITVM, Hercules stg. r., r. hand on hip, l. resting on club with lion's skin set on rock, sometimes with officina mark S (= 2) in ex. RIC 389. RSC 443, 443a. Hunter, p. xcv. *[Milan, AD 268].* **VF** £23 ($35) / **EF** £50 ($75)

11003 B. Rev. VIRTVTI AVGVSTI, similar, but the club is not set on rock, and without officina mark in ex. RIC 333. RSC 452. Hunter, p. xci. *[Cologne, AD 265–8].* **VF** £16 ($25) / **EF** £38 ($55)

11004 **Billon denarius.** E, conjoined laur. busts l. of Postumus and Hercules. Rev. CASTOR, Castor stg. l. beside horse, holding spear. RIC 335. RSC 10. Hunter, p. xc. Schulte 160. *[Cologne, AD 268].* **F** £300 ($450) / **VF** £825 ($1,250) / **EF** £2,000 ($3,000)
See note following no. 10926.

NB Many of the rare denarii of this reign are of fine style and would seem to be patterns for aurei rather than normal billon coinage struck for circulation.

11005 Similar, but conjoined busts r. Rev. FELICITAS TEMP, galley travelling l. over waves, with rowers and standard. RIC 339. RSC 55a. Hunter, p. xc. Schulte 157. *[Cologne, AD 268].* **F** £300 ($450) / **VF** £825 ($1,250) / **EF** £2,000 ($3,000)

11006 Similar, but conjoined heads instead of busts. Rev. HERCVLI ARCADIO, Hercules r., pinning down stag with his l. knee and grappling with its antlers. RIC 340. RSC 109. Hunter, p. xc. Schulte 128. *[Cologne, AD 268].* **F** £365 ($550) / **VF** £1,000 ($1,500) / **EF** £2,300 ($3,500)

11007 Obv. As 11005. Rev. HERCVLI ARGIVO, Hercules advancing l., wielding his club to attack the Hydra of Lerna. RIC 341. RSC 110. Hunter, p. xc. Schulte 126. *[Cologne, AD 268].* **F** £365 ($550) / **VF** £1,000 ($1,500) / **EF** £2,300 ($3,500)
Another variety of this type has the obverse busts to left.

11008 B. Rev. HERCVLI DEVSONIENSI, laur. bust of Hercules l. RIC —. RSC —. Hunter —. Schulte 5. *[Cologne, AD 260].* **F** £365 ($550) / **VF** £1,000 ($1,500) / **EF** £2,300 ($3,500)

This interesting legend refers to the cult of Hercules at Deuso (modern Deutz) on the Rhine which still forms the eastern bridgehead of Cologne (see also the following and nos. 10865–7, 10871, 10944–5, 11042–4, 11083–5, and 11107).

11009 **Billon denarius.** Obv. As 11005. Rev. — half-length bust of Hercules l., lion's skin on hd., holding club over. r. shoulder. RIC 343. RSC 116. Hunter, p. xc. Schulte 154. *[Cologne, AD 268].* **F** £300 ($450) / **VF** £825 ($1,250) / **EF** £2,000 ($3,000)

11010 — Rev. HERCVLI ERVMANTINO, Hercules advancing r., carrying the wild Erymanthian boar, wine-jar at feet. RIC 344. RSC 119. Hunter, p. xc. Schulte 129–31. *[Cologne, AD 268].* **F** £365 ($550) / **VF** £1,000 ($1,500) / **EF** £2,300 ($3,500)
Another variety of this type has obverse conjoined heads to left.

11011 Obv. As 11005. Rev. HERCVLI GADITANO, Hercules advancing r., lion's skin on l. arm, in combat with three soldiers representing the triple-headed monster Geryon. RIC 346. RSC 121. Hunter, p. xc. Schulte 147. *[Cologne, AD 268].*
F £365 ($550) / **VF** £1,000 ($1,500) / **EF** £2,300 ($3,500)

11012 — Rev. HERCVLI INMORTALI (*sic*), Hercules advancing r., hd. l., holding club over l. shoulder and dragging behind him the triple-headed dog Cerberus. RIC 347. RSC 122. Hunter, p. xc. Schulte 153. *[Cologne, AD 268].*
F £300 ($450) / **VF** £825 ($1,250) / **EF** £2,000 ($3,000)
Another variety of this type has obverse conjoined heads to left.

11013 — Rev. HERCVLI INVICTO, Hercules advancing l., trampling on Hippolyta, queen of the Amazons, whose girdle he holds in r. hand, club and lion's skin in l. RIC 348. RSC 123. Hunter, p. xc. Schulte 143. *[Cologne, AD 268].*
F £300 ($450) / **VF** £825 ($1,250) / **EF** £2,000 ($3,000)
Another variety of this type has obverse conjoined heads instead of busts.

11014 — Rev. HERCVLI NEMAEO, Hercules stg. l., strangling the Nemean lion, club on ground. RIC 349. RSC 132. Hunter, p. xc. Schulte 122. *[Cologne, AD 268].*
F £365 ($550) / **VF** £1,000 ($1,500) / **EF** £2,300 ($3,500)

11015 Obv. As 11004. Rev. HERCVLI PISAEO, Hercules advancing l., wielding mattock over r. shoulder, water-jar at feet. RIC 350. RSC 134. Hunter, p. xc. Schulte 135. *[Cologne, AD 268].* **F** £365 ($550) / **VF** £1,000 ($1,500) / **EF** £2,300 ($3,500)
This type celebrates Hercules of Pisa, the district around Olympia in Elis where the hero performed one of his Twelve Labours by cleansing the stables of King Augeas.

11016 Obv. As 11005. Rev. HERCVLI ROM, Hercules stg. l. beside tree bearing the golden apples in the Garden of the Hesperides, three of whom stand beside him to l. RIC 351. RSC 135. Hunter, p. xc. Schulte 148. *[Cologne, AD 268].*
F £365 ($550) / **VF** £1,000 ($1,500) / **EF** £2,300 ($3,500)
Another variety of this type has obverse conjoined heads to left.

11017 — Rev. HERCVLI THRACIO, Hercules r., overcoming the man-eating horses of Diomedes, king of the Bistones. RIC 352. RSC 140. Hunter, p. xc. Schulte 139. *[Cologne, AD 268].*
F £300 ($450) / **VF** £825 ($1,250) / **EF** £2,000 ($3,000)

11018 Similar, but with obv. C, heroic laur. bust l., lion's skin on chest , holding club over r. shoulder. RIC 353. RSC 139. Cf. Hunter, p. xc. Schulte 140. *[Cologne, AD 268].*
F £300 ($450) / **VF** £825 ($1,250) / **EF** £2,000 ($3,000)

11019 **Billon denarius.** Obv. As 11004. Rev. HILARITAS AVG, Hilaritas stg. l. between two children, holding long palm and cornucopiae. Cf. RIC 354. Cf. RSC 141. Hunter, p. xc. Schulte 159. *[Cologne, AD 268]*.　**F** £300 ($450) / **VF** £825 ($1,250) / **EF** £2,000 ($3,000)

11020 B. Rev. INVICTO AVG, rad. and cuir. bust of Postumus l., holding sceptre over r. shoulder. RIC 100. RSC 148. Hunter, p. lxxxvii. Schulte 28b. *[Cologne, AD 261]*.
F £365 ($550) / **VF** £1,000 ($1,500) / **EF** £2,300 ($3,500)

11021 D. Rev. LIBERALITAS AVG, Liberalitas stg. l., holding abacus and cornucopiae. RIC 355. RSC 187. Hunter, p. lxxxix. Schulte 73. *[Cologne, AD 263]*.
F £230 ($350) / **VF** £665 ($1,000) / **EF** £1,650 ($2,500)

11022 Obv. As 11005. Rev. PAX AVG, Pax stg. l., holding olive-branch and transverse sceptre. RIC 359. RSC 216. Hunter 45. Schulte 156. *[Cologne, AD 268]*.
F £300 ($450) / **VF** £825 ($1,250) / **EF** £2,000 ($3,000)

11023 B. Rev. P M TR P COS P P, rad. lion walking l., holding thunderbolt in its mouth. RIC 95. RSC 238. Hunter, p. lxxxvii. Schulte 27b-c. *[Cologne, AD 260]*.
F £300 ($450) / **VF** £825 ($1,250) / **EF** £2,000 ($3,000)

11024 D, conjoined laur. heads r. of Postumus and Hercules. Rev. P M TR P X COS V P P, half-length laur. bust of winged Victory r., inscribing with r. hand VO / XX on shield held before her. RIC 334. RSC 284a. Hunter, p. lxxxviii. Schulte 163b. *[Cologne, AD 269]*.
F £365 ($550) / **VF** £1,000 ($1,500) / **EF** £2,300 ($3,500)

11025 Obv. As 11004. Rev. POSTVMVS AVGVSTVS, bust of Postumus, as Hercules, r., wearing lion's skin headdress , the whole within laurel-wreath. RIC 360. RSC 290. Hunter, p. xc. Schulte 155. *[Cologne, AD 268]*.
F £365 ($550) / **VF** £1,000 ($1,500) / **EF** £2,300 ($3,500)

11026 B. Rev. SALVS PROVINCIARVM, river-god (the Rhine) reclining l., resting r. hand on boat and holding anchor in l., l. arm resting on urn. RIC —. RSC —. Hunter —. Schulte 2. *[Cologne, AD 260]*.　**F** £365 ($550) / **VF** £1,000 ($1,500) / **EF** £2,300 ($3,500) *This is one of the earliest issues of the reign and must date to the period immediately following Postumus' capture of Cologne and the execution of Gallienus' son Saloninus. Cologne was the command-centre for the Rhine frontier region. See also no. 10990.*

11027 Obv. As 11005. Rev. TRIB POT X COS V P P, Postumus in slow quadriga l., holding branch. RIC —. RSC —. Cf. Hunter, p. lxxxviii. Schulte 161b. *[Cologne, AD 269]*.
F £365 ($550) / **VF** £1,000 ($1,500) / **EF** £2,300 ($3,500)

11028 VIRTVS POSTVMI AVG, helmeted and cuir. bust r. Rev. VICTORIA AVG, Victory in galloping biga r., holding whip. RIC —. RSC —. Cf. Hunter, p. lxxxviii. Schulte 11b. *[Cologne, AD 261]*.　**F** £365 ($550) / **VF** £1,000 ($1,500) / **EF** £2,300 ($3,500)

11029

11029 **Billon quinarius.** B. Rev. FIDES MILITVM, Fides Militum stg. l., holding standard in each hand. RIC 105. RSC 68. Hunter, p. lxxxvii. Schulte Q3b-d. *[Cologne, AD 261]*.
F £170 ($250) / **VF** £500 ($750) / **EF** £1,200 ($1,800)

11030 **Billon quinarius.** D, conjoined laur. busts r. of Postumus and Hercules. Rev. PAX AVG, Pax stg. l., holding olive-branch and transverse sceptre. RIC 361. RSC 217. Cf. Hunter, p. xc. Schulte Q14. *[Cologne, AD 268].* **F** £230 ($350) / **VF** £665 ($1,000) / **EF** £1,650 ($2,500)

11031 B. Rev. P M TR P COS II P P, Postumus, in military attire, stg. l., holding globe and resting on spear. RIC 104. RSC 241. Hunter, p. lxxxvii. Schulte Q1–2. *[Cologne, AD 261].*
 F £170 ($250) / **VF** £500 ($750) / **EF** £1,200 ($1,800)

11032 B, bare-headed and cuir. bust three-quarter face to l. Rev. PROVIDENTIA AVG, Providentia stg. l., holding globe and transverse sceptre. RIC 362. RSC 297. Hunter, p. xci. Schulte Q8. *[Cologne, AD 264].* **F** £365 ($550) / **VF** £1,000 ($1,500) / **EF** £2,300 ($3,500)

11033 C, conjoined laur. hds. or busts r. of Postumus and Hercules. Rev. SALVS AVG, Aesculapius stg. facing, hd. l., holding snake-entwined staff, globe at feet to r. RIC 363. RSC 337. Hunter, p. xc. Schulte Q11–12. *[Cologne, AD 265].*
 F £230 ($350) / **VF** £665 ($1,000) / **EF** £1,650 ($2,500)

11034 Obv. Similar. Rev. SALVS POSTVMI AVG, Salus stg. r., feeding snake held in her arms. RIC —. RSC —. Hunter —. Cf. Schulte Q13 and p. 8 (Weiller, Essai). *[Cologne, AD 265].*
 F £230 ($350) / **VF** £665 ($1,000) / **EF** £1,650 ($2,500)

11035 **Bronze double sestertius.** A. Rev. EXERCITVS AVG S C, Postumus on horseback pacing l., his r. hand raised, addressing gathering of three or four soldiers holding standards. RIC 116–17. C 36. Hunter, p. xcii. Bastien 20–21. *[Cologne, AD 260].*
 F £265 ($400) / **VF** £665 ($1,000) / **EF** £2,000 ($3,000)

NB Coins of this denomination may be distinguished by the radiate crown worn by the emperor on obverse. Their weights are sometimes no heavier than the contemporary sestertii and specimens are frequently overstruck on coins of first and second century emperors, the undertype often being clearly visible. Bastien has identified the extensive coinage of a secondary mint, of uncertain location, the issues of which are generally of coarser style than those of Cologne. Additionally, there are many contemporary forgeries, some of which are of very poor style and execution.

11036 Similar, but EXERCITVS VAG (*sic*) S C on rev. RIC 117. C 37. Cf. Hunter, p. xciii. Bastien 141. *[Uncertain mint, AD 260].* **F** £230 ($350) / **VF** £600 ($900) / **EF** £1,850 ($2,750)

11037 A. Rev. FELICITAS AVG S C, Felicitas stg. l., holding long caduceus and cornucopiae. RIC 121. C 40. Hunter, p. xciv. Bastien 323. *[Uncertain mint, AD 261–2].*
 F £80 ($120) / **VF** £200 ($300) / **EF** £600 ($900)

11038 A. Rev. FELICITAS on entablature of elaborate triumphal arch, AVG in ex., two captives seated either side of trophy on roof of arch. RIC 118. C 47. Hunter 117. Bastien 142, 156. *[Uncertain mint, AD 260–61].* **F** £200 ($300) / **VF** £525 ($800) / **EF** £1,650 ($2,500)

11039 A. Rev. FELICITAS PVBLICA or PVBLICAT (*sic*), sometimes with S C, Felicitas stg., as 11037. RIC 122. C 53. Hunter, p. xcii. Bastien 23–4. *[Cologne, AD 260].*
 F £80 ($120) / **VF** £200 ($300) / **EF** £600 ($900)

11040 A. Rev. FIDES MILITVM, Fides Militum stg., as 11029. RIC 123. C 74. Hunter, p. xciv. Bastien 143. *[Uncertain mint, AD 260–61].* **F** £65 ($100) / **VF** £170 ($250) / **EF** £500 ($750)

11041 A. Rev. GERMANICVS MAX V, two captives seated at foot of trophy. RIC 129, 198. C 85–6. Hunter 118. Bastien 301–2. *[Uncertain mint, AD 261–2].*
 F £100 ($150) / **VF** £230 ($350) / **EF** £665 ($1,000)
 This reverse type is copied from an antoninianus issue of Gallienus struck at Cologne in AD 257–8 (see no. 10224).

POSTUMUS 369

11040

11042 **Bronze double sestertius.** A. Rev. HER DEVSONIENS AVG, Hercules stg. r., resting on club and holding bow, lion's skin over l. arm. RIC 130. C 89. Hunter —. Bastien 189. *[Uncertain mint, AD 260–61].* **F** £100 ($150) / **VF** £230 ($350) / **EF** £665 ($1,000)
This interesting legend refers to the cult of Hercules at Deuso (modern Deutz) on the Rhine which still forms the eastern bridgehead of Cologne (see also the following two and nos. 10865–7, 10871, 10944–5, 11008–9, 11083–5, and 11107).

11043 Similar, but with rev. legend HERC DEVSONIENSI. Cf. RIC 131. Cf. C 94. Hunter 120. Bastien 104. *[Cologne, AD 261].* **F** £80 ($120) / **VF** £200 ($300) / **EF** £600 ($900)

11044 Similar, but with rev. type Hercules stg. l. in tetrastyle temple, resting on club and holding lion's skin. RIC 134. C 99. Hunter 121. Bastien 167–8. *[Uncertain mint, AD 260–61].*
F £120 ($180) / **VF** £300 ($450) / **EF** £900 ($1,350)

11045 A. Rev. HERC PACIFERO, Hercules stg. l., holding branch in r. hand, club and lion's skin in l. RIC 135. C 106. Hunter 122. Bastien 159. *[Uncertain mint, AD 260–61].*
F £80 ($120) / **VF** £200 ($300) / **EF** £600 ($900)

11046 A. Rev. HERCVLI MAGVSANO, Hercules stg. r., r. hand on hip, l. holding lion's skin and resting on club set on rock. RIC 139. C 130. Hunter, p. xciv. Bastien 105. *[Cologne, AD 261].* **F** £150 ($225) / **VF** £365 ($550) / **EF** £1,650 ($1,100)
This interesting legend refers to the cult of Hercules at Magusa, a small town on the river Moselle (see also no. 10947).

11047 A. Rev. IMP C M CASS LAT POSTVMVS P F AVG, rad. and dr.bust of Postumus r., as on obv. RIC 140. C 142. Hunter —. Bastien 139. *[Uncertain mint, AD 260–61].*
F £230 ($350) / **VF** £600 ($900) / **EF** £1,850 ($2,750)

11048 A (IMP sometimes omitted). Rev. IOVI PROPVGNATORI, Jupiter advancing l., looking back, brandishing thunderbolt and holding eagle. RIC 141. C 156. Hunter, p. xciv. Bastien 176. *[Uncertain mint, AD 261].* **F** £80 ($120) / **VF** £200 ($300) / **EF** £600 ($900)

11049 A. Rev. LAETITIA AVG (sometimes with S C), galley with rowers travelling l. over waves. RIC 143. C 177, 179. Hunter 123. Bastien 81, 87. *[Cologne, AD 261].*
F £80 ($120) / **VF** £200 ($300) / **EF** £600 ($900)
This refers to the importance of naval power in the Gallic Empire and perhaps even to an imperial visit to Britain in the early years of Postumus' reign (see also nos. 10958 and 11087).

11050 A. Rev. MONETA AVG, Moneta stg. l., holding scales and cornucopiae. RIC 212. C 202. Hunter, p. xciv. Bastien 305. *[Uncertain mint, AD 261–2].*
F £80 ($120) / **VF** £200 ($300) / **EF** £600 ($900)

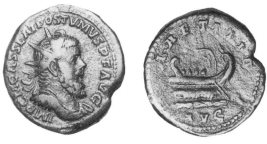

11049

11051 **Bronze double sestertius.** A. Rev. PAX AVG, Pax advancing l., holding olive-branch and
sceptre, globe at feet. Cf. RIC 218. Cf. C 222. Hunter, p. xciv. Bastien 306–306b.
[Uncertain mint, AD 261–2]. **F** £80 ($120) / **VF** £200 ($300) / **EF** £600 ($900)

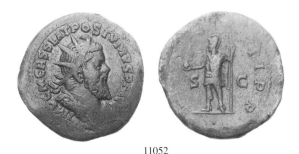

11052

11052 A. Rev. P M TR P COS II P P S C, Postumus (?), in military attire, stg. l., holding globe and
resting on spear. RIC 106. C 246. Hunter 114. Bastien 62–3. *[Cologne, AD 261].*
F £65 ($100) / **VF** £170 ($250) / **EF** £500 ($750)

11053 Similar, but with rev. type Mars or Virtus stg. r., resting on spear and shield. RIC 111. C
259. Hunter, p. xciii. Bastien 48–9. *[Cologne, AD 261].*
F £75 ($110) / **VF** £185 ($275) / **EF** £550 ($825)

11054 As 11052, but with rev. legend P M TR P COS III P P S C. RIC 113. C 262. Hunter, p. xcii.
Bastien 124. *[Cologne, AD 262].* **F** £75 ($110) / **VF** £185 ($275) / **EF** £550 ($825)

11055 Similar, but emperor wears helmet as well as rad. crown on obv. RIC 113. C 263. Hunter,
p. xcii. Bastien 125. *[Cologne, AD 262].*
F £120 ($180) / **VF** £300 ($450) / **EF** £900 ($1,350)

11057 A. Rev. P M TR P IIII COS III P P, Mars, naked, advancing r., carrying transverse spear and
trophy over l. shoulder. RIC 114. C 274. Hunter, p. xciii. Bastien 233. *[Uncertain mint,
AD 263].* **F** £100 ($150) / **VF** £230 ($350) / **EF** £665 ($1,000)

11058 A. Rev. RESTITVTOR GALLIAR S C, Postumus, in military attire, stg. l., resting on spear and
raising kneeling figure of Gallia r., holding branch. RIC 157. C 321. Hunter, p. xcii.
Bastien 28. *[Cologne, AD 260].* **F** £130 ($200) / **VF** £330 ($500) / **EF** £1,000 ($1,500)

11059 **Bronze double sestertius.** Similar, but obv. legend usually ends P AVG, and on rev. S C is omitted and Gallia holds long torch (?) instead of branch. Cf. RIC 158. Cf. C 320. Hunter, p. xcii. Bastien 30. *[Cologne, AD 260].*

F £130 ($200) / **VF** £330 ($500) / **EF** £1,000 ($1,500)

11060 A. Rev. SALVS AVG, Salus enthroned l., feeding snake arising from altar. RIC 161. C 340. Hunter, p. xcii. Bastien 32. *[Cologne, AD 260].*

F £100 ($150) / **VF** £230 ($350) / **EF** £665 ($1,000)

11061 Similar, but Salus is enthroned r. RIC 161. C 341. Hunter, p. xciv. Bastien 227. *[Uncertain mint, AD 260–61].*

F £100 ($150) / **VF** £230 ($350) / **EF** £665 ($1,000)

11062 B. Rev. — Aesculapius stg. facing, hd. l., resting on snake-entwined staff, globe at feet. RIC —. C —. Hunter, p. xciv. Bastien 284. *[Uncertain mint, AD 262–3].*

F £120 ($180) / **VF** £300 ($450) / **EF** £900 ($1,350)

11063 A. Rev. IPEI (*sic*, for SPEI) PERPETVAE, Spes advancing l., holding flower and lifting skirt. Cf. RIC 227. Cf. C 362. Hunter —. Bastien 285. *[Uncertain mint, AD 261–2].*

F £80 ($120) / **VF** £200 ($300) / **EF** £600 ($900)

11064 A. Rev. VICCTORIA (*sic*) AVG, Victory advancing l., holding wreath and palm. RIC —. C —. Hunter —. Bastien 249. *[Uncertain mint, AD 260–61].*

F £80 ($120) / **VF** £200 ($300) / **EF** £600 ($900)

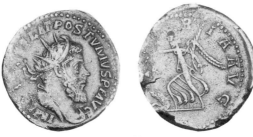

11065

11065 Similar, but VICTORIA AVG (sometimes with S C in ex.) and with seated captive at feet of Victory. RIC 169. C 380. Hunter, p. xcii. Bastien 95, 102. *[Cologne, AD 261].*

F £65 ($100) / **VF** £170 ($250) / **EF** £500 ($750)

11066 Similar (without S C), but Victory stands r. on globe between two seated captives, holding wreath and trophy over l. shoulder. Cf. RIC 175. C 394. Hunter, p. xcii. Bastien 34. *[Cologne, AD 260].*

F £100 ($150) / **VF** £230 ($350) / **EF** £665 ($1,000)

11067 As previous, but Victory holds palm instead of trophy over shoulder. RIC —. C —. Cf. Hunter, p. xciv. Bastien —. *[Uncertain mint, AD 260–61].*

F £110 ($160) / **VF** £265 ($400) / **EF** £800 ($1,200)

11068 A. Rev. VICTORIA AVG S C, Postumus, in military attire, stg. r., resting on spear and shield, trophy behind with two seated captives at base. RIC 176. C 403. Hunter, p. xciv. Bastien 150, 163, 174. *[Uncertain mint, AD 260–61].*

F £100 ($150) / **VF** £230 ($350) / **EF** £665 ($1,000)

11067

11069 **Bronze double sestertius.** A. Rev. VICTORIAE AVG (with or without S C in ex.), two Victories stg. face to face, holding between them shield attached to palm-tree with two captives seated at base. RIC 166. C 407. Hunter 104. Bastien 39, 43–4. *[Cologne, AD 260].*
F £100 ($150) / VF £230 ($350) / EF £665 ($1,000)
This type appears to have been inspired by the coinage of Septimius Severus celebrating that emperor's victories in Britain 50 years before (see Vol. II, nos. 6430 and 6443). See also nos. 11102–3.

11070

11070 A. Rev. VIRTVS AVG (with or without S C in field), Mars or Virtus stg. r., resting on spear and shield. RIC 179. C 421–2. Hunter 105. Bastien 54, 57. *[Cologne, AD 261].*
F £65 ($100) / VF £170 ($250) / EF £500 ($750)

11071 Similar, but Mars or Virtus stg. l. Cf. RIC 240. Cf. C. 439. Hunter, p. xciv. Bastien 201. *[Uncertain mint, AD 260].* F £80 ($120) / VF £200 ($300) / EF £600 ($900)

11072 A. Rev. — cuir. bust of Postumus l., wearing crested and ornamented helmet and holding spear and shield. RIC 183. C 435. Hunter —. Bastien 107. *[Cologne, AD 261].*
F £400 ($600) / VF £1,000 ($1,500) / EF £3,000 ($4,500)

11073 A. Rev. — Jupiter advancing l., looking back, brandishing thunderbolt and holding eagle. RIC 178. C 416. Hunter, p. xciv. Bastien 180, 243. *[Uncertain mint, AD 261].*
F £100 ($150) / VF £230 ($350) / EF £665 ($1,000)

11074 Similar, but Jupiter advancing r., looking back. RIC 237. C 414–15. Hunter, p. xciv. Bastien 289, 338. *[Uncertain mint, AD 261].*
F £100 ($150) / VF £230 ($350) / EF £665 ($1,000)

11075 **Bronze double sestertius.** A. Rev. — Mars, in military attire, advancing r., holding spear and
shield and trampling on suppliant captive at his feet. RIC 181. C 430. Hunter, p. xciv. Bastien
210, 216, 235. *[Uncertain mint, AD 261].* **F** £80 ($120) / **VF** £200 ($300) / **EF** £600 ($900)

11076 Similar, but Mars advancing l. RIC 181. C 433. Hunter, p. xciv. Bastien 267. *[Uncertain
mint, AD 261].* **F** £100 ($150) / **VF** £230 ($350) / **EF** £665 ($1,000)

11077 A. Rev. — Mars, in military attire, stg. l., r. foot on uncertain object, holding olive-branch
and resting on spear. Cf. RIC 238. Cf. C 426. Hunter, p. xciv. Bastien 288. *[Uncertain
mint, AD 261].* **F** £100 ($150) / **VF** £230 ($350) / **EF** £665 ($1,000)

11078 A. Rev. VIRTVS POSTVMI S C, Postumus, in military attire, stg. l., holding globe and
resting on sceptre, crowned by Victory stg. l. behind him trampling on suppliant captive
between them. RIC 185. C 450. Hunter 107. Bastien 22. *[Cologne, AD 260].*
 F £200 ($300) / **VF** £500 ($750) / **EF** £1,500 ($2,250)

11079 **Bronze sestertius.** B. Rev. ADVENTVS AVG S C, Postumus on horseback pacing l., his r.
hand raised and holding spear in l. RIC 115. Cf. C 2. Cf. Hunter, p. xciii. Bastien 10–11.
[Cologne, AD 260]. **F** £150 ($225) / **VF** £365 ($550) / **EF** £1,100 ($1,650)

NB This denomination may be distinguished by the laurel wreath worn by the emperor on
obverse as well as by the shorter form of the legend. The weights of the sestertii are often
as heavy as the double sestertii.

11080

11080 B. Rev. FELICITAS AVG (with or without S C in ex.), trophy, at foot of which two captives
seated back to back. Cf. RIC 120. C 50–51. Hunter 110. Bastien 12–14. *[Cologne,
AD 260].* **F** £110 ($160) / **VF** £265 ($400) / **EF** £800 ($1,200)

11081

11081 B. Rev. FIDES MILITVM (sometimes with, but usually without S C in ex.), Fides Militum stg.
l., holding standard in each hand. RIC 124. C 69. Hunter, p. xciii. Bastien 73–4. *[Cologne,
AD 261].* **F** £65 ($100) / **VF** £170 ($250) / **EF** £500 ($750)

11082 **Bronze sestertius.** B, laur. hd. r. Rev. FORTVNA AVG S C, Fortuna seated l., holding rudder and cornucopiae. RIC 246. C 82. Hunter, p. xciii. Bastien 128. *[Cologne, AD 264].*
F £120 ($180) / **VF** £300 ($450) / **EF** £900 ($1,350)

11083 VIRTVS POSTVMI AVG, cuir. bust l., wearing crested and ornamented helmet and holding spear and shield. Rev. HERC DEVSONIENSI, Hercules stg. r., resting on club and holding bow, lion's skin over l. arm. RIC 133. C 97. Hunter, p. xciii. Bastien 113. *[Cologne, AD 261].*
F £130 ($200) / **VF** £330 ($500) / **EF** £1,000 ($1,500)
This interesting legend refers to the cult of Hercules at Deuso (modern Deutz) on the Rhine which still forms the eastern bridgehead of Cologne (see also the following two and nos. 10865–7, 10871, 10944–5, 11008–9, 11042–4, and 11107).

11084 IMP C POSTVMVS PIVS F (or FE) AVG. Rev. HERCVLI DEVSONIENSI, laur. bust of Hercules l. RIC 137 var. C 117 var. Hunter, p. xciii. Bastien 15–16. *[Cologne, AD 260].*
F £200 ($300) / **VF** £500 ($750) / **EF** £1,500 ($2,250)

11085 Similar, but with obv. legend B and the bust of Hercules is to r. on rev. RIC 247. C 118. Hunter, p. xciii. Bastien 359. *[Uncertain mint, AD 260].*
F £170 ($250) / **VF** £430 ($650) / **EF** £1,350 ($2,000)

11086 Obv. As 11082. Rev. I O M SPONSORI SAECVLI AVG, Jupiter stg. r., holding thunderbolt and sceptre, facing Postumus, in military attire, stg. l., sacrificing over tripod-altar and holding spear. RIC 248. C 150. Hunter, p. xciii. Bastien 131. *[Cologne, AD 264].*
F £230 ($350) / **VF** £600 ($900) / **EF** £1,850 ($2,750)
This rare type celebrates the cult of Jupiter Optimus Maximus Capitolinus in Rome.

11087 B. Rev. LAETITIA AVG, galley with rowers travelling l. over waves. RIC 144. C 169. Hunter, p. xciii. Bastien 84–5. *[Cologne, AD 261].*
F £75 ($110) / **VF** £185 ($275) / **EF** £550 ($825)
This refers to the importance of naval power in the Gallic Empire and perhaps even to an imperial visit to Britain in the early years of Postumus' reign (see also nos. 10958 and 11049).

11088 B. Rev. ORIENS AVG, Sol in galloping quadriga l., r. hand raised, holding whip in l. RIC 152. C 211. Cf. Hunter, p. xciii. Bastien 5. *[Cologne, AD 260].*
F £170 ($250) / **VF** £430 ($650) / **EF** £1,350 ($2,000)

11089 B. Rev. P M TR P COS II P P S C, Postumus (?), in military attire, stg. l., holding globe and resting on spear. RIC 107. C 249. Hunter, p. xciii. Bastien 59–61. *[Cologne, AD 261].*
F £65 ($100) / **VF** £170 ($250) / **EF** £500 ($750)

11090 Similar, but with rev. type Mars or Virtus stg. r., resting on spear and shield. RIC —. C —. Hunter, p. xciii. Bastien 47. *[Cologne, AD 261].*
F £100 ($150) / **VF** £230 ($350) / **EF** £665 ($1,000)

11091 B. Rev. PROFECTIO AVGVSTI S C, Postumus on horseback pacing r., holding spear, preceded by Victory r., her wings open, holding wreath and trophy. Cf. RIC 155. C 292. Hunter, p. xciii. Bastien 19. *[Cologne, AD 260].*
F £230 ($350) / **VF** £525 ($800) / **EF** £1,650 ($2,500)

11092 B. Rev. RESTITVTOR GALLIAR (usually without S C), Postumus, in military attire, stg. l., resting on spear and raising kneeling figure of Gallia r., holding long torch (?). RIC 159. C 322. Hunter, p. xciii. Bastien 25a-27. *[Cologne, AD 260].*
F £120 ($180) / **VF** £300 ($450) / **EF** £900 ($1,350)

11093 **Bronze sestertius.** Obv. As 11082. Rev. SAECVLO FRVGIFERO, winged caduceus. Cf. RIC 250. C 334. Cf. Hunter, p. xciii. Bastien 130. *[Cologne, AD 264].*

F £170 ($250) / **VF** £430 ($650) / **EF** £1,350 ($2,000)

11094 B. Rev. SALVS AVG, Aesculapius stg. l., legs crossed, feeding snake held in his arms and resting on column behind. RIC 163 (rev. Salus). C 343 (rev. Salus). Hunter, p. xciii. Bastien 18. *[Cologne, AD 260].* F £170 ($250) / **VF** £430 ($650) / **EF** £1,350 ($2,000) *An unusual representation of Aesculapius (see also no. 11097).*

11095 A. Rev. — Salus stg. r., feeding snake held in her arms. RIC 162. C 342. Hunter, p. xcii. Bastien 2. *[Cologne, AD 260].* F £110 ($160) / **VF** £265 ($400) / **EF** £800 ($1,200) *The long form of obv. legend occurs only on the very earliest issues of this denomination (see also nos. 11098 and 11104).*

11096 B. Rev. — Salus enthroned l., feeding snake arising from altar. RIC —. C —. Hunter, p. xciii. Bastien 31. *[Cologne, AD 260].* F £100 ($150) / **VF** £230 ($350) / **EF** £665 ($1,000)

11097 B. Rev. SALVS AVGVSTI S C, Aesculapius stg., as 11094, but he touches the hd. of the snake which arises from altar before him. RIC 165. C 346. Hunter, p. xciii. Bastien 17. *[Cologne, AD 260].* F £200 ($300) / **VF** £500 ($750) / **EF** £1,500 ($2,250)

11098 A. Rev. VICTORIA AVG, Victory advancing l., holding wreath and palm, seated captive at feet. RIC 251. C 382. Hunter, p. xcii. Bastien 3. *[Cologne, AD 260].*

F £110 ($160) / **VF** £265 ($400) / **EF** £800 ($1,200) *See note following no. 11095.*

11099 Similar, but with obv. legend B and sometimes with S C in ex. on rev. RIC 170. C 383. Hunter 111–12. Bastien 93–4, 99–100. *[Cologne, AD 261].*

F £65 ($100) / **VF** £170 ($250) / **EF** £500 ($750)

11100 Similar, but with obv. type laur. and cuir. bust l., raising r. hand. RIC 170. C 384–5. Hunter, p. xciii. Bastien 121–2. *[Cologne, AD 261].*

F £130 ($200) / **VF** £330 ($500) / **EF** £1,000 ($1,500)

11101 B. Rev. VICTORIA AVG, Victory stg. r. on shield between two seated captives, holding wreath and palm-branch over l. shoulder. RIC 174. C 393. Cf. Hunter, p. xciii. Bastien 33. *[Cologne, AD 260].* F £100 ($150) / **VF** £230 ($350) / **EF** £665 ($1,000)

11102 B. Rev. — two Victories stg. face to face, holding between them shield attached to palm-tree with two captives seated at base. RIC 167. C —. Hunter, p. xciii. Bastien 35. *[Cologne, AD 260].* F £110 ($160) / **VF** £265 ($400) / **EF** £800 ($1,200) *See note following no. 11069.*

11103 Similar, but with rev. legend VICTORIAE AVG and usually with S C in ex. RIC 167. C 409–10. Hunter 113. Bastien 37–8, 42, 45–6. *[Cologne, AD 260].*

F £100 ($150) / **VF** £230 ($350) / **EF** £665 ($1,000)

11104 A. Rev. VIRTVS AVG, Mars advancing r., carrying spear and shield, trampling on suppliant captive at his feet. RIC 181. C 429. Hunter, p. xciii. Bastien 4. *[Cologne, AD 260].*

F £110 ($160) / **VF** £265 ($400) / **EF** £800 ($1,200) *See note following no. 11095.*

11105 B. Rev. — (with or without S C in field), Mars or Virtus stg. r., resting on spear and shield. RIC 180. C 423–4. Hunter, p. xciii. Bastien 9, 51–2, 55–6. *[Cologne, AD 260–61].*

F £65 ($100) / **VF** £170 ($250) / **EF** £500 ($750)

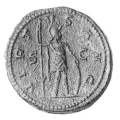

11105

11106 **Bronze sestertius.** B, laur. hd. r. Rev. VIRTVS POSTVMI AVG, Hercules r., pinning down the
Cerynian hind with his l. knee and grappling with its antlers. RIC 253. C 446. Hunter, p. xciii.
Bastien 137. *[Cologne, AD 269].* **F** £265 ($400) / **VF** £665 ($1,000) / **EF** £2,000 ($3,000)

11107 **Bronze dupondius.** B, rad. and laur. hd. r. Rev. HERCVLI DEVSONIENSI, Hercules stg. l.,
resting on club and holding trophy, lion's skin over l. arm. RIC —. C —. Hunter, p. xciii.
Bastien 132. *[Cologne, AD 264].* **F** £170 ($250) / **VF** £430 ($650) / **EF** £1,350 ($2,000)
See note following no. 11083.

NB Many bronze coins showing a radiate portrait of Postumus may appear to be dupondii
but are, in all probability, either late double sestertii of the secondary mint or simply
contemporary imitations which were abundant in the early years of this reign.

11108 POSTVMVS P F AVGVSTVS T P, rad. and cuir. bust. l. Rev. As 11106. Cf. RIC 241. Cf. C
445. Hunter, p. xciii and note 3. Bastien 138. *[Cologne, AD 269].*
F £265 ($400) / **VF** £665 ($1,000) / **EF** £2,000 ($3,000)

LAELIAN
Mar.–Apr./May AD 269

11109

*Ulpius Cornelius Laelianus, born of a noble Spanish family, rebelled against Postumus about
March AD 269 at the legionary base of Moguntiacum (Mainz) on the Rhine. This uprising may have
had the backing of Claudius II, the successor of Gallienus in Rome, but in any case it was a failure
lasting probably only a month or two. However, it did lead indirectly to the downfall of Postumus'
regime resulting in a period of instability in the Gallic Empire. Laelian was besieged in Mainz and
was ultimately deserted by his own soldiers who put him to death prior to surrendering to the
besieger. Postumus' refusal to allow his troops to sack the city seems to have been the reason for
his own assassination.*
 *The place of mintage of Laelian's brief coinage has not been determined with certainty, though
Mainz itself or Augusta Treverorum (Trier) are the most likely locations.*
Unless otherwise stated the obverse legend is IMP C LAELIANVS P F AVG *and the emperor's bust is
depicted cuirassed, or draped and cuirassed, to right, wearing a laurel-wreath on the aurei and a
radiate crown on the antoniniani.*

11109 **Gold aureus.** Rev. TEMPORVM FELICITAS, Hispania reclining l., holding branch, rabbit l. at
 her side beneath l. arm. RIC 1. C 2. Hunter, p. xcv. Schulte 1–4. Gilljam, pl. M, 1–6, 9–12.
 [Mainz or Trier]. **VF** £20,000 ($30,000) / **EF** £42,500 ($65,000)

11110 Rev. VIRTVS MILITVM, female figure (Germania?) stg. l., holding spear and standard
 inscribed XXX. Cf. RIC 3–4. Cf. C 9. Cf. Hunter, p. xcv. Schulte 5. Gilljam, pl. M, 8.
 [Mainz or Trier]. **VF** £25,000 ($37,500) / **EF** £56,500 ($85,000)
 *The numerals on the standard presumably make reference to Legio XXX Ulpia Victrix
 which was stationed at Vetera (Xanten) in Lower Germany.*

11111

11111 **Billon antoninianus.** Rev. VICTORIA AVG, Victory advancing r., holding wreath and
 palm. RIC 9. C 4. Hunter 1. Gilljam, pl. E, 4ff. *[Mainz or Trier].*
 VF £265 ($400) / **EF** £665 ($1,000)

11112 Similar, but with rev. type Victory stg. l., holding wreath and palm. RIC 6. C 3. Hunter,
 p. xcv. Gilljam, pl. G, 50. *[Mainz or Trier].* **VF** £400 ($600) / **EF** £1,000 ($1,500)

11113 As 11111, but with obv. legend IP (*sic*) C VLP COR LAELIANVS. RIC 8. Cf. C 6. Cf. Hunter,
 p. xcv, note 3. Gilljam, pl. E, 1–3. *[Mainz or Trier].* **VF** £400 ($600) / **EF** £1,000 ($1,500)

MARIUS
May–Aug./Sep. AD 269

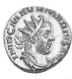

11122

*A blacksmith by trade, Marcus Aurelius Marius rose through the ranks of the Roman army and, in
the confused period following the assassination of Postumus, was proclaimed emperor by the army.
It was probably a case of being in the right place at the right time rather than the possession of any
special abilities or qualifications which led to his elevation. Predictably, his reign was of short
duration (probably about three months) before he, too, fell victim to the violent soldiery. The story
in the 'Historia Augusta' that he was killed with a sword of his own manufacture seems rather
fanciful, probably to be placed in the same category as the statement that his reign lasted for only
two or three days.*

 *Marius issued the bulk of his coinage from the mint of Cologne, but a smaller issue was
produced at the mint opened by Laelian which was probably located at Mainz or Trier.*

 There are three forms of obverse legend:

A. IMP C M AVR MARIVS AVG
B. IMP C M AVR MARIVS P F AVG
C. IMP C MARIVS P F AVG

*The emperor's bust is depicted draped and cuirassed, or cuirassed only, to right, wearing a laurel-
wreath on the aurei and a radiate crown on the antoniniani.*

11114 **Gold aureus.** B. Rev. CONCORDIA MILITVM, clasped r. hands. RIC 1. C 3. Hunter, p. xcvi.
Schulte 3–4. *[Cologne].* **VF** £20,000 ($30,000) / **EF** £42,500 ($65,000)

11115 A. Rev. FIDES MILITVM, Fides Militum stg. l., holding two standards. RIC 14. C 10. Hunter,
p. xcvi. Schulte 6. *[Mainz or Trier].* **VF** £23,500 ($35,000) / **EF** £50,000 ($75,000)

11116 B. Rev. SAEC FELICITAS, Felicitas stg. l., holding caduceus and cornucopiae. RIC 2. C 11.
Hunter, p. xcvi. Schulte 1–2. *[Cologne].* **VF** £21,500 ($32,500) / **EF** £46,650 ($70,000)

11117 B. Rev. VICTORIA AVG, Victory stg. l., resting on shield and holding palm. RIC 3. C 16.
Hunter, p. xcvi. Schulte 5. *[Cologne].* **VF** £23,500 ($35,000) / **EF** £50,000 ($75,000)

11118 **Billon antoninianus.** A. Rev. AEQVITAS AVG, Aequitas stg. l., holding scales and
cornucopiae. RIC 15. C 2. Hunter, p. xcvi. *[Mainz or Trier].*
VF £115 ($175) / **EF** £265 ($400)

11119a 1119b

11119 C. Rev. CONCORD (or CONCORDIA) MILIT (or MILITVM), clasped r. hands. RIC 6–7. C 4,
8. Hunter 1, 3. *[Cologne].* **VF** £100 ($150) / **EF** £230 ($350)

11120 11123

11120 C. Rev. SAEC FELICITAS, Felicitas stg., as 11116. RIC 10. C 13. Hunter 6. *[Cologne].*
VF £100 ($150) / **EF** £230 ($350)

11121 B. Rev. VICTORIA AVG, Victory resting on shield, as 11117. RIC 12. C 17. Hunter, p. xcvi.
[Cologne]. **VF** £100 ($150) / **EF** £230 ($350)

11122 A. Rev. — Victory advancing r., holding wreath and palm. RIC 18. C 20. Hunter 10.
[Mainz or Trier]. **VF** £100 ($150) / **EF** £230 ($350)

11123 Similar, but Victory stg. l. RIC 17. C 19. Hunter 9. *[Mainz or Trier].*
VF £100 ($150) / **EF** £230 ($350)

11124 Similar, but Victory advancing l. RIC 17. C 21. Hunter 12. *[Mainz or Trier].*
VF £115 ($175) / **EF** £265 ($400)

11125 A. Rev. VIRTVS AVG, Mars or Virtus stg. l., resting on shield and spear . RIC 19. C 22.
Hunter, p. xcvi. *[Mainz or Trier].* **VF** £110 ($160) / **EF** £250 ($375)

DOMITIAN
spring or late summer AD 269

This ruler, known from only two billon antoniniani found more than a century apart in southern France (1900) and in England (2003), appears to have made a momentary grasp at power in the Gallic Empire of the post-Postumus era. The only person in recorded history who could possibly fit the required criteria for identifying this usurper would appear to be the general Domitian mentioned in the 'Historia Augusta' in connection with the defeat of the Macriani in the Balkans in AD 261. This Domitian is reputed to have been the bravest and most trusted officer of Aureolus, commander of Gallienus' mobile field army based in Milan, and moreover regarded himself as a descendant of the 1st century Flavian emperor of that name. Aureolus rebelled against Gallienus in the summer of 268 and transferred his allegiance to Postumus. He may at this time have sent his trusted lieutenant on a mission to the Gallic court at Cologne to seek Postumus' active support, in which case Domitian would have found himself stranded in Gaul following the defeat of Aureolus' rebellion. It seems reasonable to surmise that such a man, with known imperial pretensions, would have made a bid for power in the confusion following the assassination of Postumus in the spring of AD 269 or that of Marius in the summer.

11126 **Billon antoninianus.** IMP C DOMITIANVS P F AVG, rad. and cuir. bust r. Rev. CONCORDIA MILITVM, Concordia stg. l., holding patera and cornucopiae. RIC p. 590, 1 and pl. XX, 12. C —. Hunter —. *[Cologne].* *(Only two known)*

VICTORINUS
late summer AD 269–autumn 271

11137

Marcus Piavvonius Victorinus, one of the Gallic Empire's foremost generals, ascended the throne of the rebel state soon after the assassination of Marius. He may have openly rebelled against his predecessor, an enterprise in which he was almost certainly egged on by his politically influential mother Victoria (or Victorina). His reign was much troubled by rebellions and the secession of various territories under his rule, uprisings which doubtless were fomented by the Roman emperors Claudius II and later Aurelian. However, he seems to have been a competent and popular ruler, though his predilection for seducing his officer's wives was an ominous sign for the prospects of his regime. Sure enough, this weakness eventually brought about his downfall in the autumn of AD 271 when an outraged husband decided to put an end to Victorinus' amorous adventures. The emperor's assassination took place in Cologne and once again threw the Gallic Empire into a state of political confusion.

Victorinus' gold coinage, which includes quinarii, is attractive and interesting, the engraving often reaching a high artistic level. Particularly noteworthy is the legionary series honoring the components of the army under the Gallic emperor's command (see nos. 11139–52). The antoniniani, which were struck in considerable quantities, were comparable to the contemporary products of the Central Empire. Victorinus utilized both mints inherited from his predecessor, the main issues coming from Cologne with a substantial additional output from the secondary mint of Mainz or Trier. Following his death a series of antoniniani was issued at the secondary mint by his successor Tetricus in commemoration of Victorinus' deification, the only one of the Gallic emperors to receive this honour.

The following are the principal forms of obverse legend, other varieties being noted where they occur:

A. IMP C M PIAVVONIVS VICTORINVS P F AVG
B. IMP C PI (or PIAV) VICTORINVS P F AVG
C. IMP C VICTORINVS P F AVG
D. IMP CAES VICTORINVS P F AVG
E. IMP VICTORINVS P F AVG

The obverse types of this reign are quite varied, especially on the gold, but unless otherwise stated the emperor's bust is draped and cuirassed, or cuirassed only, to right, wearing a laurel-wreath on all denominations other than the antoniniani on which a radiate crown is worn. On some varieties of the aurei the bust is bare, usually with light drapery on left shoulder.

11127 **Gold aureus.** E, laur. and cuir. bust l., holding spear and shield. Rev. **ADIVTRIX AVG**, Half-length bust of Diana right, drawing arrow from quiver at her shoulder with r. hand and holding bow in l. Cf. RIC 3. Cf. C 4. Hunter 5 var. Schulte 14. *[Cologne, AD 269–70].*
VF £8,000 ($12,000) / EF £20,000 ($30,000)
This unusual reverse legend describes the goddess of the hunt as the 'female helper' of the emperor (see also no. 11164).

 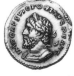

11128 11134

11128 D. Rev. **COMES AVG**, Victory stg. l., holding wreath and palm. RIC 94. C 16. Hunter, p. xcvii. Schulte 5–6. *[Cologne, AD 269].* VF £6,700 ($10,000) / EF £16,500 ($25,000)

11129 E. Rev. — helmeted and cuir. bust of Mars r. RIC 6. C 13. Hunter, p. xcix. Cf. Schulte 48. *[Mainz or Trier, AD 271].* VF £8,000 ($12,000) / EF £20,000 ($30,000)

11130 C. Rev. **COS II**, Victorinus, in military attire, stg. r., resting on spear and presenting globe to Roma enthroned l., also resting on spear and with shield at her side, soldier stg. r., holding standard, behind emperor. Cf. RIC 1. C 28. Cf. Hunter, p. xcviii. Schulte 47. *[Mainz or Trier, AD 271].* VF £8,000 ($12,000) / EF £20,000 ($30,000)

11131 A. Rev. **FIDES MILITVM**, Fides Militum stg. l., holding two standards. Cf. RIC 95. C 33. Hunter, p. xcvii. Schulte 1. *[Mainz or Trier, AD 269].*
VF £6,700 ($10,000) / EF £16,500 ($25,000)

11132 E. Rev. **GAVDIA PVBLICA**, four female figures (the Seasons?) stg. facing each other, two to r. and two to l., holding cornucopiae between them. RIC *Addenda*, p. xxi, 7a. C —. Cf. Hunter, p. xcix. Cf. Schulte 49. *[Mainz or Trier, AD 271].* (*Unique*)
This highly innovative design, featuring the earliest use of the word 'gaudium' on the Roman coinage, celebrates the joy or gladness of the people.

11133 Obv. As 11127. Rev. **INDVLGENTIA AVG**, Victorinus, in military attire, stg. r., resting on spear and raising figure of Gallia (?) who kneels l., holding cornucopiae. RIC 8. C 43. Hunter, p. xcviii. Cf. Schulte 18. *[Cologne, AD 269–70].* (*Unique*)

11134 D, laur. and cuir. bust l. Rev. **INVICTVS**, Sol advancing l., raising r. hand and holding whip in l. RIC 97. C 45. Hunter, p. xcvii. Schulte 9. *[Cologne, AD 269].*
VF £6,700 ($10,000) / EF £16,500 ($25,000)

11135 **Gold aureus.** Obv. Similar, but bust r. Rev. — rad. and dr. bust of Sol r. Cf. RIC 96. Cf. C 44.
Hunter, p. xcvii. Schulte 8. *[Cologne, AD 269].* **VF** £8,000 ($12,000) / **EF** £20,000 ($30,000)

11136 C, laur. and cuir. bust l., holding spear and shield. Rev. **INVICTVS AVG**, Victorinus, in
military attire, galloping r., thrusting spear at fallen enemy beneath horse's hooves. Cf.
RIC 9. Cf. C 51. Hunter, p. xcvii. Schulte 28. *[Cologne, AD 269–70].*
VF £8,000 ($12,000) / **EF** £20,000 ($30,000)

11137

11137 Similar, but with obv. **IMP VICTORINVS AVG**, half-length laur. and cuir bust r., holding
spear and shield. RIC —. C —. Cf. Hunter, p. xcviii. Schulte —. *[Cologne, AD 269–70].*
VF £9,300 ($14,000) / **EF** £23,500 ($35,000)

11138 C. Rev. **LAETITIA AVG N**, Laetitia stg. l., holding wreath and anchor. Cf. RIC 10 and C 55
(probably citing the Becker forgery). Cf. Hunter, p. xcix. Cf. Schulte, pp. 172–3, b and c.
[Mainz or Trier, AD 271]. **VF** £6,700 ($10,000) / **EF** £16,500 ($25,000)
The reverse type appears to be copied from the coinage of Gordian III (see no. 8572).

NB There is a Becker forgery of this type lacking the 'N' at the end of the reverse legend
(Hill, "Becker The Counterfeiter", p. 19, 235 and pl. XIII).

11139 E. Rev. **LEG PRIMA MINERVIA P F**, Victory stg. facing, hd. l., holding wreath and palm, ram
stg. r. on l. Cf. RIC 11. Cf. C 58. Cf. Hunter, p. xcviii. Schulte 29. *[Mainz or Trier,
AD 271].* **VF** £9,300 ($14,000) / **EF** £23,500 ($35,000)
*This and the following 13 types comprise Victorinus' legionary gold coinage honoring the
legions, or legionary detachments, serving in the army of the Gallic emperors. Of these,
two were stationed in Britain, Legio II Augusta at Isca (Caerleon) and Legio XX Valeria
Victrix at Deva (Chester). For legionary denarii, see nos. 11189–90.*

11140 C, conjoined busts l. of Victorinus, laur., and Sol, rad. Rev. **LEG II AVGVSTA P F**, Pegasus
flying r. RIC 12. C —. Hunter, p. xcviii. Schulte 30. *[Mainz or Trier, AD 271].*
VF £9,300 ($14,000) / **EF** £23,500 ($35,000)

11141 E. Rev. **LEG II TRAIANA P F**, Hercules stg. r., resting on club and holding bow, lion's skin
over l. arm. Cf. RIC 13. C 59. Hunter, p. xcviii. Schulte 31. *[Mainz or Trier, AD 271].*
VF £9,300 ($14,000) / **EF** £23,500 ($35,000)

11142 E. Rev. **LEG III GALLICA P F**, bull stg. r. Cf. RIC 14. C —. Hunter, p. xcviii. Schulte 32.
[Mainz or Trier, AD 271]. **VF** £9,300 ($14,000) / **EF** £23,500 ($35,000)

11143 C. Rev. **LEG IIII FLAVIA P F**, two lions stg. facing each other, small female bust r. above,
wearing helmet wrapped in elephant's skin. RIC 15. C 60. Hunter, p. xcviii. Schulte 33.
[Mainz or Trier, AD 271]. **VF** £9,300 ($14,000) / **EF** £23,500 ($35,000)

11144 Obv. As 11136. Rev. **LEG V MACIDONICA** (*sic*) **P F**, bull stg. r., to r. of which eagle stg. r. on
globe, hd l., wings spread, holding wreath in beak. RIC 16. C 61. Hunter, p. xcviii. Schulte
34. *[Mainz or Trier, AD 271].* **VF** £9,300 ($14,000) / **EF** £23,500 ($35,000)

11145 **Gold aureus.** E. Rev. LEG X FRETENSIS P F, bull stg. r. RIC 17. C 62. Hunter, p. xcviii.
Schulte 35. *[Mainz or Trier, AD 271].* VF £9,300 ($14,000) / **EF** £23,500 ($35,000)

11146 E. Rev. LEG X GEMINA P F, the two Dioscuri stg. facing side by side, their hds. turned
towards each other, each resting on spear. RIC 18. C —. Hunter, p. xcviii. Schulte 36.
[Mainz or Trier, AD 271]. VF £9,300 ($14,000) / **EF** £23,500 ($35,000)

NB Doubts have been expressed regarding the authenticity of this type and the next (cf.
Schulte pp. 139–40).

11147 E. Rev. LEG XIII GEMINA P F, lion walking l. RIC 19. C 63. Hunter 18. Schulte 37. *[Mainz
or Trier, AD 271].* VF £9,300 ($14,000) / **EF** £23,500 ($35,000)

11148 E, laur. bust l. Rev. LEG XX VAL VICTRIX P F, wild boar stg. l. RIC 22. C 66. Hunter, p. xcviii.
Schulte 39. *[Mainz or Trier, AD 271].* VF £9,300 ($14,000) / **EF** £23,500 ($35,000)

11149 Similar, but with obv. as 11140. RIC 21. C 65. Hunter, p. xcviii. Cf. Schulte 40. *[Mainz or
Trier, AD 271].* VF £9,300 ($14,000) / **EF** £23,500 ($35,000)

11150 C. Rev. LEG XXII P F, Hercules stg. facing, hd. l., resting on club and holding lion's skin,
capricorn r. on l. RIC 22. C 66. Hunter, p. xcviii. Schulte 39. *[Mainz or Trier, AD 271].*
 VF £9,300 ($14,000) / **EF** £23,500 ($35,000)
*Legio XXII Primigenia was stationed at Mainz from the time of Domitian and this type
may indicate that the mint was located in this city.*

11151 C or E. Rev. LEG XXX VLP VICT P F, Jupiter stg. facing, hd. l., resting on sceptre and
holding thunderbolt, capricorn r. on l. RIC 25. C 70, cf. 71. Hunter 19. Schulte 42–4.
[Mainz or Trier, AD 271]. VF £9,300 ($14,000) / **EF** £23,500 ($35,000)

11152 Similar, but with obv. as 11140. RIC 25. C 72. Hunter 20. Schulte 46. *[Mainz or Trier,
AD 271].* VF £9,300 ($14,000) / **EF** £23,500 ($35,000)

NB It would seem that some of the recorded specimens of this type are modern forgeries
produced in the first half of the 18th century (cf. Schulte p. 142).

11153 D. Rev. PAX AVG, Pax stg. l., holding olive-branch and sceptre. RIC 98. C 78. Hunter,
p. xcvii. Schulte, p. 172, a. *[Cologne, AD 269–70].*
 VF £6,700 ($10,000) / **EF** £16,500 ($25,000)

11154 D, laur. and cuir. bust l. (sometimes bust r.). Rev. PROVIDENTIA AVG, hd. of Medusa
facing, inclined to l. RIC 99. C 104–5. Hunter 6. Schulte 22–3. *[Cologne, AD 269–70].*
 VF £8,000 ($12,000) / **EF** £20,000 ($30,000)
*This type would appear to be derived from the coinage of Septimius Severus issued in AD
207 (see Vol. II, nos. 6231 and 6355).*

11155 E, laur. and cuir. bust l., holding spear and shield. Rev. ROMAE AETERNAE, helmeted and
dr. bust of Roma r. RIC 27. C 107. Hunter, p. xcvii. Cf. Schulte 16. *[Cologne, AD 269–70].*
 VF £8,000 ($12,000) / **EF** £20,000 ($30,000)

11156 Similar, but obv. as 11154. RIC 26. C 108. Hunter, p. xcvii. Schulte 17–17A. *[Cologne,
AD 269–70].* VF £8,000 ($12,000) / **EF** £20,000 ($30,000)

11157 Obv. As previous. Rev. SAECVLI FELICITAS, Isis stg. r., l. foot on prow, nursing infant Horus
held at her breast, rudder behind. RIC 100. C 109. Hunter, p. xcvii. Schulte 19–21.
[Cologne, AD 269–70]. VF £8,000 ($12,000) / **EF** £20,000 ($30,000)
*Another type derived from the Severan coinage, this time an issue of Julia Domna in AD
201 (see Vol. II, nos. 6565 and 6606).*

11158 **Gold aureus.** Obv. As 11137. Rev. VICTORIA AVG, half-length laur. bust of winged Victory r., holding wreath and palm. Cf. RIC 101. Cf. C, p. 86, 1. Hunter, p. xcviii. Schulte 11–12. *[Cologne, AD 269–70].* **VF** £9,300 ($14,000) / **EF** £23,500 ($35,000)

11159 Similar, but with obv. IMP VICTORINVS PIVS AVG, conjoined busts r. of Victorinus, laur., and Mars, helmeted. Cf. RIC 30, 102. Cf. C, p. 86, 2. Cf. Hunter, p. xcviii. Schulte 10. *[Cologne, AD 269–70].* **VF** £9,300 ($14,000) / **EF** £23,500 ($35,000)

11160 VICTORINVS AVG, helmeted and cuir. bust l. Rev. — Victory stg. l., holding wreath and palm. RIC 28. C 123. Hunter, p. xcix. Schulte 53. *[Mainz or Trier, AD 271].* **VF** £8,000 ($12,000) / **EF** £20,000 ($30,000)

11161 D. Rev. VOTA AVGVSTI, conjoined busts r. of Roma, helmeted, and Diana, bow before. RIC 31. C 138. Hunter, p. xcvii. Schulte 24. *[Cologne, AD 269–70].* **VF** £8,000 ($12,000) / **EF** £20,000 ($30,000)

11162 Obv. As 11155. Rev. — as previous. RIC 32. C 139. Hunter, p. xcviii. Schulte 26. *[Cologne, AD 269–70].* **VF** £8,000 ($12,000) / **EF** £20,000 ($30,000)

11163 — Rev. — dr. busts face to face of Apollo r., laur. and with quiver at shoulder, and Diana l., diad. and with bow at shoulder. RIC 33. C 137. Hunter, p. xcviii. Schulte 27. *[Cologne, AD 269–70].* **VF** £8,000 ($12,000) / **EF** £20,000 ($30,000)

11164 **Gold quinarius.** IMP VICTORINVS AVG. Rev. ADIVTRIX AVG, half-length bust of Diana, as 11127. RIC 35. C 5. Hunter, p. xcviii. Schulte Q1. *[Cologne, AD 269–70].* **VF** £9,300 ($14,000) / **EF** £23,500 ($35,000)
This unusual reverse legend describes the goddess of the hunt as the 'female helper' of the emperor.

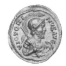

11165 11168

11165 VICTORINVS AVG, half-length helmeted and cuir bust r., holding spear and shield. Rev. P M TR P III COS II P P, Victorinus, togate, stg. l., sacrificing over tripod-altar. RIC 34. C 96. Hunter, p. xcvii. Schulte Q3. *[Cologne, AD 271].* **VF** £9,300 ($14,000) / **EF** £23,500 ($35,000)

11166 **Billon antoninianus.** IMP C PI VICTORINVS AVG. Rev. AEQVITAS AVG, Aequitas stg. l., holding scales and cornucopiae. RIC 41. C 8. Hunter, p. xcviii. *[Mainz or Trier, AD 269–70].* **VF** £16 ($25) / **EF** £45 ($65)

11167 B (PIAV). Rev. COMES AVG, Victory stg. l., holding wreath and palm, star in l. field. RIC 106. C 18. Hunter 4. *[Cologne, AD 269–70].* **VF** £16 ($25) / **EF** £45 ($65)

11168 A. Rev. FIDES MILITVM, Fides Militum stg. l., holding two standards. RIC 108. C 34. Hunter 1. *[Cologne, AD 269].* **VF** £20 ($30) / **EF** £50 ($75)

11169 B (PIAV). Rev. INVICTVS, Sol advancing l., raising r. hand and holding whip in l., sometimes with star in l. field. RIC 113. C 46. Hunter, p. xcvii. *[Cologne, AD 269–70].* **VF** £16 ($25) / **EF** £45 ($65)

11170 **Billon antoninianus.** Similar, but with obv. legend C. RIC 114. C 49. Hunter 7. *[Cologne, AD 270–71].* **VF** £14 ($20) / **EF** £40 ($60)

11171 C. Rev. IOVI STATORI, Jupiter stg. r., holding thunderbolt and sceptre. RIC 50. C 54. Hunter, p. xcix. *[Mainz or Trier, AD 270–71].* **VF** £20 ($30) / **EF** £50 ($75)

11172 C. Rev. MARS VICTOR, Mars, naked, advancing r., carrying spear and trophy. RIC 53. Cf. C 74. Hunter, p. xcix. *[Mainz or Trier, AD 270–71].* **VF** £20 ($30) / **EF** £50 ($75)

11173 C. Rev. ORIENS AVG, Sol advancing l., raising r. hand and holding whip in l., P in left field. RIC 115. Cf. C 77. Hunter, p. xcvii. *[Cologne, AD 270–71].* **VF** £20 ($30) / **EF** £50 ($75)

11174 11176

11174 B (PIAV). Rev. PAX AVG, Pax stg. l., holding olive-branch and transverse sceptre, sometimes with P or star in left field, or V in left field with or without star in r. RIC 117. C 83. Hunter 3. *[Cologne, AD 269–70].* **VF** £16 ($25) / **EF** £45 ($65)

11175 Similar, but with obv. legend C. RIC 118. C 79. Hunter 11. *[Cologne, AD 270–71].* **VF** £14 ($20) / **EF** £40 ($60)

11176 C. Rev. PIETAS AVG, Pietas stg. l., sacrificing over altar and holding box of incense. RIC 57. C 90. Hunter 26. *[Mainz or Trier, AD 270–71].* **VF** £16 ($25) / **EF** £45 ($65)

11177 IMP C VICTORINVS AVG. Rev. P M TR P III COS II (or III) P P, Victorinus, in military attire, stg. l., holding globe and spear. RIC 38–9. C 97–8. Hunter, p. xcix. *[Mainz or Trier, AD 271].* **VF** £65 ($100) / **EF** £170 ($250)

11178 C. Rev. PROVIDENTIA AVG, Providentia stg. l., holding rod and cornucopiae, globe at feet. RIC 61. C 101. Hunter 29. *[Mainz or Trier, AD 270–71].* **VF** £16 ($25) / **EF** £45 ($65)

11179 11180

11179 C. Rev. SALVS AVG, Salus stg. r., feeding snake held in her arms. RIC 67. C 112. Hunter 21. *[Mainz or Trier, AD 270–71].* **VF** £16 ($25) / **EF** £45 ($65)

11180 Similar, but with obv. type rad. and cuir. bust l. RIC 67. C 113. Hunter —. *[Mainz or Trier, AD 270–71].* **VF** £40 ($60) / **EF** £100 ($150)

11181 **Billon antoninianus.** C. Rev. — Salus stg. l., feeding snake arising from altar and holding sceptre. RIC 71. C 118. Hunter 14. *[Cologne, AD 270–71].* **VF** £16 ($25) / **EF** £45 ($65)

11182 C. Rev. SPES PVBLICA, Spes advancing l., holding flower and lifting skirt. RIC 73. C 120. Hunter, p. xcix. *[Mainz or Trier, AD 270–71].* **VF** £20 ($30) / **EF** £50 ($75)

11183 C. Rev. VBERTAS AVG, Uberitas stg. l., holding cow's udder (?) and cornucopiae. RIC 74. C 122. Hunter, p. xcix. *[Mainz or Trier, AD 270–71].* **VF** £20 ($30) / **EF** £50 ($75)

11184 C. Rev. VICTORIA AVG, Victory advancing l., holding wreath and palm. RIC 75. C 126. Hunter 15. *[Cologne, AD 270–71].* **VF** £16 ($25) / **EF** £45 ($65)

11185

11185 C. Rev. VIRTVS AVG, Mars or Virtus stg. r., resting on spear and shield. RIC 78. C 131. Hunter 16. *[Cologne, AD 270–71].* **VF** £16 ($25) / **EF** £45 ($65)

11186 **Billon denarius.** D, laur. and cuir. bust l. Rev. COMES AVG, Victory stg. l., holding wreath and palm. RIC —. C —. Hunter —. Schulte 7b. *[Cologne, AD 269].*
F £230 ($350) / **VF** £665 ($1,000) / **EF** £1,650 ($2,500)

NB As in the case of Postumus' coinage, the rare denarii of this reign are of fine style and would seem to be patterns for aurei rather than normal billon coinage struck for circulation.

11187 IMP C VICTORINVS P AVG, laur. and cuir. bust l., holding spear and shield. Rev. DEFENSOR ORBIS, Victorinus, in military attire, advancing r., holding sword(?) and shield, accompanied by soldier with spear and shield, three naked (female?) enemies before them, one stg., the other two lying on ground. RIC 90. C 29. Hunter 25. Cf. Schulte 54. *[Mainz or Trier, AD 271].* **F** £365 ($550) / **VF** £1,000 ($1,500) / **EF** £2,300 ($3,500)

11188 Similar, but with obv. type conjoined busts r. of Victorinus, laur., and Jupiter, thunderbolt before. Cf. RIC 90. Cf. C 30. Hunter —. Schulte 55. *[Mainz or Trier, AD 271].*
F £365 ($550) / **VF** £1,000 ($1,500) / **EF** £2,300 ($3,500)

11189 C. Rev. LEG XIIII GEMINA P F, eagle stg. r. on globe, hd l., wings spread, holding wreath in beak, capricorn r. on l. RIC —. C —. Hunter —. Schulte 38. *[Mainz or Trier, AD 271].*
F £300 ($450) / **VF** £825 ($1,250) / **EF** £2,000 ($3,000)

11190 E, type as 11187. Rev. LEG XXX VLP VICT P F, Jupiter stg. facing, hd. l., resting on sceptre and holding thunderbolt, capricorn r. on l. Cf. RIC 52 (misdescribed as an antoninianus, following Cohen) . Cf. C 73. Cf. Hunter, p. xcviii. Schulte 45. *[Mainz or Trier, AD 271].*
F £300 ($450) / **VF** £825 ($1,250) / **EF** £2,000 ($3,000)

11191 E. Rev. VICTORIA AVG, Victory advancing r., holding wreath and palm. RIC 93a. C 128. Hunter, p. xcviii. Schulte 50. *[Cologne, AD 271].*
F £220 ($325) / **VF** £600 ($900) / **EF** £1,500 ($2,250)

11192 **Billon denarius.** Similar, but on rev. Victory stg. l. RIC 93. C 124. Hunter, p. xcviii. Schulte 52. *[Cologne, AD 271].* **F** £230 ($350) / **VF** £665 ($1,000) / **EF** £1,650 ($2,500)

11193 E. Rev. VIRTVS AVG, Mars or Virtus stg. l., holding Victory and resting on spear and shield. RIC —. C —. Hunter —. Schulte 51. *[Cologne, AD 271].*
F £230 ($350) / **VF** £665 ($1,000) / **EF** £1,650 ($2,500)

11194 Obv. As 11188. Rev. — Victorinus, in military attire, stg. facing, hd. l., placing helmet on trophy to l., with two captives at base, and holding spear in l., he is crowned by Victory stg. l. on r., holding palm in her l. hand. RIC —. C —. Hunter —. Schulte 56. *[Mainz or Trier, AD 271].* **F** £365 ($550) / **VF** £1,000 ($1,500) / **EF** £2,300 ($3,500)

11195 **Billon quinarius.** IMP C VICTORINVS AVG. Rev. SALVS AVG, Salus stg. r., feeding snake held in her arms. RIC —. C —. Hunter 24. Schulte Q2. *[Mainz or Trier, AD 270].*
F £170 ($250) / **VF** £500 ($750)

For coins of Divus Victorinus, see under Tetricus I (nos. 11273–9).

TETRICUS I
autumn AD 271–spring 274

11228

The assassination of Victorinus in the autumn of AD 271 took the Gallic Empire by surprise, but the late emperor's mother Victoria (or Victorina) quickly siezed the initiative by nominating a close relative, Gaius Pius Esuvius Tetricus, as emperor in her son's place. The precise relationship of Tetricus to his predecessor is uncertain, though he may have been a nephew, and at the time of his elevation to the Gallic throne he was serving as governor of Aquitania. At some point he raised his young son, who bore the same name, to the rank of Caesar, and, although the evidence is confused and somewhat contradictory, he may also have made him co-Augustus late in the reign. Tetricus does not seem to have possessed the strength and abilities of his predecessors Victorinus and Postumus, though in any case the days of the western separatist state were now clearly numbered. The previous year the powerful general Aurelian had ascended the Roman throne and had quickly made clear his intention of restoring unity to the Empire. He attacked and defeated the Palmyrene Empire in the East (272) and then turned his attention to the West, beginning preparations for war in the summer of 273. The issue was ultimately decided in a battle fought at Châlons-sur-Marne in northern France in the spring of the following year. Tetricus was defeated and he and his son both abdicated and surrendered to Aurelian. After using them as ornaments in his great triumph the emperor restored their senatorial status and even granted the elder Tetricus an administrative post in the government. This suggests there may have been some secret collusion between the two rulers prior to the invasion of Gaul as Tetricus was probably anxious to extricate himself from his untenable situation without losing his life. The Tetrici lived out the remainder of their days in Rome and the dates of their eventual deaths are unknown.

The coinage of Tetricus I was generally less innovative in design than that of his immediate predecessor, though the dies for the gold were still neatly engraved and the coins carefully struck. The billon also had fewer types and the antoniniani were sometimes carelessly produced and were much imitated by irregular mints in Gaul and Britain (see under 'Barbarous Radiates'). Both mints which had operated under Victorinus (Cologne and Mainz or Trier) continued production under the Tetrici, though fundamental changes in coin production in Gaul were soon to follow with

Aurelian's reconquest of the western provinces. Issues were also made in the name of Tetricus II and, remarkably, a series of antoniniani was struck at Mainz or Trier commemorating the deification of Victorinus, the only one of the Gallic emperors to be thus honoured.
 The following are the principal forms of obverse legend:

A. IMP C C P ESV (or ESVVIVS) TETRICVS AVG
B. IMP C P ESV TETRICVS AVG
C. IMP C TETRICVS AVG
D. IMP C TETRICVS P F AVG
E. IMP C TETRICVS PIVS AVG
F. IMP TETRICVS AVG
G. IMP TETRICVS P F AVG
H. IMP TETRICVS PIVS AVG

Unless otherwise stated the emperor's bust is cuirassed only, or draped and cuirassed, to right, wearing a laurel-wreath on all denominations other than the antoniniani on which a radiate crown is worn. On some varieties of the aurei the bust is bare, usually with light drapery on left shoulder.

11196 **Gold aureus.** D. Rev. ADVENTVS AVG, Tetricus I, in military attire, on horse pacing l., his
 r. hand raised, holding transverse sceptre in l. RIC 8. C 6. Hunter, p. c. Schulte 41.
 [Cologne, AD 272]. **VF** £5,000 ($7,500) / **EF** £13,500 ($20,000)

11197 D. Rev. AEQVITAS AVG, Aequitas stg. l., holding scales and cornucopiae. RIC 9. C 8.
 Hunter, p. cii. Schulte 15–16. *[Mainz or Trier, AD 272].*
 VF £3,700 ($5,500) / **EF** £10,000 ($15,000)

11198 D. Rev. AETERNITAS AVGG, Aeternitas stg. l., holding phoenix on globe and lifting
 drapery of dress behind. RIC —. C —. Cf. Hunter, p. ciii. Schulte 72. *[Mainz or Trier,*
 AD 273–4]. **VF** £4,300 ($6,500) / **EF** £11,750 ($17,500)
 The plural ending of the reverse legend on this, and other types, has been taken as
 evidence of the elevation of the younger Tetricus to the rank of Augustus during the closing
 phase of the reign, though it may equally well reflect the desire of the Gallic emperor to be
 accepted as an imperial colleague by Aurelian in Rome (see also nos. 11200, 11204,
 11217, 11221, 11224, 11229, 11237, 11239, 11247–9, and 11258, and note following
 no. 11281).

11199

11199 G. Rev. FELICITAS PVBLICA, Felicitas stg. facing, hd. l., legs crossed, holding short
 caduceus and resting on column. Cf. RIC 11. C 36. Hunter, p. cii. Schulte 53–4. *[Mainz or*
 Trier, AD 273]. **VF** £3,700 ($5,500) / **EF** £10,000 ($15,000)

11200 D. Rev. HILARITAS AVGG, Hilaritas stg. l. between two children, holding long palm and
 cornucopiae. RIC 13. C 51. Hunter, p. cii. Schulte 70–71. *[Mainz or Trier, AD 273–4].*
 VF £4,300 ($6,500) / **EF** £11,750 ($17,500)
 See note following no. 11198.

11201 **Gold aureus.** D. Rev. IOVI CONSERVATORI, Jupiter stg. l., holding thunderbolt and sceptre, small togate figure of emperor stg. at feet to l. RIC 14. C 63. Hunter, p. cii. Schulte 17. *[Mainz or Trier, AD 272].* **VF** £4,300 ($6,500) / **EF** £11,750 ($17,500)

11202 H. Rev. IOVI VICTORI, Jupiter seated l., holding Victory and resting on spear. RIC 15. C 65. Hunter, p. ciii. Schulte 47. *[Mainz or Trier, AD 273].*
VF £4,300 ($6,500) / **EF** £11,750 ($17,500)

11203 H. Rev. LAETITIA AVG N, Laetitia stg. l., holding wreath and anchor. RIC 16. C 74. Hunter, p. ci. Schulte 14. *[Cologne, AD 272].* **VF** £3,700 ($5,500) / **EF** £10,000 ($15,000)
The reverse type appears to be copied from the coinage of Gordian III (see no. 8572).

11204 D. Rev. NOBILITAS AVGG, Nobilitas stg. r., holding sceptre and globe. Cf. RIC 17 (misdescribed following Cohen). Cf. C 84. Hunter, p. cii. Schulte 69. *[Mainz or Trier, AD 273–4].* **VF** £4,300 ($6,500) / **EF** £11,750 ($17,500)
See note following no. 11198.

11205 F, laur. and cuir. bust l., holding spear and shield. Rev. PAX AETERNA, Pax stg. l., holding olive-branch and sceptre. RIC 20. C 94. Hunter, p. ci. Cf. Schulte 9. *[Cologne, AD 272].*
VF £6,000 ($9,000) / **EF** £16,500 ($25,000)

11206 D. Rev. P M TR P COS P P, Tetricus I, togate, stg. l., holding branch and short sceptre. RIC 2. C 126. Hunter, p. c. Schulte 25. *[Cologne, AD 271].*
VF £4,300 ($6,500) / **EF** £11,750 ($17,500)

NB There are four Becker forgeries of this type, one of which has obverse legend H (cf. Hill, "Becker The Counterfeiter", p. 19, 240–43 and pl. XIII). There is also a Becker forgery of the following type on which the emperor is mistakenly shown holding a globe instead of a branch (cf. Hill, p. 19, 244 and pl. XIII).

11207 Similar, but with rev. legend P M TR P II COS P P. RIC 4. C 127. Hunter, p. c. Schulte 26–7. *[Cologne, AD 272].* **VF** £4,300 ($6,500) / **EF** £11,750 ($17,500)

11208 Similar, but with rev. type Tetricus I, in military attire, stg. r., holding transverse spear (or sceptre) and globe. RIC 5. C 128. Hunter 1. Schulte 28–9. *[Cologne, AD 272].*
VF £3,700 ($5,500) / **EF** £10,000 ($15,000)

11209 Similar, but with rev. type Tetricus I, in military attire, on horseback galloping r., holding couched spear, a second horseman (Tetricus II?) galloping r. in background behind him. RIC —. C —. Hunter, p. c. Schulte 32. *[Cologne, AD 272].*
VF £6,000 ($9,000) / **EF** £16,500 ($25,000)

11210 Similar, but with rev. type Tetricus I, togate, stg. l., sacrificing over altar and holding short sceptre, attendant stg. l. behind him, holding palm. RIC —. C —. Hunter —. Schulte 40. *[Cologne, AD 272].* **VF** £6,000 ($9,000) / **EF** £16,500 ($25,000)

11211 Similar, but with rev. type Bonus Eventus stg. l., sacrificing from patera over altar and holding corn-ears. RIC —. C —. Hunter, p. c. Cf. Schulte 38A. *[Cologne, AD 272].*
VF £4,300 ($6,500) / **EF** £11,750 ($17,500)

11212 H. Rev. P M TR P III COS P P , Fides Militum stg. l., holding standard and transverse sceptre. RIC 6. C 129. Hunter, p. ci. Schulte 42–6. *[Cologne, AD 273].*
VF £3,700 ($5,500) / **EF** £10,000 ($15,000)

NB There is a Becker forgery of this type with obverse legend D (cf. Hill, "Becker The Counterfeiter", p. 19, 245 and pl. XIII).

11212 11214

11213 **Gold aureus.** H, laur. hd. l. Rev. — Mars or Virtus stg. l., r. foot on globe, holding olive-
 branch and resting on sceptre. . RIC —. C —. Hunter, p. ci. Schulte 48. *[Cologne, AD 273].*
 VF £5,000 ($7,500) / **EF** £13,500 ($20,000)

11214 D. Rev. **P M TR P III COS II P P**, Tetricus I, in military attire, stg. r., l. foot on globe, resting
 on spear and holding parazonium. RIC 7. C 130. Hunter, p. cii. Schulte 50. *[Mainz or
 Trier, AD 273].* **VF** £4,300 ($6,500) / **EF** £11,750 ($17,500)

11215 D. Rev. **ROMAE AETERNAE**, Roma enthroned l., holding Victory and resting on spear or
 sceptre, shield at her side. RIC 21. Cf. C 137. Hunter, p. cii. Schulte 18. *[Mainz or Trier,
 AD 272].* **VF** £4,300 ($6,500) / **EF** £11,750 ($17,500)

11216 H. Rev. **SAECVLI FELICITAS**, Felicitas stg. l., sacrificing from patera over altar and holding
 long caduceus. RIC 22. C 139. Hunter, p. ci. Schulte 52. *[Cologne, AD 273].*
 VF £4,300 ($6,500) / **EF** £11,750 ($17,500)

11217 G. Rev. **SALVS AVGG**, Salus stg. l., feeding snake arising from altar and holding sceptre.
 RIC 24. Cf. C 146. Hunter, p. ciii. Schulte 62. *[Mainz or Trier, AD 273–4].*
 VF £4,300 ($6,500) / **EF** £11,750 ($17,500)
 See note following no. 11198.

11218 H, laur. hd. l. Rev. **SECVRITAS PERPETVA**, Securitas stg. facing, hd. l., legs crossed, holding
 sceptre and resting on column. RIC —. C —. Hunter —. Schulte 49. *[Cologne, AD 273].*
 VF £5,000 ($7,500) / **EF** £13,500 ($20,000)

11219 A (**ESV**). Rev. **SPES PVBLICA**, Spes advancing l., holding flower and lifting skirt. RIC 25. C
 167. Hunter, p. c. Schulte 4–5. *[Cologne, AD 271].*
 VF £4,300 ($6,500) / **EF** £11,750 ($17,500)

11220 Obv. As 11205. Rev. **TR P II COS P P**, Tetricus I in triumphal quadriga l., holding branch and
 short sceptre. RIC —. C —. Cf. Hunter, p. ci (**P M** incorrectly included in rev. legend).
 Schulte 36. *[Cologne, AD 272].* **VF** £6,000 ($9,000) / **EF** £16,500 ($25,000)

11221 G. Rev. **VBERITAS AVGG**, Uberitas stg. l., holding cow's udder (?) and cornucopiae. RIC
 29. Cf. C 177. Hunter, p. ciii. Schulte 64. *[Mainz or Trier, AD 273–4].*
 VF £4,300 ($6,500) / **EF** £11,750 ($17,500)
 See note following no. 11198.

11222 A (**ESV**), laur. and cuir. bust l. Rev. **VICTORIA AVG**, Victory advancing l., holding wreath
 and palm. RIC 30. Cf. C 183. Hunter, p. c. Schulte 3. *[Cologne, AD 271].*
 VF £5,000 ($7,500) / **EF** £13,500 ($20,000)

11223 D. Rev. — Victory advancing r., holding wreath and trophy and treading down captive
 before her. RIC 33. C 189. Hunter, p. cii. Schulte 19. *[Mainz or Trier, AD 272].*
 VF £4,300 ($6,500) / **EF** £11,750 ($17,500)

11224 **Gold aureus.** D. Rev. VICTORIA AVGG, Victory stg. r., holding trophy with both hands. RIC 35. Cf. C 192. Hunter, p. cii. Schulte 65–6, 68. *[Mainz or Trier, AD 273–4].*
VF £4,300 ($6,500) / EF £11,750 ($17,500)
See note following no. 11198.

11225 A (ESV), laur. hd. l. Rev. VICTORIA GERM, Tetricus I, in military attire, stg. l., holding globe and spear, captive seated l. at feet, crowned by Victory stg. l. behind him, holding palm. RIC 38. C 195. Hunter, p. c. Schulte 2. *[Cologne, AD 271].*
VF £5,300 ($8,000) / EF £15,000 ($22,500)

11226 D. Rev. VIRTVS AVG, Virtus seated l. on cuirass, holding branch and resting on spear. RIC 39. C 202. Hunter 2. Schulte 20–22, 24. *[Cologne, AD 272].*
VF £3,700 ($5,500) / EF £10,000 ($15,000)

11227 E. Rev. — Tetricus I, in military attire stg. l., holding globe and parazonium, captive seated l. at feet. RIC 42. C 204. Hunter, p. ci. Schulte 33. *[Cologne, AD 272].*
VF £4,300 ($6,500) / EF £11,750 ($17,500)

NB There is a Becker forgery of this type with obverse legend D (cf. Hill, "Becker The Counterfeiter", p. 19, 247 and pl. XIII).

11228 Similar, but with obv. F, laur. and cuir. bust l., holding spear and shield. RIC —. C —. Hunter, p. ci. Schulte 34. *[Cologne, AD 272].* VF £6,000 ($9,000) / EF £16,500 ($25,000)

11229 G. Rev. VIRTVS AVGG, Tetricus I, in military attire, stg. r., l. foot set on captive, resting on spear and holding globe. RIC 43. C —. Hunter, p. ciii. Schulte 73. *[Mainz or Trier, AD 273–4].* VF £4,300 ($6,500) / EF £11,750 ($17,500)
See note following no. 11198.

11230 D. Rev. VIRTVTI AVGVSTI, Hercules stg. r., r. hand on hip, l. holding lion's skin and resting on club set on rock. RIC 44. C 209. Hunter, p. cii. Schulte 31. *[Mainz or Trier, AD 272].* VF £4,300 ($6,500) / EF £11,750 ($17,500)
This type appears to have been inspired by the coinage of Gordian III (see no. 8595).

11231 **Gold quinarius.** C, bare-headed and dr. bust three-quarter face to r. Rev. VOTIS DECENNALIBVS, Victory stg. r., l. foot on globe, inscribing X on shield set on l. knee. RIC p. 405, note 2. C 212. Hunter, p. cii. Schulte 31. *[Mainz or Trier, AD 274].* *(Extremely rare)*

NB There is a Becker forgery of this type (cf. Hill, "Becker The Counterfeiter", p. 20, 248 and pl. XIII).

11232

11232 **Billon antoninianus.** D. Rev. COMES AVG (or AVG N), Victory stg. l., holding wreath and palm. RIC 56, 59. C 17, 20. Hunter 4. *[Cologne, AD 272].* VF £12 ($18) / EF £30 ($45)

11233 **Billon antoninianus.** B. Rev. CONCORD AVG, Concordia stg. l., holding patera and cornucopiae. Cf. RIC 61. C 22. Hunter, p. ciii. *[Mainz or Trier, AD 271].*
VF £15 ($22) / EF £38 ($55)

11234 D. Rev. FIDES MILITVM, Fides Militum stg. l., holding standard in each hand. RIC 68. Cf. C 41. Hunter, p. ci. *[Cologne, AD 272–3].* VF £12 ($18) / EF £30 ($45)

11235 Similar, but with obv. legend A (ESVVIVS). RIC 72. Cf. C 40. Hunter, p. ci. *[Cologne, AD 271].* VF £16 ($25) / EF £45 ($65)

11236 D. Rev. FORTVNA AVG, Fortuna stg. l., holding rudder and cornucopiae. RIC 73. C 44. Hunter, p. cii. *[Cologne, AD 272–3].* VF £15 ($22) / EF £38 ($55)

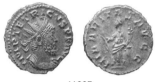

11237

11237 G. Rev. HILARITAS AVGG, Hilaritas stg. l., holding long palm and cornucopiae. RIC 80. C 54. Hunter 16. *[Mainz or Trier, AD 273–4].* VF £12 ($18) / EF £30 ($45)
See note following no. 11198.

11238 G. Rev. INVICTVS, Sol advancing l., raising r. hand and holding whip in l., sometimes with star in l. field. RIC 83. C 62. Hunter, p. ciii. *[Mainz or Trier, AD 272–3].*
VF £15 ($22) / EF £38 ($55)

11239 G. Rev. LAETITIA AVGG, Laetitia stg. l., holding wreath and anchor. RIC 88. C 71. Hunter 18. *[Mainz or Trier, AD 273–4].* VF £12 ($18) / EF £30 ($45)
See note following no. 11198.

11240 Similar, but with rev. legend LAETITIA AVG N. RIC 90. C 75. Hunter, p. ciii. *[Mainz or Trier, AD 272–3].* VF £15 ($22) / EF £38 ($55)

11241 D. Rev. MARS VICTOR, Mars, naked, advancing r., carrying spear and trophy. RIC 94. C 80. Hunter, p. cii. *[Cologne, AD 272–3].* VF £15 ($22) / EF £38 ($55)

11242 D. Rev. MONETA AVG, Moneta stg. l., holding scales and cornucopiae. RIC 95. C 82. Hunter, p. cii. *[Cologne, AD 272–3].* VF £15 ($22) / EF £38 ($55)

11243 D. Rev. PAX AVG, Pax stg. l., holding olive-branch and sceptre, sometimes with star in field. RIC 100. C 95. Hunter 6. *[Cologne, AD 272–3].* VF £12 ($18) / EF £30 ($45)

11244 G. Rev. P M TR P COS P P, Fides Militum stg. l., holding standard and spear (or two standards?). RIC 46. C 124. Hunter, p. ciii. *[Mainz or Trier, AD 271].*
VF £50 ($75) / EF £130 ($200)

11245 D. Rev. PRINC IVVENT, Tetricus I or Tetricus II stg. l., holding baton (or branch?) and sceptre. Cf. RIC 115. Cf. C 131. Hunter 10. *[Cologne, AD 273].*
VF £22 ($35) / EF £55 ($85)

11246 **Billon antoninianus.** D. Rev. PROVID AVG, Providentia stg. l., holding rod and cornucopiae. RIC 117. C 133. Hunter, p. cii. *[Cologne, AD 272 –3].* **VF** £15 ($22) / **EF** £38 ($55)

11247 D. Rev. SALVS AVGG, Salus stg. l., feeding snake arising from altar and holding anchor. RIC 126. C 154. Hunter 12. *[Cologne, AD 273–4].* **VF** £12 ($18) / **EF** £30 ($45) *For this type and the next two, see note following no. 11198.*

11248 Similar, but Salus holds wreath and anchor. RIC 128. C 155. Hunter —. *[Cologne, AD 273–4].* **VF** £12 ($18) / **EF** £30 ($45)

11249 D. Rev. SPES AVGG, Spes advancing l., holding flower and lifting skirt. RIC 132. C 163. Hunter, p. cii. *[Cologne, AD 273–4].* **VF** £12 ($18) / **EF** £30 ($45)

11250 Similar, but with reverse legend SPES PVBLICA. RIC 136. C 170. Hunter, p. ci. *[Cologne, AD 272–3].* **VF** £12 ($18) / **EF** £30 ($45)

11251 Similar, but with obv. legend A (ESVVIVS). RIC 135. C 171. Hunter, p. ci. *[Cologne, AD 271].* **VF** £16 ($25) / **EF** £45 ($65)

11252 D. Rev. VBERTAS AVG, Uberitas stg. l., holding wreath and cornucopiae. RIC 138. C 178. Hunter, p. cii. *[Cologne, AD 272–3].* **VF** £15 ($22) / **EF** £38 ($55)

11253 G. Rev. VICTORIA, Victory stg. l., holding wreath and palm, altar at feet. RIC 139. C 179. Hunter, p. ciii. *[Mainz or Trier, AD 272–3].* **VF** £16 ($25) / **EF** £45 ($65)

11254 A (ESVVIVS). Rev. VICTORIA AVG, Victory advancing left, holding wreath and palm. RIC 140. C 184. Hunter, p. ci. *[Cologne, AD 271].* **VF** £16 ($25) / **EF** £45 ($65)

11255 Similar, but with obv. legend D. RIC 141. C 185. Hunter 3. *[Cologne, AD 272–3].* **VF** £12 ($18) / **EF** £30 ($45)

11256 G. Rev. VIRTVS AVG, Mars or Virtus stg. l., resting on shield and spear. RIC 146. C 200. Hunter, p. ciii. *[Mainz or Trier, AD 272–3].* **VF** £15 ($22) / **EF** £38 ($55)

11257 Similar, but with obv. legend F and Mars or Virtus stg. r. on rev. RIC 147. C 199. Hunter, p. civ. *[Mainz or Trier, AD 273].* **VF** £15 ($22) / **EF** £38 ($55)

11258 D. Rev. VIRTVS AVGG, type as 11256. RIC 148. C 207. Hunter 13. *[Cologne, AD 272–3].* **VF** £12 ($18) / **EF** £30 ($45) *See note following no. 11198.*

11259

11259 **Billon denarius.** H. Rev. COMES AVG, Victory stg. l., holding wreath and palm. RIC 169 var. C 15 var. Hunter —. Schulte 10. *[Cologne, AD 272].*
 F £220 ($325) / **VF** £600 ($900) / **EF** £1,500 ($2,250)

NB As with the coinages of the reigns of Postumus and Victorinus, the rare denarii of the Tetrici are of fine style and would seem to be patterns for aurei rather than normal billon coinage struck for circulation.

11260 **Billon denarius.** E. Rev. PAX AETERNA, Pax stg. l., holding olive-branch and sceptre. RIC —. C —. Hunter —. Cf. Schulte 38. *[Cologne, AD 272].*
<div align="right">**F** £220 ($325) / **VF** £600 ($900) / **EF** £1,500 ($2,250)</div>

11261 E. Rev. P M TR P II COS P P, Tetricus I, in military attire, stg. r., holding transverse spear (or sceptre) and globe. RIC —. C —. Hunter —. Schulte 30. *[Cologne, AD 272].*
<div align="right">**F** £230 ($350) / **VF** £665 ($1,000) / **EF** £1,650 ($2,500)</div>

11262 H. Rev. P M TR P III COS P P, Fides Militum stg. l., holding standard and transverse sceptre. RIC —. C —. Hunter —. Schulte 43. *[Cologne, AD 273].*
<div align="right">**F** £230 ($350) / **VF** £665 ($1,000) / **EF** £1,650 ($2,500)</div>

11263 H. Rev. P M TR P COS III P P, VOT X (in ex.), togate figures of Tetricus I, on r., and Tetricus II, on l., stg. facing each other, the elder holding globe and short sceptre, the younger sacrificing from patera over tripod-altar between them and also holding short sceptre . RIC —. C —. Hunter —. Schulte 61. *[Mainz or Trier, AD 274].*
<div align="right">**F** £300 ($450) / **VF** £825 ($1,250) / **EF** £2,000 ($3,000)</div>

11264 H. Rev. SPES PVBLICA, Spes advancing l., holding flower and lifting skirt. Cf. RIC 176. Cf. C 169. Hunter —. Schulte 8b. *[Cologne, AD 272].*
<div align="right">**F** £220 ($325) / **VF** £600 ($900) / **EF** £1,500 ($2,250)</div>

11265 H. Rev. VICTORIA AVG, Victory advancing l., holding wreath and palm. RIC —. C —. Hunter —. Schulte 11. *[Cologne, AD 272].*
<div align="right">**F** £220 ($325) / **VF** £600 ($900) / **EF** £1,500 ($2,250)</div>

11266 D. Rev. VIRTVS AVG, Virtus seated l. on cuirass, holding branch and resting on sceptre or spear. RIC 177. C 203. Hunter —. Schulte 23. *[Cologne, AD 272].*
<div align="right">**F** £220 ($325) / **VF** £600 ($900) / **EF** £1,500 ($2,250)</div>

TETRICUS I AND TETRICUS II

The rare coinage in the joint names of the two Tetrici clearly suggests that the son had been raised to the rank of Augustus by his father at the time of the issue in AD 274. However, the depiction of Tetricus II as bare-headed on these coins still raises doubts as to whether or not he ever actually received the senior rank or whether there was simply an intention to do so. There is a unique antoninianus in the Ashmolean Museum, Oxford, which gives the younger Tetricus the imperial titles, including Augustus, which would seem to confirm his elevation. However, the form of the legend is curious and the piece remains controversial.

11267 **Gold aureus.** IMP C TETRICVS P F AVG, conjoined busts r. of Tetricus I, laur. and cuir., and Tetricus II, bare-headed and dr. Rev. AETERNITAS AVGG, Aeternitas stg. l., holding phoenix on globe and lifting drapery of dress behind. RIC 206. C 1. Hunter, p. cv. Schulte 57. *[Mainz or Trier, AD 274].* **VF** £10,500 ($16,000) / **EF** £26,500 ($40,000)

NB There is a Becker forgery of this type (cf. Hill, "Becker The Counterfeiter", p. 20, 249 and pl. XIII).

11268 **Gold aureus.** IMPP INVICTI PII AVGG, similar, but bust of Tetricus I is dr. Rev. HILARITAS AVGG, Hilaritas stg. l. between two children, holding long palm and cornucopiae. RIC 208. C 3. Hunter, p. cv. Schulte 56. *[Mainz or Trier, AD 274].* **VF** £10,500 ($16,000) / **EF** £26,500 ($40,000)

11269 IMPP TETRICI AVGG, busts face to face of Tetricus I l., laur. and wearing imperial mantle, and Tetricus II r., bare-headed and wearing similar garb. Rev. P M TR P COS III P P, VOT X (in ex.), togate figures of Tetricus I, on r., and Tetricus II, on l., stg. facing each other, the elder holding globe and short sceptre, the younger sacrificing from patera over tripod-altar between them and also holding short sceptre . Cf. RIC 205. Cf. C 10. Hunter, p. civ. Schulte 60. *[Mainz or Trier, AD 274].* **VF** £12,000 ($18,000) / **EF** £30,000 ($45,000)

11270 IMPP TETRICI PII AVGG, type as 11267. Rev. VIRTVS MILITVM, Tetricus I, in military attire, stg. l., holding globe and resting on sceptre, facing Virtus stg. r., holding Victory and transverse sceptre. Cf. RIC 211. C —. Hunter, p. cv. Schulte 58. *[Mainz or Trier, AD 274].*
VF £10,500 ($16,000) / **EF** £26,500 ($40,000)

11271 **Billon antoninianus.** Obv. As previous, but Tetricus I is rad. Rev. SPES PVBLICA, Spes advancing l., holding flower and lifting skirt, P in ex. RIC 213. C —. Hunter, p. cv. *[Cologne?, AD 274].* **F** £230 ($350) / **VF** £665 ($1,000)

11272 **Billon denarius.** Similar to 11269, but on obv. the bust of Tetricus I is to r., and that of Tetricus II to l.; and on rev. the stg. figures are similarly reversed, and Tetricus I is crowned by Victory stg. r. behind him. Cf. RIC 214. Cf. C 11. Hunter, p. civ. Schulte 59. *[Mainz or Trier, AD 274].* **F** £500 ($750) / **VF** £1,350 ($2,000)

Issues of Tetricus I in honour of Divus Victorinus

Of all the Gallic emperors Victorinus alone was accorded deification and a posthumous coinage in his honour. As he was the only one to be succeeded by a close relative this should occasion little surprise.

11273 **Billon antoninianus.** DIVO VICTORINO PIO, rad. and dr. bust r. Rev. CONSACRATIO, eagle stg. r. on globe, hd. l., holding wreath in beak. RIC Victorinus 83. C —. Hunter, p. 111, 1. [Mainz or Trier, AD 271]. **VF** £75 ($110) / **EF** £200 ($300)

11274 Similar, but with rad. hd. r. on obv. and CONSECRATIO on rev RIC *Victorinus* 85. C *Victorinus* 26 Hunter, p. xcix. *[Mainz or Trier, AD 271].* **VF** £75 ($110) / **EF** £200 ($300)

11275 Similar, but with obv. IMP C VICTORINVS P F AVG, rad. and dr. bust r. RIC *Victorinus* 84. C *Victorinus* 25. Hunter, p. xcix. *[Mainz or Trier, AD 271].* **VF** £60 ($90) / **EF** £170 ($250)

11276 Obv. As 11274. Rev. FIDES MILITVM, Fides Militum stg. l., holding standard in each hand. RIC *Victorinus* 86. C *Victorinus* 39. Hunter —. *[Mainz or Trier, AD 271].*
VF £50 ($75) / **EF** £130 ($200)

11277 Obv. As 11273. Rev. PAX AVG, Pax stg. l., holding olive-branch and transverse sceptre. RIC *Victorinus* 87. C —. Hunter —. *[Mainz or Trier, AD 271].*
VF £50 ($75) / **EF** £130 ($200)

11278 Obv. As 11274. Rev. PROVIDENTIA AVG, Providentia stg. l., holding rod and cornucopiae, globe at feet. RIC *Victorinus* 88. C *Victorinus* 103. Hunter —. *[Mainz or Trier, AD 271].*
VF £50 ($75) / **EF** £130 ($200)

11279 — Rev. VIRTVS AVG, Mars or Virtus stg. r., resting on spear and shield. RIC *Victorinus* 89. C *Victorinus* 132. Hunter —. *[Mainz or Trier, AD 271].* **VF** £50 ($75) / **EF** £130 ($200)

TETRICUS II
spring AD 274 (?)

11292

The younger Tetricus, also called Gaius Pius Esuvius Tetricus, received the rank of Caesar from his father at some point during the latter's reign, probably in AD 273. His coinage is not extensive but was much imitated at the time (see under 'Barbarous Radiates'), a testament to the breakdown of normal economic life in the later Gallic Empire. The problematic question of whether or not he was ever elevated to the senior rank of Augustus has already been raised in the introduction to the joint coinage of Tetricus I and Tetricus II (see above). The unique antoninianus of Tetricus II giving him full imperial titles would seem to confirm his promotion, but lingering doubts remain over the legitimacy of this piece. Following his abdication at the same time as his father Tetricus II retired into privileged private life and his ultimate fate is unknown to history.

Issues as Caesar under Tetricus I, AD 273–274

11280 **Gold aureus.** C P ESV TETRICVS CAES, bare-headed and dr. bust r. Rev. SPEI PERPETVAE, Spes advancing l., holding flower and lifting skirt. RIC 217. C 83. Hunter, p. civ. *[Mainz or Trier].* **VF** £10,500 ($16,000) / **EF** £26,500 ($40,000)

11281 — bare-headed bust r., wearing imperial mantle. Rev. SPES AVGG, type as previous. RIC 219. C 85. Hunter, p. civ. *[Mainz or Trier].* **VF** £12,000 ($18,000) / **EF** £30,000 ($45,000) *The plural ending of the reverse legend on this type clearly does not refer to Tetricus I and II and may be evidence of a desire on the part of Tetricus I to be recognized as an imperial colleague by Aurelian (see also nos. 11285–8 and 11292, and note following no. 11198).*

11282 C P ES TETRICVS CAES, bare-headed and dr. bust r. Rev. SPES PVBLICA, type as previous. RIC 221. C 94. Hunter, p. civ. *[Mainz or Trier].* **VF** £10,500 ($16,000) / **EF** £26,500 ($40,000)

11283 Similar, but with obv. legend C PIV ESV TETRICVS CAES. RIC 220. C 93. Hunter, p. civ. *[Mainz or Trier].* **VF** £10,500 ($16,000) / **EF** £26,500 ($40,000)

11284 **Billon antoninianus.** C P E TETRICVS CAES, rad. and dr. bust r. Rev. FIDES MILITVM, Fides Militum stg. l., holding standard in each hand. RIC 229 var. C 13 var. Hunter 7. *[Cologne].*
 VF £16 ($25) / **EF** £50 ($75)

NB Many of the types recorded for this denomination would appear to be hybrids or the products of irregular mints in Britain and Gaul.

11285 C PIV ESV TETRICVS CAES, type as previous. Rev. HILARITAS AVGG, Hilaritas stg. l., holding long palm and cornucopiae. RIC 232. C 17. Cf. Hunter 10. *[Mainz or Trier].*
 VF £16 ($25) / **EF** £50 ($75)
See note following no. 11281.

11286 Obv. As 11284. Rev. PIETAS AVGG, sprinkler, simpulum, jug, knife, and lituus (emblems of the priestly colleges). RIC 255. C 48, 53. Hunter 8. *[Cologne].*
 VF £16 ($25) / **EF** £50 ($75)

11287 **Billon antoninianus.** Similar, but with rev. legend PIETAS AVGVSTOR. RIC 259. C 60.
Hunter 9. *[Cologne].* **VF** £16 ($25) / **EF** £50 ($75)

11288 Similar, but with obv. legend as 11285. RIC 258. C 59. Hunter 2. *[Cologne].*
VF £16 ($25) / **EF** £50 ($75)

11289 Obv. As 11285. Rev. PRINC IVVENT, Tetricus II, in military attire, stg. l., holding branch
and spear. RIC 260. C 62. Hunter, p. civ. *[Cologne].* **VF** £20 ($30) / **EF** £55 ($85)

11290 Similar, but on rev. Tetricus II holds standard instead of branch. RIC 260. C 63. Hunter,
p. civ. *[Cologne].* **VF** £20 ($30) / **EF** £55 ($85)

11291 Similar, but Tetricus II holds baton and standard. RIC 260. C 64. Hunter, p. civ. *[Cologne].*
VF £20 ($30) / **EF** £55 ($85)

11292 Obv. As 11285. Rev. SPES AVGG, Spes advancing l., holding flower and lifting skirt. RIC
270. C 88. Hunter 11. *[Mainz or Trier].* **VF** £14 ($20) / **EF** £45 ($65)

11293 Similar, but obv. bust is to l. RIC 270. C 90. Hunter, p. civ. *[Mainz or Trier].*
VF £60 ($90) / **EF** £170 ($250)

11294 Similar, but bust to r. and with rev. legend SPES PVBLICA. RIC 272. C 97. Hunter 4.
[Cologne]. **VF** £14 ($20) / **EF** £45 ($65)

11295 **Billon denarius.** C P ES TETRICVS CAES, bare-headed and dr. bust l. Rev. PRINC IVVENTVT,
Tetricus II, in military attire, stg. l., holding standard and spear. RIC —. C —. Cf. Hunter,
p, civ. Schulte 4. *[Cologne].* **F** £300 ($450) / **VF** £1,000 ($1,500)

11296 C PIVS ESV TETRICVS CAES, bare-headed and dr. bust three-quarter face to r. Rev. PRINCIPI
IVVENT, similar, but Tetricus II holds globe instead of standard. RIC —. C —. Hunter —.
Schulte 3. *[Cologne].* **F** £600 ($900) / **VF** £2,000 ($3,000)

11297 C PIV ESV TETRICVS CAES, bare-headed and dr. bust r. Rev. PRINCIPI IVVENTVTIS, Tetricus
II, in military attire, stg. r., holding transverse spear and globe. RIC 281. C —. Hunter —.
Schulte 5. *[Cologne].* **F** £265 ($400) / **VF** £900 ($1,350)

11298 **Billon quinarius.** Obv. As previous. Rev. As 11296. RIC —. C —. Hunter —. Schulte Q1.
[Cologne]. **F** £300 ($450) / **VF** £1,000 ($1,500)

Issues as Augustus, AD 274 (?)

11299 **Billon antoninianus.** IMP C P ES TETRICVS C AVG, rad. and dr. bust r. Rev. SPES PVBLICA,
Spes advancing l., holding flower and lifting skirt, P in ex. RIC —. C —. Cf. Hunter, p. cv.
Sutherland (*ANS Museum Notes XI*, 1964), pp. 151–8 and pl. XXIX, 1. *[Cologne?].*
(Unique)
This controversial piece is in the Heberden Coin Room of the Ashmolean Museum, Oxford.

CLAUDIUS II, GOTHICUS
Sep. AD 268–Aug. 270

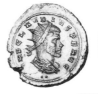

11381

Marcus Aurelius Valerius Claudius was a native of Dardania (Upper Moesia) and was born about
AD *214/15. Like so many of his fellow-countrymen he adopted a military career and in the latter*
part of Gallienus' reign he rose to a position of high command. Although Gallienus was popular
with the soldiers his senior officers, for reasons which are not entirely clear, were not so loyal. At
the time of the siege of Aureolus in Milan, in the late summer of AD *268, a conspiracy was formed*
which included Claudius and another future emperor, Aurelian. This led to Gallienus' assassination
and, after substantial bribes to the disgruntled troops, the elevation of Claudius to the imperial
throne. Despite the inauspicious beginning to his short reign the new emperor was confirmed by
the Roman Senate, who had always disliked Gallienus, and proceeded to prove himself worthy of
the trust which had been placed in him. He defeated an invasion by the Alamanni, helped weaken
the Gallic Empire of Victorinus by invading part of its territory in southern Gaul and Spain, and
finally achieved a massive victory at Naissus over the Goths who had been plundering the Balkans
for some time. For this achievement Claudius received the appellation 'Gothicus' by which he is
best known. Many of the defeated Germans were recruited into the depleted ranks of the Roman
army, but unfortunately this policy seems to have contributed to a serious outbreak of plague which
eventually claimed the life of the emperor himself at Sirmium in the summer of AD *270. The extent*
of the posthumous coinage issued to celebrate his deification indicates that he had achieved
considerable popularity by the time of his death, and almost half a century later he was even
claimed as an ancestor by Constantine the Great.

 The brevity of his reign and the overwhelming nature of the military challenges facing him did
not permit Claudius to address the serious decline of the imperial coinage. The aureus, at least,
was stabilized at about 5.2 grams (60 to the pound) but many of the the antoniniani of this reign
are amongst the most miserable examples of this denomination ever produced. The silver content
was usually about 2.5% or less while the weight was between 2.5 and 3 grams. For the most part
the same mints were active as in the latter part of Gallienus' reign: Rome and Milan in Italy; Siscia
*in the Balkans; the uncertain mint signing itself '*S P Q R*' and Cyzicus in Asia Minor; and Antioch*
in Syria, even though at this time the city was under the control of the Palmyrenes. Reform of the
coinage would have to wait a few years more, until the latter part of Aurelian's reign.

 The following are the principal forms of obverse legend, other varieties being given in full:

A. IMP C CLAVDIVS AVG
B. IMP C CLAVDIVS P F AVG
C. IMP C M AVR CLAVDIVS AVG
D. IMP CLAVDIVS AVG
E. IMP CLAVDIVS P F AVG

The normal obverse type for antoniniani is radiate head or bust of Claudius II right, draped and
cuirassed or cuirassed only. All other denominations have a laureate head or bust instead of the
radiate crown. More unusual types are described in full.

11300 **Gold 8-aureus medallion.** IMP C M AVRL (*sic*) CLAVDIVS P F AVG. Rev. CONCORDIA
 EXERCITVS, Concordia Militum stg. l., looking r., holding standard in each hand. RIC —. C
 —. Hunter 27. [Rome, AD 268]. **VF** £16,500 ($25,000) / **EF** £36,750 ($55,000)

 NB Although medallions are not normally listed in this catalogue an exception has been
 made here as a number of specimens of this type have been appearing on the market in

recent years. Gnecchi I, p. 9, no. 1 (pl. 3, 8) lists a similar piece in Vienna of lighter weight, possibly 5 aurei, with AVREL instead of AVRL in the obv. legend. This coin is cited as RIC 1.

11301 **Gold aureus.** D. Rev. CONCOR EXERC, Concordia Militum stg. l., holding standard in each hand. RIC 3. C 33. Hunter 27. *[Rome, AD 269–70].*
VF £2,300 ($3,500) / EF £6,000 ($9,000)

NB As noted above, the aurei of Claudius II generally average about 5.20 grams, though there is considerable variation.

11302 A. Rev. FELICITAS AVG, Felicitas stg. l., holding caduceus and cornucopiae. Cf. RIC 4. C 78. Hunter, p. lxxix. *[Rome, AD 268–9].* VF £2,300 ($3,500) / EF £6,000 ($9,000)

11303 A. Rev. FIDES MILITVM, Fides Militum stg. l., holding standard in each hand. RIC 5. C 90. Hunter —. *[Rome, AD 268–9].* VF £2,300 ($3,500) / EF £6,000 ($9,000)

11304 B. Rev. IOVI STATORI, Jupiter stg. r., holding sceptre and thunderbolt. RIC 130. C 123. Hunter, p. lxxviii. *[Rome, AD 268–9].* VF £2,700 ($4,000) / EF £6,700 ($10,000)

11305 A. Rev. IOVI VICTORI, Jupiter stg. l., holding thunderbolt and sceptre. RIC 6. C 126. Hunter, p. lxxix. *[Rome, AD 268–9].* VF £2,300 ($3,500) / EF £6,000 ($9,000)

11306 D. Rev. MARTI PACIF, Mars advancing to front, hd. l., holding olive-branch, spear and shield. RIC 7. C —. Cf. Hunter, p. lxxx. *[Rome, AD 269–70].*
VF £2,700 ($4,000) / EF £6,700 ($10,000)

11307 11310

11307 E. Rev. PAX EXERC, Pax stg. l., holding olive-branch and transverse sceptre. Cf. RIC 131. Cf. C 207. Hunter, p. lxxxi. *[Milan, AD 269].* VF £2,000 ($3,000) / EF £5,300 ($8,000)

11308 A. Rev. SALVS AVG, Salus stg. l., feeding snake arising from altar and holding sceptre. RIC 8. C 261. Hunter, p. lxxviii. *[Rome, AD 268–9].* VF £2,300 ($3,500) / EF £6,000 ($9,000)

11309 E. Rev. SPES PVBLICA, Spes advancing l., holding flower and lifting skirt. RIC 133. C 280. Hunter 61. *[Milan, AD 268–9].* VF £2,000 ($3,000) / EF £5,300 ($8,000)

11310 D. Rev. VICTORIA AVG, Victory stg. facing, hd l., holding wreath and palm, between two captives, the one on l. kneeling r. in attitude of supplication. RIC —. C —. Hunter, p. lxxx. *[Rome, AD 269–70].* VF £2,700 ($4,000) / EF £6,700 ($10,000)

11311 Similar, but with obv. type laur. hd. l. RIC 9. C 296. Hunter, p. lxxx. *[Rome, AD 269–70].*
VF £3,300 ($5,000) / EF £8,000 ($12,000)

11312 E. Rev. — Victory advancing l., holding wreath and palm. RIC 135. C 300. Hunter, p. lxxxi. *[Milan, AD 268–9].* VF £2,000 ($3,000) / EF £5,300 ($8,000)

11313 **Gold aureus.** C. Rev. VIRTVS CLAVDI AVG, Claudius II, in military attire, galloping right, spearing one of three enemies beneath his horse, discarded shield on ground. RIC 227. C 324. Hunter, p. lxxxiii. *[Cyzicus, AD 268].* **VF** £4,000 ($6,000) / **EF** £10,000 ($15,000)

11314 **Billon antoninianus.** A. Rev. ADVENTVS AVG, Claudius II on horseback l., raising r. hand and holding sceptre in l. RIC 13. C 3. Hunter, p. lxxviii. *[Rome, AD 268].*
VF £30 ($45) / **EF** £80 ($120)

11315 Similar, but with obv. type rad. bust l., holding spear or sceptre. RIC 13. C 4. Hunter, p. lxxviii. *[Rome, AD 268].* **VF** £75 ($110) / **EF** £200 ($300)

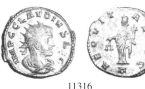

11316 11323

11316 A. Rev. AEQVITAS AVG, Aequitas stg. l., holding scales and sceptre, sometimes with officina mark H (= 8) or dot in ex. RIC 197. C 6. Hunter 73. *[Antioch, AD 268–9].*
VF £10 ($15) / **EF** £25 ($40)

11317 A, rad. hd. l. Rev. AETER AVG, Diana stg. r., holding torch with both hands, facing Sol stg. l., raising r. hand and holding whip in l. RIC 197. C 6. Hunter 73. *[Antioch, AD 269–70].*
VF £25 ($40) / **EF** £65 ($100)

11318 D. Rev. AETERNIT AVG, Sol stg. l., r. hand raised, holding globe in l., officina mark N (= 9) in field or in ex. RIC 16. C 16. Hunter, p. lxxx. *[Rome, AD 269–70].*
VF £10 ($15) / **EF** £25 ($40)

11319 A. Rev. ANNONA AVG, Annona stg. l., r. foot on prow, holding corn-ears and cornucopiae. RIC 18. C 21. Hunter 7. *[Rome, AD 268–9].* **VF** £10 ($15) / **EF** £25 ($40)

11320 D. Rev. APOLLINI CONS, Apollo stg. l., holding laurel-branch and resting on lyre set on rock, officina mark H (= 8) in field or in ex. RIC 22. Cf. C 25. Hunter 40. *[Rome, AD 269–70].* **VF** £12 ($18) / **EF** £30 ($45)

11321 A. Rev. CONCOR AVG, two veiled female figures stg. facing each other, each holding torch and corn-ears. RIC 200. C 31. Hunter, p. lxxxii. *[Antioch, AD 269–70].*
VF £20 ($30) / **EF** £50 ($75)

11322 E. Rev. CONCOR EXER, Concordia Militum stg. l., holding standard and cornucopiae, officina mark S or T (= 2 or 3) in ex. RIC 140. C 32. Hunter, p. lxxxi. *[Milan, AD 269–70].*
VF £12 ($18) / **EF** £30 ($45)

11323 A. Rev. CONSER AVG, Serapis stg. facing, hd. l., raising r. hand and holding sceptre in l., sometimes with officina mark Γ (= 3) in ex. RIC 201. C 58. Hunter 74. *[Antioch, AD 268–9].* **VF** £14 ($20) / **EF** £38 ($55)

11324 A. Rev. — Serapis stg. facing, hd. l., raising r. hand and holding sceptre in l., facing Isis stg. r., holding sistrum and basket. RIC 202. C 59. Hunter, p. lxxxii. *[Antioch, AD 269–70].* **VF** £38 ($55) / **EF** £100 ($150)

11325 **Billon antoninianus.** A. Rev. CONSERVAT PIETAT, Claudius II, in military attire, stg. l., extending hand to female figure kneeling before him and holding sceptre. RIC 28. C 62. Hunter, p. lxxviii. *[Rome, AD 268–9].* **VF** £25 ($40) / **EF** £65 ($100)

11326 B. Rev. DACIA FELIX, Dacia stg. l., holding Dacian standard surmounted by wolf's hd. (*draco*), officina mark S (= 2) in ex. RIC 143. C 64 var. Hunter, p. lxxxi. *[Milan, AD 268–9].* **VF** £38 ($55) / **EF** £100 ($150)
 The staff held by the personification of the province of Dacia has traditionally been described as "surmounted by ass's head". I am indebted to Mr. Alexandru Marian of Romania for the correct identification of the 'draco', the Dacian battle standard which was decorated with a wolf's head and the tail of a 'dragon'.

11327 A. Rev. DIANAE VICTR, Diana stg. r., holding bow and drawing arrow, stag at feet, officina mark H (= 8) in ex. RIC 205. C 67. Hunter, p. lxxxii. *[Antioch, AD 268–9].*
 VF £14 ($20) / **EF** £38 ($55)

11328 E. Rev. DIANA LVCIF, Diana stg. r., holding torch with both hands, officina mark P (= 1) in ex. RIC 144. C 69. Hunter 51. *[Milan, AD 269–70].* **VF** £12 ($18) / **EF** £30 ($45)

11329 A. Rev. FELIC AVG, Felicitas stg. r., holding sceptre, facing Fortuna stg. l., holding rudder and cornucopiae. RIC 206. C 72. Hunter, p. lxxxii. *[Antioch, AD 269–70].*
 VF £22 ($35) / **EF** £60 ($90)

11330 E. Rev. FELIC TEMPO, Felicitas stg. l., holding caduceus and sceptre, officina mark T (= 3) in ex. RIC 145. C 74. Hunter 52. *[Milan, AD 268–9].* **VF** £10 ($15) / **EF** £25 ($40)

11331 A. Rev. FELICITAS AVG, Felicitas stg. l., holding long caduceus and cornucopiae, sometimes withofficina mark B (= 2) in field. RIC 32. C 79. Hunter 11. *[Rome, AD 268–9].*
 VF £10 ($15) / **EF** £25 ($40)

11332 Similar, but with obv. legend IMP C M AVR CLAVDIVS P F AVG and without officina mark on rev. RIC —. C —. Hunter, p. lxxviii, note 7. *[Rome, AD 268].*
 VF £38 ($55) / **EF** £100 ($150)

11333 A. Rev. FIDES AVG, Mercury stg. l., holding purse and caduceus, sometimes with officina mark S or Z (= 6 or 7) in ex. RIC 207. C 83. Hunter 75. *[Antioch, AD 268–9].*
 VF £16 ($25) / **EF** £45 ($65)

11334 A. Rev. FIDES EXERCI, Fides Militum stg. facing, hd. r., holding two standards, that in l. hand transverse, sometimes with officina mark XI (= 11) in field. RIC 34. C 84. Hunter, p. lxxviii. *[Rome, AD 268–9].* **VF** £10 ($15) / **EF** £25 ($40)

11335

11335 E. Rev. FIDES MILIT, Fides Militum stg. l., holding standard in each hand, officina mark S (= 2) in ex. RIC 149. C 88. Hunter 54. *[Milan, AD 269].* **VF** £10 ($15) / **EF** £25 ($40)

11336 **Billon antoninianus.** D. Rev. FIDES MILITVM, similar, but holding standard and spear; officina mark ε (= 5) in field. RIC 38. C 92. Hunter 42. *[Rome, AD 269–70]*.
VF £10 ($15) / EF £25 ($40)

11337 D. Rev. FORTVNA REDVX, Fortuna stg. l., holding rudder and cornucopiae, officina mark Ϛ or Z (= 6 or 7) in field or in ex. RIC 41. C 104. Hunter, p. lxxx. *[Rome, AD 269–70]*.
VF £10 ($15) / EF £25 ($40)

11338 Similar, but with obv. E (sometimes with dots below hd.) and with S P Q R in ex. on rev. RIC 234. C 103. Hunter, p. lxxxiii. *[Cyzicus, AD 268–9]*. VF £16 ($25) / EF £45 ($65)

11339 A. Rev. GENIVS AVG, Genius stg. l., holding patera and cornucopiae, altar at feet, officina mark Γ (= 3) in field. RIC 45. C 110. Hunter 13. *[Rome, AD 268–9]*.
VF £12 ($18) / EF £30 ($45)

11340 D. Rev. GENIVS EXERCI, similar, but without altar and with officina mark Z (= 7) in field. RIC 49. C 115. Hunter, p. lxxx. *[Rome, AD 269–70]*. VF £12 ($18) / EF £30 ($45)

11341 A. Rev. IOVI STATORI, Jupiter stg. facing, hd. r., resting on sceptre and holding thunderbolt. RIC 52. C 124. Hunter, p. lxxviii. *[Rome, AD 268–9]*. VF £10 ($15) / EF £25 ($40)

11342 A. Rev. IOVI VICTORI, Jupiter stg. facing, hd. l., holding thunderbolt and resting on sceptre, officina mark N (= 9) in field. RIC 54. C 130. Hunter 16. *[Rome, AD 268–9]*.
VF £10 ($15) / EF £25 ($40)

11343 A. Rev. IVNO REGINA, Juno stg. l., holding patera and sceptre, peacock at feet, sometimes with officina mark B (= 2) or dot in ex. RIC 212. C 134. Hunter 76. *[Antioch, AD 268–9]*.
VF £12 ($18) / EF £30 ($45)

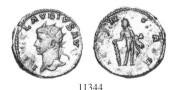

11344

11344 A, rad. hd. l. Rev. IVVENTVS AVG, Hercules stg. facing, hd. l., resting on club and holding lion's skin, sometimes with officina mark Δ (= 4) or dot in ex. RIC 213. C 136. Hunter, p. lxxxii, note 2. *[Antioch, AD 268–9]*. VF £20 ($30) / EF £50 ($75)

11345 D. Rev. LAETITIA AVG, Laetitia stg. l., holding wreath and cornucopiae, sometimes with officina mark I (= 1) in field, or II (= 2) in ex. RIC 181. C 138. Hunter, p. lxxxi. *[Siscia, AD 268–9]*. VF £10 ($15) / EF £25 ($40)

11346 Similar, but Laetitia holds anchor or rudder on globe instead of cornucopiae, and usually with officina mark XII (= 12) in field or in ex. RIC 56. C 140. Hunter 43. *[Rome, AD 269–70]*. VF £12 ($18) / EF £30 ($45)

11347 C. Rev. LAETITIA AVG N, similar, but with mint mark M C in field. RIC 235. C 142. Hunter, p. lxxxiii. *[Cyzicus, AD 268]*. VF £16 ($25) / EF £45 ($65)

11348 A. Rev. LIBERALITAS AVG, Liberalitas stg. l., holding abacus and cornucopiae. RIC 57. C 144. Hunter, p. lxxix. *[Rome, AD 268]*. VF £12 ($18) / EF £30 ($45)

11349 **Billon antoninianus.** D. Rev. LIBERT (or LIBERTAS) AVG, Libertas stg. l., holding pileus and sceptre, sometimes with officina mark X (= 10) in field. RIC 61, 63. C 150–51. Hunter 33–4. *[Rome, AD 269–70].* VF £12 ($18) / **EF** £30 ($45)

11350 D. Rev. MARS VLTOR, Mars advancing r., carrying spear and trophy, sometimes with officina mark H (= 8) in field. RIC 67. C 159. Hunter 35. *[Rome, AD 269–70].*
 VF £12 ($18) / **EF** £30 ($45)

11351 D. Rev. MARTI PACIF (or PACIFERO), Mars advancing to front, hd. l., holding olive-branch, spear and shield, sometimes with officina mark X (= 10) in field or in ex. Cf. RIC 68, 72. C 161, 169. Hunter 44. *[Rome, AD 269–70].* VF £12 ($18) / **EF** £30 ($45)

11352 C. Rev. MINERVA AVG, Minerva stg. r., resting on spear and shield, S P Q R in ex. RIC 236. C 178. Hunter, p. lxxxii. *[Cyzicus, AD 268–9].* VF £22 ($35) / **EF** £60 ($90)

11353 A. Rev. NEPTVN AVG, Neptune stg. l., holding dolphin and trident, sometimes with officina mark A (= 1) or dot in ex. RIC 214. C 183. Hunter 78. *[Antioch, AD 268–9].*
 VF £20 ($30) / **EF** £50 ($75)

11354 E. Rev. ORIENS AVG, Sol stg. facing, hd. l., raising r. hand and holding globe in l., officina mark P (= 1) in ex. RIC 153. C 185. Hunter 56. *[Milan, AD 269].*
 VF £12 ($18) / **EF** £30 ($45)

11355 D. Rev. PAX AVG, Pax stg. l., holding olive-branch and transverse sceptre, officina mark II (= 2) in field. RIC 186. C 197. Hunter, p. lxxxi. *[Siscia, AD 268–9].*
 VF £10 ($15) / **EF** £25 ($40)

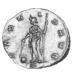

11356 11362

11356 E. Rev. — similar, but Pax advancing l., and with with officina mark T (= 3) in ex. RIC 157. C 202. Hunter 58. *[Milan, AD 269].* VF £10 ($15) / **EF** £25 ($40)

11357 D. Rev. PAX AVGVSTI, as 11355, but with officina mark A (= 1) in field. RIC 81. C 204. Hunter 45. *[Rome, AD 269–70].* VF £10 ($15) / **EF** £25 ($40)

11358 E. Rev. PAX EXERC, similar, but with officina mark T (= 3) in ex. RIC 159. Cf. C 209. Hunter, p. lxxxi. *[Milan, AD 268–9].* VF £12 ($18) / **EF** £32 ($50)

11359 A. Rev. P M TR P II COS P P, Claudius II, togate, stg. l., holding branch and short sceptre. RIC 10. C 214. Hunter, p. lxxviii. *[Rome, AD 268–9].* VF £14 ($20) / **EF** £38 ($55)

11360 D. Rev. — Claudius II, in military attire, stg. r., holding transverse sceptre (or spear) and globe, officina mark Δ (= 4) in field or in ex. RIC 12. C 216. Hunter 38. *[Rome, AD 268–9]*
 . VF £14 ($20) / **EF** £38 ($55)

11361 E. Rev. PROVID AVG, Providentia stg. l., holding globe and cornucopiae, officina mark P (= 1) in ex. RIC 162. C 219. Hunter, p. lxxxi. *[Milan, AD 269].* VF £12 ($18) / **EF** £30 ($45)

11362 **Billon antoninianus.** Similar, but Providentia holds rod and sceptre, globe at feet, officina mark T (= 3) in ex. Cf. RIC 163. C 223. Cf. Hunter, p. lxxxi. *[Milan, AD 269–70].*
VF £12 ($18) / **EF** £30 ($45)

11363 A. Rev. PROVIDENT AVG, Providentia stg. facing, hd. l., legs crossed, resting on column and holding rod and cornucopiae, globe at feet, sometimes with officina mark XII (= 12) in field. RIC 91. C 230. Hunter 22. *[Rome, AD 268–9].*
VF £10 ($15) / **EF** £25 ($40)

11364 Similar, but with obv. legend IMP C M AVR CLAVDIVS P F AVG and without officina mark on rev. RIC —. C —. Hunter, p. lxxix, note 1. *[Rome, AD 268].*
VF £38 ($55) / **EF** £100 ($150)

11365 A. Rev. REGI ARTIS, Vulcan stg. r., holding hammer and tongs, officina mark Z (= 7) in ex. RIC 215. C 239. Hunter, p. lxxxii. *[Antioch, AD 268–9].* **VF** £50 ($75) / **EF** £130 ($200) *The dedication to Vulcan on this unusual reverse type is "to the king of the art". In this context the 'art' would seem to be that of the mint personnel themselves .*

11366 A. Rev. SALVS AVG, Salus stg. l., feeding snake arising from altar and holding sceptre. RIC 98. C 265. Hunter 3. *[Rome, AD 268–9].* **VF** £10 ($15) / **EF** £25 ($40)

11367 E. Rev. — Aesculapius stg. facing, hd. l., holding snake-entwined staff; officina mark P (= 1) in ex. RIC 165. C 252. Hunter 60. *[Milan, AD 268–9].* **VF** £14 ($20) / **EF** £38 ($55)

11368 A, rad. hd. l. Rev. — Apollo stg. l., holding laurel-branch and resting on lyre. Cf. RIC 216. C 251. Hunter 80. *[Antioch, AD 268–9].* **VF** £20 ($30) / **EF** £50 ($75)

11369 — — Rev. — Diana stg. r., drawing arrow from quiver and holding bow, facing Apollo stg. l., holding laurel-branch and resting on lyre. RIC 219. C 260. Hunter, p. lxxxii. *[Antioch, AD 269–70].* **VF** £20 ($30) / **EF** £50 ($75)

11370

11370 A. Rev. — Isis stg. l., holding sistrum and basket (or bucket), officina mark ε (= 5) in ex. RIC 217. C 256. Hunter 81. *[Antioch, AD 269–70].* **VF** £25 ($40) / **EF** £65 ($100)

11371 D. Rev. SECVRIT AVG, Securitas stg. facing, hd. l., legs crossed, resting on column and holding sceptre, officina mark XI (= 11) in field or in ex. RIC 100. C 268. Cf. Hunter 47. *[Rome, AD 269–70].* **VF** £10 ($15) / **EF** £25 ($40)

11372 A, rad. hd. l. Rev. SOL (or SOLVS) AVG, Sol stg. l., raising r. hand and holding whip in l., sometimes with dot in ex. RIC 221. C 273–4. Hunter, p. lxxxii. *[Antioch, AD 268–9].*
VF £20 ($30) / **EF** £50 ($75)

11373 D. Rev. SPES AVG, Spes advancing l., holding flower and lifting skirt, officina mark I (= 1) or II (= 2) in field. RIC 191. C 276. Hunter, p. lxxxi. *[Siscia, AD 268–9].*
VF £12 ($18) / **EF** £30 ($45)

11374

11374 **Billon antoninianus.** E. Rev. SPES PVBLICA, similar, but with officina mark P (= 1) in ex. RIC 168. C 284. Hunter 62. *[Milan, AD 268–9].* **VF** £10 ($15) / **EF** £25 ($40)

11375 D. Rev. TEMPORVM FELI, Felicitas stg. l., holding long caduceus and cornucopiae, officina mark P (= 1) or S (= 2) in field. RIC 192. C 285. Hunter, p. lxxxii. *[Siscia, AD 269–70].*
VF £12 ($18) / **EF** £32 ($50)

11376 D. Rev. VBERITAS AVG, Uberitas stg. l., holding cow's udder (?) and cornucopiae, officina mark T (= 3) or Q (= 4) in field. RIC 193. C 286. Hunter 72. *[Siscia, AD 269–70].*
VF £12 ($18) / **EF** £30 ($45)

11377 E, three dots below bust. Rev. VICTOR GERMAN, two captives seated at foot of trophy. RIC 234. C 103. Hunter, p. lxxxiii. *[Cyzicus, AD 268–9].* **VF** £45 ($65) / **EF** £115 ($175)
This type commemorates Claudius' victory over the Alamanni who had invaded northern Italy (see also no. 11380).

11378 A. Rev. VICTORIA AVG, Victory stg. l., holding wreath and palm, sometimes with officina mark A (= 1) in field. RIC 104. C 293. Hunter 23. *[Rome, AD 268–9].*
VF £10 ($15) / **EF** £25 ($40)

11379 E. Rev. — Victory advancing r., holding wreath and palm, officina mark S (= 2) in ex. RIC 171. C 302. Hunter 64. *[Milan, AD 268–9].* **VF** £10 ($15) / **EF** £25 ($40)

11380 A. Rev. VICTORIA G M, Victory stg. l. between two seated captives, resting on shield and holding palm. RIC 108. C 304. Hunter, p. lxxviii. *[Rome, AD 268–9].*
VF £30 ($45) / **EF** £80 ($120)
See note following no. 11377.

11381 E, sometimes with two dots below bust. Rev. VICTORIAE (or VICTORIA) GOTHIC, two captives seated at foot of trophy, sometimes with S P Q R in ex. RIC 252. C 308. Hunter 87. *[Cyzicus, AD 269].* **VF** £38 ($55) / **EF** £100 ($150)
This type commemorates Claudius' great victory over the Goths at Naissus in Moesia.

11382 A. Rev. VIRT AVG, Vulcan stg. r., holding hammer and tongs, facing Minerva stg. l., resting on shield and holding spear. RIC 224. C 311. Hunter, p. lxxxii. *[Antioch, AD 269–70].* **VF** £22 ($35) / **EF** £60 ($90)

11383 A. Rev. VIRTVS AVG, Mars stg. l., holding olive-branch and resting on spear, shield at feet to l., sometimes with officina mark ε (= 5) in field. RIC 109. C 313. Hunter 24. *[Rome, AD 268–9].* **VF** £10 ($15) / **EF** £25 ($40)

11384 Similar, but with obv. legend IMP C M AVR CLAVDIVS P F AVG and without officina mark on rev. RIC —. C —. Hunter, p. lxxix, note 1. *[Rome, AD 268].*
VF £38 ($55) / **EF** £100 ($150)

11385 E. Rev. — Mars, naked, advancing r., carrying spear and trophy, officina mark P (= 1) in ex. RIC 172. C 315. Hunter 65. *[Milan, AD 269].* **VF** £10 ($15) / **EF** £25 ($40)

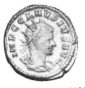

11386 11395

11386 **Billon antoninianus.** A. Rev. — Minerva stg. r., resting on spear and shield, officina mark
Ϛ (= 6) or dot in ex. RIC 225. C 316. Hunter, p. lxxxii. *[Antioch, AD 268–9].*
VF £10 ($15) / **EF** £25 ($40)

11387 D. Rev. — Mars or Virtus stg. l., resting on shield and spear , officina mark Β (= 2) in field.
RIC 111. C 318. Hunter 50. *[Rome, AD 269–70].* **VF** £10 ($15) / **EF** £25 ($40)

11388 D, rad. and cuir. bust l., holding trophy over r. shoulder, ornamented shield on l. arm. Rev.
— Claudius II, in military attire, on horseback galloping r., brandishing spear, officina
mark II (= 2) below. Cf. RIC 112 var. C 322 var. Hunter 68. *[Siscia, AD 268–9].*
VF £130 ($200) / **EF** £330 ($500)

11389 **Billon denarius.** A. Rev. FELICITAS AVG, Felicitas stg. l., holding long caduceus and
cornucopiae. RIC —. C —. Hunter —. Huvelin ("L'Atelier de Rome sous Claude II le
Gothique", in *Quaderni Ticinesi Vol. XIII*, pp. 199–213) 7. *[Rome, AD 268–9].*
F £330 ($500) / **VF** £1,000 ($1,500)

11390 **Billon quinarius.** D. Rev. AETERNITAS AVG, Sol stg. l., r. hand raised, holding globe in l.
RIC 116. C 19. Hunter, p. lxxx. Huvelin 38–42. *[Rome, AD 269–70].*
F £115 ($175) / **VF** £330 ($500)

11391 IMP CLAVDIVS P AVG. Rev. FELICITAS AVG, Felicitas stg., as 11389. RIC —. C —. Hunter,
p. lxxix. Huvelin 9. *[Rome, AD 268–9].* **F** £130 ($200) / **VF** £400 ($600)

11392 CLAVDIVS AVG. Rev. VICTORIA AVG, Victory stg. l., holding wreath and palm. RIC —. C
—. Hunter —. Huvelin 8. *[Rome, AD 268–9].* **F** £130 ($200) / **VF** £400 ($600)

11393 **Bronze as or reduced sestertius.** B. Rev. GENIVS EXERCI, Genius of the Army stg. l.,
holding patera and cornucopiae. Cf. RIC 173. C 112. Cf. Hunter, p. lxxix. Huvelin 14–15.
[Rome, AD 268–9]. **F** £150 ($225) / **VF** £465 ($700)

11394 A. Rev. IOVI VICTORI, Jupiter stg. facing, hd. l., holding thunderbolt and sceptre. RIC 124. C
128. Hunter, p. lxxix. Huvelin 21–4. *[Rome, AD 268–9].* **F** £130 ($200) / **VF** £430 ($650)

11395 A. Rev. MARS VLTOR, Mars, naked, advancing r., carrying spear and trophy. RIC 126. Cf.
C 155. Hunter, p. lxxix. Huvelin 21–4. *[Rome, AD 268–9].*
F £130 ($200) / **VF** £430 ($650)

11396 E, laur. hd. l. Rev. MARTI PACIFERO, Mars, in military attire, stg. l., holding olive-branch
and transverse spear. RIC 128, 175. C 167. Hunter —. *[Milan, AD 268–9].*
F £170 ($250) / **VF** £500 ($750)

11397 B. Rev. VICTORIA AVG, Victory stg. l., holding wreath and palm. RIC —. C 291. Hunter,
p. lxxix. Huvelin 10–13. *[Rome, AD 268–9].* **F** £130 ($200) / **VF** £430 ($650)

For coins of Divus Claudius II, see under Quintillus (nos. 11459–66).

Alexandrian Coinage

All have obv. legend AVT K KΛAVΔIOC CEB.

There are two varieties of obv. type represented by the lower case letters 'a' and 'b':

a. Laur., dr. and cuir. bust r.
b. Laur. and cuir. bust r.

11398 **Billon tetradrachm.** a. Rev. Rad. bust of Helios r., L — A (= regnal year 1) in field.
Dattari 5391. BMCG 2308. Cologne 3018. Milne 4194. *[AD 268–9].*
 VF £16 ($25) / **EF** £40 ($60)

11399 a. Rev. Hermes stg. l., r. hand on hip, holding caduceus in l., L A (= regnal year 1) before.
Dattari 5394. BMCG 2313. Cologne 3019. Milne 4220. *[AD 268–9].*
 VF £20 ($30) / **EF** £50 ($75)

11400 a. Rev. Bust of Isis r., wearing disk and plumes, knot on breast, L — A (= regnal year 1) in
field. Dattari —. BMCG —. Cologne 3021. Milne —. *[AD 268–9].*
 VF £32 ($50) / **EF** £80 ($120)

11401 a. Rev. Bust of Selene r., wearing taenia, large lunar crescent before, L A (= regnal year 1)
behind. Dattari 5408. BMCG 2309. Cologne 3025. Milne 4195. *[AD 268–9].*
 VF £16 ($25) / **EF** £40 ($60)

11402 a. Rev. Dikaiosyne (= Aequitas) stg. l., holding scales and cornucopiae, L — A (= regnal
year 1) in field. Dattari —. BMCG —. Cologne —. Milne —. Emmett 3874. *[AD 268–9].*
 VF £20 ($30) / **EF** £50 ($75)

11403 a. Rev. Elpis (= Spes) advancing l., holding flower and lifting skirt, L — A (= regnal year
1) in field. Dattari 5387. BMCG 2317. Cologne 3017. Milne 4197. *[AD 268–9].*
 VF £14 ($20) / **EF** £32 ($50)

11404 a. Rev. Nike (= Victory) advancing r., holding wreath and palm, L — A (= regnal year 1) in
field. Dattari 5400 var. BMCG 2320. Cologne 3022. Milne 4222. *[AD 268–9].*
 VF £14 ($20) / **EF** £32 ($50)

11405 a. Rev. Nike (= Victory) stg. r., inscribing L A (= regnal year 1) on shield resting on
column. Dattari 5404. BMCG 2324. Cologne 3024. Milne 4199. *[AD 268–9].*
 VF £16 ($25) / **EF** £40 ($60)

11406 a. Rev. Tyche (= Fortuna) reclining l. on couch, holding rudder, L A (= regnal year 1)
above. Dattari 5411. BMCG 2325. Cologne —. Milne 4200. *[AD 268–9].*
 VF £16 ($25) / **EF** £40 ($60)

11407 a. Rev. Eagle stg. r., hd. l., holding wreath in beak, L / A (= regnal year 1) before. Dattari
5414. BMCG 2331. Cologne 3015. Milne 4225. *[AD 268–9].*
 VF £14 ($20) / **EF** £32 ($50)

11408 b. Rev. Bust of Alexandria r., wearing close-fitting cap surmounted by turrets and arches,
L—B (= regnal year 2) in field. Dattari 5383. BMCG 2330. Cologne 3030. Milne 4246.
[AD 269–70]. **VF** £20 ($30) / **EF** £50 ($75)

11409 a. Rev. Ares, in military attire, stg. l., resting on spear and holding parazonium, L — B
(= regnal year 2) in field. Dattari 5384. BMCG 2311. Cologne 3031. Milne 4226, 4255.
[AD 269–70]. **VF** £16 ($25) / **EF** £40 ($60)

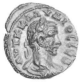

11407 11416

11410 **Billon tetradrachm.** a. Rev. Athena enthroned l., holding Nike and resting on sceptre, shield at side, L — B (= regnal year 2) in field. Dattari —. BMCG 2130. Cologne 3032. Milne (Supplement) 4257a. *[AD 269–70].* **VF** £16 ($25) / **EF** £40 ($60)

11411 b. Rev. Bust of Hermanubis r., wearing taenia and modius with lotus-petal, combined caduceus and palm before, L B (= regnal year 2) behind. Dattari 5392. BMCG 2327. Cologne 3037. Milne 4240. *[AD 269–70].* **VF** £22 ($35) / **EF** £60 ($90)

11412 a. Rev. Harpocrates of Pelusium, wearing hemhem crown, stg. facing, hd. r., holding branch and pomegranate, dancing figure of Paniskos at his feet to l., L — B (= regnal year 2) in field. Dattari 5390. BMCG 2326. Cologne 3036. Milne 4263. *[AD 269–70].* **VF** £40 ($60) / **EF** £100 ($150)

11413 b. Rev. Conjoined busts r. of Nilus, crowned with lotus, cornucopiae at r. shoulder, and Euthenia (= Abundantia), crowned with corn, L B (= regnal year 2) before. Dattari 5405. BMCG 2328. Cologne 3044. Milne 4244. *[AD 269–70].* **VF** £22 ($35) / **EF** £60 ($90)

11414 a. Rev. Poseidon stg. l., r. foot set on dolphin, holding uncertain object in r. hand and resting on trident held in l., L — B (= regnal year 2) in field. Dattari 5407. BMCG 2307. Cologne 3045. Milne 4252. *[AD 269–70].* **VF** £20 ($30) / **EF** £50 ($75)

11415 b. Rev. Dikaiosyne (= Aequitas) seated l., holding scales and cornucopiae, L B (= regnal year 2) before. Dattari 5386. BMCG 2316. Cologne 3033. Milne 4231. *[AD 269–70].* **VF** £14 ($20) / **EF** £32 ($50)

11416 a. Rev. Homonoia (= Concordia) stg. l., r. hand extended, holding double cornucopiae in l., L B (= regnal year 2) before. Dattari 5397. BMCG 2319. Cologne 3040. Milne 4259. *[AD 269–70].* **VF** £14 ($20) / **EF** £32 ($50)

11417 b. Rev. Nike (= Victory) advancing l., holding wreath and palm, L B (= regnal year 2) before. Dattari 5399. BMCG 2323. Cologne 3042. Milne 4238. *[AD 269–70].* **VF** £14 ($20) / **EF** £32 ($50)

11418 b. Rev. Eagle stg. l., hd. r., holding wreath in beak, L — B (= regnal year 2) in field. Dattari 5417. BMCG 2333. Cologne 3028. Milne 4247. *[AD 269–70].* **VF** £14 ($20) / **EF** £32 ($50)

11419 b. Rev. Eagle stg. facing, hd. r., between two vexilla, its wings open and holding wreath in beak, L B (= regnal year 2) above. Dattari —. BMCG —. Cologne —. Milne —. Emmett 3880. *[AD 269–70].* **VF** £22 ($35) / **EF** £60 ($90)

11420 a. Rev. Athena stg. facing, hd. l., resting on spear and shield, L Γ (= regnal year 3) to l. Cf. Dattari 5385. BMCG/Christiansen 3346. Cologne —. Milne 4284. *[AD 270].* **VF** £22 ($35) / **EF** £60 ($90)

NB The coins of Claudius' third regnal year at Alexandria belong to the period immediately following his death, before the news had reached Egypt and the brief coinage of Quintillus commenced (cf. M. Jessop Price, "The Lost Year: Greek Light on a Problem of Roman Chronology", *Numismatic Chronicle* 1973, pp. 75–86).

11421 **Billon tetradrachm.** a. Rev. Laur bust of Zeus r., L — Γ (= regnal year 3) in field. Dattari 5413. BMCG 2336. Cologne 3047. Milne 4291. *[AD 270].* **VF** £30 ($45) / **EF** £75 ($110)

11422 a. Rev. Tyche (= Fortuna) stg. l., holding rudder and cornucopiae, L Γ (= regnal year 3) before. Dattari 5410. BMCG/Christiansen 3355. Cologne 3048. Milne 4286. *[AD 270].*
VF £20 ($30) / **EF** £50 ($75)

11423 a. Rev. Eagle stg. r., its wings closed, holding wreath in beak, palm-branch transversely in background, L — Γ (= regnal year 3) in field. Dattari 5413. BMCG 2336. Cologne 3047. Milne 4291. *[AD 270].* **VF** £16 ($25) / **EF** £40 ($60)

11424 **Bronze hemidrachm** (28–29 mm. diam). b. Rev. Tetrastyle temple with three cone-shaped objects on roof, Eusebeia (= Pietas) stg. l. within, sacrificing at altar , L — A (= regnal year 1) in field. Dattari —. BMCG —. Cologne 3026. Milne —. *[AD 268–9].* *(Very rare)*

11425 b. Rev. Nilus reclining r., crocodile below, date L B (= regnal year 2). Dattari —. BMCG —. Cologne —. Milne —. Emmett 3904. *[AD 269–70].* *(Very rare)*

11426 b. Rev. Griffin seated r., paw on wheel, date L B (= regnal year 2). Dattari —. BMCG —. Cologne —. Milne —. Emmett 3903. *[AD 269–70].* *(Very rare)*

11427 b. Rev. Agathodaemon and Uraeus snake face to face, date L B (= regnal year 2) or L Γ (= regnal year 3). Dattari —. BMCG —. Cologne —. Milne —. Emmett 3900. *[AD 269–70 or 270].* *(Very rare)*

11428 b. Rev. Eagle stg. r., as 11423, date L B (= regnal year 2) or L Γ (= regnal year 3) in field. Dattari —. BMCG —. Cologne —. Milne —. Emmett 3900. *[AD 269–70 or 270].* *(Very rare)*

For other local coinages of Claudius II, see *Greek Imperial Coins & Their Values*, pp. 460–61.

QUINTILLUS
Aug.–Oct./Nov. AD 270

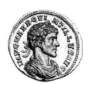

11431

At the time of Claudius' death at Sirmium in the summer of AD 270 his younger brother, Marcus Aurelius Quintillus, was in command of troops at Aquileia in northern Italy. His soldiers immediately proclaimed him emperor in his brother's place and he added Claudius' name to his own. His elevation was confirmed by the Senate and they also deified his predecessor, an event commemorated by an extensive 'Divus Claudius' coinage of antoniniani issued from Rome, Milan, Siscia, and Cyzicus. In October, however, the late emperor's cavalry commander Aurelian, who had taken over leadership of the campaign against the Goths, was proclaimed emperor by the Balkan army in opposition to Quintillus. The forces of the challenger were far superior to anything which Quintillus could muster and it was only a matter of time before his soldiers deserted him and

transferred their allegiance to his rival. Faced with an impossible situation the unfortunate emperor committed suicide after a reign of little more than two months.

Quintillus' brief coinage follows the same pattern as that of his predecessor, though only aurei and antoniniani are known together with a limited issue of billon tetradrachms from Alexandria. Gold is restricted to the Milan mint while billon was struck at all four mints which recognized the authority of Quintillus — Rome, Milan, Siscia, and Cyzicus. Antioch at this time was under the control of Vabalathus and Zenobia of Palmyra. There seems no reason to doubt that the extensive 'Divus Claudius' coinage commenced under Quintillus, though it probably extended into the early part of his successor's reign. Some scholars even believe that it may belong in its entirety to Aurelian who undoubtedly wished to be viewed as the true successor of Gothicus. For the pupeses of this catalogue, however, the posthumous coinage of Claudius II is all listed under Quintillus.

The following are the principal forms of obverse legend, other varieties being given in full:

A. IMP C M AVR CL QVINTILLVS AVG
B. IMP C M AVR QVINTILLVS AVG
C. IMP QVINTILLVS AVG
D. IMP QVINTILLVS P F AVG

The normal obverse type for antoniniani is radiate bust of Quintillus right, draped and cuirassed or cuirassed only. The very rare aurei have laureate, draped and cuirassed bust right.

11429 **Gold aureus.** B. Rev. CONCORD EXER, Concordia Militum stg. l., holding standard in each hand, officina mark T (= 3) in ex.. RIC —. C —. Cf. Hunter, p. lxxxv. *[Milan].*
VF £12,000 ($18,000) / EF £30,000 ($45,000)

NB The known aurei of Quintillus were all struck from the same elegantly engraved obverse die.

11430 B. Rev. FIDES EXERCITI, Fides Militum stg. l., holding standard in each hand. RIC —. C —. Cf. Hunter, p. lxxxv. *[Milan].* **VF £12,000 ($18,000) / EF £30,000 ($45,000)**

11431 B. Rev. FIDES MILIT, similar, but with officina mark S (= 2) in ex. Cf. RIC 2. Cf. C 24. Cf. Hunter, p. lxxxv. *[Milan].* **VF £12,000 ($18,000) / EF £30,000 ($45,000)**

11432

11432 B. Rev. MARTI PAC, Mars, in military attire, stg. facing, hd. l., holding olive-branch and transverse spear, officina mark P (= 1) in ex. RIC —. C —.Hunter —. *[Milan].*
VF £13,500 ($20,000) / EF £33,500 ($50,000)

11433 **Billon antoninianus.** A. Rev. AETERNIT AVG, Sol stg. l., r. hand raised, holding globe in l., officina mark N (= 9) in field or in ex. RIC 7. C 2. Hunter 1. *[Rome].*
VF £30 ($45) / EF £80 ($120)

11434 A. Rev. APOLLINI CONS, Apollo stg. l., holding laurel-branch and resting on lyre set on rock, officina mark H (= 8) in field or in ex. RIC 9. C 5. Hunter, p. lxxxiv. *[Rome].*
VF £30 ($45) / EF £80 ($120)

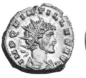

11435 11440

11435 **Billon antoninianus.** C. Rev. CONCO EXER, Concordia Militum stg. l., holding standard and cornucopiae, officina mark T (= 3) in ex. RIC 45. C 8. Hunter 23. *[Milan]*.
VF £30 ($45) / EF £80 ($120)

11436 A. Rev. CONCORDIA AVG, Concordia stg. l., sacrificing over altar and holding double cornucopiae, officina mark Δ (= 4) in field or in ex. RIC 13. C 17. Hunter 3, 5. *[Rome]*.
VF £30 ($45) / EF £80 ($120)

11437 C. Rev. DIANA LVCIF, Diana stg. r., holding long torch in both hands, officina mark P (= 1) in ex. RIC 49. C 19. Hunter 24. *[Milan]*.
VF £30 ($45) / EF £80 ($120)

11438 C. Rev. FIDES MILIT, Fides Militum stg. l., holding standard in each hand, officina mark S (= 2) in ex. RIC 52. C 25. Hunter 25. *[Milan]*.
VF £30 ($45) / EF £80 ($120)

11439 D, sometimes with one or two dots below bust. Rev. FIDES MILITVM, Fides Militum stg. l., holding standard and transverse spear. RIC 82. C 27. Hunter, p. lxxxvi. *[Cyzicus]*.
VF £32 ($50) / EF £95 ($140)

11440 A. Rev. — similar, but the spear is vertical, officina mark ε (= 5) in field or in ex. RIC 18. C 28. Hunter 7. *[Rome]*.
VF £30 ($45) / EF £80 ($120)

11441 A. Rev. FORTVNA REDVX, Fortuna stg. l., holding rudder set on globe in r. hand and cornucopiae in l., officina mark Z (= 7) in field or in ex. RIC 20. C 32. Hunter 9. *[Rome]*.
VF £30 ($45) / EF £80 ($120)

11442 C. Rev. FORTVNAE RED, similar, but holding wreath instead of cornucopiae, officina mark S (= 2) in ex. RIC 54. C 33. Hunter, p. lxxxv. *[Milan]*. VF £32 ($50) / EF £95 ($140)

11443 D, sometimes with three dots below bust. Rev. IOVI CONSERVATORI, Jupiter stg. facing, hd. l., holding thunder bolt and sceptre, small figure of emperor at feet. RIC 84. C 36. Hunter, p. lxxxvi. *[Cyzicus]*. VF £32 ($50) / EF £95 ($140)

11444 A. Rev. LAETITIA AVG, Laetitia stg. l., holding wreath and anchor set on globe, officina mark XII (= 12) in field or in ex. RIC 22. C 39. Hunter 10–11. *[Rome]*.
VF £30 ($45) / EF £80 ($120)

11445 A. Rev. LIBERTAS or LIBERITAS (*sic*) AVG, Libertas stg. l., holding pileus and cornucopiae, sometimes with officina mark P, S, or Q (= 1, 2, or 4) in field or in ex. RIC 65, 67. C 42. Hunter 29. *[Siscia]*. VF £32 ($50) / EF £95 ($140)

11446 A. Rev. MARS VLTOR, Mars advancing r., holding transverse spear and shield. RIC 69. Cf. C 45. Hunter, p. lxxxvi. *[Siscia]*. VF £32 ($50) / EF £95 ($140)
Sometimes the 'CL' in the obv. legend is omitted (RIC 70, C 44).

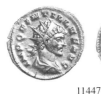

11447 11449

11447 **Billon antoninianus.** C. Rev. MARTI PACI, Mars stg. l., holding olive-branch in r. hand and transverse spear in l., officina mark P (= 1) in ex. RIC 58. Cf. C 47. Hunter 26. *[Milan].*
VF £30 ($45) / **EF** £80 ($120)

11448 A. Rev. MARTI PACIF or PACIL (*sic*), similar, but Mars advancing and also holding shield in l., officina mark X (= 10) in field or in ex. Cf. RIC 24–5. Cf. C 49–50. Cf. Hunter 12–13. *[Rome].*
VF £30 ($45) / **EF** £80 ($120)

11449 A. Rev. PAX AVGVSTI, Pax stg. l., holding olive-branch and transverse sceptre, officina mark A (= 1) in field. RIC 26. C 52. Hunter 14. *[Rome].* **VF** £30 ($45) / **EF** £80 ($120)

11450 A. Rev. PROVIDENT AVG, Providentia stg. l., holding rod and cornucopiae, globe at feet, officina mark Ϛ (= 6) in field or in ex. RIC 28. C 59. Hunter 15. *[Rome].*
VF £30 ($45) / **EF** £80 ($120)

11451 A. Rev. SECVRIT AVG, Securitas stg. facing, hd. l., legs crossed, holding sceptre and resting on column, officina mark XI (= 11) in field or in ex. RIC 31. C 63. Hunter 17. *[Rome].* **VF** £30 ($45) / **EF** £80 ($120)

11452 A (but without CL). Rev. TEMPORVM FELI, Felicitas stg. l., holding long caduceus and cornucopiae., sometimes with officina mark P (= 1) in field. RIC 77. C 67. Cf. Hunter, p. lxxxvi. *[Siscia].* **VF** £32 ($50) / **EF** £95 ($140)

11453 A. Rev. VBERITAS AVG, Uberitas stg. l., holding cow's udder (?) and cornucopiae, officina mark Q (= 4) in field. RIC 78. C 69. Hunter 30. *[Siscia].*
VF £32 ($50) / **EF** £95 ($140)

11454 A. Rev. VICTORIA AVG, Victory advancing r., holding wreath and palm, officina mark Γ (= 3) in field or in ex. RIC 33. C 70. Hunter 21. *[Rome].* **VF** £30 ($45) / **EF** £80 ($120)

11455 A. Rev. — similar, but Victory advancing l., sometimes with officina mark S (= 2) in field. RIC 80. C 71. Hunter, p. lxxxvi. *[Siscia].* **VF** £32 ($50) / **EF** £95 ($140)

11456 A. Rev. VIRTVS AVG, Mars or Virtus stg. l., resting on shield and spear , officina mark B (= 2) in field. RIC 35. C 73. Hunter 22. *[Rome].* **VF** £30 ($45) / **EF** £80 ($120)

Alexandrian Coinage

11457 **Billon tetradrachm.** A K M A KΛ KVINTIΛΛOC CEB, laur., dr. and cuir. bust r. Rev. Eagle stg. r., hd. l., holding wreath in beak, L — A (= regnal year 1) in field. Dattari 5420. BMCG 2337. Cologne 3049. Milne 4296. **VF** £65 ($100) / **EF** £170 ($250)

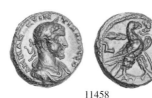

11458

11458 **Billon tetradrachm.** Similar, but the eagle's hd. is to r., palm-branch transversely in background. Dattari 5419. BMCG 2338. Cologne 3050. Milne 4298.
VF £65 ($100) / **EF** £170 ($250)

Issues of Quintillus and/or Aurelian in honour of Divus Claudius II, AD 270

Both Quintillus and Aurelian had good reason to wish to portray themselves as the true successor of the popular Claudius II. Therefore, although this extensive series of antoniniani may well have begun under Quintillus it was almost certainly continued by Aurelian. Indeed, some scholars believe that its issue may not even have commenced until the latter's reign, the brief two-month principate of Quintillus being insufficient for the inauguration of a commemorative coinage.

11459 **Billon antoninianus.** DIVO CLAVDIO, rad. hd. r. Rev. CONSECRATIO, eagle stg. l., hd. r. RIC Claudius 266. C Claudius 43. Hunter Divus Claudius 1. *[Rome].*
VF £14 ($20) / **EF** £38 ($55)

11460 Similar, but eagle stg. r., hd. l. RIC *Claudius* 266. C *Claudius* 41. Hunter *Divus Claudius* 5. *[Rome].*
VF £16 ($25) / **EF** £45 ($65)

11461 11465

11461 As 11459, but with dots below hd. on obv. RIC *Claudius* 266. Cf. C *Claudius* 43. Hunter, p. lxxxiv. *[Cyzicus].*
VF £16 ($25) / **EF** £45 ($65)

11462 Obv. As 11459. Rev. CONSECRATIO, altar-enclosure with flames rising from top, horns visible on either side. RIC *Claudius* 261. C *Claudius* 50. Hunter *Divus Claudius* 6, 7. *[Rome].*
VF £14 ($20) / **EF** £38 ($55)

11463 Obv. Similar, but sometimes rad. and dr. bust r. Rev. — (sometimes CONSACRATIO or CONSAECRATIO), similar, but with officina mark P, S, T, or Q (= 1, 2, 3, or 4) in ex. RIC *Claudius* 257, 261. C *Claudius* 39, 50. Cf. Hunter *Divus Claudius* 12. *[Siscia].*
VF £16 ($25) / **EF** £45 ($65)

11464 Obv. As 11461. Rev. As 11462, but sometimes CONSACRATIO. RIC *Claudius* 261 var. C *Claudius* 50 var. Hunter, p. lxxxiv. *[Cyzicus].*
VF £16 ($25) / **EF** £45 ($65)

11465 **Billon antoninianus.** DIVO CLAVDIO GOTHICO, rad. hd. r. Rev. As 11462, but with
officina mark T (= 3) in ex. RIC *Claudius* 264. C *Claudius* 53. Hunter *Divus Claudius* 13.
[Rome]. **VF** £40 ($60) / **EF** £100 ($150)

11466 Obv. As 11461. Rev. CONSECRATIO (or CONSACRATIO), pyramidal crematorium of three
storeys surmounted by horns (?) and flames, two figures stg. on second storey. Cf. RIC
Claudius 256. Cf. C *Claudius* 56. Hunter, p. lxxxiv. *[Cyzicus]*.
VF £20 ($30) / **EF** £50 ($75)

NB In addition to the above there are many 'hybrid' antoniniani of the Rome mint. The
commonest of these combine the regular posthumous obverse DIVO CLAVDIO, radiate head
right, with reverses of Claudius' lifetime issues, such as AEQVITAS AVG, AETERNIT AVG,
ANNONA AVG, APOLLINI CONS, FELICITAS AVG, FIDES EXERCI, FIDES MILITVM, FORTVNA
REDVX, GENIVS AVG, GENIVS EXERCI, IOVI STATORI, IOVI VICTORI, LAETITIA AVG,
LIBERT AVG, MARS VLTOR, MARTI PACIF, PAX AVG or AVGVSTI, PROVID or PROVIDENT
AVG, P M TR P II COS P P, SALVS AVG, SECVRIT AVG, SPES PVBLICA, VICTORIA AVG, and
VIRTVS AVG. A scarcer series combines the lifetime obverse IMP CLAVDIVS AVG with
posthumous reverse types, usually eagle or altar.

For later coins of Divus Claudius II, see under Constantine I in Volume IV.

"BARBAROUS RADIATES"

This interesting series of irregular issues, belonging in the main to the AD *270s, receives its name
from the radiate crown worn by the emperors on their billon antoniniani. The prototypes most
popular with the imitators were the coinages of Divus Claudius II and the Gallic usurpers Tetricus
I and II. The quality of these copies varies enormously, ranging from pieces which are almost
indistinguishable from the official issues to others which are bizarre in the extreme, some of them
displaying the abstract qualities of the Celtic coinage belonging to an earlier age. The obverse and
reverse legends are frequently blundered and in some cases have been reduced to meaningless
design elements. These unofficial radiates are found on Roman sites throughout the former western
provinces and it seems probable that they were mostly produced in Gaul, Britain, Spain, and
perhaps North Africa.*

THE THIRD CENTURY CRISIS AND RECOVERY:
2. REVIVAL UNDER THE ILLYRIAN EMPERORS,
AD 270–284/5

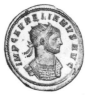

AURELIAN
Oct. AD 270–Oct./Nov. 275

11592

The reign of Aurelian marked a major turnabout in the fortunes of the Empire, both militarily and economically. Born of humble parentage in the Danubian province of Moesia Inferior during the reign of Caracalla (circa AD 214/15) Lucius Domitius Aurelianus, like many of fellow-countrymen, adopted a military career. He proved himself to be a brilliant cavalry commander and achieved high rank under Gallienus, though he was prominent in the plot which led to that emperor's assassination in AD 268. Under Claudius II (who was also from the Danubian region) Aurelian held the office of Master of the Horse and he distinguished himself in the war against the Gothic invaders. At the time of Claudius' death by plague in the summer of AD 270 Aurelian was engaged in completing operations against the Goths in the Balkans. Initially, he did not oppose Quintillus' succession and its subsequent endorsement by the Senate, but when his troops proclaimed him emperor in mid-October he quickly moved against his rival. The rumour was spread that on his deathbed Claudius had actually nominated him as his successor, a story which could well have been true given Aurelian's friendship with the emperor and his accomplishments and popularity with the army. Military support for Quintillus' cause quickly melted away and the unfortunate brother of Claudius committed suicide in late October or November. Aurelian's position was now uncontested. His ambition was nothing less than to reunite the Empire by disposing of the separatist Gallic and Palmyrene states, but first he had to confront and defeat the Alamanni and Juthungi who had succeeded in penetrating into Italy and threatening the capital itself. Having accomplished this he set about building a massive defensive wall around Rome, much of which still survives to the present day. Now free to pursue his plans of imperial reunification Aurelian set out for the East (early AD 272). Although he had recognized and granted titles to the Palmyrene rulers Vabalathus and his mother Zenobia at the beginning of his reign Aurelian was now ready to destroy their power. This he accomplished with remarkable speed during the course of the year, finally taking his eastern rivals prisoner when he besieged them in their capital city of Palmyra. Their lives were spared to adorn his triumph in Rome. Meanwhile his general, the future emperor Probus, reconquered the province of Egypt which had also been under Palmyrene control. After further military operations on the Danube in 273 the emperor began preparations for his attack on the Gallic Empire of Tetricus, a campaign which culminated in a pitched battle fought at Châlons-sur-Marne in northern France in the spring of the following year. With the collapse of the independent Gallic power, which had endured for almost 14 years since the rebellion of Postumus against Gallienus, the Empire of Rome was finally reunited.

Aurelian celebrated a magnificent triumph in his capital, the procession featuring his captured eastern and western rivals as its chief ornaments, and then he began preparations for the fulfillment of his final ambition, the conquest of the Persian Empire of the Sasanids. However, he only got as far as the Thracian city of Caenophrurium before falling victim to a conspiracy of his officers who mistakenly believed that they were under sentence of execution, a story invented by the emperor's secretary Eros to prevent his own impending punishment. Rome thus lost, under the most tragic circumstances, one of her greatest military leaders of all time after a remarkable reign of just 5 years.

Despite his preoccupation with military affairs, in AD 274 Aurelian found time to undertake an important reform of the coinage which, under his immediate predecessors, had suffered a catastrophic decline. Three years earlier his eradication of abuses in the practices of the Rome mint had led to a revolt of the moneyers which seems to have brought about the temporary closure of the facility. Between 271 and 274 an interim improvement in the quality of the billon coinage saw a small increase in the average weight of the coins and an insistence on the employment of higher standards in their production. Finally, the full reform of AD 274 saw an increase in the average weight of the antoninianus to about 3.85 grams and an improvement in its silver content to 4.5%. The reformed denomination also normally bore the mark of value XXI (or KA in Greek numerals at some mints) which is usually taken to mean that the coin was worth 1/20th of its equivalent weight in pure silver. Some scholars have preferred to assign the somewhat awkward name of 'aurelianianus' (or 'aurelianus') to the reformed antoninianus. However, there seems no pressing need to depart from the traditional nomenclature simply because Aurelian had enacted a much-needed reform of a long-established denomination which had undergone a series of debasements over the preceding decades. Other denominations featured in Aurelian's reformed coinage of AD 274–5 were a smaller billon piece with laureate portrait, probably a denarius; a laureate bronze coin, usually regarded as a sestertius of reduced weight; and a larger radiate bronze, probably a reduced double sestertius.

With the restoration of the Empire to its full territorial extent the system of mints was inevitably expanded by Aurelian. In Italy Rome was initially augmented by Milan, but in 274 the mint establishment was transferred to nearby Ticinum. With the conquest of the Gallic Empire in the same year the rebel mints of Cologne and Mainz (or Trier) were closed and were replaced by Lugdunum, which had not been active since the rebellion of Clodius Albinus eight decades before. In the militarily important region of the Balkans the products of Siscia were augmented by a new establishment at Serdica, noted for its idiosyncratic obverse legends, and also by a mint the precise location of which has yet to be determined. Cyzicus continued to be active in Asia Minor while Antioch, liberated from Palmyrene control in 272, resumed its role as the major producer of currency in the eastern Mediterranean area. It was assisted by a new mint opened by Aurelian about 273 and attributed to the Phoenician city of Tripolis.

In addition to coinage in his own name Aurelian struck extensive issues for his wife Ulpia Severina following her elevation to the rank of Augusta in AD 274. The numismatic evidence clearly indicates that her coinage continued for some time after the death of her husband, prior to the commencement of issues in the name of his successor Tacitus, but the idea of a lengthy 'interregnum' following Aurelian's assassination now seems to be discredited.

The following are the principal forms of obverse legend, other varieties being given in full:

A. AVRELIANVS AVG
B. IMP AVRELIANVS AVG
C. IMP C AVRELIANVS AVG
D. IMP C D AVRELIANVS AVG
E. IMP C DOM AVRELIANVS AVG
F. IMP C L DOM AVRELIANVS AVG
G. IMP C L DOM AVRELIANVS P F AVG

The normal obverse type for antoniniani is radiate bust of Aurelian right, draped and cuirassed or more frequently cuirassed only. More unusual types are described in full as are the obverses of all other denominations.

11467 **Gold binio or double aureus.** G, rad. and cuir. bust r. Rev. **ADVENTVS AVG**, Aurelian on horseback pacing l., his r. hand raised, holding spear in l. Cf. RIC 9. CBN 419. MIR 53e. Calicó —. C 2. Cf. Hunter 1. *[Milan, AD 272]*. **VF** £3,300 ($5,000) / **EF** £8,000 ($12,000)

NB Although averaging only 8–8.5 grams, it seems clear that these coins were intended to circulate as double aurei.

11468 **Gold aureus.** F, rad. and cuir. bust r. Rev. **APOLLINI CONS**, Apollo seated l., holding laurel-branch and resting l. arm on lyre. RIC 162. CBN —. MIR 188. Cf. Calicó 3975. Cf. C 11. Hunter, p. cxii. *[Siscia, AD 272]*. **VF** £2,000 ($3,000) / **EF** £5,000 ($7,500)

NB The pre-reform aurei were struck on a standard of 1/60th of a pound (about 5.4 grams) whereas the post-reform issues of AD 274–5 employed a higher standard of 1/50th of a pound (about 6.5 grams). However, individual specimens may fluctuate considerably above and below these levels. The emperor's portrait on this denomination may be either laureate or radiate.

11469 Similar, but with rev. type Apollo stg. l., r. hand on hd., l. holding olive-branch and resting on garlanded column. RIC 161. CBN —. MIR 187. Calicó 3977. Cf. C 13. Hunter, p. cxii. *[Siscia, AD 272]*. **VF** £2,000 ($3,000) / **EF** £5,000 ($7,500)

11470 F, laur., dr. and cuir. bust r. Rev. **CONCORD LEGI**, Concordia Militum stg. l., holding standard in each hand, two additional standards on either side. RIC 10. CBN —. Cf. MIR 31. Calicó 3978. C 21. Hunter, p. cvii. *[Rome, AD 272–3]*. **VF** £1,000 ($1,500) / **EF** £3,000 ($4,500)

11471 C, laur. and cuir. bust r. Rev. **CONCORDI LEGI**, similar, but without the two additional standards. RIC 169. CBN 675. MIR 169h. Cf. Calicó 3980. Cf. C 27. Hunter, p. cxii. *[Siscia, AD 270–71]*. **VF** £1,000 ($1,500) / **EF** £3,000 ($4,500)

11472 Obv. As 11468. Rev. Rev. **CONCORDIA AVG**, Concordia seated l., holding patera and double cornucopiae. RIC 164. CBN —. MIR 201. Calicó 3982. C 31 var. Hunter, p. cxii. *[Siscia, AD 272]*. **VF** £1,500 ($2,250) / **EF** £4,000 ($6,000)

11473

11473 C, laur., dr. and cuir. bust r. Rev. **CONCORDIA MILI**, Concordia Militum seated l., holding standard in each hand. Cf. RIC 166. CBN 343. MIR 9d. Cf. Calicó 3985. C 41. Hunter, p. cx. *[Milan, AD 270]*. **VF** £800 ($1,200) / **EF** £2,300 ($3,500)

11474 — — Rev. — two Concordiae stg. facing each other, holding standard between them, each holding an additional standard in the other hand. Cf. RIC 167. CBN —. MIR 18d. Cf. Calicó 3989. C 49. Hunter —. *[Milan, AD 270–71]*. **VF** £900 ($1,350) / **EF** £2,700 ($4,000)

11475 — — Rev. **DACIA FELIX**, Dacia stg. l., holding Dacian standard surmounted by wolf's hd. (*draco*), officina mark **S** (= 2) in ex. RIC —. CBN —. MIR 17d. Calicó 3997a. C —. Hunter —. *[Milan, AD 270–71]*. **VF** £2,700 ($4,000) / **EF** £6,700 ($10,000)

The staff held by the personification of the province of Dacia has traditionally been described as "surmounted by ass's head". I am indebted to Mr. Alexandru Marian of Romania for the correct identification of the 'draco', the Dacian battle standard which was decorated with a wolf's head and the tail of a 'dragon' (see also no. 11528).

11476 **Gold aureus.** D, laur., dr. and cuir. bust r. Rev. FIDES MILI, Fides Militum stg. l., holding standard in each hand. Cf. RIC 89. CBN 672. MIR 168o. Cf. Calicó 3999. C 79. Cf. Hunter, p. cx. *[Siscia, AD 270–71].* **VF** £800 ($1,200) / **EF** £2,300 ($3,500)

11477 E, laur. and cuir. bust r. Rev. FIDES MILIT, similar, but with officina mark S (= 2) in ex. RIC 91. CBN —. MIR 15. Calicó 4000. C 81. Hunter, p. cx. *[Milan, AD 270–71].* **VF** £900 ($1,350) / **EF** £2,700 ($4,000)

11478 Obv. As 11471. Rev. FIDES MILITVM, as 11476. Cf. RIC 93. CBN —. MIR 167. Cf. Calicó 4002. C 84. Cf. Hunter, p. cx. *[Siscia, AD 271].* **VF** £800 ($1,200) / **EF** £2,300 ($3,500)

11479 11481

11479 B, rad., dr. and cuir. bust r. Rev. FORTVNA REDVX, Fortuna seated l., holding rudder and cornucopiae, wheel beneath seat, officina mark P (= 1) and star in ex. RIC 171. CBN —. MIR 211e. Calicó 4007. C 94 var. Hunter 69 var. *[Siscia, AD 272].* **VF** £1,500 ($2,250) / **EF** £4,000 ($6,000)

11480 Obv. As 11468. Rev. GENIVS ILLVR, Genius of Illyricum stg. l., holding patera and cornucopiae, standard behind. RIC 172. CBN —. MIR 179. Calicó 4009. C 101. Hunter, p. cxii. *[Siscia, AD 271].* **VF** £2,300 ($3,500) / **EF** £6,000 ($9,000)

11481 Obv. As 11473. Rev. MARTI PACI (or PACIFERO), Mars, in military attire, stg. l., holding olive-branch and transverse spear, sometimes with officina mark P (= 1) in ex. RIC —. CBN —. MIR 12–13. Calicó 4013–14. C —. Hunter, p. cx. *[Milan, AD 270–71].* **VF** £1,200 ($1,800) / **EF** £3,300 ($5,000)

11482 C, rad. and cuir. bust r. Rev. ORIENS AVG, Sol stg. facing, hd. l., his r. hand raised, holding globe in l., I L in ex. RIC 18 = 188. CBN 887. MIR 218. Calicó 4015. C 138. Hunter, p. cxii. *[Siscia, AD 274].* **VF** £2,000 ($3,000) / **EF** £5,000 ($7,500)
I L is a mark of value indicating that the coin represents 1/50th of a pound of gold. The obverse is struck from an antoninianus die.

11483 — — Rev. — Sol advancing l. between two seated captives, his r. hand raised, holding globe in l. RIC —. CBN 572. MIR 69. Calicó —. Cf. C 152. Hunter —. *[Ticinum, AD 274].* **VF** £2,000 ($3,000) / **EF** £5,000 ($7,500)
Struck with antoninianus dies.

11484 Obv. As 11476. Rev. PANNONIAE, Pannonia stg. facing, hd. r., her r. hand raised, holding transverse standard in l. RIC —. CBN —. MIR 22. Calicó —. C —. Hunter —. *[Milan, AD 270–71].* **VF** £2,700 ($4,000) / **EF** £6,700 ($10,000)

11485 **Gold aureus.** Obv. As 11468. Rev. P M TR P COS, Apollo seated l., holding laurel-branch and resting l. arm on lyre. RIC 157. CBN —. MIR 189. Calicó 4018. C 172. Hunter, p. cxi. *[Siscia, AD 272]*. **VF** £2,000 ($3,000) / **EF** £5,000 ($7,500)

11486 A, laur. and cuir. bust r. Rev. P M TR P COS P P, rad. lion springing l., holding thunderbolt in jaws. Cf. RIC 159. CBN —. MIR 129A. Cf. Calicó 4022. C —. Hunter, p. cxi. *[Rome, AD 274–5]*. **VF** £2,300 ($3,500) / **EF** £6,000 ($9,000)
This type and the next were inspired by the coinage of Caracalla issued sixty years before (see Volume II, nos. 6719 and 6726).

11487 G, laur. and cuir. bust r. Rev. — similar, but with star beneath the lion which is sometimes walking instead of springing. Cf. RIC 158. CBN —. MIR 129B-C. Cf. Calicó 4019–20. C 173–4. Hunter, p. cxi. *[Rome, AD 274–5]*. **VF** £2,300 ($3,500) / **EF** £6,000 ($9,000)

11488 Obv. As 11473. Rev. P M TB (*sic*) P VI COS II P P, Mars, naked, advancing r., carrying spear and trophy over shoulder. RIC —. CBN —. MIR 384. Calicó —. C —. Hunter —. *[Tripolis, AD 274]*. **VF** £1,200 ($1,800) / **EF** £3,300 ($5,000)

11489 — Rev. P M TB (*sic*) P VII COS II P P, as previous. Cf. RIC 16 = 186. CBN 618. MIR 77. Cf. Calicó 4024. C 179. Cf. Hunter, p. cxii. *[Ticinum, AD 274]*.
 VF £1,200 ($1,800) / **EF** £3,300 ($5,000)

11490 — Rev. PROVIDEN DEOR, Fides Militum stg. r., holding standard in each hand, facing rad. Sol stg. l., his r. hand raised, holding globe in l. Cf. RIC 19 = 189. CBN —. MIR 78a. Cf. Calicó 4025. C —. Cf. Hunter, p. cxii. *[Ticinum, AD 274]*.
 VF £1,200 ($1,800) / **EF** £3,300 ($5,000)

11491 Obv. As 11482. Rev. RESTITVTOR ORIENTIS, Sol advancing l. between two seated captives, his r. hand raised, holding whip in l. RIC —. CBN —. MIR 372. Calicó —. C —. Hunter —. *[Antioch, AD 273]*. **VF** £2,300 ($3,500) / **EF** £5,700 ($8,500)
This and the following two types refer to the defeat of the Palmyrene Empire and the restoration of the eastern provinces to Roman rule in AD 272. (see also nos. 11595–6 and 11601–2).

11492 Obv. As 11471. Rev. — Sol stg. facing, hd. l., his r. hand raised, holding globe in l. RIC 374. CBN 1362 (attributed to Tripolis). MIR 364c. Calicó 4026. C 214. Hunter 109. *[Antioch, AD 273]*. **VF** £900 ($1,350) / **EF** £2,700 ($4,000)

11493 Obv. As 11486. Rev. — Aurelian, in military attire, on horseback galloping r., thrusting spear at two enemies on ground. RIC —. CBN —. MIR 365. Calicó 4031. C —. Hunter —. *[Antioch, AD 273]*. **VF** £2,300 ($3,500) / **EF** £6,000 ($9,000)

11494 Obv. As 11470. Rev. VICTORIA AVG, Victory advancing r., holding wreath and palm. Cf. RIC 12. CBN 385. MIR 38. Cf. Calicó 4036. C 245. Cf. Hunter, p. cviii. *[Milan, AD 271]*.
 VF £900 ($1,350) / **EF** £2,700 ($4,000)

11495 B, laur., dr. and cuir. bust r. Rev. — similar, but with officina mark P (= 1) in l. field and star in r. RIC 177 var. (bust cuir. l.). CBN —. MIR 203. Calicó 4038 var. C 246 var. Hunter, p. cxii. *[Siscia, AD 272]*. **VF** £900 ($1,350) / **EF** £2,700 ($4,000)

11496 C, laur. and cuir. bust l. Rev. — as 11494. RIC 323, 376. CBN 1364 (attributed to Tripolis). MIR 362. Calicó 4033. C 244. Hunter, p. cxvi. *[Antioch, AD 273]*.
 VF £1,200 ($1,800) / **EF** £3,300 ($5,000)

11497 **Gold aureus.** B, laur. and cuir. bust r. Rev. — Victory advancing l., holding wreath and
 palm, seated captive at feet. Cf. RIC 96. CBN —. MIR 126g. Cf. Calicó 4042. Cf. C 252.
 Cf. Hunter, p. cx. *[Rome, AD 274–5].* **VF** £900 ($1,350) / **EF** £2,700 ($4,000)

 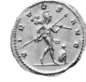

 11498 11499

11498 Obv. As 11487. Rev. VIRTVS AVG, Mars, naked, advancing r., carrying transverse spear
 and trophy, captive at feet. RIC 15, 182. CBN 424 (attributed to Milan). MIR 127q. Calicó
 4048. C 269 var. Cf. Hunter, pp. cviii, cxii. *[Rome, AD 274–5].*
 VF £800 ($1,200) / **EF** £2,300 ($3,500)

11499 Obv. As 11497. Rev. — similar, but without captive. Cf. RIC 1, 181. CBN 83. MIR 128.
 Cf. Calicó 4043. C 262 var. Cf. Hunter, pp. cx, cxi. *[Rome, AD 274–5].*
 VF £800 ($1,200) / **EF** £2,300 ($3,500)

11500 Obv. As 11476. Rev. — trophy, with two captives seated l. and r. at base. RIC —. CBN —.
 MIR 165. Calicó 4053. C —. Hunter —. *[Siscia, AD 271].*
 VF £2,300 ($3,500) / **EF** £5,700 ($8,500)

11501 — Rev. — Aurelian galloping, as 11493, but only one enemy below horse. RIC —. CBN
 —. MIR 166. Calicó —. C —. Hunter —. *[Siscia, AD 271].*
 VF £2,300 ($3,500) / **EF** £6,000 ($9,000)

11502 Obv. As 11473. Rev. VIRTVS AVGVSTI, Mars, in military attire, advancing r., carrying
 transverse spear and trophy. Cf. RIC 98. CBN —. MIR 163. Cf. Calicó 4056. C —. Cf.
 Hunter, p. cxi. *[Siscia, AD 271].* **VF** £900 ($1,350) / **EF** £2,700 ($4,000)

11503 — Rev. —trophy and captives, as 11500, but the captive on l. turns his hd. to r. Cf. RIC 99.
 CBN 674. MIR 164f. Calicó 4054. C 278. Cf. Hunter, p cxi. *[Siscia, AD 271].*
 VF £2,000 ($3,000) / **EF** £5,300 ($8,000)

11504 — Rev. VIRTVS EQVIT, Aurelian on horseback pacing l., his r. hand raised, holding sceptre
 in l. Cf. RIC 100 (rev. misdescribed after Cohen). CBN 342. MIR 28. Cf. Calicó 4057. Cf.
 C 279. Cf. Hunter, p. cx. *[Milan, AD 271].* **VF** £1,500 ($2,250) / **EF** £4,000 ($6,000)

11505 Obv. As 11486. Rev. VIRTVS ILLVRICI, Mars and captive, as 11498. RIC 380. CBN 1366
 (attributed to Tripolis). MIR 363i. Calicó 4061. Cf. C 280. Hunter, p. cxvi. *[Antioch,
 AD 273].* **VF** £1,200 ($1,800) / **EF** £3,300 ($5,000)

 NB a 5- or 6-aureus piece (29.80 grams) of the Milan mint (AD 270–71) has also been
 recorded: obv. E, laureate, draped and cuirassed bust left, holding spear and shield with
 Medusa head; rev. MARTI PACIFERO, Mars, in military attire, standing left, holding olive-
 branch and transverse spear (MIR 11, citing specimen in Celje, Slovenia).

11506 **Billon antoninianus.** B. Rev. ADVENTVS AVG, Aurelian on horeback galloping r.,
 thrusting spear at two enemies on ground, sometimes with officina mark Δ or Q (= 4) in
 ex. RIC 42. CBN 64, 66, 69. MIR 108. C 4. Hunter 4. *[Rome, AD 273].*
 VF £22 ($35) / **EF** £55 ($85)

NB During the course of this reign the antoninianus underwent a series of upgrades aimed at improving both the silver content and the appearance of the discredited denomination. The first step in this process was the enactment of a 'proto-reform' in AD 271, the year which saw the revolt of the moneyers in the capital brought about by the emperor's purge of corrupt mint officials. The measures taken on this occasion were brought to completion in 274 when the new mark XXI (or KA) was introduced (probably denoting a 5% silver content) and the weight of the coin was increased to an average of 3.85 grams.

11507 **Billon antoninianus.** F. Rev. **AETERNIT AVG**, Sol stg. l., raising r. hand and holding globe in l., officina mark **N** (= 9) in field or in ex. RIC 20. CBN 42, 44. MIR 94. C 5. Hunter 2. *[Rome, AD 270–71].* **VF** £10 ($15) / **EF** £25 ($40)

11508 B (one or two dots below bust). Rev. **AETERNITAS AVG**, She-wolf stg. r., suckling the twins Romulus and Remus. RIC 326. CBN 1096. MIR 303. C 7. Hunter, p. cxv. *[Cyzicus, AD 271].* **VF** £20 ($30) / **EF** £50 ($75)

11509 D. Rev. **ANNONA AVG**, Annona stg. l., holding corn-ears and cornucopiae, prow at feet, officina mark **P** (= 1) in field. RIC 190. CBN —. MIR 156. C —. Cf. Hunter, p. cxii. *[Siscia, AD 270].* **VF** £20 ($30) / **EF** £50 ($75)

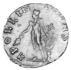

11510

11510 F. Rev. **APOLLINI CONS**, Apollo stg. l., holding laurel-branch and resting on lyre set on rock, officina mark **H** (= 8) in field or in ex. RIC 22. CBN 40. MIR 93a. C 14. Hunter, p. cvii. *[Rome, AD 270–71].* **VF** £10 ($15) / **EF** £25 ($40)

11511 B. Rev. **CONCO EXER**, Concordia Militum stg. l., holding standard and cornucopiae, officina mark **T** (=3) in ex. RIC 101. CBN 368 MIR 21. C 19. Hunter, p. cx. *[Milan, AD 270–71].* **VF** £10 ($15) / **EF** £25 ($40)

11512 B. Rev. **CONCORD LEGI**, Concordia Militum stg. l., holding standard in each hand, officina mark **P**, **S**, or **T** (= 1, 2, or 3) in ex. RIC 102. CBN 387. MIR 30. C 22. Hunter 35. *[Milan, AD 271].* **VF** £12 ($18) / **EF** £30 ($45)

11513 Similar, but sometimes **CONCORDI** for **CONCORD** and there are two additional standards, one on each side. RIC 103–4. CBN 378. MIR 32–3. C 28. Hunter 36–7. *[Milan, AD 271].* **VF** £12 ($18) / **EF** £30 ($45)

11514 B. Rev. **CONCORD MILIT**, Aurelian, in military attire, stg. r., holding short sceptre and receiving globe from Jupiter stg. l., holding sceptre, mint mark **C** between two stars in ex. RIC 342. CBN 1157. MIR 322. C 23. Hunter, p. cxv. *[Cyzicus, AD 272].* **VF** £12 ($18) / **EF** £30 ($45)

11515 B. Rev. — Aurelian, togate, stg. r., holding short sceptre, clasping r. hands with Concordia stg. l., officina mark **Γ** (= 3) in ex. RIC 391. CBN 987. MIR 276a-d. C 25. Cf. Hunter, p. cxvii. *[Uncertain Balkan mint, AD 272].* **VF** £12 ($18) / **EF** £30 ($45)

11516 **Billon antoninianus.** B. Rev. CONCORDIA AVG, similar, but emperor not holding sceptre, officina mark S (= 2) in ex. RIC 119. CBN 393. MIR 47. C 37. Hunter 38. *[Milan, AD 272]*.
VF £12 ($18) / **EF** £30 ($45)

11517 B. Rev. — Concordia seated l., holding patera and double cornucopiae, officina mark P, S, T, or Q (= 1, 2, 3, or 4) preceded by star in ex. RIC 213. CBN 734. MIR 2021. C 32. Hunter, p. cxiii. *[Milan, AD 272]*.
VF £12 ($18) / **EF** £30 ($45)

11518 C. Rev. CONCORDIA MILI, Concordia Militum with two standards, as 11512, officina mark P, S, T, or Q (= 1, 2, 3, or 4) in field or in ex. Cf. RIC 192. CBN 682, 690, 693, 701. MIR 174. C —. Cf. Hunter, p. cxii. *[Siscia, AD 271]*.
VF £10 ($15) / **EF** £25 ($40)

11519 C. Rev. — Concordia Militum with four standards, as 11513, officina mark T (= 3) in ex. RIC —. CBN —. MIR 173. C —.Hunter —. *[Siscia, AD 271]*.
VF £20 ($30) / **EF** £50 ($75)

11520 B. Rev. — Concordia Militum seated l., holding standard in each hand, officina mark P, S, or T (= 1, 2, or 3) in ex. RIC 106. CBN 373. MIR 34. C 44. Hunter, p. cx. *[Milan, AD 271]*.
VF £10 ($15) / **EF** £25 ($40)

11521 C. Rev. — two Concordiae stg. facing each other, holding standard between them, each holding an additional standard in the other hand, officina mark P, S, T, or Q (= 1, 2, 3, or 4) in ex. RIC 199. CBN 680, 681, 688, 700. MIR 176d, g. C 52. Hunter, p. cxii. *[Siscia, AD 271]*.
VF £12 ($18) / **EF** £30 ($45)

11522 B. Rev. CONCORDIA MILITVM, Aurelian, togate, stg. r., clasping r. hands with Concordia stg. l., officina mark S (= 2) in ex. RIC 120. CBN 455. MIR 48. C 61. Hunter 39. *[Milan, AD 272]*.
VF £12 ($18) / **EF** £30 ($45)

NB This reverse type was issued from at least five mints employing different mint marks, both in the pre- and post-reform periods.

11523

11523 C. Rev. — similar, but with XXI followed by officina mark P-VI (= 1–6) in ex. RIC 244. CBN 892, 901, 907, 911, 917, 926. MIR 229. Cf. C 60. Hunter 85–9. *[Siscia, AD 274]*.
VF £15 ($22) / **EF** £38 ($55)

11524 D. Rev. CONSERVATOR AVG, Aesculapius stg. facing, hd. l., holding snake-entwined staff, mint mark SERD in ex. RIC 258. CBN —. MIR 240e, f. C 71. Hunter, p. cxiv. *[Serdica, AD 272]*.
VF £40 ($60) / **EF** £100 ($150)
An early example of an explicit mint mark.

11525 C. Rev. CONSERVAT AVG, Sol stg. l., r. hand raised and holding globe in l., his r. foot set on captive seated l. on ground, officina mark A, B, Γ, Δ, ε, or S (= 1, 2, 3, 4, 5, or 6) in ex. RIC 384. CBN 1268–75. MIR 374. C 68. Hunter 110. *[Antioch, AD 273]*.
VF £12 ($18) / **EF** £30 ($45)

11526 **Billon antoninianus.** Similar, but with rev. type Sol advancing r. on prostrate captive r., holding short sceptre or parazonium and globe, **XXI** below, officina marks as previous, but in field. RIC 383. CBN 1304–6. MIR 379. C 66. Hunter, p. cxvi. *[Antioch, AD 274].*
VF £20 ($30) / **EF** £50 ($75)

11527 B. Rev. **CONS PRINC AVG**, Aurelian, in military attire, stg. facing, hd. l., crowning trophy at foot of which two captives are seated, and holding sceptre in l. RIC 3. CBN —. MIR 368f. C 72 var. Hunter, p. cx. *[Antioch, AD 273].* **VF** £65 ($100) / **EF** £170 ($250)

11528 B. Rev. **DACIA FELIX**, Dacia stg. l., holding Dacian standard surmounted by wolf's hd. (*draco*), officina mark **S** (= 2) in ex. RIC 108. CBN 361. MIR 17A. C 73. Hunter 40. *[Milan, AD 270–71].* **VF** £20 ($30) / **EF** £50 ($75)
See note following no. 11475.

11529 B. Rev. **FELIC SAECV** (or **SAECVLI**), Felicitas stg. l., sacrificing over altar and holding long caduceus, officina mark **S** or **T** (= 2 or 3) in ex. RIC 121–2. CBN 395. MIR 36–7. C 75. Hunter 41. *[Milan, AD 271].* **VF** £10 ($15) / **EF** £25 ($40)

11530 E (three dots below bust). Rev. **FELICIT TEMP**, Felicitas stg. l., holding long caduceus and cornucopiae. RIC 327. CBN 1089. MIR 293e. C 77. Hunter —. *[Cyzicus, AD 270–71].*
VF £12 ($18) / **EF** £30 ($45)

11531 B. Rev. **FIDES EXERCITI**, Mars, naked, advancing r., carrying spear and trophy. RIC 393. CBN 956–7. MIR 269. C 78. Hunter —. *[Uncertain Balkan mint, AD 271].*
VF £12 ($18) / **EF** £30 ($45)

11532 B. Rev. **FIDES MILIT**, Fides Militum stg. l., holding standard in each hand, officina mark **S** (= 2) in ex. RIC 109. CBN 365. MIR 16. C 82. Hunter, p. cx. *[Milan, AD 270–71].*
VF £10 ($15) / **EF** £25 ($40)

11533 F. Rev. **FIDES MILITVM**, similar, but holding standard and sceptre, officina mark ε (= 5) in field). RIC 28. CBN —. MIR 90. C —. Hunter, p. cvii. *[Rome, AD 270–71].*
VF £12 ($18) / **EF** £30 ($45)

11534 E (two dots below bust). Rev. — similar, but holding standard and transverse sceptre, no officina mark. RIC 328. CBN 1072. MIR 292e. C 86. Cf. Hunter 120. *[Cyzicus, AD 270–71].* **VF** £12 ($18) / **EF** £30 ($45)

11535 Similar, but with obv. type rad., dr. and cuir. bust l. RIC 328. CBN 1081. MIR 292f. Cf. C 87. Cf. Hunter, p. cxvii. *[Cyzicus, AD 270–71].* **VF** £22 ($35) / **EF** £60 ($90)

11536 B. Rev. Rev. — Aurelian, in military attire, stg. r., holding short sceptre and receiving globe from Jupiter stg. l., holding sceptre, mint mark **C** preceded or followed by star in ex. RIC 344. CBN 1154–5. MIR 319. C 92. Hunter, p. cxv. *[Cyzicus, AD 272].*
VF £12 ($18) / **EF** £30 ($45)

11537 B. Rev. — (sometimes **FIDIS** for **FIDES**), Aurelian, in military attire, stg. l. between two standards, touching the one on l. and holding sceptre in l., sometimes with officina mark **IV** (= 6?) in ex. Cf. RIC 46. CBN 67 var. MIR 103A, B. Cf. C 91. Hunter 5. *[Rome, AD 272].*
VF £15 ($22) / **EF** £38 ($55)

11538 F. Rev. **FORTVNA REDVX**, Fortuna stg. l., holding rudder and cornucopiae, officina mark **Z** (= 7) in field. RIC 29. CBN 37. MIR 92. C 97. Hunter, p. cvii. *[Rome, AD 270–71].*
VF £10 ($15) / **EF** £25 ($40)

11539 **Billon antoninianus.** B. Rev. — similar, but Fortuna seated l. with wheel below seat, officina mark P , S, T, or Q (= 1, 2, 3, or 4) in ex. RIC 128. CBN 436, 452, 469, 477. MIR 16. C 82. Hunter, p. cx. *[Milan, AD 270–71].* **VF** £10 ($15) / **EF** £25 ($40)

11540 B. Rev. GENIVS EXERCITI, Genius of the Army stg. l., holding patera and cornucopiae, standard behind. RIC 345. CBN 1113. MIR 315. C 100. Cf. Hunter 121. *[Cyzicus, AD 271].*
 VF £10 ($15) / **EF** £25 ($40)

 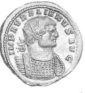

11541 11542

11541 B. Rev. GENIVS ILLVR, Genius of Illyricum stg. l., holding patera and cornucopiae, standard behind, officina mark P, S, T, or Q (= 1, 2, 3, or 4) in field or in ex., sometimes accompanied by star in field or in ex. RIC 223. CBN 714–22. MIR 181a-g, n-o, 182. C 103. Hunter, p. cxiii. *[Siscia, AD 271].* **VF** £16 ($25) / **EF** £45 ($65)

11542 B. Rev. IOVI CONSER, Aurelian receiving globe from Jupiter, as 11536, officina mark P or S (= 1 or 2) in ex. RIC 260. CBN 1001, 1005. MIR 243m. C 105. Hunter —. *[Serdica, AD 272].* **VF** £12 ($18) / **EF** £30 ($45)

11543 Similar, but on rev. Aurelian holds long sceptre, officina mark A or B (= 1 or 2) in ex. Cf. RIC 48. CBN 61, 63. MIR 112c. C 105. Hunter 6. *[Rome, AD 272].*
 VF £12 ($18) / **EF** £30 ($45)

11544 G. Rev. — Jupiter stg. r., resting on spear and receiving globe from Sol stg. l., holding whip and resting r. foot on seated captive, XXI followed by officina mark T (= 3) in ex. Cf. RIC 275 var. CBN —. MIR 253. C —. Hunter —. *[Serdica, AD 274].*
 VF £12 ($18) / **EF** £30 ($45)

11545 E (one or two dots below bust). Rev. IOVI CONSERVATORI, Jupiter stg. l., holding thunderbolt and sceptre. RIC —. CBN —. MIR 297. C —. Hunter —. *[Cyzicus, AD 270–71].* **VF** £20 ($30) / **EF** £50 ($75)

11546 B. Rev. — Aurelian receiving globe from Jupiter, as 11536, officina mark P (= 1) in ex. Cf. RIC 131. CBN 441. MIR 45. Cf. C 113. Cf. Hunter, p. cx. *[Milan, AD 272].*
 VF £12 ($18) / **EF** £30 ($45)

11547 B. Rev. — female figure stg. r., presenting wreath to Aurelian, in military attire, stg. l., his r. hand extended, holding sceptre in l., officina mark P (= 1) in ex. RIC —. CBN —. MIR 46. C —. Hunter —. *[Milan, AD 272].* **VF** £20 ($30) / **EF** £50 ($75)

11548 B. Rev. IOVI STATORI, Jupiter stg., as 11545, officina mark P or S (= 1 or 2) in ex. RIC 267 var. CBN 994 var. MIR 241g-i. C 115. Hunter, p. cxiv, note 2. *[Serdica, AD 272].*
 VF £15 ($22) / **EF** £38 ($55)

11549 B (one or two dots below bust). Rev. — Jupiter stg. facing, hd. l. (sometimes r.), resting on sceptre and holding thunderbolt. Cf. RIC 333. CBN 1112. MIR 306a-c. Cf. C 115. Cf. Hunter, p cxv. *[Cyzicus, AD 271].* **VF** £15 ($22) / **EF** £38 ($55)

11550 **Billon antoninianus.** Similar, but emperor's bust is to l. Cf. RIC 333. CBN —. MIR 306e.
C —. Hunter —. *[Cyzicus, AD 271].* **VF** £30 ($45) / **EF** £75 ($110)

11551 B. Rev. **IOVI VICTORI**, Jupiter stg. l., holding Victory and sceptre, eagle at feet, officina
mark **V** (= 5) in ex. RIC 49. CBN —. MIR 109. C 117. Hunter, p cviii. *[Rome, AD 272].*
 VF £15 ($22) / **EF** £38 ($55)

11552 F. Rev. **LAETITIA AVG**, Laetitia stg. l., holding wreath and anchor set on globe, officina
mark **XII** (= 12) in field or in ex. RIC 32. CBN 53, 55. MIR 97. C 118. Hunter, p cvii.
[Rome, AD 270–71]. **VF** £12 ($18) / **EF** £30 ($45)

11553 B. Rev. **LIBERALIT AVG**, Liberalitas stg. l., holding abacus and cornucopiae, star in left
field, officina mark **T** (= 3) in r. RIC 229. CBN —. MIR 209. C —. Hunter, p. cxiii.
[Siscia, AD 272]. **VF** £16 ($25) / **EF** £45 ($65)

11554 C. Rev. **LIBERITAS** (*sic*) **AVG**, Uberitas stg. l., holding cow's udder (?) and cornucopiae,
sometimes with officina mark **S** (= 2) in field. RIC 206. CBN 710. MIR 157. C 122.
Hunter, p. cxiii. *[Siscia, AD 270].* **VF** £15 ($22) / **EF** £38 ($55)

11555 B. Rev. **LIBERT AVG**, Libertas stg. l., holding pileus and sceptre. RIC 396. CBN 958. MIR
270a. C 119. Cf. Hunter, p. cxvii. *[Uncertain Balkan mint, AD 271].*
 VF £12 ($18) / **EF** £30 ($45)

11556 B. Rev. **MARS INVICTVS**, Mars, naked, stg. r., resting on spear and receiving globe from
Sol stg. l., holding whip, sometimes setting r. foot on seated captive at his feet, **XXI** in ex.,
sometimes with officina mark **A, B Γ, Δ**, or **ε** (= 1, 2, 3, 4, or 5) in field. RIC 357–8. CBN
1216, 1218. MIR 349–50. C 123–4. Hunter 102–3. *[Cyzicus, AD 274–5].*
 VF £22 ($35) / **EF** £60 ($90)

11557 B. Rev. **MARTI PACI**, Mars, in military attire, advancing l., holding olive-branch, spear and
shield, officina mark **P** (= 1) in ex. Cf. RIC 112, 133. CBN —. MIR 41. C 128. Hunter,
p. cx. *[Milan, AD 271].* **VF** £12 ($18) / **EF** £30 ($45)

11558 Similar, but Mars is stg. l., and without shield. RIC 133. CBN 358. MIR 14. Cf. C 129.
Hunter 43. *[Milan, AD 270–71].* **VF** £10 ($15) / **EF** £25 ($40)

11559 B. Rev. **MARTI PACIF**, as 11557, but Mars is sometimes stg. l., officina mark **Ω** (= 4) in ex.
RIC 133. CBN 415. MIR 42. C 130. Hunter, p. cx. *[Milan, AD 271].*
 VF £12 ($18) / **EF** £30 ($45)

11560 B (one dot below bust). Rev. **MINERVA AVG**, Minerva stg. l., resting on shield and holding
spear. RIC 334. CBN 1097. MIR 308a-c. C 137. Hunter, p. cxv. *[Cyzicus, AD 271].*
 VF £16 ($25) / **EF** £45 ($65)

11561 Similar, but with rev. type Minerva stg. r., holding spear and resting on shield. RIC 334.
CBN 1099. MIR 309. C 134 var. Hunter, p. cxv. *[Cyzicus, AD 271].*
 VF £16 ($25) / **EF** £45 ($65)

11562 B. Rev. **ORIENS AVG**, Sol stg. l., raising r. hand and holding globe in l. RIC 397. CBN 961.
MIR 271. C —. Hunter —. *[Uncertain Balkan mint, AD 271].*
 VF £16 ($25) / **EF** £45 ($65)

11563 Similar, but Sol holds whip instead of globe, star and officina mark **Ω** (= 4) in field. RIC
230. CBN —. MIR 210. C 157. Hunter, p. cxiii. *[Siscia, AD 272].*
 VF £16 ($25) / **EF** £45 ($65)

11564 **Billon antoninianus.** A. Rev. — Sol stg. facing, hd. l., raising r. hand and holding globe in l., captive seated l. at his feet, officina mark P, S, T, or Q (= 1, 2, 3, or 4) in ex. RIC 135. CBN 540–59. MIR 67. C 142. Hunter 47–8. *[Milan, AD 273].***VF** £12 ($18) / **EF** £30 ($45)

NB This reverse type was issued from at least five mints employing different mint marks, both in the pre- and post-reform periods.

11565 11569

11565 B. Rev. — similar, but the captive reclines r. at Sol's feet, his l. hand raised, officina mark P, S, T, Q, V, or VI (= 1, 2, 3, 4, 5, or 6) in ex. RIC —. CBN 70–80. MIR 115b, e. C 144. Hunter —. *[Rome, AD 273].* **VF** £16 ($25) / **EF** £45 ($65)

11566 C. Rev. — Sol advancing l., raising r. hand and holding globe in l., his r. foot on captive seated l., **XXI** in ex., sometimes with officina mark A, B Γ, Δ, or ε (= 1, 2, 3, 4, or 5) in field. RIC 360. CBN 1205. MIR 345. C 147. Hunter, p. cxvi. *[Cyzicus, AD 274–5].* **VF** £15 ($22) / **EF** £38 ($55)

11567 C. Rev. — Sol stg. r. on prostrate enemy, holding sword (?) and globe, officina mark P (= 1) below. RIC —. CBN —. MIR 250. C —. Hunter —. *[Serdica, AD 273].* **VF** £30 ($45) / **EF** £75 ($110)

11568 B. Rev. — Sol advancing r., treading down enemy and holding vexillum in r. hand and globe surmounted by crescent in l., **XXI** in ex., officina mark A, B Γ, Δ, ε, ς, or Z (= 1, 2, 3, 4, 5, 6, or 7) in field. Cf. RIC 65. CBN 163–70. MIR 125. Cf. C 160. Cf. Hunter, p. cix. *[Rome, AD 274].* **VF** £15 ($22) / **EF** £38 ($55)

11569 B. Rev. — similar, but Sol holds laurel-branch and bow, mint mark **XXI R** in ex., officina mark A, B Γ, Δ, ς, Z, H, star, or I (= 1, 2, 3, 4, 5, 6, 7, 8, 9, or 10) in field. RIC 64. CBN 188–217. MIR 130e-h. C 159. Hunter 23. *[Rome, AD 274–5].* **VF** £15 ($22) / **EF** £38 ($55) *The star in rev. field would appear to indicate the 9th officina.*

11570 Similar, but with obv. type rad. and cuir. bust r., wearing imperial mantle and holding eagle-tipped sceptre. RIC 64. CBN —. MIR 130m. C —. Hunter —. *[Rome, AD 274–5].* **VF** £100 ($150) / **EF** £230 ($350)

11571 B. Rev. — Sol stg. facing, hd. l., between two seated captives, raising r. hand and holding globe in l, mint mark **XXI R** preceded by officina mark A, B Δ, or ε (= 1, 2, 4, or 5) in ex. RIC 63. CBN 172, 177, 180. MIR 131. C 145. Hunter 22. *[Rome, AD 274–5].* **VF** £15 ($22) / **EF** £38 ($55)

11572 B. Rev. — Sol advancing l. between two captives, stepping on the one to l., raising r. hand and holding globe in l., **XXI** followed by officina mark P, S, or T (= 1, 2, or 3) in ex. Cf. RIC 279. CBN 1012, 1014, 1017. MIR 254a-d, h-n. Cf. C 154. Cf. Hunter, p. cxiv, note 1. *[Serdica, AD 274].* **VF** £15 ($22) / **EF** £38 ($55)

NB This reverse type was issued from at least six mints employing different mint marks, both in the pre- and post-reform periods.

11572

11573 **Billon antoninianus.** C. Rev. ORIENS AVG, similar, but Sol does not always step on the captive to l., and he holds whip instead of globe in l., star in field, officina mark S, T, V, or VI (= 2, 3, 5, or 6) in ex. RIC 255. CBN —. MIR 228. C 158. Hunter, p. cxiii. *[Siscia, AD 273]*.
VF £15 ($22) / EF £38 ($55)

11574 C. Rev. — Aurelian, in military attire, stg. r., resting on sceptre and receiving globe from Sol stg. l., holding whip in l. hand, sometimes with captive seated r. between them, officina mark Q, V, or VI (= 4, 5, or 6) in ex. Cf. RIC 282. CBN 849. MIR 216–17. C —. Hunter, p. cxiii. *[Siscia, AD 273]*.
VF £22 ($35) / EF £60 ($90)

11575 B or C. Rev. — similar, but with captive seated l. between the figures, Sol's r. foot usually on his back, XXI preceded or followed by officina mark P, S, or T (= 1, 2, or 3) in ex. Cf. RIC 283. CBN —. MIR 255d-n, w-x. C —. Cf. Hunter, p. cxiv, note 1. *[Serdica, AD 274]*.
VF £22 ($35) / EF £60 ($90)

11576 B. Rev. PACATOR ORBIS, Aurelian, in military attire, stg. l., sacrificing over tripod-altar and holding spear. RIC 4. CBN —. MIR 2. C 163. Hunter, p. cx. *[Trier or Lugdunum, AD 274]*.
VF £32 ($50) / EF £80 ($120)
Göbl (in MIR) considers that this initial issue after the defeat of Tetricus was made at Trier prior to the opening of the new Gallic mint of Lugdunum (see also no. 11626).

11576a C. Rev. — Sol advancing l., raising r. hand and holding whip in l., officina and mint marks A L or C L (= officina 1 or 3) sometimes associated with dots in ex. RIC 6. CBN 1–2, 6, 12. MIR 3, 5, 7. C 161. Hunter, p. cx. *[Lugdunum, AD 274–5]*. VF £16 ($25) / EF £45 ($65)

11577 B. Rev. PACATOR ORIENTIS, Aurelian, in military attire, stg. r., resting on spear and holding parazonium, his l. foot set on captive seated r. before him, officina mark T (= 3) in l. field, star in r. RIC 231. CBN —. MIR 192. C 164 var. Hunter, p. cxiii. *[Siscia, AD 272]*.
VF £55 ($80) / EF £130 ($200)

11578 B. Rev. PANNONIAE, Pannonia stg. facing, hd. r., her r. hand raised, holding transverse standard in l., officina mark T (= 3) in ex. Cf. RIC 113. CBN 375. MIR 22A. C 166. Hunter 44. *[Milan, AD 270–71]*. VF £20 ($30) / EF £50 ($75)

11579 B. Rev. PAX AETERNA, Pax stg. l., holding olive-branch and vertical sceptre. RIC 114. CBN —. MIR 26. C —. Hunter, p. cx. *[Milan, AD 270–71]*. VF £16 ($25) / EF £45 ($65)

11580 B. Rev. PAX AVGVSTI, similar, but sceptre is transverse. RIC 398. CBN 962. MIR 272. C 167. Hunter —. *[Uncertain Balkan mint, AD 271]*. VF £12 ($18) / EF £30 ($45)

11581 B. Rev. — similar, but Pax advancing l., star and officina mark P, S, T, or Q (= 1, 2, 3, or 4) in field or in ex. RIC 232. CBN 760, 761, 768. MIR 190. C 169. Hunter 81. *[Siscia, AD 272]*.
VF £10 ($15) / EF £25 ($40)

11582 B. Rev. — similar, but Pax seated l., star in field or in ex., officina mark P (= 1) in ex. RIC —. CBN —. MIR 191. C —. Hunter —. *[Siscia, AD 272]*. VF £20 ($30) / EF £50 ($75)

11583 **Billon antoninianus.** B. Rev. PIETAS AVG, Aurelian and Severina (or Pietas) stg. facing each other, each holding short sceptre and sacrificing from patera over altar between them, officina mark S (= 2) in ex. Cf. RIC 138. CBN 463. MIR 61. C 171. Hunter 51. *[Milan, AD 272]*. **VF** £16 ($25) / **EF** £45 ($65)

11584 B (one or two dots below bust). Rev. P M TR P P P COS, Neptune stg. l., r. foot on prow, holding dolphin and trident. RIC 324 var. CBN —. MIR 301. C 175 var. Hunter, p. cxv. *[Cyzicus, AD 271]*. **VF** £40 ($60) / **EF** £100 ($150)

11585 Similar, but Neptune's foot is set on rock instead of prow, and his r. hand rests on his r. leg and does not hold dolphin. RIC 324 var. CBN —. MIR 301A. C 175 var. Hunter, p. cxv, var. *[Cyzicus, AD 271]*. **VF** £40 ($60) / **EF** £100 ($150)

11586 Obv. Similar. Rev. P M TR PT P P COS, lion walking r. Cf. RIC 325. CBN 1095. MIR 302. C 176. Cf. Hunter, p. cxv. *[Cyzicus, AD 271]*. **VF** £40 ($60) / **EF** £100 ($150)

11587

11587 C. Rev. PROVIDEN DEOR, Fides Militum stg. r., holding standard in each hand, facing Sol stg. l., raising r. hand and holding globe in l., officina and mint marks P XX T, S XX T, T XX T, or Q XX T (= officina 1, 2, 3, or 4) in ex. RIC 152. CBN 620, 624, 631, 635. MIR 78Ac. C 183. Hunter 63. *[Ticinum, AD 274–5]*. **VF** £15 ($22) / **EF** £38 ($55)
The mint initial 'T' also serves as the 'I' of the mark of value 'XXI'.

11588 F. Rev. PROVIDENT AVG, Providentia stg. l., holding rod and sceptre, globe at feet, officina mark S (= 6) in field. RIC 36. CBN 34. MIR 91. C 189. Hunter, p. cviii. *[Rome, AD 270–71]*. **VF** £12 ($18) / **EF** £30 ($45)

11589 B (one dot below bust). Rev. — Mercury stg. l., holding purse and caduceus. RIC 336. CBN 1104. MIR 311a-c. C 185. Hunter, p. cxv. *[Cyzicus, AD 271]*. **VF** £22 ($35) / **EF** £55 ($85)

11590 B (one or two dots below bust). Rev. — Venus Victrix stg. l., holding helmet and transverse sceptre and resting l. arm on shield. RIC 335. CBN 1102. MIR 310a, b. C 186. Hunter, p. cxv. *[Cyzicus, AD 271]*. **VF** £22 ($35) / **EF** £55 ($85)

11591 B. Rev. RESTIT SAECVLI, female figure stg. r., holding wreath in raised r. hand, facing Aurelian, in military attire, stg. l., his r. hand extended, holding sceptre in l., star and officina mark S (= 2) in ex. Cf. RIC 235. CBN 777. MIR 198. C 191. Cf. Hunter, p. cxiii. *[Siscia, AD 272]*. **VF** £22 ($35) / **EF** £55 ($85)

11592 C. Rev. RESTITVT ORBIS, as previous, star in field between the figures, KA and officina mark A, B, Γ, or Δ (= 1, 2, 3, or 4) in ex. RIC 288. CBN 1027, 1040. MIR 259b-c. C 194. Hunter 100. *[Serdica, AD 274–5]*. **VF** £15 ($22) / **EF** £38 ($55)
There are several unusual varieties of obverse legend for this type (cf. the following two examples).

NB This reverse type was issued from at least eight mints employing different mint marks, both in the pre- and post-reform periods.

11593 **Billon antoninianus.** Similar, but with obv. legend IMP C AVRELIANVS INVICTVS AVG.
RIC 301. CBN 1048. MIR 259y. C 199. Hunter, p. cxv, note 2. *[Serdica, AD 274–5].*
VF £100 ($150) / **EF** £230 ($350)

11594 Similar, but with obv. legend DEO ET DOMINO NATO AVRELIANO AVG. RIC 306. CBN
1053. MIR 261ee. C 200. Hunter, p. cxv, note 2. *[Serdica, AD 274–5].*
VF £130 ($200) / **EF** £300 ($450)

11595 B. Rev. RESTITVT ORIENTIS, as 11591, star and officina mark S, T, or Q (= 2, 3, or 4) in ex.
RIC 234. CBN 755. MIR 183. C 201. Hunter, p. cxiii. *[Siscia, AD 272].*
VF £12 ($18) / **EF** £30 ($45)
*This and the following type refer to the defeat of the Palmyrene Empire and the restoration
of the eastern provinces to Roman rule in AD 272. (see also nos. 11491–3 and 11601–2).*

11596 B. Rev. — Aurelian, in military attire, stg. l., raising turreted female figure kneeling r. and
holding sceptre, mint mark C with one or two stars, or mint and officina marks C P or C S
(= officina 1 or 2) with star between in ex. RIC 351. CBN 1160, 1163, 1165. MIR 320,
324, 330. C 204. Hunter 101. *[Cyzicus, AD 272].*
VF £15 ($22) / **EF** £38 ($55)

11597

11597 B. Rev. RESTITVTOR EXERCITI, Mars, in military attire, stg. r., holding spear in l. hand and
presenting globe to Aurelian, also in military attire, stg l., holding sceptre in l., XXI in ex.,
usually with officina mark A, B Γ, Δ, or ε (= 1, 2, 3, 4, or 5) in field. RIC 366. CBN
1219–20, 1223, 1226, 1228–9. MIR 348. C 206. Hunter 105–7. *[Cyzicus, AD 274–5].*
VF £16 ($25) / **EF** £45 ($65)

11598 C. Rev. RESTITVTOR ORBIS, female figure facing Aurelian, as 11591, but with small
kneeling suppliant r. between them, star and officina mark A, B, Γ, or Δ (= 1, 2, 3, or 4) in
ex. Cf. RIC 349. CBN 1169, 1172, 1174–5. MIR 337. C 212. Hunter, p. cxv. *[Cyzicus,
AD 272].*
VF £16 ($25) / **EF** £45 ($65)

11599 B. Rev. — Victory stg. r., holding wreath in raised r. hand and palm in l., facing Aurelian,
in military attire, stg. l., his r. hand extended, holding sceptre in l., XXI in ex., usually with
officina mark A, B Γ, Δ, or ε (= 1, 2, 3, 4, or 5) in field. RIC 369. CBN 1231–6. MIR 347.
C 208. Hunter 108. *[Cyzicus, AD 274–5].*
VF £16 ($25) / **EF** £45 ($65)

11600 C. Rev. — Aurelian, in military attire, stg. r., holding spear in l. hand and receiving globe
from Sol stg. l., holding whip in l. hand. Cf. RIC 367 (misdescribed). CBN —. MIR 343a.
C 207 var. Hunter —. *[Cyzicus, AD 273].*
VF £22 ($35) / **EF** £60 ($90)

11601 B. Rev. RESTITVTOR ORIENTIS, Sol stg. l., raising r. hand and holding globe in l., mint
mark C between two stars in ex. RIC —. CBN —. MIR 323. C —. Hunter, p. cxv.
[Cyzicus, AD 272].
VF £22 ($35) / **EF** £60 ($90)
See note following no. 11595.

11602 **Billon antoninianus.** B. Rev. — Aurelian raising kneeling female figure, as 11596, officina mark P, S, T, or Q (= 1, 2, 3, or 4) preceded by star in ex., or the star in field. RIC 233. CBN 795. MIR 193. C 204 var. Hunter, p. cxiii. *[Siscia, AD 272].*
VF £15 ($22) / **EF** £38 ($55)

11603 B. Rev. **ROMAE AETER** (or **AETERNAE**), Aurelian, togate, stg. r., receiving Victory from Roma seated l., holding sceptre in l., shield at side, officina mark Q (= 4) in ex. RIC 142. CBN 479, 528. MIR 64–5. C 219–20, 222. Hunter, p. cxi. *[Milan, AD 272].*
VF £15 ($22) / **EF** £38 ($55)

11604 B (one dot below bust). Rev. **ROMAE AETERNE** (*sic*), Roma seated l., holding Victory and sceptre, shield at side. RIC 337. CBN 1105–7. MIR 312a-c. C —. Hunter, p. cxv. *[Cyzicus, AD 271].*
VF £15 ($22) / **EF** £38 ($55)

11605 B. Rev. **SAECVLI FELICITAS**, Aurelian, in military attire, stg. r., holding transverse spear and globe. Cf. RIC 352. CBN 1137. MIR 316a. C 223. Cf. Hunter, p. cxvii. *[Cyzicus, AD 271].*
VF £12 ($18) / **EF** £30 ($45)

11606 F. Rev. **SECVRIT AVG**, Securitas stg. facing, hd. l., legs crossed, holding short sceptre and resting on column, officina mark XI (= 11) in field or in ex. RIC 38. CBN 50. MIR 96. C 227. Hunter, p. cviii. *[Rome, AD 270–71].*
VF £12 ($18) / **EF** £30 ($45)

11607 C. Rev. **SOLI CONSERVATORI**, Sol stg. r., presenting globe to Aurelian, in military attire, stg. l., holding sceptre in l. hand, officina mark A (= 1) between two kneeling captives. Cf. RIC 353. CBN —. MIR 336. Cf. C 228. Cf. Hunter, p. cxv. *[Cyzicus, AD 272].*
VF £32 ($50) / **EF** £80 ($120)

11608 B. Rev. **SOLI INVICTO**, Sol stg. facing, hd. l., raising r. hand and holding globe in l., officina mark A, B Γ, Δ, or ε (= 1, 2, 3, 4, or 5) in ex. RIC 54. CBN 57, 59–60. MIR 113. C 230. Hunter 9. *[Rome, AD 272].*
VF £10 ($15) / **EF** £25 ($40)

11609 11610

11609 C, rad. and cuir. bust l. Rev. — (sometimes with dot at end of legend), similar, but with captive seated l. at Sol's feet, star in l. field, nothing in ex. RIC 390. CBN 1368. MIR 390c. C 233. Hunter 116. *[Tripolis, AD 274].*
VF £12 ($18) / **EF** £30 ($45)

11610 C. Rev. — Sol advancing l. between two captives, usually stepping on the one to l., raising r. hand and holding globe in l., star in field, officina and mint marks P XX T, S XX T, T XX T, or Q XX T (= officina 1, 2, 3, or 4) in ex. RIC 154. CBN 583, 588, 595, 601. MIR 73. C 234. Hunter 65, 67–8. *[Ticinum, AD 274].*
VF £15 ($22) / **EF** £38 ($55)
The mint initial 'T' also serves as the 'I' of the mark of value 'XXI'.

11611 **IMP C AVRELIANVS P F AVG.** Rev. — similar, but Sol holds whip instead of globe, and with XXI and officina mark T (= 3) in ex., nothing in field. RIC 311 var. CBN 1020. MIR 257v, y. C —. Hunter —. *[Serdica, AD 274].*
VF £22 ($35) / **EF** £60 ($90)

11612 **Billon antoninianus.** C. Rev. SOLI INVICTO, Mars, in military attire, stg. r., resting on spear and usually with shield at side, receiving globe from Sol stg. l., holding whip and sometimes setting his r. foot on captive seated between them, XXI and officina mark S or T (= 2 or 3) in ex. Cf. RIC 312. CBN 1019 var. MIR 258n. Cf. C 237. Cf. Hunter, cxiv. *[Serdica, AD 274].* **VF** £22 ($35) / **EF** £60 ($90)

11613 C. Rev. TEMPORVM FELI, Felicitas stg l., holding long caduceus and cornucopiae. RIC —. CBN —. MIR 159A. C —. Hunter —. *[Siscia, AD 270].* **VF** £20 ($30) / **EF** £50 ($75)

11614 C. Rev. VBERITAS AVG, Uberitas stg. l., holding cow's udder (?) and cornucopiae, officina mark Q (= 4) in field or in ex. RIC 208. CBN 713. MIR 159. C 239. Hunter, p. cxiii. *[Siscia, AD 270].* **VF** £15 ($22) / **EF** £38 ($55)

11615 B. Rev. VICTORIA AET, Victory stg. l. on globe, holding wreath and palm. RIC —. CBN 1150. MIR 318. C —. Hunter —. *[Cyzicus, AD 271].* **VF** £20 ($30) / **EF** £50 ($75)

11616 B. Rev. VICTORIA AVG, Victory advancing r., holding wreath and palm, usually with officina mark T (= 3) in ex. RIC 143. CBN 404. MIR 39. C 243. Hunter, p. cx. *[Milan, AD 271].* **VF** £10 ($15) / **EF** £25 ($40)

11617 B. Rev. — similar, but Victory advancing l., star and officina mark S (= 2) in field or in ex. RIC 237. CBN 731–2. MIR 205. C 248. Hunter, p. cxiii. *[Siscia, AD 272].* **VF** £12 ($18) / **EF** £30 ($45)

11618 D. Rev. — Victory stg. l., holding wreath and palm. RIC 272. CBN —. MIR 239. C —. Hunter, p. cxiv, var. *[Serdica, AD 272].* **VF** £15 ($22) / **EF** £38 ($55)

11619 B. Rev. — Victory hovering to front, hd. l., between two shields, holding open wreath with both hands, star and officina mark P, S, T, or Q (= 1, 2, 3, or 4) in field. RIC 238. CBN 778, 785–6. MIR 206. C 258. Hunter 82. *[Siscia, AD 272].* **VF** £15 ($22) / **EF** £38 ($55)
 This is a revival of a type issued in AD 220/21 under Elagabalus (see Volume II, nos. 7535 and 7554). See also under Gallienus (nos. 10391 and 10492), under Tacitus (no. 11820), and under Probus (no. 11929).

11620 B. Rev. — Aurelian, in military attire, stg. l., holding globe and transverse sceptre, crowned by Victory stg. l. behind him, holding palm, officina mark S (= 2) and star in ex. RIC 239. CBN —. MIR 207. C —. Hunter, p. cxiii. *[Siscia, AD 272].*
 VF £32 ($50) / **EF** £80 ($120)

11621 B. Rev. — trophy between two seated captives, mint mark C with star in ex. RIC 354. CBN 1156. MIR 321. C —. Cf. Hunter, p. cxv. *[Cyzicus, AD 272].*
 VF £32 ($50) / **EF** £80 ($120)

11622 B (one dot below bust). Rev. VICTORIA GERN (*sic*), Victory advancing l., holding wreath and palm. RIC 355, note 2. CBN 1151. MIR 317. Cf. C 259. Cf. Hunter, p. cxv. *[Cyzicus, AD 271].* **VF** £40 ($60) / **EF** £100 ($150)

11623 B. Rev. VICTORIA PARTICA, Victory crowning emperor, as 11620, officina mark S (= 2) and star in ex. RIC 240. CBN —. MIR 208. C —. Cf. Hunter, p. cxiii. *[Siscia, AD 272].*
 VF £55 ($80) / **EF** £130 ($200)

11624 E (two dots below bust). Rev. VICTORIAE GOTHIC, as 11621, but without mint mark. RIC 339. CBN 1083. MIR 295e. Cf. C 260. Cf. Hunter, p. cxv. *[Cyzicus, AD 270–71].*
 VF £40 ($60) / **EF** £100 ($150)

11625 **Billon antoninianus.** B. Rev. VIRT MILITVM, Aurelian, in military attire, stg. r., holding spear and globe, facing soldier (or Virtus) stg. l., presenting wreath-bearing Victory and holding transverse spear, officina mark T (= 3) in ex. Cf. RIC 146. CBN 511. MIR 63. C 261. Hunter, p. cxi. *[Milan, AD 272].* **VF** £12 ($18) / **EF** £30 ($45)

11626 B. Rev. VIRTVS AVG, Mars, in military attire, stg. l., holding olive-branch and resting on spear, shield at feet. RIC 5. CBN —. MIR 1. C —. Hunter, p. cx. *[Trier or Lugdunum, AD 274].* **VF** £32 ($50) / **EF** £80 ($120)
Göbl (in MIR) considers that this initial issue after the defeat of Tetricus was made at Trier prior to the opening of the new Gallic mint of Lugdunum (see also no. 11576).

11627 F. Rev. — Mars or Virtus stg. l., resting on spear and shield, officina mark B (= 2) in field. RIC 41. CBN 22. MIR 85. C 274. Hunter, p. cviii. *[Rome, AD 270–71].* **VF** £12 ($18) / **EF** £30 ($45)

11628 B (one dot below bust). Rev. — similar, but stg. r. and with no officina mark. RIC 341. CBN 1108. MIR 314a, c. C —. Hunter, p. cxv. *[Cyzicus, AD 271].* **VF** £12 ($18) / **EF** £30 ($45)

11629 C. Rev. — Hercules, naked, stg. r., resting on club and receiving globe from Sol stg. l., holding whip and setting his r. foot on captive seated between them, officina mark P (= 1) and XXI in ex. Cf. RIC 318. CBN —. MIR 252. Cf. C 273. Hunter —. *[Serdica, AD 274].* **VF** £32 ($50) / **EF** £80 ($120)

11630 B. Rev. — Hercules, naked, advancing r., lion's skin over shoulder, brandishing club and holding bow, sometimes with officina mark T or Γ (= 3) in ex. Cf. RIC 57. CBN —. MIR 106. C 271. Cf. Hunter, p. cviii. *[Rome, AD 272].* **VF** £25 ($40) / **EF** £65 ($100)

11631 B. Rev. — Aurelian r., facing soldier (or Virtus) l., as 11625, officina mark T (= 3) in ex. RIC 149. CBN 407. MIR 50. C 276. Hunter, p. cxi. *[Milan, AD 272].* **VF** £12 ($18) / **EF** £30 ($45)

11632 C. Rev. — Aurelian, in military attire, on horseback galloping r., spearing enemy on ground beneath him. RIC —. CBN —. MIR 166A. C —. Hunter —. *[Siscia, AD 271].* **VF** £65 ($100) / **EF** £170 ($250)

11633 B. Rev. VIRTVS EQVIT, Aurelian on horseback pacing l., his r. hand raised, holding sceptre in l., officina mark S or T (= 2 or 3) in ex. RIC 115. CBN 384. MIR 28A. C —. Hunter, p. cx. *[Milan, AD 271].* **VF** £40 ($60) / **EF** £100 ($150)

11634 C. Rev. VIRTVS ILLVRICI, Mars advancing r., carrying transverse spear and shield, captive at feet, officina mark B or ε (= 2 or 5) in ex. Cf. RIC 388. CBN —. MIR 367. Cf. C 283. Cf. Hunter, p. cxvi. *[Antioch, AD 273].* **VF** £40 ($60) / **EF** £100 ($150)

11635 B. Rev. VIRTVS MILITVM, Aurelian r., facing soldier (or Virtus) l., as 11625, officina mark T (= 3) in ex. Cf. RIC 147. CBN 473. MIR 62. C 285. Hunter 45. *[Milan, AD 272].* **VF** £12 ($18) / **EF** £30 ($45)

11636 Similar, but Aurelian is stg. l. and soldier (or Virtus) is stg. r., star and officina mark P, S, T, or Q (= 1, 2, 3, or 4) in ex. RIC 242. CBN 748, 753, 758. MIR 186. C 286. Hunter, p. cxiii. *[Siscia, AD 272].* **VF** £14 ($20) / **EF** £32 ($50)

NB For antoniniani depicting Aurelian issued by the Palmyrenes at Antioch, see under Vabalathus (no. 11718).

11637 **Billon denarius.** B, laur. and cuir. bust r. Rev. ORIENS AVG, Sol stg. l., raising r. hand and
holding globe in l. RIC 67. CBN —. MIR 134. Cf. C 139 (misdescribed). Hunter, p. cviii.
[Rome, AD 274–5]. **VF** £80 ($120) / **EF** £170 ($250)

11638 Obv. Similar. Rev. PROVIDEN AVG, Providentia stg. l., holding rod and cornucopiae, globe
at feet, officina mark B (= 2) in ex. RIC 69. CBN 248. MIR 140f, h. C 181. Hunter, p. cviii.
[Rome, AD 274–5]. **VF** £60 ($90) / **EF** £130 ($200)

11639 C, laur., dr, and cuir. bust r. Rev. VICTORIA AVG, Victory advancing l., holding wreath and
palm, officina mark B (= 2) in ex. RIC —. CBN —. MIR 138. C —. Cf. Hunter, p. cix.
[Rome, AD 274–5]. **VF** £50 ($75) / **EF** £115 ($175)

11640 Obv. As 11637. Rev. — similar, but with VSV in ex. and officina mark B (= 2) in field. RIC
71. CBN 185. MIR 135f, h. C 250. Cf. Hunter, p. cix. *[Rome, AD 274–5].*
 VF £50 ($75) / **EF** £115 ($175)
*The inscription in the exergue was interpreted by Mattingly ("Roman Coins", p. 130) as
an abbreviation of "usualis", marking the coin as the "normal" monetary unit of account,
i.e. a denarius. See also the following and nos. 11708–9.*

11641 — Rev. — as previous, but with captive seated at feet of Victory. RIC 73. CBN —. MIR
135A. Cf. C 257. Hunter, p. cix. *[Rome, AD 274–5].* **VF** £60 ($90) / **EF** £130 ($200)

11642 B, laur., dr. and cuir. bust r. Rev. — as previous, but with mint mark R instead of VSV in
ex., and no officina mark in field. RIC —. CBN 237. MIR —. Cf. C 255. Hunter 24.
[Rome, AD 274–5]. **VF** £50 ($75) / **EF** £115 ($175)

11643 11646

11643 Obv. As 11637. Rev. — as previous, but with officina mark A, B, Γ, or ε (= 1, 2, 3, or 5)
instead of R in ex. RIC 73. CBN 240, 259, 265, 283. MIR 139f. C 255 var. Hunter, p. cix.
[Rome, AD 274–5]. **VF** £40 ($60) / **EF** £100 ($150)

11644 B, laur. bust r., wearing imperial mantle and holding eagle-tipped sceptre. Rev. — as
previous, with officina mark A (= 1) in ex. RIC —. CBN 247. MIR —. C —. Hunter —.
[Rome, AD 274–5]. **VF** £200 ($300) / **EF** £430 ($650)

11645 Obv. As 11637. Rev. VIRTVS AVG, Hercules stg. r., r. hand on hip, l. resting on club
wrapped in lion's skin. RIC 74. CBN —. MIR 246 (attributed to Serdica, AD 273). C 272.
Hunter, p. cix. *[Rome, AD 274–5].* **VF** £95 ($140) / **EF** £200 ($300)

11646 **Bronze reduced sestertius or as.** B, laur. and cuir. or dr. and cuir. bust r. Rev.
CONCORDIA AVG, Aurelian, in military attire, stg. l., holding sceptre in l. hand and
clasping r. hands with Severina stg. r., rad. bust of Sol r. in upper field between them,
usually with officina mark Γ, Δ, or Z (= 3, 4, or 7) in ex. RIC 80. CBN 298, 301, 303, 314.
MIR 145a, d, f. C 35. Hunter 25, 33. *[Rome, AD 274–5].*
 F £25 ($40) / **VF** £65 ($100) / **EF** £200 ($300)

11647

11647 **Bronze reduced sestertius or as.** Similar, but with obv. type laur., dr. and cuir. bust l., his
r. hand raised. RIC 81. CBN 307. MIR 145b. C 36. Hunter, p. cix. *[Rome, AD 274–5].*
F £65 ($100) / **VF** £170 ($250) / **EF** £500 ($750)

11648 Similar, but with obv. type laur. and cuir. bust l., holding spear or sceptre over r. shoulder,
shield on l. shoulder. RIC —. CBN —. MIR 145g. C —. Cf. Hunter, p. cix. *[Rome,
AD 274–5].* **F** £120 ($180) / **VF** £300 ($450) / **EF** £900 ($1,350)

11649 C, laur., dr. and cuir. bust r. Rev. GENIVS EXERCI, Genius of the Army stg. l., holding patera
and cornucopiae. RIC 83. CBN 56. MIR 83. C —. Hunter, p. cx. *[Rome, AD 270–71].*
F £95 ($140) / **VF** £230 ($350) / **EF** £665 ($1,000)

11650 B, laur. and cuir. bust r. Rev. ROMAE AETER, Roma seated l. on cuirass, holding Victory
and sceptre, shield at side. Cf. RIC 84 = 85. CBN 171. MIR 146. Cf. C 216 = 218. Cf.
Hunter, p. cx. *[Rome, AD 274–5].* **F** £110 ($160) / **VF** £265 ($400) / **EF** £800 ($1,200)

11651 SOL DOMINVS IMPERI ROMANI, bare-headed and dr. bust of Sol r. Rev. AVRELIANVS AVG
CONS, Aurelian, in military attire. stg. l., sacrificing from patera over tripod-altar and
holding long sceptre, sometimes with S (= Serdica?) in ex. RIC 319 (Serdica). CBN 1023
(Serdica). MIR 151k (Rome). C 16. Cf. Hunter, p. cxv (Serdica). *[Rome or Serdica,
AD 274–5].* **F** £170 ($250) / **VF** £430 ($650) / **EF** £1,350 ($2,000)

11652 Similar, but on rev. Aurelian is veiled and togate and holds short sceptre in l. hand. RIC
319 (Serdica). CBN 1022 (Serdica). MIR 152k (Rome). C 15. Cf. Hunter, p. cxv (Serdica).
[Rome or Serdica, AD 274–5]. **F** £170 ($250) / **VF** £430 ($650) / **EF** £1,350 ($2,000)

11653 SOL DOM IMP ROMANI, rad. and dr. bust of Sol r., foreparts of four horses galloping r.
before him. Rev. As 11651. RIC 320 var (Serdica). CBN —. MIR 151L (Rome). C —. Cf.
Hunter, p. cxv (Serdica). *[Rome or Serdica, AD 274–5].*
F £265 ($400) / **VF** £665 ($1,000) / **EF** £2,000 ($3,000)

11654 Similar, but rev. as 11652. RIC 320 (Serdica). CBN —. MIR 152L (Rome). Cf. C 17. Cf.
Hunter, p. cxv (Serdica). *[Rome or Serdica, AD 274–5].*
F £265 ($400) / **VF** £665 ($1,000) / **EF** £2,000 ($3,000)

11655 SOL DOM IMP ROM, rad. and dr. bust of Sol three-quarter face to l., foreparts of four horses
galloping before him, two to l. and two to r. Rev. As 11651. RIC 322 (Serdica). CBN —.
MIR 151m (Rome). C —. Hunter —. *[Rome or Serdica, AD 274–5].*
F £300 ($450) / **VF** £800 ($1,200) / **EF** £2,300 ($3,500)

Alexandrian Coinage

Confusion in Egypt resulting from ignorance of the exact date of the death of Claudius II, compounded by the disruption caused by the invasion of the country by the Palmyrene forces in November AD 270, has led to problems over the interpretation of the dates appearing on Aurelian's Alexandrian coinage. The situation was brilliantly elucidated by the late Martin Price in an article entitled "The Lost Year: Greek Light on a Problem of Roman Chronology" published in the Numismatic Chronicle 1973, pp. 75–86. Aurelian's first issue (year 1) was made when news of Quintillus' death reached Egypt just prior to the Palmyrene invasion. At this time it was not known at Alexandria that Aurelian reckoned his dies imperii from the death of Claudius which had occurred in August, meaning that Aurelian was already in his second Alexandrian year in the closing months of 270. This issue was followed by the joint coinage of Vabalathus and Aurelian, produced by the Palmyrenes, and this naturally carried on the dating of the initial issue, i.e. year 1 of Aurelian = AD 270–71 and year 2 = AD 271–2. Thus, when Aurelian regained possession of Egypt in May/June AD 272 he considered that he was in his third Alexandrian year while the mint was issuing coins showing him still in his second. A brief issue dated year 2 was produced for Aurelian alone, probably in June, but the emperor then summarily changed the reckoning to year 3 for the period June-late August. It then advanced to year 4 at the end of August and was thereafter renewed annually until late August AD 275 when Aurelian entered his final Alexandrian year (7).

There are two varieties of obv. legend represented by the upper case letters 'A' and 'B':

A. AVT K Λ Δ AVPHΛIANOC CEB
B. A K Λ ΔOM AVPHΛIANOC CEB

There are two varieties of obv. type represented by the lower case letters 'a' and 'b':

a. Laur., dr. and cuir. bust r.
b. Laur. and cuir. bust r.

11656 **Billon tetradrachm.** Ba. Rev. Eagle stg. r., hd. l., holding wreath in beak, L — A (= regnal year 1) in field. Dattari 5479. BMCG 2354. Cologne 3051. Milne 4299. *[Oct.-Nov. AD 270].* **VF** £10 ($15) / **EF** £30 ($45)

11657 Aa. Rev. Alexandria, turreted, stg. l., holding bust of Sarapis and resting on sceptre, L — B (= regnal year 2) in field. Dattari 5435. BMCG —. Cologne —. Milne 4355. *[June AD 272].* **VF** £10 ($15) / **EF** £30 ($45)

11658 Aa. Rev. Athena seated l., holding Nike and resting on sceptre, shield at side, L Γ (= regnal year 3) before. Dattari 5438 var. BMCG 2340. Cologne —. Milne 4358. *[June-Aug. AD 272].* **VF** £10 ($15) / **EF** £30 ($45)

11659 Aa. Rev. Eirene (= Pax) stg. l., holding olive-branch and transverse sceptre, L Γ (= regnal year 3) before. Dattari 5446. BMCG 2346 var. Cologne —. Milne 4359. *[June-Aug. AD 272].* **VF** £10 ($15) / **EF** £30 ($45)

11660 Aa. Rev. Eagle stg. l., hd. r., holding wreath in beak, L — Γ (= regnal year 3) in field. Dattari 5473 var. BMCG 2357. Cologne 3067. Milne 4367. *[June-Aug. AD 272].* **VF** £10 ($15) / **EF** £30 ($45)

11661 Aa. Rev. Eagle flying to front, hd. r., holding wreath in talons, L Γ (= regnal year 3) in field below. Dattari 5491 var. BMCG —. Cologne —. Milne 4370. *[June-Aug. AD 272].* **VF** £12 ($18) / **EF** £38 ($55)

11662 **Billon tetradrachm.** Bb. Rev, Nike (= Victory) advancing r., holding wreath and palm, L — Γ (= regnal year 3) in field. Dattari 5455. BMCG 2350. Cologne —. Milne 4362. *[June-Aug. AD 272].* **VF** £10 ($15) / **EF** £30 ($45)

11663 Aa. Rev. Aurelian, in military attire, on horseback pacing l., his r. hand raised, holding sceptre in l., L Γ (= regnal year 3) before. Dattari 5433. BMCG 2353 var. Cologne 3070. Milne 4372. *[June-Aug. AD 272].* **VF** £16 ($25) / **EF** £45 ($65)

11664 Aa. Rev. She-wolf stg. r., suckling the twins Romulus and Remus, L Γ (= regnal year 3) above. Cf. Dattari 5496. BMCG 2351 var. Cologne 3071. Milne 4371. *[June–Aug. AD 272].* **VF** £16 ($25) / **EF** £45 ($65)

11665 Aa. Rev. Eagle stg. facing, hd. l., supporting open laurel-wreath on its outspread wings, L Γ (= regnal year 3) above eagle's hd. Dattari —. BMCG —. Cologne 3068. Milne —. *[June–Aug. AD 272].* **VF** £16 ($25) / **EF** £45 ($65)

11666 Aa. Rev. Dikaiosyne (= Aequitas) stg. l., holding scales and cornucopiae, L Δ (= regnal year 4) before. Dattari 5442. BMCG 2344. Cologne —. Milne 4375. *[AD 272–3].* **VF** £8 ($12) / **EF** £22 ($35)

11667 Aa. Rev. Homonoia (= Concordia) stg. l., r. hand extended, holding double cornucopiae in l., L Δ (= regnal year 4) before. Dattari 5451. BMCG 2348. Cologne —. Milne 4376. *[AD 272–3].* **VF** £8 ($12) / **EF** £22 ($35)

11668 Bb. Rev. Similar, but Homonoia seated l., L — Δ (= regnal year 4) in field. Dattari 5452. BMCG —. Cologne —. Milne 4377. *[AD 272–3].* **VF** £8 ($12) / **EF** £25 ($40)

11669 Bb. Rev. Nike (= Victory) advancing l., holding wreath and palm, L — Δ (= regnal year 4) in field. Dattari —. BMCG —. Cologne —. Milne 4380. *[AD 272–3].* **VF** £12 ($18) / **EF** £38 ($55)

11670 Bb. Rev. Similar, but Nike holds wreath and trophy over shoulder in r. hand, palm in l., L — Δ (= regnal year 4) in field, sometimes with star to l. Dattari 5461–2. BMCG/Christiansen 3371. Cologne —. Milne —. *[AD 272–3].* **VF** £12 ($18) / **EF** £38 ($55)

11671 Aa. Rev. Tyche (= Fortuna) stg. l., holding rudder and cornucopiae, L Δ (= regnal year 4) before. Dattari 5465. BMCG —. Cologne —. Milne —. *[AD 272–3].* **VF** £12 ($18) / **EF** £38 ($55)

11672 Bb. Rev. Aurelian, in military attire, stg. l. between two captives, holding Victory and resting on sceptre, L — Δ (= regnal year 4) in field. Dattari 5431 var. BMCG/Christiansen 3383. Cologne —. Milne 4404. *[AD 272–3].* **VF** £12 ($18) / **EF** £38 ($55)

11673 Ba. Rev. Similar, but without the captives and the regnal date is to l. Dattari —. BMCG —. Cologne —. Milne 4406. *[AD 272–3].* **VF** £16 ($25) / **EF** £45 ($65)

11674 Bb. Rev. Aurelian, in military attire, galloping r., thrusting spear at enemy lying on ground below horse, L Δ (= regnal year 4) behind. Dattari —. BMCG/Christiansen 3382. Cologne 3080. Milne 4407. *[AD 272–3].* **VF** £20 ($30) / **EF** £50 ($75)

11675 Bb. Rev. Eagle stg. l., its wings closed, holding wreath in beak, L Δ (= regnal year 4) before, star behind. Dattari 5470. BMCG 2363. Cologne 3073. Milne 4381. *[AD 272–3].* **VF** £8 ($12) / **EF** £22 ($35)

11676 **Billon tetradrachm.** Similar, but eagle stg. r., its wings open. Dattari 5482. BMCG 2364. Cologne 3074. Milne 4390. *[AD 272–3].* **VF** £8 ($12) / **EF** £22 ($35)

11677 Aa. Rev. Eagle stg. r., its wings closed, holding wreath in beak, palm-branch transversely in background, L — Δ (= regnal year 4) in field. Dattari 5487. BMCG 2368. Cologne 3072. Milne 4383. *[AD 272–3].* **VF** £8 ($12) / **EF** £22 ($35)

11678 Bb. Rev. Eagle stg. r., hd. l., its wings open, holding wreath in beak, L Δ (= regnal year 4) to r. Dattari —. BMCG —. Cologne —. Milne —. Curtis 1780. *[AD 272–3].*
 VF £12 ($18) / **EF** £38 ($55)

11679 Aa. Rev. Eagle supporting wreath, as 11665, but its hd. to r. with L Δ (= regnal year 4) above. Dattari 5493. BMCG/Christiansen 3378. Cologne —. Milne —. *[AD 272–3].*
 VF £16 ($25) / **EF** £45 ($65)

11680 Bb. Rev. Eagle flying r., hd. l., holding wreath in talons, L Δ (= regnal year 4) to r., with or without star. Dattari 5492. BMCG 2365–6. Cologne 3076. Milne 4398, 4400. *[AD 272–3].*
 VF £8 ($12) / **EF** £25 ($40)

11681 Bb. Rev. Eagle stg. l. between two vexilla, its hd r. and wings open, holding wreath in beak, L Δ (= regnal year 4) above, with or without star. Dattari 5494–5. BMCG 2370. Cologne 3077–8. Milne 4393, 4396. *[AD 272–3].* **VF** £8 ($12) / **EF** £25 ($40)

11682 Ab. Rev. ETOVC E (= regnal year 5), Bust of Sarapis r., wearing modius. Dattari —. BMCG —. Cologne —. Milne 4415. *[AD 273–4].* **VF** £20 ($30) / **EF** £50 ($75)

11683 Bb. Rev. Laur. bust of Zeus r., L — E (= regnal year 5) in field, sometimes with star to r. Dattari 5466. BMCG —. Cologne 3094. Milne 4408. *[AD 273–4].*
 VF £16 ($25) / **EF** £45 ($65)

11684 Bb. Rev. Nike (= Victory) seated r. on cuirass, holding shield inscribed L E (= regnal year 5). Dattari 5460. BMCG —. Cologne —. Milne —. *[AD 273–4].*
 VF £16 ($25) / **EF** £45 ($65)

11685 Bb. Rev. Tyche (= Fortuna) reclining l. on couch, holding rudder, L E (= regnal year 5) above. Dattari —. BMCG —. Cologne 3093. Milne 4414. *[AD 273–4].*
 VF £12 ($18) / **EF** £38 ($55)

11686 Bb. Rev. ETOVC E (= regnal year 5), eagle stg. l., hd. r., wings open, holding wreath in beak, sometimes with star in upper field to l. Dattari 5489–90. BMCG 2360–61. Cologne 3083, 3087. Milne 4426, 4430. *[AD 273–4].* **VF** £8 ($12) / **EF** £22 ($35)

11687

11687 Bb. Rev. L E (= regnal year 5) within laurel-wreath. Dattari 5469. BMCG 2373. Cologne 3089. Milne 4434. *[AD 273–4].* **VF** £20 ($30) / **EF** £50 ($75)

11688 **Billon tetradrachm.** Similar, but the date within wreath on rev. has the form ETOVC / E in two lines, sometimes with star above. Dattari 5467–8. BMCG 2372. Cologne 3090–91. Milne 4435, 4437. *[AD 273–4].* **VF** £16 ($25) / **EF** £45 ($65)

11689 Bb. Rev. ETOVC Ϛ (= regnal year 6), Alexandria, turreted, stg. l., raising r. hand and holding transverse sceptre in l. Dattari 5434. BMCG/Christiansen 3372. Cologne —. Milne 4447. *[AD 274–5].* **VF** £12 ($18) / **EF** £38 ($55)

11690 Bb. Rev. ETOVC Ϛ (= regnal year 6), Ares, helmeted and in military attire, stg. l., raising r. hand and holding transverse sceptre in l. Dattari 5463 (Roma). BMCG 2343. Cologne 3097. Milne 4446 (Roma). *[AD 274–5].* **VF** £12 ($18) / **EF** £38 ($55)

11691 Bb. Rev. ETOVC Ϛ (= regnal year 6), Sarapis stg. facing, hd.r., resting on sceptre. Dattari 5464. BMCG —. Cologne —. Milne 4445. *[AD 274–5].* **VF** £16 ($25) / **EF** £45 ($65)

11692 Bb. Rev. ETOVC Ϛ (= regnal year 6), Elpis (= Spes) advancing l., holding flower and lifting skirt. Dattari 5449. BMCG 2347. Cologne —. Milne 4441. *[AD 274–5].* **VF** £8 ($12) / **EF** £25 ($40)

11693 Bb. Rev. ETOVC Ϛ (= regnal year 6), Nike (= Victory) advancing r., holding wreath and palm. Dattari 5459. BMCG —. Cologne —. Milne 4444. *[AD 274–5].* **VF** £10 ($15) / **EF** £30 ($45)

11694 Bb. Rev. ETOVC Z (= regnal year 7), Athena seated, as 11658. Dattari 5441. BMCG —. Cologne 3098. Milne 4466. *[AD 275].* **VF** £12 ($18) / **EF** £38 ($55)

11695 Bb. Rev. ETOVC Z (= regnal year 7), Dikaiosyne stg., as 11666. Dattari 5444. BMCG 2345. Cologne 3099. Milne 4469. *[AD 275].* **VF** £10 ($15) / **EF** £30 ($45)

For additional depictions of Aurelian on the coinage of Alexandria, see under Vabalathus (nos. 11719–22); and for his other local coinages, see *Greek Imperial Coins and Their Values*, p. 462.

**AURELIAN AND
SEVERINA**

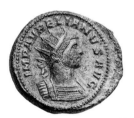

11696

Ulpia Severina, wife of Aurelian, was raised to the rank of Augusta in AD 274 at which time her coinage commenced. In addition to issues in her sole name a joint coinage was produced in two denominations of the reformed aes.

11696 **Bronze reduced double sestertius or dupondius.** IMP AVRELIANVS AVG, rad. and cuir. bust of Aurelian r. Rev. SEVERINA AVG, diad. and dr. bust of Severina r., crescent behind shoulders. RIC 1, 2. CBN 322. MIR 143. C 1, 2. Hunter 1. *[Rome, AD 274–5].* **F** £230 ($350) / **VF** £525 ($800) / **EF** £1,650 ($2,500)

11697 **Bronze reduced sestertius or as.** Similar, but Aurelian is laur. instead of rad., and Severina does not have crescent behind her shoulders. RIC 4. CBN —. MIR 144. C —. Hunter 4. *[Rome, AD 274–5].* **F** £170 ($250) / **VF** £400 ($600) / **EF** £1,350 ($2,000)

AURELIAN AND VABALATHUS

Between AD 270 and 272 Vabalathus, king of Palmyra, issued antoniniani at Antioch and billon tetradrachms and bronzes at Alexandria bearing both his own portrait and that of Aurelian. As these issues were made under Palmyrene authority they are listed under Vabalathus (see nos. 11718–22).

Issues of Quintillus and/or Aurelian in honour of Divus Claudius II, AD 270

Although this extensive series of antoniniani may well have begun under Quintillus it was almost certainly continued by Aurelian. Indeed, some scholars believe that its issue may not even have commenced until the latter's reign, the brief two-month principate of Quintillus being insufficient for the inauguration of a commemorative coinage (see nos. 11459–66).

SEVERINA

11700

Little is known of the history or ancestry of Ulpia Severina, wife of Aurelian, though her name would indicate a Spanish origin. As she did not become Augusta until late in her husband's reign Severina's coinage extends only over a short period (AD 274–5) but is nevertheless of considerable interest. The numismatic evidence makes it clear that issues in her name continued for some time after Aurelian's death, though the precise length of this 'interregnum' period is much disputed by scholars. It was formerly believed that the accession of Tacitus was delayed as long as six months, but it now seems likely that the new emperor's proclamation took place less than two months after his predecessor's murder. The ultimate fate of Severina is unknown, but it may be presumed that she retired into private life and was honoured by her husband's successors.
There are two principal varieties of obverse legend:

A. SEVERINA AVG
B. SEVERINAE AVG

The normal obverse type is diademed and draped bust of Severina right, with crescent behind shoulders on all coins other than denarii and reduced sestertii/asses.

11698 **Gold aureus.** A. Rev. CONCORDIAE MILITVM, Concordia Militum stg. l., holding standard in each hand, mint mark R in ex. RIC 2. CBN —. MIR 153. Calicó 4065. C —. Hunter, p. cxviii. *[Rome, AD 275].* **VF** £5,000 ($7,500) / **EF** £12,000 ($18,000)

11699 Similar, but without mint mark. Cf. RIC 2 (Rome) and 11 (Siscia). CBN 657. MIR 79. Cf. Calicó 4063. C 6. Cf. Hunter, p. cxviii. *[Ticinum, AD 275].*
 VF £4,000 ($6,000) / **EF** £10,000 ($15,000)

11700 Similar, but with obv. legend B. Cf. RIC 12 (obv. legend A in error). CBN —. MIR 236. Cf. Calicó 4064. C —. Hunter, p. cxviii. *[Siscia, AD 275].*
 VF £4,000 ($6,000) / **EF** £10,000 ($15,000)

11701 **Billon antoninianus.** A. Rev. CONCORD MILIT, Concordia seated l., holding patera and
 cornucopiae, officina mark B or D (= 2 or 4) followed by mint mark L in ex. RIC 1. CBN 3,
 5, 10, 14. MIR 3, 5, 7. C 5. Hunter, p. cxviii. *[Lugdunum, AD 274–5].*
 <div align="right">VF £32 ($50) / **EF** £85 ($130)</div>

11702 SEVERINA P F AVG. Rev. CONCORDIA AVG, Severina stg. l., clasping r. hands with bare-
 headed togate figure (Genius of the Senate?) stg. r., officina mark P, S, T, Q, V, or VI (= 1,
 2, 3, 4, 5, or 6) in field, XXI in ex. RIC 19. CBN 1357–61. MIR 382. C 1. Hunter 31.
 [Antioch, AD 275]. VF £30 ($45) / **EF** £80 ($120)
 *The unorthodox titulature in the obverse legend, reminiscent of Julia Domna's IVLIA PIA
 FELIX AVG, together with the singular ending of the reverse legend and the unusual type,
 strongly suggest that Severina was regarded at Antioch as a reigning empress at the time
 this issue was made.*

11703 A (rarely AVGVSTA for AVG). Rev. CONCORDIA AVGG, similar, but the togate figure is
 that of Aurelian, laur., usually with star in field, KA followed by officina mark Γ or Δ (= 3
 or 4) in ex. RIC 16–17. CBN 1055, 1057, 1060. MIR 265–7. C 2. Hunter, p. cxviii.
 [Serdica, AD 274–5]. VF £30 ($45) / **EF** £80 ($120)

<div align="center">11704 11705</div>

11704 A. Rev. — Aurelian, togate, stg. l., holding short sceptre in l. hand and clasping r. hands
 with Severina stg. r., holding sceptre (?) in l., officina mark Γ or S (= 3 or 6) followed by
 XXI and mint mark R in ex. RIC 3. CBN 174, 181. MIR 132. C 3. Hunter 4. *[Rome,
 AD 274–5].* VF £30 ($45) / **EF** £80 ($120)

11705 A. Rev. CONCORDIAE MILITVM, Concordia Militum, as 11698, but with mint mark XXI R
 in ex., and usually with officina mark A, B, Γ, Δ, Ε, S, Z, or H (= 1, 2, 3, 4, 5, 6, 7, or 8) in
 field. RIC 4. CBN 218–19, 221, 224, 228, 230, 234. MIR 154. C 7. Hunter 8, 11–14.
 [Rome, AD 275]. VF £25 ($40) / **EF** £75 ($110)

11706 B. Rev. — similar, but with XXI in ex., and officina mark P, S, T, Q, V, or IV (= 1, 2, 3, 4, 5,
 or 6) in field. RIC 13. CBN 941, 944, 946, 949, 953–4. MIR 237. C 8. Hunter 28–9.
 [Siscia, AD 275]. VF £30 ($45) / **EF** £80 ($120)
 Officina mark IV in this series represents the sixth officina (= VI reversed).

11707 A. Rev. PROVIDEN DEOR, Fides Militum stg. r., holding standard in each hand, facing Sol stg.
 l., raising r. hand and holding globe in l., officina and mint marks V XX T or U XX T (= 5th
 officina), or VI XX T or UI (ligatured) XX T (= 6th officina) in ex. RIC 9. CBN 640, 646, 649,
 656. MIR 78Ad. C 12. Hunter 25–6. *[Ticinum, AD 274–5].* VF £25 ($40) / **EF** £75 ($110)
 The mint initial 'T' also serves as the 'I' of the mark of value 'XXI'.

11708 **Billon denarius.** A. Rev. LAETITIA AVG, Laetitia stg. l., holding wreath and anchor,
 officina mark Γ (= 3) in field, VSV in ex. RIC 5. CBN 186. MIR 136. C 11. Hunter,
 p. cxviii. *[Rome, AD 274–5].* VF £65 ($100) / **EF** £150 ($225)
 *The inscription in the exergue was interpreted by Mattingly ("Roman Coins", p. 130) as
 an abbreviation of "usualis", marking the coin as the "normal" monetary unit of account,
 i.e. a denarius. See also the following and nos. 11640–41.*

11707 11709

11709 **Billon denarius.** A. Rev. **VENVS FELIX**, Venus stg. l., holding apple (?) and sceptre, officina
mark Γ (= 3) in field, **VSV** in ex. RIC 6. CBN 187. MIR 137. Cf. C 14. Hunter, p. cxviii.
[Rome, AD 274–5]. **VF** £60 ($90) / **EF** £130 ($200)

11710 Similar, but without **VSV** and with officina mark Γ, Δ, Ɛ, or Ϛ (= 3, 4, 5, or 6) in ex. (more
rarely in field). RIC 6. CBN 266, 278, 285, 287. MIR 141–2. C 14. Hunter 1, 3. *[Rome,
AD 274–5].* **VF** £55 ($80) / **EF** £115 ($175)

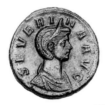

11711

11711 **Bronze reduced sestertius or as.** A. Rev. **IVNO REGINA**, Juno stg. l., holding patera and
sceptre, peacock at feet, usually with officina mark Ϛ or Z (= 6 or 7) in ex. RIC 7. CBN
319. MIR 147. C 9. Hunter 15, 17, 19. *[Rome, AD 274–5].*
F £32 ($50) / **VF** £85 ($125) / **EF** £250 ($375)

Alexandrian Coinage

All have obv. legend **OVΛΠ CEVHPINA CEB** and obv. type diad. and dr. but r. Reverses are as
follows:

11712 **Billon tetradrachm.** ETOVC Ϛ (= regnal year 6), Dikaiosyne (= Aequitas) stg. l., holding
scales and cornucopiae. Dattari 5499. BMCG 2375. Cologne —. Milne 4440. *[AD 274–5].*
VF £16 ($25) / **EF** £40 ($60)

11713 — eagle stg. l., hd. r., holding wreath in beak. Dattari 5506. BMCG 2380. Cologne 3103.
Milne 4463. *[AD 274–5].* **VF** £16 ($25) / **EF** £40 ($60)

11714 ETOVC Z (= regnal year 7), Athena seated l., holding Nike and resting on sceptre, shield at
side. Dattari 5498. BMCG 2374. Cologne 3106. Milne 4467. *[AD 275].*
VF £16 ($25) / **EF** £40 ($60)

11715 — Elpis (= Spes) advancing l., holding flower and lifting skirt. Dattari 5502. BMCG 2378.
Cologne 3108. Milne 4474. *[AD 275].* **VF** £16 ($25) / **EF** £40 ($60)

 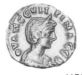

11713 11715

11716 **Billon tetradrachm.** — Nike (= Victory) advancing r., holding wreath and palm. Dattari
 5498. BMCG 2374. Cologne 3106. Milne 4467. *[AD 275]*. **VF** £16 ($25) / **EF** £40 ($60)

11717 — Eagle stg. r., its wings closed, holding wreath in beak, palm-branch transversely in
 background. Dattari 5505. BMCG 2383. Cologne 3105. Milne 4480. *[AD 275]*.
 VF £16 ($25) / **EF** £40 ($60)

<div align="center">

VABALATHUS

King of Palmyra AD 267–spring 272

Augustus spring-summer AD 272

</div>

11723

*Julius Aurelius Septimius Vabalathus Athenodorus was the son of Septimius Odaenathus of
Palmyra and his second wife Zenobia. Following the capture in* AD *260 of the Emperor Valerian by
the Sasanid ruler Shapur, and the subsequent partial collapse of Roman power in much of the East,
Odaenathus came to the forefront as Gallienus' lieutenant in the region. After he had checked the
advance of the invading Persians and inflicted several defeats on Shapur's armies he eliminated
the usurper Quietus after besieging him in the Syrian city of Emesa. For these achievements and
his loyalty to the Roman cause Odaenathus was rewarded by Gallienus with the imposing title
corrector totius Orientis ('administrator of the whole east'), an honour which he bore proudly until
his assassination in 267. It is difficult to know who was behind Odaenathus' downfall but the direct
beneficiary was his widow, Zenobia, who now became the effective ruler of the Palmyrene state
together with her 10-year-old son Vabalathus. Relations with the Romans now became very
strained as Gallienus, Claudius, and Quintillus all refused to grant Vabalathus the titles which had
been borne by his father. Unable at the time of his accession to confront his eastern rival Aurelian
acquiesced in the granting of the titles to Vabalathus, a concession which led to a joint coinage
being issued by the Palmyrenes at Antioch and at the Egyptian capital of Alexandria, which had
only recently been captured by Zenobia. However, by the spring of* AD *272 Aurelian felt sufficiently
secure to be able to undertake an invasion of the East where he inflicted a series of defeats on the
enemy, ultimately liberating the entire area from Palmyrene control. With the fall of Palmyra itself
in the summer both Zenobia and Vabalathus were taken prisoner and transported to Rome in order
to adorn Aurelian's triumph. Vabalathus' subsequent fate is unknown, though his mother was
treated honourably and was permitted to retire to a villa near Tibur. Her descendants were still
prominent among the Roman aristocracy as much as a century later.*

 Vabalathus' coinage falls into two phases, the first of which belongs to the period late AD *270-
spring 272. It begins with Aurelian's granting of titles to Vabalathus and comprises billon
antoniniani of the Antioch mint and billon tetradrachms of Alexandria, both series showing the
bust of the Palmyrene king on one side and that of the Roman emperor on the other. The
tetradrachms are of especial interest as they bear dual regnal dates, those of Vabalathus reckoned
from the time of his father's death in 267. The dates of Aurelian were numbered from the death of*

Quintillus late in 270, though Aurelian counted them from the death of Claudius II in August, before the end of the Alexandrian year, thus causing a temporary chronological confusion in the series until Aurelian regained possession of Egypt. The second phase of Vabalathus' coinage again comprises antoniniani and tetradrachms but now accord him the full imperial title of Augustus. These must post-date Aurelian's declaration of war against Palmyra in the spring of AD 272 and represent the final brief issues of the regime prior to Aurelian's reconquest of the East. The antoniniani may again be from Antioch, though there are distinct differences from the earlier series and an emergency issue from Emesa has been suggested as a possible alternative.

Joint coinage with Aurelian, late AD 270–spring 272

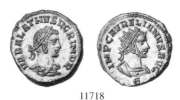

11718

11718 **Billon antoninianus.** VABALATHVS V C R IM D R, laur., dr. and cuir. bust of Vabalathus r. Rev. IMP C AVRELIANVS AVG, rad. and cuir. bust of Aurelian r., officina mark A, B Γ, Δ, Ɛ, Ϛ, Z, or H (= 1, 2, 3, 4, 5, 6, 7, or 8) below. RIC 381. CBN 1238, 1241, 1244, 1246, 1248, 1253, 1255, 1258. MIR 353. Cf. C 1. Hunter1, 5, 7. *[Antioch].* **VF** £30 ($45) / **EF** £100 ($150)
The curious obv. legend has been variously interpreted by scholars, but the most likely expansion of Vabalathus' titles appears to be "Vir Clarissimus, Rex, Imperator, Dux Romanorum". The placing of the officina mark below the bust of Aurelian is a clear indication that this was to be regarded as the reverse side of the coin.

11719 **Billon tetradrachm.** I A C OVABAΛΛAΘOC AΘHN (or AΘHNO) V A (or AVT) C P (or PⲰ), laur. and diad., dr. and cuir. bust of Vabalathus r. Rev. AVT K Λ Δ (or ΔOM) AVPHΛIANOC CEB, laur., dr. and cuir. bust of Aurelian r., L — A (= regnal year 1) in field. Dattari 5421. BMCG —. Cologne 3053. Milne 4303. *[Alexandria, AD 270–71].*
VF £30 ($45) / **EF** £100 ($150)
On the analogy of the antoniniani it would seem likely that the bust of Vabalathus was intended to occupy the obverse of this coin. Most cataloguers, however, have preferred to regard the bust of Aurelian as the obv. type even though the mint was operating under Palmyrene control (see however no. 11722 below).

11720 11721

11720 Similar, but with L — Δ (= regnal year 4) in obv. field or more rarely below bust of Vabalathus, and on rev. the L — A (= regnal year 1) is sometimes before bust of Aurelian instead of in field. Dattari 5422–3. BMCG 2384, 2386. Cologne 3054, 3056. Milne 4308, 4319, 4324. *[Alexandria, AD 270–71].* **VF** £25 ($40) / **EF** £85 ($125)

11721 Billon tetradrachm. Similar, but with L — ε (= regnal year 5) in obv. field, and on rev. with L B (= regnal year 2) usually before bust of Aurelian but sometimes in field. Dattari 5424–5. BMCG 2387, 2390. Cologne 3058, 3063. Milne 4330, 4333. *[Alexandria, AD 271–2].* **VF** £25 ($40) / **EF** £85 ($125)

11722 Bronze of uncertain denomination. ΑΥΡΗΛΙΑΝΟC ΚΑΙ ΑΘΗΝΟΔΩΡΟC (ΚΑΙ sometimes omitted), laur., dr. and cuir. busts of Aurelian r. and Vabalathus, also diad., l., face to face. Rev. L A (= regnal year 1) above L Δ (= regnal year 4) within laurel-wreath. Dattari 5429–30. BMCG 2394–5. Cologne 3057. Milne 4327. *[Alexandria, AD 270–71].* **F** £100 ($150) / **VF** £230 ($350)

The size and weight of specimens of this type vary considerably, from about 21 millimetres and 4.3 grams to 25 millimetres and 8.6 grams. This indicates that two distinct denominations may have been intended. The placement of Aurelian's name, portrait and date clearly indicates that on this issue at least the emperor was accorded precedence over the Palmyrene king. This may signify that on all Alexandrian issues Aurelian was regarded as the senior of the two rulers, contrary to the evidence afforded by the Antiochene antoniniani.

Issues as Augustus, spring-summer AD 272

11723 Billon antoninianus. IM C VHABALATHVS AVG, rad., dr. and cuir. bust r. Rev. AEQVITAS AVG, Aequitas stg. l., holding scales and cornucopiae, star in field. RIC 1. CBN 1263. MIR 354. Cf. C 1 (rev. misdescribed). Cf. Hunter, p. cxix. *[Antioch or Emesa].* **VF** £365 ($550) / **EF** £800 ($1,200)

11724 — — Rev. AETERNITAS AVG, Sol stg. facing, hd. l., raising r. hand and holding globe in l., sometimes with star in field and/or officina mark A (= 1) in ex. RIC 2. CBN —. MIR 355. C 2. Cf. Hunter, p. cxix. *[Antioch or Emesa].* **VF** £365 ($550) / **EF** £800 ($1,200)

11725 — — Rev. IOVI STATORI, Jupiter stg l., holding globe and sceptre, eagle at feet, star in field with or without officina mark Ϛ (= 6) in ex. RIC 3. CBN 1264. MIR 356. Cf. C 3. Cf. Hunter, p. cxix. *[Antioch or Emesa].* **VF** £365 ($550) / **EF** £800 ($1,200)

11726 — — Rev. IVENVS (*sic*) AVG, Hercules stg. r., resting on club and holding three apples, lion's skin on l. arm, star in field. RIC 4. CBN 1265. MIR 359. C 4. Cf. Hunter, p. cxix. *[Antioch or Emesa].* **VF** £365 ($550) / **EF** £800 ($1,200)

11727 — — Rev. VENVS AVG, Venus Victrix stg. l., holding helmet and transverse spear and resting on shield behind, star in field, sometimes with officina mark ε (= 5) in ex. RIC 5. CBN 1266. MIR 361. C 5. Cf. Hunter, p. cxix. *[Antioch or Emesa].* **VF** £365 ($550) / **EF** £800 ($1,200)

11728 — — Rev. VICTORIA AVG, Victory advancing l., holding wreath and palm, star in field. RIC 6. CBN 1267. MIR 357. C 6. Cf. Hunter, p. cxix. *[Antioch or Emesa].* **VF** £365 ($550) / **EF** £800 ($1,200)

11729 — — Rev. VIRTVS AVG, Mars or Virtus stg. r., resting on spear and shield, star in field. Cf. RIC 8. CBN —. MIR 358. C 8. Cf. Hunter, p. cxix. *[Antioch or Emesa].* **VF** £365 ($550) / **EF** £800 ($1,200)

11730 Billon tetradrachm. AVT K OVABAΛΛAΘOC AΘHNO CEB, laur. and diad., dr. and cuir. bust r. Rev. Rad. Bust of Helios r., L — E (= regnal year 5) in field. Dattari 5508. BMCG/Christiansen 3387. Cologne —. Milne 4349. *[Alexandria].* **VF** £365 ($550) / **EF** £1,000 ($1,500)

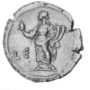

11731

11731 **Billon tetradrachm.** Obv. As 11730. Rev. Homonoia (= Concordia) stg. l., r. hand raised, holding double cornucopiae in l., L E (= regnal year 5) before or in field. Dattari 5509–10. BMCG 2397. Cologne 3064. Milne 4350, 4352. *[Alexandria].* **VF** £300 ($450) / **EF** £800 ($1,200)

ZENOBIA
Queen of Palmyra AD 267–spring 272
Augusta spring–summer AD 272

11732

Septimia Zenobia, known as Bath Zabbai in Aramaic, was the second wife of Septimius Odaenathus, king of Palmyra. A woman of great ambition, somewhat in the mould of Queen Cleopatra of Egypt three centuries before, she claimed descent from the Hellenistic rulers of Syria and Egypt, an ancestry which is likely to have been spurious. The mysterious assassinations in AD 267 of Odaenathus and his son by his first marriage, an episode which may well have been engineered by Zenobia herself, led to the elevation to the Palmyrene throne of her young son Vabalathus and placed her in a position of great power. Zenobia was well aware of the Romans' ultimate desire to eliminate her kingdom. Accordingly, she struck first and, taking advantage of the dispute over the succession following the death of Claudius II in 270, she invaded and conquered Egypt and much of Asia Minor. This gave her control over the two great mints of Antioch and Alexandria at which point coins were struck in the joint names of Vabalathus and the new emperor Aurelian. However, as related above under Vabalathus, Aurelian soon took the offensive and in a lightning campaign in 272 inflicted a series of crushing defeats on the overly-ambitious Palmyrenes, taking both Zenobia and her son prisoner. They later ornamented the emperor's great triumphal procession in Rome after which it seems Zenobia was permitted to retire into private life in a villa near Tibur, where the foothills of the Apennines provided a delightful and highly fashionable location for luxury homes.

* Zenobia did not participate in the joint coinage issued between AD 270 and 272 at Antioch and Alexandria. The only issues in her name belong to the period subsequent to Aurelian's invasion of the East in the spring of 272. In consequence, her coins are all of considerable rarity.*

11732 **Billon antoninianus.** S ZENOBIA AVG, diad. and dr. bust r., crescent behind shoulders. Rev. IVNO REGINA, Juno stg. l., holding patera and sceptre, peacock at feet, star in field, sometimes (possibly always) officina mark H (= 8) in ex. Cf. RIC 2. CBN (Addendum) 1267a. MIR 360. C —. Cf. Hunter, p. cxix. *[Antioch or Emesa].*
 VF £1,000 ($1,500) / **EF** £2,300 ($3,500)

11733 **Billon tetradrachm.** CEΠTIM ZHNOBIA CEB, diad. and dr. bust r. Rev. Rad. bust of Selene r., large lunar crescent before, L / E (= regnal year 5) behind. Cf. Dattari 5513. BMCG 2398. Cologne —. Milne —. *[Alexandria].* **VF** £600 ($900) / **EF** £1,650 ($2,500)

 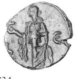

11734 11735

11734 **Billon tetradrachm.** Obv. Similar, CEΠTIMIA but for CEΠTIM. Rev. Elpis (= Spes) advancing l., holding flower and lifting skirt, L — E (= regnal year 5) in field. Dattari 5511. BMCG 2399. Cologne 3065. Milne —. *[Alexandria].* **VF** £525 ($800) / **EF** £1,500 ($2,250)

11735 Obv. As 11733. Rev. Homonoia (= Concordia) stg. l., r. hand raised, holding double cornucopiae in l., L E (= regnal year 5) before or in field. Cf. Dattari 5512. BMCG 2400. Cologne —. Cf. Milne 4353. *[Alexandria].* **VF** £525 ($800) / **EF** £1,500 ($2,250)

TACITUS
Nov./Dec. AD 275–Jun. 276

 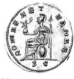

11757

The circumstances of the rise to power of Marcus Claudius Tacitus are more than usually obscure, even for an age in which the documentary sources are notoriously corrupt. What is clear from the numismatic evidence is that there was a delay between the death of Aurelian and the commencement of Tacitus's reign, an interregnum probably lasting little more than a month during which coinage continued in the name of the widowed empress Severina. Tacitus then ascended the throne, late in the year AD 275, and reigned for about six months until his death in the early summer. The traditional account, however, reports a delay of some six months during which there was prolonged contact between the Roman Senate and the conscience-stricken army in the Balkans over who should select a successor to the slain Aurelian. The Senate is then said to have chosen one of its own number, a senator already in his 70s, who bravely set about campaigning against the barbarian invaders of Asia Minor, a task which ultimately overwhelmed his failing health and brought about his early demise at Tyana in Cappadocia. The story further elaborates that the new emperor claimed descent from the famous 1st/2nd century historian Cornelius Tacitus. The reported length of the interregnum is demonstrably erroneous and how much of the other information can be given serious credence is legitimately open to doubt. In view of the vigour which he demonstrated in confronting the Gothic invaders of Asia Minor it seems reasonable to mistrust his reported age. Like the other emperors of this turbulent period he probably had an extensive military career and may also have been a native of the Balkan provinces. The connection with the historian of an earlier age may be nothing more than a fiction on the part of a much later writer intrigued by the emperor's name. Even the cause of his death is open to speculation. The story that he expired of a fever brought on by exhaustion does not seem to have the ring of truth and another military assassination — the norm for the era — seems closer to probability. On Tacitus' death power was seized by his half-brother Marcus Annius Florianus but the succession was soon contested by a more powerful candidate for imperial office, Marcus Aurelius Probus.

Tacitus generally maintained the standards of Aurelian's reformed currency system, though there were a few innovations. The gold aureus was struck in two distinct versions, the heavier weighing about 6.5 grams or 1/50th of a pound of gold (the same as Aurelian's reformed aureus)

and a new lighter version struck at 1/70th of a pound which weighed about 4.6 grams. As usual during this period, the weights of individual specimens may vary considerably. Rare double antoniniani, marked **XI** *and* **IA** *instead of* **XXI** *and* **KA**, *were issued at the eastern mints of Antioch and Tripolis. Aurelian's billon denarius was discontinued and the bronze reduced sestertii (or asses) were only produced in very small quantities. Aurelian's network of mints, as it existed at the end of his reign, was maintained without change by his successor.*

The following are the principal forms of obverse legend, other varieties being given in full:

A. IMP C CL TACITVS AVG
B. IMP C M CL TACITVS AVG
C. IMP C M CL TACITVS P AVG
D. IMP C M CL TACITVS P F AVG
E. IMP C M CLA TACITVS AVG
F. IMP CL TACITVS AVG

The normal obverse type for antoniniani and double antoniniani is radiate bust of Tacitus right, draped and cuirassed or cuirassed only. More unusual types are described in full as are the obverses of all other denominations.

11736 **Gold heavy aureus.** B, rad., dr. and cuir. bust r. Rev. **CONSERVAT AVG, VOT X** in ex., Sol mounting quadriga l., holding whip, the horses prancing. RIC —. CBN —. Calicó 4067. C —. Hunter —. *[Rome].* **VF** £3,300 ($5,000) / **EF** £8,000 ($12,000)

> **NB** In continuation of Aurelian's reformed standard this denomination was struck at 50 to the pound. This produced an average weight of about 6.5 grams, though weights of individual specimens may vary considerably from this norm.

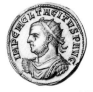

11737

11737 C, rad., dr. and cuir. bust l. Rev. **ROMAE AETERNAE**, Roma seated l., holding Victory and sceptre, shield at side. RIC —. CBN —. Calicó 4089a. C —. Hunter —. *[Siscia].* **VF** £3,300 ($5,000) / **EF** £8,000 ($12,000)

11738 Similar, but with obv. type rad. and cuir. bust l., holding sceptre or spear over shoulder and shield on l. arm. Cf. RIC 74. CBN 1719. Calicó 4090. C 111. Hunter, p. cxxv, note 5. *[Siscia].* **VF** £3,300 ($5,000) / **EF** £8,000 ($12,000)

11739 E, rad., dr. and cuir. bust r., holding sceptre or spear over shoulder . Rev. — similar, but Roma holds Victory on globe. Cf. RIC 175. CBN —. Calicó 4103 and cf. 4094. C —. Hunter —. *[Siscia].* **VF** £3,300 ($5,000) / **EF** £8,000 ($12,000)

11740 Obv. As 11736. Rev. — similar, but Roma holds spear instead of sceptre and with **S C** in ex. RIC —. CBN —. Calicó 4097a (Antioch). C —. Cf. Hunter, p. cxx, note 4. *[Cyzicus or Serdica].* **VF** £2,700 ($4,000) / **EF** £6,700 ($10,000)

11741 C, rad. and cuir. bust l., holding spear over shoulder. Rev. **SALVS PVBLICA**, Salus stg. r., feeding snake held in her arms. RIC —. CBN —. Calicó 4113. C —. Hunter —. *[Lugdunum?].* **VF** £3,300 ($5,000) / **EF** £8,000 ($12,000)

11742 **Gold heavy aureus.** Obv. As 11736. Rev. VICTORIA GOTTHICA COS II, Victory advancing r.,
holding wreath and palm, captive at feet. Cf. RIC 110. Cf. CBN 1781. Cf. Calicó 4118. C 164.
Hunter, p. cxxiv, note 1. *[Ticinum or Serdica].* **VF** £4,300 ($6,500) / **EF** £10,000 ($15,000)
*This commemorates Tacitus' victory over the Gothic invaders of Asia Minor (see also nos.
11821–2).*

11743 D, laur., dr. and cuir. bust r. Rev. VIRTVS AVG, Mars, naked, advancing r., carry spear and
trophy over shoulder. RIC 177. CBN —. Calicó 4121. C —. Hunter, p. cxxvi. *[Siscia].*
VF £2,500 ($3,750) / **EF** £6,000 ($9,000)

11744 Obv. As 11736. Rev. VIRTVS MILITVM, Tacitus, in military attire, on horseback galloping
r., thrusting spear at enemy (sometimes omitted) beneath horse. RIC 179. CBN 1795.
Calicó 4122, 4123a var. C —. Hunter, p. cxxvi. *[Siscia or Cyzicus].*
VF £3,300 ($5,000) / **EF** £8,000 ($12,000)

11745 **Gold light aureus.** B, laur., dr. and cuir. bust r. Rev. CONSERVAT AVG, Sol stg. facing, hd.
l., raising r. hand and holding globe in l. RIC —. CBN —. Calicó 4066. C —. Hunter —.
[Rome]. **VF** £2,000 ($3,000) / **EF** £5,000 ($7,500)

NB This denomination was struck on a standard of 1/70th of a pound averaging about 4.6
grams. Weights of individual specimens may vary considerably from this norm.

11746 C, laur., dr. and cuir. bust r. Rev. CONSERVATOR AVG, Castor stg. l. beside horse, holding
sceptre or spear. RIC 111. CBN 1715. Calicó 4069. C 30. Hunter 39. *[Ticinum or Siscia].*
VF £3,300 ($5,000) / **EF** £8,000 ($12,000)
*This type was derived from the coinage of Geta, younger son of Septimius Severus, which
was itself derived from the coinage of Commodus (see Vol. II, nos. 5611, 7152 and 7169).
See also nos. 10926 and 11004.*

11747 A, laur., dr. and cuir. bust r. Rev. FELICIT TEMPORVM, Felicitas stg. l., holding short
caduceus and resting on sceptre. RIC —. CBN —. Calicó 4072. C —. Hunter —. *[Rome or
Ticinum].* **VF** £2,000 ($3,000) / **EF** £5,000 ($7,500)

11748 Obv. As 11745. Rev. MARS VICTOR, Mars, naked, advancing r., carry spear and trophy
over shoulder, captive at feet. RIC 112. CBN 1716. Calicó 4074. C 55. Hunter, p. cxxiv.
[Ticinum or Siscia]. **VF** £1,850 ($2,750) / **EF** £4,300 ($6,500)

11749 B, laur. and dr. bust r. Rev. PAX AVG, Pax stg. l., holding olive-branch and transverse
sceptre. RIC —. CBN —. Calicó 4074a. C —. Hunter —. *[Rome].*
VF £2,000 ($3,000) / **EF** £5,000 ($7,500)

11750 B, laur. and cuir. bust r. Rev. PAX AVGVSTI, similar, but Pax advancing l. RIC 71. CBN —.
Calicó 4075. C —. Hunter, p. cxx. *[Rome].* **VF** £2,000 ($3,000) / **EF** £5,000 ($7,500)

11751 D, laur., dr. and cuir. bust r. Rev. PAX PERPETVA, similar, but Pax is stg. facing, hd. l.,
sometimes resting on column. RIC 72–3. CBN —. Calicó 4076–7. C 78. Hunter, p. cxx.
[Rome]. **VF** £2,000 ($3,000) / **EF** £5,000 ($7,500)

11752 Obv. As 11745. Rev. PAX PVBLICA, as 11749. RIC 3. CBN —. Calicó 4078. C 79. Hunter,
p. cxxii. *[Lugdunum].* **VF** £1,850 ($2,750) / **EF** £4,300 ($6,500)

11753 E, laur., dr. and cuir. bust r. Rev. P M TR P CONSVL, Tacitus, togate, seated l. on curule
chair, holding globe and short sceptre. Cf. RIC 70. CBN 1714. Cf. Calicó 4083. Cf. C 84.
Hunter 1. *[Rome or Siscia].* **VF** £2,700 ($4,000) / **EF** £6,700 ($10,000)

11754 **Gold light aureus.** F, laur., dr. and cuir. bust r. Rev. PROVIDENTIA DEORVM, Providentia
stg. l., holding rod and cornucopiae, globe at feet. RIC 9. CBN —. Calicó 4087. C —.
Hunter, p. cxxii. *[Lugdunum].* **VF** £1,850 ($2,750) / **EF** £4,300 ($6,500)

11755 Obv. As 11745, or cuir. only. Rev. ROMAE AETERNAE, Roma seated l., holding Victory and
sceptre, shield at side. RIC 75. CBN 1718. Calicó 4092. C 115. Hunter, p. cxx. *[Rome or
Siscia].* **VF** £1,650 ($2,500) / **EF** £4,000 ($6,000)

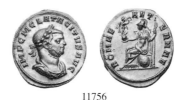

11756

11756 Obv. As 11753. Rev. — similar, but Roma holds Victory on globe. RIC 77. CBN 1718.
Calicó 4101. C 114. Hunter, p. cxx. *[Rome or Siscia].*
VF £1,650 ($2,500) / **EF** £4,000 ($6,000)

11757 Obv. As 11745. Rev. — similar, but Roma sometimes holds spear instead of sceptre, and
with S C in ex. RIC 205 (Cyzicus), 209 (Antioch). CBN 1782–3. Calicó 4096, 4096a
(Antioch). C 116. Cf. Hunter, p. cxx, note 4. *[Cyzicus or Serdica].*
VF £1,850 ($2,750) / **EF** £4,300 ($6,500)

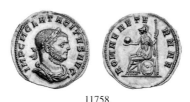

11758

11758 Obv. As 11753. Rev. — similar, but Roma holds plain globus, without Victory, and sceptre,
no S C in ex. RIC 79 (Rome), 117 (Ticinum). CBN 1717 var. Calicó 4110, 4110a. C 121.
Cf. Hunter, p. cxx. *[Rome or Siscia].* **VF** £1,850 ($2,750) / **EF** £4,300 ($6,500)

11759 Obv. As 11746. Rev. SECVRIT PVBLICA, Securitas stg. facing, hd. l., legs crossed, holding
sceptre and resting on column. RIC 118. CBN —. Calicó 4114. C 132. Hunter, p. cxxiv.
[Ticinum or Siscia]. **VF** £2,000 ($3,000) / **EF** £5,000 ($7,500)

11760 Obv. As 11745. Rev. VICTORIA AVG, Victory stg. l., holding holding wreath and palm.
RIC 80. CBN —. Calicó 4115. C 150. Hunter, p. cxx. *[Rome].*
VF £1,850 ($2,750) / **EF** £4,300 ($6,500)

11761 — Rev. VIRTVS AVG, Mars or Virtus stg. l., resting on shield and spear . RIC 81. CBN —.
Calicó 4119. C 169. Hunter, p. cxx. *[Rome].* **VF** £2,000 ($3,000) / **EF** £5,000 ($7,500)

11762 **Billon double antoninianus.** B. Rev. CLEMENTIA TEMP, Tacitus, in military attire, stg. r., usually holding short eagle-tipped sceptre and receiving globe from Jupiter stg. l., holding sceptre, XI in ex., officina mark A-H (= 1–8) in field. RIC 211. CBN 1832–4, 1837. Cf. C 20. Hunter, p. cxxvi. *[Antioch].* **VF** £45 ($65) / **EF** £100 ($150)
The mark of value XI (IA at Tripolis) indicates that the alloy from which these coins were struck contains double the proportion of silver than that used for the antoniniani (marked XXI and KA), i.e. 1/10th instead of 1/20th.

11763 B. Rev. — Mars, in military attire, stg. l., r. knee bent, holding olive-branch and resting on shield, spear propped against l. arm, IA in ex, star in field. RIC 214. CBN 1846. Cf. C 15. Hunter, p. cxxvii. *[Tripolis].* **VF** £50 ($75) / **EF** £115 ($175)

11764 B. Rev. — Tacitus and Jupiter, as 11762, but with IA in ex. and star in field. RIC —. CBN 1848. Cf. C 20. Hunter, p. cxxvii. *[Tripolis].* **VF** £50 ($75) / **EF** £115 ($175)

11765 D. Rev. PROVIDENTIA DEORVM, as previous. RIC —. CBN —. Cf. C 106. Cf. Hunter, p. cxxvii. *[Tripolis].* **VF** £55 ($85) / **EF** £130 ($200)

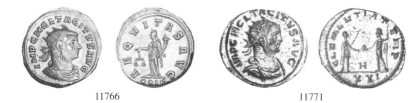

11766 11771

11766 **Billon antoninianus.** B. Rev. AEQVITAS AVG, Aequitas stg. l., holding scales and cornucopiae, XXI and officina mark Γ (= 3) in ex. (the officina mark is sometimes in field). RIC 82. CBN 1602, 1604. Cf. C 7. Hunter 3. *[Rome].* **VF** £16 ($25) / **EF** £45 ($65)

11767 E. Rev. ANNONA AVGVSTI, Annona stg. l., holding corn-ears and cornucopiae, modius at feet, officina mark T (= 3) in ex. RIC 125. CBN 1726. C 14. Hunter, p. cxxiv. *[Ticinum or Siscia].* **VF** £20 ($30) / **EF** £50 ($75)

11768 B. Rev. CLEMENTIA TEMP, Clementia stg. facing, hd. l., legs crossed, holding sceptre and resting on column, XXI and officina mark Z (= 7) in ex. (the officina mark is sometimes in field). Cf. RIC 84. CBN 1637, 1641. C 16. Hunter 14 var. *[Rome].* **VF** £16 ($25) / **EF** £45 ($65)

11769 B. Rev. — Mars with olive-branch, as 11763, officina mark Z (= 7) in ex. (sometimes with XXI or ++I in ex. preceding the officina mark or the officina mark is in field). RIC 83. CBN 1549, 1578, 1581, 1584. C 15. Hunter 4. *[Rome].* **VF** £16 ($25) / **EF** £45 ($65)

11770 B. Rev. — Mars, in military attire, stg. r., holding spear in l. hand and presenting globe to Tacitus, also in military attire, stg l., holding sceptre in l., officina mark P, S, T, Q, or V (= 1, 2, 3, 4, or 5) in ex. Cf. RIC 126. CBN 1801, 1804–5, 1808. C 19. Cf. Hunter, p. cxxiv. *[Cyzicus].* **VF** £20 ($30) / **EF** £50 ($75)

11771 B. Rev. — Tacitus and Jupiter, as 11762, but with XXI instead of XI in ex. RIC 210. CBN 1816, 1818, 1820, 1822, 1824, 1826–7. C 20. Hunter 69–71. *[Antioch].* **VF** £16 ($25) / **EF** £45 ($65)

 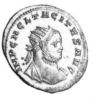

11772 11773

11772 **Billon antoninianus.** C. Rev. CONCORD MILIT or CONCORDIA MILITVM, Tacitus, togate,
 stg. r., clasping r. hands with Concordia stg. l., officina mark P-VI (= 1–6) sometimes
 preceded by XXI in ex. RIC 129, 131. CBN 1740, 1742, 1747–8. C 22–3. Hunter 65 and
 p. cxxiv. *[Ticinum or Siscia].* **VF** £16 ($25) / **EF** £45 ($65)

11773 B, sometimes bare bust r. with drapery over shoulders. Rev. CONSERVAT MILIT, Mars and
 Tacitus, as 11770, but with KA in ex. and officina mark A or B (= 1 or 2) in field. Cf. RIC
 193. CBN 1774, 1776, 1780. Cf. C 25. Hunter, p. cxxvi. *[Serdica].*
 VF £20 ($30) / **EF** £50 ($75)

11774 B. Rev. As previous, but with CONSERVATOR MILITVM and officina mark Ɛ (= 5). RIC —.
 CBN 1800. Cf. C 31. Hunter —. *[Cyzicus].* **VF** £20 ($30) / **EF** £50 ($75)

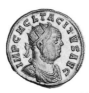 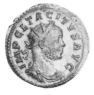

11775 11780

11775 B. Rev. FELICIT TEMP, Felicitas stg. l., holding short caduceus and sceptre, officina mark V
 (= 5) in ex. RIC 140. CBN 1659. C 40. Hunter 48. *[Ticinum].*
 VF £16 ($25) / **EF** £45 ($65)

11776 B. Rev. FELICITAS AVG, Felicitas stg. l., holding long caduceus and cornucopiae, officina
 mark P or T (= 1 or 3) in ex. RIC 136. CBN 1760. C —. Hunter 49. *[Ticinum or Siscia].*
 VF £20 ($30) / **EF** £50 ($75)

11777 B. Rev. — Felicitas stg. l., holding patera and long caduceus, altar at feet, officina mark P,
 S, or T (= 1, 2, or 3) in ex. RIC 135. CBN 1762. C 32. Hunter, p. cxxiv. *[Ticinum or
 Siscia].* **VF** £20 ($30) / **EF** £50 ($75)

11778 D. Rev. FELICITAS SAECVLI, as previous, but with officina letter C (= 3) and star in field.
 RIC 21. CBN 1505. C 35. Hunter, p. cxxiii. *[Lugdunum].* **VF** £16 ($25) / **EF** £45 ($65)

11779 B. Rev. FELICITAS TEMP, as 11775, but with officina mark B (= 2) in ex. RIC —. CBN 1548.
 C —. Hunter —. *[Rome].* **VF** £22 ($35) / **EF** £55 ($85)

11780 F. Rev. FIDES MILITVM, Fides Militum stg. l., holding standard in each hand, officina mark
 B (= 2) and A in ex. RIC 27. CBN 1443. C 47. Hunter, p. cxxii. *[Lugdunum].*
 VF £16 ($25) / **EF** £45 ($65)

11781 **Billon antoninianus.** E. Rev. LAETITIA AVG, Laetitia stg. l., holding wreath and anchor set on globe, officina mark VI (= 6) in ex. RIC 144 var. CBN 1736. C 49. Hunter, p. cxxiv. *[Ticinum or Siscia].* VF £16 ($25) / **EF** £45 ($65)

 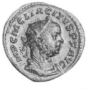

11782 11783

11782 Obv. As 11773. Rev. LAETITIA FVND, similar, but the anchor is not set on globe, XXI followed by officina mark B (= 2) in ex. RIC 89. CBN 1593, 1600. C 52. Hunter 8. *[Rome].*
VF £16 ($25) / **EF** £45 ($65)

11783 D. Rev. MARS VICTOR, Mars, naked, advancing r., carrying transverse spear and trophy, officina mark B (= 2) and star in field. RIC 29. CBN 1491. C 56. Hunter, p. cxxiii. *[Lugdunum].* VF £16 ($25) / **EF** £45 ($65)

11784 B. Rev. MARTI PACIF, Mars, in military attire, advancing l., holding olive-branch, spear and shield, officina mark S (= 2) in ex. RIC 145. CBN 1651, 1684. Cf. C 60. Hunter 50–51. *[Ticinum].* VF £16 ($25) / **EF** £45 ($65)

11785 D. Rev. PAX AETERNA, Pax stg. l., holding olive-branch and sceptre, officina mark III (= 3) in ex., star in field. RIC 33. CBN 1536. C 64. Hunter, p. cxxiii. *[Lugdunum].*
VF £16 ($25) / **EF** £45 ($65)

11786 B. Rev. PAX AVG, similar, but with B L (= 2nd officina of Lugdunum) in ex., nothing in field. Cf. RIC 36. CBN 1439. Cf. C 66. Hunter —. *[Lugdunum].*
VF £22 ($35) / **EF** £55 ($85)

11787 F. Rev. — similar, but Pax advancing l., and with D L (= 4th officina of Lugdunum) in ex. RIC —. CBN 1441. C —. Hunter —. *[Lugdunum].* VF £22 ($35) / **EF** £55 ($85)

11788

11788 C. Rev. PAX AVGVSTI, Pax stg. l., holding olive-branch and transverse sceptre, officina mark Q (= 4) in field, XXI in ex. RIC 186. CBN 1749. C 76. Hunter, p. cxxv. *[Siscia].*
VF £20 ($30) / **EF** £50 ($75)

11789 D. Rev. PAX PVBLICA, similar, but with no mint marks. RIC 44. CBN 1406. C 81. Hunter, p. cxxiii. *[Lugdunum].* VF £16 ($25) / **EF** £45 ($65)

11790 **Billon antoninianus.** Similar, but with obv. type rad. and cuir. bust l. Cf. RIC 44. CBN
 1409. Cf. C 82. Hunter 31. *[Lugdunum].* **VF** £32 ($50) / **EF** £80 ($120)

11791 A. Rev. PROVID D AVG (*sic*), Providentia stg. l., holding rod and cornucopiae, globe at
 feet. RIC 47. CBN 1427. C —. Hunter —. *[Lugdunum].* **VF** £22 ($35) / **EF** £55 ($85)

11792 D. Rev. PROVID DEOR, as previous. RIC 48. CBN 1417. C 88. Hunter 32. *[Lugdunum].*
 VF £16 ($25) / **EF** £45 ($65)

11793 11800

11793 B. Rev. PROVIDE AVG, Providentia stg. l., holding globe and transverse sceptre, officina
 mark Q (= 4) in ex. RIC 152. CBN 1656, 1765. Cf. C 90. Hunter, p. cxxiv. *[Ticinum or
 Siscia].* **VF** £16 ($25) / **EF** £45 ($65)

11794 Similar, but with obv. IMP C M CL TACITVS AVG COS III, rad. bust l., wearing imperial
 mantle and holding eagle-tipped sceptre and mappa. RIC —. CBN —. Cf. C 92. Hunter,
 p. cxxiv, note 3. *[Ticinum or Siscia].* **VF** £150 ($225) / **EF** £300 ($450)
 *Tacitus is only known to have held the consulship twice, the second occasion being in AD
 276, so this obverse is either a mistake on the part of the die-engraver or a misreading by
 the original cataloguer. The issue probably dates to January of 276.*

11795 B. Rev. PROVIDEN DEOR, Fides Militum stg. r., holding standard in each hand, facing Sol
 stg. l., raising r. hand and holding globe in l., KA followed by officina mark A, Γ, or Δ (= 1,
 3, or 4) in ex., sometimes with star in field. RIC 195. CBN 1785–8, 1790–91. C 94.
 Hunter, p. cxxvi. *[Serdica].* **VF** £20 ($30) / **EF** £50 ($75)

11796 Similar, but with obv. legend IMP C TACITVS INVICTVS AVG (or P F AVG). RIC 196–7.
 CBN —. C 95. Hunter, p. cxxvi. *[Serdica].* **VF** £65 ($100) / **EF** £150 ($225)

11797 As 11795, but with obv. type rad., dr. and cuir. bust l., holding spear and shield with
 Medusa hd. RIC —. CBN 1792. Cf. C 97. Cf. Hunter, p. cxxvi. *[Serdica].*
 VF £85 ($130) / **EF** £200 ($300)

11798 IMP C TACITVS AVG. Rev. PROVIDENT DEOR, Tacitus, in military attire, stg. r., holding
 short eagle-tipped sceptre and receiving globe from Jupiter stg. l., holding sceptre, XXI in
 ex., officina mark P, S, T, Q, V, VI, Z, or H (= 1, 2, 3, 4, 5, 6, 7, or 8) in field. RIC 212. CBN
 1810–13. Cf. C 99. Hunter, p. cxxvii. *[Antioch].* **VF** £20 ($30) / **EF** £50 ($75)

11799 B, sometimes bare bust r. with drapery over shoulders. Rev. PROVIDENTIA AVG,
 Providentia stg. with globe at feet, as 11791, XXI followed by officina mark A (= 1) in ex.
 RIC 92. CBN 1587, 1590. C 100. Hunter 10. *[Rome].* **VF** £16 ($25) / **EF** £45 ($65)

11800 E. Rev. PROVIDENTIA DEORVM, as previous, but with officina mark S (= 2) in ex. RIC 155.
 CBN 1723. C 103. Hunter 42 var. *[Ticinum or Siscia].* **VF** £16 ($25) / **EF** £45 ($65)

11801 D. Rev. — as 11798, but with KA in ex. and star and pellet in field. RIC —. CBN 1838. Cf.
 C 106. Hunter, p. cxxvii var. *[Tripolis].* **VF** £22 ($35) / **EF** £55 ($85)

11802 **Billon antoninianus.** Obv. As 11798. Rev. RESTITVT ORBIS, female figure stg. r., holding wreath in raised r. hand, facing Tacitus, in military attire, stg. l., his r. hand extended, holding sceptre in l., XXI in ex., officina mark P or S (= 1 or 2) in field. RIC —. CBN 1814. C —. Hunter, p. cxxvii. *[Antioch]*. VF £22 ($35) / EF £55 ($85)

11803 F. Rev. RESTITVTOR ORBIS, Victory stg. r., holding wreath in raised r. hand and palm in l., facing Tacitus, in military attire, stg. l., his r. hand extended, holding sceptre in l., officina mark B (= 2) and A in ex. RIC 55. CBN 1446. C 108. Hunter, p. cxxii. *[Lugdunum]*. VF £20 ($30) / EF £50 ($75)

11804 B. Rev. ROMAE AETER, Roma seated l., holding Victory and resting on sceptre, shield at side, officina mark Q (= 4) in ex. RIC 156. CBN 1658. C 110. Hunter, p. cxxv. *[Ticinum]*. VF £20 ($30) / EF £50 ($75)

11805 C. Rev. ROMAE AETERNAE, similar, but with XXI followed by officina mark P, T, V, or VI (= 1, 3, 5 or 6) in ex. RIC 188. CBN 1752. C 118. Hunter, p. cxxv. *[Siscia]*. VF £16 ($25) / EF £45 ($65)

11806 Similar, but Roma holds globe instead of Victory, and with XXI followed by officina mark P or S (= 1 or 2) in ex. RIC —. CBN 1754. C —. Hunter 64 var. *[Siscia]*. VF £20 ($30) / EF £50 ($75)

11807 Obv. As 11799. Rev. SALVS AVG, Salus stg. l., feeding snake arising from altar and resting on sceptre, XXI in ex. sometimes followed by officina mark Δ (= 4) or with the officina mark in field. Cf. RIC 93 (misdescribed). CBN 1562–3. C 123. Hunter 5, 12. *[Rome]*. VF £16 ($25) / EF £45 ($65)

11808 F. Rev. — Salus stg. r., feeding snake held in her arms, officina mark C (= 3) and star in field. RIC 57. CBN 1514. C 125. Hunter 29. *[Lugdunum]*. VF £16 ($25) / EF £45 ($65)

11809 B. Rev. — Salus seated l., feeding snake arising from altar before her, officina mark T (= 3) in ex. RIC —. CBN 1653. C 124. Hunter, p. cxxv. *[Ticinum]*. VF £16 ($25) / EF £45 ($65)

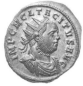

11810 11812

11810 B. Rev. SALVS PVBLI, Salus stg. r., as 11808, officina mark T (= 3) in ex. RIC 160. CBN 1655, 1687, 1690. C 126. Hunter, p. cxxiv. *[Ticinum]*. VF £16 ($25) / EF £45 ($65)

11811 As 11808, but with rev. legend SALVS PVBLICA. RIC 58. CBN 1516. C 130. Hunter, p. cxxiii. *[Lugdunum]*. VF £16 ($25) / EF £45 ($65)

11812 B. Rev. SECVRIT PERP, Securitas stg. facing, hd. l., legs crossed, r. hand on hd., resting l. arm on column, officina mark U or VI (= 5 or 6) in ex. RIC 163. CBN 1662, 1704, 1706, 1708. C 131. Hunter 54. *[Ticinum]*. VF £16 ($25) / EF £45 ($65)

11813 Similar, but with rev. legend SECVRITAS P R, officina mark U (= 5) in ex. RIC 164. CBN —. Cf. C 133. Hunter 55. *[Ticinum]*. VF £20 ($30) / EF £50 ($75)

11814 **Billon antoninianus.** E. Rev. SPES AVG, Spes advancing l., holding flower and lifting skirt, officina mark T (= 3) in field or in ex. RIC 166. CBN 1728. C 135. Hunter, p. cxxv. *[Ticinum or Siscia].* **VF** £20 ($30) / **EF** £50 ($75)

11815 F. Rev. SPES PVBLICA, similar, but with officina mark C (= 3) and A in ex. RIC 61. CBN 1449. C 137. Cf. Hunter, p. cxxii. *[Lugdunum].* **VF** £16 ($25) / **EF** £45 ($65)

11816 B. Rev. — Victory and emperor stg. facing each other, as 11803, KA in ex., officina mark A, B, or Γ (1, 2, or 3) in field. RIC 208 var. CBN 1796, 1798. Cf. C 140 (rev. misdescribed). Cf. Hunter, p. cxxvi (Serdica). *[Cyzicus].* **VF** £20 ($30) / **EF** £50 ($75)

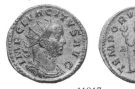

11817

11817 F. Rev. TEMPORVM FELICITAS, Felicitas stg. l., holding long caduceus and cornucopiae, officina mark A or Δ (= 1 or 4) and star in field. RIC 65. CBN 1487, 1521. C 144. Hunter 28. *[Lugdunum].* **VF** £16 ($25) / **EF** £45 ($65)

11818 B, sometimes bare bust r. with drapery over shoulders. Rev. VBERTAS (or VBERITAS) AVG, Uberitas stg. l., holding cow's udder (?) and cornucopiae, XXI usually followed by officina mark Є (= 5) in ex., the officina mark sometimes in field. RIC 95. CBN 1621–4, 1626. C 148. Hunter 15–16. *[Rome].* **VF** £16 ($25) / **EF** £45 ($65)

11819 B. Rev. VICTORIA AVG, Victory stg. l., holding wreath and palm, XXI followed by officina mark A (= 1) in ex. RIC 97. CBN 1557. C 153. Hunter, p. cxxi. *[Rome].*
 VF £16 ($25) / **EF** £45 ($65)

11820 B. Rev. — Victory hovering to front, hd. l., between two shields, holding open wreath with both hands, officina mark P (= 1) below. RIC 170. CBN 1647. C 156. Hunter 58. *[Ticinum].* **VF** £20 ($30) / **EF** £50 ($75)
 This is a revival of a type issued in AD 220/21 under Elagabalus (see Volume II, nos. 7535 and 7554). See also under Gallienus (nos. 10391 and 10492), under Aurelian (no. 11619), and under Probus (no. 11929).

11821 B. Rev. VICTORIA GOTTHI, Victory stg. l., as 11819, officina mark P (= 1) in ex. RIC 172. CBN 1674, 1676. C 157. Hunter 59. *[Ticinum].* **VF** £32 ($50) / **EF** £85 ($125)
 This and the following type commemorate Tacitus' victory over the Gothic invaders of Asia Minor (see also no. 11742).

11822 Similar, but with obv. D, rad. and cuir. bust l. RIC — (omitted in error). CBN 1679. C 159. Cf. Hunter, p. cxxv, note 4. *[Ticinum].* **VF** £55 ($85) / **EF** £130 ($200)

11823 B. Rev. VIRTVS AVG, Mars or Virtus stg. l., resting on shield and spear (or sceptre). RIC 68. CBN 1431. C 170. Hunter 33. *[Lugdunum].* **VF** £16 ($25) / **EF** £45 ($65)

11824 **Billon denarius.** B, laur. and cuir. bust r. Rev. PROVIDEN AVG, Providentia stg. l., holding rod and cornucopiae, globe at feet. RIC 98. CBN — . Cf. C 93. Hunter, p. cxxi. *[Rome].*
 VF £300 ($450) / **EF** £825 ($1,250)

11825 **Billon denarius.** D, laur. and cuir. bust l., holding sceptre over shoulder and shield on l. arm. Rev. VICTORIA AVG, Victory stg. l., holding wreath and palm. RIC 99. CBN 1665. C 151. Hunter, p. cxxi. *[Rome or Ticinum].* **VF** £365 ($550) / **EF** £1,000 ($1,500)

11826 **Billon quinarius.** B, laur. and dr. bust r. Rev. PROVIDENTIA AVG, as 11824. RIC 102. CBN —. C 101. Hunter, p. cxxi. *[Rome].* **VF** £265 ($400) / **EF** £750 ($1,100)

11827 — — Rev. As 11825. RIC 103. CBN —. C 154. Hunter, p. cxxi. *[Rome].*
VF £265 ($400) / **EF** £750 ($1,100)

11828 **Bronze reduced sestertius or as.** B, laur., dr. and cuir. bust r. Rev. FIDES MILITVM, Fides Militum stg. l., holding standard in each hand. RIC 107. CBN —. C 44. Hunter 17. *[Rome].* **F** £200 ($300) / **VF** £500 ($750)

11829 — — Rev. MARS VLTOR, Mars, in military attire, advancing r., holding transverse spear and shield. RIC 108. CBN 1554. C 59. Hunter, p. cxxii. *[Rome].*
F £200 ($300) / **VF** £500 ($750)

Alexandrian Coinage

All have obv. A K KΛ TAKITOC CEB, laur., dr. and cuir. bust r. The reverses are as follows:

11830 **Billon tetradrachm.** ETOVC A (= regnal year 1), Athena seated l., holding Nike and resting on sceptre, shield at side. Dattari 5514. BMCG 2402. Cologne 3114. Milne 4488.
VF £20 ($30) / **EF** £45 ($65)

11831

11835

11831 — — Dikaiosyne (= Aequitas) stg. l., holding scales and cornucopiae. Dattari 5515. BMCG 2403. Cologne 3115. Milne 4489. **VF** £16 ($25) / **EF** £40 ($60)

11832 — — Elpis (= Spes) advancing l., holding flower and lifting skirt. Dattari 5516. BMCG 2404. Cologne 3118. Milne 4493. **VF** £16 ($25) / **EF** £40 ($60)

11833 — — Nike (= Victory) advancing r., holding wreath and palm. Dattari 5518. BMCG 2405. Cologne 3120. Milne 4497. **VF** £16 ($25) / **EF** £40 ($60)

11834 — — eagle stg. r., holding wreath in beak, palm-branch transversely in background. Dattari 5521 var. BMCG/Christiansen 3426. Cologne 3110. Milne 4499.
VF £20 ($30) / **EF** £45 ($65)

11835 — — eagle stg. r., hd. l., holding wreath in beak. Dattari 5519. BMCG 2408. Cologne 3111. Milne 4501. **VF** £16 ($25) / **EF** £40 ($60)

11836 — — similar, but eagle stands l., hd. r. Dattari —. BMCG 2406. Cologne 3113. Milne 4504.
VF £16 ($25) / **EF** £40 ($60)

For another local issue of Tacitus (from Perga in Pamphylia), see *Greek Imperial Coins & Their Values*, pp. 464–5. This is the last reign from which Roman provincial coins have been recorded other than the billon of Alexandria.

FLORIAN
Jun.–Aug./Sep. AD 276

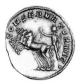

11841

The reign of Marcus Annius Florianus, the younger half-brother of Tacitus, probably lasted less than three months. In a situation reminiscent of the brief reign of Quintillus six years before, Florian was confronted by a more powerful rival and his own troops abandoned him in order to avoid civil war. At the outset of Tacitus' reign he had appointed Florian to the position of praetorian prefect and both brothers had been active in the war against the Gothic invaders of Asia Minor. At the time of Tacitus' sudden death in Cappadocia in the early summer of AD 276 Florian assumed the imperial power and was initially supported by his army and by the majority of the provinces. But a threat soon arose in Syria and Egypt where Marcus Aurelius Probus, one of Aurelian's most capable generals, held a high military command. Just a few weeks after the death of Tacitus Probus was proclaimed emperor by his troops and prepared to advance against Florian in Asia Minor. A head to head confrontation was avoided by the challenger who knew his army could not match the size of his opponent's force. This policy eventually paid off as the effects of the summer heat on Florian's exhausted northern troops, plus the realization that they were up against a superior commander, persuaded them to transfer their allegiance. The unfortunate Florian was murdered leaving Probus in uncontested possession of the imperial throne.

Florian's coinage continued in the pattern established under his immediate predecessor, though only six of Tacitus' eight mints struck for the new emperor. Antioch and Tripolis in the east immediately fell under Probus' control, as did the Egyptian mint of Alexandria with its distinctive Greek tetradrachms for local circulation.

The following are the principal forms of obverse legend, other varieties being given in full:

A. IMP C FLORIANVS AVG
B. IMP C M AN FLORIANVS AVG
C. IMP C M AN FLORIANVS P AVG
D. IMP C M AN FLORIANVS P F AVG
E. IMP C M ANN FLORIANVS AVG
F. IMP M ANNIVS FLORIANVS AVG

The normal obverse type for antoniniani is radiate bust of Florian right, draped and cuirassed or cuirassed only. More unusual types are described in full as are the obverses of all other denominations.

11837

11837 **Gold heavy aureus.** A, laur. and dr. bust r. Rev. CONSERVATOR AVG, Sol mounting quadriga l., holding whip, the horses prancing. RIC 115. CBN —. Calicó 4128. C 17. Hunter, p. cxxvii. [Rome]. **VF** £6,700 ($10,000) / **EF** £16,500 ($25,000)

NB This denomination was struck on a standard of 1/50th of a pound with specimens averaging about 6.5 grams.

11838 **Gold heavy aureus.** Similar, but with obv. IMP C M ANNIVS FLORIANVS AVG, laur., dr. and cuir. bust r. RIC 17, 114. CBN —. Calicó 4124. C 16. Hunter, p. cxxvii. *[Rome or Cyzicus]*.
VF £6,700 ($10,000) / **EF** £16,500 ($25,000)

11839 E, laur., dr. and cuir. bust r. Rev. IOVI VICTORI, Jupiter stg. l., holding Victory and sceptre, eagle at feet. RIC 19. CBN 1886. Calicó 4129. C 37. Hunter, p. cxxvii. *[Rome]*.
VF £6,700 ($10,000) / **EF** £16,500 ($25,000)
The only documented specimen of this type was stolen from the French Cabinet in the great robbery of 1831 and presumably was melted down.

11840 — — Rev. ROMAE AETERNAE, Roma seated l., holding Victory and sceptre, shield at side. RIC 22. CBN 1887. Calicó 4132. C 82. Hunter, p. cxxvii. *[Rome]*.
VF £6,700 ($10,000) / **EF** £16,500 ($25,000)

11841 **Gold light aureus.** As 11838. RIC 17, 114. CBN —. Calicó 4125. C 16. Hunter, p. cxxvii. *[Rome or Cyzicus]*. **VF** £5,300 ($8,000) / **EF** £13,500 ($20,000)

NB This denomination was struck on a standard of 1/70th of a pound with specimens averaging about 4.6 grams.

11842 VIRTVS FLORIANI AVG, laur. and cuir. bust l., holding sceptre over shoulder and shield on l. arm. Rev. MARTI VICTORI, Mars, naked, advancing r., carrying spear and trophy over shoulder. RIC 20. CBN —. Calicó 4130. C 42. Hunter, p. cxxvii. *[Rome]*.
VF £6,000 ($9,000) / **EF** £15,000 ($22,500)

11843 — — Rev. PERPETVITATE AVG, Providentia stg. facing, hd. l., holding globe and transverse sceptre and resting l. arm on column. RIC 21. CBN —. Calicó 4131. C 55. Hunter, p. cxxvii. *[Rome]*. **VF** £6,000 ($9,000) / **EF** £15,000 ($22,500)

11844 11845

11844 — — Rev. VICTORIA PERPET, Victory stg. r., l, foot on helmet, inscribing XXX on shield set on trunk of palm-tree. RIC 23. CBN —. Calicó 4134. C 92. Hunter, p. cxxvii. *[Rome]*.
VF £5,300 ($8,000) / **EF** £13,500 ($20,000)

11845 — — Rev. VIRTVS AVGVSTI, Mars advancing, as 11842, but with captive seated at feet. RIC 24. CBN —. Calicó 4135. C 106. Hunter 1. *[Rome]*.
VF £5,300 ($8,000) / **EF** £13,500 ($20,000)

11846 **Billon antoninianus.** A. Rev. AEQVITAS AVG, Aequitas stg. l., holding scales and cornucopiae, XXI and officina mark Γ (= 3) in ex. (the officina mark is sometimes in field). RIC 25. CBN 1897, 1899. C 1. Hunter 2. *[Rome]*. **VF** £40 ($60) / **EF** £100 ($150)

11847 D. Rev. AETERNITAS AVG, Aeternitas stg. l., holding globe and rudder , sometimes with officina mark IIII (= 4) in ex. RIC 2. CBN 1852, 1862. C 3. Hunter 9. *[Lugdunum]*.
VF £48 ($70) / **EF** £115 ($175)

11846 11849

11848 **Billon antoninianus.** Similar, but Aeternitas holds sceptre instead of rudder. RIC 4. Cf. CBN
 1864 and pl. 65. C 5. Hunter, p. cxxviii. *[Lugdunum].* **VF** £50 ($75) / **EF** £125 ($185)

11849 D. Rev. — Florian, in military attire, stg. l., resting on spear and holding parazonium,
 crowned by Hercules, naked, stg. l., holding club and lion's skin in l. hand. RIC —. CBN
 —. C —. Hunter, p. cxxviii. *[Lugdunum].* **VF** £115 ($175) / **EF** £265 ($400)

11850 A. Rev. CLEMENTIA TEMP, Clementia stg. facing, hd. l., legs crossed, holding sceptre and
 resting l. arm on column, XXI and officina mark Z (= 7) in ex. RIC 27. CBN 1917. C 7.
 Hunter, p. cxxviii. *[Rome].* **VF** £40 ($60) / **EF** £100 ($150)

11851 11854

11851 C. Rev. CONCORD MILIT, Florian, togate, stg. r., clasping r. hands with Concordia stg. l.,
 usually with officina mark P-VI (= 1–6) in ex. RIC 57. CBN 1937, 1943, 1951, 1961. C
 10–11. Hunter, p. cxxix. *[Ticinum or Siscia].* **VF** £40 ($60) / **EF** £100 ($150)

11852 B. Rev. CONCORDIA EXERCI, Concordia Militum stg. l., holding standard in each hand,
 officina mark VI (= 6) and mint mark TI in ex. RIC 58. CBN 1936. C 13. Hunter 18 var.
 [Ticinum]. **VF** £48 ($70) / **EF** £115 ($175)

11853 IMP FLORIANVS AVG. Rev. CONCORDIA MILITVM, Victory stg. r., holding wreath in raised
 r. hand and palm in l., facing Florian, in military attire, stg. l., his r. hand extended, holding
 sceptre in l., officina mark P-V (= 1–5) in ex. RIC 116. CBN 1977, 1979, 1982, 1984,
 1987. C 15. Hunter 20. *[Cyzicus].* **VF** £40 ($60) / **EF** £100 ($150)

11854 C. Rev. FELICITAS AVG, Felicitas stg. l., holding patera and long caduceus, altar at feet,
 officina mark P-V (= 1–5) in field or in ex. RIC 61. CBN 1938, 1944, 1952, 1958. C 19–20.
 Hunter 13–15. *[Ticinum or Siscia].* **VF** £40 ($60) / **EF** £100 ($150)

11855 Similar, but without altar and Felicitas holds long caduceus and cornucopiae, officina mark
 T or Q (= 3 or 4) in field or in ex. RIC 60. CBN 1955–6. C 18. Hunter 16. *[Ticinum or
 Siscia].* **VF** £45 ($65) / **EF** £110 ($165)

11856 C. Rev. FELICITAS SAECVLI, Felicitas with altar, as 11854, officina mark P or V (= 1 or 5) in
 ex. RIC 62. CBN 1942. C 22. Hunter 17. *[Ticinum or Siscia].*
 VF £48 ($70) / **EF** £115 ($175)

11857

11857 **Billon antoninianus.** A. Rev. FIDES MILIT, Fides Militum stg. l., holding sceptre and transverse standard, XXI and officina mark Ɛ (= 5) in ex. RIC 30. CBN 1904. C 25. Hunter 3. *[Rome].* VF £40 ($60) / EF £100 ($150)

11858 F. Rev. INDVLGENTIA AVG, Indulgentia as Spes advancing l., holding flower and lifting skirt, officina mark V (= 5) and mint mark TI in ex. RIC 66. CBN 1935. C 29. Hunter, p. cxxix. *[Ticinum].* VF £50 ($75) / EF £125 ($185)

11859 B. Rev. IOVI CONSERVAT, Jupiter stg. l., holding thunderbolt and sceptre, officina mark T (= 3) and mint mark TI in ex. RIC 68. CBN 1934. C 31. Hunter, p. cxxix. *[Ticinum].*
VF £48 ($70) / EF £115 ($175)

11860 A. Rev. IOVI STATORI, Jupiter stg. facing, hd. r., holding sceptre and thunderbolt, XXI and officina mark Z (= 7) in ex. RIC 32. CBN 1923. C 35. Hunter 4. *[Rome].*
VF £45 ($65) / EF £110 ($165)

11861 A. Rev. LAETITIA FVND, Laetitia stg. l., holding wreath and anchor, XXI and officina mark B (= 2) in ex. (the officina mark is sometimes in field). RIC 34. CBN 1893, 1896. C 38. Hunter, p. cxxviii. *[Rome].* VF £40 ($60) / EF £100 ($150)

11862 C. Rev. MARTI PACIF, Mars, in military attire, advancing l., holding olive-branch in r. hand and spear and shield in l., officina mark S or V (= 2 or 5) in ex. RIC 72. CBN 1962. C 40. Hunter, p. cxxix. *[Ticinum or Siscia].* VF £45 ($65) / EF £110 ($165)

11863 D. Rev. PACATOR ORBIS, Sol advancing l., raising r. hand and holding whip in l., usually with officina mark III (= 3) in ex. RIC 7. CBN 1856. C 47. Hunter, p. cxxviii. *[Lugdunum].*
VF £45 ($65) / EF £110 ($165)

11864 C. Rev. PAX AVGVSTI, Pax stg. (sometimes advancing) l., holding olive-branch and sceptre, officina mark P (= 1) in ex. RIC 73, 75. CBN —. C 52–3. Hunter, p. cxxix. *[Ticinum or Siscia].* VF £45 ($65) / EF £110 ($165)

11865 B. Rev. PERPETVITATE AVG, Perpetuitas/Providentia stg. facing, hd. l., holding globe and transverse sceptre and resting l. arm on column, officina mark Q (= 4) and mint mark TI in ex. RIC 77. CBN —. C 57. Hunter, p. cxxix. *[Ticinum].* VF £50 ($75) / EF £125 ($185)

11866 B. Rev. PRINCIPI IVVENTVT, Florian, in military attire, stg. l., holding globe and spear or sceptre, officina mark P (= 1) and mint mark TI in ex. RIC 81. CBN 1931. C 61. Hunter, p. cxxix. *[Ticinum].* VF £50 ($75) / EF £125 ($185)
This reverse type is normally reserved for an heir to the throne and it is highly unusual to find it referring to a reigning emperor (see also nos. 11913 and 12008).

11867 C. Rev. PROVIDE AVG, Providentia stg. l., holding globe and transverse sceptre, officina mark VI (= 6) in ex. RIC 82. CBN 1963. C 64. Hunter, p. cxxix. *[Ticinum or Siscia].*
VF £45 ($65) / EF £110 ($165)

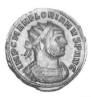

11867 11869

11868 **Billon antoninianus.** F. Rev. PROVIDEN AVG, Providentia stg. l., holding rod and sceptre, globe at feet, officina mark S (= 2) and mint mark TI in ex. RIC 88 var. CBN 1932. C 68. Hunter, p. cxxix. *[Ticinum]*. **VF** £45 ($65) / **EF** £110 ($165)

11869 C. Rev. PROVIDEN DEOR, Fides Militum stg. r., holding standard in each hand, facing Sol stg. l., raising r. hand and holding globe in l., officina mark A, B, Γ, or Δ (= 1, 2, 3, or 4) in ex., usually with star in field. RIC 110. CBN 1975. C 70. Hunter, p. cxxx. *[Serdica]*.
 VF £45 ($65) / **EF** £110 ($165)

11870 B. Rev. PROVIDENTIA AVG, as 11868, but with officina mark III (= 3) in ex. RIC 10. CBN 1873. C 75. Hunter, p. cxxix. *[Lugdunum]*. **VF** £40 ($60) / **EF** £100 ($150)

11871 A. Rev. — similar, but Providentia holds cornucopiae instead of sceptre, and with XXI and officina mark A (= 1) in ex. Cf. RIC 37. CBN 1888. C 76. Hunter 6. *[Rome]*.
 VF £40 ($60) / **EF** £100 ($150)

11872 A. Rev. SALVS AVG, Salus stg. l., feeding snake arising from altar and holding sceptre, XXI and officina mark Δ (= 4) in ex. (the officina mark is sometimes in field). RIC 40. CBN 1901. C 83. Hunter, p. cxxviii. *[Rome]*. **VF** £45 ($65) / **EF** £110 ($165)

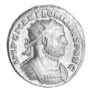

11873 11874

11873 C. Rev. SECVRITAS SAECVLI, Securitas seated l., at ease, her hd. propped on l. hand and holding sceptre in r., officina mark P or V (= 1 or 5) in ex. RIC 95. CBN —. C 87. Hunter, p. cxxix. *[Ticinum or Siscia]*. **VF** £45 ($65) / **EF** £110 ($165)

11874 D. Rev. TEMPORVM FELICITAS, Felicitas stg. facing, hd. r., holding long caduceus and cornucopiae, officina mark I (= 1) in ex. RIC 11. CBN 1853. C 88. Hunter, p. cxxviii. *[Lugdunum]*. **VF** £40 ($60) / **EF** £100 ($150)

11875 E. Rev. VBERITAS (or VBERTAS) AVG, Uberitas stg. l., holding cow's udder (?) and cornucopiae, XXI and officina mark B or Ɛ (= 2 or 5) in ex. RIC 41. CBN —. C 90. Hunter, p. cxxvii. *[Rome]*. **VF** £48 ($70) / **EF** £115 ($175)

11876 E. Rev. VICTORIA PERPETVA AVG, Victory stg. r. facing Florian l., as 11853, star in field, KA and officina mark B, Γ, or Δ (= 2, 3, or 4) in ex. RIC —. CBN 1972. Cf. C 93. Hunter, p. cxxx. *[Serdica]*. **VF** £55 ($80) / **EF** £130 ($200)

11877 **Billon antoninianus.** A. Rev. VIRTVS AVG, Florian, in military attire, stg. r., holding transverse spear and globe, XXI and officina mark Ϛ (= 6) in ex. RIC 47. CBN 1912. C 97. Hunter 7. *[Rome]*. **VF** £40 ($60) / **EF** £100 ($150)

11878 D. Rev. — Florian on horseback galloping r., brandishing spear and trampling down enemy on ground before him. RIC 13. CBN 1850. C 102. Cf. Hunter 10. *[Lugdunum]*.
 VF £80 ($120) / **EF** £200 ($300)

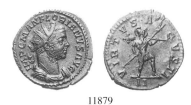

11879

11879 B. Rev. VIRTVS AVGVSTI, Mars, in military attire, advancing r., holding transverse spear and trophy over shoulder, officina mark II (= 2) in ex. RIC 15. CBN 1869. C 105. Hunter, p. cxxix. *[Lugdunum]*. **VF** £40 ($60) / **EF** £100 ($150)

11880 B. Rev. — Florian, in military attire, advancing r., holding transverse spear and shield, captive at feet, officina mark IIII (= 4) in ex. RIC 16. CBN 1878. C 107. Hunter, p. cxxix. *[Lugdunum]*. **VF** £45 ($65) / **EF** £110 ($165)

11881 **Billon denarius.** VIRTVS FLORIANI AVG, laur. and cuir. bust l., holding sceptre over shoulder and shield on l. arm. Rev. VIRTVS AVG, Florian, in military attire, stg. l., holding globe and sceptre. RIC 49. CBN —. C 95. Hunter, p. cxxviii. *[Rome]*.
 VF £525 ($800) / **EF** £1,500 ($2,250)

11882 **Billon quinarius.** A, laur., dr. and cuir. bust r. Rev. VIRTVS AVG, Florian, in military attire, stg. r., holding transverse spear and globe. RIC 50. CBN —. C 100. Hunter, p. cxxviii. *[Rome]*. **VF** £365 ($550) / **EF** £1,000 ($1,500)

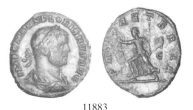

11883

11883 **Bronze reduced sestertius or as.** E, laur., dr. and cuir. bust r. Rev. PAX AETERNA S C, Pax advancing l., holding olive-branch and sceptre. RIC 51 var. CBN —. C 48 var. Hunter, p. cxxviii. *[Rome]*. **F** £230 ($350) / **VF** £600 ($900)

NB The remarkable reappearance of the traditional formula 'S C' on Florian's *aes* coinage would seem to be evidence of a brief reassertion of senatorial authority in a reign throughout which the emperor was absent in the East.

11884 **Bronze reduced sestertius or as.** Obv. As 11883. Rev. Securitas stg. facing, hd. l., legs crossed, holding sceptre and resting on column. RIC 53. CBN 1926. C 85. Hunter, p. cxxviii. *[Rome].* **F** £230 ($350) / **VF** £600 ($900)

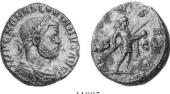

11885

11885 — — Rev. **VIRTVS AVG S C**, Florian stg. r., as 11882. RIC 55. CBN 1927. C 96. Hunter, p. cxxviii. *[Rome].* **F** £230 ($350) / **VF** £600 ($900)

NB There is no Alexandrian coinage in the name of Florian as Probus was proclaimed rival emperor in the East soon after the death of Tacitus in June, AD 276.

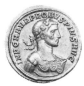

PROBUS
Jun./Jul. AD 276–Sep./Oct. 282

11934

Marcus Aurelius Probus was born at Sirmium on the Danubian frontier late in the reign of Severus Alexander, probably about AD 232. Like so many of his fellow-countrymen he joined the Roman army and rose rapidly through the ranks, eventually becoming one of the Empire's foremost generals. Aurelian entrusted him with command of the German frontier where he successfully confronted Alamannic raids, and later he played a vital role in the defeat of Zenobia and Vabalathus by recovering Egypt from Palmyrene control. Under Aurelian's successor Tacitus he received the supreme command in the East, a powerful and highly prestigious posting. Having thus reached the pinnacle of his military career it was not surprising that his troops in Syria and Egypt proclaimed him emperor very soon after the death of Tacitus, even though the late-emperor's half-brother Florian had already been elevated to the purple and recognized by the Senate and most of the provinces. Despite his larger army Florian was no match for a general of Probus' calibre and after the two armies confronted one another the emperor's troops began to desert to the other side. After a lengthy standoff he was murdered by his own officers who were desirous of avoiding an unnecessary and costly civil war and Probus was left in undisputed possession of the throne. He now made his way to Rome where he received confirmation of his elevation from the Senate — a mere formality — before proceeding to confront a series of barbarian threats to the imperial frontiers. Probus' achievements, and those of the generals he appointed, were impressive, being reminiscent of the activities of his compatriot Aurelian a few years earlier. Alamannic and Frankish invaders were expelled across the Rhine frontier, while the Burgundians and Vandals were defeated in Raetia. By AD 280 he was able to turn his attention to the East where his primary objective was to confront the Sasanid Persians. But circumstances conspired to prevent him from pursuing this goal. Initially, Julius Saturninus, one of his commanders in Syria, was proclaimed emperor by his troops and even had time to issue gold coins at Antioch before being besieged by Probus' forces and killed by his own men. This was followed by an uprising in southern Asia Minor where banditry was rampant in the mountainous region of Isauria. Probus' lieutenants dealt with this menace, capturing the outlaw leader Lydius who had taken refuge in the fortress of Cremna. In the meantime the emperor had had to return rapidly to the West where a more serious uprising was under way in Gaul and Germany. This revolt was led by two of Probus' senior

officers, Proculus and Bonosus, who set up their headquarters in Cologne. Both were defeated by Probus and another uprising by a governor in Britain was speedily suppressed. The emperor proceeded to Rome where he celebrated a great triumph in commemoration of his achievements, just as Aurelian had done seven years before. He then began preparations to resume his attack on Persia but fate intervened once again, this time in the form of a serious revolt headed by the praetorian prefect Carus, who had been proclaimed emperor by the army in Raetia and Noricum. This time, it seems, the army had had enough of Probus' harsh discipline. His policy of employing troops not engaged in warfare on a wide variety of agricultural and civil-engineering projects further aggravated their grievances and the emperor finally fell victim to their wrath when he was attacked by soldiers while supervising a land reclamation project near Sirmium (autumn, AD 282).

The vast antoninianus coinage of Probus is of exceptional interest and the system of mint marks employed is of considerable complexity. As usual, the weights of the gold denominations are quite variable, though it seems that a standard of 1/50th of a pound was intended for the aureus resulting in an average weight for individual specimens of about 6.50 grams. Gold quinarii were produced for the first time since the reign of Philip I (though some were issued under the Gallic emperors) and, as under Aurelian, there are heavier aurei weighing between 8 and 9 grams which should probably be regarded as binios. Like his immediate predecessors Probus produced a limited number of aes types at Rome, though the range of denominations seems to have been expanded. A few billon denarii and quinarii completed the monetary system. Another interesting feature of Probus' coinage, which provided a limited foretaste of future developments under the Tetrarchy, was the expansion of mint marks in some issues to include the initial letter or letters of the mint name. But perhaps the most noteworthy characteristic, on both aurei and antoniniani, was the dramatic proliferation of obverse bust varieties, unmatched by the coinage of any other reign, to include numerous left-facing military types and others showing the emperor in an elaborate imperial mantle and holding an eagle-tipped sceptre. Such busts had appeared under previous emperors and were to recur occasionally in succeeding reigns, but they were always limited issues which are rare today. Under Probus, however, they form part of the regular output of many of the mints.

The following varieties of obv. legend are represented by upper case letters, others (principally from the Serdica mint) being given in full:

A. IMP C M AVR PROBVS AVG
B. IMP C M AVR PROBVS P AVG
C. IMP C M AVR PROBVS P F AVG
D. IMP C PROBVS AVG
E. IMP C PROBVS P AVG
F. IMP C PROBVS P F AVG
G. IMP PROBVS AVG
H. IMP PROBVS P AVG
J. IMP PROBVS P F AVG
K. PROBVS AVG
L. PROBVS P AVG
M. PROBVS P F AVG
N. VIRTVS PROBI AVG

The following varieties of obv. type are represented by lower case letters, others being given in full:

a. Rad. and cuir. bust r.
b. Rad., dr. and cuir. (or dr. only) bust r.
c. Rad. bust l., wearing imperial mantle and holding eagle-tipped sceptre.
d. Cuir. bust l., wearing rad. helmet and holding spear and shield.
e. Laur. and cuir. bust r.
f. Laur., dr. and cuir. bust r.
g. Laur. and cuir. bust l., holding spear (or sceptre)
h. Helmeted and cuir. bust l., holding spear (or sceptre) and shield

When a shield is depicted it is sometimes elaborately decorated or may even bear an inscription.

11886 **Gold binio or double aureus.** C, rad. and cuir. half-length bust l., holding globe
surmounted by Victory and baton. Rev. **ADLOCVTIO AVG**, Probus, accompanied by officer,
stg. r. on platform, holding spear in l. hand and addressing two soldiers stg. l. at foot of
platform, each holding standard and shield. Cf. RIC 581. Cf. Calicó 4137. C 19. Hunter
183. Pink, p. 49, series 2. [Siscia, AD 277]. **VF** £6,700 ($10,000) / **EF** £16,500 ($25,000)

NB Although averaging only about 8.5 grams, it seems clear that these coins were
intended to circulate as double aurei.

11887 G, rad. and cuir. bust l., holding sceptre. Rev. — Probus, accompanied by officer, stg. l. on
platform, addressing gathering of four soldiers, two on each side of platform, each pair
presenting to the emperor a bound captive, six standards in background. RIC 580. Calicó
4136. C 18. Cf. Hunter, p. cxliv. Pink, p. 49, series 2. *[Siscia, AD 277]*.
VF £6,700 ($10,000) / **EF** £16,500 ($25,000)

11888 Ca. Rev. **ADVENTVS AVG**, Probus on horseback pacing l., his r. hand raised, holding spear
in l. RIC —. Calicó 4142. C —. Hunter —. Pink, p. 40, series 2. Pink, p. 58, series 6.
[Rome, AD 281]. **VF** £3,300 ($5,000) / **EF** £8,000 ($12,000)

11889 Ca. Rev. **FIDES MILITVM**, Fides Militum stg. l., holding standard in each hand. RIC —.
Calicó —. C —. Hunter 1. Pink —. *[Rome, AD 281]*.
VF £2,700 ($4,000) / **EF** £6,700 ($10,000)

11890 Similar, but with obv. **IMP C PROBVS INVICTVS AVG**, b. RIC 823. Calicó 4155. C 250.
Hunter, p. cl. Pink —. *[Serdica, AD 280]*. **VF** £3,300 ($5,000) / **EF** £8,000 ($12,000)

 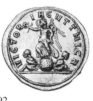

11891 11892

11891 Cc. Rev. **TEMP FELICITAS**, Saturn or Tempus stg. facing, hd. r., resting r. hand on Zodiacal
circle, within which are figures of the four seasons, and holding sceptre in l., naked child
(the new year?) stg. l. on r., holding cornucopiae, mint mark **SIS** in ex. RIC 598. Calicó
4206. C 710. Hunter, p. cxliv. Pink, p. 49, series 2. *[Siscia, AD 277]*.
VF £8,000 ($12,000) / **EF** £20,000 ($30,000)

11892 Cb. Rev. **VICTORIA GVTTHICA** (*sic*), Victory stg. l. on globe between two seated captives,
holding wreath and palm. RIC —. Calicó —. C —. Hunter —. Pink —. *[Siscia, AD 278]*.
VF £4,700 ($7,000) / **EF** £12,000 ($18,000)

11893 Ca. Rev. **VICTORIAE AVGVSTI**, two Victories stg. facing each other, attaching shield
inscribed **VOT / X** to palm tree at base of which are two seated captives, mint mark **SIS** in
ex. RIC 601. Calicó 4234. C 793. Hunter, p. cxliv. Pink, p. 49, series 2. *[Siscia, AD 277]*.
VF £4,000 ($6,000) / **EF** £10,000 ($15,000)

11894 **Gold aureus.** Af. Rev. **ADVENTVS AVG**, Probus on horseback pacing l., his r. hand raised,
holding sceptre in l., preceded by Victory holding wreath and palm. RIC 890. Calicó 4138,
4138a. C —. Hunter, p. clii. Pink, p. 44, series 3. *[Cyzicus, AD 280]*.
VF £2,000 ($3,000) / **EF** £5,300 ($8,000)

NB This denomination averages about 6.5 grams, though weights are quite variable and some specimens are significantly heavier or lighter.

11895 **Gold aureus.** Similar, but on rev. emperor is followed by soldier holding spear and shield, and with mint mark SIS in ex. RIC —. Calicó —. C —. Hunter 185. Pink—. *[Siscia, AD 277].* **VF** £2,300 ($3,500) / **EF** £6,000 ($9,000)

11896 Cc, but laur. Rev. ADVENTVS PROBI AVG, Probus on horseback pacing l., his r. hand raised, holding sceptre in l., captive seated on ground before horse. RIC 2. Calicó 4143. C 54. Hunter, p. cxxxvii. Pink, p. 69, series 4. *[Lugdunum, AD 277].* **VF** £2,700 ($4,000) / **EF** £6,700 ($10,000)

11897 Gg. Rev. AETERNITAS AVG, Sol stg. facing, hd. l., raising r. hand and holding globe in l. RIC 134. Calicó 4144. C 77. Hunter, p. cxxxiii. Pink, p. 59, series 6. *[Rome, AD 281].* **VF** £1,850 ($2,750) / **EF** £5,000 ($7,500)

11898 11899

11898 B, laur. and cuir. bust l. Rev. CONSERVAT AVG, as previous. RIC 309. Calicó 4153. C 178. Hunter, p. cxxxix. Pink, p. 62, series 3. *[Ticinum, AD 277].* **VF** £1,500 ($2,250) / **EF** £4,300 ($6,500)

11899 Af. Rev. — Sol in galloping quadriga l., holding whip, VOT X in ex. RIC —. Calicó 4154a. C —. Hunter —. Pink —. *[Antioch, AD 280].* **VF** £2,300 ($3,500) / **EF** £6,000 ($9,000)

11900 B, laur. bust l., wearing imperial mantle and holding branch or flowers in r. hand, eagle-tipped sceptre in l. Rev. HERCVLI ARCADIO, Hercules r., pinning down stag with his l. knee and grappling with its antlers. RIC 585. Calicó 4155a. C —. Hunter, p. cxliv. Pink, p. 52, series 5. *[Siscia, AD 278].* **VF** £6,700 ($10,000) / **EF** £16,500 ($25,000)
This and the following two types are based on the 'Labours of Hercules' series issued at Cologne late in the reign of Postumus (see nos. 10868, etc.).

11901 Cc, but laur. Rev. HERCVLI ERYMANTHIO, Hercules stg. facing, carrying the wild Erymanthian boar. RIC 586–7 var. Calicó 4156. C 272 var. Hunter, p. cxliv. Pink, p. 52, series 5. *[Siscia, AD 278].* **VF** £6,700 ($10,000) / **EF** £16,500 ($25,000)

11902 Af. Rev. HERCVLI INMORTALI (*sic*), Hercules advancing r., hd. l., holding club over l. shoulder and dragging behind him the triple-headed dog Cerberus. RIC 588. Calicó 4159. C 273. Cf. Hunter, p. cxliv. Pink, p. 52, series 5. *[Siscia, AD 278].* **VF** £6,700 ($10,000) / **EF** £16,500 ($25,000)

11903 Ae. Rev. HERCVLI ROMANO AVG, Hercules stg. facing, hd. l., resting r. hand on trophy and holding club in l. RIC 4. Calicó 4162. Cf. C 298. Hunter, p. cxxxvii. Pink, p. 69, series 3. *[Lugdunum, AD 277].* **VF** £2,000 ($3,000) / **EF** £5,300 ($8,000)
This is a revival of a reverse type originally featured on the coinage of Commodus in AD 192 (see Vol. II, nos. 5586, 5646, and 5752).

11904 **Gold aureus.** Ae. Rev. MARS VICTOR, Mars, naked, advancing r., carrying transverse
spear and trophy over shoulder. RIC 6. Calicó 4166. Cf. C 333. Hunter 76. Pink, p. 69,
series 3. *[Lugdunum, AD 277].* **VF** £1,250 ($1,850) / **EF** £3,700 ($5,500)

11905 Af. Rev. — similar, but with captive seated at feet of Mars. Cf. RIC 824 (rev. type
misdescribed). Calicó 4163 (misdescribed as Lugdunum mint). C 331. Hunter, p. cl. Pink,
p. 46, series 5. *[Serdica, AD 280].* **VF** £1,350 ($2,000) / **EF** £4,000 ($6,000)

11906

11906 Similar, but with obv. legend IMP C PROBVS INVICTVS AVG. RIC 825. Calicó 4165. C —.
Hunter, p. cl. Pink, p. 46, series 5. *[Serdica, AD 280].*
VF £1,850 ($2,750) / **EF** £5,000 ($7,500)

11907 Af. Rev. ORIENS AVG (or AVGVSTI), Sol stg. facing, hd. l., raising r. hand and holding
globe in l., mint mark SIS in ex. RIC 589–90. Calicó 4169–70. C 386, 392. Hunter 184 var.
Pink, p. 49, series 2. *[Siscia, AD 277].* **VF** £1,250 ($1,850) / **EF** £3,700 ($5,500)

11908 Jc, but laur. Rev. PACATOR ORBIS, Probus, in military attire, stg. l. amidst four suppliants,
two of whom are kneeling, his r. hand extended, holding transverse sceptre in l. RIC 136.
Calicó 4172. Cf. C 395. Hunter, p. cxxxiii. Pink, p. 59, series 6. *[Rome, AD 281].*
VF £5,500 ($8,000) / **EF** £13,500 ($20,000)

11909 Fh. Rev. PACI PERPETVAE AVG, Probus stg. l., holding globe and sceptre, altar at feet,
crowned by Victory stg. l. behind, also holding palm. RIC 7. Calicó 4174. C —. Hunter,
p. cxxxvii. Pink, p. 70, series 7. *[Lugdunum, AD 281].*
VF £4,000 ($6,000) / **EF** £10,000 ($15,000)

11910 Ae. Rev. PAX AETERNA, Pax stg. l., holding olive-branch and transverse sceptre. RIC 8.
Calicó 4175. C 396. Hunter, p. cxxxviii. Pink, p. 70, series 7. *[Lugdunum, AD 281].*
VF £1,500 ($2,250) / **EF** £4,300 ($6,500)

11911 N, helmeted and cuir. bust l. Rev. PM TRI P COS III, Probus in quadriga pacing r., holding
eagle-tipped sceptre. RIC 579. Calicó 4177. C 453. Hunter 1842 var. (obv. bust r.). Pink—.
[Siscia, AD 279]. **VF** £4,000 ($6,000) / **EF** £10,000 ($15,000)

11912 Af. Rev. P M TR P V COS IIII P P, Probus in quadriga pacing l., holding olive-branch and
sceptre, mint mark ANT below legend in ex. RIC 914. Calicó 4178. C —. Hunter, p. cliii.
Cf. Pink, p. 40, series 2 (COS III). *[Antioch, AD 281].*
VF £3,300 ($5,000) / **EF** £8,000 ($12,000)

11913 Gf. Rev. PRINCIPIS IVVENTVTI (*sic*), Probus, in military attire, stg. r., holding transverse
spear or sceptre and globe. RIC 892 (attributed to Cyzicus). Calicó 4180 (attributed to
Cyzicus). C 462. Hunter, p. cxliv. Pink, p. 49, series 2. *[Siscia, AD 277].*
VF £1,850 ($2,750) / **EF** £5,000 ($7,500)
This reverse type is normally reserved for an heir to the throne and it is highly unusual to
find it referring to a reigning emperor (see also nos. 11866 and 12008).

11914 **Gold aureus.** Af. Rev. RESTITVTOR VRBIS, Roma seated l., holding Victory and sceptre (or spear), shield at side, crescent in ex. RIC 926. Calicó 4182. C —. Hunter, p. cliii. Cf. Pink, p. 41, series 2, note (authenticity doubted). *[Tripolis, AD 280]*.
VF £2,300 ($3,500) / EF £6,000 ($9,000)
This is a revival of an aureus type issued by Septimius Severus in AD 207 (see Vol. II, no. 6232). On the original, however, Roma holds the Palladium instead of Victory.

11915 Af. Rev. ROMA AETERNA, similar, but without crescent in ex. RIC 893. Calicó 4183. C 525. Hunter, p. clii. Pink, p. 44, series 3. *[Cyzicus, AD 280]*.
VF £1,350 ($2,000) / EF £4,000 ($6,000)

11916 Ae. Rev. ROMAE AETERNAE, as previous. RIC 827. Calicó 4187. C 541. Hunter, p. cl. Pink, p. 46, series 5. *[Serdica, AD 280]*. VF £1,350 ($2,000) / EF £4,000 ($6,000)

11917 Ff. Rev. — similar, but Roma holds globe instead of Victory, and without shield at her side. RIC —. Calicó 4187a. C —. Hunter, p. cxliv. Pink, p. 49, series 2. *[Siscia, AD 277]*.
VF £1,500 ($2,250) / EF £4,300 ($6,500)

11918 Cf. Rev. SALVS AVG, Salus seated r., feeding snake arising from altar. RIC 137 (attributed to Rome). Calicó 4188 (Rome). C 589. Hunter, p. cxxxiii (Rome). Cf. Pink, p. 52, series 5. *[Siscia, AD 278]*. VF £1,500 ($2,250) / EF £4,300 ($6,500)

 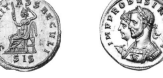

11919 11920

11919 Af. Rev. SECVRITAS SAECVLI, Securitas seated l., at ease, her hd. propped on l. hand and holding sceptre in r., mint mark SIS in ex. RIC 594. Calicó 4189. Cf. C 629 (Securitas stg., in error). Hunter 186. Pink, p. 49, series 2. *[Siscia, AD 277]*.
VF £1,250 ($1,850) / EF £3,700 ($5,500)

11920 Similar, but with obv. IMP PROBVS INV AVG, conjoined busts l. of Probus, laur. and cuir., and Sol, rad. and dr. Cf. RIC 596. Calicó 4198. Cf. C 632 (Securitas stg., in error). Hunter, p. cxliv. Pink, p. 49, series 2. *[Siscia, AD 277]*.
VF £6,700 ($10,000) / EF £16,500 ($25,000)

11921 N, helmeted and cuir. bust l., holding Victory (?) in r. hand, spear and small shield at l. shoulder. Rev. SOLI INVICTO, Sol in facing quadriga, r. hand raised and holding globe and whip in l., the horses spread, two on l. and two on r. RIC 311. Calicó 4200. C 668. Hunter, p. cxxxix. Pink, p. 62, series 3. *[Ticinum, AD 277]*.
VF £5,500 ($8,000) / EF £13,500 ($20,000)

11922 Af. Rev. — Sol stg. facing, hd. l., raising r. hand and holding globe in l., crescent in field. RIC —. Calicó 4200a. C —. Hunter —. Pink —. *[Antioch or Tripolis, AD 280]*.
VF £1,850 ($2,750) / EF £5,000 ($7,500)

11923 Gh. Rev. SOLI INVICTO COMITI AVG, rad. and dr. bust of Sol r. RIC 138. Calicó 4203–4. C 696. Hunter 3. Pink, p. 59, series 6. *[Rome, AD 281]*.
VF £4,000 ($6,000) / EF £10,000 ($15,000)

11924 **Gold aureus.** Similar, but with obv. SOL COMIS PROBI AVG, conjoined busts l. of Probus, helmeted and cuir., and Sol, rad., the emperor holding spear and shield. Cf. RIC 829. Calicó 4202. C —. Hunter, p. cl. Pink, p. 46, series 5. *[Serdica, AD 280].*
 VF £6,700 ($10,000) / **EF** £16,500 ($25,000)

11925 A, laur. and cuir. bust l. Rev. TRI POT COS P P, Probus in quadriga pacing l., holding olive-branch. RIC 1. Calicó 4208. C 731. Hunter, p. cxxxvii. Pink, p. 69, series 4. *[Lugdunum, AD 277].*
 VF £3,700 ($5,500) / **EF** £9,000 ($13,500)

11926 Jg. Rev. VBIQVE PAX, Victory in biga galloping r., holding palm. RIC 139. Calicó 4209. C —. Hunter, p. cxxxiii. Pink, p. 59, series 6. *[Rome, AD 281].*
 VF £3,300 ($5,000) / **EF** £8,000 ($12,000)

11927 J, heroic bust of Probus l., laur. and wearing aegis, holding spear before him. Rev. VICT PROBI AVG, Roma seated l., resting on sceptre and presenting Victory to Probus stg. r. before her, in military attire, standard in background between them, soldier stg. r. behind the emperor holding another standard, wreath in ex. Cf. RIC 140 (wrong obv. legend). Calicó 4210. C 733. Hunter, p. cxxxvi. Pink, p. 59, series 6. *[Rome, AD 281].*
 VF £6,700 ($10,000) / **EF** £16,500 ($25,000)

11928 Fg. Rev. VICTORIA AVG, Victory stg. r. on globe between two seated captives, holding wreath and palm. RIC 600. Calicó 4213. C —. Hunter, p. cxliv. Pink, p. 52, series 5. *[Siscia, AD 278].*
 VF £1,500 ($2,250) / **EF** £4,300 ($6,500)

11929 Af. Rev. — Victory hovering l. between two shields, holding open wreath with both hands. RIC —. Calicó 4214a. C —. Hunter —. Pink —. *[Siscia?, AD 277–8].*
 VF £2,000 ($3,000) / **EF** £5,300 ($8,000)
 This is a revival of a type issued in AD 220/21 under Elagabalus (see Volume II, nos. 7535 and 7554). See also under Gallienus (nos. 10391 and 10492), under Aurelian (no. 11619), and under Tacitus (no. 11820).

11930

11930 Gg. Rev. VICTORIA GERM, trophy between two seated German captives. RIC 142. Calicó 4216, 4216a. C 763. Hunter, p. cxxxiv. Cf. Pink, p. 59, series 6. *[Rome, AD 281].*
 VF £2,300 ($3,500) / **EF** £6,000 ($9,000)

11931 Ae. Rev. VICTORIA GOTHIC, Victory advancing l., holding wreath and palm, captive at feet. RIC 10. Calicó 4218. C 777. Hunter, p. cxxxviii. Pink, p. 69, series 3. *[Lugdunum, AD 277].*
 VF £2,000 ($3,000) / **EF** £5,300 ($8,000)

11932 Af. Rev. VICTORIA PERPETVA, Victory in biga galloping l. RIC 830. Calicó 4220. C 778. Hunter, p. cl. Pink, p. 46, series 5. *[Serdica, AD 280].*
 VF £2,300 ($3,500) / **EF** £6,000 ($9,000)

11933 A, laur. and cuir. bust l. Rev. VICTORIA PROBI AVG, Victory, holding wreath and palm, advancing r. towards trophy between two seated captives. RIC 11. Calicó 4221. C 779 var. Hunter, p. cxxxviii. Pink, p. 70, series 7. *[Lugdunum, AD 281].*
 VF £2,300 ($3,500) / **EF** £6,000 ($9,000)

11934 **Gold aureus.** IMP C M AVR PROBVS PIVS AVG, e (but fuller bust with elaborate cuirass). Rev. VICTORIAE AVG, Victory in slow quadriga pacing l., holding wreath and palm. RIC 833. Calicó 4228. C —. Hunter, p. cl. Pink, p. 46, series 5. *[Serdica, AD 280].*

 VF £2,000 ($3,000) / **EF** £5,300 ($8,000)

11935 Af. Rev. — Victory in biga galloping r., holding whip, sometimes with with mint mark A or A and dot in ex. RIC 918. Calicó 4231–4232a. C 786. Hunter, p. cliii. Pink, p. 40, series 2. *[Antioch, AD 280].* **VF** £2,000 ($3,000) / **EF** £5,300 ($8,000)

11936 Similar, but with rev. legend VICTORIAE AVGG (no mint mark). RIC 919. Calicó 4233. C —. Hunter, p. cliii. Cf. Pink, p. 40, series 2, note 3. *[Antioch, AD 280].*

 VF £2,700 ($4,000) / **EF** £6,700 ($10,000)

 It has been suggested that the plural ending of the reverse legend may indicate that this type was struck during the usurpation of Saturninus in AD 280 (cf. Pommeroy, 'The Revolt of Saturninus' in Schweizerische Numismatische Rundschau 19, 1969, pp. 54–5).

11937 Jg. Rev. VICTORIOSO SEMPER, Probus, in military attire, stg. l. amidst four suppliants, two of whom are kneeling, his r. hand extended, holding transverse sceptre in l., wreath in ex. RIC 143. Calicó 4238. C 795. Hunter, p. cxxxvi. Pink, p. 59, series 6. *[Rome, AD 281].*

 VF £5,500 ($8,000) / **EF** £13,500 ($20,000)

11938 Jg. Rev. VIRT PROBI AVG, Mars advancing r., carrying transverse spear and trophy over shoulder. RIC 145. Cf. Calicó 4240. C —. Hunter, p. cxxxiv. Pink, p. 59, series 6. *[Rome, AD 281].* **VF** £1,850 ($2,750) / **EF** £5,000 ($7,500)

11939

11939 Jg. Rev. VIRTVS AVG, Probus, in military attire, seated l. on curule chair, receiving globe from Mars stg. r. before him, holding spear, and crowned by Victory stg. l. behind him, holding palm, soldier in background holding standard, another standard to r., wreath in ex. RIC 146. Calicó 4241. C 837. Hunter 33. Pink, p. 59, series 6. *[Rome, AD 281].*

 VF £5,500 ($8,000) / **EF** £13,500 ($20,000)

11940 N, helmeted and cuir. bust r. Rev. — Probus on horseback pacing l., his r. hand raised, holding sceptre in l., captive seated on ground before. RIC 899. Calicó 4242. C —. Hunter, p. clii. Pink, p. 44, series 3. *[Cyzicus, AD 280].* **VF** £2,300 ($3,500) / **EF** £6,000 ($9,000)

11941 Af. Rev. VIRTVS AVGVSTI, Mars advancing, as 11938, but he is between two seated captives, mint mark SIS in ex. RIC 603. Calicó 4243–4243b. C 862. Hunter, p. cxliv. Pink, p. 49, series 2. *[Siscia, AD 277].* **VF** £1,350 ($2,000) / **EF** £4,000 ($6,000)

11942 Ae. Rev. — Probus, in military attire, stg. facing, hd. l., placing r. hand on trophy with two captives seated at base and holding sceptre in l. RIC 12. Calicó 4245. Cf. C 863. Hunter, p. cxxxviii. Pink, p. 69, series 3. *[Lugdunum, AD 277].*

 VF £1,500 ($2,250) / **EF** £4,300 ($6,500)

11943 **Gold aureus.** Af. Rev. VIRTVS PROBI AVG, Probus, in military attire, stg. r., l. foot on seated captive, holding spear and parazonium, another captive kneeling r. behind. RIC 13. Calicó 4246. C 906. Hunter, p. cxxxviii. Pink, p. 70, series 7. *[Lugdunum, AD 281].*
VF £1,500 ($2,250) / **EF** £4,300 ($6,500)

11944 C, helmeted and cuir. bust r. Rev. — Probus on horseback galloping r., holding shield in l. hand and spearing enemy who is trampled by his horse, shield on ground below. RIC 900 (attributed to Cyzicus). Calicó 4250 (Cyzicus). C 909. Cf. Hunter, p. cl. Pink, p. 46, series 5. *[Serdica, AD 280].*
VF £2,300 ($3,500) / **EF** £6,000 ($9,000)

11945 Af. Rev. VIRTVTI AVGVSTI, Hercules stg. r., r. hand on hip, l. resting on club wrapped in lion's skin and set on rock. RIC 902. Calicó 4255–6. C 943. Cf. Hunter, p. clii. Pink, p. 44, series 3. *[Cyzicus, AD 280].* **VF** £1,850 ($2,750) / **EF** £5,000 ($7,500)
This type appears to have been inspired by the coinage of Gordian III (see no. 8595).

11946 **Gold quinarius.** Ke. Rev. FIDES MILITVM, Fides Militum stg. l., holding standard in each hand. RIC 147. C —. Hunter, p. cxxxiii. Pink, p. 59, series 6. *[Rome, AD 281].*
VF £2,000 ($3,000) / **EF** £5,300 ($8,000)

11947

11947 Le. Rev. MARS VLTOR, Mars, in military attire, advancing r., holding transverse spear and shield. RIC 148. C 348. Hunter, p. cxxxiii. Pink, p. 59, series 6. *[Rome, AD 281].*
VF £1,650 ($2,500) / **EF** £4,700 ($7,000)

11948 Ge. Rev. VICTORIA GER, trophy between two seated German captives. RIC 149. C 755. Hunter, p. cxxxiv. Pink, p. 59, series 6. *[Rome, AD 281].*
VF £2,300 ($3,500) / **EF** £6,000($9,000)

11949 **Billon antoninianus.** Fa. Rev. ABVNDANTIA AVG, Abundantia stg. r., emptying cornucopiae held in both hands, officina mark IIII (= 4) in ex. RIC 17. C 1. Hunter 82. Pink, p. 69, series 5. *[Lugdunum, AD 279–80].* **VF** £14 ($20) / **EF** £38 ($55)

11950

11950 Fa. Rev. ADLOCVTIO AVG, Probus, in military attire, stg. l. on platform, accompanied by officer stg. behind him, haranguing large gathering of soldiers and being presented with two bound captives by cavalrymen with horses on either side, no mint mark. RIC 321 var. C —. Hunter, p. cxl. Pink, p. 4, series 4. *[Ticinum, AD 278].*
F £220 ($325) / **VF** £750 ($1,100)

11951 **Billon antoninianus.** Similar, but with obv. IMP C PROBVS AVG COS (or CONS) III, c. RIC 320. C 27. Hunter, p. cxl. Pink, p. 64, series 5. *[Ticinum, AD 279].*

F £250 ($375) / **VF** £825 ($1,250)

11952 Ab. Rev. ADVENTVS AVG, Probus on horseback pacing l., his r. hand raised, holding sceptre in l., XXI followed by officina mark P, S, T, Q, V, or VI (1, 2, 3, 4, 5, or 6) in ex. RIC 625. C 47. Hunter, p. cxlv. Pink, p. 50, series 4. *[Siscia, AD 277].* **VF** £12 ($18) / **EF** £32 ($50)

11953 Gd. Rev. — similar, but with captive seated on ground before horse, mint and officina marks R A, R B, R Γ, R Δ, R Ε, R Ϛ, or R Z (= officina 1, 2, 3, 4, 5, 6, or 7) in ex. with symbols star, crescent, crescent with dot, or wreath between them. RIC 157. C 39. Hunter 15, 22, 30, 41, 53, and pp. cxxxvi-vii. Pink, pp. 56–7, series 3–5. *[Rome, AD 278–80].*

VF £14 ($20) / **EF** £38 ($55)

11954 11955

11954 Fa. Rev. ADVENTVS PROBI AVG, as previous, but with officina mark I, III, or IIII (= 1, 3, or 4) in ex. RIC 19, 63. C 68. Hunter, p. cxxxviii. Pink, p. 68, series 3. *[Lugdunum, AD 277].*

VF £14 ($20) / **EF** £38 ($55)

11955 Dd. Rev. — as 11953, but without symbol or with star between the mint and officina marks. RIC 164. C 66. Hunter, p. cxxxv. Pink, pp. 55–6, series 2–3. *[Rome, AD 277–8].*

VF £14 ($20) / **EF** £38 ($55)

11956 Aa. Rev. AEQVITAS AVG, Aequitas stg. l., holding scales and cornucopiae, XXI followed by officina mark Γ (= 3) in ex. (the officina mark is sometimes in field). RIC 150. C 74. Hunter 4. Pink, p. 54, series 1. *[Rome, AD 276].* **VF** £14 ($20) / **EF** £38 ($55)

11957 Ma. Rev. AETERNITAS AVG, Sol stg. facing, hd. l., raising r. hand and holding globe in l., mint and officina marks R Z (= 7th officina) in ex. with I between. RIC 168. C 78. Hunter, p. cxxxvii. Pink, p. 59, series 7. *[Rome, AD 282].* **VF** £16 ($25) / **EF** £45 ($65)

The letter 'I' appearing between the mint and officina marks forms part of the word 'AEQVITI'. This may have been Probus' personal signum, or signet, and other letters in the word are combined with the mint marks of other reverse types in this series.

11958 Ab. Rev. — she-wolf stg. r., suckling the twins Romulus and Remus, XXI followed by officina mark P or S (= 1 or 2) in ex. RIC 639. C 80. Hunter, p. cxlv. Pink, p. 51, series 4. *[Siscia, AD 277].* **VF** £20 ($30) / **EF** £50 ($75)

11959 Aa. Rev. CLEMENTIA TEMP, Clementia stg. facing, hd. l., legs crossed, holding sceptre and resting on column, XXI followed by officina mark Z (= 7) in ex. (the officina mark is sometimes in field). RIC 642 (attributed to Siscia). C 84. Hunter, p. cxxxiv. Pink, p. 55, series 1. *[Rome, AD 276].* **VF** £16 ($25) / **EF** £45 ($65)

11960 Ab. Rev. — Probus, in military attire, stg. r., holding sceptre and receiving globe from Jupiter stg. l., holding sceptre, XXI in ex., officina mark A to H, and ΕΔ (= 1 to 8, and 9) in field. RIC 921. C 87. Hunter, p. cliii. Pink, p. 40, series 2. *[Antioch, AD 280–81].*

VF £10 ($15) / **EF** £30 ($45)

11961 **Billon antoninianus.** Cb. Rev. CLEMENTIA TEMP, similar, but the globe is surmounted by
Victory. RIC 922. C 99. Hunter 327. Pink, p. 40, series 2. *[Antioch, AD 280–81].*
VF £10 ($15) / **EF** £30 ($45)

11962 11964

11962 Fa. Rev. COMES AVG, Minerva stg. l., holding olive-branch and resting on shield, spear
propped against l. arm, officina mark A (= 1) in field. RIC 116. C 105. Hunter 93. Pink,
p. 70, series 8. *[Lugdunum, AD 282].* **VF** £15 ($22) / **EF** £40 ($60)

11963 Similar, but with rev. legend COMITI PROBI AVG and with officina mark I (= 1) in ex. RIC
69. C 106. Hunter 83. Pink, p. 70, series 6. *[Lugdunum, AD 281].*
VF £16 ($25) / **EF** £45 ($65)

11964 Ab. Rev. CONCORD AVG, Fides Militum stg. r., holding standard in each hand, facing Sol
stg. l., raising r. hand and holding globe in l., officina and mint marks S XX T (= 2nd
officina) in ex. RIC 323. C 112. Hunter 103. Pink, p. 61, series 3. *[Ticinum, AD 277].*
VF £15 ($22) / **EF** £40 ($60)
The mint initial 'T' also serves as the 'I' of the mark of value 'XXI'.

11965 11967

11965 IMP C PROBVS AVG CONS IIII, c. Rev. CONCORD MILIT, Concordia Militum stg. l., holding
standard in each hand, XXI preceded by officina letter P (= 1) in ex., E in field. RIC 485. C
129. Hunter, p. cxl. Pink, p. 67, series 9. *[Ticinum, AD 281].*
VF £45 ($65) / **EF** £100 ($150)
*The letter appearing in the reverse field forms part of the word 'EQVITI'. This may have
been Probus' personal signum, or signet, and other letters in the word are combined with
the mint marks of other reverse types in this series.*

11966 Ja. Rev. CONCORDIA AVG, Concordia stg. l., holding patera and double cornucopiae, XXI
in ex., officina mark P-VII (= 1–7) in field. RIC 661. C 150. Hunter 250–51. Pink, p. 53,
series 7. *[Siscia, AD 280].* **VF** £12 ($18) / **EF** £32 ($50)

11967 Jc. Rev. CONCORDIA MILIT, Probus, togate, stg. r., clasping r. hands with Concordia stg. l.,
XXI in ex., officina mark P-VII (= 1–7) in field. RIC 666. C 161. Hunter, p. cxlvi. Pink,
p. 53, series 7. *[Siscia, AD 280].* **VF** £14 ($20) / **EF** £38 ($55)

11968 **Billon antoninianus.** Ab. Rev. CONCORDIA MILITVM, Victory stg. r., holding wreath in
raised r. hand and palm in l., facing Probus, in military attire, stg. l., his r. hand extended,
holding sceptre in l., XXI preceded or followed by mint mark MC in ex., officina mark P-V
(= 1–5) in field. RIC 908. C 173. Hunter 324–5. Pink, p. 43, series 3. *[Cyzicus, AD 280].*
 VF £14 ($20) / **EF** £38 ($55)

 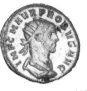

 11969 11973

11969 Nd. Rev. CONSERVAT AVG, Sol holding globe, as 11957, officina and mint marks T XX T
(= 3rd officina) in ex. RIC 351. C 199. Hunter 114. Cf. Pink, p. 61, series 3. *[Ticinum,
AD 277].* **VF** £14 ($20) / **EF** £38 ($55)
The mint initial 'T' also serves as the 'I' of the mark of value 'XXI'.

11970 Fa. Rev. FELICIT TEMP, Felicitas stg. l., holding caduceus and sceptre, sometimes with
officina mark II (= 2) in ex. RIC 26. C 210. Hunter, p. cxxxviii. Pink, p. 70, series 6.
[Lugdunum, AD 281]. **VF** £12 ($18) / **EF** £32 ($50)

11971 Ab. Rev. FELICITAS AVG, Felicitas stg. l., holding patera and long caduceus, altar at feet,
XXI in ex., officina mark A-Ɛ (= 1–5) in field. RIC 675. C 214. Hunter 282. Pink, p. 47,
series 1. *[Siscia, AD 276].* **VF** £12 ($18) / **EF** £32 ($50)

11972 Similar, but Felicitas holds cornucopiae instead of caduceus. RIC 676. C 215. Hunter,
p. cxlix. Pink, p. 47, series 1. *[Siscia, AD 276].* **VF** £14 ($20) / **EF** £38 ($55)

11973 Similar, but Felicitas holds long caduceus and cornucopiae (no altar). RIC 682. C 218.
Hunter 283–4. Pink, p. 47, series 1. *[Siscia, AD 276].* **VF** £12 ($18) / **EF** £32 ($50)

11974 Bb. Rev. FELICITAS AVG N, as previous, XXI in ex., usually with officina mark Δ or Ɛ (= 4
or 5) in field. RIC 685 var. C 223 var. Hunter, p. cxlix. Pink, p. 50, series 2. *[Siscia,
AD 277].* **VF** £15 ($22) / **EF** £40 ($60)

11975 Ab. Rev. — as 11972, XXI in ex., officina mark A (= 1) in field. RIC —. C —. Hunter,
p. cxlix. Pink, p. 50, series 2. *[Siscia, AD 277].* **VF** £16 ($25) / **EF** £45 ($65)

11976 Cb. Rev. FELICITAS SAECVLI, as 11971, XXI followed by officina mark S (= 2) in ex. RIC
688. C 235. Hunter, p. cxlv. Pink, p. 51, series 5. *[Siscia, AD 278].*
 VF £15 ($22) / **EF** £40 ($60)

11977 Nd. Rev. FELICITAS SEC, as 11973, officina and mint marks S XX T (= 2nd officina) in ex.,
sometimes with star in field. RIC 361. C 231. Cf. Hunter, p. cxli. Pink, p. 61, series 3.
[Ticinum, AD 277]. **VF** £14 ($20) / **EF** £38 ($55)
The mint initial 'T' also serves as the 'I' of the mark of value 'XXI'.

11978 Fa. Rev. FIDES MILIT, Fides Militum stg. l., holding standard in each hand, officina and mint
marks VI XX T (= 6th officina) in ex. RIC 365. C 239. Hunter 129. Pink, p. 63, series 4.
[Ticinum, AD 278]. **VF** £10 ($15) / **EF** £30 ($45)
The mint initial 'T' also serves as the 'I' of the mark of value 'XXI'.

 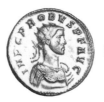

11977 11978

11979 **Billon antoninianus.** Aa. Rev. FIDES MILIT, Fides Militum stg. l., holding sceptre and transverse standard, XXI followed by officina mark Ɛ (= 5) in ex. (the officina mark is sometimes in field). RIC 151 var. C 248. Hunter, p. cxxxiv. Pink, p. 54, series 1 *[Rome, AD 276].* **VF** £12 ($18) / **EF** £32 ($50)

11980 IMP C PROBVS AVG CONS III, c. Rev. — similar, but with mint mark as 11978. Cf. RIC 369. Cf. C 249. Cf. Hunter, p. cxl. Pink, p. 64, series 5. *[Ticinum, AD 279].*
 VF £45 ($65) / **EF** £100 ($150)

11981 Ja. Rev. FIDES MILITVM, as 11978, but with mint and officina marks R Ɛ (= 5th officina) in ex. with wreath or thunderbolt between. Cf. RIC 169. Cf. C 254. Hunter 38, 47. Pink, pp. 57–8, series 5 and 6. *[Rome, AD 280–81].* **VF** £10 ($15) / **EF** £30 ($45)

11982 Ab. Rev. — as 11979. RIC 151 var. C 261. Hunter, p. cxxxiv. Pink, p. 54, series 1 *[Rome, AD 276].* **VF** £14 ($20) / **EF** £38 ($55)

11983 F, rad. and cuir. bust l. Rev. — Fides Militum seated l., holding standard in each hand, a third standard set in ground to l., XXI followed by officina mark P or V (= 1 or 5) in ex. RIC 692. C 263. Hunter 217. Pink, p. 50, series 4. *[Siscia, AD 277].* **VF** £16 ($25) / **EF** £45 ($65)

11984 Fa. Rev. HERCVLI PACIF (or PACIFERO), Hercules stg. l., holding branch in raised r. hand and club and lion's skin in l., officina and mint marks S XX T, V XX T, or VI XX T (= 2nd, 5th, or 6th officina) in ex. RIC 375, 381. C 281, 289. Hunter 130 and p. cxli. Pink, p. 63, series 4. *[Ticinum, AD 278].* **VF** £12 ($18) / **EF** £32 ($50)
 The reverse legend on this type may sometimes read ERCVLI or AERCVLI or some other variant of HERCVLI. The mint initial 'T' also serves as the 'I' of the mark of value 'XXI'.

11985 Ab. Rev. INDVLGENTIA AVG, Spes advancing l., holding flower and lifting skirt, officina and mint marks V TI (= 5th officina) in ex. RIC 314. C 303. Hunter, p. cxl. Pink, p. 60, series 1. *[Ticinum, AD 276].* **VF** £65 ($100) / **EF** £170 ($250)

 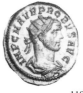

11986 11988

11986 Ja. Rev. IOVI CONS PROB AVG, Jupiter stg. l., holding thunderbolt and sceptre, mint and officina marks R B (= 2nd officina) in ex. with wreath or thunderbolt between. RIC 173. C 306. Hunter 48. Pink, pp. 57–8, series 5 and 6. *[Rome, AD 280–81].*
 VF £12 ($18) / **EF** £32 ($50)

11987 **Billon antoninianus.** Ab. Rev. IOVI CONSERVAT, as previous, but with officina and mint marks T TI (= 3rd officina) in ex. RIC 315. C 320. Hunter 100. Pink, p. 60, series 1. *[Ticinum, AD 276].* **VF** £14 ($20) / **EF** £38 ($55)

11988 Similar, but with rev. type Probus, in military attire, stg. r., holding short sceptre and receiving globe from Jupiter stg. l., holding sceptre, officina and mint marks V XX T (= 5th officina) in ex., sometimes with star in field. RIC 386. C 307, 313. Hunter, p. cxli. Pink, p. 61, series 2. *[Ticinum, AD 276].* **VF** £10 ($15) / **EF** £30 ($45)
The reverse legend on this type may sometimes read CONSERVA or CONSERVATO instead of CONSERVAT. The mint initial 'T' also serves as the 'I' of the mark of value 'XXI'.

11989 Aa. Rev. IOVI STATORI, Jupiter stg. facing, hd. r., holding sceptre and thunderbolt, XXI followed by officina mark Z (= 7) in ex. (the officina mark is sometimes in field). RIC 152. C 322. Hunter, p. cxxxiv. Pink, p. 54, series 1 *[Rome, AD 276].*
VF £14 ($20) / **EF** £38 ($55)

11990 Aa. Rev. LAETITIA AVG (or AVGVSTI), Laetitia stg. l., holding wreath and anchor, officina mark IIII (= 4) in ex. RIC 31. C 324, 329. Hunter 77. Pink, p. 68, series 2 and 3. *[Lugdunum, AD 276 and 277].* **VF** £12 ($18) / **EF** £32 ($50)

11991 Ab. Rev. LAETITIA FVND, similar, but with XXI followed by officina mark B (= 2) in ex. (the officina mark is sometimes in field). Cf. RIC 153. C 330. Hunter, p. cxxxiv. Pink, p. 54, series 1 *[Rome, AD 276].* **VF** £14 ($20) / **EF** £38 ($55)

11992 Fa. Rev. MARS VICTOR, Mars, naked, advancing r., carrying spear and trophy over shoulder, officina mark II or III (= 2 or 3) in ex. RIC 84. C 334. Hunter 85. Pink, p. 68, series 3. *[Lugdunum, AD 277].* **VF** £12 ($18) / **EF** £32 ($50)

11993 Ma. Rev. MARTI PACIF, Mars, in military attire, advancing l., holding olive-branch in r. hand and shield and spear in l., mint and officina marks R Γ (= 3rd officina) in ex. with Q between. RIC 177. C 350. Hunter 62. Pink, p. 59, series 7. *[Rome, AD 282].*
VF £12 ($18) / **EF** £32 ($50)
The letter 'Q' appearing in the exergue forms part of the word 'EQVITI'. This may have been Probus' personal signum, or signet, and other letters in the word are combined with the mint marks of other reverse types in this series.

11994 Aa. Rev. MARTI PACIFERO, Mars, in military attire, stg. l., holding olive-branch and spear, shield to l., officina mark II (= 2) in ex. RIC 42. C 365. Hunter, p. cxxxviii. Pink, p. 68, series 2. *[Lugdunum, AD 276].* **VF** £14 ($20) / **EF** £38 ($55)

11995 Fa. Rev. MARTI VICTORI AVG, as previous. RIC 89. C 367. Hunter, p. cxxxviii. Pink, p. 70, series 6. *[Lugdunum, AD 281].* **VF** £20 ($30) / **EF** £50 ($75)

11996 Aa. Rev. ORIENS AVG, Sol stg. r., holding whip and bow and treading down captive, officina mark III (= 3) in ex. RIC 45. Cf. C 387. Hunter, p. cxxxviii. Pink, p. 68, series 2. *[Lugdunum, AD 276].* **VF** £15 ($22) / **EF** £40 ($60)

11997 Aa. Rev. — Sol advancing l. between two captives, stepping on the one to l., raising r. hand and holding globe in l., officina mark I (= 1) in ex. RIC 44. Cf. C 388. Hunter 79. Pink, p. 68, series 2. *[Lugdunum, AD 276].* **VF** £12 ($18) / **EF** £32 ($50)

11998 Ac. Rev. — Sol in galloping quadriga l., officina and mint marks S XX T (= 2nd officina) in ex. RIC —. C —. Hunter, p. cxli. Pink, p. 61, series 4. *[Ticinum, AD 278].*
VF £22 ($35) / **EF** £55 ($85)
The mint initial 'T' also serves as the 'I' of the mark of value 'XXI'.

 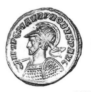

 11999 12001

11999 **Billon antoninianus.** Fa. Rev. ORIGINI AVG, She-wolf stg. r., suckling the twins Romulus
 and Remus, XXI followed by officina mark T (= 3) in ex. RIC 703. C 394. Hunter, p. cxlv.
 Pink, p. 51, series 4. *[Siscia, AD 277].* **VF** £50 ($75) / **EF** £130 ($200)

12000 Fa. Rev. PAX AVG, Pax stg. l., holding olive-branch and transverse sceptre, XXI in ex.,
 officina mark P-VI (= 1–6) in field. RIC 706. C 401. Hunter 247. Pink, p. 53, series 7.
 [Siscia, AD 280]. **VF** £10 ($15) / **EF** £30 ($45)

12001 Bd. Rev. PAX AVGVSTI, as previous. RIC 715. C 423. Hunter, p. cxlvi. Pink, p. 53, series
 7. *[Siscia, AD 280].* **VF** £12 ($18) / **EF** £32 ($50)

12002 IMP C PROBVS AVG CONS IIII, c. Rev. — as previous, but with XXI preceded by officina
 mark V (= 5) in ex., and with T in field. RIC 521. C 431. Hunter, p. cxl. Pink, p. 67, series
 9. *[Ticinum, AD 281].* **VF** £45 ($65) / **EF** £100 ($150)
 *The letter 'T' appearing in the reverse field forms part of the word 'EQVITI'. This may have
 been Probus' personal signum, or signet, and other letters in the word are combined with
 the mint marks of other reverse types in this series.*

12003 Ab. Rev. PERPETVITATE AVG, Perpetuitas/Providentia stg. facing, hd. l., holding globe and
 transverse sceptre and resting l. arm on column, officina mark Q (= 4) and mint mark TI in
 ex. RIC 317. C 434. Hunter, p. cxl. Pink, p. 60, series 1. *[Ticinum, AD 276].*
 VF £22 ($35) / **EF** £55 ($85)

12004 Fa. Rev. PIETAS (or PIAETAS) AVG, Pietas stg. l., holding patera and box of incense, altar at
 feet, officina mark III (= 3) in ex. RIC 93, 96. C 435, 437. Hunter 88. Pink, p. 70, series 6
 and 7. *[Lugdunum, AD 281].* **VF** £12 ($18) / **EF** £32 ($50)

 12005

12005 Bc. Rev. P M TR P COS P P, Probus, in military attire, stg. l. between two standards, raising
 r. hand and holding sceptre in l., XXI or KA followed by officina mark P-VI (= 1–6) in ex.
 RIC 609. C 441. Hunter, p. cxliv. Pink, pp. 50–51, series 4. *[Siscia, AD 277].*
 VF £20 ($30) / **EF** £50 ($75)

12006 Cd. Rev. P M TRI P COS II P P, lion, sometimes rad., walking l. (or r.), sometimes devouring
 bull's hd., sometimes holding thunderbolt in jaws, XXI followed by officina mark P-VI (=
 1–6) in ex., sometimes with star in field. RIC 613. C 448. Hunter, p. cxlv. Pink, p. 51,
 series 5. *[Siscia, AD 278].* **VF** £45 ($65) / **EF** £100 ($150)

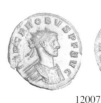

12007 12012

12007 **Billon antoninianus.** Fa. Rev. P M TRI P COS III P P, as previous, but no star in field. Cf.
 RIC 616. Cf. C 457–8. Hunter, p. cxlv. Pink, p. 52, series 6. *[Siscia, AD 279].*
 VF £45 ($65) / **EF** £100 ($150)

12008 Ab. Rev. PRINCIPI IVVENTVT, Probus, in military attire, stg. l., holding globe and spear or
 sceptre, officina mark P (= 1) and mint mark TI in ex. RIC 318. C 464. Hunter, p. cxl. Pink,
 p. 60, series 1. *[Ticinum, AD 276].* **VF** £22 ($35) / **EF** £55 ($85)
 *This reverse type is normally reserved for an heir to the throne and it is highly unusual to
 find it referring to a reigning emperor (see also nos. 11866 and 11913).*

12009 IMP PROBVS INV AVG, a. Rev. PROV PROBI AVG NOSTRI, Providentia stg. l., holding rod
 and cornucopiae, globe at feet, XXI (sometimes KA) in ex., officina mark ε or ς (= 5 or 6)
 in field. RIC 729. C 503. Hunter, p. cxlix and note 1. Pink, p. 50, series 2. *[Siscia, AD 277].*
 VF £45 ($65) / **EF** £100 ($150)

12010 Aa. Rev. PROVIDE AVG, Providentia stg. l., holding globe and transverse sceptre, XXI in
 ex., officina mark ς (= 6) in field. RIC 716. C 468. Hunter, p. cxlix. Pink, p. 47, series 1.
 [Siscia, AD 276]. **VF** £12 ($18) / **EF** £32 ($50)

12011 Ab. Rev. PROVIDEN DEOR, Fides Militum stg. r., holding standard in each hand, facing Sol
 stg. l., raising r. hand and holding globe in l., KA followed by officina mark A-Δ (= 1–4) in
 ex. (sometimes with dots either side of officina mark), star in field. RIC 845. C 472. Hunter
 296, 298. Pink, p. 45, series 2. *[Serdica, AD 276].* **VF** £14 ($20) / **EF** £38 ($55)

12012 Similar, but with obv. legend BONO IMP C PROBO AVG. Cf. RIC 850. C 476 var. Hunter,
 p. cli. Pink, p. 45, series 2. *[Serdica, AD 276].* **VF** £65 ($100) / **EF** £170 ($250)

12013 Db. Rev. PROVIDENT AVG, Providentia stg., as 12010, XXI preceded by officina mark S
 (= 2) in ex., E in field. RIC 466. C 477. Hunter, p. cxlii. Pink, p. 66, series 7. *[Ticinum,
 AD 280].* **VF** £12 ($18) / **EF** £32 ($50)
 *The letter 'E' appearing in the reverse field forms part of the word 'AEQVIT'. This may
 have been Probus' personal signum, or signet, and other letters in the word are combined
 with the mint marks of other reverse types in this series.*

12014 Similar, but with obv. IMP C M AVR PROBVS AVG CONS III, c, and with Ω in rev. field. RIC
 493. C 491. Hunter, p. cxl. Pink, p. 66, series 8. *[Ticinum, AD 280].*
 VF £45 ($65) / **EF** £100 ($150)
 *The letter 'Ω' appearing in the reverse field forms part of the word 'EQVITI' (see previous
 note).*

12015 Ma. Rev. PROVIDENTIA AVG, as 12010, but with mint and officina marks R ς (= 6th
 officina) in ex. with T between. RIC 181. C 493. Hunter, p. cxxxvii. Pink, p. 59, series 7.
 [Rome, AD 282]. **VF** £14 ($20) / **EF** £38 ($55)
 *The letter 'T' appearing between the mint and officina marks forms part of the word
 'AEQVITI' (see previous note).*

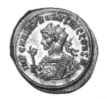

12014

12016 **Billon antoninianus.** Aa. Rev. PROVIDENTIA AVG, Providentia stg. l., holding globe and
cornucopiae, officina mark III (= 3) in ex. RIC 46. C 496. Hunter, p. cxxxviii. Pink, p. 68,
series 2. *[Lugdunum, AD 276]*. **VF** £14 ($20) / **EF** £38 ($55)

12017 Aa. Rev. — similar, but Providentia holds rod and sceptre, globe at feet. RIC 47. C 497.
Hunter, p. cxxxviii. Pink, p. 68, series 1. *[Lugdunum, AD 276]*. **VF** £14 ($20) / **EF** £38 ($55)

12018 Aa. Rev. — similar, but Providentia holds cornucopiae instead of sceptre, XXI followed by
officina mark A (= 1) in ex. (the officina mark is sometimes in field). Cf. RIC 726
(attributed to Siscia). C 498. Hunter, p. cxxxiv. Pink, p. 54, series 1. *[Rome, AD 276]*.
VF £14 ($20) / **EF** £38 ($55)

12019 IMP PROBVS INV AVG, b. Rev. PROVIDENTIA AVG N, as previous, XXI in ex., sometimes
with officina mark Ϛ (= 6) in field. RIC 727. C 500. Hunter, p. cxlix and note 5. Pink, p. 50,
series 2. *[Siscia, AD 277]*. **VF** £38 ($55) / **EF** £85 ($125)

12020 — — Rev. RESTITVT ILIVRICI (*sic*), two female figures stg. back to back between two
standards, each raising the folds of her robe, XXI in ex. Cf. RIC 730. Cf. C 505. Cf. Hunter,
p. cxlix and note 5. Pink, p. 50, series 2. *[Siscia, AD 277]*.
VF £200 ($300) / **EF** £500 ($750)

12021 Cb. Rev. RESTITVT ORBIS, female figure stg. r., holding wreath in raised r. hand, facing
Probus, in military attire, stg. l., holding globe in extended r. hand and sceptre in l., XXI in
ex., officina mark A-H (= 1–8) or ΕΔ (= 5+4 = 9) in field. RIC 925. C 509. Hunter 332–9.
Pink, p. 40, series 2. *[Antioch, AD 280–81]*. **VF** £10 ($15) / **EF** £30 ($45)

12022

12022 BONO IMP C PROBO P F AVG, b. Rev. — similar, but emperor does not hold globe in r.
hand, KA followed by officina mark A-Δ (= 1–4) in ex., star in field. RIC —. C —. Hunter
—. Pink —. *[Serdica, AD 276]*. **VF** £100 ($150) / **EF** £230 ($350)

12023 Ab. Rev. RESTITVT SAEC, Probus, in military attire, stg. l., holding globe and sceptre or
spear, crowned by Victory stg. l. behind him, holding palm, VI XX T (= 6th officina) in ex.
RIC 401. C 511. Hunter 111. Pink, p. 61, series 2. *[Ticinum, AD 276]*.
VF £15 ($22) / **EF** £40 ($60)
The mint initial 'T' also serves as the 'I' of the mark of value 'XXI'.

12024 **Billon antoninianus.** Cb. Rev. RESTITVTOR EXERCITI, Mars, in military attire, stg. r., holding spear in l. hand and presenting globe to Probus, also in military attire, stg l., holding sceptre in l., XXI preceded (or followed) by mint mark M C in ex., officina mark P-V (= 1–5) in field. RIC 909. C 514. Hunter, p. clii. Pink, p. 43, series 3. *[Cyzicus, AD 280].* VF £16 ($25) / EF £45 ($65)

12025 Nd. Rev. RESTITVTOR SECVLI, Probus, in military attire, stg. l., r. foot on captive, holding globe and spear and crowned by Sol stg. l. behind him, holding whip, P XX T (= 1st officina) in ex. RIC 405. C 521. Hunter, p. cxli. Pink, p. 61, series 3. *[Ticinum, AD 277].*
VF £30 ($45) / EF £75 ($110)
On this type and the next the mint initial 'T' also serves as the 'I' of the mark of value 'XXI'.

12026 Ab. Rev. ROMAE AETER (or AETERN), Probus, togate, stg. r., receiving Victory from Roma seated l., holding sceptre, shield at side, Q XX T (= 4th officina) in ex. RIC 407. C 527. Hunter, p. cxli. Pink, p. 61, series 2. *[Ticinum, AD 276].* VF £22 ($35) / EF £60 ($90)

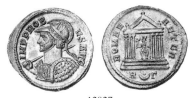

12027

12027 Gd. Rev. — (or AETERNAE), hexastyle temple within which Roma seated facing, holding Victory and sceptre, mint and officina marks R A (or B, Γ, Δ, Ε, S, or Z = 1, 2, 3, 4, 5, 6, or 7) in ex., sometimes with star, crescent, crescent with dot, or wreath between. RIC 186, 195. C 532, 546. Hunter, p. cxxxv. Pink, pp. 55–7, series 2–5. *[Rome, AD 277–80].*
VF £14 ($20) / EF £38 ($55)

12028 Fb. Rev. SALVS AVG, Salus stg. l., feeding snake arising from altar and holding sceptre, officina mark B (= 2) in field or ex. RIC 124. C 566. Hunter, p. cxxxix. Pink, p. 70, series 8. *[Lugdunum, AD 282].* VF £12 ($18) / EF £32 ($50)

12029 Ja. Rev. — Salus stg. r., feeding snake held in her arms, XXI followed by officina mark P-V (= 1–5) in ex. RIC 748. C 572. Hunter, p. cxlv. Pink, p. 51, series 5. *[Siscia, AD 278].*
VF £12 ($18) / EF £32 ($50)

12030 Cc. Rev. — Salus seated l., feeding snake arising from altar and resting l. arm on throne, XXI followed by officina mark P-VI (= 1–6) in ex. RIC 751. C 593. Hunter, p. cxlv. Pink, p. 50, series 4. *[Siscia, AD 277].* VF £14 ($20) / EF £38 ($55)

12031 N, rad. and cuir. bust l., holding spear and shield. Rev. SALVS PVBLI (or PVBLIC, or PVBLICA), Salus holding snake, as 12029, but with XXI preceded by officina mark Γ (= 3) in ex. RIC 569. C 601, 609. Hunter 174. Pink, p. 65, series 6B. *[Ticinum, AD 279].*
VF £16 ($25) / EF £45 ($65)

12032 Similar, but with obv. IMP C PROBVS AVG CONS III, c. RIC 571. Cf. C 603, 605. Hunter, p. cxl. Pink, p. 65, series 6B. *[Ticinum, AD 279].* VF £45 ($65) / EF £100 ($150)

12033 Dc. Rev. SECVRIT PERP, Securitas stg. facing, hd. l., legs crossed, r. hand on hd., resting l. arm on column, XXI preceded by officina mark VI (= 6) in ex., I (usually with star) in field. RIC 525. C 612. Hunter 170. Pink, p. 67, series 9 and 10. *[Ticinum, AD 281–2].*
VF £14 ($20) / EF £38 ($55)

The 'I' appearing in the reverse field represents the final letter of the word 'EQVITI'. This may have been Probus' personal signum, or signet, and other letters in the word are combined with the mint marks of other reverse types in this series.

12034 **Billon antoninianus.** Aa. Rev. SECVRITAS ORBIS, similar, but Securitas holds sceptre in r. hand and with officina mark I (= 1) in ex. RIC 49. C 624. Hunter 80. Pink, p. 68, series 2. *[Lugdunum, AD 276].* **VF** £15 ($22) / **EF** £40 ($60)

12035 IMP C PROBVS INV AVG, b. Rev. SECVRITAS PERPETVA, as 12033, but with XXI in ex. and officina mark Δ (= 4) in field. RIC 759. Cf. C 627. Hunter, p. cxlix and note 6. Pink, p. 50, series 2. *[Siscia, AD 277].* **VF** £38 ($55) / **EF** £85 ($125)

12036 Ab. Rev. SECVRITAS SAECVLI, Securitas seated l., at ease, her hd. propped on l. hand and holding sceptre in r., XXI in ex., officina mark A, B, or Ɛ (= 1, 2, or 5) in field. Cf. RIC 763. Cf. C 633. Hunter, p. cxlix. Pink, p. 48, series 2B. *[Siscia, AD 277].*
VF £16 ($25) / **EF** £45 ($65)

 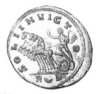

12037 12038

12037 Cd. Rev. SISCIA PROBI AVG, city-goddess of Siscia, holding open diadem with both hands, seated l. between two river-gods (Savus and Colapis), flowing water below, XXI followed by officina mark Q, V, or VI (= 4, 5, or 6) in ex. RIC 764. C 638 var. Hunter, p. cxlv. Pink, p. 51, series 4. *[Siscia, AD 277].* **VF** £130 ($200) / **EF** £300 ($450)
The important mint-city of Siscia was situated at the confluence of the rivers Savus and Colapis in Pannonia. The reason for the appearance of this exceptional type at this time is unclear, though it could have marked the 15th anniversary of the founding of the mint by Gallienus in AD 262 (see no. 10361). Alternatively, it has been suggested that Siscia rather than Sirmium was the true birthplace of the emperor, though there is no further evidence of this.

12038 Gc. Rev. SOLI INVICTO, Sol in galloping quadriga l., his r. hand raised, holding whip and globe in l., mint and officina marks R B (or Γ or Ɛ = 2, 3, or 5) in ex., with star, crescent, crescent with dot, or wreath between. RIC 202. C 644. Hunter 17, 19, 25. Pink, pp. 56–7, series 3–5. *[Rome, AD 278–80].* **VF** £14 ($20) / **EF** £38 ($55)

12039 12041

12039 Nd. Rev. — Sol in facing quadriga, his r. hand raised, holding globe and whip in l., the horses spread, two on l. and two on r., XXI in ex., officina mark A-Ɛ (= 1–5) in field, or sometimes following the mark of value in ex. RIC 779 var. C 671, 690. Hunter, pp. cxlviii–cxlix. Pink, pp. 47, 50, series 2A, 3. *[Siscia, AD 277].* **VF** £14 ($20) / **EF** £38 ($55)

12040 **Billon antoninianus.** Cb. Rev. — similar, but with KA followed by officina mark A-Δ (= 1–4) in ex. RIC 861. C 681. Hunter, p. cli. Pink, p. 45, series 4. *[Serdica, AD 277].*
VF £14 ($20) / **EF** £38 ($55)

12041 Cc. Rev. — similar, but with mint mark C M above XXI in ex., usually followed by officina mark P-V (= 1–5). RIC 911. C 682. Hunter 314–18. Pink, p. 44, series 3. *[Cyzicus, AD 280].*
VF £15 ($22) / **EF** £40 ($60)

12042 Cc. Rev. SOLI INVICTO AVG, Sol in quadriga l., as 12038, XXI followed by officina mark P, S, or T (= 1, 2, or 3) in ex. RIC 783. C 693. Hunter —. Pink, p. 50, series 4. *[Siscia, AD 277].*
VF £20 ($30) / **EF** £50 ($75)

12043 C, rad. and cuir. bust l., holding spear and shield. Rev. — Sol in facing quadriga, as 12039, XXI followed by officina mark P, S, or VI (= 1, 2, or 6) in ex. Cf. RIC 781. C 695. Hunter —. Pink, p. 51, series 4. *[Siscia, AD 277].*
VF £20 ($30) / **EF** £50 ($75)

12044 Ab. Rev. SPES AVG, Spes advancing l., holding flower and lifting skirt, officina mark C (= 3, sometimes reversed) in field. RIC 127. C 702. Hunter, p. cxxxix. Pink, p. 70, series 8. *[Lugdunum, AD 282].*
VF £12 ($18) / **EF** £32 ($50)

12045 IMP PROBVS INV AVG, b. Rev. SPES AVG N, as previous, XXI in ex. RIC 790. C 705. Cf. Hunter, p. cxlix and note 5. Cf. Pink, p. 50, series 2. *[Siscia, AD 277].*
VF £38 ($55) / **EF** £85 ($125)

12046 Similar, but with rev. legend SPES AVGVSTI NOSTRI. RIC 791. C 706. Hunter, p. cxlix and note 5. Pink, p. 50, series 2. *[Siscia, AD 277].*
VF £60 ($90) / **EF** £130 ($200)

12047 Ab. Rev. SPES PROBI AVG, as 12044, but with officina mark II or III (= 2 or 3) in ex. RIC 99. C 707. Hunter, p. cxxxviii. Pink, p. 70, series 6. *[Lugdunum, AD 281].*
VF £22 ($35) / **EF** £55 ($85)

12048

12048 Fa. Rev. TEMPOR FELICI, Felicitas stg. r., holding long caduceus and cornucopiae, officina mark I (= 1) in ex. RIC 104. C 713. Hunter, p. cxxxviii. Pink, p. 69, series 3–5. *[Lugdunum, AD 277–80].*
VF £12 ($18) / **EF** £32 ($50)

12049 Similar, but with TEMPOR FELICIT and officina mark II (= 2) in ex., or with B (= 2) in field. RIC 107, 129. C 727. Hunter 91, 94. Pink, p. 70, series 7 and 8. *[Lugdunum, AD 281–2].*
VF £12 ($18) / **EF** £32 ($50)

12050 Similar, but with TEMPORVM FELICITAS and officina mark I (= 1) in ex. RIC 53. C 728. Hunter, p. cxxxviii. Pink, p. 68, series 3. *[Lugdunum, AD 277].*
VF £14 ($20) / **EF** £38 ($55)

12051 Ab. Rev. VICT PROBI AVG NOSTRI, Victory advancing r., holding wreath and palm, XXI or KA in ex., officina mark E or ς (= 5 or 6) in field. RIC 793. C —. Hunter, p. cl. Pink, p. 50, series 2. *[Siscia, AD 277].*
VF £38 ($55) / **EF** £85 ($125)

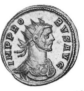

12052 12055

12052 **Billon antoninianus.** Gd. Rev. VICTORIA AVG, Victory advancing l., holding wreath and
trophy, mint and officina marks R Ϛ (= 6) in ex., with wreath or thunderbolt between. RIC
214. C 741. Hunter 54. Pink, pp. 57–8, series 5 and 6. *[Rome, AD 280–81].*
VF £12 ($18) / **EF** £32 ($50)

12053 IMP C PROBVS AVG CONS III, c. Rev. — trophy between two captives seated at base, P XX T
(= 1st officina) in ex. RIC 424. C 751. Hunter, p. cxl. Pink, p. 64, series 5. *[Ticinum,*
AD 279]. **VF** £45 ($65) / **EF** £100 ($150)
The mint initial 'T' also serves as the 'I' of the mark of value 'XXI'.

12054 Ga. Rev. VICTORIA GERM, Victory advancing r. between two captives, holding wreath and
trophy, mint and officina marks R Z (= 7) in ex. with star between. RIC 219 (218 is
misdescribed). C 759. Hunter, p. cxxxv. Pink, p. 56, series 3. *[Rome, AD 278].*
VF £25 ($40) / **EF** £60 ($90)

12055 Ga. Rev. — trophy, as 12053, but with mint and officina marks R A (= 1) in ex., with star,
crescent, crescent with dot, or wreath between. RIC 222. C 768. Hunter 26. Pink, pp. 56–7,
series 3–5. *[Rome, AD 278–80].* **VF** £15 ($22) / **EF** £40 ($60)

12056 Fc. Rev. VICTORIAE AVG, Victory in galloping biga r., holding whip, XXI followed by
officina mark V or VI (= 5 or 6) in ex. RIC 796. C 789. Hunter, p. cxlvi. Cf. Pink, p. 50,
series 4. *[Siscia, AD 277].* **VF** £22 ($35) / **EF** £55 ($85)

12057 Bd. Rev. — two Victories stg. facing each other, clasping r. hands, palm-tree in
background, KA followed by officina mark P, T, or Q (= 1, 3, or 4) in ex. RIC 800. Cf. C
791. Hunter, p. cxlvi. Pink, p. 51, series 4. *[Siscia, AD 277].*
VF £80 ($120) / **EF** £185 ($275)

12058 Fa. Rev. VIRTVS AVG, Mars advancing r., carrying transverse spear and trophy over
shoulder, P XX T (= 1st officina) in ex. RIC 428. C 801. Hunter, p. cxli. Pink, p. 63,
series 4B. *[Ticinum, AD 278].* **VF** £12 ($18) / **EF** £32 ($50)
On this type and the next the mint initial 'T' also serves as the 'I' of the mark of value 'XXI'.

12059

12059 Fc. Rev. — Mars or Virtus stg. l., holding Victory and resting on shield, spear propped
against l. arm, Q XX T (= 4th officina) in ex. RIC 436. C 817. Hunter, p. cxlii. Pink, p. 63,
series 4B. *[Ticinum, AD 278].* **VF** £14 ($20) / **EF** £38 ($55)

12060 **Billon antoninianus.** Fa. Rev. — Hercules stg. (or advancing) l., holding branch and club, lion's skin over l. arm, **XXI** preceded by officina mark Δ (= 4) in ex. RIC 576 var. C 836 var. Hunter 176. Pink, p. 65, series 6B. *[Ticinum, AD 279].* **VF** £45 ($65) / **EF** £100 ($150)

12061 Ab. Rev. — Probus, in military attire, stg. r., holding transverse spear and globe, **XXI** followed by officina mark **A**, **Ϛ**, or **Z** (= 1, 6, or 7) in ex. RIC 801 (attributed to Siscia). C 840. Hunter 279 (tentatively attributed to Siscia). Pink, p. 55, series 1. *[Rome, AD 276–7].* **VF** £14 ($20) / **EF** £38 ($55)

12062 Fa. Rev. — Probus, in military attire, on horseback galloping r., thrusting spear at enemy beneath his horse, **P-VI XX T** (= 1st-6th officinae) in ex. RIC 447 var. Cf. C 849. Hunter 137. Pink, p. 63, series 4B. *[Ticinum, AD 278].* **VF** £16 ($25) / **EF** £45 ($65) *The mint initial 'T' also serves as the 'I' of the mark of value 'XXI'.*

12063 Cc. Rev. **VIRTVS AVGVSTI**, Mars or Virtus stg. l., resting on shield and spear, mint and officina marks **R A-Z** (= 1-7) in ex., sometimes with star between. RIC 234. C 857. Hunter 13–14. Pink, pp. 56–7, series 2 and 3. *[Rome, AD 277–8].* **VF** £14 ($20) / **EF** £38 ($55)

12064 Ab. Rev. — Mars carrying trophy, as 12058, mint and officina marks **R A-Z** (= 1-7) in ex. RIC 240. C 858. Hunter, p. cxxxv. Pink, p. 55, series 2. *[Rome, AD 277].* **VF** £12 ($18) / **EF** £32 ($50)

12065 Aa. Rev. — Probus, in military attire, stg. facing, hd. l., placing r. hand on trophy with captive seated at base and holding sceptre in l., mint mark **R** only, or followed by officina mark **A-Z** (= 1-7) in ex. RIC 243. C 864. Hunter 5. Pink, p. 55, series 2. *[Rome, AD 277].* **VF** £14 ($20) / **EF** £38 ($55)

12066 Aa. Rev. — Probus, in military attire, advancing r., holding transverse spear and shield, captive at feet, officina mark **IIII** (= 4) in ex. RIC 56. C 869. Hunter, p. cxxxviii. Pink, p. 68, series 1. *[Lugdunum, AD 276].* **VF** £15 ($22) / **EF** £40 ($60)

12067 Cc. Rev. — Probus galloping r., as 12062, **XXI** in ex. followed by officina mark **Ɛ** or **Ϛ** (= 5 or 6), or with officina mark **Γ** or **Ɛ** (= 3 or 5) in field. RIC 806. C 873. Hunter, pp. cxlviii and cl. Pink, pp. 47 and 50, series 2A and 3. *[Siscia, AD 277].* **VF** £16 ($25) / **EF** £45 ($65)

12068 Similar, but Probus galloping l., **XXI** in ex., officina mark Δ (= 4) in field. RIC 806. Cf. C 874. Cf. Hunter, p. cl. Pink, p. 47, series 2A. *[Siscia, AD 277].* **VF** £16 ($25) / **EF** £45 ($65)

12069 Nd. Rev. **VIRTVS INVICTI AVG**, Probus, in military attire, stg. l., r. foot on captive, holding Victory and parazonium, crowned by Sol stg. l. behind him, holding whip, **T XX T** (= 3rd officina) in ex. RIC 456. C 849. Hunter, p. cxlii. Pink, p. 61, series 3. *[Ticinum, AD 277].* **VF** £45 ($65) / **EF** £100 ($150) *On this type and the next the mint initial 'T' also serves as the 'I' of the mark of value 'XXI'.*

12070 Nd. Rev. — Probus galloping r., as 12062, but sometimes with Victory in background to r., **P** (or **T-VI**) **XX T** (= 1st or 3rd-6th officinae) in ex. RIC 454. C 878–9. Hunter, p. cxlii. Pink, pp. 61–2, series 3. *[Ticinum, AD 277].* **VF** £20 ($30) / **EF** £50 ($75)

12071 Cc. Rev. **VIRTVS PROBI AVG**, Mars advancing r., carrying transverse spear and trophy over shoulder, **XXI** followed by officina mark **P-VI** (= 1–6) in ex., or with officina mark in field. RIC 810. C 900. Hunter 236. Pink, pp. 51 and 53, series 5 and 7. *[Siscia, AD 278, 280].* **VF** £14 ($20) / **EF** £38 ($55)

 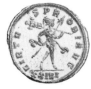

12071 12074

12072 **Billon antoninianus.** Aa. Rev. VIRTVS PROBI AVG, similar, but with two captives seated at
 feet of Mars, to l. and to r. RIC 811. C 903. Hunter 213. Pink, p. 51, series 4. *[Siscia,
 AD 277].* **VF** £16 ($25) / **EF** £45 ($65)

12073 Cc. Rev. — Probus, in military attire, on horseback galloping r., thrusting spear at enemy
 beneath his horse, XXI followed by officina mark P-VI (= 1–6) in ex., or with officina mark
 in field. RIC 817. C 918. Hunter 198 and 237–8. Pink, pp. 50 and 53, series 3 and 7.
 [Siscia, AD 277, 280]. **VF** £15 ($22) / **EF** £40 ($60)

12074 Cc. Rev. — similar, but Probus is galloping to l. RIC 818. C 930. Hunter 199. Pink, pp. 50
 and 53, series 3 and 7. *[Siscia, AD 277, 280].* **VF** £15 ($22) / **EF** £40 ($60)

 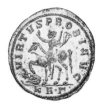

12075

12075 Cd. Rev. — Probus on horseback pacing l., raising r. hand and holding sceptre in l., captive
 seated on ground before horse, KA followed by officina mark A, B, Γ, or Δ (= 1, 2, 3, or 4),
 sometimes flanked by dots, in ex. RIC 886. C 928. Hunter 299. Pink, p. 45, series 4.
 [Serdica, AD 277]. **VF** £14 ($20) / **EF** £38 ($55)

12076 Cc. Rev. — trophy between two seated captives, XXI followed by officina mark P-VI (=
 1–6) in ex. RIC 820. C 942. Hunter 201–2. Pink, p. 50, series 4. *[Siscia, AD 277].*
 VF £16 ($25) / **EF** £45 ($65)

12077 Nd. Rev. VOTIS X ET XX FEL within laurel-wreath. RIC 459. C 946. Hunter, p. cxlii. Pink,
 p. 62, series 3. *[Ticinum, AD 277].* **VF** £65 ($100) / **EF** £170 ($250)

12078 Similar, but with obv. IMP C PROBVS AVG CONS III, c. RIC 461. C 948. Hunter 99. Pink,
 p. 64, series 5. *[Ticinum, AD 279].* **VF** £80 ($120) / **EF** £200 ($300)

12079 Ac. Rev. VOTIS X PROBI AVG ET XX within laurel-wreath. RIC 462. C 950. Hunter, p. cxlii.
 Pink, p. 62, series 3. *[Ticinum, AD 277].* **VF** £100 ($150) / **EF** £230 ($350)

12080 **Billon denarius.** Me. Rev. MARS VLTOR, Mars, in military attire, advancing r., holding
 transverse spear and shield. RIC —. C —. Hunter —. Pink, p. 59, series 6. *[Rome,
 AD 281].* **VF** £220 ($325) / **EF** £525 ($800)

12081 **Billon denarius.** Gf. Rev. P M TR P COS P P, Probus, in military attire, stg. l. between two standards, raising r. hand and holding sceptre in l. RIC 244. C 439. Hunter, p. cxxxiii. Pink, p. 56, series 2. *[Rome, AD 277].* **VF** £240 ($365) / **EF** £600 ($900)

12082 Df. Rev. P M TRI P COS II P P, Probus, in military attire, stg. l., holding globe in r. hand, spear and shield in l., captive seated at feet. RIC 245. C 445. Hunter, p. cxxxiii. Pink —. *[Rome, AD 278].* **VF** £265 ($400) / **EF** £665 ($1,000)

12083 Fc (but laur.). Rev. P M TRI P COS III, Probus in quadriga pacing r., holding eagle-tipped sceptre. RIC 247. C 454. Hunter, p. cxxxiii. Pink —. *[Rome, AD 279].* **VF** £300 ($450) / **EF** £800 ($1,200)

12084 Ge. Rev. P M TR P V COS IIII P P, Probus stg. l., as 12081. Cf. RIC 248. C —. Hunter, p. cxxxiii. Pink, p. 58, series 6. *[Rome, AD 281].* **VF** £265 ($400) / **EF** £665 ($1,000)

12085 Je. Rev. P M TR P VI COS V P P, as previous. RIC 249. Cf. C 461 (described as a quinarius). Hunter 67. Pink, p. 58, series 6. *[Rome, AD 282].* **VF** £240 ($365) / **EF** £600 ($900)

12086 Je. Rev. PROVIDENTIA AVG, Providentia stg. l., holding rod and cornucopiae, globe at feet. RIC 252. C 499. Hunter, p. cxxxiii. Pink, p. 56, series 2. *[Rome, AD 277].* **VF** £220 ($325) / **EF** £525 ($800)

12087 Je. Rev. VICTORIA GERM, Victory advancing r. between two captives, holding wreath and palm (or trophy). RIC 255. C 760. Hunter, p. cxxxiv. Pink, p. 56, series 3. *[Rome, AD 278].* **VF** £240 ($365) / **EF** £600 ($900)

12088 Je. Rev. — similar, but Victory is advancing l., holding palm instead of trophy. RIC 256 var. C 761 var. Hunter, p. cxxxiv. Pink, p. 56, series 3. *[Rome, AD 278].* **VF** £240 ($365) / **EF** £600 ($900)

12089 Je. Rev. — trophy between two captives seated at base. RIC 258. C 767 var. Hunter, p. cxxxiv. Pink, p. 56, series 3. *[Rome, AD 278].* **VF** £265 ($400) / **EF** £665 ($1,000)

12090 **Billon quinarius.** N, hd. r., wearing lion's skin. Rev. ADVENTVS AVG, Probus on horseback pacing l., his r. hand raised, holding sceptre in l., preceded by Victory holding wreath and palm and followed by soldier holding trophy. RIC 261. C 31. Hunter, p. cxxxiii. Pink, p. 59, series 6. *[Rome, AD 281].* **VF** £300 ($450) / **EF** £800 ($1,200)

12091 Ac (but laur.). Rev. FELICIA TEMPORA, the four seasons as children at play. RIC 262. C 208. Hunter, p. cxxxiii. Pink, p. 52, series 5. *[Siscia?, AD 278].* **VF** £265 ($400) / **EF** £665 ($1,000)

12092 Le. Rev. FIDES MILITVM, Fides Militum stg. l., holding standard in each hand. RIC 265. C 253. Hunter, p. cxxxiii. Pink, p. 59, series 6. *[Rome, AD 281].* **VF** £170 ($250) / **EF** £430 ($650)

12093 Le. Rev. MARS VLTOR, Mars advancing r., as 12080. Cf. RIC 266. Cf. C 349. Hunter, p. cxxxiii. Pink, p. 59, series 6. *[Rome, AD 281].* **VF** £170 ($250) / **EF** £430 ($650)

12094 AVR PROBVS AVG, laur. and cuir. bust l., holding spear and shield. Rev. ORIENS AVG, Sol in quadriga galloping l. RIC 267. C 391. Hunter, p. cxxxii. Pink, p. 62, series 4A. *[Ticinum?, AD 278].* **VF** £240 ($365) / **EF** £600 ($900)

12095 D, laur. and cuir. bust l. Rev. P M TR P COS IIII, Mars, helmeted and in military attire, stg. l., holding globe in r. hand, spear and shield on ground in l., captive seated at feet to l. RIC —. C —. Hunter, p. cxxxiii. Pink, p. 58, series 6. *[Rome, AD 281].* **VF** £200 ($300) / **EF** £500 ($750)

 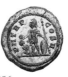

12093 12096

12096 **Billon quinarius.** Gc (but laur.). Rev. P M TR P COS V, as previous. RIC —. C —. Hunter —. Pink —. *[Rome, AD 282].* **VF** £220 ($325) / **EF** £525 ($800)

12097 Je. Rev. VICTOR GER, Victory r. between captives, as 12087. RIC 268. C 734. Hunter, p. cxxxiii. Pink, p. 59, series 6. *[Rome, AD 278].* **VF** £185 ($275) / **EF** £465 ($700)

12098 Ge. Rev. VICTORIA AVG, Victory stg. l., holding wreath and palm. RIC 270. C 737. Hunter, p. cxxxiii. Pink, p. 59, series 6. *[Rome, AD 281].* **VF** £170 ($250) / **EF** £430 ($650)

12099 D, conjoined laur. busts r. of Probus and Hercules. Rev. — similar, but Victory stg. r. between two captives. Cf. RIC 271. Cf. C 749. Cf. Hunter, p. cxxxiv. Pink, p. 56, series 3. *[Rome, AD 278].* **VF** £300 ($450) / **EF** £800 ($1,200)

12100

12100 Je. Rev. VICTORIA GER (or GERM), trophy between two captives seated at base. RIC 274. C 774. Hunter, p. cxxxiv. Pink, p. 59, series 6. *[Rome, AD 281].* **VF** £185 ($275) / **EF** £465 ($700)

12101 Ge. Rev. VIRTVS AVG, Probus, in military attire, stg. r., holding transverse spear and globe. RIC 280. C 843. Hunter 69. Pink, p. 56, series 2. *[Rome, AD 277].* **VF** £170 ($250) / **EF** £430 ($650)

12102 Obv. As 12099. Rev. — Probus, in military attire, stg. l., holding Victory on globe and resting on spear, crowned by Mars stg. l. behind him, resting on shield. RIC 282. C 845. Hunter, p. cxxxiv, note 1. Pink, p. 63, series 4. *[Ticinum?, AD 278].* **VF** £300 ($450) / **EF** £800 ($1,200)

12103 Ke. Rev. — Probus, in military attire, on horseback galloping r., attacking enemy (or two enemies) on ground beneath horse. RIC 284. C 850. Hunter 71. Pink, p. 59, series 6. *[Rome, AD 281].* **VF** £220 ($325) / **EF** £525 ($800)

12104 **Bronze reduced double sestertius or dupondius.** F, rad., dr. and cuir. bust l., holding spear. Rev. ADLOCVTIO AVG, Probus, in military attire, stg. l. on platform, accompanied by officer stg. behind him, haranguing gathering of six soldiers with standards, three on each side. RIC 289. C 23. Hunter, p. cxxxvii. Pink —. *[Rome, AD 281].* **F** £500 ($750) / **VF** £1,200 ($1,800)

12105 Ma. Rev. FIDES MILITVM, Fides Militum stg. l., holding standard in each hand. RIC 290. C —. Hunter, p. cxxxvii. Pink —. *[Rome, AD 281].* **F** £200 ($300) / **VF** £500 ($750)

12106 **Bronze reduced double sestertius or dupondius.** F, rad. and cuir. bust l., with spear and shield, r. hand holding horse. Rev. VICTORIA AVG, trophy between two captives seated at base. RIC 291. C —. Hunter, p. cxxxvii. Pink —. *[Rome, AD 281].*
F £300 ($450) / **VF** £665 ($1,000)

12107 **Bronze reduced sestertius or as.** Me. Rev. ADLOCVTIO AVG, as 12104. RIC 292. C 22. Hunter, p. cxxxvii. Pink, p. 58, series 6. *[Rome, AD 281].*
F £430 ($650) / **VF** £1,100 ($1,650)

12108 Be. Rev. CONSERVAT AVG, Sol advancing l., raising r. hand and holding whip in l. RIC 294. C 204. Hunter 72. Pink, p. 56, series 2, var. *[Rome, AD 277].*
F £170 ($250) / **VF** £430 ($650)

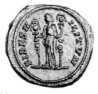

12109 12112

12109 Me. Rev. FIDES MILIT (or MILITVM), as 12105. RIC 295. C 251 var. Hunter 74. Pink, p. 59, series 6. *[Rome, AD 281].* **F** £150 ($225) / **VF** £400 ($600)
It is unclear whether this type exists in two denominations or only one (see no. 12117).

12110 Me. Rev. VBIQVE PAX, Victory in galloping biga r. RIC 296. C 732. Hunter, p. cxxxvii. Pink, p. 59, series 6. *[Rome, AD 281].* **F** £230 ($350) / **VF** £525 ($800)

12111 Ge. Rev. VICTORIA AVG, Victory stg. l., holding wreath and palm. RIC 297. C 736. Hunter, p. cxxxvii. Pink, p. 59, series 6. *[Rome, AD 281].* **F** £150 ($225) / **VF** £400 ($600)
It is unclear whether this type exists in two denominations or only one (see no. 12118).

12112 Ce. Rev. VICTORIA GERM, Victory advancing r. between two seated captives, holding wreath and trophy. Cf. RIC 299 (misdescribed, after Cohen). Cf. C 758. Hunter, p. cxxxvii. Pink, p. 56, series 3. *[Rome, AD 278].* **F** £170 ($250) / **VF** £430 ($650)

12113 Ae. Rev. — trophy, as 12106. RIC 300. C 764. Hunter, p. cxxxvii. Pink, p. 56, series 3. *[Rome, AD 278].* **F** £170 ($250) / **VF** £430 ($650)

12114 Me. Rev. VIRT PROBI AVG, Probus, in military attire, on horseback galloping r., attacking enemy on ground beneath horse, soldier in background. RIC —. C —. Cf. Hunter, p. cxxxvii. Pink, p. 59, series 6. *[Rome, AD 281].* **F** £230 ($350) / **VF** £525 ($800)

12115 Be. Rev. VIRTVS AVG, Probus, in military attire, stg. r., holding transverse spear and globe. RIC 301. C 838. Hunter 73. Pink, p. 56, series 2. *[Rome, AD 277].*
F £150 ($225) / **VF** £400 ($600)

12116 Je. Rev. VIRTVS AVGVSTI, Mars or Virtus stg. l., resting on shield and spear. RIC — (but cf. 304). Cf. C 852. Hunter, p. cxxxvii. Pink, p. 56, series 2. *[Rome, AD 277].*
F £150 ($225) / **VF** £400 ($600)
It is unclear whether this type exists in two denominations or only one (see no. 12119).

12115

12117 **Bronze reduced as or semis.** Me. Rev. FIDES MILITVM, as 12105. RIC 302. C 251. Hunter,
p. cxxxvii. Cf. Pink, p. 59, series 6. *[Rome, AD 281].* F £130 ($200) / **VF** £400 ($500)
It is unclear whether this type exists in two denominations or only one (see no. 12109).

NB Coins of this denomination are smaller and lighter than the reduced sestertii/asses
(22–23 mm. diameter and less than 5 grams, compared to 25–27 mm. and about 8 grams).

12118 Me. Rev. VICTORIA AVG, Victory stg. l., as 12111. RIC 303. C 738. Hunter, p. cxxxvii.
Cf. Pink, p. 59, series 6. *[Rome, AD 281].* F £130 ($200) / **VF** £400 ($500)
It is unclear whether this type exists in two denominations or only one (see no. 12111).

12119 Je. Rev. VIRTVS AVGVSTI, Mars or Virtus, as 12116. RIC 304. Cf. C 852. Hunter,
p. cxxxvii. Cf. Pink, p. 56, series 2. *[Rome, AD 277].* F £130 ($200) / **VF** £400 ($500)
It is unclear whether this type exists in two denominations or only one (see no. 12116).

Alexandrian Coinage

All have obv. A K M AVP ΠΡΟΒΟC CEB, laur. and cuir. bust r. The reverses are as follows:

12120 **Billon tetradrachm.** Dikaiosyne (= Aequitas) stg. l., holding scales and cornucopiae, L A
(= regnal year 1) before. Dattari 5526. BMCG 2411. Cologne 3123. Milne 4512. *[AD 276].*
VF £8 ($12) / **EF** £22 ($35)

12121 Elpis (= Spes) advancing l., holding flower and lifting skirt, L A (= regnal year 1) before.
Dattari 5532. BMCG 2416. Cologne 3124. Milne 4514. *[AD 276].*
VF £8 ($12) / **EF** £22 ($35)

12122 Eagle stg. r., hd. l., holding wreath in beak, L — A (= regnal year 1) in field. Dattari 5548.
BMCG 2425. Cologne 3121. Milne 4517. *[AD 276].* **VF** £8 ($12) / **EF** £22 ($35)

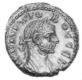

12123 12124

12123 Similar, but eagle stg. l., hd. r., L — B (= regnal year 2) in field. Dattari 5552. BMCG 2427.
Cologne 3126. Milne 4545. *[AD 276–7].* **VF** £6 ($10) / **EF** £20 ($30)

12124 Eirene (= Pax) stg. l., holding olive-branch and transverse sceptre, L Γ (= regnal year 3)
before. Dattari 5529. BMCG 2413. Cologne 3132. Milne 4551. *[AD 277–8].*
VF £8 ($12) / **EF** £22 ($35)

12125 **Billon tetradrachm.** Nike (= Victory) advancing l., holding wreath with both hands, L Γ (=
regnal year 3) before. Dattari 5537. BMCG —. Cologne —. Milne 4555. *[AD 277–8].*
VF £10 ($15) / **EF** £25 ($40)

12126 Probus on horseback pacing l., his r. hand raised, holding sceptre in l., L Γ (= regnal year 3)
behind. Dattari 5522. BMCG/Christiansen 3445. Cologne —. Milne —. *[AD 277–8].*
VF £14 ($20) / **EF** £32 ($50)

12127 Eagle stg. facing, hd. r., wings open, holding wreath in beak, L — Γ (= regnal year 3) in
field. Dattari 5560. BMCG 2433. Cologne 3131. Milne 4565. *[AD 277–8].*
VF £6 ($10) / **EF** £20 ($30)

12128 Tyche (= Fortuna) stg. l., holding rudder and cornucopiae, L Δ (= regnal year 4) before.
Dattari 5546. BMCG 2424. Cologne 3141. Milne 4583. *[AD 278–9].*
VF £8 ($12) / **EF** £22 ($35)

12129 Eagle stg. r., holding wreath in beak, palm transversely in background, L — Δ (= regnal
year 4) in field. Dattari 5563. BMCG 2440. Cologne 3135. Milne 4586. *[AD 278–9].*
VF £6 ($10) / **EF** £20 ($30)

12130 Athena enthroned l., holding Nike and sceptre, shield at side, L ε (= regnal year 5) before.
Dattari 5524. BMCG 2409. Cologne 3146. Milne (Supplement) 4594a. *[AD 279–80].*
VF £8 ($12) / **EF** £22 ($35)

12131 Bust of Sarapis r., wearing modius, L — ε (= regnal year 5) in field. Dattari 5544. BMCG
—. Cologne —. Milne (Supplement) 4594a. *[AD 279–80].* VF £12 ($18) / **EF** £30 ($45)

12132 Dikaiosyne (= Aequitas) seated l., holding scales and cornucopiae, L ε (= regnal year 5)
before. Dattari 5528. BMCG —. Cologne —. Milne 4605. *[AD 279–80].*
VF £10 ($15) / **EF** £25 ($40)

12133 Homonoia (= Concordia) stg. l., r. hand extended, holding double cornucopiae in l., L ε
(= regnal year 5) before. Dattari 5534. BMCG 2418. Cologne 3147. Milne 4595.
[AD 279–80]. VF £8 ($12) / **EF** £22 ($35)

12134 Athena seated l. on cuirass, holding Nike and sceptre, L ς (= regnal year 6) before. Dattari
5525. BMCG 2410. Cologne 3152. Milne 4617. *[AD 280–81].* VF £8 ($12) / **EF** £22 ($35)

12135 As 12133, but Homonoia seated l., L ς (= regnal year 6) before. Dattari 5535. BMCG
2419. Cologne 3153. Milne 4622. *[AD 280–81].* VF £8 ($12) / **EF** £22 ($35)

12136 Nike (= Victory) advancing r., holding wreath and palm, L — Z (= regnal year 7) in field.
Dattari 5543 var. BMCG 2422. Cologne 3157. Milne 4637. *[AD 281–2].*
VF £8 ($12) / **EF** £22 ($35)

12137 Eagle stg. r., wings open, holding wreath in beak, L — H (= regnal year 8) in field. Cf.
Dattari 5559. BMCG 2438. Cologne 3158. Milne 4658. *[AD 282].*
VF £10 ($15) / **EF** £25 ($40)

SATURNINUS
AD 280

Sextus (or Gaius) Julius Saturninus, a general of Probus possibly of Moorish origin, was serving in Syria in AD 280 and may even have been the governor of that province. When a revolt broke out in the East, possibly originating in Egypt, Saturninus' soldiers invested him with the purple. This may well have been against his will as he immediately made peace overtures to Probus and even appears to have struck aurei in the emperor's name (see no. 11936). Probus, who was campaigning in southern Asia Minor at the time of this episode, countered by sending an army against the usurper, a move that he deemed sufficient to deal with the threat. Seeing the strength of the forces sent against them the soldiers of Saturninus withdrew their support and the reluctant rebel was murdered in his own camp. From the extreme rarity of his coinage, which is known only in gold, it would seem that Saturninus' revolt was of very brief duration. It seems reasonable to surmise that the place of mintage was Antioch, the capital of Syria.

12138 **Gold aureus.** IMP C IVL SATVRNINVS AVG, laur. and cuir. bust r. Rev. VICTORIAE AVG, Victory advancing r., holding wreath and palm. RIC p. 591, 1 and pl. XX, 14. Cf. C vi, p. 348 (no coins recorded). Hunter —. *[Antioch].* (*Extremely rare*)

NB See also under Probus, no. 11936.

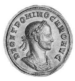

CARUS
Sep./Oct. AD 282–Jul./Aug. 283

12156

Marcus Aurelius Carus, probably a native of Narbo in southern Gaul, was appointed praetorian prefect by Probus in AD 276. In the late summer of 282 he was mustering troops in Raetia and Noricum for Probus' projected Persian campaign. It was later claimed that the soldiers enthusiasm for the prefect led them to proclaim him Augustus in opposition to the unpopular Probus, thus provoking a general military revolt which led to the assassination of the emperor. Carus summarily advised the Senate of his elevation by the army and immediately bestowed the rank of Caesar on his elder son, Carinus, and, a month or two later, on his younger son, Numerian. After a highly successful campaign against the Sarmatians and Quadi, who had crossed the Danube and ravaged Pannonia, Carus decided to go ahead with his predecessor's plan of attacking Sasanid Persia in revenge for the capture of the emperor Valerian more than two decades before. Leaving Carinus in Rome to administer the western provinces Carus marched east in company with Numerian. During his stay in Antioch prior to setting out on his invasion of Persia he further elevated Carinus and Numerian to the rank of Augustus (February/March AD 283). This was only the second time in Roman history that three emperors had reigned jointly, the previous occasion being Septimius Severus, Caracalla and Geta more than seventy years before. Carus wished to ensure the smooth succession of his sons should anything untoward befall him during the course of the war, a wise precaution in the light of ensuing events. Although the Persian campaign was initially a great success, resulting in the capture of the Sasanid capital Ctesiphon on the river Tigris, at the height of his triumph Carus was found dead in his tent during a violent thunderstorm (summer 283). His sudden death was attributed to a lightning strike but it seems more likely that he was the victim of treachery, possibly on the part of his praetorian prefect Arrius Aper. This ambitious man was the father-in-law of the young Numerian and thus had a strong motive to remove Carus from the political scene. Subsequent events were apparently to confirm this suspicion.

Carus' coinage is, of course, on a smaller scale than that of his predecessor and its obverse types are less varied, though it does have some interesting features. The aureus was struck initially

on a significantly lighter standard than under Probus (about 4.6 grams or 1/70th of a pound) though before the end of the reign the standard seems to have been raised to 1/60th of a pound or 5.4 grams. In the billon coinage there were rare issues of double antoniniani at Lugdunum and Siscia. Coins were struck for each of the emperor's two sons, first as Caesar and subsequently as Augustus, and there were also 'dynastic' issues combining the portraits of Carus and Carinus. The mint system remained much the same, though Serdica was no longer active having been closed under Probus about AD 280.

The following are the principal forms of obverse legend, other varieties being given in full:

A. IMP CARVS P F AVG
B. IMP C CARVS P F AVG
C. IMP C M AVR CARVS AVG
D. IMP C M AVR CARVS P F AVG
E. IMP C M AVR KARVS P F AVG

The normal obverse type for aurei is laureate, draped, and cuirassed bust of Carus right, and for antoniniani radiate bust right, draped or cuirassed, or draped and cuirassed. More unusual types are described in full as are the obverses of all other denominations.

12139

12139 **Gold aureus.** D. Rev. **ADVENTVS CARI AVG**, Carus on horseback pacing l., his r. hand raised, holding sceptre in l. RIC —. Calicó 4260. Cf. C 6 (incomplete description). Hunter 18. Pink, p. 42, series 1. *[Siscia, AD 282].* **VF** £4,000 ($6,000) / **EF** £10,000 ($15,000)

NB Most coins of this denomination average about 4.6 grams (70 to the pound) though towards the end of the reign the standard seems to have been temporarily raised to 5.4 grams (60 to the pound).

12140 A, laur. and cuir. bust l., holding spear and shield. Rev. **FORTVNA AVG**, Fortuna stg. l., holding rudder and cornucopiae. RIC 1. Calicó 4263. C 33. Hunter, p. clvi. Pink, p. 21, series 1. *[Lugdunum, AD 282].* **VF** £3,300 ($5,000) / **EF** £8,300 ($12,500)

12141 IMP C M AVR CARVS P A. Rev. **INDVLGENTIA AVG**, Victory advancing l., holding wreath and palm. RIC 130. Calicó 4265. C —. Hunter —. Cf. Pink, p. 57. *[Uncertain eastern mint, AD 283].* **VF** £5,000 ($7,500) / **EF** £12,000 ($18,000)

12142 D. Rev. Rev. **MARS VLTOR**, Mars advancing r., holding spear and shield. RIC 92. Calicó 4266–7. C 39. Hunter, p. clviii. Pink, p. 42, series 1. *[Siscia, AD 282].* **VF** £3,300 ($5,000) / **EF** £8,300 ($12,500)

12143 Similar, but with rev. legend **MARTI PROPVGNATORI**. RIC —. Calicó 4268a. C —. Hunter —. Pink —. *[Siscia, AD 282].* **VF** £4,000 ($6,000) / **EF** £10,000 ($15,000)

12144 D. Rev. **ORIENS CARI AVG**, Sol stg. l., raising r. hand and holding whip in l., crescent in ex. RIC —. Calicó 4268b. C —. Hunter —. Pink —. *[Cyzicus, AD 282].* **VF** £4,000 ($6,000) / **EF** £10,000 ($15,000)

12145 **Gold aureus.** D. Rev. PAX AETERNA, Pax advancing l., holding olive-branch and sceptre. RIC 31. Calicó 4269. C 44. Hunter, p. clv. Pink, p. 27, series 1. *[Ticinum or Rome, AD 282].* VF £3,000 ($4,500) / EF £7,700 ($11,500)

12146 Similar, but with rev. legend PAX AVG. RIC 2 and 115. Calicó 4270. C 46. Hunter, pp. clvi and clviii. Pink, p. 21, series 1, and p. 52, series 1. *[Lugdunum and Cyzicus, AD 282].* VF £3,000 ($4,500) / EF £7,700 ($11,500)

12147 D. Rev. PROVIDENT (or PROVIDENTIA) AVG, Providentia stg. l., holding globe and transverse sceptre. RIC 32 and 62. Calicó 4271 and 4271a. C 66. Hunter, pp. clv and clvii. Pink, p. 26, first issue. *[Ticinum or Rome, AD 282].* VF £3,300 ($5,000) / EF £8,300 ($12,500)

12148 D. Rev. ROMAE AETERNAE, Roma seated l., holding wreath and sceptre, shield at side. RIC 94. Calicó 4272. C 73. Hunter, p. clviii. Pink, p. 42, series 1. *[Siscia, AD 282].* VF £3,300 ($5,000) / EF £8,300 ($12,500)

12149 Similar, but on rev. Roma holds Victory instead of wreath, and with mint mark S M A in ex. RIC —. Calicó 4274. C —. Hunter —. Pink —. *[Antioch, AD 283].* VF £4,000 ($6,000) / EF £10,000 ($15,000)

12150 D. Rev. SPES PVBLICA, Spes advancing l., holding flower and lifting skirt. RIC 63. Calicó 4275–6. C 76. Hunter, pp. clv and clvii. Pink, p. 26, first issue. *[Ticinum or Rome, AD 282].* VF £3,000 ($4,500) / EF £7,700 ($11,500)

12151 IMP CAESAR M AVR CARVS AVG. Rev. VICTOR CARO, Victory advancing r., holding wreath and palm. RIC 131. Calicó 4280a. Cf. C 82 (rev. type misdescribed?). Hunter, p. clx. Cf. Pink, p. 57. *[Alexandria?, AD 283].* VF £5,000 ($7,500) / EF £12,000 ($18,000)

12152 Similar, but with rev. legend VICTOR CARINO AVG. RIC 132. Calicó 4281. C —. Hunter, p. clx. Cf. Pink, p. 57. *[Alexandria?, AD 283].* VF £5,000 ($7,500) / EF £12,000 ($18,000)

12153 D. Rev. VICTORI AVG, Victory in galloping biga l., holding wreath and palm, mint mark K or crescent in ex. RIC 116. Calicó 4282–3. C 83. Hunter, p. clviii. Pink, pp. 52–3, series 1 and 2. *[Cyzicus, AD 282].* VF £4,000 ($6,000) / EF £10,000 ($15,000)

12154

12154 D. Rev. VICTORIA AVG, Victory stg. l. on globe, holding wreath and palm. RIC 95. Calicó 4284–85a. C 84. Hunter, p. clviii. Pink, p. 42, series 1. *[Siscia, AD 282].* VF £2,700 ($4,000) / EF £6,700 ($10,000)

12155 Similar, but with obv. type laur., dr. and cuir. bust l. RIC 95. Calicó 4286, 4286a. Cf. C 85. Hunter 19. Pink, p. 42, series 1. *[Siscia, AD 282].* VF £3,300 ($5,000) / EF £8,300 ($12,500)

12156 **Gold aureus.** As 12154, but with obv. legend DEO ET DOMINO CARO AVG. RIC 96.
Calicó 4287–8. C 86. Hunter, p. clviii, note 2. Pink, p. 42, series 1. *[Siscia, AD 282].*
VF £4,400 ($6,600) / EF £11,000 ($16,500)

12157 D. Rev. VICTORIA AVGG, Victory advancing l., holding wreath and palm. RIC 97. Calicó
4289. C —. Hunter, p. clviii. Pink, p. 44, series 2B. *[Siscia, AD 282].*
VF £3,300 ($5,000) / EF £8,300 ($12,500)

12158 D. Rev. VICTORIAE AVGG, Victory advancing r., holding wreath and palm, mint mark S M
A in ex. RIC 122. Calicó 4290. C —. Hunter, p. clix. Pink, p. 56, series 3. *[Antioch,*
AD 283]. VF £3,700 ($5,500) / EF £9,000 ($13,500)

12159 D. Rev. VICTORIAE AVGG FEL, Victory hovering l., holding open wreath with both hands
over shield set on base. RIC 98. Calicó 4291. Cf. C 95 (inaccurate description). Cf. Hunter,
p. clviii. Pink, p. 43, series 2a. *[Siscia, AD 282].*
VF £4,000 ($6,000) / EF £10,000 ($15,000)
This is a revival of a Severan type issued in AD 199 (see Vol. II, no. 6381).

12160 D. Rev. VIRTVS AVGG, Mars, naked, advancing r., carrying transverse spear and trophy.
RIC 34, 65. Calicó 4292. C 109. Hunter, pp. clv and clvii. Pink, p. 27, series 1. *[Ticinum or*
Rome, AD 282]. VF £3,000 ($4,500) / EF £7,700 ($11,500)

12161 D. Rev. VIRTVS CARI INVICTI AVG, Hercules stg. r., r. hand on hip, l. resting on club
wrapped in lion's skin and set on rock, mint mark K or crescent in ex. RIC 117. Calicó
4293–4. Cf. C 118. Hunter, p. clviii. Pink, pp. 52–3, series 1 and 2. *[Cyzicus, AD 282].*
VF £4,000 ($6,000) / EF £10,000 ($15,000)

12162 **Billon double antoninianus.** D, dr. and cuir. bust r., wearing double rad. crown. Rev.
ABVNDANTIA AVG, galley travelling l. over waves, X ET I in ex. RIC 5. C 5. Hunter,
p. clvi, note 2. Pink, p. 21, series 1. *[Lugdunum, AD 282].*
VF £220 ($325) / EF £500 ($750)
The mark of value X ET I indicates that the alloy from which these coins were struck
contains double the proportion of silver than that used for the antoniniani (marked XXI),
i.e. 1/10th instead of 1/20th.

12163 D, rad. and dr. bust r. Rev. FELICITAS REIPVBLICAE, Felicitas stg. l., holding caduceus and
transverse sceptre and resting l. arm on column, XI in ex. Cf. RIC 101 (misdescribed as an
antoninianus). C 26. Hunter, p. clviii, note 3. Pink, p. 42, series 1. *[Siscia, AD 282].*
VF £150 ($225) / EF £330 ($500)

12164 Similar, but with obv. DEO ET DOMINO CARO AVG (or INVIC AVG), confronted rad. busts
of Sol, dr., r. and Carus, cuir., l., and sometimes with XII instead of XI in ex. RIC 99. C
27–8. Hunter, p. clviii, note 3. Pink, p. 42, series 1. *[Siscia, AD 282].*
VF £430 ($650) / EF £430 ($1,500)

12165 **Billon antoninianus.** D or E. Rev. ABVNDANTIA (or ABVNDANT) AVG, Abundantia stg.
r., emptying cornucopiae, T XXI (= 3rd officina) in ex. RIC 66–7. C 1, 4. Hunter, p. clvii.
Pink, p. 26, first issue. *[Ticinum, AD 282].* VF £22 ($35) / EF £55 ($85)

12166 C. Rev. AEQVITAS AVGG, Aequitas stg. l., holding scales and cornucopiae, officina mark
A (= 1) in field. RIC 8. C 8. Hunter, p. clvii. Pink, p. 22, series 4. *[Lugdunum, AD 283].*
VF £20 ($30) / EF £50 ($75)

12167 12171

12167 **Billon antoninianus.** D. Rev. AETERNIT IMPERI, Sol advancing l., raising r. hand and
holding whip in l., KA preceded or followed by officina mark A (= 1) in ex. RIC 35. C 11.
Hunter 2. Pink, p. 32, series 2a, b. *[Rome, AD 282].* **VF** £20 ($30) / **EF** £50 ($75)

12168 D. Rev. ANNONA AVGG, Annona stg. l., holding corn-ears and cornucopiae, modius at
feet, mint and officina marks R B (= 2nd officina) or AK preceded by officina mark B (= 2)
in ex. RIC 37. C 12. Hunter, p. clvi. Pink, p. 31, series 1a, b. *[Rome, AD 282].*
VF £20 ($30) / **EF** £50 ($75)

12169 D. Rev. CLEMENTIA TEMP, Carus, in military attire, stg. r., holding short sceptre and
receiving Victory on globe from Jupiter stg. l., holding sceptre, officina mark Γ, Δ, or Ϛ
(= 3, 4, or 6) in ex., or officina mark A–Ϛ (= 1–6) in field and XXI in ex. RIC 118. C 13.
Hunter 23. Pink, pp. 52–3, series 1–2. *[Cyzicus, AD 282].* **VF** £20 ($30) / **EF** £50 ($75)

12170 A. Rev. FIDES MILIT, Fides Militum stg. l., holding standard in each hand, P XX T (= 1st
officina) in ex. RIC 70. C 29. Hunter, p. clvii. Pink, p. 29, series 5. *[Ticinum, AD 283].*
VF £20 ($30) / **EF** £50 ($75)
The mint initial 'T' also serves as the 'I' of the mark of value 'XXI'.

12171 A. Rev. IOVI VICTORI, Jupiter stg. l., holding Victory and sceptre, eagle at feet, KA
followed by officina mark B (= 2) in ex. RIC 39. C 36. Hunter 5. Pink, p. 33, series 2c.
[Rome, AD 282]. **VF** £20 ($30) / **EF** £50 ($75)

12172 D. Rev. PAX AVG, Pax stg. (or advancing) l., holding olive-branch and sceptre, officina
mark B (= 2) in field. RIC 10. C 47. Hunter, p. clvi. Pink, p. 21, series 1. *[Lugdunum,
AD 282].* **VF** £22 ($35) / **EF** £55 ($85)

12173 12178

12173 C. Rev. PAX AVGG, similar. RIC 13. C 48. Hunter 7. Pink, p. 21, series 2. *[Lugdunum,
AD 282].* **VF** £20 ($30) / **EF** £50 ($75)

12174 D. Rev. PAX AVGVSTI, similar, but with XXI in ex. and officina mark T (= 3) in field. RIC
103. C 54. Hunter, p. clviii. Pink, p. 43, series 1. *[Siscia, AD 282].*
VF £22 ($35) / **EF** £55 ($85)

12175 **Billon antoninianus.** D or E. Rev. PAX EXERCITI, Pax stg. l., holding olive-branch and standard, VI XXI (= 6th officina) in ex. RIC 72–3. C 59–60. Hunter, p. clvii. Pink, p. 26, first issue. *[Ticinum, AD 282].* **VF** £22 ($35) / **EF** £55 ($85)

12176 — Rev. PERPETVITATI AVG, Perpetuitas/Providentia stg. facing, hd. l., holding globe and transverse sceptre and resting l. arm on column, V XXI (= 5th officina) in ex. RIC 76–7. C 61. Hunter, p. clvii. Pink, p. 26, first issue. *[Ticinum, AD 282].* **VF** £30 ($45) / **EF** £75 ($110)

12177 D. Rev. PROVIDENT AVGG, Providentia stg. l., holding rod and sceptre, globe at feet, mint and officina marks R Δ (= 4th officina) or AK or KA preceded by officina mark Δ (= 4) in ex. RIC 42. C 69. Hunter, p. clvi. Pink, pp. 31–2, series 1–2a. *[Rome, AD 282].*
 VF £20 ($30) / **EF** £50 ($75)

12178 D. Rev. PROVIDENTIA AVG, Providentia stg. l., holding globe and transverse sceptre, XXI in ex., officina mark II (= 2) with or without star or pellet above in field. RIC 105. C 70. Hunter, p. clviii. Pink, p. 43, series 1. *[Siscia, AD 282].* **VF** £20 ($30) / **EF** £50 ($75)

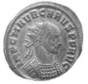

12179 12180

12179 D. Rev. RESTITVT ORBIS, female figure stg. r., holding wreath in raised r. hand, facing Carus, in military attire, stg. l., holding globe in extended r. hand and sceptre in l., XXI in ex., sometimes followed by officina mark P, II, or T (= 1, 2, or 3), or with P, II, or T in field, sometimes with star or pellet above (one variety has XXI P in ex. and star in field). RIC 106. C 71. Hunter 21. Pink, p. 41, first issue. *[Siscia, AD 282].* **VF** £20 ($30) / **EF** £50 ($75)

12180 A. Rev. SPES PVBLICA, Spes advancing l., holding flower and lifting skirt, S XXI (= 2nd officina) in ex. RIC 82. C 79. Hunter 15. Pink, p. 28, series 2. *[Ticinum, AD 282].*
 VF £20 ($30) / **EF** £50 ($75)

12181 D or E. Rev. VICTORIA AVG, Victory advancing l., holding wreath and palm, P XXI (= 1st officina) in ex. RIC 84–5. C 93–4. Hunter, p. clvii. Pink, p. 26, first issue. *[Ticinum, AD 282].* **VF** £20 ($30) / **EF** £50 ($75)

12182 D. Rev. VICTORIA AVGG, as previous, but with officina mark A (= 1) in field. RIC 21. C 96. Hunter, p. clvii. Pink, p. 21, series 1. *[Lugdunum, AD 282].*
 VF £20 ($30) / **EF** £50 ($75)

12183 D. Rev. — Victory advancing r., holding wreath and palm, mint and officina marks R A (= 1st officina) in ex. RIC 44. C 98. Hunter, p. clvi. Pink, p. 31, series 1a. *[Rome, AD 282].*
 VF £20 ($30) / **EF** £50 ($75)

12184 C. Rev. — Victory stg. l. on globe between two captives, holding wreath and palm, officina mark A (= 1) in field. RIC 24. C 99. Hunter 9. Pink, p. 21, series 2. *[Lugdunum, AD 282].*
 VF £22 ($35) / **EF** £55 ($85)

12185 Similar, but with obv. VIRTVS CARI AVG, cuir. bust l., wearing rad. helmet and holding spear and shield. RIC 25. C 104. Hunter, p. clvii, note 1. Pink, p. 21, series 2. *[Lugdunum, AD 282].* **VF** £40 ($60) / **EF** £100 ($150)

12186 **Billon antoninianus.** A. Rev. VIRTVS AVG, Mars or Virtus stg. r., resting on spear and shield, Q XXI (= 4th officina) in ex. RIC 91. C 106. Hunter, p. clvii. Pink, p. 28, series 2. *[Ticinum, AD 282].* VF £20 ($30) / EF £50 ($75)

12187 D. Rev. VIRTVS AVGG, Mars or Virtus stg. l., resting on shield and spear, mint and officina marks R Γ (= 3rd officina), or KA preceded or followed by officina mark Γ (= 3) in ex. RIC 45. C 114. Hunter 3. Pink, pp. 31–2, series 1a, 2a-b. *[Rome, AD 282].*
 VF £20 ($30) / EF £50 ($75)

12188 D. Rev. — Carus and Carinus, both in military attire, stg. facing each other, the figure on r. presenting to the other a globe which is usually surmounted by Victory, the one on l. holding short sceptre, the other resting on long sceptre (or spear), XXI in ex., officina mark A-εΔ (= 1–9), sometimes with star above, in field. RIC 124. C 115–16. Hunter 24–5. Pink, p. 55, series 1. *[Antioch, AD 282].* VF £20 ($30) / EF £50 ($75)
 On this type and the following two the figure on right sometimes appears to be Jupiter.

12189 D. Rev. — similar, but the globe is never surmounted by Victory and sometimes with dot at end of legend, mint mark TR (sometimes with star above) in field. RIC 128. C 115. Hunter, p. clix. Pink, p. 57, series 1. *[Tripolis, AD 283].* VF £22 ($35) / EF £55 ($85)

12190 D. Rev. VIRTVS AVGGG, as 12188, but the globe is always surmounted by Victory and always with star in upper field. RIC 125. C 117. Hunter, p. clix. Pink, p. 55, series 2. *[Antioch, AD 283].* VF £22 ($35) / EF £55 ($85)

12191 **Billon denarius.** A, laur. and cuir. bust r. Rev. PAX AETERNA, Pax advancing l., holding wreath and transverse sceptre. Cf. RIC 59 (described as an as, after Cohen). Cf. C 45. Hunter, p. clv. Pink, p. 27, series 1. *[Rome or Ticinum, AD 282].*
 VF £265 ($400) / EF £665 ($1,000)

12192 — Rev. PROVIDE AVGG, Providentia stg. l., holding rod and sceptre, globe at feet. RIC 53. C —. Hunter, p. clv. Pink, p. 27, series 1. *[Rome or Ticinum, AD 282].*
 VF £265 ($400) / EF £665 ($1,000)

12193 IMP M AVR CARVS AVG, cuir. bust l., wearing laur. helmet and holding spear and shield. Rev. SPES PVBLICA, Carus and Carinus (or Carinus and Numerian) galloping r., side by side, their r. hands raised. Cf. RIC 51–2 (obv. misdescribed, after Cohen). Cf. C 80–81 (= the same coin). Hunter, p. clv. Pink, p. 22, series 3. *[Rome or Lugdunum, AD 283].*
 VF £400 ($600) / EF £1,000 ($1,500)
 This may be a pattern for an aureus rather than a denarius struck for circulation.

12194 **Billon quinarius.** A, or IMP CARVS AVG, laur. and cuir. bust r. Rev. VIRTVS AVGG, Mars or Virtus stg. l., resting on shield and spear. RIC 56, 58. C 111–12. Hunter, p. clv. Pink, p. 27, series 1. *[Rome or Ticinum, AD 282].* VF £200 ($300) / EF £500 ($750)

12195 **Bronze reduced sestertius or as.** C, laur. and cuir. bust r. Rev. PAX AVGVSTORVM, Pax advancing l., holding olive-branch and sceptre. RIC 60. C 55. Hunter, p. clvi. Pink, p. 27, series 1. *[Rome or Ticinum, AD 282].* F £265 ($400) / VF £600 ($900)

12196 **Bronze reduced as or semis?** D, laur. and cuir. bust r. Rev. PRINCIPI IVVENTVT, Carus (or Carinus?), in military attire, stg. l., holding standard and spear. RIC 61. Cf. C 65 (misdescribed). Hunter, p. clv. Pink, p. 27, series 1. *[Rome or Ticinum, AD 282].*
 F £230 ($350) / VF £525 ($800)
 It is uncertain whether coins of this type represent a different denomination or whether there was merely a reduction in the weight standard of the sestertius.

For coins of Divus Carus, see under Carinus (nos. 12393–406).

Alexandrian Coinage

All have obv. A K M A KAPOC CEB, laur., dr. and cuir. bust r. There is only one regnal year (L A = AD 282–3). The reverse types are as follows:

12197

12197 **Billon tetradrachm.** Dikaiosyne (= Aequitas) stg. l., holding scales and cornucopiae, L A before, sometimes with star behind. Dattari 5565–6. BMCG 2441. Cologne 3161. Milne 4660. **VF** £13 ($20) / **EF** £32 ($50)

12198 Eagle stg. r., holding wreath in beak, palm transversely in background, L — A in field. Dattari 5569. BMCG 2442. Cologne 3159. Milne 4670. **VF** £13 ($20) / **EF** £32 ($50)

12199 Eagle stg. l., hd. r., between two vexilla, wings open and holding wreath in beak, L A above, sometimes with star. Dattari 5567–8. BMCG 2443–4. Cologne 3160. Milne 4674. **VF** £13 ($20) / **EF** £32 ($50)

For the posthumous Alexandrian coinage issued in the name of Carus, see under Carinus (nos. 12405–6).

CARUS AND CARINUS

Carus' elder son, Marcus Aurelius Carinus, was given the rank of Caesar about October AD 282, soon after his father's elevation to the imperial throne. The following year, about February/March, he was further promoted to the status of Augustus and co-emperor. An interesting, though rare, joint coinage was struck in the names of the imperial father and son both before and after Carinus' had achieved the rank of Augustus.

12200 **Gold aureus.** IMP C M AVR CARVS P F AVG, laur., dr. and cuir. bust of Carus r. Rev. KARINVS NOBIL CAES, laur, dr. and cuir. bust of Carinus r. RIC 133. Calicó 4295. C 3. Hunter, p. clxvii. Pink, p. 26, series 1. *[Ticinum or Rome, AD 282].*
VF £5,300 ($8,000) / **EF** £13,500 ($20,000)

12201 Similar, but with obv. legend IMP C M AVR KARVS AVG. RIC 134. Calicó 4296. C 4. Hunter, p. clxvii. Pink, p. 21, series 1. *[Lugdunum, AD 282].*
VF £5,300 ($8,000) / **EF** £13,500 ($20,000)

12202 KARVS ET KARINVS AVGG, conjoined laur. and cuir. busts of Carus and Carinus r. Rev. SPES PVBLICA, Carus and Carinus (or Carinus and Numerian) galloping r., side by side, their r. hands raised. RIC 135. Calicó 4297. C —. Hunter, p. clxvii. Cf. Pink, p. 22, series 3. *[Lugdunum, AD 283].* **VF** £5,300 ($8,000) / **EF** £13,500 ($20,000)

NB There is also a gold multiple of 4 or 5 aurei from the Siscia mint issued in AD 283, obv. IMPP CARVS ET CARINVS AVGG, confronted busts of Carus and Carinus, rev. VICTORIAE AVGVSTT (*sic*), two Victories supporting shield inscribed VOTIS X, mint mark SIS in ex. (Gnecchi I, p. 11, 1, RIC 146, Cohen 11, Pink, p. 44, series 3).

12203	**Gold quinarius.** CARVS AVG, laur., dr. and cuir. half-length bust of Carus l., holding Victory on globe and parazonium. Rev. M AVR CARINVS C, similar bust of Carinus l., but without parazonium. RIC 145. C —. Hunter, p. clxvi. Pink, p. 27, series 1. *[Ticinum or Rome, AD 282].*	*(Unique?)*

12204	**Billon antoninianus.** CARVS ET CARINVS AVGG, conjoined rad. and cuir. busts of Carus and Carinus r. Rev. PAX AVGG, Pax stg. (or advancing) l., holding olive-branch and sceptre, officina mark B (= 2) in field. Cf. RIC 138–40. Cf. C 5–7. Hunter, p. clxvii. Pink, p. 22, series 3. *[Lugdunum, AD 283].*	**VF** £365 ($550) / **EF** £825 ($1,250)

12205	Similar, but with rev. SAECVLI FELICITAS, Carus, in military attire, stg. r., holding transverse spear and globe, officina mark D (= 4, sometimes reversed) in field. Cf. RIC 141. Cf. C 9. Hunter, p. clxvii. Pink, p. 22, series 3. *[Lugdunum, AD 283].*	**VF** £365 ($550) / **EF** £825 ($1,250)

12206	Similar, but with rev. VICTORIA AVGG, Victory stg. l. on globe between two captives, holding wreath and palm, officina mark A (= 1) in field. RIC 142. C 10. Hunter, p. clxvii. Pink, p. 22, series 3. *[Lugdunum, AD 283].*	**VF** £365 ($550) / **EF** £825 ($1,250)

12207	Similar, but without globe and captives and Victory is advancing l. RIC 143. C —. Hunter, p. clxvii. Pink, p. 22, series 3. *[Lugdunum, AD 283].*	**VF** £365 ($550) / **EF** £825 ($1,250)

12208	**Billon denarius.** IMP C M AVR CARVS P F AVG, laur. and cuir. bust of Carus r. Rev. CARINVS NOBIL CAES, laur. and cuir. bust of Carinus r. RIC 144. C 1. Hunter, p. clxvi. Pink —. *[Ticinum or Rome, AD 282].*	*(Doubtful)*

NUMERIAN

12240

Marcus Aurelius Numerianus was the younger son of Carus and was probably in his late twenties at the time of his father's accession. Numerian received the rank of Caesar late in AD 282 about a month after the same title had been bestowed on his elder brother, Carinus. He assisted his father in a successful campaign against the Sarmatians and Quadi in Pannonia and remained with Carus when the army crossed to Asia for the war against Persia. Carinus stayed in the West to take care of any problems in the northern frontier region. At Antioch, as preparations were under way for the eastern campaign, Carus took the wise precaution of elevating both of his sons to the rank of Augustus and co-emperor (February/March 283). Following Carus' sudden and mysterious death after his capture of the Sasanid capital of Ctesiphon the young and inexperienced Numerian found himself in sole charge of the Persian War, a situation which his scholarly nature did not relish. He negotiated a favorable peace with the defeated Persians, doubtless assisted by his father-in-law the praetorian prefect Arrius Aper, and then began a slow return progress through Asia to meet with his brother to discuss future plans. The proposed meeting never took place as Numerian supposedly fell ill on the journey and was confined to a closed litter where he was discovered to be dead as the army approached Nicomedia (October/November 284). Arrius Aper was accused of the murder by Diocles, commander of the emperor's bodyguard, and was summarily executed. It is possible that Diocles himself had been administering poison to Numerian and had simply used Aper as a convenient scapegoat. The enraged soldiers unanimously proclaimed Diocles emperor in

Numerian's place and, under the Latinized name of Diocletian, he continued the westward advance to challenge Carinus for the supreme imperial authority.

Numerian's coinage is divided into two principal groups, those issued during the three or four months that he bore the junior title of Caesar, and those struck after his elevation to the rank of Augustus in February/March 283. A brief posthumous coinage of antoniniani was produced in his name by Carinus in late AD 284-early 285.

The following are the principal forms of obverse legend, other varieties being given in full:

As Caesar

A. IMP C M AVR NVMERIANVS NOB C
B. M AVR NVMERIANVS C
C. M AVR NVMERIANVS CAES
D. M AVR NVMERIANVS NOB C
E. NVMERIANVS NOB CAES

As Augustus

F. IMP C M AVR NVMERIANVS AVG
G. IMP C M AVR NVMERIANVS P F AVG
H. IMP C NVMERIANVS AVG
J. IMP C NVMERIANVS P F AVG
K. IMP NVMERIANVS AVG
L. IMP NVMERIANVS P F AVG

The normal obverse type for aurei is laureate bust of Numerian right, draped or cuirassed, or draped and cuirassed, and for antoniniani radiate bust right, draped or cuirassed, or draped and cuirassed. More unusual types are described in full as are the obverses of all other denominations.

Issues as Caesar under Carus, Nov/Dec. AD 282-Feb./Mar. 283

12209 **Gold aureus.** A. Rev. CONSERVAT AVGGG, Sol stg. l., raising r. hand and holding globe in l., mint mark S M A in ex. RIC 373. Calicó 4303. C 13 var. Hunter, p. clxxi. Pink, p. 55, series 2. *[Antioch, AD 283].* **VF** £4,300 ($6,500) / **EF** £11,750 ($17,500)

12210 D. Rev. PRINCIPI IVVENT, Numerian, in military attire, stg. l., holding branch and sceptre. RIC 369. Calicó 4312. C 65. Hunter 11. Pink, p. 44, series 2B. *[Siscia, AD 282].*
 VF £4,300 ($6,500) / **EF** £11,750 ($17,500)

12211 D. Rev. PRINCIPI IVVENTVT, Numerian, in military attire, stg. l. amidst four standards, raising r. hand and resting on spear held in l. RIC 352. Calicó 4313. C —. Hunter, p. clxix. Pink, p. 28, series 2. *[Ticinum or Lugdunum, AD 282].*
 VF £4,300 ($6,500) / **EF** £11,750 ($17,500)

12212 E (but NVMAERIANVS). Rev. VICTORIA CAESARIS, Victory in biga galloping l., holding wrea th and palm, mint mark K in ex. RIC 371. Calicó 4327. C 98. Hunter, p. clxxi. Pink, p. 53, series 2. *[Cyzicus, AD 282].* **VF** £5,300 ($8,000) / **EF** £13,500 ($20,000)

12213 A. Rev. VICTORIAE AVGG, Victory advancing r., holding wreath and palm, mint mark S M A in ex. RIC 374. Calicó 4329–30. C —. Hunter, p. clxxi. Pink —. *[Antioch, AD 283].*
 VF £4,300 ($6,500) / **EF** £11,750 ($17,500)

12214 A. Rev. VIRTVS AVGGG, Hercules stg. r., r. hand on hip, l. resting on club wrapped in lion's skin and set on rock, mint mark S M A in ex. RIC 375. Calicó 4338–9. Cf. C 114. Hunter —. Cf. Pink, p. 55, series 2. *[Antioch, AD 283].*
 VF £4,300 ($6,500) / **EF** £11,750 ($17,500)

12215 **Billon antoninianus.** E. Rev. CLEMENTIA TEMP, Numerian, in military attire, stg. r., holding short sceptre and receiving Victory on globe from Jupiter stg. l., holding sceptre, officina mark A-S (= 1–6) in field, XXI in ex. RIC 372. C 9. Hunter 12–13. Pink, p. 53, series 2. *[Cyzicus, AD 282].* **VF** £20 ($30) / **EF** £50 ($75)

12216 D. Rev. MARS VICTOR, Mars, naked, advancing r., carrying spear and trophy over l. shoulder, officina mark C (= 3) in field. RIC 353. C 18. Hunter 5. Pink, p. 22, series 2. *[Lugdunum, AD 282].* **VF** £20 ($30) / **EF** £50 ($75)

12217 12222

12217 B. Rev. PRINCIPI IVVENT (or IVVENTVT), Numerian, in military attire, stg. l., holding globe and resting on sceptre, KA preceded or followed by officina mark S (= 6) in ex. RIC 360, 365. C 66, 74. Hunter 3–4. Pink, p. 33, series 2c. *[Rome, AD 282].*
 VF £20 ($30) / **EF** £50 ($75)

12218 D. Rev. PRINCIPI IVVENTVT, similar, but with officina mark C (= 3, sometimes reversed) in field. RIC 356. C 72. Hunter 6. Pink, p. 21, series 2. *[Lugdunum, AD 282].*
 VF £20 ($30) / **EF** £50 ($75)

12219 D. Rev. — Numerian, in military attire, stg. l., holding baton and transverse sceptre, XXI preceded by officina mark V or VI (= 5 or 6) in ex. RIC 366. C 76. Hunter 7, 9. Pink, p. 28, series 2. *[Ticinum, AD 282].* **VF** £20 ($30) / **EF** £50 ($75)

12220 D. Rev. — similar, but prince holds standard and vertical spear. RIC 368. C 81. Hunter 10. Pink, p. 28, series 2. *[Ticinum, AD 282].* **VF** £22 ($35) / **EF** £55 ($85)

12221 D. Rev. VICTORIA AVGG, Victory stg. l. on globe between two captives, holding wreath and palm, officina mark C (= 3) in field. RIC 358. C 97. Hunter, p. clxix. Pink —.
 [Lugdunum, AD 282]. **VF** £22 ($35) / **EF** £55 ($85)

12222 D. Rev. VIRTVS AVGG, Carus and Numerian (or Carinus and Numerian), both in military attire, stg. facing each other, the figure on r. presenting to the other a globe which is usually surmounted by Victory, the one on l. holding short sceptre, the other resting on long sceptre (or spear), XXI in ex., officina mark Γ (= 3) in field. RIC — (but cf. 377). C 107. Hunter, p. clxx. Pink, p. 44, series 2B. *[Siscia, AD 282].* **VF** £20 ($30) / **EF** £50 ($75)
 On this type and the following three the figure on right sometimes appears to be Jupiter.

12223 A. Rev. — similar, but with officina mark A-εΔ (= 1–9, sometimes with star above) in field. Cf. RIC 376. C 111 var. Hunter, p. clxxi. Pink, p. 55, series 1b. *[Antioch, AD 282].*
 VF £20 ($30) / **EF** £50 ($75)

12224 A. Rev. — similar, but the globe is not surmounted by Victory, sometimes with dot at end of legend, and with mint mark TR (sometimes with star above) in field. RIC 380. C 111. Hunter 16. Pink, p. 57, series 1. *[Tripolis, AD 283].* **VF** £22 ($35) / **EF** £55 ($85)

12225 **Billon antoninianus.** A. Rev. VIRTVS AVGGG, as 12223 (always with star in upper field). RIC 378. C 115. Hunter 14. Pink, p. 55, series 2. *[Antioch, AD 283].* **VF** £22 ($35) / **EF** £55 ($85)

Issues as Augustus, with Carus and Carinus, Feb./Mar.- Jul./Aug. AD 283, with Carinus until Oct./Nov. 284

12226 **Gold aureus.** J. Rev. ABVNDANTIA AVGG, Abundantia stg. l., emptying cornucopiae. RIC 451. Calicó 4298. C 2. Hunter, p. clxxi. Pink, p. 46, series 5.2. *[Siscia, AD 284].*
VF £4,000 ($6,000) / **EF** £10,000 ($15,000)

12227 J. Rev. ADVENTVS AVGG NN, Carinus and Numerian, both in military attire, stg. facing each other, holding between them globe surmounted by Victory who crowns them both, the figure on l. (Numerian) also holding short sceptre, the other resting on long sceptre (or spear), mint mark C in ex. RIC 462. Calicó 4300–01. Cf. C 5. Hunter, p. clxxi. Pink, p. 53, series 3. *[Cyzicus, AD 284].* **VF** £5,300 ($8,000) / **EF** £13,500 ($20,000)

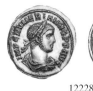

12228 12230

12228 J. Rev. CONCORDIAE AVGG NN, Carinus and Numerian, both togate, stg. facing each other, clasping r. hands and each holding short sceptre in l. RIC —. Calicó 4302. C —. Hunter —. Pink —. *[Cyzicus, AD 284].* **VF** £6,700 ($10,000) / **EF** £16,500 ($25,000)

12229 J. Rev. MARTI PACIFERO, Mars advancing l., holding olive-branch and spear. RIC 402. Calicó 4306. C —. Hunter, p. clxxi. Pink, p. 47, series 6. *[Siscia, AD 284].*
VF £4,300 ($6,500) / **EF** £11,750 ($17,500)

12230 J. Rev. ORIENS AVGG, Sol stg. l., raising r. hand and holding globe in l., star in field. RIC 454. Calicó 4309. C 33. Hunter, p. clxxi. Pink, p. 46, series 5.2. *[Siscia, AD 284].*
VF £4,000 ($6,000) / **EF** £10,000 ($15,000)

12231 H. Rev. — similar, but Sol is stg. facing, hd. l., and without star in field. RIC 381. Calicó 4307. Cf. C 34 (misdescribed). Hunter —. Pink, p. 24, series 6. *[Siscia, AD 284].*
VF £4,000 ($6,000) / **EF** £10,000 ($15,000)

12232 K. Rev. P M TRI P COS P P, Numerian in quadriga pacing r., holding branch. RIC —. Calicó 4311. C —. Hunter —. Cf. Pink, p. 46, series 5.1. *[Siscia or Rome, AD 284].*
VF £8,000 ($12,000) / **EF** £20,000 ($30,000)

12233 J. Rev. ROMAE AETERNAE, Roma seated l., holding patera (or wreath) and resting on spear, shield at side. RIC 457. Calicó 4314. C —. Hunter, p. clxxi. Pink, p. 47, series 6. *[Siscia, AD 284].* **VF** £4,300 ($6,500) / **EF** £11,750 ($17,500)

12234 L. Rev. SALVS AVGG, Salus seated l., feeding snake arising from altar and resting l. arm on throne. RIC 404. Calicó 4315. C 86. Hunter, p. clxix. Pink, p. 35, series 4. *[Rome, AD 283].*
VF £4,000 ($6,000) / **EF** £10,000 ($15,000)

12234

12235 **Gold aureus.** J. Rev. SPES AVGG, Spes advancing l., holding flower and lifting skirt. RIC
455. Calicó 4316, 4316a. C 88. Hunter, p. clxxi. Pink, p. 47, series 6. *[Siscia, AD 284].*
VF £4,000 ($6,000) / **EF** £10,000 ($15,000)

12236 L. Rev. VENERI VICTRICI, Venus stg. l., holding Victory and apple. RIC 405. Calicó
4319–21. C 93. Hunter, p. clxix. Pink, p. 35, series 4. *[Rome, AD 283].*
VF £4,000 ($6,000) / **EF** £10,000 ($15,000)

12237 J. Rev. VICTORIA AVGG, Victory advancing l., holding wreath and palm. RIC 458. Calicó
4322–3. C 96. Hunter, p. clxxi. Pink, p. 47, series 6. *[Siscia, AD 284].*
VF £4,000 ($6,000) / **EF** £10,000 ($15,000)

12238 L. Rev. — Numerian, in military attire, stg. l., crowned by Victory stg. l. behind him, his r.
hand extended towards two suppliants before him and holding transverse spear in l. RIC
443. Calicó 4326. C —. Hunter, p. clxx. Pink, p. 45, series 4. *[Siscia, AD 283].*
VF £6,700 ($10,000) / **EF** £16,500 ($25,000)

12239 G. Rev. VICTORIAE AVGG, Victory advancing r., holding wreath and palm, mint mark S M
A in ex. RIC 464. Calicó 4331. C 99. Hunter, p. clxxii. Pink, p. 56, series 3. *[Antioch,
AD 283].*
VF £4,300 ($6,500) / **EF** £11,750 ($17,500)

12240 L. Rev. VIRTVS AVGG, Hercules stg. r., r. hand on hip, l. resting on club wrapped in lion's
skin and set on rock. RIC 407. Calicó 4332–4. C 100. Hunter, p. clxix. Pink, p. 35, series
4. *[Rome, AD 283].*
VF £4,000 ($6,000) / **EF** £10,000 ($15,000)

12241 G. Rev. — similar, but with mint mark S M A in ex. RIC 465. Calicó 4337. C —. Hunter,
p. clxxii. Pink, p. 56, series 4. *[Antioch, AD 284].*
VF £4,300 ($6,500) / **EF** £11,750 ($17,500)

NB There is also a gold multiple, probably of 5 aurei, from the Siscia mint issued in AD 283,
obv. IMP NVMERIANVS AVG, elaborate diad. and cuir. bust l., holding horse's hd. by bridle
in r. hand and spear over shoulder in l., rev. VIRTVS AVGVSTORVM, Carus (or Carinus) and
Numerian riding towards each other, crowned by two Victories in background, attacking
group of six enemies on ground before them (Gnecchi I, p. 11, 1, RIC 401, cf. Cohen 117
for a pattern in bronze, Pink, p. 45, series 4). There is also a bronze medallion from the
same mint and period which is probably a pattern for another gold multiple, obv. IMP
NVMERIANVS P F AVG, laur. and cuir. bust r., holding spear and globe, rev. TRIVNFV
QVADOR, Carus (or Carinus) and Numerian in triumphal quadriga l., preceded by Victory,
soldiers with trophy and captives in background, two captives seated back to back amidst
arms in ex. (Gnecchi II, p. 123, 11, RIC —, Cohen 91, Pink, p. 45, series 4).

12242 **Billon antoninianus.** H. Rev. AEQVITAS AVGG, Aequitas stg. l., holding scales and
cornucopiae, officina mark B (= 2) in field. RIC 383. C 6. Hunter, p. clxx. Pink —.
[Lugdunum, AD 284]. VF £22 ($35) / **EF** £55 ($85)
This is possibly a hybrid with a reverse of Carinus.

12243

12243 **Billon antoninianus.** J. Rev. CLEMENTIA TEMP, Numerian, in military attire, stg. r., holding short sceptre and receiving Victory on globe from Jupiter stg. l., holding sceptre, officina mark A-Ϛ (= 1–6) in field, XXI in ex. RIC 463. C 8. Hunter 41–3. Pink, p. 53, series 3. *[Cyzicus, AD 284].* VF £20 ($30) / EF £50 ($75)

12244 H. Rev. FELICITAS AVGG, Felicitas stg. facing, hd. l., legs crossed, holding caduceus in r. hand and resting l. arm on column, officina mark B (= 2) in field, sometimes with mint mark LVG in ex. RIC 384. C 14. Hunter 29. Pink, p. 23, series 5. *[Lugdunum, AD 284].* VF £20 ($30) / EF £50 ($75)

12245 J. Rev. FIDES EXERCIT AVGG, Fides Militum seated l., holding patera and standard, two additional standards in background to l., mint mark S M S followed by XXI in ex., officina mark Γ (= 3) in field. RIC 463. C 8. Hunter 41–3. Pink, p. 53, series 3. *[Siscia, AD 284].* VF £22 ($35) / EF £55 ($85)

12246 K. Rev. IOVI VICTORI, Jupiter stg. l., holding Victory and sceptre, eagle at feet, KA followed by officina mark B (= 2) in ex. RIC 410. C 16. Hunter 18. Pink, p. 34, series 3b. *[Rome, AD 283].* VF £20 ($30) / EF £50 ($75)

12247 F. Rev. MARS VICTOR, Mars, naked, advancing r., carrying spear and trophy over l. shoulder, officina mark C (= 3) in field. RIC 386. C 24. Hunter, p. clxx. Pink, p. 22, series 4. *[Lugdunum, AD 283].* VF £20 ($30) / EF £50 ($75)

12248 K. Rev. ORIENS AVGG, Sol advancing l., raising r. hand and holding whip in l., KA followed by officina mark Ϛ (= 6) in ex. RIC 412. C 37. Hunter 20. Pink, p. 37, series 4. *[Rome, AD 283].* VF £20 ($30) / EF £50 ($75)

12249 12250

12249 F. Rev. PAX AVGG, Pax stg. l., holding olive-branch and transverse sceptre, officina mark B (= 2) in field. RIC 393. C 50. Hunter, p. clxx. Pink, p. 22, series 4. *[Lugdunum, AD 283].* VF £20 ($30) / EF £50 ($75)

12250 K. Rev. PIETAS AVGG, Mercury stg. l., holding purse and caduceus, KA followed by officina mark Δ (= 4) in ex. RIC 416. C 57. Hunter 21–2. Pink, p. 34, series 3b. *[Rome, AD 283].* VF £22 ($35) / EF £55 ($85)

12251 **Billon antoninianus.** H. Rev. PIETAS AVGG, Pietas stg. r. before altar, her r. hand extended, holding uncertain object (incense bottle?) in l., officina mark C (= 3) in field, sometimes with mint mark LVG in ex. RIC 396. C 63. Hunter 34. Pink, p. 23, series 5. *[Lugdunum, AD 284].* **VF** £22 ($35) / **EF** £55 ($85)

12252 L. Rev. PRINCIPI IVVENTVT, Numerian, in military attire, stg. l., holding baton and transverse sceptre, XXI preceded by officina mark V or VI (= 5 or 6) in ex. RIC 444. C 79. Hunter, p. clxx. Pink, p. 28, series 3. *[Ticinum, AD 283].* **VF** £22 ($35) / **EF** £55 ($85)

12253 L. Rev. PROVIDENT AVGG, Providentia stg. l., holding corn-ears and cornucopiae, modius at feet, mint marks as previous. RIC 447. C 83. Hunter 36–7. Pink, p. 29, series 4. *[Ticinum, AD 283].* **VF** £20 ($30) / **EF** £50 ($75)

12254 L. Rev. ROMAE AETERN, Roma seated l., holding Victory and sceptre, shield at side, officina and mint marks VI XXI T (= 6th officina) in ex. RIC 449. C 85. Hunter 39. Pink, p. 29, series 5. *[Ticinum, AD 283].* **VF** £20 ($30) / **EF** £50 ($75)

12255 L. Rev. SECVRIT AVG, Securitas stg. facing, hd. l., legs crossed, r. hand on hd., l. arm resting on column, officina and mint marks V XXI T (= 5th officina) in ex. RIC 450. C 87. Hunter 40. Pink, p. 29, series 5. *[Ticinum, AD 283].* **VF** £20 ($30) / **EF** £50 ($75)

12256 G. Rev. VIRTVS AVGG, Carinus and Numerian, both in military attire, stg. facing each other, the figure on r. presenting to the other a globe which is usually surmounted by Victory, the one on l. holding short sceptre (sometimes eagle-tipped), the other resting on long sceptre (or spear), XXI in ex., officina mark A-ε∆ (= 1–9), sometimes with star above, in field. RIC 466. C 108. Hunter 44. Pink, p. 56, series 4. *[Antioch, AD 284].*
 VF £20 ($30) / **EF** £50 ($75)
On this type and the next the figure on right sometimes appears to be Jupiter.

12257 G. Rev. — similar, but the globe is not surmounted by Victory, sometimes with dot at end of legend, and with mint mark TR with star above in field. RIC 470. C 113. Hunter, p. clxxii. Pink, p. 57, series 2. *[Tripolis, AD 284].* **VF** £22 ($35) / **EF** £55 ($85)

12258 12259

12258 K. Rev. VNDIQVE VICTORES, Numerian, in military attire, stg. l., holding globe and resting on sceptre, KA followed by officina mark S (= 6) in ex. RIC 423. C 118. Hunter 23. Pink, p. 35, series 3b. *[Rome, AD 283].* **VF** £40 ($60) / **EF** £100 ($150)
This exceptional legend, never used before on the imperial coinage, describes the young emperor as "everywhere victorious", a bold claim in the light of his unwarlike character and limited experience as a military commander.

12259 Similar, but Numerian is stg. between two seated captives. RIC 423. C 120. Hunter 25. Pink, p. 35, series 3b. *[Rome, AD 283].* **VF** £40 ($60) / **EF** £100 ($150)

12260 J. Rev. VOTA PVBLICA, Carinus and Numerian, both in military attire, stg. facing each other, sacrificing over altar between them, two standards in background, mint and officina marks S M S XXI Γ (= 3rd officina) in ex. RIC 461. C 122. Hunter, p. clxxi. Pink, p. 48, series 6. *[Siscia, AD 284].* **VF** £32 ($50) / **EF** £85 ($125)

NUMERIAN 505

12261 **Billon denarius.** K, laur. and dr., or dr. and cuir., bust r. Rev. **PAX AVGG**, Pax advancing l., holding olive-branch and sceptre. RIC 431. C —. Hunter, p. clxix. Pink, p. 48, series 6. *[Rome or Siscia, AD 284].* **VF** £265 ($400) / **EF** £665 ($1,000)

12262 Obv. Similar. Rev. **VIRTVS AVGG**, Mars or Virtus stg. l., resting on shield and spear. RIC 433 var. C 102 var. Hunter, p. clxix. Pink, p. 36, series 4. *[Rome, AD 283].* **VF** £265 ($400) / **EF** £665 ($1,000)

12263 — Rev. — Hercules stg. r., r. hand on hip, l. resting on club wrapped in lion's skin and set on rock. RIC —. C —. Hunter, p. clxix. Pink, p. 36, series 4. *[Rome, AD 283].* **VF** £330 ($500) / **EF** £825 ($1,250)

12264 **Billon quinarius.** As 12261 (rev. **PAX AVGG**, Pax advancing l.). RIC 435. C 53. Hunter 26–7. Pink, p. 48, series 6. *[Rome or Siscia, AD 284].* **VF** £200 ($300) / **EF** £500 ($750)

12265 Obv. As 12261. Rev. **PIETAS AVGG**, Mercury stg. l., holding purse and caduceus. RIC 437. C 58. Hunter, p. clxix. Pink, p. 36, series 4. *[Rome, AD 283].* **VF** £230 ($350) / **EF** £600 ($900)

12266 As 12263 (rev. **VIRTVS AVGG**, Hercules resting on club). RIC 439. C 101. Hunter, p. clxix. Pink, p. 36, series 4. *[Rome, AD 283].* **VF** £230 ($350) / **EF** £600 ($900)

12267 **Bronze reduced sestertius or as.** J, laur. and dr. bust r. Rev. **PAX AVGG**, Pax advancing l., as 12261. RIC 440. Cf. C 52. Hunter —. Cf. Pink, p. 48, note 76. *[Rome or Siscia, AD 284].* **F** £250 ($375) / **VF** £665 ($1,000)

For coins of Divus Numerian, see under Carinus (nos. 12407–9).

Alexandrian Coinage

As Caesar

All have obv. **A K M A NOVMEPIANOC K C**, laur., dr. and cuir. bust r. The reverse types are as follows:

12268 **Billon tetradrachm.** Dikaiosyne (= Aequitas) stg. l., holding scales and cornucopiae, **L A** (= regnal year 1) before, sometimes with star behind. Dattari 5599–5600. BMCG 2462. Cologne 3188. Milne 4664, 4684. *[AD 282–3].* **VF** £13 ($20) / **EF** £32 ($50)

12269 Nike (= Victory) advancing r., holding wreath and palm, **L — A** (= regnal year 1) in field, sometimes with star before. Dattari 5601–2. BMCG —. Cologne —. Milne 4666. *[AD 282–3].* **VF** £16 ($25) / **EF** £40 ($60)

12270

12270 Eagle stg. facing between two vexilla, hd. r., wings open, holding wreath in beak, **L A** (= regnal year 1) above, sometimes with star. Dattari 5604–5. BMCG 2463. Cologne 3187. Milne 4682, 4694. *[AD 282–3].* **VF** £13 ($20) / **EF** £32 ($50)

12271 **Billon tetradrachm.** Eagle stg. r., holding wreath in beak, palm transversely in background, L — A (= regnal year 1) in field. Dattari 5603. BMCG —. Cologne —. Milne 4673. *[AD 282–3].* **VF** £16 ($25) / **EF** £40 ($60)

12272 Athena seated l., holding Nike and sceptre, shield at side, L — B (= regnal year 2) in field. Dattari 5598. BMCG —. Cologne —. Milne 4698. *[AD 283].* **VF** £20 ($30) / **EF** £50 ($75)
The continued use of this obverse legend on a coin issued at least six months after Numerian had received the title of Augustus suggests some confusion in Egypt over the precise form of his titulature.

As Augustus

All have obv. A K M A NOVMEPIANOC CEB, laur., dr. and cuir. bust r. The reverse types are as follows:

12273 **Billon tetradrachm.** Athena seated l., as previous, but sometimes with star behind. Dattari 5607–8. BMCG 2464. Cologne 3192, 3194. Milne 4699, 4719. *[AD 283–4].*
VF £13 ($20) / **EF** £32 ($50)

12274 Eagle between vexilla, as 12270, but with L B (= regnal year 2) above, sometimes with star. Dattari 5616–17. BMCG 2472–3. Cologne 3190–91. Milne 4711, 4729. *[AD 283–4].*
VF £13 ($20) / **EF** £32 ($50)

12274 12277

12275 Sarapis, wearing modius, walking r., his r. hand raised, holding transverse sceptre in l., L Γ (= regnal year 3) behind, star before. Dattari 5613. BMCG —. Cologne —. Milne —. *[AD 284].* **VF** £32 ($50) / **EF** £80 ($120)

12276 Eirene (= Pax) stg. l., holding olive-branch and transverse sceptre, ETOVC before, Γ (= regnal year 3) behind. Dattari 5609. BMCG 2466. Cologne 3198. Milne 4735. *[AD 284].*
VF £16 ($25) / **EF** £40 ($60)

12277 Nike advancing r., as 12269, but with ETOVC behind and Γ (= regnal year 3) before. Dattari 5612. BMCG 2469. Cologne 3199. Milne 4739. *[AD 284].* **VF** £16 ($25) / **EF** £40 ($60)

12278 Eagle stg. l., hd. r., wings closed, holding wreath in beak, ETOVC before, Γ (= regnal year 3) behind. Dattari 5614. BMCG/Christiansen 3458. Cologne 3196. Milne —. *[AD 284].*
VF £16 ($25) / **EF** £40 ($60)

12279 Similar, but with LEΓ B TPAI (= *Legio II Traiana*) before and L Γ (= regnal year 3) behind. Dattari 5615. BMCG 2470. Cologne 3197. Milne 4747. *[AD 284].*
VF £20 ($30) / **EF** £50 ($75)
Legio II Traiana was raised by Trajan early in the 2nd century for service in the Dacian Wars. It was later transferred to Syria and under Hadrian, circa AD 125, it was sent to its eventual permanent station at Nicopolis, close to Alexandria in Egypt. It probably participated in the Persian Wars of Carus and Numerian and may have distinguished itself during that campaign (see also no. 12386).

12279

12280 **Billon tetradrachm.** Carinus and Numerian, both togate, stg. facing each other, clasping r.
hands, L — Γ (= regnal year 3) in field. Dattari 5606. BMCG —. Cologne —. Milne —.
[AD 284]. **VF** £45 ($65) / **EF** £100 ($150)

CARINUS
Feb./Mar. AD 283–spring 285

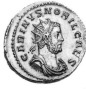

12305

*Marcus Aurelius Carinus, the elder son of Carus, was born about the middle of the 3rd century and
was thus in his early thirties at the time his father bestowed on him the rank of Caesar, a month or
so prior to the same title being given to his younger brother Numerian. Carus obviously had great
confidence in Carinus' abilities as he left him in charge of the western provinces when, early in AD
283, he and Numerian departed for the East to wage war on the Sasanid Persian Empire. Carinus
would never see his father or brother again. Carus died in Persia during the summer and
Numerian fell mysteriously and fatally ill while travelling through Asia Minor to meet his brother
in the autumn of AD 284. In reality, both may have been the victims of the praetorian prefect Arrius
Aper who was executed by Diocletian after the death of Numerian. Diocletian was now proclaimed
emperor by the eastern army and the Empire braced itself for a civil war between the two
contenders for supreme power. In the meantime Carinus had been busy campaigning in various
provinces, principally on the Rhine and Danube frontiers and in the far west in Britain. But he was
now confronted with much more serious challenges. Diocletian was planning to attack him at the
head of the eastern legions while in the north Julian, governor of Venetia, raised the standards of
rebellion in Pannonia and began issuing a fine series of gold and billon coins from the important
mint of Siscia. Carinus rose to the occasion and marched against the rebel, defeating him in a
battle fought in January or February of AD 285. He now moved on to challenge his more serious
rival and sometime in the spring the armies of the east and west joined battle at Margum (modern
Dubravica near Belgrade). It was a closely fought contest and Carinus appeared to have the upper
hand until he fell victim to one of his own officers whose wife (according to the Historia Augusta)
he had seduced. This battle proved to be a pivotal event in the history of the Empire as Diocletian's
success led to the founding of the late Roman state which broke with many of the traditions of the
principate established by Augustus more than 300 years before. A hostile tradition, based on
propaganda disseminated by his successful rival Diocletian, paints a fiercely critical picture of
Carinus' character which seems too exaggerated to be given serious credence. Carinus probably
had his shortcomings, but he was certainly an efficient soldier and if his reign had not been cut
short in such tragic circumstances posterity might well have viewed him in quite a different light.
The regime which followed him completely changed the structure and administration of the
Empire, as well as the imperial coinage itself, so it is hardly surprising that the history of Carinus
is lost in the shadow of the momentous achievements of his successor, Diocletian, and the
tetrarchic system of government which he established.*

Carinus' coinage is divided into two principal groups, those issued during the four or five months that he bore the junior title of Caesar, and those struck after his elevation to the rank of Augustus in February/March 283. He also struck coins for his wife, Magnia Urbica, and posthumous issues in the names of Divus Carus, Divus Numerian, and Divus Nigrinian, the last probably his own son.

The following are the principal forms of obverse legend, other varieties being given in full:

As Caesar

A. CARINVS NOBIL CAES
B. IMP C M AVR CARINVS NOB C
C. M AVR CARINVS NOB C
D. M AVR CARINVS NOB CAES

As Augustus

E. IMP CARINVS AVG
F. IMP CARINVS P F AVG
G. IMP C CARINVS P F AVG
H. IMP C M AVR CARINVS AVG
J. IMP C M AVR CARINVS P F AVG
K. IMP M AVR CARINVS P F AVG

The normal obverse type for aurei is laureate bust of Carinus right, draped or cuirassed, or draped and cuirassed, and for antoniniani radiate bust right, draped or cuirassed, or draped and cuirassed. More unusual types are described in full as are the obverses of all other denominations.

Issues as Caesar under Carus, Oct. AD 282-Feb./Mar. 283

12281 **Gold aureus.** D. Rev. MARS VLTOR, Mars, in military attire, advancing r., holding transverse spear and shield. RIC 188. Calicó 4348. C 49 var. Hunter, p. clxiv. Pink, p. 42, series 1. *[Siscia, AD 282].* **VF** £2,700 ($4,000) / **EF** £6,700 ($10,000)

12282

12282 D. Rev. PAX AETERNA, Pax advancing l., holding olive-branch and sceptre. RIC 153. Calicó 4351. C 62. Hunter, p. clx. Pink, p. 27, series 1. *[Ticinum or Rome, AD 282].*
 VF £2,700 ($4,000) / **EF** £6,700 ($10,000)

12283 A. Rev. PRINCIPI IVVENTVT, Carinus, in military attire, stg. l. amidst four standards, raising r. hand and resting on spear held in l. RIC 147. Calicó 4354. C 90. Hunter, p. clxii. Pink, p. 28, series 2. *[Ticinum or Lugdunum, AD 282].*
 VF £3,300 ($5,000) / **EF** £8,300 ($12,500)

12284 D. Rev. PRINCIPIS IVVENTVTI, Carinus, in military attire, stg. r., holding transverse spear and globe, crescent in ex. RIC 199. Calicó 4355. C 109. Hunter, p. clxv. Pink, p. 52, series 1. *[Cyzicus, AD 282].* **VF** £3,300 ($5,000) / **EF** £8,300 ($12,500)

12285 **Gold aureus.** D, laur., dr. and cuir. bust l., viewed from back, holding spear and shield. Rev. ROMAE AETERNAE, Roma seated l., holding wreath and sceptre, shield at side. RIC 189. Calicó 4356. C 114. Hunter, p. clxiv. Pink, p. 42, series 1. *[Siscia, AD 282]*.
VF £3,300 ($5,000) / EF £8,300 ($12,500)

12286 IMP CAESAR M AVR CARINVS. Rev. VICTOR CARO, Victory advancing r., holding wreath and palm. RIC 210. Calicó 4368. C 132. Hunter, p. clxvi. Cf. Pink, p. 57. *[Alexandria?, AD 283]*.
VF £5,000 ($7,500) / EF £12,000 ($18,000)

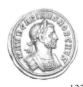 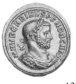

12287 12289

12287 D. Rev. VICTORIA AVG, Victory stg. l. on globe, holding wreath and palm. Cf. RIC 190. Calicó 4372–73a. Cf. C 139. Hunter, p. clxiv. Pink, p. 42, series 1. *[Siscia, AD 282]*.
VF £2,700 ($4,000) / EF £6,700 ($10,000)

12288 B. Rev. VICTORIA AVGG, Carinus, in military attire, stg. l., crowned by Victory stg. l. behind him, his r. hand extended towards two suppliants before him and holding transverse spear in l., star in ex. RIC 204. Calicó 4383. C 155. Hunter 18. Pink, p. 43, series 2A. *[Siscia, AD 282]*.
VF £5,300 ($8,000) / EF £13,500 ($20,000)

12289 M AVR CARINVS P F NOB CAES. Rev. VICTORIA AVGVSTORVM, Carinus, togate, stg. r., and Carus, in military attire, stg. l., holding Victory between them, Carus also holding transverse sceptre, sometimes with wreath in ex. RIC 193. Calicó 4384–5. C 156. Hunter, p. clxiv. Pink, p. 43, series 2A. *[Siscia, AD 282]*.
VF £4,000 ($6,000) / EF £10,000 ($15,000)

12290 D. Rev. VICTORIA CAESARIS, Victory in biga galloping l., holding wrea th and palm, mint mark K or crescent in ex. RIC 201. Calicó 4386–7. Cf. C 157. Hunter, p. clxv. Pink, pp. 52–3, series 1–2. *[Cyzicus, AD 282]*. VF £4,000 ($6,000) / EF £10,000 ($15,000)

12291 B. Rev. VICTORIAE AVGG, Victory advancing r., holding wreath and palm, mint mark S M A in ex. RIC —. Calicó 4393–93b. C —. Hunter —. Pink —. *[Antioch, AD 283]*.
VF £3,700 ($5,500) / EF £9,000 ($13,500)

12292 B. Rev. VIRTVS AVGGG, Mars or Virtus stg. r., resting on spear and shield, mint mark S M A in ex. RIC 205. Calicó 4403. Cf. C 186. Cf. Hunter, p. clxv. Cf. Pink, p. 55, series 2. *[Antioch, AD 283]*. VF £3,300 ($5,000) / EF £8,300 ($12,500)

NB There is also a gold multiple, probably of 5 aurei, from the Siscia mint, obv. M AVR CARINVS NOB CAES, laur. and cuir. bust r., rev. VICTORIE (*sic*) AVGG, two Victories attaching shield to palm-tree with two captives seated at base (in private collection, unpublished in the principal sources).

12293 **Billon double antoninianus.** D, rad. and cuir. bust r. Rev. FELICITAS REIPVBLICAE, Felicitas stg. l., holding caduceus and transverse sceptre and resting l. arm on column, XI in ex. RIC 194. Cf. C 25. Hunter, p. clxv, note 4. Pink, p. 42, series 1. *[Siscia, AD 282]*.
VF £150 ($225) / EF £330 ($500)

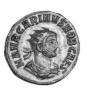

12294 12298

12294 **Billon antoninianus.** D. Rev. CLEMENTIA TEMP, Carinus, in military attire, stg. r., holding
 short sceptre and receiving Victory on globe from Jupiter stg. l., holding sceptre, officina
 mark A or Γ (= 1 or 3) in ex., or A-ς (= 1–6) in field and XXI in ex. RIC 202. C 19. Hunter,
 p. clxv. Pink, pp. 52–3, series 1–2. *[Cyzicus, AD 282].* VF £16 ($25) / EF £45 ($65)

12295 M AVR CARINVS P F NOB CAES. Rev. FIDES MILITVM, Fides Militum stg. l., holding
 standard in each hand, officina mark P (= 1) in field, XXI in ex. RIC 195. C 29. Hunter,
 p. clxiv, note 5. Pink, p. 42, series 1. *[Siscia, AD 282].* VF £20 ($30) / EF £50 ($75)

12296 D. Rev. PIETAS AVGG, emblems of the priestly colleges (lituus, knife, jug, simpulum and
 sprinkler) variously arranged, mint and officina marks R Z (= 7th officina) in ex., or K, AK,
 or KA preceded or followed by officina mark Z (= 7) in ex. RIC 155. C 74. Hunter 3–4.
 Pink, pp. 31–2, series 1–2b. *[Rome, AD 282].* VF £22 ($35) / EF £55 ($85)

12297 C. Rev. PRINCIPI IVVENT, Carinus, in military attire, stg. l., holding standard and sceptre
 (or spear), XXI preceded by officina mark V or VI (= 5 or 6) in ex. RIC 177. C 84. Hunter,
 p. clxiii. Pink, p. 28, series 1. *[Ticinum, AD 282].* VF £20 ($30) / EF £50 ($75)

12298 D. Rev. — similar, but Carinus holds baton and transverse spear, two standards behind,
 star in field, XXI followed by officina mark T (= 3) in ex. RIC 198. C 87. Hunter, p. clxiv.
 Pink, p. 41, series first issue. *[Siscia, AD 282].* VF £20 ($30) / EF £50 ($75)

12299 Similar, but without the two standards, XXI in ex., officina mark T (= 3) with or without
 star or dot in field. RIC 197. C 89. Hunter, p. clxiv. Pink, p. 41, first issue. *[Siscia, AD 282].*
 VF £20 ($30) / EF £50 ($75)

12300 A, rad. and cuir. bust l., holding spear and shield. Rev. PRINCIPI IVVENTVT, Carinus, in
 military attire, stg. l., holding globe and sceptre (or spear), officina mark C (= 3) in field.
 RIC 150. C 93. Hunter, p. clxiii. Pink, p. 21, series 2. *[Lugdunum, AD 282].*
 VF £32 ($50) / EF £80 ($120)

12301 A. Rev. — similar, but Carinus holds standard instead of sceptre or spear. RIC 151. C 96.
 Hunter, p. clxiii. Pink, p. 21, series 2. *[Lugdunum, AD 282].* VF £20 ($30) / EF £50 ($75)

12302 C. Rev. — as 12300, but with captive seated at prince's feet to l., and with XXI preceded by
 officina mark T or Q (= 3 or 4) in ex. RIC 182. C 97. Hunter 17. Pink, p. 28, series 2.
 [Ticinum, AD 282]. VF £20 ($30) / EF £50 ($75)

12303 D. Rev. — Carinus with standard and sceptre or spear, as 12297, but with mint and officina
 marks R ε (= 5th officina) in ex., or with K, AK, or KA preceded or followed by officina
 mark ε (= 5) in ex. RIC 158. C 103. Hunter 5. Pink, pp. 31–2, series 1–2b. *[Rome,
 AD 282].* VF £20 ($30) / EF £50 ($75)

12304 **Billon antoninianus.** C. Rev. PRINCIPI IVVENTVTI, Carinus with baton and spear and two standards, as 12298, but with XXI preceded by officina mark V or VI (= 5 or 6) in ex. RIC 183. C 107. Hunter, p. clxiii. Pink, p. 28, series 1. *[Ticinum, AD 282].*
VF £20 ($30) / **EF** £50 ($75)

12305 A. Rev. SAECVLI FELICITAS, Carinus, in military attire, stg. r., holding transverse spear and globe, officina mark D (= 4, sometimes reversed) in field. RIC 152. C 115. Hunter 13, 15. Pink, p. 22, series 2. *[Lugdunum, AD 282].*
VF £20 ($30) / **EF** £50 ($75)

12306 Similar, but with obv. as 12300. RIC 152. C 117. Hunter, p. clxiii. Pink, p. 22, series 2. *[Lugdunum, AD 282].*
VF £32 ($50) / **EF** £80 ($120)

12307 B. Rev. VIRTVS AVGG, Carus and Carinus, both in military attire, stg. facing each other, the figure on r. presenting to the other a globe which is usually surmounted by Victory, the one on l. holding short sceptre, the other resting on long sceptre (or spear), XXI in ex., officina mark A-εΔ (= 1–9), sometimes with star above, in field. RIC 206. C 177, 182. Hunter 20–21. Pink, p. 55, series 1. *[Antioch, AD 282].* VF £16 ($25) / **EF** £45 ($65)
On this type and the following two the figure on right sometimes appears to be Jupiter.

12308 B. Rev. — similar, but the globe is never surmounted by Victory, sometimes with dot at end of legend, and with mint mark TR (sometimes with star above) in field. RIC 209. C 177. Hunter, p. clxvi. Pink, p. 57, series 1. *[Tripolis, AD 283].* VF £20 ($30) / **EF** £50 ($75)

12309

12309 B. Rev. VIRTVS AVGGG, as 12307, but the globe is always surmounted by Victory and always with star in upper field. RIC 208. C 188. Hunter, p. clxvi. Pink, p. 55, series 2. *[Antioch, AD 283].*
VF £20 ($30) / **EF** £50 ($75)

12310 **Billon denarius.** D, laur., dr. and cuir. bust r. rev. MARS VLTOR, Mars, in military attire, advancing r., holding transverse spear and shield. RIC 163. C —. Hunter, p. clx. Pink, p. 27, series 1. *[Rome or Ticinum, AD 282].* VF £330 ($500) / **EF** £825 ($1,250)

12311 Obv. Similar. Rev. PAX AETERNA, Pax advancing l., holding wreath and transverse sceptre. RIC —. C —. Hunter, p. clv. Pink, p. 27, series 1. *[Rome or Ticinum, AD 282].*
VF £330 ($500) / **EF** £825 ($1,250)

12312 — PROVIDE AVGG, Providentia stg. l., holding rod and sceptre, globe at feet. RIC —. C —. Hunter —. Pink, p. 27, series 1. *[Rome or Ticinum, AD 282].*
VF £330 ($500) / **EF** £825 ($1,250)

12313 **Billon quinarius.** M AVR CARINVS C, laur. and cuir. bust r. Rev. GENIVS EXERC, Genius of the Army stg. l. in distyle temple, sacrificing over altar and holding cornucopiae. RIC 165. C 36. Hunter, p. clx. Pink, p. 27, series 1. *[Rome or Ticinum, AD 282].*
VF £265 ($400) / **EF** £665 ($1,000)

12314 **Billon quinarius.** M AVR CARINVS C, laur., dr. and cuir. bust r. Rev. MARTI VICTORI, Mars advancing r., as 12310. RIC 166. C —. Hunter, p. clx. Pink, p. 27, series 1. *[Rome or Ticinum, AD 282].* **VF** £200 ($300) / **EF** £500 ($750)

12315 CARINVS N CAES, as previous. Rev. VIRTVS AVGG, Mars or Virtus stg. l., resting on shield and spear. RIC 171. C —. Hunter, p. clx. Pink, p. 27, series 1. *[Rome or Ticinum, AD 282].*
 VF £200 ($300) / **EF** £500 ($750)

12316 **Bronze reduced sestertius or as.** D, laur. and dr. bust r. Rev. PAX AVGVSTORVM, Pax advancing l., holding olive-branch and sceptre. RIC 173. C 70. Hunter, p. clxi. Pink, p. 27, series 1. *[Rome or Ticinum, AD 282].* **F** £265 ($400) / **VF** £600 ($900)
 This type and the next exist in a range of sizes and weights and it possible that some of the smaller and lighter specimens may represent a separate denomination — a reduced as or semis. Alternatively, there may have been a reduction in the weight standard of the sestertius during the course of the issue.

12317 Obv. Similar. Rev. PRINCIPI IVVENT (or IVVENTVT), Carinus, in military attire, stg. l., holding standard and sceptre (or spear). RIC 174. C 81. Hunter 12. Pink, p. 27, series 1. *[Rome or Ticinum, AD 282].* **F** £265 ($400) / **VF** £600 ($900)

Issues as Augustus, with Carus and Numerian, Feb./Mar.- Jul./Aug. AD 283, with Numerian until Oct./Nov. 284, alone until spring 285

12318 **Gold aureus.** G. Rev. ABVNDANTIA AVG, Abundantia stg. l., emptying cornucopiae. RIC 307. Calicó 4340. C —. Hunter, p. clxiv. Pink, p. 49, series 7. *[Siscia, AD 284].*
 VF £3,000 ($4,500) / **EF** £7,700 ($11,500)

12319 Similar, but rev. legends ends AVGG. RIC 308. Calicó 4341. Cf. C 1. Hunter, p. clxiv. Pink, p. 47, series 6. *[Siscia, AD 284].* **VF** £2,700 ($4,000) / **EF** £6,700 ($10,000)

12320 K. Rev. ADVENTVS AVGG NN, Carinus and Numerian, both in military attire, stg. facing each other, holding between them globe surmounted by Victory who crowns them both, the figure on l. (Numerian) also holding short sceptre, the other resting on long sceptre (or spear), mint mark C in ex. RIC 317. Calicó 4342. C —. Hunter, p. clxv. Pink, p. 53, series 3. *[Cyzicus, AD 284].* **VF** £4,300 ($6,500) / **EF** £11,750 ($17,500)

12321 G. Rev. CONCORDIA AVG, Concordia seated left, holding patera and cornucopiae. RIC 227. Calicó 4343. C 22. Hunter, p. clxi. Pink, p. 49, series 7. *[Siscia or Rome, AD 284].*
 VF £3,000 ($4,500) / **EF** £7,700 ($11,500)

12322 F, laur. and cuir. bust l. Rev. FELICIT PVBLICA, Felicitas stg. facing, hd. l., legs crossed, holding caduceus in r. hand and resting l. arm on column. RIC 292. Calicó 4344. Cf. C 23. Hunter, p. clxiv. Pink, p. 45, series 4. *[Siscia or Ticinum, AD 283].*
 VF £4,000 ($6,000) / **EF** £10,000 ($15,000)
 This is of smaller diameter than normal for an aureus, hence Cohen's description of it as a gold quinarius. The weight, however, is regular.

12323 F. Rev. FIDES MILITVM, Fides Militum stg. l., holding standard in each hand. RIC 228. Calicó 4345. C 27. Hunter, p. clxi. Pink, p. 38, series 5. *[Rome, AD 284].*
 VF £3,000 ($4,500) / **EF** £7,700 ($11,500)

12324 J, laur. and cuir. bust l. Rev. LIBERALITAS AVGG, Liberalitas stg. l., holding abacus and cornucopiae, star in field. RIC 309. Calicó 4347. C 48. Hunter, p. clxiv. Pink, p. 46, series 5.2. *[Siscia, AD 284].* **VF** £3,300 ($5,000) / **EF** £8,300 ($12,500)

12325 **Gold aureus.** J, laur., dr. and cuir. bust l., viewed from back, holding spear and shield.
Rev. ORIENS AVGG, Sol stg. facing, hd. l., raising r. hand and holding globe in l., star in
field. RIC 310. Calicó 4350. C 59. Hunter, p. clxiv. Pink, p. 46, series 5.2. *[Siscia, AD 284].*
 VF £4,000 ($6,000) / **EF** £10,000 ($15,000)

12326 F. Rev. P M TRI P COS P P, Carinus in quadriga pacing r., holding branch. RIC 226. Calicó
4352. C 79. Hunter, p. clx. Pink, p. 46, series 5.1. *[Siscia or Rome, AD 284].*
 VF £6,700 ($10,000) / **EF** £16,500 ($25,000)

12327 F. Rev. SALVS AVG, Salus seated l., feeding snake arising from altar. RIC —. Calicó 4357.
C —. Hunter —. Pink, p. 38, series 5. *[Rome, AD 284].*
 VF £3,000 ($4,500) / **EF** £7,700 ($11,500)

12328 Similar, but rev. legends ends AVGG. RIC 229. Calicó 4358. Cf. C 121 (incomplete
description). Hunter, p. clxi. Pink, p. 35, series 4. *[Rome, AD 283].*
 VF £2,700 ($4,000) / **EF** £6,700 ($10,000)

12329 G. Rev. SPES AVGG, Spes advancing l., holding flower and lifting skirt. Cf. RIC 311.
Calicó 4361. C 127. Hunter, p. clxiv. Pink, p. 47, series 6. *[Siscia, AD 284].*
 VF £2,700 ($4,000) / **EF** £6,700 ($10,000)

12330 J. Rev. VENERI VICTRICI, Venus stg. l., holding Victory and apple. RIC 230. Calicó 4362. C
130. Hunter, p. clx. Pink, p. 35, series 4. *[Rome, AD 283].*
 VF £3,000 ($4,500) / **EF** £7,700 ($11,500)

12331 G. Rev. VICTORIA AVG, Victory advancing l., holding wreath and palm. RIC 312. Calicó
4369–70. C 133. Hunter, p. clxiv. Pink, p. 49, series 7. *[Siscia, AD 284].*
 VF £2,700 ($4,000) / **EF** £6,700 ($10,000)

12332 Similar, but Victory advancing r. RIC —. Calicó 4371. C —. Hunter, p. clxiv. Pink, p. 49,
series 7. *[Siscia, AD 284].* **VF** £3,300 ($5,000) / **EF** £8,300 ($12,500)

12333 IMP CARINVS P AVG, laur. and cuir. bust l., holding holding spear and shield. Rev.
VICTORIA AVGG, Victory stg. l. on globe, holding wreath and palm. RIC 211. Calicó
4376. C 142. Hunter, p. clxii. Pink, p. 24, series 6. *[Lugdunum, AD 284].*
 VF £4,000 ($6,000) / **EF** £10,000 ($15,000)

12334 G. Rev. — Victory advancing l., as 12331. RIC 313. Calicó 4379. C 146. Hunter, p. clxiv.
Pink, p. 47, series 6. *[Siscia, AD 284]* **VF** £2,700 ($4,000) / **EF** £6,700 ($10,000)

12335 J. Rev. VICTORIA GERMANICA, Victory in galloping biga l., holding wreath and palm,
enemy on ground beneath horses. RIC 319. Calicó 4388–90. C 158. Hunter, p. clxv. Pink,
p. 53, series 3. *[Cyzicus, AD 284].* **VF** £4,300 ($6,500) / **EF** £11,750 ($17,500)

12336

12336 F. Rev. VIRTVS AVG, Hercules stg. r., r. hand on hip, l. resting on club wrapped in lion's
skin and set on rock. RIC 233. Calicó 4394–95a. C 160. Hunter 22. Pink, p. 37, series 5.
[Rome, AD 284]. **VF** £2,700 ($4,000) / **EF** £6,700 ($10,000)

12337 **Gold aureus.** Similar, but rev. legends ends **AVGG**. RIC 235. Calicó 4397–9. C 163. Hunter,
p. clxi. Pink, p. 35, series 4. *[Rome, AD 283].* **VF** £2,300 ($3,500) / **EF** £6,000 ($9,000)

> **NB** There is also a gold multiple, probably of 5 aurei, issued at Siscia early in AD 284, obv.
> **IMP C M AVR CARINVS P F AVG**, laur., dr. and cuir. bust r., rev. **VIRTVS AVGVSTOR**,
> Carinus r. and Numerian l., both in military attire, stg. facing each other, Carinus crowned
> by Sol stg. behind him and presenting Victory to his brother, who is similarly crowned by
> Hercules holding club and lion's skin (Gnecchi I, p. 10, 1, RIC 225, Cohen 189, Pink,
> p. 46, series 5).

12338 **Gold quinarius.** F, laur. and dr. bust r. Rev. **VIRTVS AVGG**, Mars advancing r., holding
spear and shield, two captives at feet. RIC —. C —. Cf. Hunter, p. clxi. Pink, p. 35, series
4. *[Rome, AD 283].* (*Extremely rare*)

12339 12342

12339 **Billon antoninianus.** H. Rev. **AEQVITAS AVGG**, Aequitas stg. l., holding scales and
cornucopiae, officina mark **A** (= 1) in field. RIC 212. C 8. Hunter 34. Pink, p. 22, series 4.
[Lugdunum, AD 283]. **VF** £16 ($25) / **EF** £45 ($65)

12340 F. Rev. **AETERNIT AVG**, Aeternitas stg. l., holding globe surmounted by phoenix and lifting
her robe, **KA** followed by officina mark **Γ** (= 3) in ex., sometimes with crescent (or crescent
and dot) between **K** and **A** or between **A** and **Γ**. RIC 244. C 10. Hunter 26, 29. Pink,
pp. 38–9, series 5–6. *[Rome, AD 284–5].* **VF** £20 ($30) / **EF** £50 ($75)

12341 Similar, but rev. legends ends **AVGG** and no crescent in mint mark. RIC 248. C 14. Hunter,
p. clxiii. Pink, p. 37, series 5. *[Rome, AD 285].* **VF** £20 ($30) / **EF** £50 ($75)

12342 K. Rev. **CLEMENTIA TEMP**, Carinus, in military attire, stg. r., holding short sceptre and
receiving Victory on globe from Jupiter stg. l., holding sceptre, officina mark **A-Ϛ** (= 1–6)
in field, **XXI** in ex. RIC 324. C 20. Hunter, p. clxv. Pink, p. 53, series 3. *[Cyzicus, AD 284].*
VF £16 ($25) / **EF** £45 ($65)

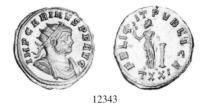

12343

12343 F. Rev. **FELICIT** (or **FELICITAS**) **PVBLICA**, Felicitas resting on column, as 12322, **XXI**
preceded by officina mark **T** or **Q** (= 3 or 4) in ex. RIC 295. C 24. Hunter 40–42. Pink,
p. 29, series 4. *[Ticinum, AD 283].* **VF** £16 ($25) / **EF** £45 ($65)

12344

12344 **Billon antoninianus.** F. Rev. FIDES MILITVM, Fides Militum stg. l., holding standard in
each hand, KA followed by officina mark Ɛ (= 5) in ex., sometimes with crescent (or
crescent and dot) between K and A or between A and Ɛ. RIC 253. C 28. Hunter 30. Pink,
pp. 37–9, series 4–6. *[Rome, AD 283–5].* VF £16 ($25) / **EF** £45 ($65)

12345 F. Rev. FORTVNA REDVX, Fortuna seated l., holding rudder and cornucopiae, XXI preceded
by officina mark T (= 3) and followed by mint mark T in ex. RIC 298. C 34. Hunter,
p. clxiii. Pink, p. 29, series 5. *[Ticinum, AD 283].* VF £16 ($25) / **EF** £45 ($65)

12346 H. Rev. GENIVS EXERCITI, Genius of the Army stg. l., holding patera and cornucopiae, KA
followed by officina mark A (= 1) in ex. RIC 255. C 38. Hunter, p. clxii. Pink, p. 34, series
3b. *[Rome, AD 283].* VF £16 ($25) / **EF** £45 ($65)

12347 J. Rev. IOVI CONSER, Carinus and Jupiter, similar to 12342, but the globe is not
surmounted by Victory, mint mark S M S XXI in ex., officina mark B or Γ (= 2 or 3) in field.
RIC 314. Cf. C 40–41. Hunter, p. clxv. Pink, p. 48, series 6. *[Siscia, AD 284].*
VF £30 ($45) / **EF** £75 ($110)

12348 F. Rev. IOVI VICTORI, Jupiter stg. l., holding Victory and sceptre, eagle at feet, KA
followed by officina mark B (= 2) in ex., sometimes with crescent (or crescent and dot)
between K and A or between A and B. RIC 258. C 45. Hunter 27. Pink, pp. 38–9, series
5–6. *[Rome, AD 284–5].* VF £16 ($25) / **EF** £45 ($65)

12349 F. Rev. LAETITIA FVND, Laetitia stg. l., holding wreath and rudder, KA followed by officina
mark Γ (= 3) in ex. RIC 261. C 47. Hunter 28. Pink, p. 38, series 5. *[Rome, AD 284].*
VF £20 ($30) / **EF** £50 ($75)

12350 F. Rev. ORIENS AVG, Sol stg. (or advancing) l., raising r. hand and holding whip in l., KA
followed by officina mark Ϛ (= 6) in ex., sometimes with crescent (or crescent and dot)
between K and A or between A and Ϛ. Cf. RIC 262. Cf. C 60 (misdescribed). Hunter,
p. clxii. Pink, p. 39, series 5–6. *[Rome, AD 284–5].* VF £20 ($30) / **EF** £50 ($75)

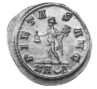

12351

12351 F. Rev. PIETAS AVG, Mercury stg. l., holding purse and caduceus, KA followed by officina
mark Δ (= 4) in ex., sometimes with crescent (or crescent and dot) between K and A or
between A and Δ. RIC 264. C 72. Hunter 31. Pink, pp. 38–9, series 5–6. *[Rome,
AD 284–5].* VF £20 ($30) / **EF** £50 ($75)

12352 **Billon antoninianus.** F. Rev. PRINCIPI IVVENTVT, Carinus, in military attire, stg. l., holding globe and sceptre (or spear), captive seated at feet to l., XXI preceded by officina mark T or Q (= 3 or 4) in ex. RIC 302. C 99. Hunter, p. clxiii. Pink, p. 28, series 3. *[Ticinum, AD 283].* **VF £22 ($35) / EF £55 ($85)**

12353 F. Rev. PROVIDENT AVGG, Providentia stg. l., holding corn-ears and cornucopiae, modius at feet, XXI preceded by officina mark V or VI (= 5 or 6) in ex. RIC 303. C 111. Hunter, p. clxiii. Cf. Pink, p. 28, series 4. *[Ticinum, AD 283].* **VF £22 ($35) / EF £55 ($85)** *This is possibly a hybrid with a reverse of Numerian.*

12354 H. Rev. SAECVLI FELICTAS, Carinus, in military attire, stg. r., holding transverse spear and globe, officina mark D (= 4) in field. RIC 214. C 120. Hunter 37. Pink, p. 22, series 4. *[Lugdunum, AD 283].* **VF £16 ($25) / EF £45 ($65)**

12355 Similar, but with obv. F, rad. bust l., wearing imperial mantle and holding sceptre surmounted by eagle. RIC 215. C 118. Cf. Hunter, p. clxiii. Pink, p. 23, series 5. *[Lugdunum, AD 284].* **VF £40 ($60) / EF £100 ($150)**

12356 H. Rev. SALVS AVGG, Salus stg. r., feeding snake held in her arms, officina mark D (= 4) in field, sometimes with mint mark LVG in ex. RIC 216. C 122. Hunter, p. clxiii. Pink, p. 23, series 4. *[Lugdunum, AD 283].* **VF £16 ($25) / EF £45 ($65)**

12357 F. Rev. VICTORIA AVG, Victory advancing l., holding wreath and palm, XXI preceded by officina mark Q (= 4) and followed by mint mark T in ex. RIC 304. C 135. Hunter, p. clxiii. Pink, p. 29, series 5. *[Ticinum, AD 283].* **VF £16 ($25) / EF £45 ($65)**

 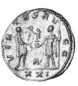

12358 12362

12358 F. Rev. VICTORIA AVGG, similar, but with officina mark A (= 1) in field, nothing in ex. RIC 220. C 151. Hunter, p. clxiii. Pink, p. 24, series 6. *[Lugdunum, AD 284].* **VF £16 ($25) / EF £45 ($65)**

12359 Similar, but Victory stg. r. on globe. RIC 222. C 143. Hunter, p. clxiii. Pink —. *[Lugdunum, AD 284].* **VF £20 ($30) / EF £50 ($75)**

12360 J. Rev. VIRTVS AVGG, Mars advancing r., holding transverse spear and shield, KA followed by officina mark ε (= 5) in ex. RIC 270. C 171. Hunter, p. clxi. Pink, p. 33, series 3a. *[Rome, AD 283].* **VF £20 ($30) / EF £50 ($75)**

12361 H. Rev. — Virtus stg. r., foot on helmet, resting on spear and holding parazonium, officina mark A (= 1) in field, sometimes with mint mark LVG in ex. RIC 223. C 173. Hunter 39. Pink, p. 23, series 4. *[Lugdunum, AD 283].* **VF £16 ($25) / EF £45 ($65)**

12362 J. Rev. — Carinus and Numerian, both in military attire, stg. facing each other, the figure on r. presenting to the other a globe which is usually surmounted by Victory, the one on l. holding short sceptre (sometimes eagle-tipped), the other resting on long sceptre (or spear), XXI in ex., officina mark A-εΔ (= 1–9), sometimes with star above, in field. RIC 325. C 184. Hunter 46–8. Pink, p. 56, series 4. *[Antioch, AD 284].* **VF £16 ($25) / EF £45 ($65)** *On this type and the next the figure on right sometimes appears to be Jupiter.*

12363 **Billon antoninianus.** J. Rev. — similar, but the globe is not surmounted by Victory, sometimes with dot at end of legend, and with mint mark TR with star above in field. RIC 329. C 179, 181. Hunter, p. clxvi. Pink, p. 57, series 2. *[Tripolis, AD 284].*

VF £20 ($30) / **EF** £50 ($75)

12364 J. Rev. VIRTVTI AVGG, Hercules resting on club, as 12336, KA followed by officina mark Z (= 7) in ex. RIC 271. C 191. Hunter 24. Pink, p. 34, series 3a. *[Rome, AD 283].*

VF £22 ($35) / **EF** £55 ($85)

12365 J. Rev. VOTA PVBLICA, Carinus and Numerian, both in military attire, stg. facing each other, sacrificing over altar between them, two standards in background, mint and officina marks S M S XXI B *or* Γ (= 2nd or 3rd officina) in ex. RIC 315. C 194. Hunter 43. Pink, p. 48, series 6. *[Siscia, AD 284].* VF £30 ($45) / **EF** £75 ($110)

12366 **Billon denarius.** F, laur. and cuir. bust r. Rev. PAX AVGG, Pax advancing l., holding olive-branch and sceptre. RIC —. C —. Hunter 33. Pink, p. 48, series 6. *[Rome or Siscia, AD 284].* VF £265 ($400) / **EF** £665 ($1,000)

12367 **Billon quinarius.** IMP CARINVS P AVG, laur. and cuir. bust r. Rev. As previous, but with Δ in ex. RIC 278. C 67. Hunter, p. clxi. Pink, p. 48, series 6. *[Rome or Siscia, AD 284].*

VF £200 ($300) / **EF** £500 ($750)

12368

12368 Obv. As 12366. Rev. VIRTVS AVGG, Mars or Virtus stg. l., resting on shield and spear. RIC 283. C 169. Hunter, p. clxi. Pink, p. 36, series 4. *[Rome, AD 283].*

VF £200 ($300) / **EF** £500 ($750)

12369 E, laur. and cuir. bust r. Rev. — Hercules resting on club, as 12336. RIC 284. C 166. Hunter, p. clxix. Pink, p. 36, series 4. *[Rome, AD 283].* VF £230 ($350) / **EF** £600 ($900)

12370 **Bronze reduced sestertius or as.** J, laur., dr. and cuir. bust r. Rev. PAX AVGG, Pax advancing l., as 12366. RIC 285, 289. C 64–5. Hunter, p. clxi. Pink, p. 48, series 6. *[Rome or Siscia, AD 284].* F £250 ($375) / **VF** £550 ($850)

NB The *aes* coinage of this reign exists in a range of sizes and weights and it possible that some of the smaller and lighter specimens may represent a separate denomination — a reduced as or semis. Alternatively, there may have been a reduction in the weight standard of the sestertius during the course of the issue.

12371 Obv. As 12366. Rev. VICTORIA AVG, Victory advancing l., holding wreath and palm. RIC 286. C 134. Hunter, p. clxi. Pink, p. 38, series 5. *[Rome, AD 284].*

F £250 ($375) / **VF** £550 ($850)

12372 — Rev. VIRTVS AVGG, Hercules resting on club, as 12336. Cf. RIC 287, 291 (the first misdescribed). C 165. Hunter, p. clxi. Pink, p. 36, series 4. *[Rome, AD 283].*

F £250 ($375) / **VF** £550 ($850)

12373 — Rev. — Carinus, in military attire, stg. r., holding spear and globe. RIC 288, 290. C 174–5. Hunter, p. clxi. Pink, p. 36, series 4. *[Rome, AD 283].* F £250 ($375) / **VF** £550 ($850)

Alexandrian Coinage

As Caesar

All have obv. A K M A KAPINOC K, laur. and cuir. bust r. The reverse types are as follows:

12374 **Billon tetradrachm.** Nike (= Victory) advancing r., holding wreath and palm, L — A (= regnal year 1) in field, sometimes with star before. Dattari 5574–5. BMCG —. Cologne 3171. Milne 4665, 4686. *[AD 282–3]*. **VF** £15 ($22) / **EF** £38 ($55)

12375 Tyche (= Fortuna) stg. l., holding rudder and cornucopiae, L A (= regnal year 1) before, sometimes with star behind. Dattari 5576–7. BMCG 2448. Cologne 3172. Milne 4667, 4687. *[AD 282–3]*. **VF** £12 ($18) / **EF** £30 ($45)

12376 Eagle stg. facing between two vexilla, hd. r., wings open, holding wreath in beak, L A (= regnal year 1) above, sometimes with star. Dattari 5578–9. BMCG 2449. Cologne 3169. Milne 4679, 4692. *[AD 282–3]*. **VF** £12 ($18) / **EF** £30 ($45)

As Augustus

All have obv. A K M A KAPINOC CEB, laur. and cuir. bust r. The reverse types are as follows:

12377 **Billon tetradrachm.** Tyche stg., as 12375, star in rev. field. Dattari 5591. BMCG 2458. Cologne —. Milne 4688. *[AD 283]*. **VF** £13 ($20) / **EF** £32 ($50)

12378 Athena seated l., holding Nike and sceptre, shield at side, L — B (= regnal year 2) in field. Dattari 5581. BMCG/Christiansen 3452. Cologne 3176. Milne 4697. *[AD 283–4]*. **VF** £13 ($20) / **EF** £32 ($50)

 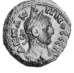 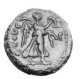

12379 12383

12379 Elpis (= Spes) advancing l., holding flower and lifting skirt, L — B (= regnal year 2) in field, sometimes with star behind. Dattari 5584–5. BMCG 2453–4. Cologne 3177, 3180. Milne 4701, 4721. *[AD 283–4]*. **F** £12 ($18) / **VF** £30 ($45)

12380 Eagle between two vexilla, as 12376, L B (= regnal year 2) above, sometimes with star. Dattari 5596–7. BMCG 2472–3. Cologne 3174–5. Milne 4710, 4728. *[AD 283–4]*. **VF** £12 ($18) / **EF** £30 ($45)

12381 Eirene (= Pax) stg. l., holding olive-branch and transverse sceptre, ETOVC before, Γ (= regnal year 3) behind. Dattari 5583. BMCG 2452. Cologne 3184. Milne —. *[AD 284–5]*. **VF** £16 ($25) / **EF** £40 ($60)

12382 Homonoia (= Concordia) stg. l., r. hand extended, holding double cornucopiae in l., ETOVC before, Γ (= regnal year 3) behind. Dattari 5586. BMCG 2455. Cologne 3185. Milne 4737. *[AD 284–5]*. **VF** £12 ($18) / **EF** £30 ($45)

12383 **Billon tetradrachm.** Nike advancing, as 12374, ETOVC behind, Γ (= regnal year 3) before. Dattari 5590. BMCG 2457. Cologne 3186. Milne 4738. *[AD 284–5].*
VF £12 ($18) / **EF** £30 ($45)

12384 Carinus and Numerian, both togate, stg. facing each other, clasping r. hands, L — Γ (= regnal year 3) in field. Dattari —. BMCG —. Cologne —. Milne —. Emmett 4008 (citing ANS). *[AD 284].*
VF £45 ($65) / **EF** £100 ($150)

12385 Eagle stg. l., hd. r., wings closed, holding wreath in beak, ETOVC before, Γ (= regnal year 3) behind. Dattari 5592. BMCG 2460. Cologne 3182. Milne 4741. *[AD 284–5].*
VF £13 ($20) / **EF** £32 ($50)

12386 Similar, but with LEΓ B TPAI (= *Legio II Traiana*) before and L Γ (= regnal year 3) behind. Dattari 5593. BMCG 2459. Cologne 3183. Milne 4742. *[AD 284–5].*
VF £20 ($30) / **EF** £50 ($75)

Legio II Traiana was raised by Trajan early in the 2nd century for service in the Dacian Wars. It was later transferred to Syria and under Hadrian, circa AD 125, it was sent to its eventual permanent station at Nicopolis, close to Alexandria in Egypt. It probably participated in the Persian Wars of Carus and Numerian and may have distinguished itself during that campaign (see also no. 12279).

CARINUS AND NUMERIAN

This rare series was probably issued in the summer of AD 284, a few months prior to the death of Numerian in Asia Minor on his way to an autumn meeting with his brother.

12387 **Gold aureus.** CARINVS ET NVMERIANVS AVGG, conjoined laur. and dr. busts r. of Carinus and Numerian. Rev. VICTORIA AVGG, Victory advancing l., holding wreath and palm. RIC 330. Calicó 4405. C 2. Hunter, p. clxvii. Pink, p. 23, series 6. [Lugdunum or Rome, AD 284].
VF £4,000 ($6,000) / **EF** £10,000 ($15,000)

12388 Similar, but with rev. type Victory advancing r., holding trophy with both hands. RIC — (but cf. 332 for a denarius which may be a pattern for the aureus). Calicó 4405a. C — (cf. 4). Hunter, p. clxvii. Pink, p. 24, series 6. *[Lugdunum or Rome, AD 284].*
VF £4,000 ($6,000) / **EF** £10,000 ($15,000)

12389 **Billon denarius.** As 12387. RIC 31. C 3. Hunter 1. Pink, p. 23, series 6. *[Lugdunum or Rome, AD 284].* VF £665 ($1,000) / **EF** £1,650 ($2,500)
This and the next may be patterns for aurei rather than normal billon coinage struck for circulation.

12390 As 12388. RIC 332. C 4. Hunter, p. clxvii. Pink, p. 24, series 6. *[Lugdunum or Rome, AD 284].* VF £665 ($1,000) / **EF** £1,650 ($2,500)

CARINUS AND MAGNIA URBICA

Carinus and Magnia Urbica were probably married in the summer of AD 283 and this was doubtless the occasion for the striking of this very rare issue.

12391 **Gold binio.** IMP CARINVS P F AVG, laur. and cuir. bust of Carinus right. Rev. MAGNIA VRBICA AVG, diad. and dr. bust of Magnia Urbica r. Gnecchi I, p. 10, 1. RIC 334. C —. Cf. Hunter, p. clxvii. Pink, p. 36, series 4. *[Rome, AD 283].* *(Unique)*
Although struck with aureus dies this piece is on a large flan weighing 12.50 grams. Gnecchi records that it was found on the Capitoline Hill in Rome in 1902.

12392 **Billon quinarius.** IMP CARINVS AVG, cuir. bust l., wearing laur. helmet and holding horse's hd. by bridle in r. hand and shield in l. Rev. As previous, but empress wears elaborate robe. RIC 335. C 1. Cf. Hunter, p. clxvii. Pink, p. 36, series 4. *[Rome, AD 283].* *(Unique?)*
This may be a pattern for a gold quinarius rather than a regular billon issue.

Issues of Carinus and Numerian in honour of Divus Carus

Carus died in the summer of AD 283 but it was not until the following year that Carinus and Numerian issued commemorative antoniniani recording his deification. Following the death of Numerian towards the end of 284 Carinus struck further posthumous issues, including gold, for Carus as well as antoniniani for Numerian and aurei and antoniniani for a boy named Nigrinian, who seems to have been the emperor's son.

12393 **Gold aureus.** DIVO CARO PIO, laur. hd. of Carus r. Rev. CONSECRATIO, eagle with open wings stg. r., usually on globe, hd. l. RIC 4. Calico 4261–2. C (Carus) 14. Hunter 4. Pink, p. 24, special issue. *[Lugdunum, AD 284–5].*
 VF £2,700 ($4,000) / **EF** £6,700 ($10,000)

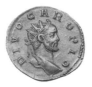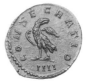

12394

12394 **Billon antoninianus.** DIVO CARO PIO, rad. hd. of Carus r. Rev. — eagle with open wings stg. l., hd. r., usually with officina mark I, II, III, or IIII (= 1, 2, 3, or 4) in ex. RIC 29. C (Carus) 18. Hunter 6–11. Pink, p. 24, special issue. *[Lugdunum, AD 284–5].*
 VF £22 ($35) / **EF** £55 ($85)

12395 DIVO CARO, rad. hd. of Carus r. Rev. — eagle stg. facing, wings spread, hd. l., KA followed by officina mark A (= 1) in ex., sometimes with crescent (or crescent and dot) between the two A's. RIC 47. C (Carus) 15. Hunter 1. Pink, pp. 38–9, series 5–6. *[Rome, AD 284–5].* **VF** £22 ($35) / **EF** £55 ($85)

12396 **Billon antoninianus.** Obv. Similar, but DIVO CARO PERS. Rev. — similar, but always with crescent (or crescent and dot) between the two A's in the mint mark. RIC 48. C (Carus) 17. Hunter, p. clix. Pink, p. 39, series 6. *[Rome, AD 285].* VF £45 ($65) / **EF** £100 ($150)

12397 DIVO CARO PARTHICO, rad. hd. of Carus r. Rev. — eagle stg. r. on globe, hd. l., XXI in ex., officina mark A (= 1) in field. RIC 108. C (Carus) 19. Hunter, p. clix. Pink, p. 46, series 5.2. *[Siscia, AD 284].* VF £32 ($50) / **EF** £80 ($120)

12398 DIVO CARO AVG, rad. hd. of Carus r. Rev. — eagle stg. l., XXI in ex., officina mark Δ (= 4) in field. RIC 126. C (Carus) 16. Hunter, p. clx. Pink, p. 56, series 4. *[Antioch, AD 284].* VF £22 ($35) / **EF** £55 ($85)

12399 Similar, but with T — R in rev. field instead of officina mark. RIC 129. C (Carus) 16. Hunter, p. clx. Pink, p. 57, note 87. *[Tripolis, AD 284].* VF £32 ($50) / **EF** £80 ($120)

12400 Obv. As 12395. Rev. — altar-enclosure with double panelled doors, horns visible above on either side , flames rising from top of altar, KA in ex. followed by officina mark Γ (= 3), or by officina mark A (= 1) with crescent (or crescent and dot) between the two A's. RIC 49. C (Carus) 20. Hunter 3. Pink, pp. 38–9, series 5–6. *[Rome, AD 284–5].* VF £22 ($35) / **EF** £55 ($85)

12401 Obv. As 12396. Rev. — similar, but always with KA A in ex. with crescent (or crescent and dot) between the two A's. RIC 50. C —. Hunter, p. clix. Pink, p. 39, series 6. *[Rome, AD 285].* VF £45 ($65) / **EF** £100 ($150)

12402 Obv. As 12397. Rev. CONSECRATIO AVG, eagle stg. l. (or r.), mint mark S M S XXI in ex., officina mark A (= 1) in field. RIC 112. C (Carus) 22. Cf. Hunter, p. clix. Pink, p. 48, series 6. *[Siscia, AD 284].* VF £32 ($50) / **EF** £80 ($120)

12403 12406

12403 — Rev. — altar-enclosure, as 12400, but with XXI in ex. followed by officina mark A (= 1) or with officina mark in field, or with mint mark S M S XXI in ex. with officina mark A in field. RIC 111. C (Carus) 23. Hunter 12. Pink, pp. 46 and 48, series 5.2 and 6. *[Siscia, AD 284].* VF £32 ($50) / **EF** £80 ($120)

12404 As 12397, but with rev. legend CONSECRATIO AVGVSTI. RIC 113. C —. Hunter, p. clix. Pink, p. 46, series 5.2. *[Siscia, AD 284].* VF £32 ($50) / **EF** £80 ($120)

12405 **Billon tetradrachm.** ΘΕω ΚΑΡω CEB, laur. hd. of Carus r. Rev. ΑΦΙΕΡωCIC, eagle stg. l., hd. r., wings open, sometimes with star above. Dattari 5572–3. BMCG 2445. Cologne 3164. Milne 4708, 4725. *[Alexandria, AD 283–4 or 284–5].* VF £20 ($30) / **EF** £50 ($75)
This type and the next are remarkable in the Alexandrian series for being undated.

12406 **Billon tetradrachm.** Similar, but with rev. type circular lighted altar on base, adorned with
two laurel-branches, sometimes with star in upper field to l. Dattari 5570–71. BMCG
2446–7. Cologne 3167. Milne 4713, 4731. *[Alexandria, AD 283–4 or 284–5].*

VF £20 ($30) / EF £50 ($75)

Issues of Carinus in honour of Divus Numerian

*Numerian died under mysterious circumstances in October/November 284 while traveling through
Asia Minor to meet his brother, thus triggering the events which led to the downfall of Carinus the
following year. The posthumous coinage in Numerian's name seems to have begun at the end of
284 and continued into the early part of 285. Unlike the Divus Carus coinage it was issued entirely
from Rome and no gold has yet been recorded.*

12407 12409

12407 **Billon antoninianus.** DIVO NVMERIANO, rad. hd. of Numerian r. Rev. CONSECRATIO,
eagle stg. facing, wings spread, hd. l., KA followed by officina mark A (= 1) in ex.,
sometimes with crescent (or crescent and dot) between the two A's. RIC 424. C
(Numerian) 10. Hunter 1–2. Pink, pp. 38–9, series 5–6. *[Rome, AD 284–5].*

VF £30 ($45) / EF £75 ($110)

12408 Similar, but with obv. legend DIVI NVMERIANO AVG, KA followed by officina mark A (=
1) in ex. on rev. RIC 425. C —. Hunter, p. clxxii, note 2. Pink —. *[Rome, AD 284–5].*

VF £40 ($60) / EF £100 ($150)

12409 Obv. As 12407. Rev. — lighted altar adorned with garlands, KA followed by officina mark
A (= 1) in ex., with crescent (or crescent and dot) between the two A's. RIC 426. C 12.
Hunter, p. clxxii. Pink, p. 39, series 6. *[Rome, AD 285].* VF £32 ($50) / EF £80 ($120)

Issues of Carinus in honour of Divus Nigrinian

*This young prince is known to have been a grandson of Carus but beyond that we have no certain
knowledge other than that provided by his posthumous coinage, which exists in both gold and
billon. This was struck at Rome in late AD 284/early 285 concurrently with issues in the names of
Divus Numerian and Divus Carus. Nigrinian is generally assumed to have been the son of Carinus
and Magnia Urbica and to have died in infancy during AD 284.*

12410 **Gold aureus.** DIVO NIGRINIANO, bare hd. of Nigrinian r. Rev. CONSECRATIO, pyramidal
crematorium of four storeys with garlanded base, surmounted by prince in biga facing.
RIC 471. Calico 4412. C (Nigrinian) 1. Hunter, p. clxxii. Pink, p. 38, series 5. *[Rome,
AD 284].* VF £12,000 ($18,000) / EF £30,000 ($45,000)

 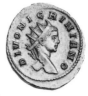

12411

12411 **Billon antoninianus.** Obv. Similar, but rad. hd. Rev. — eagle stg. facing, wings spread, hd. l., KA followed by officina mark A (= 1) in ex., sometimes with crescent (or crescent and dot) between the two A's, or with crescent (or crescent and dot) following the second A. RIC 472. C (Nigrinian) 2. Hunter 1–2. Pink, pp. 38–9, series 5–6. *[Rome, AD 284–5].*
VF £650 ($1,000) / **EF** £1,650 ($2,500)

12412 Similar, but with heroic bust of Nigrinian showing bare chest, and with KA followed by officina mark A (= 1) in ex. on rev. Cf. RIC 472. C (Nigrinian) 3. Hunter —. Pink, p. 38, series 5. *[Rome, AD 284].* VF £800 ($1,200) / **EF** £2,000 ($3,000)

12413 Obv. As 12411. Rev. — lighted altar adorned with garlands, KA followed by officina mark A (= 1) in ex., sometimes with crescent (or crescent and dot) between the two A's. RIC 474. C 5. Hunter 4. Pink, pp. 38–9, series 5–6. *[Rome, AD 284–5].*
VF £650 ($1,000) / **EF** £1,650 ($2,500)

MAGNIA URBICA

12423

History records nothing of the life of this empress though the numismatic evidence makes it clear that she was the wife of Carinus and possibly also the mother of Nigrinian. Her coinage commenced in the summer of AD 283 and it seems reasonable to assume that this was also the date of her marriage. Her fate subsequent to the murder of her husband in 285 is quite unknown.

There are three principal varieties of obverse legend:

A. MAGN VRBICA AVG
B. MAGNIA VRBICA AVG
C. MAGNIAE VRBICAE AVG

The normal obverse type is diademed and draped bust of Magnia Urbica right, with crescent behind shoulders on the antoniniani. At Ticinum her drapery has a more elaborate form resembling an imperial mantle.

12414 **Gold aureus.** C. Rev. CONCORDIA AVGG, Concordia seated left, holding patera and single or double cornucopiae. RIC 348. Calico 4406–7. C 1. Hunter, p. clxviii. Pink, p. 47, series 6. *[Siscia, AD 284].* VF £5,300 ($8,000) / **EF** £13,500 ($20,000)

12415 **Gold aureus.** B. Rev. PVDICITIA AVG, Pudicitia seated l., drawing veil from face and holding transverse sceptre. RIC 339. Calico 4408. C 5. Hunter 1. Pink, p. 35, series 4. *[Rome, AD 283].* **VF** £5,300 ($8,000) / **EF** £13,500 ($20,000)

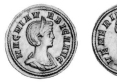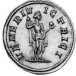

12416

12416 B. Rev. VENERI VICTRICI, Venus stg. r., drawing drapery from r. shoulder and holding apple in l. RIC 340. Calico 4409–10a. C 8. Hunter, p. clxviii. Pink, p. 35, series 4. *[Rome, AD 283].* **VF** £4,700 ($7,000) / **EF** £12,000 ($18,000)

12417 B. Rev. VENVS GENETRIX, Venus stg. l., holding apple and sceptre. RIC 336. Calico 4411. C 10. Hunter, p. clxviii. Pink, p. 24. note 23. *[Lugdunum, AD 284].* **VF** £5,300 ($8,000) / **EF** £13,500 ($20,000)

12418 **Billon antoninianus.** A. Rev. IVNO REGINA, Juno stg. l., holding patera and sceptre, sometimes with peacock at feet, KA followed by officina mark Ϛ (= 6) in ex. RIC 341. C 3–4. Hunter, p. clxviii. Pink, p. 39, series 5. *[Rome, AD 284].* **VF** £170 ($250) / **EF** £365 ($550)

12419 C. Rev. SALVS PVBLICA, Salus seated l., feeding snake arising from altar, mint mark S M S XXI in ex., officina mark A (= 1) in field. RIC 349. C 7. Hunter, p. clxviii. Pink, p. 49, series 6. *[Siscia, AD 284].* **VF** £150 ($225) / **EF** £330 ($500)

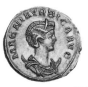

12420 12421

12420 B. Rev. VENVS CELEST, Venus stg. l., holding and apple and sceptre, XXI preceded by officina mark S (= 2) in ex. RIC 345. C 9. Hunter 10. Cf. Pink, p. 29, series 5. *[Ticinum, AD 283].* **VF** £150 ($225) / **EF** £330 ($500)

12421 B. Rev. VENVS GENETRIX, as previous, but nothing ex. and with officina mark D (= 4) in field. RIC 337. C 11. Hunter 8. Pink, p. 24, series 6. *[Lugdunum, AD 284].* **VF** £150 ($225) / **EF** £330 ($500)

12422 C. Rev. — similar, but with Cupid at feet of Venus to l., mint mark S M S XXI in ex., officina mark A (= 1) in field. RIC 350. C 13. Hunter, p. clxviii. Pink, p. 48, series 6. *[Siscia, AD 284].* **VF** £170 ($250) / **EF** £365 ($550)

12423 **Billon antoninianus.** B. Rev. VENVS VICTRIX, Venus stg. l., holding helmet (or Victory) and transverse sceptre and usually resting l. arm on shield behind, XXI in ex. preceded by officina mark S (= 2) and followed by mint mark T (the mint mark is sometimes in field). RIC 347. C 15, 18. Hunter 11. Cf. Pink, p. 29, series 5. *[Ticinum, AD 283].*

VF £150 ($225) / EF £330 ($500)

12424 A. Rev. — Venus stg. l., holding helmet and resting on sceptre, shield at feet to l., KA followed by officina mark S (= 6) in ex., sometimes with crescent (or crescent and dot) between the A and the S, or between the K and the A. RIC 343. C 17. Hunter 2, 4–5. Pink, pp. 39–40, series 5–6. *[Rome, AD 284–5].*

VF £130 ($200) / EF £300 ($450)

12425 **Billon denarius.** B. Rev. VENVS GENETRIX, Venus stg. l., holding apple and sceptre. RIC 338. C 12. Hunter, p. clxviii. Pink Pink, p. 24. note 23. *[Lugdunum, AD 284].* *(Unverified)* *If authentic this may be a pattern for an aureus rather than a denarius struck for circulation.*

12426 MAG VRBICA AVG. Rev. VENERI VICTRICI, Venus stg. r., drawing drapery from r. shoulder and holding apple in l. RIC —. C —. Hunter, p. clxviii. Pink, p. 36, series 4. *[Rome, AD 283].* *(Unique?)* *This may also be a pattern for an aureus.*

12427 **Billon quinarius.** Obv. As previous. Rev. VENERI VICTRI, as previous. RIC 344. C —. Hunter, p. clxviii. Pink, p. 36, series 4. *[Rome, AD 283].* *(Unique?)*

JULIAN OF PANNONIA
Nov. AD 284–Feb. 285

12430

Marcus Aurelius Julianus was the governor of Venetia in northern Italy at the time of Numerian's death in Asia Minor in October/November AD 284. The army of Pannonia immediately proclaimed Julian emperor in opposition to the unpopular Carinus and the usurper made plans to invade Italy. However, Carinus was equal to the challenge and quickly marched against his rival, inflicting total defeat on him in a battle fought near Verona in January or February of 285. Julian perished on the battlefield leaving Carinus and Diocletian to contest control of the Empire. The coinage of Julian is remarkably well-designed and executed for an ephemeral usurper. This was due to his control of the important Pannonian mint of Siscia which produced for him gold aurei of a single type and several varieties of billon antoniniani, all of the finest style of the period.

12428 **Gold aureus.** IMP C IVLIANVS P F AVG, laur., dr. and cuir. bust r. Rev. LIBERTAS PVBLICA, Libertas stg. l., holding pileus and cornucopiae, usually with star in field. RIC 1. Calico 4413, 4416. C 3–4. Hunter 1–2. Pink, p. 49. *[Siscia, AD 284–5].*

VF £6,000 ($9,000) / EF £16,500 ($25,000)

12429 **Billon antoninianus.** IMP C M AVR IVLIANVS P F AVG, rad., dr. and cuir. bust r. Rev. FELICITAS TEMPORVM, Felicitas stg. l., holding short caduceus and resting on sceptre, XXI in ex., mint and officina marks S — B (= 2nd officina) in field. RIC 2. C 1. Hunter, p. clxxiii. Pink, p. 49. *[Siscia, AD 284–5].*

VF £650 ($1,000) / EF £1,650 ($2,500)

12430 **Billon antoninianus.** Obv. As 12429. Rev. **PANNONIAE AVG**, the two Pannoniae stg. facing
 side by side, their hds. turned away from one another, each with r. arm extended, the figure
 on r. holding standard, **XXI** followed by officina mark **Γ** (= 3) in ex., mint mark **S** in field or
 in ex. following officina mark. RIC 4. Cf. C 5–6. Hunter 3. Pink, p. 50. *[Siscia, AD 284–5].*
 VF £800 ($1,200) / **EF** £2,000 ($3,000)

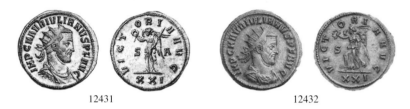

12431 12432

12431 — Rev. **VICTORIA AVG**, Victory stg. l., holding wreath and palm, **XXI** in ex., mint and
 officina marks **S** — **A** (= 1st officina) in field. RIC 5. C 8. Hunter, p. clxxiii. Pink, p. 49.
 [Siscia, AD 284–5]. **VF** £650 ($1,000) / **EF** £1,650 ($2,500)

12432 Similar, but Victory advancing l. RIC 5. C 7. Hunter, p. clxxiii. Pink, p. 49. *[Siscia,
 AD 284–5].* **VF** £650 ($1,000) / **EF** £1,650 ($2,500)

(Continued in Volume IV)

BOOKS AND MONOGRAPHS
ON ROMAN COINS

Where a letter appears in brackets preceding the author's name this indicates the abbreviation used in the catalogue listings in this book when referring to the work in question.

REPUBLICAN

(**B**) BABELON, E. *Description Historique et Chronologique des Monnaies de la République Romaine*. 2 vols. 1885–6.

BANTI, A. *Corpus Nummorum Romanorum, Monetazione Repubblicana*. 9 vols. 1980–1.

BELLONI, G.G. *Le Monete Romane dell'età Repubblicana*. 1960.

(**BMCRR**) GRUEBER, H.A. *Coins of the Roman Republic in the British Museum*. 3 vols. 1910 (revised edition 1970).

BUTTREY, T.V. *The Triumviral Portrait Gold of the Quattuorviri Monetales of 42 BC*. 1956.

CARSON, R.A.G. *Principal Coins of the Romans*. Vol. I. The Republic, *c*. 290–31 BC. 1978.

COHEN, H. *Description Générale des Monnaies de la République Romaine*. 1857.

CRAWFORD, M.H. *Roman Republican Coin Hoards*. 1969.

CRAWFORD, M.H. *Coinage and Money under the Roman Republic*. 1985.

(**CRI**) SEAR, D.R. *The History and Coinage of the Roman Imperators, 49–27 BC*. 1998.

(**CRR**) SYDENHAM, E.A. *The Coinage of the Roman Republic*. 1952.

HAEBERLIN, E.J. *Aes Grave. Das Schwergeld Roms und Mittel Italiens*. 2 vols. 1910.

(**ICC**) THURLOW, B.K. and VECCHI, *Italian Cast Coinage*. 1979.

PINK, K. *The Triumviri Monetales and the Structure of the Coinage of the Roman Republic*. 1952.

ROLLAND, H. *Numismatique de la République Romaine*. 1924.

(**RRC**) CRAWFORD, M.H. *Roman Republican Coinage*. 2 vols. 1974.

(**RRM**) HARLAN, M. *Roman Republican Moneyers and Their Coins, 63 BC–49 BC*. 1995.

(**RSC**) SEABY, H.A. *Roman Silver Coins*. Vol. I. Republic–Augustus. 3rd edition. 1978.

SYDENHAM, E.A. *Aes Grave*. 1926.

THOMSEN, R. *Early Roman Coinage. A Study of the Chronology*. 3 vols. 1957–61.

IMPERIAL

AKERMAN, J.Y. *Coins of the Romans relating to Britain*. 1844.

ALFÖLDI, A. & E. and CLAY, C.L. *Die Kontorniat-Medaillons*. 2 vols. 1976.

ASKEW, G. *The Coinage of Roman Britain*. 2nd edition. 1980.

BALDUS, H.R. *Uranius Antoninus – Münzprägung und Geschichte*. 1971.

BANTI, A. *I Grande Bronzi Imperiali*. 9 vols. 1983–6.

BANTI, A. and SIMONETTI, L. *Corpus Nummorum Romanorum*. 18 vols. 1972–8.

BASTIEN, P. *Le Monnayage de Magnence (350–353)*. 1964.

BASTIEN, P. *Le Monnayage de Bronze de Postume*. 1967.

BASTIEN, P. *Le Monnayage de l'Atelier de Lyon. De la réouverture de l'Atelier par Aurélien à la mort de Carin (fin 274–285)*. 1976.

BASTIEN, P. *Le Monnayage de l'Atelier de Lyon. Dioclétien et ses corégents avant la Réforme Monétaire (285–294)*. 1972.

BASTIEN, P. *Le Monnayage de l'Atelier de Lyon. De la Réforme de Dioclétien à la fermeture temporaire de l'Atelier en 316 (294–316)*. 1980.

BASTIEN, P. *Le Monnayage de l'Atelier de Lyon. De la réouverture de l'Atelier en 318 à la mort de Constantin (318–337)*. 1982.

BASTIEN, P. *Le Monnayage de l'Atelier de Lyon. De la mort de Constantin à la mort to Julien (337–363)*. 1985.

BASTIEN, P. *Le Monnayage de l'Atelier de Lyon du règne de Jovien à la mort de Jovin (363–413)*. 1987.

BASTIEN, P. and HUVELIN, H. *Trouvaille de Folles de la Periode Constantinienne (307–317)*. 1969.

BASTIEN, P. and METZGER, C. *Le Trésor de Beaurains (dit d'Arras)*. 1977.

BASTIEN, P. and VASSELLE, F. *Le Trésor Monetaire de Domqueur (Somme)*. 1965.

BESLEY, E. and BLAND, R. *The Cunetio Treasure, Roman Coinage of the Third Century* AD. 1983.

BLAND, R. (editor). *The Chalfont Hoard and other Roman Coin Hoards*. 1992.

BLAND, R. and BURNETT, A. (editors). *The Normanby Hoard and other Roman Coin Hoards*. 1988.

(**BMCRE**) *Coins of the Roman Empire in the British Museum*.
 Vol. I. Augustus–Vitellius, by H. Mattingly. 1923 (revised edition 1976).
 Vol. II. Vespasian–Domitian, by H. Mattingly. 1930 (revised edition 1976).
 Vol. III. Nerva–Hadrian, by H. Mattingly. 1936 (revised edition 1966).
 Vol. IV. Antoninus Pius–Commodus, by H. Mattingly. 1940 (revised edition, in 2 vols., 1968).
 Vol. V. Pertinax–Elagabalus, by H. Mattingly. 2 vols. 1950 (revised edition in 2 vols., 1976).
 Vol. VI. Severus Alexander–Balbinus and Pupienus, by R.A.G. Carson. 1962.

BREGLIA, L. *Roman Imperial Coins, Their Art and Technique*. 1968.

BRUCK, G. *Die Spätrömische Kupferprägung*. 1961.

(**C**) COHEN, H. *Description Historique des Monnaies frappées sous l'Empire Romain*. 2nd edition. 8 vols. 1880–92.

CARRADICE, I. *Coinage and Finances in the Reign of Domitian, AD 81–96*. 1983.

CARSON, R.A.G. *Principal Coins of the Romans*. Vol. 2. The Principate, 31 BC–AD 296. 1979.

CARSON, R.A.G. *Principal Coins of the Romans*. Vol. 3. The Dominate, AD 294–498. 1981.

CARSON, R.A.G., HILL, P.V. and KENT, J.P.C. *Late Roman Bronze Coinage, AD 324–498*. 1960.

CASEY, P.J. *Roman Coinage in Britain*. 1980.

CAYÓN, J.R. *Los Sestercios del Imperio Romano*. 1984.
 Vol. I. De Pompeyo Magno a Matidia (del 81 a.C. al 117 d.C.).
 Vol. II. De Adriano a Faustina Madre (del 117 d.C. al 161 d.C.).
 Vol. III. De Marco Aurelio a Caracalla (del 161 d.C. al 217 d.C.).

(**CBN**) GIARD, J.-P. *Catalogue des Monnaies de l'Empire Romain*.
 Vol. I. Auguste. 1976 (revised edition 1988).
 Vol. II. De Tibère à Néron. 1988
 Vol. III. Du Soulèvement de 68 après J.-C. à Nerva. 1998.

(**CSS**) HILL, P.V. *The Coinage of Septimius Severus and his Family of the Mint of Rome, AD 193–217*. 1977.

EDDY, S.K. *The Minting of Antoniniani AD 238–249 and the Smyrna Hoard*. 1967.

FRANKE, P.R. and HIRMER, M. *Römische Kaiserporträts im Münzbild*. 3rd edition. 1972.

FROEHNER, W. *Medaillons de l'Empire Romain*. 1878.

GILLJAM, H.H. *Antoniniani und Aurei des Ulpius Cornelius Laelianus, Gegenkaiser des Postumus*. 1982.

GNECCHI, F. *The Coin Types of Imperial Rome*. 1908.

GNECCHI, F. *I Medaglioni Romani*. 3 vols. 1912.

GÖBL, R. *Regalianus und Dryantilla*. 1970.

GRANT, M. *Roman Anniversary Issues: an exploratory study of the numismatic and medallic commemoration of anniversary years, 49 B.C.–A.D. 375*. 1950.

GRANT, M. *Roman Imperial Money*. 1954.

GRANT, M. *Roman History from Coins: some uses of the Imperial coinage to the historian*. 1958.

GRANT, M. *The Six Main* Aes *Coinages of Augustus*. 1953.

GRIERSON, P. and MAYS, M. *Catalogue of Late Roman Coins in the Dumbarton Oaks Collection and in the Whittemore Collection, from Arcadius and Honorius to the Accession of Anastasius*. 1992.

GRUEBER, H.A. *Roman Medallions in the British Museum*. 1874.

HAHN, W. *Moneta Imperii Romani-Byzantini: Die Ostprägung des Römischen Reiches im 5. Jahrhundert (408–491)*. 1989.

HILL, P.V. *'Barbarous Radiates' – Imitations of Third-Century Roman Coins*. 1949.

KING, C.E. (see SEABY, H.A., *Roman Silver Coins*, Vol. V).

KRAAY, C.M. *The Aes Coinage of Galba*. 1956.

MAC DOWALL, D.W. *The Western Coinages of Nero*. 1979.

MARTIN, P.-H. *Die Anonymen Münzen des Jahres 68 nach Christus*. 1974.

MAURICE, J. *Numismatique Constantinienne*. 3 vols. 1908–12.

MAZZINI, G. *Monete Imperiali Romane*. 5 vols. 1957–8.

METCALF, W.E. *The Cistophori of Hadrian*. 1980.

MILLER, D. *Coins of Roman Britain*. 1976.

(MIR) *Moneta Imperii Romani*.
> Vols. 2 and 3. Die Münzprägung der Kaiser Tiberius und Caius (Caligula) 14/41, by W. Szaivert. 1984.
> Vol. 18. Die Münzprägung der Kaiser Marcus Aurelius, Lucius Verus und Commodus (161/192), by W. Szaivert. 1986.
> Vol. 27. Die Münzprägung des Kaisers Maximinus I Thrax (235/238), by M. Alram. 1989.
> Vol. 47. Die Münzprägung des Kaisers Aurelianus (270/275), by R. Göbl. 2 vols.1995.

MONTENEGRO, E. *Monete Imperiali Romane*. 1988.

(MPN) BLAND, R.F., BURNETT, A.M., BENDALL, S. *The Mints of Pescennius Niger*. 1987.

REECE, R. *Coinage in Roman Britain*. 1987.

(RIC) *Roman Imperial Coinage*.
> Vol. I. Augustus–Vitellius, by H. Mattingly and E.A. Sydenham. 1923 (revised edition 1984 by C.H.V. Sutherland).
> Vol. II. Vespasian–Hadrian, by H. Mattingly and E.A. Sydenham. 1926.
> Vol. III. Antoninus Pius–Commodus, by H. Mattingly and E.A. Sydenham. 1930.
> Vol. IV, part I. Pertinax–Geta, by H. Mattingly and E.A. Sydenham. 1936.
> Vol. IV, part II. Macrinus–Pupienus, by H. Mattingly, E.A. Sydenham and C.H.V. Sutherland. 1938.
> Vol. IV, part III. Gordian III–Uranius Antoninus, by H. Mattingly, E.A. Sydenham and C.H.V. Sutherland. 1949.
> Vol. V, part I. Valerian–Florian, by P.H. Webb. 1927.
> Vol. V, part II. Probus–Amandus, by P.H. Webb. 1933.
> Vol. VI. Diocletian–Maximinus, by C.H.V. Sutherland. 1967.
> Vol. VII. Constantine and Licinius, by P.M. Bruun. 1966.
> Vol. VIII. The Family of Constantine, by J.P.C. Kent. 1981.
> Vol. IX. Valentinian I–Theodosius I, by J.W.E. Pearce. 1951.
> Vol. X. The Divided Empire and the Fall of the Western Parts, AD 395–491, by J.P.C. Kent. 1994.

ROBERTSON, A.S. *Roman Imperial Coins in the Hunter Coin Cabinet, University of Glasgow*.
> Vol. I. Augustus–Nerva. 1962.
> Vol. II. Trajan–Commodus. 1971.
> Vol. III. Pertinax–Aemilian. 1977.

Vol. IV. Valerian I–Allectus. 1978.
Vol. V. Diocletian (Reform)–Zeno. 1982.
RODEWALD, C. *Money in the Age of Tiberius*. 1976.
(**RSC**) SEABY, H.A. Roman Silver Coins.
 Vol. I. The Republic–Augustus. 3rd edition. 1978.
 Vol. II. Tiberius–Commodus. 3rd edition. 1979.
 Vol. III. Pertinax–Balbinus and Pupienus. 2nd edition. 1982.
 Vol. IV. Gordian III–Postumus. 2nd edition. 1982.
 Vol. V. Carausius–Romulus Augustus (by C.E. King). 1987.
SABATIER, J. *Medaillons Contorniates*. 1860.
SCHULTE, B. *Die Goldprägung der Gallischen Kaiser von Postumus bis Tetricus*. 1983.
SHIEL, N. *The Episode of Carausius and Allectus*. 1977.
STRACK, P.L. *Untersuchungen zur Römischen Reichsprägung des Zweiten Jahrhunderts*. 3 vols.
 1931–7.
SUTHERLAND, C.H.V. *Romano-British Imitations of Bronze Coins of Claudius I*. 1935.
SUTHERLAND, C.H.V. *Coinage and Currency in Roman Britain*. 1937.
SUTHERLAND, C.H.V. *Coinage in Roman Imperial Policy, 31 BC–AD 68*. 1951.
SUTHERLAND, C.H.V. *The Emperor and the Coinage: Julio-Claudian Studies*. 1976.
SUTHERLAND, C.H.V. and KRAAY, C.M. *Catalogue of Coins of the Roman Empire in the
 Ashmolean Museum*. Part I. Augustus. 1975.
SUTHERLAND, C.H.V., OLCAY, N. and MERRINGTON, K.E. *The Cistophori of Augustus*.
 1970.
SYDENHAM, E.A. *The Coinage of Nero*. 1920.
SYDENHAM, E.A. *Historical References on Coins of the Roman Empire from Augustus to
 Gallienus*. 1917.
(**T**) THIRION, M. *Les Monnaies d'Elagabale*. 1968.
TOYNBEE, J.M.C. *Roman Historical Portraits*. 1978.
TOYNBEE, J.M.C. *Roman Medallions*. 1944.
TRILLMICH, W. *Familienpropaganda der Kaiser Caligula und Claudius*. 1978.
TURNER, P.J. *Roman Coins from India*. 1989.
(**UCR**) HILL, P.V. *The Dating and Arrangement of the Undated Coins of Rome, AD 98–148*. 1970.
ULRICH-BANSA, O. Moneta Mediolanensis. 1947.
VAGI, D.L. *Coinage and History of the Roman Empire*. 2 vols. 1999.
VAN METER, D. *The Handbook of Roman Imperial Coins*. 1991.
VOETTER, O. *Die Münzen der Römischen Kaiser, Kaiserinnen und Caesaren von Diocletianus bis
 Romulus (284–476)*. 1921.
WEBB, P.H. *The Reign and Coinage of Carausius*. 1908.

PROVINCIAL

BELLINGER, A.R. *The Syrian Tetradrachms of Caracalla and Macrinus*. 1940.
(**BMCG**) *Catalogue of the Greek Coins in the British Museum*. 29 vols. 1873–1927.
(**BMCG Supplement**) CHRISTIANSEN, E. *Coins of Alexandria and the Nomes, a Supplement to
 the British Museum Catalogue*. 1991.
BUTCHER, K. *Roman Provincial Coins: an Introduction to the Greek Imperials*. 1988.
(**Cologne**) GEISSEN, A. and WEISER, W. *Katalog Alexandrinischer Kaisermünzen der
 Sammlung des Instituts für Altertumskunde der Universität zu Köln*. 5 vols. 1974–83.
CURTIS, J.W. *The Tetradrachms of Roman Egypt*. 1957 (reprinted with supplements 1990).
(**Dattari**) DATTARI, G. *Monete Imperiali Greche. Numi Augg. Alexandrini*. 2 vols. 1901.
Die Antiken Münzen Nord-Griechenlands.
 Vol. I. Dacien und Moesien, by B. Pick and K. Regling. 2 parts, 1898 and 1910.
 Vol. II. Thrakien, by M.L. Strack. 1912.
 Vol. III. Makedonia und Paionia, by H. Gaebler. 2 parts, 1906 and 1935.
FORRER, L., *The Weber Collection of Greek Coins*. 3 vols. 1922–9.

GRANT, M. *From Imperium to Auctoritas: a historical study of the aes coinage in the Roman Empire, 49 BC–AD 14.* 1946.

GRANT, M. *Aspects of the Principate of Tiberius: historical comments on the colonial coinage issued outside Spain.* 1950.

GROSE, S.W. *Catalogue of the McClean Collection of Greek Coins (Fitzwilliam Museum).* 3 vols. 1923–9.

HEAD, B.V. *Historia Numorum.* 2nd edition. 1911.

HEISS, A. *Description Général des Monnaies Antiques de l'Espagne.* 1870.

HOWGEGO, C.J. *Greek Imperial Countermarks, Studies in the Provincial Coinage of the Roman Empire.* 1985.

KADMAN, L. *Corpus Nummorum Palaestinensium.*
 Vol. I. The Coins of Aelia Capitolina. 1956.
 Vol. II. The Coins of Caesarea Maritima. 1957.
 Vol. IV. The Coins of Akko Ptolemais. 1961.

KRAFT, K. *Das System der Kaiserzeitlichen Münzprägung in Kleinasien, Materialien und Entwürfe.* 1972.

LINDGREN, H.C. *Ancient Greek Bronze Coins: European Mints.* 1989.

LINDGREN, H.C. and KOVACS, F.L. *Ancient Bronze Coins of Asia Minor and the Levant.* 1985.

MACDONALD, G. *Catalogue of Greek Coins in the Hunterian Collection, University of Glasgow.* 1899–1905.

(**Milne**) MILNE, J.G. *Catalogue of Alexandrian Coins, University of Oxford, Ashmolean Museum.* 1933 (revised edition 1971 with supplement by C.M. Kraay).

MIONNET, T.-E. *Description des Médailles antiques, grecques et Romaines.* 1806–8 (supplement 1819–37).

MULLER, L. *Numismatique de l'Ancienne Afrique.* 1860–3.

ROSENBERGER, M. *City-Coins of Palestine.* 3 vols. 1972–7.

ROSENBERGER, M. *The Coinage of Eastern Palestine.* 1978.

(**RPC**) *Roman Provincial Coinage.*
 Vol. I. From the Death of Caesar to the Death of Vitellius, 44 BC–AD 69. 2 vols. 1992 (Supplement 1998).
 Vol. II. From Vespasian to Domitian, AD 69–96. 2 vols. 1999.

SEAR, D.R. *Greek Imperial Coins and Their Values.* 1982.

SPIJKERMAN, A. *The Coins of the Decapolis and Provincia Arabia.* 1978.

SUTHERLAND, C.H.V. and KRAAY, C.M. *Catalogue of Coins of the Roman Empire in the Ashmolean Museum.* Part I. Augustus. 1975.

SVORONOS, J.N. *Numismatique de la Crète Ancienne.* 1890.

SYDENHAM, E.A. *The Coinage of Caesarea in Cappadocia.* 1933.

Sylloge Nummorum Graecorum.
 Danish Series. The Royal Collection of Coins and Medals, Danish National Museum, Copenhagen. In 43 parts, 1942–77.
 German Series. Sammlung von Aulock. In 18 parts. 1957–68.
 Switzerland. Levante–Cilicia. 1986 (Supplement 1993).

VON FRITZE, H. *Die Antiken Münzen Mysiens: Adramytion–Kisthene.* 1913.

WADDINGTON, W.H., BABELON, E. and REINACH, T. *Recueil Général des Monnaies Grecques d'Asie Mineure.* 4 vols. 1904–12.

WRUCK, W. *Die Syrische Provinzialprägung von Augustus bis Traian.* 1931.

GENERAL

AKERMAN, J.Y. *A Descriptive Catalogue of Rare and Unedited Roman Coins.* 2 vols. 1834.

BOYNE, W. *A Manual of Roman Coins; from the Earliest Period to the Extinction of the Empire; with Rarity Guide.* 1865 (revised reprint 1968).

BRITISH MUSEUM. *A Guide to the Exhibition of Roman Coins in the British Museum.* 1963.

BURNETT, A. *Coinage in the Roman World.* 1987.

FOSS, C. *Roman Historical Coins*. 1988.

GNECCHI, F. *Roman Coins: Elementary Manual*. 1903.

HILL, G.F. *Historical Roman Coins*. 1909.

HILL, G.F. *Handbook of Greek and Roman Coins*. 1899.

JONES, J. MELVILLE. *A Dictionary of Ancient Roman Coins*. 1990.

KENT, J.P.C. and HIRMER, M. and A. *Roman Coins*. 1978.

LEVY, BOB (with Introduction by David R. Sear). *From the Coin's Point of View*. 1993.

MATTINGLY, H. *Roman Coins from the Earliest Times to the Fall of the Western Empire*. 2nd edition. 1960.

MILNE, J.G. *Greek and Roman Coins and the Study of History*. 1939.

MOMMSEN, T. *Die Geschichte des RömischenMünzwesens*. 1860 (reprinted edition 1956).

PENN, R.G. *Medicine on Ancient Greek and Roman Coins*. 1994.

SEAR, D.R. *The Emperors of Rome and Byzantium*. 2nd edition. 1981.

STEVENSON, S.W. *A Dictionary of Roman Coins*. 1889 (reprinted edition 1964).

SUTHERLAND, C.H.V. *Roman Coins*. 1974.

INDEX TO VOLUME III

References in this index are either to page numbers, in the case of text, or to catalogue entry numbers, in the case of coin listings.

ABBREVIATIONS	page 74
ALEXANDRIAN COINAGE of Maximinus I	nos. 8368–98
Maximus	nos. 8416–44
Gordian I Africanus	nos. 8455–64
Gordian II Africanus	nos. 8474–82
Balbinus	nos. 8507–15
Pupienus	nos. 8547–56
Gordian III, as Caesar	nos. 8811–23
Gordian III, as Augustus	nos. 8824–64
Tranquillina	nos. 8874–900
Philip I	nos. 9068–130
Otacilia Severa	nos. 9189–234
Philip II, as Caesar	nos. 9294–317
Philip II, as Augustus	nos. 9318–41
Trajan Decius	nos. 9434–55
Herennia Etruscilla	nos. 9509–12
Herennius Etruscus	nos. 9543–7
Hostilian	nos. 9598–600
Trebonianus Gallus	nos. 9698–711
Volusian	nos. 9814–26
Aemilian	nos. 9867–74
Valerian	nos. 10042–62
Gallienus	nos. 10534–95
Salonina	nos. 10692–726
Valerian Junior	nos. 10750–59
Saloninus	nos. 10782–94
Macrian	nos. 10814–16
Quietus	nos. 10835–8
Claudius II, Gothicus	nos. 11398–428
Quintillus	nos. 11457–8
Aurelian	nos. 11656–95
Severina	nos. 11712–17
Vabalathus and Aurelian	nos. 11719–22
Vabalathus	nos. 11730–31
Zenobia	nos. 11733–5
Tacitus	nos. 11830–36